www.wadsworth.com

www.wadsworth.com is the World Wide Web site for Wadsworth and is your direct source to dozens of online resources.

At *www.wadsworth.com* you can find out about supplements, demonstration software, and student resources.
You can also send email to many of our authors and preview new publications and exciting new technologies.

www.wadsworth.com
Changing the way the world learns®

From the Wadsworth Series in Broadcast and Production

Writing for Television, Radio, and New Media

Eighth Edition

Robert L. Hilliard
Emerson College

THOMSON ™

WADSWORTH

Australia • Canada • Mexico • Singapore • Spain
United Kingdom • United States

Publisher: Holly J. Allen

Assistant Editor: Shona Burke

Technology Project Manager: Jeanette Wiseman

Marketing Manager: Kimberly Russell

Marketing Assistant: Neena Chandra

Advertising Project Manager: Shemika Britt

Project Manager, Editorial Production: Mary Noel

Print/Media Buyer: Kris Waller

Permissions Editor: Robert Kauser

Production Service: Robin Gold, Forbes Mill Press

Text Designer: Robin Gold

Copy Editor: Robin Gold

Cover Designer: Laurie Anderson

Cover Image: © Helene Hubert, PhotoDisc

Compositor: Linda Weidemann, Wolf Creek Press

Text and Cover Printer: Webcom

Printed in Canada

2 3 4 5 6 7 07 06 05 04

For more information about our products, contact us at:
Thomson Learning Academic Resource Center
1-800-423-0563

For permission to use material from this text, contact us by:
Phone: 1-800-730-2214
Fax: 1-800-730-2215
Web: http://www.thomsonrights.com

Library of Congress Control Number: 2002117142

Student Edition with InfoTrac College Edition:
ISBN 0-534-56417-8

Wadsworth/Thomson Learning
10 Davis Drive
Belmont, CA 94002-3098
USA
www.wadsworth.com

Asia
Thomson Learning
5 Shenton Way #01-01
UIC Building
Singapore 068808

Australia/New Zealand
Thomson Learning
102 Dodds Street
Southbank, Victoria 3006
Australia

Canada
Nelson
1120 Birchmount Road
Toronto, Ontario M1K 5G4
Canada

Europe/Middle East/Africa
Thomson Learning
High Holborn House
50/51 Bedford Row
London WC1R 4LR
United Kingdom

To
Mara and Carl
and
Mark and Desiree
and
Zeke and Natasha

Contents

4 COMMERCIALS AND ANNOUNCEMENTS 66

5 NEWS AND SPORTS 120

6 FEATURES AND DOCUMENTARIES 181

7 INTERVIEW AND TALK PROGRAMS 223

11 PROFESSIONAL OPPORTUNITIES 406

Preface

As with previous editions of *Writing for Television and Radio,* revisions to this Eighth Edition were based on comments and suggestions from users of the book—principally, professors in colleges and universities in the United States and abroad, and students and professionals who have used the book as a text or for reference.

In this edition I have retained the combination of basic principles and hands-on application for each audio and video format presented, an approach that has helped make this book the leading text in its field since it was first published. In addition, this edition continues to provide self-contained content within each chapter for more teaching flexibility. This edition also continues to feature suggestions for writing for special audiences, such as racial and ethnic groups, women, and children. It is my hope that this material will help students become more aware of the multicultural society in which they live—an imperative for current and future professionals, who must understand the needs, concerns, and goals of all peoples and nations if they are to function effectively and contribute meaningfully to an increasingly shrinking world. The terrorist attacks of September 11, 2001, and the war with Iraq make this even more important.

One of the key changes to this edition is that the separate chapter on writing for the Internet has been removed and its content integrated throughout the book. This new approach reflects the increasing presence of the Internet in all media writing. This edition has been further updated by the addition of many more contemporary examples. And, at the suggestion of users of the text, the chapter on playwriting has been expanded to include examples of writing for television dramas and made-for-TV films.

For the student, I wish to emphasize a key rationale for this book: Creativity and talent cannot be taught, but principles and techniques can. If you are willing to devote time, energy, and hard work to learning the basics of writing, you will be able to write at least an adequate script for any video, audio, or cyberspace program or project. If you also have writing talent and the determination to combine it with effective principles and techniques, you are on your way to making important contributions to the media industries. With persistence and luck, you may also find yourself with an Emmy on your mantle and a Porsche in your driveway.

But while you are doing all that, do not forget that television, radio, and now the Internet are the most powerful forces in the world for affecting the minds, emotions, and even the actions of humankind. Like it or not, as a writer for the media, you are (or will be) in a position of tremendous power—and with power goes responsibility. You can choose to use your power to serve *only* the bottom-line economic self-interest that dominates most of the media, or you can choose to *also* make certain that you serve the audience's individual and group well-being. In other words, you can use the media's influence to help make a better world for everyone.

I would like to acknowledge the assistance of Holly Allen, publisher, Nicole George, former assistant editor, and other members of the Wadsworth staff in the publishing of this edition of *Writing for Television and Radio*. And continued kudos to retired editor Becky Hayden. I thank Robin Gold of Forbes Mill Press for her always excellent editing and production. I also appreciate the contributions of my graduate assistants Linda Onyango, Brian Knoth, and Yasmin Madan for obtaining illustrative materials, with my special appreciation to Kris Britt Montag for her excellent work in compiling an updated glossary, list of selected readings, and section on Internet terminology and references and for obtaining new script examples. Finally, I am grateful for the contributions to this edition of colleagues, friends, and strangers, all of whom are duly identified where their contributions appear.

Sincere thanks also go to the following reviewers for their helpful comments and suggestions for this edition: Rustin Greene, James Madison University; Michael Murray, University of Missouri; Judy Oskam, Texas Tech University; Paula Otto, Virginia Commonwealth University; Daniel Panici, University of Southern Maine; and Mike Savoie, Valdosta State University.

About the Author

Robert L. Hilliard began his media writing career as a sports reporter and, after service in World War II, became a radio writer-announcer and a writer-director in the fledgling field of television. While working in the media in New York, including a stint as a newspaper theatre and television critic, he developed the broadcasting curricula at two area colleges. He taught a writing course that became the basis for this book, first published in 1962 and named by *Writer's Market* as one of the 10 best books on writing.

He spent more than 15 years at the Federal Communications Commission (FCC) in Washington, D.C., as Chief of the Educational (Public) Broadcasting Branch. He also served as Chair of the Federal Interagency Media Committee, linking 25 federal agencies and reporting to the White House, and chaired other federal media and education groups. Hilliard left Washington to become Emerson College's first Dean of Graduate Studies and is currently a tenured professor of media arts. He has been an officer, board member, and committee or project chair for a number of professional organizations and national, state, and community groups.

Hilliard earned a B.A. degree from the University of Delaware, M.A. and M.F.A. degrees at Western Reserve University, and a Ph.D. from Columbia University. He has published more than 30 volumes on the media, including, with co-author Michael Keith, *The Broadcast Century: A Biography of American Radio and Television; Global Broadcasting Systems; Waves of Rancor: Tuning In the Radical Right;* and *Dirty Discourse: Sex and Indecency on American Radio.* He is also author of *Surviving the Americans: The Continued Struggle of the Jews After Liberation* and *Media, Education, and America's Counter-Culture Revolution.*

Dedicating his work in communications to world peace, equal opportunity, and civil justice, Hilliard has been a consultant for government, industry, and education in the United States and abroad, lectured on all continents, published dozens of articles, and made hundreds of speeches on media potentials and responsibilities, including their application to world affairs and education.

1

The Mass Media

During the process of writing, the writer is isolated, alone in a room with a typewriter or a word processor. Yet, every word, every visual image has to be created with the thousands and even millions of people watching or listening in mind. When you write for a mass medium, you are writing for a mass audience. The nature of that audience must constantly be in the forefront of your mind and be the key to what you create.

Although millions may hear or see what you have written, they will experience it individually or in small groups: a family at home in a living room, a few youngsters in a schoolyard, several college students in a dorm common room, an individual on a bus or subway, a person alone in a bedroom, a commuter in a car. The Internet audience is even more individualized—one person sitting alone at a computer—yet, at the same time, potentially millions of people throughout the world seeing and hearing at the same moment what you wrote. At one and the same time, you are writing for an individual, for a small number of people who have a lot in common, and for a large number of people who have little in common.

Reaching such an audience effectively is especially difficult because it is not a "captive" audience. Most of what airs over television, radio, and cyberspace is free. Unlike the theatre or movie audience, which has paid a fee and is not likely to leave unless seriously bored or offended, the television or radio audience can press a button, turn a dial, hit a key, or click a mouse to move to something else if it doesn't like what it sees or hears.

People who go to a play or film usually know something about what they are going to see from reading reviews or being influenced by ads. Although some television viewers carefully select shows, most viewers tune in to particular **formats** (evening soaps, family **sitcoms,** police shows) and to specified continuing series, including local and network newscasts, by force of habit. Many people will switch to another program if the one they are

watching does not hold their interest, or they will watch only half-heartedly or intermittently, missing some of the story content and, most important from the point of view of the network and station, the commercials. Radio listeners do the same. They may tune in to a particular music or talk-show format, but if the music or discussion subject is not exactly what they want at the moment, it's easy for them to flip the dial to something more interesting. Many viewers and listeners shop around the dial at random until they find something that grabs their attention. Internet users have an even wider choice than do radio and TV users. Although the latter may have hundreds of channels to choose from, the former can browse the World Wide Web and choose from hundreds of thousands of sources.

What does this mean for the writer? You must capture the attention of the audience as soon as possible and hold it. Every picture and every word must be purposeful, directed toward keeping the audience's interest. As a writer you must make certain that no irrelevancies and no extraneous moments are in your script. Write directly, sharply, and simply! The mass media audience is as diverse as the population of the United States is. The opinions; prejudices; educational, social, and political backgrounds; economic status; and personal creeds of people watching television programming vary from A to Z. Because radio is localized and fractionalized, the audience for a given radio station is likely to be much more homogeneous. The Internet audience consists of as many diverse beliefs, interests, traditions, and backgrounds as there are people in the world.

Because financial rather than artistic or social considerations control programming decisions and content, the producers and advertisers try to reach and hold as large a segment of the viewing or listening population as possible. In television, the easiest and most effective way to do this is to find the broadest common denominator—which frequently turns out to be the lowest. The term *LCD* is used to describe this lowest common denominator programming target. Despite increasing **narrowcasting** programming—programs oriented toward specialized audiences, reflecting the growing number of program and distribution sources such as multinetwork and multichannel cable systems—the primary aim of television producers too often still seems to be to present material that will not offend anyone.

The most popular shows—sitcoms, action adventure, police, lawyers, hospitals—follow that formula. Programs wiling to deal in depth with ideas or to present controversial material are in the minority. There are exceptions. *60 Minutes* does from time to time deal with significant issues, although the degree of controversy the program is willing to tackle is usually mild. Its success prompted a spate of similar shows, such as *Dateline, 48 Hours,* and *20/20.* They sometimes cover key events and touch on issues, but mostly limit their contents to noncontroversial human interest features. News and documentary programs that do deal with controversial issues in depth don't last long. A prime example was Michael Moore's *TV Nation* in the 1990s. It satirized America's and the world's sacred cows and garnered critical acclaim as well as an Emmy award. It was dumped by both CBS and FOX despite tens of thousands of letters from the public supporting the show. The same fate befell *Politically Incorrect* in 2002 when the host, Bill Maher, dared to exercise his constitutional freedom of speech to question the policies of the president and the government in power at that time.

Nonnews programs such as *The West Wing, NYPD Blue, The Practice,* and *Boston Public* have dealt with controversial issues of significance to America and the world to a greater extent than have news programs. However, they don't dare deal with issues that are too controversial. One of the best-written and produced programs in the early 2000s, *The Education of Max Bickford,* did, and didn't last long.

Although usually conservative on ideas, television became less conservative about social behavior at the end of the twentieth century and the beginning of the twenty-first century. Partial nudity and profane language became more and more acceptable. *NYPD Blue* set the tone for such content in the 1990s within the context of well-written drama. Sitcoms such as *Friends* and *Sex in the City* have carried on this approach.

Controversy developed more slowly on television than it did on radio. *Donahue* was the model for programs such as *The Oprah Winfrey Show* and *Larry King Live!* Fueled by the nation's conservative political trend through the 1980s and 1990s, unabashedly right-wing commentators such as Rush Limbaugh began to dominate the radio airwaves with their talk shows. Hundreds of radio stations, broadcast television, and cable channels encouraged arguments on controversial issues, with studio guests and call-ins. Some programs, such as the *Jerry Springer Show,* encouraged not only arguments but anger leading to violence. In addition, "reality" shows featuring quasi-documentary, quasi-news approaches became a fad and drew high **ratings.**

Although obscene material is banned from the airways by law, indecent and profane material is permissible under certain circumstances. As epitomized by Howard Stern, radio "shock jocks" have taken advantage of those circumstances, despite frequent fines by the Federal Communications Commission. As described in the Hilliard and Keith book, *Dirty Discourse,* sex and salaciousness have become staples of many morning and afternoon, as well as late evening radio shows, not only in shock jock programs but in the lyrics of much contemporary music, particularly rap.

DEMOGRAPHICS

Radio audiences are not as diverse as are television audiences. When network radio, which was comparable to network television today, disappeared in the 1950s as television took over the older medium's most attractive programs and stars, radio, to survive, became fragmented into local audiences. Individual stations developed formats that appealed to specifically targeted groups of listeners.

The makeup of the potential audience for a given program or station is called **demographics.** The principal demographics are age, gender, and the given market's locale. Some demographic studies go deeper, into job or profession, income, and education. When the audience's beliefs, attitudes, and behavior are included—such as political affiliation, religion, where the viewer or listener shops, and what brands he or she buys—it is called psychographics. These conditions and interests of the audience determine the kinds of writing that appeal to the given audience, as well as the product or service the audience is

most likely to purchase. The demographics of radio audiences sometimes are even more precise than those of television audiences. Because radio is virtually all music—with the exception of some full-service stations, talk stations, all-news and all-sports stations, and a few other specialized stations—each station attempts to program to a specified group of loyal listeners who are attracted to a particular music type and format. Radio stations even break down their potential audience into which interest groups might be listening in a particular place (home, work, car) and at a particular time of day or night. Cable audiences are fairly easily targeted because most cable channels are narrow in content, with the given channel's viewers interested in that kind of programming. Individual Web sites are quite narrow in scope, and those who log on, with the exception of some browsers, do so because they are interested in that site's subject matter.

A successful program type or format prompts repetition. When *Hill Street Blues* became successful, a plethora of copycat police programs hit the screen. *ER*'s success inspired a spate of hospital shows. Formula writing dominates most television series. Several decades ago, after a study of competition and responsibility in network television broadcasting, the **Federal Communications Commission (FCC)** stated, "By and large, episodes of television series are produced on the basis of 'formulas'—approved in advance by the network corporation and often its mass advertisers—which 'set' the characters, 'freeze' theme and action, and limit subject matter to 'tested' commercial patterns." Things haven't changed! There are exceptions. Some individual program series present individual episodes of high quality. Opportunity does exist for the writer to develop scripts of high artistic value as well as scripts requiring a mastery of formula technique.

THE ELECTRONIC MEDIA

Thus far we have dealt, principally, with the television and radio media. What about films made for TV? What about **cable?** Is there a difference between a script prepared for a cable pay channel and that written for a local cable access channel? Is a different writing approach needed for material distributed by satellite? Are there special techniques in writing for **fiber optic systems?** Does one write differently for the Internet? What about other systems that make up the panoply of *electronic mass media?* By and large, the means of distribution is irrelevant. To paraphrase Gertrude Stein, writing is writing is writing. No matter what technology is used to send out and receive the video or audio signal, the program form is essentially the same. The demographics may differ among people watching a local cable access channel or a local station broadcast channel or a channel received on a home satellite dish. The material permissible on an over-the-air station can differ from that seen on a pay-per-view "adult" channel. But the techniques of writing programs for the type of format, whether for broadcast or cable, remain the same. *Television* is the term used here to describe all video writing, and *radio* is the term used to describe all audio writing for the mass media.

Therefore, no distinction is made in this book among writing for broadcast, cable, or satellite transmission except where the demographics or other special considerations

mandate different format or technique requirements. That is not true, however, for cyberspace. Although at this point in its development, the Internet's entertainment and news programs are largely unchanged adaptations of audio and video writing, as the Internet continues to grow into its potential as a communications medium, it will require different approaches and techniques.

Production techniques, however, are a different matter. The writer must know the production elements to understand what each medium can do and must know how to write specifically for the eye and ear, in addition to mastering the use of words. For example, the film format for television is not the same as the tape format. Different considerations apply to shows taped for editing than apply to **live-type** shows taped before a studio audience. Further differences exist between studio and field productions. Within each format, reflecting different aesthetic as well as physical approaches, are varying production techniques, made possible by different equipment and technical devices. The writer must understand and use the production elements, just as a painter understands and uses different brushes, canvasses, and paints. The writer's basic tools will be covered in Chapter 2.

In recent years, a rapidly increasing number of people throughout the world have been viewing and listening to more and more video and audio programs on the "new media"—specifically, the Internet. Although other technologies developed after radio and television, such as cable and satellite, are often referred to as "new media," they are essentially distribution systems. Except for programming in the larger sense—such as narrowcasting, given the multiple channels and fragmented video audiences here in the United States—their aesthetics are essentially the same as the older media. That is, they rarely require special or different writing techniques for their programs. They merely distribute through an additional service the programs that otherwise would be aired over traditional television or radio.

But cyberspace is different. The Internet sets up a number of special technical, aesthetic, and psychological parameters that the writer must understand and use if he or she is to prepare a script that has optimum impact in the new medium. In this sense, the Internet is to the writer today what television was when it first opened up to programming. The writer than had to deal with a number of different configurations—as discussed in Chapters 1, 3, and 10—that made, for example, the approaches used for writing a drama or documentary for film or a play for the stage or any program for radio inapplicable to TV.

TELEVISION AND THE MASS AUDIENCE

Television can combine the live performance values of theatre, the mechanical abilities of film, the sound and audience orientation of radio, and its own electronic capacities. Television can use the best of all previous communication media.

Television combines both subjectivity and objectivity in relation to the audience, fusing two areas frequently thought of as mutually exclusive. With the camera and various electronic devices, the writer and director can subjectively orient the audience's attentions and emotions by directing them to specific stimuli. The television audience cannot choose

its focus, as does the stage audience, from among all the aspects of any given presentation. The television audience can be directed, through a **close-up,** a **zoom,** a **split screen,** or other camera or **control board (switcher)** movement, to focus on whatever object or occurrence most effectively achieves the purpose of the specific moment in the script. Attention can be directed to subtle reaction as well as to obvious action.

Objectivity is crucial to lending credibility to nondramatic programming such as newscasts and documentaries. Creating an objective orientation is accomplished by bringing the performer more openly and directly to the viewer, for example, through the close-up or the zoom, than can be done in the large auditorium or theatre, even with a live performance, or in the expanse of a movie house. Unlike most drama, where the purpose is to create illusion, the performer in the nondramatic program (television host/hostess, announcer, newscaster) wants to achieve a non-illusionary relationship with the audience. At the same time, the small screen, the limited length of most programs, and the intimacy of the living room create effects and require techniques different from those of a film shown in a movie theatre.

Stemming from the early days of television when all productions were live with continuous action, nonfilmed television continues to maintain a continuity of action that differs from the usually frequent changes in picture that one sees on the movie screen. Some television programs are still done as if they were live: taped with few breaks in the action. In this respect, television borrows a key aesthetic element from the theatre.

Television is restricted by the small screen, which limits the number of characters and the size of the setting (note how poorly large scale films look on television), and by the limited time available for a given dramatic program (approximately 21 minutes of playing time for a half-hour show and 42 minutes for the hour show, after commercial and **intro** and **outro** time has been subtracted). Television uses virtually every mechanical technique of film, adding electronic techniques of its own to give it a special versatility and flexibility. Even so, the most successful shows still reflect a cognizance of the small screen and limited time, concentrating on slice-of-life vignettes of clearly defined characters.

There is a negative side to television's mechanical and electronic expansion. After videotape's advent in 1956 with its editing capabilities, television gradually moved from live to taped and filmed shows, and the center of television production, which had been in New York City with its abundance of trained theatre performers, moved to Hollywood. Soon the Hollywood approach dominated television. Some television critics argue that much of television has become a boxed-in version of the motion picture. Conversely, some film critics believe that television techniques imported to Hollywood may be negatively affecting films, and have made them "smaller, busier, and blander."

The writer must always keep in mind that television is visual. Where a visual element can achieve the desired effect, it should take precedence over dialogue; in many instances, dialogue may be superfluous. A story is told about a famous Broadway playwright, noted for his scintillating dialogue, who was hired to write a film script. He wrote a 30-page first act treatment in which a husband and wife on vacation reach their hotel and go to their hotel room. Thirty minutes of witty and sparkling conversation reveal that the wife has be-

come increasingly disturbed over her husband's attention to other women. An experienced movie director went over the treatment and thought it presented a good situation. However, for the 30 pages of dialogue he substituted less than 1 page of visual directions in which the husband and wife enter the hotel, perfunctorily register, walk to the elevator, enter the elevator where the husband looks appraisingly at the female elevator operator, and the wife's face expresses great displeasure as the elevator doors close.

That many television writers have not yet learned the visual essence of their medium can be determined by a simple test. Turn on your television set and turn the brightness down until the picture is gone, leaving the audio as is. Note in how many programs, from commercials to dramas, you will "see" just about as much as you would with the video on. Is much of television, as some critics say, still just radio with pictures?

Radio and the Mass Audience

Radio is not limited by what can get presented visually. By combining sound effects, music, dialogue, and even silence, the writer can develop a picture in the audience's mind that is limited only by the listener's imagination. Radio permits the writer complete freedom of time and place. There is no limitation on the setting or on movement. The writer can create unlimited forms of physical action and bypass in a twinkling of a musical bridge minutes or centuries of time and galaxies of space.

Before the advent of television, when drama was a staple of radio, writers set the stage for what later were to become the science fiction favorites of television, such as *Star Trek* and its clones, and of film, such as *Star Wars*. Writer Howard Koch's and director Orson Welles's *War of the Worlds* is still famous for its many provocative radio productions throughout the world. Regrettably, radio has become virtually all music. Except for commercials and occasional features, and the growth of talk shows in the past decade, artistic writing and directing in commercial radio are virtually dormant. But they are not dead, and they offer excellent opportunities for those who want to explore the aural medium's potentials.

The radio audience hears only what the writer-director wants it to hear. Audience members "see" a picture in their imaginations. The radio writer can create this mind picture more effectively than can the writer in any other medium because in radio the imagination is not limited by what the eye sees. Radio's subjectivity enables the writer to create places, characters, and events that might be extremely difficult or too costly to show visually.

The writer can place the audience right alongside of or at any chosen distance from a character or performer. Voice distances and relationships to the microphone determine the audience's view of the characters and of the setting. For example, if the audience is listening to two people in conversation and the writer has the first person fade off from the microphone, the audience, in its imagination, stays with the second person and sees the first one moving away. Of course, different listeners may imagine the same sound stimulus in different ways because each person's psychological and experiential background is different. Nevertheless, the good writer finds enough common elements to stimulate common emotions and reactions.

No television show, for example, has ever created the mass hysteria of radio's *War of the Worlds.*

A scene must be set in dialogue and sound rather than established through sight. This must not be done too obviously. Radio often uses a narrator or announcer to set the mood, establish character relationships, give information about program participants, describe the scene, summarize the action, and even comment on the attitude the audience might be expected to have toward the program, participants, or performers. The background material, which sometimes can be shown in its entirety on television through visual action alone, must be given on radio through dialogue, music, sound—and silence.

Because drama has almost totally disappeared from radio, except for some programming on public radio stations, we tend to ignore the aesthetic potentials of the medium. We sometimes forget that a staple of radio, commercials, can be highly artistic, and often can be, in fact, minidramas.

You can easily tell the difference between the quality of a commercial expressly written for radio and that of a television commercial whose sound track is used for a radio spot. Bernard Mann, former president of WGLD and other stations in North Carolina, who began as a broadcast writing student in college and whose experience has included serving as the president of the National Radio Broadcasters Association, stated:

> One of my great frustrations is that too little of the writing done for radio is imaginative. We have almost made it part of the indoctrination program for **copywriters** at our radio stations to listen to some of the old radio shows. During that time, listeners were challenged to use their imagination. Nothing has changed. The medium is still the same. The opportunity for the writer to challenge the listener is still there. It's just not being used very much. Of course, radio today has very little original drama, but every day thousands of pieces of copy are turned out with very little imagination. Often an advertiser will tell a salesperson, "I can't use radio, it must have a picture," but I think that's radio's strength. The picture leaves nothing to the imagination, but a description will be colored by the listener to be more toward what he or she wants or likes.

Radio is indeed the art of the imagination. Technologies such as multitrack and digital recording further enhance this aural medium's potential. The radio writer is restricted only by the breadth and depth of the mind's eye of the audience. A vivid illustration of this potential and, appropriately, an example of good scriptwriting, is Stan Freberg's award-winning promotional spot for radio, "Stretching the Imagination" (top of next page).

THE INTERNET AUDIENCE

The Internet audience is quite different from that for other media. It consists of single individuals in a one-to-one communication exchange. Through the Internet's interactive capabilities, each member of the audience may be a participant in the communication process, rather than a passive viewer or listener. The Internet has flexibility as well as control over the material being presented. Internet users have an even wider choice of selections than

MAN:		Radio? Why should I advertise on radio? There's nothing to look at … no pictures.
GUY:		Listen, you can do things on radio you couldn't possibly do on TV.
MAN:		That'll be the day.
GUY:		Ah huh. All right, watch this. (AHEM) O.K. people, now I give you the cue, I want the 700-foot mountain of whipped cream to roll into Lake Michigan which has been drained and filled with hot chocolate. Then the royal Canadian Air Force will fly overhead towing the 10-ton maraschino cherry which will be dropped into the whipped cream, to the cheering of 25,000 extras. All right … cue the mountain …
SOUND:		GROANING AND CREAKING OF MOUNTAINS INTO BIG SPLASH!
GUY:		Cue the air force!
SOUND:		DRONE OF MANY PLANES.
GUY:		Cue the maraschino cherry …
SOUND:		WHISTLE OF BOMB INTO BLOOP! OF CHERRY HITTING WHIPPED CREAM.
GUY:		Okay, twenty-five thousand cheering extras …
SOUND:		ROAR OF MIGHTY CROWD. SOUND BUILDS UP AND CUTS OFF SHARP! Now … you wanta try that on television?
MAN:		Well …
GUY:		You see … radio is a very special medium, because it stretches the imagination.
MAN:		Doesn't television stretch the imagination?
GUY:		Up to 21 inches, yes.

Courtesy of Freberg, Ltd.

do radio and TV users. The latter have perhaps hundreds of channels to choose from, but the former can browse the World Wide Web and can choose from literally hundreds of thousands of sources. Most important is that although traditional media are controlled by multinational corporations and self-serving corporate executives—the gatekeepers who allow only the programming that serves their vested interests—there are no gatekeepers of the Internet—except where some governments attempt to control the Internet service providers (ISPs) and through them the programming. The Internet is open and free to alternative programming from any group or individual source. (Examples of these differences are illustrated in Chapter 5, News and Sports.)

What does this mean for producers, directors, and, for purposes of this book, script writers? A medium interprets what we have written for an audience. Writing for films is different than writing for stage, just as writing for radio is different than writing for film or stage, just as writing for television is different than writing for radio. We write to fit the aesthetic and technical requirements of the given medium.

The new kid on the media block is cyberspace—the Internet. Multimedia elements can pop up in windows. Users interact with a remote, mouse, or keyboard. Although the Web is increasingly a source of distribution for film, video, and audio on a mass scale, and although producers of Hollywood films, television programs, and radio and music audio materials are therefore preparing their materials to meet Internet requirements and potentials, many are simply using the Internet as a distribution medium without understanding that it is an entirely different creative environment for their productions than traditional film, television, or radio. At this writing, too few professionals have learned how to make high quality, interactive cinema, video, or audio specifically for the Internet. Note the word "interactive." It is a key to writing for the new medium. For example, the impact of the Internet on journalism might result in journalists assuming greater responsibility for accuracy and greater excellence in writing, given the viewers' and listeners' opportunity to double-check any news story from an immediately available variety of sources and to compare the art and effect of a story with other reports. Further, the Internet news audience can have instant access to a wider variety of opinions and interpretations of the news and is able to bypass biased news, whether the bias is a result of nationalism or local pride or political or economic—that is, advertiser—pressure. Simply put, with news, as with all other aspects of the Internet relative to programming, the individual audience member is in control and participates actively and interactively, rather than—as with traditional video, audio, and film distribution—passively. The writer must learn how to both stimulate and take advantage of this interactive independence of the audience.

Although the receptor, or audience, in this medium is given unlimited interactive opportunities, the writer must remember that as the creator, the guide, the influencer, he or she must not lose control of the material. If the writer has a point of view, the writer does not want the audience to wander in cyberspace unguided and to come to just any feeling, thought, or conclusion. The writer has a purpose and must present as many opportunities for interactivity as possible, but for each of those activities, the writer must also provide stimuli that, in any combination and from whatever source, can lead the receptor to the thought and feeling that the writer intended to convey. Even with an ostensibly totally objective format—such as hard news—the writer must be certain that all points of view and interpretations are available. If the older media are skewing the news—as they frequently do because of advertiser, owner, or, sometimes, producer-writer control—the Internet offers the possibility of implementing the presentation of alternative viewpoints to popular thought and belief otherwise usually unavailable. The receptor might do extensive Web browsing, but the writer can help orient the browser to sites that offset restricted attitudes and information.

The National Association of Advertisers and the American Association of Advertising Agencies have developed a project to measure Internet audiences. The principles of measurement essentially follow those used for TV and radio, stressing information needed for effective ad placement, length, and duration. The process also seeks out pertinent demographics needed by the advertisers, including target audience identification. Ironically, it aims to respect the privacy of the "logger" and to get necessary information about the audience members in a non-intrusive way. But the goals are the same as they are now for

advertising on TV and radio. In 1998, Neilsen began comprehensive ratings measurement of Internet audiences.

Advertisers—and producers—on the Internet realize that it provides an instant global market. The trend is toward increasingly large monopolies and toward consolidation of media industries into fewer and fewer mogul gatekeepers, thus restricting creative options and diversity of views (writer-critic A.J. Liebling once observed that freedom of the press belonged to the person who owned one). Even so, the writer needs to be aware that literally the whole multicultural, multi-opinion world is watching or listening. This creates different requirements for content and for technique than if the material is to be seen or heard principally in one's own country or in a limited region or locality.

The path is not easy for even experienced "broadcast" writers—that is, those who have been writing for TV and radio—to move into the new media, much less those just entering the field. In addition to the creative artistic adjustments already mentioned, there is also a turf problem. It appears that the progenitors of the machinery continue to see its principal contributions in a technological environment, rather than in one oriented to the creative and intrepretive arts. As Daniel Roth wrote in *Fortune* magazine, writers for the older media are having a hard time adjusting to the "techie"-culture types who continue to control the Internet. a key issue is approach. The older media types put content first and tend to look down on the technical emphases. Conversely, the techies are usually impatient with and even contemptuous of the TV and radio video-audio people, believing that the latter cannot or will not adjust to the new technical-dominated communications world. Thus far, the techies have dominated, with the tools and processes of Internet communication considered by the new media operators as more important than the material to be disseminated.

But as more and more people seek broadcast-type programming on the Internet, this attitude is gradually changing. In the meantime, broadcasters are trying to maximize their proficiency and access. For example the National Association of Broadcasters Web site (www.nab.org) has links to new technology, convergence, and Internet information and advice on developments in the new media that affect broadcasters.

The Internet can have a salutary as well as a competitive effect on the more traditional media. In addition to its extension of popular music, the Web has made it possible for some otherwise dormant radio formats to revive. For example, a number of people in many different communities might like to hear science fiction drama or listen to the Library of Congress "books-on-tape" series. With not enough people in any one community to make such programs economically feasible for any given radio station, such programs are rarely presented. On the Internet, however, an otherwise "dead" program could be carried, reaching enough people nationally and internationally to be successful.

SUBJECT MATTER

The writer not only has to exercise talent in producing quality material, but also has to exercise judgment in the specific material used. Television and radio writing particularly are greatly affected by censorship.

Censorship comes from many sources. The production agency, whether an independent producer or a network, usually has guidelines about what materials are acceptable. Advertisers exercise a significant role in determining content, frequently refusing to sponsor a program to which they have some objection. Pressure groups petition and even picket networks, stations, and producers. Television critic Jay Nelson Tuck once wrote, not altogether facetiously, that three dirty postcards from a vacant lot can influence a sponsor to do almost anything. Even the government has gotten into the act.

Censorable Material

Although prevented by the Communications Act of 1934 from censoring program material, the FCC is authorized to levy fines or suspend a station's license for "communications containing profane or obscene words, language, or meaning." "Indecency" clause implementation depends on the FCC commissioners' orientation at any given time. The conservative public attitudes that grew under President Reagan in the 1980s prompted the FCC to take action against programming the FCC deemed offensive, including restricting so-called adult material to a "safe harbor," nighttime and early morning hours, a time period that changed over the years as the federal courts ruled on challenges to the regulation and its decisions. In 1996, despite objections from civil liberties groups and Action for Children's Television, the Supreme Court ruled that the FCC has the right to establish a "safe harbor" for adult programming, ostensibly to protect child viewers. The hours of 10 P.M. to 6 A.M. compose the "safe harbor," based on the assumption that children will not be watching television during that period. Conversely, programming that is deemed "adult" may not be broadcast between 6 A.M. and 10 P.M.

America's increasing conservatism in the last decades of the twentieth century was reflected in the FCC's crackdown on talk show hosts who presented materials the Commission deemed offensive. Though not ever specifically defining what it meant by indecency, the FCC relied on what was called the "Miller test"—the 1973 Supreme Court decision in *Miller v. California* that applied three criteria in judging whether a work was indecent or obscene: (1) that, applying contemporary community standards, the work appeals to the average person's prurient interests; (2) that the work describes sexual conduct in a patently offensive way, as defined by state law, and (3) that the work as a whole lacks literary, artistic, political, or scientific value. Although many critics cannot understand how the FCC can enunciate what contemporary community standards for the average person can possibly be, the Commission nevertheless fined several companies, stations, and performers for indecent programming, most notably Infinity Broadcasting and talk-show host Howard Stern.

In fact, at this writing, the Supreme Court has ruled on only one indecency case pertaining specifically to the electronic media, excluding the Internet: The so-called "Seven Dirty Words" case in which Pacifica radio station WBAI in New York carried the George Carlin routine as a segment in a comedy program. The FCC fine was upheld by the Supreme Court in 1978, but the court did not further define indecency. Thus, the broadcast

writer continues to play Russian roulette when writing, knowing for certain only that the Seven Dirty Words routine cannot be aired on a broadcast station. Subsequent complaints brought before the FCC have been judged individually by what the Commissioners at the given time consider to be average community standards.

The Telecommunications Act of 1996 included a provision that requires new television sets to contain a "V-chip" that permits the screening of programs that fall into different rating categories for "violence, sex, and other indecent material." A companion Communications Decency Act also banned the transmission of "indecent" material via computer, ostensibly to protect children. Although the former was implemented, the courts have found the latter and subsequent similar legislation banning certain content from the Internet to be unconstitutional violations of the First Amendment rights of freedom of speech and press.

Compared with media content of only a decade ago, broadcasting is slowly coming to realize that at least some facts of life cannot be made to disappear by banning them from public discussion or observation or by pretending that they do not exist. Talk shows, discussion programs, and dramas deal with explicit sexual references and frequently with sexual acts, the latter sometimes simulated even if not fully seen. Language approximates that used in real life, from sitcoms to serious drama, although some of the most common four-letter words have not yet made it to broadcast television. More freedom of language usage is found on cable, particularly on pay channels.

Nevertheless, television and radio remain very sensitive to public pressure, especially that brought upon the sponsor, and broadcasting usually pulls back at even a hint of pressure. Erik Barnouw, discussing movie censorship in his book *Mass Communication,* wrote: "Banning evil example . . . does not ban it from life. It may not strengthen our power to cope with it. It may have the opposite effect. Code rules multiply, but they do not produce morality. They do not stop vulgarity. Trying to banish forbidden impulses, censors may only change the disguises in which they appear. They ban passionate love-making, and excessive violence takes its place."

Controversial Material

Freedom of expression and democratic exchange of ideas in television and radio are endangered because many media executives fear controversy. On the grounds of service to the sponsor and on the basis of good ratings for noncontroversial, generally mediocre entertainment, controversial material and performers frequently have been banned. Many companies refuse to sponsor a program with controversial material if they feel it might in any way alienate any potential customers. Erik Barnouw observed that "when a story editor says 'we can't use anything controversial,' and says it with a tone of conscious virtue, then there is danger."

Most broadcasters fought for years to abolish the **Fairness doctrine,** which authorized the FCC to require stations, in some circumstances, to present more than one side of significant issues in the community, therefore bringing controversy to the fore. Following

President Reagans' veto of a congressional bill making the Fairness Doctrine into law, the FCC abolished it in 1987.

The history of censorship of controversial material in broadcasting is a long one, and, unfortunately, one in which both broadcasters and the public never seem to learn the lessons of integrity and democracy. One of the United States' darkest and most shameful periods was the blacklist of the 1950s, during the heyday of McCarthyism, when Senator Joseph McCarthy cowed most of America into supporting his demagoguery of guilt-by-accusation—even false accusation. Broadcasters cooperated with charlatans to deny freedom of speech and the freedom to work to countless performers, directors, producers, and writers who were accused by self-proclaimed groups of super-patriots of being un-American. Broadcasters panicked and threw courage to the winds and ethics out the windows. Many careers and a number of lives were destroyed. Although broadcasters have since apologized for their undemocratic and cowardly behavior, political considerations are still a priority on the censorship list. In the early 2000s, political conformity resulted in the mainstream media by and large reporting inaccurately or not at all on nationwide protests against the abrogation of America's cherished civil liberties by the federal government under the Patriot Act of 2001 and on massive anti-war protests. With few exceptions, only alternative media sites on the Internet reported what was happening.

Several classic situations have resulted from censoring material that might put the sponsor's product or service in a poor light or that might suggest a competing product. Among them is a program that dealt with the German concentration camp atrocities of the 1930s and 1940s from which the sponsoring gas company eliminated all references to gas chambers. Another program deleted references to President Lincoln's name in an historical drama because it was also the name of a car produced by a competitor of the automobile sponsor. In retrospect such situations are funny, but they were not funny then and would not be now to the writer forced to compromise the integrity of his or her script.

Censorship is sometimes the result of an owner's attitudes toward or conflict with the content of a program. For example, the American Broadcasting Company's highly regarded news program, *20/20,* had a segment prepared on hiring and safety problems at the Walt Disney World entertainment complex. Written assurances were given that there would be no problem with ABC's corporate ownership—the Walt Disney Company. The story was killed. It should be noted, however, that *20/20* had previously aired a story critical of another Disney project. Some censorship takes place not because of feared public reaction or even because of a sponsor's vested interest, but because of direct prejudice. One program, the true story of a large department store owner who was Jewish and who gave his entire fortune to fight cancer, was cancelled by the sponsor because the play allegedly would give "Jewish department store owners" an unfair advantage over other department store owners.

Media executives and sponsors alone are not to blame. Writers and other personnel often give up their integrity out of fear for their jobs or to curry favor with their employers. In Boston, for example, after a local station cancelled a program under pressure from a local religious group, a director of the New England chapter of the National Academy of Television Arts and Sciences (NATAS) introduced the following resolution:

Freedom of the press, including television, is a cornerstone of American democracy. The United States is one of the few countries in the world where the media legally have freedom from the control of outside forces. To abandon that freedom under pressure from any group, public or private, no matter how laudatory its aims, is to subvert a basic principle of democracy, and to undermine one of our cherished freedoms. As communicators in New England, we urge our broadcasting colleagues here and throughout the nation to stand firm, with courage and conviction, not to succumb, but to maintain the open marketplace of ideas that has marked freedom of speech, thought, and press in our country. We pledge our support to our colleagues in this endeavor.

The other members of the NATAS Board of Directors refused even to consider that resolution. One NATAS officer suggested that the resolution "was perceived by many as a criticism of the actions taken by a member station." Of course it was. Not only, therefore, do outside pressures determine programming decisions and content, but the pressures of management also tend to force individual broadcasters and writers to give up the principle and courage to support freedom of ideas and speech.

The late Sydney W. Head, a leading teacher and writer in the communications field, stated, "television, as a medium, appears to be highly responsive to the conventional conservative values," and that a danger to society from television is that television will not likely lend its support to the unorthodox, but "it will add to cultural inertia." The media's great impact and television's and radio's ability to affect people's minds and emotions so strongly are clearly recognized by the media controllers or, as they are often called, the gatekeepers, who by and large represent the status quo of established business, industry, social, and political thought and power. In her book, *Screened Out: How The Media Control Us And What We Can Do About It,* Carla Brooks Johnston notes the increasing global control of the media by fewer and fewer companies that decide what the public is permitted to see and hear. It is not surprising that the conglomerate-controlled mainstream media have only superficially covered or distorted the growing worldwide protests in the early 2000s against corporate globalization. In this instance, as in others, the full stories may be found principally on the Internet.

Commercials *do* sell products and services, and Madison Avenue advertising agencies wield considerable impact. News and public affairs programs and even entertainment shows have had remarkable impact in changing many of our political and social beliefs, policies, and practices. Broadcasting's cooperation with manipulative politicians, spin-doctors, "sound-bites" and other nonsubstantive and non-issue reportage in covering politics and elections indicates how effectively the media can influence and even control the political process.

At the same time, the media have been responsible, through similar control, for great progress in human endeavors. Television's coverage of the civil rights movement in the 1960s often is credited with motivating many people to insist on congressional action guaranteeing all Americans civil rights. Television's bringing of the Vietnam War into the nation's living rooms is credited with motivating millions of citizens to pressure our government to end the war, resulting in one president ending his political career and another eventually ending the nation's overt military activities in Southeast Asia.

Conversely, the media have from time to time voluntarily cooperated with the government and military in denying information to the American public. Following the media's revelations of the military's lies and deceptions in the Vietnam War, thus strengthening the public's resolution to bring that war to an end, the Pentagon took pains to see that it would not happen again and imposed strict censorship of all news in subsequent conflicts, including the invasion of Grenada, the action in Panama, and the Gulf War. Although many media organizations later apologized to the America public for deliberately keeping it in the dark about what was really happening in the Persian Gulf in 1991, the media once again showed its lack of integrity and courage by allowing itself to report false and incomplete information during the U.S. involvement in the NATO action in Yugoslavia in 1999. News guru Walter Cronkite publicly criticized the government and the military for its censorship and the media for its complicity with that censorship in its reporting of the Kosovo crisis. As noted earlier, the media's abandonment of its traditional freedoms and its obligation to serve the public was exacerbated in its coverage—or, rather lack of coverage—of the government's nonmilitary actions in the "war against terrorism" following the terrorist attacks on the United States in 2001.

Frank Stanton, former president of CBS, said this:

> The effect of broadcasting upon the democratic experience has gone far beyond elections. The monumental events of this century—depression, wars, uneasy peace, the birth of more new nations in two decades than had occurred before in two centuries, undreamed of scientific breakthroughs, profound social revolution—all these were made immediate, intimate realities to Americans through, first, the ears of radio and, later, the eyes of television. No longer were the decisions of the American people made in an information vacuum, as they witnessed the towering events of their time that were bound to have incisive political repercussions.

Sadly, the media, by and large, have restored that information vacuum.

The media writer who prepares material dealing with issues and events has the satisfaction of knowing that he or she can contribute to human progress and thought and is participating directly in changing society and solving problems of humanity. Not many professions allow you to accomplish this on such a broad and grand scale! Theoretically, the writer can help fulfill the mass media's responsibility to serve the public's best interests, to raise and energize the country's cultural and educational standards, and to strengthen the country as a whole. Realistically, the best-intentioned writer is still under the control of the network or station or advertiser, whose first loyalties usually are directed toward its own needs and not necessarily those of the public. Occasionally, these interests coincide. The writer who wants to keep a job is pressured to serve the employer's interests. Hopefully, conscience will prompt the writer to serve the public interest as well.

2

Basic Elements of Production

The media writer must know the tools the director uses to bring the script to life, whether for a six-hour miniseries or a 30-second commercial—or even a piece of cyberspace spam. When you write for a visual or aural medium, you should be familiar with the key production techniques that can facilitate and enhance a script. You should learn what the camera can and cannot do; what sound or visual effects are possible in the control room; how microphones help create mind pictures; what terminology to use in furnishing directions, descriptions, and transitions; what a Web site consists of; and other technical and production devices and terms that are essential for effective writing.

New developments in media technology are continuous. Digital audio offered new production and writing advantages. Electronic news gathering and electronic field production (**ENG and EFP**) are standard: ENG provides light, flexible use of cameras to gather news quickly and in places previously difficult or impossible to reach, and EFP provides **minicam** equipment that allows commercials and non-news materials to be produced away from the studio. Videotape has replaced film for many television formats, such as news, documentaries, panels, game shows, and soap operas, reversing the trend that began when television production moved to Hollywood shortly after videotape's introduction in 1956. **Multiplexing, quadruplexing,** the **electronic synthesizer,** and **automation,** among other techniques, are institutionalized. Although the formats themselves have remained relatively unchanged, the techniques the writer can use within any given format expand with each new technology.

Viewers may regard cable and satellite television as different from the broadcast television service, but the difference is principally in the means of transmission. The medium is still television. The writing is still basically the same. But the programming can differ in some respects, requiring a different orientation by the writer. For example,

many cable franchises have local origination channels, providing local, frequently live productions. The type and content of these programs usually are of semiprofessional quality with dedicated subject matter aimed at and often produced by special interest groups. The writer should have an awareness of the restrictions of live production using limited and sometimes inadequate equipment. Frequently, local origination and especially public access channels provide an opportunity for television exposure for neighborhood, ethnic, minority, and other culturally diverse groups that traditionally have been denied equal access to the media.

Because cable requires a user fee, and some channels are, in fact, "pay" television per channel or per view, cable viewers may represent a relatively affluent and culturally sophisticated audience. This sometimes means you can write on a higher level than in broadcasting's usual lowest-common-denominator orientation. Distribution systems such as **direct broadcast satellite (DBS), fiber optics,** and **lasers** further broaden the writer's role. The Internet's **interactive** capabilities open the door to service-oriented programming and two-way communication. Computer-based instruction, banking by wire, marketing through television, library access, data services, and other interactive services have expanded the writer's job from the traditional creative pattern in broadcasting to that of computer program writer.

Basic writing technique, however, is not likely to change appreciably. Format adaptations do occur. The continuing multiple-slices-of-life format involving multiple characters introduced by *Hill Street Blues* was copied by numerous subsequent shows, and the "reality" approach that came into popularity at the end of the 1980s immediately pervaded many different programs. The dramatic show, news program, documentary, commercial, and other genres also seek new forms and techniques to attract new audiences.

TELEVISION

Although the television writer does not have to know all the elements of production to write a script, he or she should have a basic understanding of the special mechanical and electronic devices of the medium. The writer should be familiar with (1) the studio, (2) the camera, with its movements, lenses, and shots, (3) the control room, including editing techniques, (4) special video effects, and (5) sound.

The Studio

Television studios vary greatly in size and equipment. Some have extensive state-of-the-art electronic and mechanical equipment and are as large as a movie sound stage. Others are small and cramped, with barely enough equipment to produce a broadcast-quality show. Although network studios, regional stations, and large independent production houses are likely to have the best studios, one occasionally finds a college or a school system with facilities that rival the best professional situation. The writer should know the size and facilities of the studio: Will it accommodate large sets, many sets, creative camera move-

ment, and lighting? Are field settings necessary? Can the program be produced in film form, with the availability of cranes, outdoor effects, and other special mechanical studio devices? Does the size of the studio require a live-type, taped approach? Should the script be a combination of studio shooting plus exteriors using EFP equipment? In other words, before writing the final draft of the script (and, if possible, even the first draft), the writer should know what technical facilities will be available to produce the script, including what can and cannot be done in the studio likely to be used.

The Camera: Movement

Whether the show is being recorded on film or tape, using a film script or a one- or two-column television script, the basic camera movements and the terminology are essentially the same. The principal difference is the style of shooting: short, individual takes for film, longer and sometimes continuous action sequences for video. Instant video taping has brought the two approaches closer by combining elements of both. More and more filmed shows tend toward videotape, to facilitate instant editing not possible when one has to wait for the processing of the day's film shoot.

The writer should consider the film or video camera as a moving and adjustable proscenium through which the writer and director can direct the audience's attention. Four major areas of audience attention can be changed via the camera: (1) the distance between the audience and the subject, (2) the amount of the subject the audience sees, (3) the audience position in relation to the subject, and (4) the angle at which the viewer sees the subject. The writer must understand and be prepared to designate any and all of the following six specific movements to direct the audience's attention:

1 *Dolly-in and dolly-out.* The camera is mounted on a dolly stand that permits smooth forward or backward movement. This movement to or away from the subject permits a change of orientation to the subject while retaining a continuity of action.

2 *Zoom-in and zoom-out.* Used to accomplish more easily the same purpose as the dolly from mid- and long-distances, the zoom can narrow the angle of view and compress depth, making people or objects appear closer. Some writers and directors believe that psychologically the dolly is more effective, moving the audience closer to or further from the subject, whereas the zoom gives the feeling of moving the subject closer to or further from the audience.

3 *Tilt up and tilt down.* This means pointing the camera up or down, thus changing the view from the same position to a higher or lower part of the subject. The tilt is also called **pan up** or **pan down.**

4 *Pan right and pan left.* The camera moves right or left on its axis. This movement is used to follow a character or a particular action, or to direct the audience's attention to a particular subject.

5 *Follow right and follow left.* This is also called the **travel shot** or **truck shot.** The camera is set at a right angle to the subject and either follows alongside a moving subject or, if the subject is stationary, such as an advertising display, follows down the line of the subject. The audience, through the camera lens pointed sharply to the right or left, sees the items in the display. This shot is not used as frequently as the preceding ones.

6 *Boom shot.* Originally familiar equipment in Hollywood filmmaking, the camera boom has also become a standard part of television production practice. A crane, usually attached to a moving dolly, enables the camera to **boom** up or down from its basic position, at various angles—usually high up—to the subject. This is known also as a **crane shot.**

Note the use of the basic camera positions in the following scripts. In the first, which uses the standard television format, the writer would not ordinarily specify so many camera directions. The director would determine them and write them in the left-hand column of the script. They are included here to indicate to the beginning writer the variety of camera and shot possibilities. This approximates a *shooting script,* with the video directions that the director, rather than the writer, would insert.

VIDEO	AUDIO
ESTABLISHING SHOT.	DETECTIVE BYRON: (AT DESK, IN FRONT OF HIM, ON CHAIRS IN A ROW, ARE FOUR YOUNG MEN IN JEANS AND LEATHER JACKETS, WITH MOTORCYCLE HELMETS NEARBY.) All right. So a store was robbed. So all of you were seen in the store at the time of the robbery. So there was no one else in the store except the clerk. So none of you know anything about the robbery.
DOLLY IN FOR CLOSE-UP OF BYRON.	(GETTING ANGRY) You may be young punks but you're still punks, and you can stand trial whether you're seventeen or seventy. And if you're not going to cooperate now, I'll see that you get the stiffest sentence possible.
DOLLY OUT FOR LONG SHOT OF ENTIRE GROUP. CUT TO CLOSE-UP.	Now, I'm going to ask you again, each one of you. And this is your last chance. If you talk, only the guilty one will be charged with larceny. The others

Continued

VIDEO	AUDIO
PAN RIGHT ACROSS BOYS' FACES, FROM ONE TO THE OTHER, AS BYRON TALKS.	will have only a petty theft charge on them, and I'll see they get a suspended sentence. Otherwise I'll send you all up for five to ten.
FOLLOW SHOT ALONG LINE OF CHAIRS IN FRONT OF BOYS, GETTING FACIAL REACTIONS OF EACH ONE AS THEY RESPOND.	(OFF CAMERA) Joey? JOEY: (STARES STRAIGHT AHEAD, NOT ANSWERING.) BYRON: (OFF CAMERA) Al? AL: I got nothin' to say. BYRON: (OFF CAMERA) Bill? BILL: Me, too. I don't know nothin'. BYRON: (OFF CAMERA) OK, Johnny. It's up to you.
TILT DOWN TO JOHNNY'S BOOT AS HE REACHES FOR HANDLE OF KNIFE. PAN UP WITH HAND AS IT MOVES AWAY FROM THE BOOT INTO AN INSIDE POCKET OF HIS JACKET. CUT TO MEDIUM SHOT ON BOOM CAMERA OF JOHNNY WITHDRAWING HAND FROM POCKET, BOOM DOWN TO OBJECT IN JOHNNY'S HAND. [Ordinarily, a boom shot would not be used here. A zoom lens would be easier to use and at least as effective.]	JOHNNY: (THERE IS NO ANSWER. THEN JOHNNY SLOWLY SHAKES HIS HEAD. IMPERCEPTIBLY, BYRON NOT NOTICING, HE REACHES DOWN TO HIS MOTORCYCLE BOOT FOR THE HANDLE OF A KNIFE. SUDDENLY THE HAND STOPS AND MOVES UP TO THE INSIDE POCKET OF HIS JACKET. JOHNNY TAKES AN OBJECT FROM HIS POCKET, SLOWLY OPENS HIS HAND.)

The Camera: Lenses

Until the advent of the zoom lens, four basic turret lenses were available. Framing a shot took time; dollying in or out to get the right distance and composition took time; focusing took time. Though the zoom hasn't solved all camera movement and shot problems, it has given the writer and director more options. Remote and studio zoom lenses differ in the

required light levels and angle width needed. The attention-getting dramatic shots required in commercials necessitate highly sophisticated and flexible lenses.

A good lens can save production time. For example, many lenses require pauses in the shooting sequence for readjustment or change; a lens that can go smoothly with perfect focus from an extreme close-up to a wide long shot and then back again facilitates continuing, efficient shooting. ENG/EFP lenses focus at a distance as close as three feet to the subject. Some lenses with micro-capability focus from just a few inches away.

The Camera: Shots

Among the directions most frequently specified by the writer are the shots designating how much of the subject is to be seen, as illustrated in the last script example. Ordinarily, shot designations are the director's choice, but in some instances the writer needs to capture a specific subject for the logical continuity of the script or for the proper psychological effect of the moment upon the audience. When the specific shot required might not be obvious to the director within the context of the scene, the writer has the prerogative of inserting it into the script.

Shot designations range from the close-up to the medium shot to the long shot. Within these categories are gradations, such as the medium long shot and the extreme close-up. The writer can indicate the kind of shot and the specific subject to be encompassed by a given shot; for example, "XCU [for extreme close-up] Joe's right hand." The terms and their meanings apply to both the television and the film format. Here are the most commonly used shots:

- *Close-up (CU).* The writer states in the script, "CU Harry," "CU Harry's fingers as he twists the dials of the safe," or "CU Harry's feet on the pedals of the piano." A **close-up** of a human subject usually consists of just the face, but can include some of the upper body. Unless specifically designated otherwise, the letters **XCU** or **ECU** (*extreme close-up*) usually mean the face alone. Variations of the close shot are the *shoulder shot*, which indicates the area from the shoulders to the top of the head, the *bust shot, waist shot, hip shot,* and *knee shot.*

- *Medium shot (MS).* In the *medium shot* (**MS**) the camera picks up a good part of the individual, group, or object, usually filling the screen (but not in its entirety), without showing too much of the physical environment.

- *Long shot (LS).* The *long shot* (**LS**), sometimes called the **establishing shot** or *wide shot* (**WS**), is used primarily to establish the entire setting or as much of it as is necessary to orient the audience properly. From the long shot the camera may go to the medium shot and then to the close-up, creating a dramatic movement from an overall view to the essence of the scene or situation. Conversely, the camera may move from the extreme close-up to the clarifying broadness of the *extreme long shot* (**XLS**). Both approaches are used frequently to open a sequence.

- *Full shot (FS).* In the *full shot* (**FS**), the subject is put on the screen in its entirety. For example, "FS Harry" means that the audience sees Harry from head to toe. "FS family at dinner table" means that the family seated around the dinner table is seen completely. Some writers and directors use the designation **FF** for *full figure shot.*

- *Variations.* Many variations of these shots are used when necessary to clarify what the writer or director desires. For example, if two people in conversation are to be the focal point of the shot, the term *two-shot* (**2S**) is appropriate. If the two people are to fill the screen, *tight 2S* is the right term, as illustrated in the next script example. Similarly, *medium two-shot* (**M2S**), *three-shot* (**3S**), and other more specific shot designations may be used.

Note the use of different types of shots in the following hypothetical script example. The video directions are necessary at the beginning of this script because the writer is telling the story solely with pictures. Most of the subsequent video directions would have been left out by the writer, leaving that job to the director, except at the end where they are necessary once again to convey the meaning and the action. Note that in many of the actual scripts used in this book, the writers provide very few video directions.

VIDEO	AUDIO
FADE IN ON LONG SHOT OF OUTSIDE OF BAR. ESTABLISH STREET FRONT AND OUTSIDE OF BAR. DOLLY IN TO MEDIUM SHOT, THEN TO CLOSE-UP OF SIGN ON THE WINDOW: "HARRY SMITH, PROP." CUT TO INSIDE OF BAR, CLOSE-UP OF MAN'S HAND DRAWING A GLASS OF BEER FROM THE TAP. FOLLOW MAN'S HAND WITH GLASS TO TOP OF BAR WHERE HE PUTS DOWN GLASS. DOLLY OUT SLOWLY TO MEDIUM SHOT OF HARRY, SERVING THE BEER, AND MAC, SITTING AT BAR. ZOOM OUT TO WIDE SHOT, ESTABLISHING ENTIRE INSIDE OF BAR, SEVERAL PEOPLE ON STOOLS, AND SMALL TABLE AT RIGHT OF BAR WITH THREE MEN SEATED, PLAYING CARDS.	
	JOE: (AT TABLE) Harry. Bring us another deck. This one's getting too dirty for honest card players.

Continued

VIDEO	AUDIO
	HARRY: Okay. (HE REACHES UNDER THE BAR, GETS A DECK OF CARDS, GOES TO THE TABLE.)
TIGHT 2S HARRY AND JOE	JOE: (TAKING THE CARDS, WHISPERS TO HARRY.) Who's the guy at the bar? He looks familiar.
	HARRY: Name of Mac. From Jersey someplace.
CUT TO CU JOE	JOE: Keep him there. Looks like somebody we got business with. (LOOKS AROUND TABLE.)
CUT TO FS TABLE	Right, boys? (THE MEN AT THE TABLE NOD KNOWINGLY TO HARRY.)
	HARRY: Okay if I go back to the bar?
	JOE: Go ahead.
PAN WITH HARRY TO BAR. DOLLY IN TO BAR, MS HARRY AND MAC AS HARRY POURS HIM ANOTHER DRINK. MCU HARRY AS HE WRITES. CUT TO CU OF WORDS ON PIECE OF PAPER.	HARRY: (WALKS BACK TO BAR, POURS DRINK FOR MAC. SCRIBBLES SOMETHING ON PIECE OF PAPER, PUTS IT ON BAR IN FRONT OF MAC.)

Control Room Techniques and Editing

The technicians in the control room have various electronic devices for modifying the picture and moving from one picture to another, giving television its ability to direct the attention and control the audience's view. The technicians in the film editing room have the same capabilities except that the modifications are done solely during the editing process. In live-type taped video, the modifications can be done as the program is being recorded, as well as during a subsequent tape-editing process. The writer should be familiar enough with control room techniques to know the medium's potentials and to indicate on the script, when necessary, special picture modifications or special changes in time or place. The terms have the same meanings in television and film.

- *Fade.* The **fade-in** brings the picture in from a black (or blank) screen. The **fade-out** takes the picture out until a black level is reached. (You've often heard the phrase "fade to black.") The fade is used primarily to indicate a passage of time, and in this function serves much like a curtain or blackout on the stage. The fade also can be used to

indicate a change of place. Depending on the action sequence, the fade-in or fade-out can be fast or slow. The writer usually indicates the fade-in and fade-out on the script.

- **Dissolve.** While one picture is being reduced in intensity, the other picture is being raised, one picture smoothly dissolving into the next—replacing or being replaced by the other. The **dissolve** is used primarily to indicate a change of place, but sometimes to indicate a change of time. The dissolve has various modifications. An important one is the *matched dissolve,* in which two similar or identical subjects are placed one over the other, with one fading in and the other fading out, showing a metamorphosis taking place. Dissolving from a newly lit candle to a candle burned down to indicate a passage of time is a matched dissolve. The dissolve can vary in time from a *fast dissolve* (almost a split-second movement) to a *slow dissolve* (as long as five seconds). At no point in the dissolve does the screen go to black. The writer usually indicates the dissolve in the script.

- *Cut.* The **Cut** is the technique most commonly used and consists simply of switching instantaneously from one picture to another. Care must be taken to avoid too much cutting; make certain that the cutting is consistent with the mood, rhythm, pace, and psychological approach of the program as a whole. The television writer usually leaves the designation of cuts to the director. In the film script, especially when the transition from one sequence to the next is a sharp, instantaneous effect rather than a dissolve or fade, the writer may indicate "cut to . . ."

- *Superimposition.* The **super** is the placing of one image over another. It sometimes is used in stream-of-consciousness sequences when the memory being recalled is pictured on the screen along with the person doing the recalling. To obtain necessary contrast in the superimposition, one picture must have higher light intensity than the other. The superimposition sometimes is used for nondramatic effects, such as placing a commercial name or product over a picture. The writer usually indicates the superimposition. Although the principles of the super continue to be used, the mechanical control room superimposition has been replaced, in almost all studios, by the more effective *key* or *matte.*

- *Key or matte.* A **key** is a two-source special effect where a foreground image is cut into a background image and filled back in with itself. A **matte** is a similar technique, but can add color to the foreground image. **Character generators** (**chyrons** or **vidifonts**) electronically cut letters into background pictures. Titles and commercial names of products are keyed or matted. **Chroma key** is an electronic effect that cuts a given color out of a picture and replaces it with another visual. Newscasts use this technique; the blue background behind the newscaster is replaced with a slide or taped sequence.

- *Wipe.* One picture wiping another picture off the screen in the manner of a window shade being pulled over a window is known as a **wipe.** The wipe can be from any direction—horizontal, vertical, or diagonal. Wipes can also *blossom out* from the center of a picture or *envelope* it from all sides. Wipes often designate a change of place or time.

■ **Split screen.** In the **split screen** the picture on the air is divided, with the shots from two or more cameras or other sources occupying adjoining places on the screen. A common use is for phone conversations, showing the persons speaking on separate halves of the screen. The screen can be split into many parts and into many shapes, as is sometimes done when news correspondents report from different parts of the world. One segment of virtually any size can be split off from the rest of the screen; in sports broadcasts, for example, one corner of the screen might show the runner taking a lead off first base while the rest of the screen shows the pitcher about to throw to the batter.

The following standard two-column script illustrates the uses of control room techniques. The *commentary* column at the left is *not* part of the script, but is used here as a learning device for understanding how the writer uses and designates the appropriate terms.

COMMENTARY	VIDEO	AUDIO
1. The fade-in is used for the beginning of the sequence.	FADE IN ON SHERIFF'S OFFICE. SHERIFF FEARLESS AND DEPUTY FEARFUL ARE SEATED AT THE DESK IN THE CENTER OF THE ROOM.	FEARLESS: I wonder what Bad Bart is up to. He's been in town since yesterday. I've got to figure out his plan if I'm to prevent bloodshed. FEARFUL: I've got faith in you, Fearless. I heard that he's been with Miss Susie in her room. FEARLESS: Good. We can trust her. She'll find out for us. FEARFUL: But I'm worried about her safety. FEARLESS: Yup. I wonder how she is making out. That Bad Bart is a mean one.
2. The dissolve is used here for a change of place without passage of time. This scene takes place simultaneously or immediately following the one in the sheriff's office.	DISSOLVE TO MISS SUSIE'S HOTEL ROOM. BART IS SEATED IN AN EASY CHAIR. SUSIE IS IN A STRAIGHT CHAIR AT THE OTHER END OF THE ROOM.	BART: I ain't really a killer, Miss Susie. It's only my reputation that's hurting me. Only because of one youthful indiscretion. SUSIE: What was that, Mr. Bart?

Continued

COMMENTARY	VIDEO	AUDIO
3. The superimposition is used here for a memory recall device.	SUPERIMPOSE, OVER CU BART, FACE OF MAN HE KILLED AS HE DESCRIBES SCENE.	BART: I can remember as well as yesterday. I was only a kid then. I thought he drew a gun on me. Maybe he did and maybe he didn't. But I shot him. And I'll remember his face as sure as I'll live—always. SUSIE: I guess you aren't really all bad, Mr. Bart.
4. The writer doesn't usually indicate the cuts to be used. Here, however, the cut specifically indicates a different view of the character in the same continuous time sequence.	PAN WITH BART TO THE HALL DOOR. CUT TO HALL AS HE ENTERS IT.	BART: You've convinced me, Miss Susie. I've never had a fine woman speak to me so nice before. I'm going to turn over a new leaf. (WALKS INTO THE HALL. AN EARLY MODEL TELEPHONE IS ON THE WALL.) I'm going to call the sheriff. Operator, get me the sheriff's office.
5. The wipe here moves from left to right or right to left. It designates a change of place. The use of the split screen indicates the putting of two different places before the audience at the same time.	HORIZONTAL WIPE INTO SPLIT SCREEN. BART IN ONE HALF, SHERIFF PICKING UP TELEPHONE IN OTHER HALF.	FEARLESS: Sheriff's office. BART: Sheriff. This is Bad Bart. I'm going to give myself up and confess all my crimes. I've turned over a new leaf. FEARLESS: You expect me to believe that, Bart? BART: No, I don't. But all I'm asking is a chance to prove it. FEARLESS: How do you propose to do that?
	WIPE OFF SHERIFF OFFICE SCENE. CU BART'S FACE AS HE MAKES HIS DECISION.	BART: I'm coming over to your office. And I'm not going to be wearing my guns.

Continued

COMMENTARY	VIDEO	AUDIO
6. The fade here indicates the passage of time.	FADE OUT. FADE IN ON MISS SUSIE SEATED ON HER BED.	SUSIE: That's all there was to it, Fearless. The more I talked to him, the more I could see that underneath it all he had a good heart.
7. The sustained opening on Susie is necessary, for live-type, continuous action television, to provide time for Bart to get off the set and for Fearless to get on. The fifteen or twenty seconds in which we do not yet see Fearless, though Susie's dialogue indicates he is there, should be sufficient "cover" time.		(SHE WALKS TO THE SMALL TABLE AT THE FOOT OF THE BED, TAKES A GLASS AND BOTTLE, THEN WALKS OVER TO THE EASY CHAIR. WE SEE SHERIFF FEARLESS IN THE EASY CHAIR.) Here, Fearless, have a sarsaparilla. You deserve one after what you've done today.
		FEARLESS: No, Susie. It was you who really did the work. And you deserve the drink. (AFTER A MOMENT) You know, there's only one thing I'm sorry for.
		SUSIE: What's that?
		FEARLESS: That Bart turned out to be good, deep down inside, and gave himself up.
		SUSIE: Why?
		FEARLESS: Well, there's this new gun I received this morning from the East that I haven't yet had a chance to use!
8. Fade is used to signify the end of a sequence, a passage of time, and a change of place.	THEME MUSIC IN AND UP STRONG. SLOW FADE OUT.	

Continued

COMMENTARY	VIDEO	AUDIO
9. Since this is a videotaped studio show, stock film or tape and tape shot in the field may be necessary for the exterior scene, not reproducible in a studio.	FADE IN STOCK FILM OR TAPE OF SOUTH DAKOTA BADLANDS, CUT TO FEARLESS AND SUSIE ON THEIR HORSES ON THE TRAIL WAVING GOODBYE TO BART, WHO RIDES OFF INTO THE DISTANCE.	
10. Key or matte permits the insertion of words onto the picture.	KEY CREDITS OVER THE SCENE AS FEARLESS AND SUSIE CONTINUE TO WAVE.	

Sound

In the technical—not the artistic—sense, video and audio use sound in essentially the same ways, except for some obvious differences. The microphone (**mic**) in the television play is not stationary, but is on a boom and dolly to follow the moving performers. Chest mics, table mics, and cordless mics are used in television, usually for the nondramatic studio program such as news, panel, and interview shows, and sometimes for plays in preset positions and situations. In television, the dialogue and sound on the set usually emanate from and are coordinated with the visual action. Off-screen (**OS**) sound effects can be used, but they must clearly represent something happening off-screen; if they represent an action taking place on camera, they must appear to come from that source.

The term *off-camera* (**OC**) is used in the script for the character or sound heard but not seen. Sound can be prerecorded for television or, as is frequently done with filmed productions, added after the action has been shot. Television and radio both use narration, but narration is infrequent in the visual medium. In television the *voice-over* (**VO**) can be a narrator, announcer, or the prerecorded thoughts of the character.

Television uses music as program content, background, and theme. Other uses of sound and music in radio can be adapted to television, as long as the writer remembers that in television the sound or music does not replace visual action but, rather, complements or heightens it.

RADIO

Microphone use, sound effects, and music are the primary technical and production elements the radio writer should be aware of and should be able to indicate in the script. The

writer should further understand how the studio and control room can or cannot implement the purposes of the script. Although the most creative uses of radio's potentials can be realized in the drama, few plays are heard on radio anymore. Nevertheless, these same creative techniques can be applied to commercials, many of which are short dramatic sequences, and to lesser degrees to other radio formats.

The Microphone

The basic element of radio broadcasting is the microphone, usually abbreviated as *mic,* but sometimes seen in its older abbreviation, *mike.* The number of microphones used in a show usually is limited. For the standard program—a disc jockey or news program—only one is needed. A panel, discussion, or interview program may have a mic for each person or for every two people.

Not all microphones are the same. The audio engineer selects certain types of microphones for their sensitivity and specific effects uses. The writer has only one important responsibility in this area: To indicate the performer's relationship to the microphone. This physical relationship determines the listener's orientation. For example, the audience might be with a character riding in a car. The car approaches the edge of a cliff. The writer must decide whether to put the sound of the character's scream and the noise of the car as it hurtles off the cliff on mic, thus keeping the audience with the car, or to fade these sounds into the distance, orienting the audience to a vantage point at the top of the cliff, hearing the character and car going downward.

There are five basic microphone positions. The writer should indicate every position except **on mic,** which is taken for granted when no position is designated next to the line of dialogue. If the performer has been in another position and suddenly speaks from an on mic position, then "on mic" should be written in.

- *On mic.* The performer speaks from a position right at the microphone. The listener is oriented to the imaginary setting in the same physical spot as the performer.

- *Off mic.* The performer is some distance away from the microphone. This conveys to the audience the impression that the sound or voice is at a proportionate distance away from the physical orientation point of the listener, which is usually at the center of the scene. The writer can vary this listener orientation. By removing the performer's voice but indicating through the dialogue that the performer has remained in the same physical place, the writer removes the listener rather than the performer from the central point of action.

- *Fading on.* The performer slowly moves toward the microphone. To the listener, the performer is approaching the physical center of the action.

- *Fading off.* The performer moves away from the microphone while speaking, thus moving away from the central orientation point.

■ *Behind obstructions.* The performer sounds as if there were a barrier between him or her and the focal point of the audience's orientation. The writer indicates that the performer is behind a door, outside a window, or perhaps under the bandstand. The writer may suggest special microphones. The filter mic, for example, creates the impression that a voice or sound is coming over a telephone. The voice at the focal point of the audience's orientation, even though speaking over a telephone, too, would be on mic. The echo chamber, another device, creates various degrees of an echo sound, ranging from an impression that a person is locked in a closet to that of being lost in a boundless cavern.

Note how the five basic mic positions are used in the following script example. The *commentary* column on the left is *not* a part of the script, but is used here solely as a learning device. *Note, too, that although the radio scripts in this book are single-spaced for space reasons, ALL radio scripts should be double-spaced.*

COMMENTARY	AUDIO
1. With no mention of position, the character is assumed to be ON MIC.	GEORGE: I'm bushed, Myra. Another day like the one today, and I'll just … (THE DOORBELL RINGS)
	MYRA: Stay where you are, George. I'll answer the door.
	GEORGE: Thanks, hon. (DOORBELL RINGS AGAIN)
2. The orientation of the audience stays with George as Myra leaves the focal point of the action.	MYRA: (RECEDING FOOTSTEPS, FADING) I'm coming … I'm coming. I wonder who it could be at this hour.
3. George must give the impression of projecting across the room to Myra who is now at the front door.	GEORGE: (CALLING) See who it is before you open the door.
	MYRA: (OFF) All right, George.
4. Myra's physical position is now clear to the audience through the distance of her voice. As soon as she comes ON MIC, the audience's physical position arbitrarily is oriented to that of Myra at the door.	(ON MIC) Who is it?

Continued

COMMENTARY	AUDIO
5. *This is an example of the behind-an-obstruction position.*	MESSENGER: (BEHIND DOOR) Telegram for Mr. George Groo.
6. *The physical orientation of the audience stays with Myra. George is now OFF MIC.*	MYRA: Just a minute. (CALLING) George, telegram for you. GEORGE: (OFF) Sign for me, will you Myra? MYRA: Yes. (SOUND OF DOOR OPENING) I'll sign for it. (SOUND OF PAPER BEING HANDED OVER AND THE SCRATCH OF PENCIL ON PAPER) MESSENGER: Thank you ma'am. (SOUND OF DOOR BEING CLOSED) MYRA: (SOUND OF TELEGRAM BEING OPENED) I'll open it and . . . (SILENCE FOR A MOMENT)
7. *Note the complete shift of audience orientation. The audience, at the door with Myra, initially hears George from the other end of the room; George, fading on, approaches the spot where the audience and Myra are. Finally, George is at that spot. Note the use of the term ON MIC at the end, when the character comes to that position from another position.*	GEORGE: (OFF) Well, Myra, what is it? (STILL SILENCE) GEORGE: (FADING ON) Myra, in heaven's name, what happened? What does the telegram say? (ON MIC) Myra, let me see that telegram!

Sound Effects

There are two major categories of sound effects: recorded and manual. Virtually any sound effect desired can be found on disc, record, or tape. For split-second incorporation of sound into the program's action, manual or live effects sometimes are more effective. Manual effects include such sounds as the opening and closing of a door (coming from a miniature door located near the microphone of the sound effects operator) and the rattling of cellophane to simulate the sound of fire. Natural effects are those emanating from their natural sources, such as the sound of walking where a microphone is held near the feet of a sound effects person. Combinations of sounds can be made from an amalgamation of recorded, manual, and natural effects.

Inexperienced writers occasionally overdo the use of sound. Sound effects should be used only when necessary, and then only in relation to the principles that determine the listener's orientation. Think of your own orientation to sound when listening to the radio. For example, a high pitch, high volume, or rising pitch generally suggests a climax or some disturbing element whereas a low pitch, low volume, or descending pitch usually generally suggests something soothing and calm. Combinations of these sounds and the relationship of the specific sound to the specific context of the script can alter these generalizations. For instance, a low pitch in the proper place can indicate something ominous and foreboding rather than calm; the combination of a low pitch and high volume, as in thunder or an explosion, creates anything but a soothing effect. A high or ascending pitch can, in context, indicate something happy and bright. Sound effects can be used for many purposes, such as the following:

■ *Establish locale or setting.* The sound of marching feet, the clanging of metal doors, and the blowing of a whistle suggest a prison. Soft violin music, the occasional clatter of dishes and silverware, the clinking of glasses, and whispered talking suggest a restaurant, perhaps an old-world Hungarian or Russian restaurant.

■ *Direct audience attention and emotion.* Emphasis on a distinctive sound can specifically orient the audience. For example, the sudden banging of a gavel in a courtroom scene will immediately orient the audience toward the judge's bench. If the audience is aware that a person alone at home is an intended murder victim, the sound of steps on a sidewalk followed by the sound of knocking on a door, or the more subtle sound of turning a doorknob, will direct the audience's attention toward the front door and orient its emotions toward suspenseful terror and expected violence.

■ *Establish time.* A clock striking the hour or a rooster's crow are rather obvious but nevertheless accepted devices. The echo of footsteps along a pavement, with no other sounds heard, designates a quiet street very late at night or very early in the morning. If an element referred to in the program, such as a passing freight train, has been established as going by at a certain time, every time that sound effect—the passing train—is used, the audience will know the time.

■ *Establish mood.* The sounds of laughter, loud music, and much tinkling of glasses establish a different mood for a party than would subdued whispers and the soft music of a string quartet. Sound can be used effectively as counterpoint to an individual character's mood. The attitudes and emotions of a worried, sullen, morose, and fretful character may be heightened by placing the person in the midst of sounds of a wild party.

■ *Signify entrances and exits.* The sound of footsteps fading off and the opening and closing of a door—or the reverse, the opening and closing of a door and sound of footsteps coming on—unmistakably signify an exit or an entrance. Other sounds can be used to show a character's coming to or leaving a specific place. The departure of a soldier from an enemy-held jungle island after a secret reconnaissance mission can be portrayed by the

sounds of boat paddles, the whine of bullets, and the chatter of jungle birds and animals. If the bullet, bird, and animal sounds remain at a steady level and the paddling of the boat fades off, the audience remains on the island and sees the soldier leave. The audience leaves with the soldier if the paddling remains at an on-mic level and the island sounds fade off.

■ *Serve as transition.* If the transition is to cover a change of place, the sounds used can be the means of transportation. The young graduate, about to leave home, says tender farewells. The farewells **cross-fade** into airplane sounds, which in turn cross-fade into the sounds of the hustle and bustle of a big city. These sounds cross-fade into a dialogue sequence in which the graduate rents an apartment. The change of place has been achieved with sound providing an effective transition.

If the transition is to cover a lapse of time, the sound may be that of a timing device, such as a clock striking three, the clock tick fading out and fading in again, and the clock striking six. The sound indicating the transition need not relate to the specific cause of the transition and can be of a general nature. For example, a **montage** of street sounds covers a change of place and a lapse of time for someone going to a store, in a commercial, to buy the advertised product. Sometimes a montage, which is a blending of a number of sounds, can be especially effective when no single sound fits the specific situation.

In a nondramatic sequence, such as a transition between program segments, sound relating to the next segment can be used. In some situations the sounds may relate to the program as a whole rather than to a specific circumstance, such as a news ticker sound as a transition or establishing sound for a news program.

■ *Create nonrealistic effects.* Note Norman Corwin's description in "The Plot to Overthrow Christmas" of the audience's journey to Hades, "to the regions where legions of the damned go."

CLANG ON CHINESE GONG. TWO THUNDER PEALS. OSCILLATOR IN A HIGH PITCH BEFORE THUNDER IS ENTIRELY OUT. BRING PITCH DOWN GRADUALLY AND FADE IN ECHO CHAMBER, WHILE HEAVY STATIC FADES IN. THEN OUT TO LEAVE NOTHING BUT OSCILLATOR AT A LOW OMINOUS PITCH. THEN RAISE PITCH SLOWLY, HOLD FOR A FEW SECONDS.

Combinations of sound and music can be used to create almost any nonrealistic effect, from the simplest to the most complex.

Sound can achieve several purposes at the same time. A classic sound effects sequence—to many the best and most famous in radio history—accompanied comedian Jack Benny's periodic visits to his private vault on his radio show. Younger people who have

listened to revivals of old-time radio programs may have heard it. The sounds establish setting and mood, orient the audience's emotions and direct its attention, signify entrances and exits, serve as transitions between places and the passage of time, and create nonrealistic effects.

SOUND: FOOTSTEPS …DOOR OPENS …FOOTSTEPS GOING DOWN …TAKING ON HOLLOW SOUND …HEAVY IRON DOOR HANDLE TURNING …CHAINS CLANKING …DOOR CREAKS OPEN …SIX MORE HOLLOW FOOTSTEPS …SECOND CLANKING OF CHAINS …HANDLE TURNS …HEAVY IRON DOOR OPENS CREAKING …TWO MORE FOOTSTEPS (DIALOGUE BETWEEN THE GUARD AND JACK) …LIGHT TURNING SOUND OF VAULT COMBINATION …LIGHT TURNING SOUND …LIGHT TURNING SOUND … LIGHT TURNING SOUND …HANDLE TURNS …USUAL ALARMS WITH BELLS, AUTO HORNS, WHISTLES, THINGS FALLING …ENDING WITH B.O. FOGHORN …

Courtesy of J & M Productions, Inc.

Keep in mind that many sounds, no matter how well or accurately done, sometimes are not immediately identifiable to the audience, and often can be confused with similar sounds. The writer may have to identify the sounds through the dialogue. For example, the rattling of paper can sound like fire, and the opening and closing of a desk drawer can sound like the opening and closing of almost anything else. The following sequence attempts to make the sounds clear as a natural part of the dialogue.

DICK: (RUFFLING THE PAGES OF A MANUSCRIPT) Just about the worst piece of junk I've ever written in my life.

ANNE: Well, even if you don't like it, I think it can become a bestseller.

DICK: (RUFFLING PAGES AGAIN) Three hundred and forty-two pages of pure unadulterated mediocrity. Listen to them. They even sound off-key. (SOUND OF A DESK DRAWER OPENING) There. That's where it belongs. (SOUND OF MANUSCRIPT BEING THROWN INTO THE DRAWER)

ANNE: Don't lock it up in your desk. I think it's good.

DICK: Nope! That drawer is the place where all bad, dead manuscripts belong. (SOUND OF DESK DRAWER CLOSING) Amen!

Music

Music is radio's principal programming today, but music goes beyond content alone. The writer should also understand how to use music as a bed, program theme, bridge, or sound effect, and for background or mood.

■ *Content.* Recorded (on record, tape, cartridge, and compact disc) music, played by disc jockeys, dominates radio programming.

■ *Bed.* *Bedding* is the generic term used to describe music used under or as backup of an announcer's sound tracks.

■ *Theme.* From the earliest days of radio, star performers used theme music for personal identification. Listeners who heard the beginning of the song "The Make Believe Ballroom" knew immediately that it was time for Martin Block, one of radio's first and premiere disc jockeys. The first few bars of "Love in Bloom" meant that Jack Benny was about to make his entrance. "A Hard Day's Night" signaled the appearance of the Beatles. "Hello Love" is identified with the American Public Radio Network's *A Prairie Home Companion* show. "Born in the USA" is Bruce Springsteen. "The Material Girl" introduces Madonna. "Billie Jean" means Michael Jackson, and "A Beautiful Day" means U2. Music can be used as a program theme or to peg a specific event or particular personality. The action or performer is identifiable as soon as the theme music is heard. A theme can be used for the opening, closing, and commercial break transitions in a show. The following script is an example.

MUSIC:	THEME, "ROCK AROUND THE CLOCK," IN, UP, AND UNDER.
DEEJAY:	Welcome to another afternoon session of "The Best of America's Rock Stars," with music, gossip, information, and a special guest, live, interviewed by yours truly, your rocking host, Joe J. Deejay.
MUSIC:	THEME UP AND OUT.
CART:	:60 COMMERCIAL
DEEJAY:	First on our agenda is our special guest. One of the greatest stars of all time, in this country and internationally.
MUSIC:	"BORN IN THE USA" IN, UP, AND UNDER.
DEEJAY:	Welcome, Bruce Springsteen, to "The Best of America's Rock Stars."
MUSIC:	OUT
DEEJAY:	Bruce, what brings you to our city …?

After the final commercial and Deejay's outro (the announcer's final comments, as differentiated from intro, or introduction), the theme is brought in, up, and out to close the show.

■ *Bridge.* The musical bridge is the most commonly used device to create transitions. Music lasting only a few notes or a few bars can be used to indicate the breaks between segments of the program. The music bridge also can be used to distinguish the commercial inserts from the rest of the programs.

In a dramatic sequence (in a commercial, for example), the music bridge frequently indicates a change of place or a passage of time. Care must be taken that the bridge represents the mood and content of the particular moment. The bridge usually is only a few seconds long. When it is very short, only a second or two, it is called a *stab.* Note the bridge in the next script example.

SOUND:	WATER RUNNING, ECHO IN BATHROOM
MARY:	I hate to say this, John, but if you want to make a good impression on your boss today, you ought to change your brand of toothpaste.
JOHN:	This one tastes good.
MARY:	But it doesn't give you the fresh breath of Angelmint.
JOHN:	I'm glad you told me. I do want that promotion.
MUSIC:	BRIDGE
SOUND:	DRUG STORE NOISES
JOHN:	A tube of Angelmint, please.
CLERK:	Yes, sir. It's our best-selling toothpaste.
SOUND:	CASH REGISTER
MUSIC:	BRIDGE
JOHN:	Mary, Mary, I got the promotion, thanks to you.
MARY:	Thanks to Angelmint, John.
MUSIC:	STAB AND OUT

■ *Sound effect.* Brass and percussion instruments can convey or heighten the feeling of a storm better than sound effects alone. Some effects cannot be presented effectively except through music. How better to convey on radio the sound of a person falling from the top of a tall building than through music moving in a spiral rhythm from a high to a low pitch and ending in a crash?

■ *Background or mood.* Music can heighten the content and mood of a sequence. The music must serve as a subtle aid, however; it must not be obvious or, sometimes, even evident. The listener who is aware of the background music during a commercial sequence has been distracted from the primary purpose of the production. The music should have its effect without the audience consciously realizing it. Background and mood music should not be overdone or used excessively. Well-known compositions should be avoided because they can distract the audience with their familiarity.

Sound and Music Techniques and Terms

Several important terms are used by the writer to designate the techniques that manipulate music and sound. These techniques are applied at the control board.

■ *Segue.* **Segue** (pronounced seg-way) is the smooth transition from one sound into the next. This particularly applies to the transitions between musical numbers, when one number is faded out as the next number is faded in. Segues are used in dramatic sequences as well as in music, but in the former the overlapping of sounds makes the technique a cross-fade rather than a segue—as seen in the following music program:

ANNOUNCER:	Our program continues with excerpts from famous musical compositions dealing with the Romeo and Juliet theme. First we hear from Tchaikovsky's <u>Romeo and Juliet</u> overture, followed by Prokofiev's <u>Romeo and Juliet</u> ballet, and finally Gounod's opera <u>Romeo et Juliette</u>.
MUSIC:	TCHAIKOVSKY'S <u>ROMEO AND JULIET</u>. SEGUE TO PROKOFIEV'S <u>ROMEO AND JULIET</u>. SEGUE TO GOUNOD'S <u>ROMEO ET JULIETTE</u>.
ANNOUNCER:	You have heard ...

and in this dramatic sequence:

ANNOUNCER:	And now, a word from Millwieser's Light Beer.
MUSIC:	IN AND UP, HOLD FOR FIVE SECONDS AND OUT. SEGUE INTO
SOUND:	TINKLING OF GLASSES, VOICES IN BACKGROUND IN CONVERSATION, MUSIC PLAYING.

■ *Cross-fade.* The *dissolving* from one sound into another, *cross-fade* sometimes is used interchangeably with *segue.* But cross-fade is the crossing of sounds as one fades in and the other fades out, whereas the segue is simply the immediate following of one sound by another. In the following example, the telephone ringing becomes blended for a second or two with the music before the music is entirely faded out, and then only the telephone ringing remains.

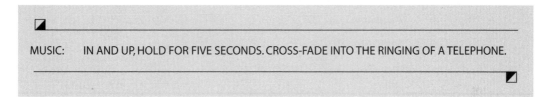

MUSIC: IN AND UP, HOLD FOR FIVE SECONDS. CROSS-FADE INTO THE RINGING OF A TELEPHONE.

■ *Blending.* **Blending** refers to two or more different sounds combined and going out over the air simultaneously. Blending can include combinations of dialogue and music, dialogue and sound effects, sound effects and music, or all three. The example of the tinkling glasses, background voices, and music illustrates the latter.

■ *Cutting or switching.* **Cutting** or **switching,** the sudden cutting off of one sound and the immediate intrusion of another, is a jarring break, sometimes used for a special effect. Cutting can simply designate a sharp change from one microphone to another or to a different sound source. It also can be used for remotes.

ANNOUNCER: We now switch you to Times Square where Tom Rogers is ready with his "Probing Microphone."

CUT TO ROGERS AT TIMES SQUARE

ROGERS: Good afternoon. For our first interview, we have over here . . .

■ *Fade-in and fade-out.* Bringing up the volume or turning it down is a relatively simple operation that is frequently used to fade the music under dialogue, as well as to bring music into and out of the program. The writer indicates that the music should *fade in, up* (higher in volume), *under* (lower in volume), or *out.* The following example illustrates fade-in and fade-out on the disc jockey show.

MUSIC:	THEME,"YOU RAPPED MY RAPPER WITH A RAP." (FADE) IN, UP, AND UNDER.
ANNOUNCER:	Welcome to the Rappin' Robert Rap Repertory.
MUSIC:	THEME UP, HOLD FOR FIVE SECONDS, THEN UNDER AND (FADE) OUT
ANNOUNCER:	This is Rappin' Robert ready to bring you the next full hour right from the top of the charts. And starting with number one of the rack, it's The Kitchen Sink and their new hit …
MUSIC:	SNEAK IN AND HOLD UNDER
ANNOUNCER:	… that's right, you know it, The Kitchen Sink with "Dirty Dishes."
MUSIC:	UP FAST, HOLD TO FINISH, AND OUT.

The Studio

The physical limitations of a radio studio can affect the writer's purposes. Try to determine if the studio is large enough and has the equipment necessary to perform your script properly. Most professional studios are acoustically satisfactory, but some are not, and you should learn whether it is possible to achieve the sensitivity of sound required by your script. Although many music stations do not have a separate studio, performing all of their air work in the control room, some stations have separate studios for panel, interview, and other shows that cannot originate with one or two people seated at the control board or turntable. The studio will contain microphones and other equipment, sometimes including manual sound effects, necessary for live production.

The Control Room

The control room is the center of operations, where all of the sound—talk, music, effects— are coordinated. All the inputs are carefully mixed by the engineer at the control board and sent out to the listener. The control board regulates the volume of output from all sources and can fade or blend the sound or any one or combination of inputs. The control room usually contains CD, tape, cartridge machines, and, still in some, turntables for playing prerecorded material, and microphones for the deejays and announcers. The control room also contains equipment for recording material, sometimes an entire program, for later broadcast.

More Radio Terminology

Some terms the writer should know that frequently appear in the production script: **bed** (a music base), **SFX** (sound effects), **cart** (cartridge, containing the prerecorded material

to be played), **ATR** (audio tape recorder, serving the same function as the cart, but less often), **RT** (reel type), **CD** (compact audio disc), and mic (microphone).

INTERNET INTERACTIVE TECHNIQUE

A key addition of the Internet to the media mix is its ability to be interactive—between the presenter (writer) and the receptor (the audience). Interactivity suggests an exploitation of the Internet's multimedia potentials: not only a mix of audio and video, but also live action, controlled sound, still photographs, charts and graphs, text, and animation. For the first time, the writer can combine virtually all media techniques in an interactive way for a mass audience. This not only permits but also requires a new set of writing concepts, approaches, and techniques. Interactivity requires a larger number of variables in writing. The writer presents information, ideas, and emotional stimulation in the form of links; one item is linked to the next according to the desire of the individual members of the audience on an individual basis, but not in a point-by-point logical or, as in previous media, linear fashion.

The writer has to prepare a virtually unlimited series of options for the audience, specific choices that the audience might make that will, in turn, affect the next item in the chain. More than in other media, the writer must both anticipate what individual audience members' reactions and counter reactions will be and design a writing product that will guide the audience toward those choices that the writer thinks will achieve the purpose of the program or script.

Instead of presenting material in the traditional manner of step-by-step logical linear progression, the writer for cyberspace is in the center of a creative universe, able to reach out into an infinity of space and time to integrate a limitless number and variety of ideas, concepts, impressions, information, aural and visual materials, and emotional and intellectual stimuli in any form, placement, and mixture, in an interactive or non-interactive mode.

Both the writer and the receptor must have complete flexibility. The computer permits the receptor to mix and match, in effect making choices, even at random, from the totality of what has been presented, from any bit of material no matter where and when and how presented. Thus, because the Internet process itself dominates the content, Marshall McLuhan's dictum that "the medium is the message" takes on added meaning.

Approach

The word "hypertext" is frequently associated with creating material—writing—for the Internet. In simple terms, hypertext refers to the ability to convey our thoughts closer to the way we think—many ideas, many viewpoints rushing through our minds almost simultaneously, rather than in the logical linear fashion that we put them down on paper after we have properly organized them to make them understandable through the linear mode of communication. The Internet's hypertext, or interactive, ability means we can present a conglomeration of stimuli virtually at once, with a variety of multimedia providing the receptor—the audience—with a multitude of information and ideas about any and all things. In this respect, the Internet does for aural-visual-print communication

what Picasso's cubism did for painting. As Picasso interpreters have stated, the early twentieth century developments in communication and transportation no longer restricted the view of an object to a single plane, but the transcending of space and time made it possible to see an object from many viewpoints virtually at the same time. This is what the Internet has done for communication: Hypertext interactivity enables the receptor to receive and also to originate many varied stimuli from a virtually unrestricted space-time continuum with many varied sources virtually at the same time.

The writer of the drama, for example, can provide the receptor with the opportunity to see the unfolding of the plot through the eyes of any or all characters, with the plot concomitantly developing by virtue of the characters' own psyches, backgrounds, and motivations. The audience can pick and choose in any combination. For example, in covering a Congressional hearing on the government's failure to prevent the 2001 terrorist attacks on the World Trade Center and the Pentagon, the Internet audience could branch off from the linear narrative at any time to obtain information on the al Qaeda papers warning of an attack that the Clinton administration turned over to the Bush administration, photos and narration about the known attackers, including their families and homes, documents revealing what the CIA, FBI, and National Security Agency knew and didn't know, background on Osama bin Laden and his Afghanistan headquarters—in other words, selecting at any moment in the hearings additional in-depth information on any of the principals, events, or sites, visual information about any of the subjects, explanations of any legal term or procedure, and on and on. The receptor is also the creator, in the center of a universe of available stimuli—or to use an Internet term, in the center of a giant, unending Web—who can reach out anywhere in that Web, either specifically or at random, for whatever stimuli may be desired or available.

Process

Although this book does not intend to present information on writing a software program—which is essentially what the writer of basic material for the Internet does—adapting the traditional television, radio, or film format to the Internet does require at least an overview of the process. One frequently used process is to create a chart of sequence boxes, like the outline for a term paper. But instead of moving from box to box or step one to step two in a logical linear fashion, as soon as one item is put in a box, all possible links to material pertaining to that item are linked by arrows from that box to appropriate additional boxes. In turn, further possible links are then designated. What develops is a gigantic web, with arrows crisscrossing each other, designating the links (and information or stimuli) needed to create the whole. Each link can be of any combination of traditional media: print, charts and graphs, visual movement, audio, photographs, talking heads, drawings, and so on. For most writers, these options loom like a large burden, especially for those of us who can create words, but can't create pictures. But available software permits you to insert any kind of visual materials, music, drawings, audio, and other nonprint stimuli, in monochrome or color, at any place in any form. Further, you can provide instructions to the receptor at any stage—go forward, go back, click here for a link, click for a visual, and so on.

This means, of course, that the writer for the Internet must learn the potentials of this new writing tool, just as the potentials of the television, radio, and film media have been learned for most effective use of those media.

Although the creative writer interested in the content of a given format might have difficulty determining the mechanical requirements for full receptor interactivity—that is, directions for using the mouse for clicking or pointing at designated icons to recall material, pop-up boxes, or sidebars, scroll, rollover items, and other procedures—it is necessary to incorporate the technical directions as part of the interactive writer-receptor process. Learning how to do this will help you present the different levels of stimuli to the receptor. First, most obviously, is the material that appears forthrightly on the computer screen. A second level of stimuli appears as the receptor moves the mouse at random or follows your directions to move the mouse over the so-called "hot" areas of the screen that reveal additional stimuli. The third level is reached when the receptor makes a conscious choice of the alternatives you provide, by clicking the mouse on a specific icon to deliberately seek out interactive stimuli. The writer, by understanding this process, retains control of the receptor's experience, even while providing the receptor with the flexibility of going beyond what appears to be obvious on the screen to seek out stimuli that is of personal interest and importance.

Technique

The special considerations that went into writing for the new television medium over a half-century ago, compared with writing for the cinema at that time, are almost the same as those of writing for the new cyberspace medium today. Foremost is the limited viewing area of the computer monitor compared with the average TV screen. The viewing area is small, usually only a part of the monitor screen. The term "streaming video" is applied to the carriage of the moving visual images. Lack of bandwidth—and therefore lack of definition—is another key factor. Poor resolution requires an avoidance of wide shots with a number of characters, and of night scenes or scenes in dark or dimly lit settings. Sometimes additional light sources will provide better definition, and electronic adjustment sometimes helps, but don't count on it. Most computers are still too slow to accommodate much movement, and action should be planned accordingly. The speed of a computer—or, more precisely, lack thereof—also suggests that you should limit the number of people speaking at one time and, to be safe, should have dialogue that does not impinge on other dialogue. That is, not too many sound sources at the same time. A further consideration is the attention span of the person sitting at the computer screen. It generally is much shorter than that of a person sitting in an easy chair in front of a large-screen TV set. Therefore, scenes and the program as a whole should be shorter than what one would write for television and, most certainly, for films. Conversely, the "do's" as differentiated from the "don'ts" suggest that you should concentrate on close-ups where possible, on sharp, crisp dialogue, on minimal movement of the performers, on a slow pace of the script, on conciseness, and on a clear beginning and end.

The lack of depth on the computer screen limits the kinds of background action or information and transitions that have become accepted on television. For example, you may

have a dramatic scene with a bank guard in the foreground and a bank robber waving a gun at a teller in the background. In films and on television that would easily work. But on the Internet the background figures would be too fuzzy to convey anything clearly. Further, the Internet does not yet adapt well to standard TV special effects, such as wipes and dissolves. Therefore, using them to create a transition from one place to another or for a passage of time may leave the viewer wondering where they are and what the sequence of events is. But these are technical problems, and by the time you are reading this, many of them may have already been solved, given the rapid advances in computer technology. Just as writers did for early television, focus on the positive aspects of the Internet, principally its interactive ability.

APPLICATION AND REVIEW

Television

1 Write a short sequence in which you use the following camera movements: dolly-in and dolly-out, pan, follow, boom, and zoom.

2 Write a short sequence in which you indicate the following shots: CU, M2S, LS, FS, XLS, XCU.

3 Write a short sequence in which you designate the following effects: fade-in and fade-out, dissolve, wipe, and key.

4 Watch several television programs and analyze the camera movements, types of shots, and editing effects. Can you determine the writer's contributions in relation to the use of these techniques as differentiated from the director's work?

Radio

1 Write a short sequence in which you use all five microphone positions: on mic, off mic, fading on, fading off, and behind obstructions.

2 Write one or more short sequences in which you use sound effects to establish locale or setting, direct the audience's attention by emphasizing a particular sound, establish time, establish mood, show an entrance or exit, and create a transition.

3 Write one or more short sequences in which you use music as a bridge, as a sound effect, and to establish background or mood.

4 Write a short script in which you use the following techniques: segue, cross-fade, blending, cutting or switching, and fade-in or fade-out.

3

Format and Style

Script formats vary among stations, independent studios, and production houses. Some standard conventions and basic script formats are widely used, however, and are acceptable to almost everyone in the field. These formats are presented in this chapter and constitute most of the script examples throughout this book. As much as possible, scripts are presented as they were written or produced professionally. The principal difference is that although television and radio scripts usually are double-spaced to make it easier for the performer to read and for the director and other production personnel to make notations, in this book—to save space—many of the scripts are single-spaced and typeset rather than typed. Professional radio scripts are always double-spaced.

Four basic script formats are used in television and radio: (1) the single-column format endemic to radio; (2) the single-column format sometimes used in television; (3) the two-column principal television format, with video on the left and audio on the right; and (4) the film or screenplay format, with each sequence consecutively numbered. Final production scripts in radio are sometimes two columns, with the technical sources on the left and the continuity on the right. Television scripts sometimes have the audio on the left and the video on the right. (If you are reading this as part of a course in video, film, or audio writing, your instructor will probably recommend a format, whether one of these or an additional one. The key is to be consistent within the format you use.)

The single-column format differs for radio and television. The single-column television script resembles that of the stage play, with only essential character movements added to the dialogue, and virtually no video or audio techniques inserted. Because radio is not a visual medium, music, sound effects, and microphone positions are essential parts of the script.

In the two-column television format, the video directions are most often found on the left side and the audio information, including the dialogue, is found on the right. The video

column contains all the video directions deemed necessary by the writer. Although the writer cannot be cautioned too often to refrain from intruding on the director's domain—too many writers feel compelled to write in every dissolve, cut, and zoom—the writer frequently uses visual images rather than dialogue to tell the story, and these must be included.

The two-column radio format has all the production information on the left side, including which cart to play, microphone to use, and turntable to roll. On the right side are the directions and dialogue that usually are found in the one-column audio script.

Although formats vary from station to station, the two-column format is used most often in taped television production and in some filmed productions such as documentaries and industrial shows. The two-column format is fairly standard for television news.

The dramatic screenplay, with or without numbered sequences, is used for filmed dramas, including, usually, commercials. Some writers prefer not to actually number the sequences because they feel numbering makes the script look too technical and impedes the flow of the story. Other writers use numbering to provide quicker identification of and access to individual sequences for editing purposes, just as the producer and director require numbering to determine more easily how to plan set, location, and cast time. Films are shot out of sequence; all scenes in a given setting are shot consecutively, no matter where they are chronologically located in the script. Some writers, as well as producers and directors, believe that numbering the sequences provides a better understanding of a given script's production requirements. For example, 150 different sequences may be acceptable for a given budget, but 250 may not be.

Script preparation begins with a **summary** or an **outline,** whether for a 30-second commercial or a two-hour drama special. The outline, or summary, is a short overview, written in narrative form, of the script. The **treatment** or **scenario** is a more detailed chronological rundown of the prospective script, giving information on the setting, plot, and characters and examples of the dialogue. For a commercial, the summary or outline might be a few sentences, with the scenario or treatment ranging from a paragraph to a page. For the one-hour drama or documentary, the summary might be two or three pages, with the treatment as long as a fifth of the entire projected script. Developing the treatment for a play is covered in detail in Chapter 10.

In the next section, the following outline and scenario will be developed into scripts representing the four basic different formats to provide a comparison of approaches for one-column television, two-column television, film, and one-column radio. The story used here could be part of a commercial or a segment from a play.

Outline or summary

A man and woman, about 60, are at the beach and find a kind of beauty in being in love that they did not feel when they were younger. The story shows that romance in older years sometimes can be even more joyful and exciting than in youth.

Continued

Treatment or scenario

It is morning. Gladys and Reginald are on a beach, by the water's edge, holding hands and looking lovingly at each other. They are about 60, but their romantic closeness makes them seem much younger. They kiss.

GLADYS: I did not feel so beautiful when I was 20.

REGINALD: We weren't in love like this at that age.

The next scene shows Gladys and Reginald, hand in hand, entering a beach house.

SCRIPT

Sometimes the finished script prepared by the writer is little more than the scenario, containing only the continuity—the character's actions and dialogue—and few video or audio directions.

VIDEO	AUDIO
A BEACH AT SUNRISE	GLADYS AND REGINALD ARE BY THE WATER'S EDGE, HOLDING HANDS. THEY ARE ABOUT 60, BUT THEIR BRIGHTNESS OF LOOK AND POSTURE MAKE THEM SEEM YOUNGER. THEY KISS.
	GLADYS: I did not feel so beautiful when I was 20.
	REGINALD: (GRINNING) Me, neither. But we weren't in love like this when we were 20.
ENTRANCE HALL OF BEACH HOUSE— MORNING	THE DOOR OPENS AND GLADYS AND REGINALD WALK IN, HAND IN HAND, LAUGHING.

Television

The television writer writes visually, showing rather than telling, where appropriate. In the following television formats, the writer has added video directions that convey to the director the exact visual effects the writer deems necessary to tell the story effectively to the viewer.

Television—One-Column

FADE UP:

A BEACH AT SUNRISE, THE WAVES BREAKING ON THE SAND.

TWO PEOPLE ARE IN THE DISTANCE, AT THE WATER'S EDGE, HOLDING HANDS,
STARING TOWARD THE SEA. THEY ARE ABOUT 60, BUT THEIR BRIGHTNESS OF
LOOK AND POSTURE MAKE THEM SEEM MUCH YOUNGER. THEY SLOWLY TURN
THEIR FACES TO EACH OTHER AND KISS.

GLADYS: I did not feel so beautiful when I was 20.

REGINALD. (GRINNING) Me, neither. But we weren't in love like this when we were 20.

DISSOLVE TO ENTRANCE HALL OF A BEACH HOUSE. IT IS MORNING.

(THE DOOR OPENS AND GLADYS AND REGINALD WALK IN, HAND IN HAND,
LAUGHING.)

In the one-column format, and sometimes in the two-column format, the character's name is centered, rather than placed to the left:

THEY SLOWLY TURN THEIR FACES TO EACH OTHER AND KISS.

<div align="center">GLADYS</div>

I did not feel so beautiful when I was 20.

<div align="center">REGINALD</div>

(GRINNING) Me, neither. But were weren't in love like this when we were 20.

DISSOLVE TO ENTRANCE HALL OF A BEACH HOUSE.

Television—Two-Column

VIDEO	AUDIO
FADE IN ON BEACH AT SUNRISE. PAN ALONG SHORE LINE AS WAVES BREAK ON SAND.	(GLADYS AND REGINALD ARE SEEN IN THE DISTANCE, BY THE WATER'S EDGE, HOLDING HANDS, STARING AT THE SEA. THEY ARE ABOUT 60, BUT THEIR BRIGHTNESS OF LOOK AND POSTURE MAKE THEM SEEM MUCH YOUNGER.)
ZOOM IN SLOWLY	(GLADYS AND REGINALD TURN THEIR FACES TO EACH OTHER AND KISS. THEIR FACES REMAIN CLOSE, ALMOST TOUCHING.)
	GLADYS: I did not feel so beautiful when I was 20.
	REGINALD: (GRINNING) Me, neither. But we weren't in love like this when we were 20.
DISSOLVE TO ENTRANCE HALL OF BEACH HOUSE—MORNING	(THE DOOR OPENS AND GLADYS AND REGINALD WALK IN, HAND IN HAND, LAUGHING.)

Film

The numbers in the left-hand column of the following script refer to each shot or sequence. The numbers make it possible to easily designate which sequences will be filmed at a given time or on a given day, such as "TUESDAY, CALL 7:00 A.M., Living Room Set—sequences 42, 45, 46, 78, 79, 82."

FADE IN

1. EXT. BEACH—SUNRISE

2. PAN SHORE LINE AS WAVES BREAK ON SAND

3. EXT. BEACH—SUNRISE

 Two figures are seen in the distance, alone with the vastness of sand and water around them.

4. ZOOM SLOWLY IN UNTIL WE ESTABLISH THAT THE FIGURES ARE A MAN AND WOMAN.

Continued

5. MEDIUM LONG SHOT

The man and woman are standing by the water's edge, holding hands, staring toward the sea. They are about 60, but their brightness of look and posture make them seem much younger.

6. MEDIUM SHOT, REVERSE ANGLE

They slowly turn their faces to each other and kiss.

7. CLOSE SHOT

8. MEDIUM CLOSE SHOT

Their heads and faces are close, still almost touching.

GLADYS
I did not feel so beautiful when I was 20.

9. CLOSE SHOT

REGINALD
(grinning)
Me, neither, but we weren't in love like this when we were 20.

CUT TO:

10. INT. BEACH HOUSE—ENTRANCE HALL—MORNING
The door opens and Gladys and Reginald walk in, hand in hand, laughing.

Radio

Note how much more dialogue is necessary to convey the same story in sound alone.

SOUND:	OCEAN WAVES, SEAGULLS, FOOTSTEPS OF TWO PEOPLE ON THE SAND, OCEAN SOUND COMING CLOSER AS THE PEOPLE APPROACH THE WATER.
GLADYS:	(FADING ON) The ocean is so beautiful. I remember first coming to this beach 40 years ago, Reginald. I was 20 years old.
REGINALD:	I remember this beach, too, Gladys.
GLADYS:	I did not feel so beautiful then as I do now.
SOUND:	SOFTLY KISSING

Continued

REGINALD:	Me, neither. But were weren't in love like this when we were twenty.
GLADYS:	(SUGGESTIVELY) Let's go back to the beach house.
MUSIC:	BRIDGE
SOUND:	GLADYS AND REGINALD'S FOOTSTEPS GOING UP STAIRS. DOOR OPENING.
REGINALD:	(LAUGHTER IN HIS VOICE) What a beautiful morning this is!
GLADYS:	(LAUGHTER IN HER VOICE) It's a glorious day!

SCRIPT GUIDELINES

Radio producer Christopher Outwin has noted that audio script formats frequently have split pages: "The left-hand side of the page usually is reserved for technical instructions and the sources for each channel of sound. The right-hand side of the page usually is reserved for descriptions of actual audio content, in-cues and out-cues, and the actual narrative or dialogue itself." Outwin stressed that the script information must be complete enough to ensure that all engineering, directorial, and performance members of the team understand precisely what they are supposed to do and when they are supposed to do it— but the script should not be cluttered. "Production personnel need to be able to find their places and execute their duties quickly and without confusion."

Television production teachers as well as producers usually recommend the split two-column format for studio or multicamera production and the full-page format for single-camera production in the field. As a writer you should have in your mind the pictures you want the audience to see, and you should describe them in your script. But while you tell the director what should be shown on the screen, don't tell him or her how to do it—how to use the cameras, how to move the talent, or what the camera shots should be. Those are the director's responsibilities—and problems, Nevertheless, convey clearly what the visual message should be; if there is any question in your mind that the descriptions might not be perceived exactly as intended, then insert and specify video directions as necessary.

An excellent set of professional script guidelines for the *filmed teleplay* is contained in the *Professional Writer's Teleplay/Screenplay Format,* issued by the Writers Guild of America. The following are the basic format directions suggested by the Guild:

1 All camera directions, scene descriptions, and stage directions are typed across each page, from margin to margin.

2 All dialogue is typed within a column approximately 3 inches wide running down the center of the page. The name of the character who speaks is typed just above his line

of dialogue. Parenthetical notations as to how the lines should be spoken are typed beneath the character's name and a little to the left.

3 Single spacing is used in all dialogue, camera directions, stage directions, and descriptions of scenes.

4 Double spacing is used between the speech of one character and the speech of another; between a speech and a camera or stage direction, and between one camera shot and another.

5 When a method of scene transition (such as DISSOLVE TO) is indicated between two scenes, it is always set apart from both scenes by double spacing.

6 The following script elements are always typed in capital letters:

CAMERA SHOTS & CAMERA DIRECTIONS

INT. OR EXT. (Interior or Exterior)

INDICATION OF LOCALE (at beginning of scene)

INDICATION OF NIGHT OR DAY (at beginning of scene)

METHOD OF TRANSITION (when specified)

NAMES OF ALL CHARACTERS (when indicated above the dialogue they speak, and the *first time* they appear in descriptive paragraphs)

The Guild booklet provides the following sample script, the first part explaining format approaches and the subsequent pages illustrating how to present actual story material and directions.

<u>ACT ONE</u>
(Act designations are used only in teleplays)
FADE IN:
EXTERIOR OR INTERIOR LOCATION—SPECIFY DAY OR NIGHT CAMERA SHOT—SUBJECT OF CAMERA SHOT INDICATED HERE

Descriptions of scenes, characters, and action are typed across the page like this. Music and sound effects are typed here too.

CHARACTER
(manner in which the character speaks)
The actual lines of dialogue go here.

Continued

2nd CHARACTER

Speaks here.

3rd CHARACTER

Speaks here. Note that all dialogue is typed within a column running down the center of the page.

Additional descriptions and CAMERA MOVEMENTS are typed in this manner whenever they are needed.

TRANSITIONAL INSTRUCTIONS (CUT TO, DISSOLVE TO, etc.)

Note: Transitional instructions are used very sparingly by the professional writer who leaves most such decisions up to the director. It is only when a specific effect is required such as JUMP CUT or SMASH CUT that the manner of transition should be indicated.

NEXT SCENE OR CAMERA SHOT TYPED HERE

FADE IN:

EXT. SUBURBAN RAILROAD STATION—LATE AFTERNOON ESTABLISHING SHOT

It is the end of a hot summer day. A train has just pulled into the station, and COMMUTERS are pouring out—some with jackets thrown over their arms, many with loosened ties. Outside the station, a number of WIVES are waiting in cars for their commuter husbands. Car horns are HONKING in chaotic profusion.

MED. TWO-SHOT—JACK DOBBS AND FRED McALLISTER

They are youngish middle-aged businessmen who have just gotten off the train. JACK is bull-necked, nearly bald, powerfully built; he is a former athlete who keeps himself in excellent shape. FRED has the more typical suburban pot-belly and slouch; a man of dry martinis and electric golf carts.

FRED

Need a lift?

JACK

No, thanks. Joan's picking me up.
(looking around at the cars)
I guess she must have got stuck in traffic.

A horn HONKS raspingly.

FRED
(dolefully)
I'd know that sweet voice anywhere. See you tomorrow.

Continued

JACK

Bring money!

Fred goes off to his waiting wife, as CAMERA MOVES IN CLOSE on Jack. His eyes continue to search the station parking field. Behind him, the train may be seen pulling out of the station.

JACK'S POV—PANNING SHOT—THE STATION PARKING LOT

It is now completely empty of cars. A few scraps of paper are blowing across the parking field, propelled by the hot summer wind.

BACK TO JACK

as he continues to gaze at the empty parking field. He is puzzled, and a little worried. Then making a sudden decision, he turns towards the station hack stand.

JACK
(calling)

Taxi!

A moment later; a taxi glides up to where he stands, Jack enters the taxi.

DISSOLVE TO:

EXT. A LOVELY SUBURBAN STREET—LATE AFTERNOON HIGH ANGLE SHOT—STREET AND HOUSES

A taxi pulls up to a white colonial house. Jack gets out, and pays the DRIVER. The taxi ROARS away.

CLOSE-UP—JACK

as he turns towards the house, and stops suddenly—a look of bewilderment on his face.

JACK'S POV—THE HOUSE

The grass is overgrown. A white-haired WORKMAN is nailing wooden boards across a window.

PANNING JACK

He approaches the house, and stops near the Workman.

JACK

What's going on?

The Workman ignores him, and continues his hammering.

JACK (Cont'd)
(a pause, then angrily)
Hey, mister! You hard of hearing, or something? I asked you what's going on!

The preceding format directions and script illustrations are courtesy of Writers Guild of America, East, Inc., from its booklet *Professional Writer's Teleplay/Screenplay Format*, written by Jerome Coopersmith, illustrated by Carol Kardon.

STYLE

Writing for the Ear and Eye

By the time you take a course in writing for television and radio, you've probably had more than a dozen years worth of courses in writing for print—from the elementary school three-R classes to college studies in writing literature, poetry, and essays. But you've likely had few if any courses in writing for the electronic media, even though the overwhelming majority of people in the world spend more of their time communicating and being communicated to visually and aurally than with print.

In broadcast writing, *be brief.* Although your writing for print—whether news, an essay, a novel, a short story, or other form—can be as long or as short as it needs to be for optimum effectiveness, your broadcast writing is constrained by time. A good news story in a newspaper ranges from hundreds to thousands of words. The same story on radio or television may have to fit into 30 seconds—perhaps no more than 100 words—or, if an important story, 90 seconds or two minutes. And unless you have reached the stature of writing a miniseries of four, six, or more hours, you have to condense what might in print be the contents of a novel or a play into the equivalent of 42 minutes for the hour show or about an hour and a half for the two-hour television special.

Retain an informal tone. The listener or viewer does not have the luxury of rereading formal or intellectually challenging passages to better understand what is being presented. On radio or television, a message is heard or seen just once. Although formal language and content structure can be appropriate for some documentaries and news/talk shows, the audience members who miss the next bit of action because they stopped to consider the previously presented material will quickly be lost.

Be specific. Vague, generalized action or information tends to be confusing and might persuade the audience to switch stations. Make sure that whatever is presented, whether visual or aural, is simple and clear. Ambiguity can be intriguing in print, but it usually is dull and boring on the air. This does not suggest that you write down to a low level of intellect or understanding. The content you present can be both significant and sophisticated. But you must write in a way that will reach and affect the audience; otherwise, you've wasted their time and yours.

Remember, too, that although the term *mass media* is used, *the radio-television communication process is essentially one-to-one:* The presenter at the microphone or in front of the camera and the individual receptor at home. The material should be written as if the presenter were sitting informally in the audience's living room making the presentation.

Personalize. Demographics are essential to understanding and reaching a specific audience. Try to relate the style and content of your writing to that audience and, as much as possible, to each individual member of that audience.

Be natural. Young writers frequently confuse flowery language with high style, and simple, uncluttered sentences with low style. It takes time to shed the glamour of ostentation. This is especially true in the electronic media. Remember the comment in Chapter 1

(p. 6) about the playwright whose 30 pages of scintillating, sophisticated dialogue were replaced by 30 seconds of terse visual writing.

Avoid the tendency to write in the following manner:

> Enough timber was consumed by the rampaging fire in the north woods to create 232 thousand square feet of prime building lumber; the embers of these never-to-be-realized residential manors reaching into the heavens above charred, twisted treetops, disappearing into the void like hordes of migrating fireflies.

Learn to write it this way:

> The north woods fire destroyed enough timber to build 100 six-room homes, and the smoke and flame were visible as far as 40 miles away.

As a young sportswriter, this author developed his style of writing by pretending that he was saying the things he was writing to a group of people in a bar or sitting around a living room. Later he adapted the style to the broadcast media by changing the group to a single individual. When you are at your typewriter, word processor, or computer, writing for television or radio, create in your mind a typical viewer or listener, an imaginary member of the audience to whom you are "speaking" directly, one-to-one. The key: use informal, concise, active, down-to-earth language.

Simplicity

Ernest Hemingway's style as a journalist and novelist would have adapted very effectively to the electronic media. Hemingway advised young writers to "strip language clean . . . down to the bones." Be simple and direct. Use words of two syllables instead of three. That isn't catering to the lowest common denominator, but to the essence of aural and visual communication. In the electronic media, the language goes by so quickly that one has neither the opportunity nor the luxury of savoring it, thinking about the nuances of a word or sentence, as one does when reading. The action cannot be stopped in a television or radio news story, feature, or sitcom (unless you are viewing it on tape or DVD), as it can when you slow down to reread or pause in the middle of a print story to think about what you have read.

Choose words that are familiar to everyone in the audience. Don't lose your viewers or listeners by being pretentious or by trying to teach them new vocabulary words. The best way to teach is through the contents and purpose of the script as a whole—through the presentation of ideas. The more sharply and clearly the ideas are presented, the more effectively the audience will understand and learn.

Sometimes choosing simple words is hard to do because you must at the same time avoid cliches and trite expressions. Pity the scriptwriter for the disc jockey show featuring a popular pianist. "Meandering on the keyboard"? "Rhythmical fingering of the blacks and whites"? "Carousing on the 88s"? You wouldn't use any of these phrases, of course. But how many times can you repeat "playing the piano"?

Look for fresh ways to say the same thing, and if you can't find a new way that isn't dull, pretentious, or inane, then just say it as simply and directly as possible.

Don't use words that might be common in *your* conversation but are not ordinarily used. As a college-trained professional, your vocabulary is at least a cut above that of most people you are trying to reach. Someday, perhaps, when you've achieved a reputation that prompts people to listen to you not because of what you say, but because of who you are, you can use language and ideas on a level the audience might otherwise tune out. Again, this is not to say that you shouldn't raise the level of the audience's consciousness, but unless you keep the audience tuned in, there is no consciousness to raise.

Grammar

A character you create for a play can use slang or incorrect grammar as part of that fictional person's characteristics. Other than that, however, you must use proper and effective grammar if your ideas are to be communicated and accepted. A news script with grammatical errors not only will embarrass the anchor reading it but also will result in the writer losing his or her job. If proper grammar, however, creates a stilted sentence or phrase, difficult to read or comprehend, then shortcuts are required. Frequently, a short, incomplete sentence is better than a rambling complete sentence. Just like the sentence you are now reading.

Verbs

Use the present tense and the active voice, with the subjects of the sentences doing or causing the action. It would be grammatically correct to say, "Last night another rebel village was destroyed by the Army, and many women and children were killed," but it would be more effective, as well as grammatically correct, to say, "The Army destroyed another rebel village last night and killed many women and children." In introducing movie idol George Starwars in an interview script, you might say, "The new movie, *The Unmaking of a President,* was completed last week by George Starwars." It would be better to say, "Last week George Starwars completed the new movie, *The Unmaking of a President.*"

Keep in mind the sportswriting analogy offered earlier in this section: Be conversational.

The Right Word

Make sure you use the right word. In English, many words have multiple meanings. Sometimes, even in context, meanings can be mistaken. Be certain that every word you use is the best word to convey what you mean, that it cannot be confused with another meaning, and that it is not too abstract or vague to make your meaning clear and specific.

Keep a dictionary handy. Use a thesaurus. Have a basic book on grammar, punctuation, and spelling available. Considering the inconsistency of spelling rules in English, it is hard to resist President Andrew Jackson's admonition that "it's a mighty poor mind that can't think of more than one way to spell a word." Nevertheless, an important sign of professional literacy is the proper use of words. For example, do you know the difference between *its* and

it's, your and *you're, there* and *their, then* and *than?* Making errors such as these when trying to get into the professional field almost guarantees continuation of your amateur status.

If you've ever been in a newsroom and have pulled copy off a wire service machine, you'll remember that the wire service puts the phonetic spelling of difficult words in the continuity of the script or at the beginning or end of the stories. If you have any doubt whether the word you are using will be pronounced correctly, do the same thing. For example; "Our special guest on *Meet the Reporters* today is Worcester (WOOSTER) State Representative Joe Cholmondeley (CHUMLEE)." When you've finished your script, read it out loud and proofread your copy. Redo your script if necessary to get a clean copy to submit to the producer or script editor. A sure sign of a careless, unprofessional writer is a sloppy script with many errors.

Punctuation

Punctuation is more functional in broadcast scripts than in other types of writing. Punctuation tells the performer where to start and stop. It indicates whether there is to be a pause (by using an ellipsis: . . .), a shorter pause (dash: —), an emphasis (!), a questioning tone (?), and other time and inflection cues. How would you read each of the following?

- She thinks he is a good actor.

- She thinks he's a good actor!

- She thinks he's a good actor?

- She thinks he's a . . . good actor.

Underlining a word or sentence automatically gives it emphasis when read aloud.

Abbreviations

With certain exceptions, avoid abbreviations. Remember, you are writing material for a performer to read or to memorize and say aloud. Writing "dep't" and "corp" suggests that you want the performer to pronounce them D-E-E-P-T and K-A-W-R-P. Write out "department" and "corporation." Common terms that cannot be misunderstood or mispronounced, such as *Mr., Prof.,* and *Dr.,* need not be written out. Terms that are usually pronounced in their abbreviated forms, such as *AT&T, YMCA,* and *CIA,* remain so in the script. On the other hand, some common terms that frequently are seen as abbreviations, but always are pronounced in full, should not be abbreviated. Dates are an example. *Mon., Feb. 29,* should be written out as *Monday, February 29th* (or even "twenty-ninth").

Gender

Jane Pauley is no more an *anchorman* than Dan Rather is an *anchorwoman.* The term *he* or *his* is not acceptable for generic use, especially for professional communicators. "In the his-

tory of medicine, the doctor hasn't always had his patients' best interests in mind" would be better written, "In the history of medicine, the doctor hasn't always had his or her patients' best interests in mind" or still better, "In the history of medicine, doctors have not always had their patients' best interests in mind."

The elimination of sexist and racist terms is relatively recent, and habits of bias die hard. Jane Pauley may be an *anchorwoman;* Dan Rather may be an *anchorman.* Either may be an *anchorperson* or *anchor.* The gender-describing suffix is disappearing, and the most direct nonsexist way of describing someone is by the position held. Pauley may be an *anchor,* just as Rather may be an *anchor. Chairman, chairwoman,* and *chairperson* have given way to *chair,* in the manner that *secretary* became the descriptive word for that position, not *secretaryman, secretarywoman,* or *secretaryperson.* The professional communicator must take the lead in being sensitive to language changes and move the general public toward the elimination of the prejudice and inequality that are fueled by bias in language.

Accuracy and Research

Whether writing a play, documentary, or news story, be sure you have the facts before you write. If you set your play in a northern urban high school, know precisely what the students and faculty are like in that milieu and what the physical, psychological, administrative, academic, and social atmosphere is at such a school. You can then selectively dramatize those elements that fit your play, eliminating those that you don't want but doing it from a sound, accurate base.

If you are doing a feature on clergy raping and sexually abusing children, be sure you are thoroughly familiar not only with the events but also with the people, their backgrounds, the church, and all the other variables necessary for developing an accurate script.

Learn to do thorough research. The success or failure of a script is determined in the preparation period; the actual writing is only one part of the process. Where do you do research? Everywhere. Each format chapter in this book contains information on obtaining materials when you are preparing an outline or script for that particular program genre. Note especially the research section in Chapter 7, which describes the various information sources that should be checked when preparing an interview. In fact, many programs, as well as networks, stations, and production houses, employ people just to do such research. These can be excellent starting positions for young college graduates entering the field.

In general, there are several key sources. Look into your own knowledge and experiences first. You may frequently find information on the topic that you had forgotten you knew. All of us, no matter how long we've been around, have more or less limited backgrounds, and we need to go further than our own selves. Recorded material is important: books, magazines, newspapers, photographs, diaries, letters, and audio and video records and tapes. Individuals who are experts on a given subject or who know a given person are good sources, although it is important to get a cross-section of such individuals to avoid slanted conclusions. Libraries, workplaces, organizations and associations, participants, video and audio archives, relatives, neighbors and friends, event sites, artifacts, museums,

and educational institutions are some key sources of information. Through the Internet you can access material on virtually any subject. You can get information from official government sources or from Web sites serving specialized and even arcane interests. Using the Internet does not obviate the need for doing individual field research, but it can save much time and energy, allowing you to complete research and prepare a script in a shorter time than otherwise would be needed. A warning: Because anyone, regardless of credentials, can set up an Internet Web site, it is sometimes difficult to know whether the information you are getting is valid or unreliable. Before you use any material obtained from the Internet, protect your personal reputation by being certain it comes from a reputable site and by double-checking it with a proven knowledgeable and reliable source.

Be sure to get all the information you need to be objective. You might not want to be objective. Perhaps you want to slant your feature to meet the political views of the station's owner, or create a misleading commercial to meet the sponsor's orders, or self-censor a play or documentary to avoid controversial issues that might displease potential buyers of the advertiser's product. But at least put yourself in the position of being able to be honest and objective if you want to be. And have the integrity and courage to be.

Finally, broaden your abilities and expand your skills. The media encompass all the disciplines of the world, and as a writer or in any capacity that gets the program on the air, you should have a background in breadth and depth, especially in the arts and humanities, most particularly in history, political science, sociology, and psychology. Read a lot: books, plays, and film, television, and radio scripts. Learn content and writing techniques from them. Good writers are invariably good readers first.

THE COMPUTER

Would *Hamlet* have been a different play if Shakespeare had written it on a typewriter rather than with a quill pen on foolscap? Would Arthur Miller's *Death of a Salesman* have been different if written on a computer or word processor? Take the exact same piece of material: a news report, a commercial, or a documentary feature. Would it come out exactly the same if written with a pencil on paper, with a typewriter, or with a computer? You will find clear and distinct differences in writing the same material for different media, and in using the techniques of varying media in preparing material for one medium. Does this principle apply to the use of different tools in writing, as well? Some writers insist that the tools with which they write affect the feeling and rhythm that are used in creating a work. Would there be more and slower character development and more measured pace in a dramatic script—even a sitcom—written by hand than in one attuned to the mechanical rhythms and speed of a computer? Is there a difference in the scene the artist paints if she or he uses oils or charcoal or water colors?

If not content difference, is there an aesthetic difference? Does this have a direct analogy for the writer? No comprehensive studies yet suggest acceptable answers. But the question has been raised. It is important to you, personally, because as a writer you will find yourself in situations where you have to produce scripts using various writing methods.

For example, in an ad agency, around a conference table, you may be asked to revise, on the spot, the continuity in a commercial. You may be asked to do a **rewrite** and add material on the set of a newscast just minutes before air time. During the field recording of a documentary, you may have to come up with new and changed questions, answers, and transitions while the crew and the subjects are immediately available. You'd better be able to think quickly and effectively with a piece of paper in front of you and a pen in your hand, as well as with a laptop word processor.

All good writers will tell you that there is an ambience between them and the tool they use for creative writing. Until the advent of typewriters, writers wrote by hand with whatever pen or pencil or equivalent tool was available. Some writers still write only with a pen or pencil and insist that they cannot write effectively with a mechanical device.

Many writers will tell you that they can think only with a typewriter. An entire generation of writers grew up writing their first creative words on a typewriter and believe that they can't work with a pen or pencil. At the same time, they will tell you that the mechanical steps needed to operate and make corrections on a word processor make it impossible for them to maintain a flow of ideas and creative juices when using a computer for writing.

Your generation—people of college age— has moved into a new era of writing tool, the word processor. With schools offering computer courses from the elementary grades up during the past decade, newly developing writers find the computer the easiest writing tool. Aside from its symbiotic relationship with any given writer, the computer is the most efficient writing tool. It saves time on editing. It permits instant reproduction. When properly used, it permits a writer to turn out a product much faster than any other way. It enables a team of writers, even from different geographical areas, to work at the same time on the same script. It permits the writer to immediately incorporate information, ideas, and materials from any source anyplace in the script. Laptop computers are gradually replacing the restaurant place mat as the medium for recording sudden script inspirations.

Newspaper and broadcasting newsrooms use word processors. Writers of drama who may question the mechanical effect imposed on their writing by computers nevertheless are eager to take advantage of the transfer of material from computer to computer, enabling them to get instant criticism on any or all of what they've written, giving them wider access to such assistance and greater overall and quicker productivity.

Word-processing software can provide the basic formats discussed earlier in this chapter for television, film, and radio scripts: the two-column format, the one-column script, and the dramatic screenplay or the numbered-sequences script.

Software Types

Four basic categories of software are used in writing for media. *Word processing* enables you to write letters, term papers, scripts, and similar work.

The *database* files and retrieves information in any format you want to design. For example, when you have finished your script on your word-processing software, you can use your database software to call up the name and address of your literary agent. Using your

word-processing software and the database, you can write the agent a letter, prepare a copy of your new script, and type the envelope label for the agent.

Spreadsheet software helps you keep track of your financial information and budgets. You can extend your writing into the production area by figuring out all the finances for production planning. You can keep track of your royalties and, considering the especially burdensome recordkeeping imposed on writers by the tax code, spreadsheets can help you straighten out your tax records and determine your tax liabilities. May you be successful enough as a writer to require that kind of service from your computer.

Communications software takes your script from the confines of the desk. A modem permits script development from a number of sources at once, facilitates critiques of your script at any time in the writing process, provides for changes quickly and easily at any stage of writing, and allows instantaneous editing based on comments from producers, directors, agents, script editors, and others. Software for the one- and two-column formats and, separately, for the dramatic screenplay automatically sets up the proper margins and spacing for the script form you choose, capitalizes the characters' names and any other terms you wish, puts stage directions and other appropriate information in parentheses, numbers sequences in the dramatic screenplay format, and automatically renumbers the sequences correctly if you edit, delete, or add scenes. It also reprints and readjusts pages, and shortens or lengthens them as necessary. It tracks which scenes have been cut or added and designates which is new material and which is old as the script is printed. A screenwriting program can change a script in a one-column format into a two-column format, or into a numbered-sequence column. Software can also draw **storyboard** frames that permit drawings—the kind of material required in the preparation of commercials and public service announcements. You can continuously check the continuity process in your writing from all the material you have written on the project, accepted and rejected, good and bad.

Writing is no longer limited to words on a page. Compact disks, CD Roms, and sound cards fed into a computer can integrate still pictures, moving pictures, and sound tracks into a writing project. Professor Marcia Peoples Halio of the University of Delaware's writing program stated in the university's alumni journal, "too often students use computers as very expensive typewriters, and we want them to do much more . . . they should know how to block off a chunk of text and move it around, how to complete on-line revisions and how to work with a split screen, so that they're looking at their notes on one side of the screen while also working on a document." Software changes constantly, becoming increasingly sophisticated with each passing year. When you are ready to use your computer for formatting scripts, check with your local computer software outlet for the latest and most efficient program that will best serve your specific needs.

Computers and the Screenplay

Although most screenwriters won't admit it, in recent years many of them have begun to use what is called "story development software." ScriptZone, for example, offers a sample analysis of a screenplay to help the writer determine whether comparable elements in his

or her screenplay need the same kind of critical revision. Scriptdude provides software that will virtually develop a story line and even characters and dialogue. Write a Blockbuster is a program that takes you step by step through the process of writing the kind of screenplay that has been most successful in Hollywood. Use of such software and Internet Web site material tends to create more and more formula writing, and providing these basic approaches does not replace each writer's greatest asset: personal creativity. But many writers use these programs to remind them of key techniques that they might have overlooked when writing their screenplays.

Computers and the News

The computer is used in three major ways in both the newspaper and broadcast newsroom. The first is the actual writing and editing of the story—composing the content and words and editing those words. The story, completed on one computer, is edited by the editor on another computer. Using a **modem** to transfer material from one computer to another permits a story to be written in Chicago, edited in Los Angeles, and produced in New York. Laptop computers are invaluable for on-the-spot composition, even as the news story is breaking. By plugging the laptop computer into a telephone line, the writer or editor can relay the story to a computer in the newsroom.

A second computer use is for creating **graphics,** including charts, graphs, maps, and other visuals that are used in newspapers and on television. In broadcasting, the graphic can be electronically fed right into the newscast. Even radio has used specialized sounds created by computers, in a sense providing an audio "graphic."

The third major computer use in news is accessing information, obtaining databases for material that can be used in writing the story. Getting the text of a just-passed piece of legislation and obtaining "morgue" information on all the stories ever published in a given newspaper on the particular news topic are two types of information retrieval.

A fourth use, not applicable to broadcast news, but important for newspapers and journals, is laying out the page—designing the format for that particular issue.

Computers in Production

If your role as writer extends into the actual production process, you can find software that facilitates your job immeasurably. The writer-producer or writer-director can convert the content into a breakdown detailing every production item required by the script. This could include every character's costume needs, every special effect, all audio effects, the number of extras required and their costumes, and all props, whether in the field or in the studio, whether large like an automobile or small like a piece of jewelry. Software can also provide a production board, which lists every element in any given scene and which includes boxes that can be checked as each item is accounted for. The computer can be used to work out detailed production schedules, too, based on which characters are required for which scene and on which sets. And a spreadsheet can be used for the production budget.

INTERNET FORMAT AND STYLE

Professor Maurice Methot of Emerson College notes that "a Web site is not normally 'scripted' in the sense of linear drama. The code that lays the content out into the browser is more integral to the user's experience than any linear storyboard, but this code is meaningless unless interpreted by the browser." Methot offers the following format and style approaches for the Internet writer:

The task of developing "guidelines" for the effective design and layout of text on the Internet is as broad as the subject of computer/human interface itself. On the net, the text is "content," the design and nature of which is determined by various factors. among these are:

1. intended audience
2. purpose of display
3. nature of Web project
4. nature of interface design paradigm
5. target technology base

While one may assume that the design possibilities of text-based content intended for Web distribution are determined by the parameters of the layout protocol (HTML), the truth is that stand-alone applications that run within the browser window, using such language and plug-in specifications as Java, Flash, and Shockwave mean that the possibilities for text on the Web are as vast as digital technology itself. Web pages can retrieve vast amounts of raw quantitative data and display it according to an infinite variety of visual means. The sheer quantity of content—text and otherwise—is an ongoing challenge to organize. Text on the Web is, by nature, hyper-textual, which means that anything can be linked to anything else. This unique quality, along with an abundance of content on the Web, means that the challenges have much to do with creating an interface that can be navigated in a coherent and useful way.

The age of information comes with certain presumptions that can exert an influence on how text is used in a Web design. One common wisdom derived from this mindset is the assumption that "people don't go to the Web to read." But a Web site that is primarily text-based—an online magazine, for example—may simply follow the conventions of print journalism, using short paragraphs and pyramid structure, and leave it at that. Of course, the degree of the users' needs/interests will determine their willingness to navigate bad design. But if an informational Web site or database search/retrieval system is so badly designed that users cannot locate the desired data with relative ease, they are likely to quit in frustration and look for the data elsewhere. It is important to remember that while the Web may not be the primary source for certain types of reading, the overall trend continues toward digital; there is no reason not to read from high definition computer displays. Today, the Web is the primary source for certain types of information. Each webspace—personal, corporate, or otherwise—can be seen as an outstanding outpouring of human identity which draws its context and design from aesthetics—from the front page of the *Wall Street Journal* to abstract art. Text on the Web can be informational, narrative, poetic, random, abstract, computer-generated, true, untrue, journalistic,

angry, personal, decorative, morphing, shifting in color, fading, moving, appearing, hysterical, read out loud, whispered, linear, circular, blasphemous. Digital can be an entirely powerful tool and text an entirely malleable content.

Text on the Web is ephemeral, much more so than in any other medium. While every form of media has some method of archival and retrieval, the nature of the Web is such that things "exist" only for as long as data is kept accessible online. When a server is down, unless the data is duplicated elsewhere, the data contained therein is for all intents and purposes "out of print." Given the inherent hyper-textual nature of the Web, with its infinite set of possible meshings, when links are "broken" the continuity of the Web is affected. Broken links textual discontinuities become part of the Web discourse.

Text on the Web can be computer generated and computer controlled, not only in terms of HOW it is displayed (font type, font size, spacing, kerning, color, etc.), but also in terms of CONTENT. It is in this context that the line between text-as-message and text-as-computer-interface-element becomes fuzzy. Indeed, if we make the conceptual leap to the understanding that, at the core, all interactive digital is, to some extent, a "front end" intended to allow for (hopefully) easy navigation of the database concealed "under the hood," then we can begin to understand why simply adapting the print media model to network digital media can lead to false assumptions.

Methot offers "a few guidelines that can be useful in creating Web sites that are 'reader-friendly'":

1 Do not use fonts smaller than 12 points in size.

2 At large sizes, almost any font is okay, but at smaller sizes stick to sans-serif fonts.

3 Avoid tight spacing.

4 Leading (space between the lines of text) should be set at one or two points higher than the actual size of the text itself.

5 Keep text organized in small, digestible, bulleted "textbites." Avoid wide columns and long paragraphs.

6 Restrict text color to those hues that allow the text to be as readable as possible against the background color (or image) of the page.

7 Try to limit the amount of text on any single page.

4

Commercials and Announcements

It is often said that Madison Avenue has perfected the techniques of persuasion so artistically and effectively that it could sell refrigerators at the North Pole and heaters at the equator. *Madison Avenue,* of course, is a euphemism for the advertising industry in the United States.

Television and radio commercials, though changing in form, type, length, and technique, nevertheless have been for many decades the staple of commercial broadcasting and have been perfected to a high art.

Some commercials are good because they are well crafted, sometimes more aesthetically pleasing than the programs they are in. Others are good because they are educational, providing the consumer with information on available goods and services.

Some commercials, however, insult our logic and intelligence with their biased or misleading content. Others play upon the emotions of people to buy things they can't afford and pressure children to ask for toys and other items their parents may not have money for. All of us, whether we admit it or not, have at one time or another been influenced sufficiently by commercials to buy something that we didn't need or want and that was probably no good for us. Charles "Chuck" Barclay, when he was director of Creative Services for the Radio Advertising Bureau, observed, "Even the worst commercial, repeated often enough, sometimes produces results."

S. J. Paul, publisher of *Television/Radio Age,* wrote in one of his editorials, "The commercial makers are themselves the stars of the radio-television structure. For in the short time frame of 20, 30, or 60 seconds a mood is created—a message is transmitted—and a sales point is made. This finished product is the result of many talents. In some cases, as it has often been remarked, the commercials are better than the programs."

Commercials constitute the principal financial base for the United States broadcasting system. One exception is public broadcasting. But with increasing deregulation, public television and radio stations give more than just an underwriting credit. They often give the **logo** or slogan and even an identifying comment about the underwriter's product or service. Cable television, which some once considered a possible alternative to commercial-cluttered broadcasting, has been expanding its advertising. One commercial-free alternative is *pay-per-view* television. Many observers believe, however, that its operators will not be willing to forego the lucrative income derived from adding commercials to their programs.

The title of this chapter is "Commercials and Announcements." Although the meaning of *commercial* is clear, the term *announcement* is sometimes confusing. *Announcement* can be used to designate any short nonentertainment, nonnews presentation on the air, including a commercial. Usually it refers to the noncommercial announcement, with the word *spot* most often used to mean a commercial.

Announcements have the same structure, form, and lengths as commercials. They usually are divided into two categories: (1) **promos** and (2) **PSAs,** or *public service announcements.* The commercial is designed to sell a product or service for a profit-making advertiser. The promo most often promotes the station itself: an upcoming program or series, a station personality, a contest for listeners—anything that induces the public to tune in or otherwise support the station.

The PSA is similar to the commercial except that it does not sell a product or service for money, but is made on behalf of a nonprofit organization or activity and can include advancing an idea or policy. Principally, the PSA seeks support for activities of the nonprofit group: health organizations such as the American Cancer Society's antismoking campaign; citizen environmental groups' antipollution efforts; fund-raising for Christmas toys for indigent families in the community; support of shelters for the homeless; understanding and preventing AIDS; a bake sale at the local high school; information about public services available from local government offices. The following is an example of a PSA promoting a cause in which the station itself is directly participating.

[You will note in this chapter a variety of script forms and styles. These reflect the different approaches among advertising agencies. Within each agency, however, the form and style are consistent.]

"Walk for Hunger"—20 seconds

VIDEO	AUDIO
Dissolves of shots of people at food pantry; tight shots of a variety of folks.	<u>V.O. AND MUSIC</u> DID YOU KNOW THAT MORE THAN HALF A MILLION MEN, WOMEN AND CHILDREN IN

Continued

VIDEO	AUDIO
	MASSACHUSETTS DON'T HAVE ENOUGH TO EAT? WE CAN'T MAKE THE PROBLEM OF HUNGER GO AWAY, BUT WE <u>CAN</u> TAKE A STEP IN THE RIGHT DIRECTION.
Dissolve to info graphic.	JOIN CHANNEL 7 AS WE SPONSOR THE WALK FOR HUNGER ON SUNDAY, MAY 3rd. CALL PROJECT BREAD AT 227-3796.

Courtesy of WHDH-TV, Channel 7, Boston

The writer has a responsibility to the agency, advertiser, and station to create not only the most artistically attractive message possible, but also one that convinces and sells. At the same time, the power of the commercial or announcement charges the writer with the responsibility of being certain that the commercial has a positive effect on public health, ethics, and actions.

ETHICAL CONSIDERATIONS

Commercial advertising can be used responsibly; it can also be used irresponsibly. In this media area, more than any other, you will be faced throughout your career with hard ethical choices.

Suppose you are employed by an advertising agency and are assigned this commercial campaign: A leading beer company wants to expand its market among new young drinkers of minimum legal drinking age, with an emphasis on increasing its share of on-premises (bars, restaurants) consumption.

Would you give any thought as to whether any ethical considerations are involved in such an assignment? At one of the annual International Radio and Television Society (IRTS) Faculty/Industry Seminars in New York, this assignment was given to the approximately 75 faculty participants from colleges and universities throughout the country. The participants were to work from a real beer company's plans and budget, under the guidance of that company's representatives. This was a practical exercise in which the beer company would, as some participants put it, "pick their brains." As was traditional with IRTS seminars, the exercise was as close to a real working situation as possible.

That particular beer company had over the years developed a reputation as an anti-union, antiminority, antifemale employer, and some participants who were given the exercise were among those nationwide who had been boycotting that beer for some years.

About one-third of the participants publicly objected to the assignment, with many refusing to work on it—in effect, quitting their "jobs." About another third, although not making a public stand, stated their reservations about doing the project.

One cannot work in the media in a vacuum. A writer in any genre of broadcasting must be knowledgeable about the world around him or her. Some participants in this exercise felt that in good conscience they could not prepare an advertising campaign that might be valuable to a company whose practices they believed were inimical to their personal ethical standards. Most of those objecting to the project did not want to lend their efforts to a campaign that encouraged increased alcohol consumption, especially among young people.

What, if anything, would you have done, and why?

The ethical, responsible ad writer should identify with the anonymous creator of commercials who wrote in *Television/Radio Age* that "accounting to a set of practical, working rules allows a good balance of involvement with the industry and accountability to the consumer public. It's hard to try and dupe, or con, the viewer when you feel 'we are they'... and realize that you are only cheating yourself."

LENGTHS AND PLACEMENT OF COMMERCIALS AND ANNOUNCEMENTS

Commercials are usually 30 or 60 seconds long. With the increasing cost of commercial time and production, the "split-30"—two 15-second commercials in a 30-second space— became popular, as did later the 15-second stand-alone announcement. Although not as frequently, one also finds 10-second, 20-second, 90-second, two-minute, and even longer spots, especially on cable.

Public service announcements, or PSAs, are not paid for, but usually follow the same time lengths, mostly 30 and 60 seconds. They take second place to paid commercials and are aired only when the station hasn't sold the complete available commercial time segments. For that reason, many PSAs produced by or for the nonprofit organization are sent to the station in two or more versions, including a 10-second one, for greater possibility of use.

Station *promos* have similar time lengths. Station **IDs** (station identifications, consisting of the call letters or *logo,* city, and sometimes an identifying or promotional phrase about the station), many of which are highly creative, usually are ten seconds long for a station break. Sometimes IDs have a commercial attached—two seconds for the station ID and the remaining eight seconds for a paid advertisement.

Many copywriters use a word count scale to determine how many words will go into a given time segment. Although such a count can be fairly accurate for radio, nonaural visual material must be included to get a good approximation for television. In addition, the lengths of individual words, complexity of ideas, need for emphasis through pause and variation in rate, and personality of the performer delivering the announcement also affect the number of words that can be spoken effectively in a given length of time.

In general, however, the 10-second announcement contains about 25 words; the 20-second announcement about 45 words; the 30-second spot about 65 words; the 45-second spot about 100 words; the 60-second announcement about 125 words; the 90-second announcement about 190 words; and the two-minute spot about 250 words.

The ID is given at the station break, usually every half-hour on the hour and half-hour. Other announcements, including commercials, PSAs, and promos, can also be given then, depending on how much time is available between programs. Time availability can vary from literally only a few seconds to several minutes. Program lengths usually are a half or full hour, and sometimes 15 minutes. Television scheduling is more rigid than that of radio, and therefore inserting spots in the latter is more flexible.

Although most announcements are clustered at logical breaks, including the beginning and end of programs, most commercial programs have built-in commercial breaks, some at the halfway mark for half-hour programs, and at the one-third and two-third marks for hour-long shows. Programs with relatively good ratings draw more commercials, of course, and movies, for example, may have interruptions every few minutes. Stations that are network affiliates carry the network commercials, but are given specified times within the network programs for inserting local announcements.

The ID

The station identification, as required by the Federal Communications Commission, must contain the station's call letters and the originating city and, optionally, the name of a larger city that is the principal area of service. Some stations include the station's frequency to help the audience remember the radio or television channel they should tune to. A simple, direct ID would be the following:

You are listening to WNBC, 660, New York.

To make themselves more distinctive, many stations add a qualifying phrase designed to promote the station's format, if a radio station, or the station's image, if television. The ID is a public relations trademark for the station and should be identifying and distinguishing at the same time. For example:

America's number one fine music station, WBBB-FM, New York.

CBS-TV's ID has made the network and its affiliates unmistakable.

VIDEO	AUDIO
Channel 2's "Eye"	Keep your eye on Channel 2, CBS, New York

Some stations use music or sound effects to promote their stations in the IDs. KFOG, San Francisco, used a foghorn sound. WGLD, High Point, North Carolina, established in its ID an identification between its format, beautiful music, and its key promotional word, gold. The first of two following IDs reminds new or infrequent listeners of the format; the second ID doesn't have to.

With beautiful music … this is gold at FM-100 … WGLD, High Point

At FM-100, this is gold … WGLD-FM, High Point

Some IDs include a paid commercial, such as "This is WRLH at 4 P.M., Soporific Watch Time. See the Soporific Wrist Alarm—date and calendar—twenty-one jewels."

The PSA

PSAs frequently are given as part of the ID. For example, "This is WMVH, your election station. If you've been listening to the important campaign issues on WMVH, you'll want to vote on Election Day. Register today so you can." The sponsoring organizations often issue kits containing the same announcement in various lengths, to maximize the possibility of their use. Following are illustrations from the "register to vote" campaign.

10-SECOND ANNOUNCEMENT

ANNOUNCER: You can't vote if you're not registered. Protect your right to vote. Register now at
_____, _____, _____.
 (place) (dates) (hours)

20-SECOND ANNOUNCEMENT

ANNOUNCER: The right to vote is a great right. It helps you run your government. But you can't vote unless you're registered. Register now so you can vote on Election Day. Register now at_____, _____, _____.
 (place) (dates) (hours)
Register now.

30-SECOND ANNOUNCEMENT

ANNOUNCER: It's not much bigger than a phone booth. But it's the place where your town gets its schools built and its streets paved. What is it? It's your precinct voting booth. And you'll be locked out of this year's important election on _____—if
 (date)
your name's not in the book … the voter's registration book. So get your name in the book.
Go to _____, _____, _____.
 (place) (dates) (hours)
Register before the deadline _____. Register now.
 (date)

Courtesy of American Heritage Foundation

PSAs are written also to fit into particular program types, to relate to holidays or to special occasions—for all and any purposes that may enhance the possibility of their use. Remember that they are not paid advertising and the organization depends upon the station's goodwill and time availability to carry them. The more flexibility the PSA has in content and length, the easier it is for the station to place it. Following are some illustrations.

WASHINGTON'S BIRTHDAY SPOT
(20 Seconds, Radio)

This is station _____ reminding you that a holiday like Washington's Birthday brings a sort of break into the routine of daily living. This applies also to America's estimated 400,000 legally blind people—or had you thought of them as a group apart? They certainly aren't. For information about blindness contact your nearest agency for the blind or the American Foundation for the Blind, 15 West 16th Street, New York City.

Courtesy American Foundation for the Blind

TIME SIGNAL
(20 Seconds, Radio)

ANNOUNCER: It's _____ …and right now an emotionally disturbed child in
 (time)

 _____ needs your help and understanding. This is National Child
 (town or area)

 Guidance Week. Observe it …and attend the special program on emotionally
 disturbed children in _____ presented by the _____
 (town or area)

 PTA, on _____ at _____.
 (date) (place)

DISC JOCKEY PROGRAM
(30 Seconds, Radio)

DISC JOCKEY: _____ ...a recording that sold a million copies. Easy listening, too.
(title and artist)
But here's a figure that's not easy to listen to: Over 1,000,000 American children are
seriously emotionally ill. During National Child Guidance Week, the _____
PTA, in cooperation with the American Child Guidance Foundation, is holding a
special meeting to acquaint you with the problems faced by children in
_____. It's to your benefit to attend.
(town or area)
Be there ... _____ ...to learn what you can do to help.
(date and address)

LOCAL WEATHER FORECAST
(20 Seconds, Radio)

ANNOUNCER: That's the weather forecast for _____, but the outlook for children
(town or area)
with emotional illness is always gloomy. This is National Child Guidance Week, and
you can help by learning the facts about the problem in _____. Attend
(town or area)
the _____ PTA meeting on _____ at _____.
(date) (place)

Prepared for American Child Guidance Foundation, Inc. by its agents, Batten, Barton, Durstine & Osborne, Inc.

Sometimes the PSA can be equivalent to a commercial, not only providing information, but also motivating the audience to take action, such as attending a fund-raising event for a worthy cause, and giving details about place, time, and cost. The PSA can even seek the audience's direct participation in raising funds—similar to selling a product, but for a nonprofit, human service purpose, as in the following:

HEARTS IN BLOOM—LIVE COPY
30 SECONDS

THIS WINTER, GIVE THE GIFT OF LIFE. THE AMERICAN HEART ASSOCIATION'S HEARTS IN BLOOM CAMPAIGN CAN BRING HEARTWARMING BOUQUETS TO YOUR OFFICE, AND HELP FIGHT THIS NATION'S NUMBER ONE KILLER—HEART DISEASE.

YOU CAN HELP BY SIGNING UP THIS JANUARY AS YOUR COMPANY'S HEARTS IN BLOOM COORDINATOR AND TAKING ORDERS FROM YOUR FELLOW EMPLOYEES. TO FIND OUT HOW, CALL THE AHA AT 508-620-1700, AND ASK FOR EXTENSION 3946. IT WILL DO YOUR HEART GOOD!

Courtesy of the American Heart Association

WRITING STYLES

Keep the commercial or PSA in good taste. Although the style of writing can capitalize on visual and aural elements that are exciting to the audience, there are boundaries between what is attractive to the viewer or listener and what becomes repugnant or disturbing. Remember, the sponsor does not want to alienate a single potential customer. Some ads oriented to 17–25-year-olds use a "high tech" approach—the sometimes frantic, hyperproduced, high-decibel elements that proved so successful in music videos. These ads can carry the viewer right to the edge of bad taste—sexual innuendo, physical or psychological violence, implications of nudity or partial nudity—but they should not go over the line.

Humor, drama, music, and other techniques can be used to persuade the audience to subscribe to the product or service. Within each format, be direct and simple. If the commercial or PSA is to seem sincere, the performer must have material that is conversational and informal within the context of the situation, so that the audience really believes what it sees and hears. In a rap music type of commercial, for example, the performers' language may seem obtuse and complicated, but it is appropriate for the situation and normal for the audience ages it is aimed at. In one popular spot approach, one simply watches or hears a conversation among some people, the kind of conversation one would likely be part of at a gathering of that age group. The audience identifies with the group. Without even verbally identifying the product name in the television version of the ad, the commercial discloses it by directing attention to the labels on the characters' clothing.

In making the characters in the ad identifiable, the writer does not necessarily use ultracolloquial or slang dialogue. Such dialogue is perfectly acceptable when it fits the situation—just as one develops appropriate dialogue for the characters in a play. On the whole, vocabulary should be dignified, but not colorless; attention-getting, but not trite; simple and direct, but not inane or illiterate.

The writing should be grammatically correct, except, of course, if the performers' characterizations call for nongrammatical dialogue. Action verbs are extremely effective, as are concrete, specific words and ideas. If you want to make an important point, repeat that point, usually in different words or forms. An exception is a slogan or trademark, where word-for-word repetition is important. Keep in mind that there is a distinct difference between the television and the radio ad, even for the same product or service. Although some spots can be and are used on both media, television announcements can be virtually all, if not completely, visual.

Avoid false claims, phony testimonials, and other elements of obvious exaggeration. Aside from ethical considerations, such a commercial could antagonize much of the audience, even while deceiving another part. In small stations, where the deejay or announcer presents the commercial and also frequently has sold the time and produced it, there are sometimes pressures to make extravagant claims to keep the account.

TECHNIQUES

There are no essential differences between writing the commercial and the PSA. The audience analysis, familiarization with the product or service, appeals to the viewers' or listeners' needs and wants, effective organization, and format types are the same. The principal distinction to remember is that the commercial sells a product or service for money whereas the PSA usually sells an idea or action.

Successful announcement writing requires more than technique, talent, and hard work. Roy Grace, one creator of the award-winning Volkswagen ads for the Doyle Dane Bernbach advertising agency (DDB), asserted that "50% is doing the work and 50% is" believing enough in what you create to fight for it and sell it to the account executive. John Noble, co-creator with Grace of the VW ads, warned, "there are account men who can talk young creative people out of a concept very easily. . . . There should be a battle." Robert Levenson, as creative director of DDB, offered guidelines for copywriters:

1 The commercial should be clearly on the product.

2 The discipline of keeping your eye on what you are selling and how clearly you're selling it is half the battle.

3 The commercial still isn't good without the skills, the talents, the instincts, the hard work that the best creative people bring to their jobs.

4 The discipline comes first. Then we get to . . . attention-getting, warm, human, life-like, funny, and all the rest.

5 Here's the test: If you look at a commercial and fall in love with the brilliance of it, try taking the product out of it. If you still love the commercial, it's no good. Don't make your commercial interesting; make your products interesting.

Audience Analysis

Advertisers seek audiences who are most likely to buy their products or services. A product designed for women between 17 and 39—cosmetics, for example—would not be advertised on a program that reaches a predominantly male audience, such as a sports show. Once the target audience is determined, the commercial is designed to appeal to the specific needs and wants of that audience. Audience analysis is called *demographics,* which may include such information as age, gender, economic level, political orientation, occupation, educational level, ethnic background, geographical concentration, and product knowledge. *Psychographics,* even more detailed audience analysis, includes such elements as lifestyles, primary interests, and attitudes and beliefs.

Although writers attempt to appeal to the largest number of people expected to watch the program and the commercial, you must take care not to spread the message too thin. Television audiences tuned to network programs tend to be disunified demographically. Independent local or regional stations can determine audience demographics more easily because of the smaller number of viewers limited to a smaller area. Local cable systems can determine demographics most accurately, serving a proscribed area and knowing exactly who their subscribers are. Most radio stations have highly structured formats, appealing to specific audiences in their communities, so each station can determine its demographics with relative ease.

After analyzing as fully as possible the audience likely to view the commercial, the writer consciously includes materials that appeal to that audience. The same audience analysis criteria apply to public service announcements.

Audience analysis is then combined with specific needs and wants appeals within the commercial to make the most effective impact. Before this step, however, the writer must be thoroughly familiar with the product or service to be advertised.

Familiarization with the Product

In addition to personal observation or use of the product, the writer should collect as much information about it as possible from those connected with it. A good source of information is the research or promotion department of the advertiser's company. Develop receptive and flexible attitudes toward products and services. Aside from ethical considerations, you may be given the assignment for a product or service that seems totally dull and uninteresting to you. In fact, it may seem the same way to most of the potential customers. Your job is to make it exciting.

If you are given a new instant camera to promote that is easy to load, has a self-focusing, long-distance lens, uses fast color film, can be carried in your pocket, and costs half as much as the comparable competitive models, your job as a copywriter is relatively easy. The writers who first developed the commercials in this country for a low-cost, high-gas-mileage, long-lasting-engine small car with large seating capacity and storage-space once made Volkswagen the largest selling foreign automobile in the United States.

On the other hand, you may have to deal with a seemingly prosaic product like a pill for indigestion, or the services of one of the many clonelike fast food chains, or a long-standing and accepted product like telephone service. Creative copywriters greatly increased the sales of all three of these advertisers by developing unique and novel ways of presenting their wares, and coming up with ads that had the entire country saying, "Try it, you'll like it," "Take a break today," and "Reach out and touch someone."

Appeals

The third important factor in preparing a commercial or PSA is to appeal to the audience's basic needs or wants. All viewers and listeners are motivated by essential psychological and intellectual concerns, some conscious, most subconscious. By playing on these motivations, the copywriter can make almost any audience feel or believe almost anything and, in many cases, even persuade the audience to take some action—such as running right out and buying the product or phoning an 800-number to purchase a service.

Three basic appeals, applied through the ages and based on Aristotle's three key elements of persuasion—ethos, logos, and pathos—translate today as ethical, logical, and emotional appeals.

Ethical Appeal

Aristotle called persuasion by someone recognized as a "good person" an ethical appeal. When a well-known or well-respected person tells us something, we tend to believe it more than if the same statement had come from a noncelebrity. For example, we not only buy products advertised by entertainment stars, but we even pay attention to political and social comments by a pop singer or a baseball player, whose actual knowledge of the subject may be nil. Later in this chapter you will study the *testimonial* as one principal commercial form. The testimonial is based on *ethical appeal.*

A further application of *ethos* or ethical appeal relates the concept of the product or the manner in which the product is presented to the audience's ethical values. Of course, this varies in different sections of the country and even within the same market and is determined by psychographic surveys.

Logical Appeal

The logical appeal is exactly what it says. The persuasion is based on the facts, attempting to convince the potential buyer that the product or service fills a logical, practical need. For example, study the next commercial you see for an automobile. Does it recommend that you buy the car because its shorter length will make it easier for the owner to find a parking space in most cities? Because the car's lower horsepower will save on gasoline? Because its fewer cylinders limit its speed and might not only prevent speeding tickets, but also perhaps save its passengers' lives as well? If so, then the ad appeals to logic. Note, however, what most car ads really do appeal to—under *emotional appeals.*

How many ads can you remember that have consisted principally of logical appeals? Probably very few. Ads for most space-age electronics, such as DVD players, high-definition digital receivers, and large-screen TVs usually emphasize styling and size rather than quality, construction, and durability. Some commercials, however, do use logical appeals. Computer hardware and software ads frequently stress the computer's greater capacity and flexibility and the software's multiple uses, although many of the prospective customers don't need the complexity of the product they are being motivated to buy or are not aware that the rapid advances and changes in the computer field may make their expensive new purchase obsolete within months or even weeks.

Many commercials only appear to use logical appeals. Closer examination reveals the appeals are really emotional in content, the most used and most effective type in advertising.

Emotional Appeals

An emotional appeal does not mean one that evokes laughter or tears, but one that appeals to the nonlogical, nonintellectual aspects of the viewer's or listener's personality. It is an appeal to the audience's basic needs or wants. Take the automobile advertising example. Most car ads emphasize size, power, and styling. Even compact cars are sold with the slogan "big car room." Television ads show cars driving at powerful ultra-high speeds, zooming dangerously around curves on small country roads. Minivan commercials stress the logic of family use, even though emphasizing the size to accommodate many people and the power to carry them. Most auto ads highlight design and equipment by featuring passengers who look like movie stars, with the implication that people who drive these automobiles associate with beautiful, rich people or that if you own that car you will certainly attract them.

These are emotional appeals: appeals to feelings rather than reason. These auto commercial approaches appeal to basic emotional needs: power, prestige, and good taste. The power to attract love or sex partners, the power to move quickly without any impediment through life, the prestige of associating with prestigious people, the prestige of owning something that draws envy from others, the good taste to more than keep up with the Joneses.

Other emotional appeals that have proven highly motivating in commercials and PSAs are love of family, as evidenced in insurance company commercials, patriotism, good taste, reputation, religion, and loyalty to a group. Conformity to public opinion is effectively used in advertisements for young people's clothes that may be torn, discolored, and even uncomfortable, but promoted as necessary for peer acceptance. The appeal to self-preservation is perhaps the strongest emotional appeal of all. Drug commercials, among others, make good use of this technique.

The following commercial is a good illustration of the appeal to prestige. The implications are that if you serve Libby's foods you have good taste, are a smart shopper, and have more sophistication and intelligence than those who do not serve Libby's. (The implications of emotional appeals may, of course, be quite valid.)

VIDEO	AUDIO
1. MCU ANNOUNCER BESIDE LIBBY'S DISPLAY.	ANNOUNCER: LIBBY's presents a word quiz. What is the meaning of the word "epicure"? Well, according to our dictionary the word means a person who shows good taste in selection of food. And that's a perfect description of the homemaker who makes a habit of serving . . .
2. INDICATES DISPLAY.	LIBBY's famous foods. Yes, everyone in every family goes for
3. INDICATES EACH PRODUCT IN SYNC (IF POSSIBLE CUT TO CU LIBBY'S PEACHES . . . THEN PAN IN SYNC).	LIBBY's Peaches . . . Fruit Cocktail . . . LIBBY'S Pineapple-Chunks, Crushed or Sliced . . . Pineapple Juice . . . LIBBY's Peas . . . Beets . . . Corn—Whole Kernel or Cream Styled . . . LIBBY's Tomato Juice . . . Corned Beef Hash . . . and LIBBY'S Beef Stew. AND right now, smart shoppers are stocking up
4. HOLDS UP LIBBY'S COUPONS (IF POSSIBLE CUT TO CU LIBBY'S COUPONS).	on LIBBY'S famous foods . . . because there's still time to cash in those LIBBY'S dollar-saving coupons you received. You can save whole
5. MOVE IN FOR CU LIBBY'S DISPLAY.	dollars on this week's food bill. So stock up now on LIBBY'S famous foods . . . and cash in your LIBBY'S coupons and save! Always make LIBBY'S a "regular" on your shopping list!

Courtesy of Nestlé Foods Corp.

Did you note the appeal to love of family in the statement that "everyone in every family goes for . . ."? Did you note the logical appeal at the end of the commercial, on saving money by using Libby's coupons? If you had written the commercial, would you have included another logical appeal, such as stressing "nutritious food"?

■ *Following are four award-winning announcements designed for large audience segments, but at the same time containing specific appeals to particular characteristics of the prospective audience. Can you identify at least one major appeal in each of the spots?*

VIDEO	AUDIO
1. MAN AND WOMAN AT DINING ROOM TABLE, EATING DINNER. WOMAN LOOKS DEPRESSED.	1. WOMAN: Joey called this morning. MAN: So, how's Joey … Joey?!?
2. CLOSEUP OF MAN.	2. MAN: What's wrong?
3. CLOSEUP OF WOMAN.	3. WOMAN: Nothing. MAN: Nothing?
4. CLOSEUP OF MAN.	4. MAN: Our Joey called 2000 miles … the kids alright?
5. CU OF WOMAN.	5. WOMAN: Fine. MAN: Sally? WOMAN: Fine
6. CU OF MAN.	6. MAN: The kids are fine, Sally's fine … So why did he call? WOMAN: I asked him that, too.
7. CU OF WOMAN CRYING.	7. MAN: And why are you crying? WOMAN: Cause Joey said, "I called, just cause I love you, Mom."
8. MAN PUTS ARM AROUND WOMAN, AND KISSES HER. SUPER: REACH OUT AND TOUCH SOMEONE. BELL SYSTEM LOGO.	8. SINGERS: Reach out, reach out and …

Courtesy of American Telephone and Telegraph Company, Long Lines Department

VIDEO	AUDIO
CUT TO BICYCLIST RIDING DOWN STREET.	May a little bitty bit of sunshine come your way
AERIAL VIEW OF BICYCLIST RIDING DOWN STREET.	come your way

Continued

VIDEO	AUDIO
SIDE VIEW OF BICYCLIST RIDING PAST WATER FOUNTAIN.	(MU)
CUT TO BICYCLIST RIDING ON HIGHWAY.	a little bit of love and happiness
CUT TO SIDE VIEW OF BICYCLIST ON HIGH BRIDGE SURROUNDED BY TREES.	everyday, everyday I wish you
CUT TO SIDE VIEW OF BICYCLIST ON HIGHWAY.	no good-byes
CUT TO PAN ACROSS OF CU OF BICYCLISTS.	but a new friend every morning
CUT TO BICYCLIST RIDING IN COUNTRY NEAR FIELDS.	clear blue skies are the simple things in
CUT TO BICYCLIST RIDING ON HIGHWAY IN COUNTRY IN THE RAIN.	life that are good and true that's the world I wish for you
CUT TO CU OF COCA-COLA CAP ON BOTTLE BEING OPENED.	It's the real thing
CUT TO SIDE VIEW OF BICYCLIST DRINKING COKE.	may you always have someone
CUT TO BICYCLISTS FIXING THEIR BIKES AND DRINKING COKE.	to share all your happy moments through
CUT TO PAN UP OF COKE BEING POURED INTO GLASS.	somebody who will sit
CUT TO CU OF BICYCLIST DRINKING COKE.	and laugh and share some Coke
CUT TO GIRL AND BOY ON BLANKET IN GRASS DRINKING COKE.	with you
CUT TO BICYCLIST RIDING IN TUNNEL.	because they're the real things
CUT TO BICYCLIST RIDING IN SMALL COUNTRY TOWN.	and I'd like to fill your life with
CUT TO CYCLIST RIDING PAST HOUSES WITH TWO ELDERLY LADIES STANDING IN FRONT.	the real thing

Courtesy of The Coca-Cola Company, McCann-Erickson, Inc.

VIDEO	AUDIO
FADE IN:	NARRATOR: Next time she wants a cigarette give her a kiss instead.
SC 1 MCU Couple side by side. Woman puts cigarette in mouth. Man takes cigarette away and gives her a kiss. DISSOLVE TO:	
SC 2 TITLE "For tips on quitting call us American Cancer Society" (sword) FADE OUT	For tips on quitting call the American Cancer Society.

Courtesy of the American Cancer Society

PEPSI COMMERCIAL

Today will stay with you for the rest of your life.

Today you're bringing home your new baby and your wife.

And all around are people who mean the world to you.

sharing your jublilation,

part of the Pepsi Generation.

C'mon, c'mon, c'mon, c'mon and have a Pepsi Day.

Continued

C'mon, c'mon, c'mon, and taste the Pepsi Way

Your baby's home, your family's here,

to celebrate and hold her near..

C'mon, c'mon, and Have a Pepsi Day

You're the Pepsi Generation.

Have a Pepsi Day!

©PepsiCo, Inc. Material reprinted with permission of PepsiCo., Inc., owner of the registered trademarks "Pepsi," "Pepsi-Cola," and "Have a Pepsi Day."

The AT&T and Pepsi commercials clearly appeal primarily to love of family. The Coke commercial combines the appeal of adventure and new experience with the power to attract love or companionship. The American Cancer Society PSA appeals to self-preservation. These spots are oriented to specific age and economic levels. Other announcements for these products or services are oriented to other demographic groups. The Pepsi spot writer consciously aimed the message toward a nonmajority group and showed the kind of sensitivity in portrayals noted earlier in our discussion of ethical considerations.

■ *The following television PSAs combine logical and emotional appeals to stress the strongest motivation: self-preservation. Note how the same message can be presented in three different ways, to appeal to three different audience groups: the general public, parents, and youth.*

ANNCR: This is secondhand smoke. It's what you breathe when you're in a room where other people smoke. The same stuff you smell on your clothes goes into your lungs and increases your risk of getting lung cancer by 34%. You know, there's a warning label on cigarette packs for people who smoke. Where do you think the tobacco industry should put the warning for people who breathe?

SUPER: It's time we made smoking history.

LEGAL: A message from the Massachusetts Department of Public Health.

Courtesy of Houston Effler and the Massachusetts Department of Public Health

* * *

(guy cutting out pictures of his daughter)

FATHER: I know I shouldn't smoke. I've tried to quit a million times. I know about lung cancer, strokes, heart disease … all that stuff. I mean, they're listed right on the side of the pack. Still doesn't make quitting any easier. But I'm going to keep at it.

(guy slips picture of his daughter in cellophane of pack)

FATHER: Because the way I see it, if the reasons on the side of the pack don't get to me, the reason on the front will.

SUPER: Call 1-800-TRY-TO-STOP.

SUPER: It's time we made smoking history.
A message from the Massachusetts Department of Public Health.

Courtesy of Houston Effler and the Massachusetts Department of Public Health

* * *

ANNCR: Couple a kids in Chicopee hang at a mall, lots a cool stores, lots a cool food, second hand smoke, not cool. They don't like it, what do they do? They go to the top guy, the head mall honcho. They talk to people, they talk to chickens. Big meetings, small meetings, the big picture, the bottom line, before long, done deal. Hello, smoke free mall. Couple of kids, they had an idea. They took control. They changed the rules, so can you.

SUPER: It's time we made smoking history.

LEGAL: A message from the Massachusetts Department of Public Health.

Courtesy of Houston Effler and the Massachusetts Department of Public Health

Organization of the Commercial or Announcement

The purpose of the commercial or announcement is to persuade. Many experts in rhetoric have developed systems for persuasion. College students usually are exposed to such systems in elementary communication, business, or philosophy courses. Essentially, five steps of persuasion can be applied to virtually every television or radio commercial or PSA.

First, get the audience's attention. This can be accomplished by many means, including humor, a startling statement or visual, a rhetorical question, vivid description, a novel situation, and suspenseful conflict. Sound, such as pings, chords, or special effects, attracts attention. Keep in mind that the television viewer is prone to use the commercial break to head for a bathroom, a beer, a phone call, or food. If you don't get a viewer's attention in the first few seconds, before he or she leaves the area of the television set, you've lost your viewer.

Radio listeners usually carry their radios with them wherever they go, so they are likely to remain tuned in. Nevertheless, if the announcement doesn't get their immediate attention, they can easily be distracted by a conversation or some other activity and miss it. Even if the audience members stay at the television set or keep the radio on, they will tune out or temporarily switch channels or frequencies if the spot is not entertaining enough to hold them.

Second, after you get the audience's attention, hold its interest. One effective technique is constructing the minidrama, establishing a conflict that keeps the audience viewing or listening for the climax or resolution. In effect, this approach follows the same plot structure as the play does, except this minidrama unfolds in 30 or 60 seconds. Anecdotes, testimonials, statistics, examples, and exciting visuals and sound are among the devices that can be used to hold interest.

Third, create an impression that some sort of problem exists, related to the function of the product or service being presented. This can be done subtly by implication, or more directly, even in a short spot.

Fourth, plant the idea that the problem can be solved by using the particular product or service. Sometimes, the product or service has not yet been introduced, but is saved until the final step.

Fifth, finish with a strong emotional and/or logical and/or ethical appeal to motivate the audience to take action on the product or service: Put it on a grocery list, mail in a donation to a charity, or run right out and buy whatever it is.

In most cases immediate action is, of course, not obtained, and the audience may not consciously make a written or mental note to do anything about it. But all of us, at one time or another, have bought or done something that we likely would not have, had we not been influenced, even subconsciously, by the television or radio announcements for that product or service.

The Xerox "Hannigan" commercial illustrates how the five steps of persuasion can be compacted into a tight sequence of only 30 seconds. The first **frame** of the *storyboard* contains the attention-getting factor. The second frame holds the viewer's interest by

reinforcing the initial attention-getter. The third indicates that a problem exists. The fourth shows how the problem can be solved. The subsequent frames reinforce frame four with logical appeals and stimulate the desired action. The final frame caps the commercial with an emotional appeal that implies power and prestige for the product user.

XEROX COMMERCIAL

SECRETARY (SAYS NAMES THROUGHOUT) Hannigan . . . Flannigan . . . Mulligan . . . Finnigan . . .

ANNCR: (VO) The firm of Hannigan, Flannigan, Mulligan, Finnigan, Gilligan and Logan had a big name . . .

but a small office. Too small for a copier with an automatic sorter.

Until Xerox created the 3400 small copier.

With its automatic sorter . . .

It made up to 15 sets of documents in a small amount of time

and a small amount of space. Which made . . .

Hannigan, Flannigan, Mulligan, Finnigan, Gilligan, Logan . . .

. . . and O'Rourke, very happy. (SUPER: XEROX)

Courtesy of Xerox Corporation (Needham, Harper & Steers, Inc.)

■ *Find the persuasion steps in the following announcements. Remember that the five steps are a guide, not a mandate, in structuring a commercial, and sometimes you may not find all five, or you may find a given step very subtly made and barely perceptible. In most commercials and PSAs, however, the first four steps are clearly evident and the fifth one is frequently included.*

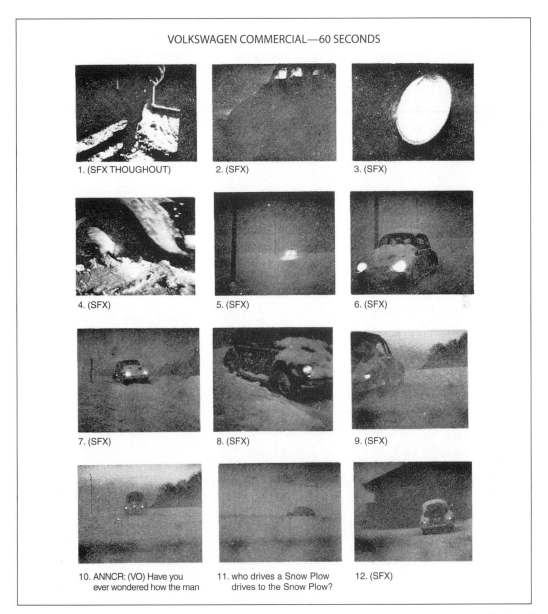

VOLKSWAGEN COMMERCIAL—60 SECONDS

1. (SFX THOUGHOUT)
2. (SFX)
3. (SFX)
4. (SFX)
5. (SFX)
6. (SFX)
7. (SFX)
8. (SFX)
9. (SFX)
10. ANNCR: (VO) Have you ever wondered how the man
11. who drives a Snow Plow drives to the Snow Plow?
12. (SFX)

Continued

13. This one drives a Volkswagen.

14. (SFX)

15. So you can stop wondering.

16. (SFX)

17. (SFX)

18. (SFX)

19. (SFX)

Doyle Dane Bernbach Inc. for Volkswagen of America

60-SECOND TV SPOT

VIDEO	AUDIO
OPEN ON RUGGED-LOOKING MAN AT COCKTAIL PARTY SMOKING CIGARETTE AND TALKING.	RUGGED MAN: (OC) (Speaking sympathetically) Hey, Harry, you look like you haven't seen the sun for a month. You ought to get out more.
CUT TO REVEAL AN ANEMIC-LOOKING MAN.	HARRY: (OC) I go out. What do you mean go out?
CUT TO RUGGED-LOOKING MAN.	RUGGED-LOOKING MAN: You'd feel better if you got out in the great outdoors …

Continued

VIDEO	AUDIO
RUGGED-LOOKING MAN STRETCHES EXPANSIVELY, ATTEMPTING TO CONVEY THE JOY OF THE OUTDOORS.	… stretched your muscles … got your lungs full of fresh air.
CUT TO HARRY, THE ANEMIC-LOOKING MAN. HE REACTS AGGRESSIVELY, AS THOUGH HE HAS BEEN PERSONALLY ATTACKED BY THE RUGGED-LOOKING OUTDOORSMAN.	HARRY: (Angrily … feeling he has been personally attacked.) What fresh air? You call the air around here fresh air?
CONTINUE WITH HARRY'S DIATRIBE. HE PUFFS ON A CIGARETTE.	HARRY: It's like living in a coal mine, it's so polluted around here.
CONTINUE WITH HARRY, SMOKING AS HE TALKS.	HARRY: You know what you see on your windowsill in the morning? Soot! This thick. (He gestures with fingers.)
OTHERS GATHER AROUND HARRY, ALL OF THEM SMOKING.	HARRY'S VOICE CONTINUES: And in traffic—in your car—carbon monoxide.
PAN ACROSS CIGARETTES OF ONLOOKERS.	HARRY'S VOICE CONTINUES: Every day it's killing you.
ECU CIGARETTES.	HARRY CONTINUES: You want me to get more fresh air …
ECU CIGARETTES.	HARRY: … then start doing something about the air pollution in this town.
PAN UPWARD FROM ONLOOKERS TO SMOKE RISING TO CEILING.	HARRY: Tear down the smoke stacks …
SCREEN FULL OF SMOKE.	HARRY: Get rid of that big incinerator out on the flats …
FREEZE FRAME ON HARRY'S FACE, SEEN DIMLY THROUGH SMOKE.	ANNOUNCER: (VO) If you'd like to do something about air pollution, we suggest you start with your own lungs.

Courtesy of American Cancer Society

THE TELEVISION STORYBOARD

Clients, producers, and account executives like to see as early and as fully as possible what the visual contents of the commercial or PSA will look like. After the basic ideas have been formed, producing the actual copy begins with the written word, including verbal descriptions of the script video portion. The next step is producing a series of drawings—a **storyboard**—showing what the described scenes will actually look like. The storyboard shows the sequence of picture action, optical effects, camera angles and distances, and settings. Under each drawing is a caption containing the dialogue and stating the sound and music to be heard.

Some storyboards are prepared for the preliminary presentation, along with the script draft, by the writer. Depending on the writer's art skills, the storyboard can be as simple as a series of stick figures. In large agencies the writer works with an artist, who prepares the initial storyboard. Final storyboards, prepared for client conferences by the agency artist, are sometimes as complete and excellent as the artwork for a high-quality animated film.

The Dunkin' Donuts storyboard shows the drawings prepared at the agency, followed by the same sequences as actually filmed for the finished commercial.

DUNKIN' DONUTS "WAKE UP TIME" STORYBOARD—30 SECONDS

	(MUSIC UNDER)
	SFX: ALARM CLOCK RINGS
FRED (OC):	Time to make the donuts. The donuts.
ANNCR (VO):	It isn't easy owning a Dunkin' Donuts.
FRED (OC):	Time to make the donuts.

ANNCR (VO):	Because, unlike most supermarkets, we make our donuts fresh day and night.

Continued

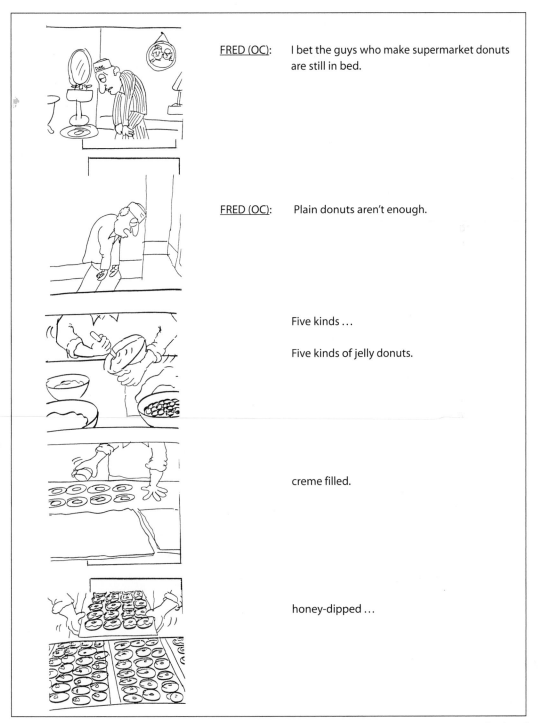

FRED (OC): I bet the guys who make supermarket donuts are still in bed.

FRED (OC): Plain donuts aren't enough.

Five kinds …

Five kinds of jelly donuts.

creme filled.

honey-dipped …

Continued

ANNCR (VO): Of course, when you make donuts this good, there is one reward: they taste so great, people buy an awful lot of 'em.

SUPER: DUNKIN' DONUTS IT'S WORTH THE TRIP.

FRED (OC): Good mornin', folks!

DUNKIN' DONUTS "WAKE UP TIME" FINAL PRODUCTION—30 SECONDS

1. (MUSIC UNDER) (SFX: ALARM CLOCK RINGS) FRED: (OC) Time to make the donuts.

2. The donuts.

3. ANNCR: (VO) It isn't easy owning a Dunkin' Donuts. FRED: (OC) Time to make the donuts.

4. ANNCR: (VO) Because, unlike most supermarkets,

5. we make our donuts fresh day

6. and night.

7. FRED: (OC) I bet the guys who make supermarket donuts are still in bed.

8. Plain donuts aren't enough.

9. Five kinds. . .

10. VOICE UNDER: Five kinds of jelly donuts, creme filled, honey-dipped... ANNCR: (VO) Of course, when you make donuts this good,

11. there is one reward: they taste so great. FRED: (OC) Good mornin', folks!

12. ANNCR: (VO) people buy an awful lot of 'em.

Written and produced by Ally & Gargano, Inc., Advertising; courtesy of Dunkin' Donuts of America, Inc.

Because television is visual, many critics believe that writers in all formats, including commercials, should use principally the medium's video aspects, rather than present radio with pictures. In effect, the storyboard should be the essence of, if not the complete commercial. This has happened when a product or service has gotten so well known that live or animated action or nondialogue effects such as music result in an effective commercial without the product's or service's name being mentioned in the script dialogue or continuity. For example, the song "You Deserve a Break Today" is associated with McDonald's.

The same general approach—that is, not stating verbally the sponsor's name—sometimes is used in a visual-only commercial. An example is the following Pepsi spot.

PEPSI STORYBOARD DESCRIPTIONS

INNERTUBE:
Open on a Pepsi bottle with a straw in it. Camera pulls back to reveal a cute young kid on a beach with a cute sailor cap on. He's drinking the Pepsi through the straw, and getting quickly to the bottom of the bottle. Camera pulls in closer. We see the young kid sucking on the straw so hard that his face is starting to be sucked in; the sailor cap starts to turn inward. In one quick swoop, the kid gets sucked into the straw, and into the bottle. The camera pulls back to reveal the bottle on the beach.

Courtesy of Pepsico, Inc.

FORMATS

The five major format types for commercials and PSAs are the straight sell, the testimonial, humor, music, and the dramatization. Any single announcement can combine two or more of these approaches.

The Straight Sell

This should be a clear, simple statement about the product or service. Don't involve the announcer or station too closely with what is being sold or promoted, except, of course, when the announcement is a promo for the station itself or a fund-raising or other support spot for a cause or organization with which the station and its personnel want to be publicly associated. Do not say "our product" or "our store" unless a personality is presenting the commercial, where the combination of the straight sell and testimonial can be strengthened by the personality's direct involvement.

Although the straight sell should be direct, it should not hit the audience over the head, nor be so laborious as to antagonize any potential customers. The writing should stress something special about the product or service, real or implied, that makes it different or better than the competition's.

Sometimes creativity seems to be totally inartistic. Although we associate aesthetic innovation with commercials using drama, music, and similar formats, a simple, yet different, straight sell approach can result in an announcement that not only is effective in promoting the product or service, but also captures the public's imagination and interest. Such a spot is Sy Sperling advertising the Hair Club for Men.

HAIR CLUB FOR MEN SCRIPT

VIDEO	AUDIO
OPEN ON CU OF SY.	SY: I'm Sy Sperling, President of Hair Club for Men. If you've ever thought about doing something about your thinning hair …
PULL BACK TO SHOW BOOKLET COVER IN SY'S HANDS.	… then this important, new booklet is something you should have.
ZOOM IN ON BOOKLET COVER AND SUPER PHONE NUMBER.	And I'll see that you get it free if you call our toll-free number.
CUT TO MS OF SY.	The booklet is an honest, straightforward discussion of all hair replacement techniques, including, of course, our own, exclusive

Continued

VIDEO	AUDIO
SY WALKS RIGHT AS CAMERA FOLLOWS. PAN RIGHT TO CU OF TABLE OF CONTENTS. SY POINTS TO EACH ITEM.	Strand-by-Strand hair system. It covers the good and not-so-good points of toupees, wigs, weaves, the suture process, transplants and a lot more. It's designed to give you the facts you need to make an intelligent choice about what's best for you.
PAN LEFT TO SY AS HE WALKS LEFT TO CENTER OF DESK.	So, to get your free copy, no charge, no strings, just call our toll-free number now. I'll send you the booklet along with a full-color supplement showing before and after photos of real Hair Club clients.
SUPER PHONE NUMBER.	So, call now for your free copy.
SY PICKS UP HIS "BEFORE" PHOTO.	And, by the way,
CU OF SY WITH HIS "BEFORE" PHOTO NEXT TO HIS FACE.	I'm not only the Hair Club president. I'm also a client.
FREEZE.	
DISSOLVE TO BLACK.	
SUPER LOGO.	

Courtesy of Berton Miller Associates, Inc.

HAIR CLUB FOR MEN STORYBOARD

SV: I'm Sy Sperling, President of Hair Club for Men®. If you've ever thought about doing something about your thinning hair . . .

. . . then this important, new booklet is something you should have.

Continued

And I'll see that you get it free if you call our toll-free number.

The booklet is an honest, straightforward discussion of all hair replacement techniques, including of course our own, exclusive Strand-by-Strand® hair system.

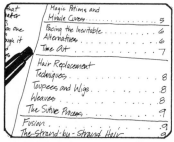

It covers the good and not-so-good points of toupees, wigs, weaves, the suture process, transplants and a lot more. It's designed to give you the facts you need to make an intelligent choice about what's best for you.

And by the way, I'm not only the Hair Club for Men president. I'm also a client.

Courtesy of Berton Miller Associates, Inc.

The Testimonial

When the testimonial is given by a celebrity, the emotional appeals of prestige, power, and good taste are primary. What simpler way to reach the status of the celebrity, if only in one respect, than by using the same product or service he or she uses? For the celebrity testimonial to be effective, its content and style, including the setting, action, and type of dialogue, must be consistent with the public image of the personality. The audience must believe that the celebrity really believes what he or she is saying about the product or service.

Important ethical considerations arise for the writer when commercials are aimed at children. Promotion of a product, such as a toy or cereal, by someone admired by youngsters—for instance, the host of the television program on which the commercial is featured—may have an undue and unfair influence. Children are easily susceptible to such promotion.

Two personality testimonials follow. The first is a commercial, winner of many awards and a coup in celebrity testimonials because it features one of the most prestigious artists of the century, the late Sir Laurence Olivier. The second is a PSA that seeks support from the public in preventing nuclear war and features another prestigious artist, Meryl Streep. Note how both announcements combine the testimonial with the straight sell.

60 SECONDS

VIDEO	AUDIO
LS OLIVIER, CAMERA IN HAND, APPROACHING VASE OF FLOWERS FROM OUT OF DARK BACKGROUND.	FOOTSTEPS
MLS OLIVIER, HOLDING UP AND POINTING TO CAMERA, FLOWERS IN FOREGROUND. MS OLIVIER PREPARING CAMERA TO TAKE PICTURE.	OLIVIER: Polaroid's new SX-70.
MS OLIVIER POINTING TO BUTTON ON CAMERA.	OLIVIER: Just touch the button …
MCU OLIVIER TAKING PICTURE OF FLOWERS.	
CU OLIVIER TAKING PICTURE OF FLOWERS, ONE PICTURE OUT OF CAMERA.	OLIVIER: Now, these pictures,
CU OLIVIER TAKING PICTURE OF FLOWERS, TWO PICTURES OUT OF CAMERA.	OLIVIER: developing themselves, outside the camera,
CU OLIVIER TAKING PICTURE OF FLOWERS, THREE PICTURES OUT OF CAMERA.	OLIVIER: are hard and dry.
MCU THREE PICTURES STILL ALMOST BLANK.	MUSIC

Continued

VIDEO	AUDIO
CU THREE PICTURES, FLOWERS BARELY BEGINNING TO SHOW.	OLIVIER: There's nothing to peel,
CU THREE PICTURES, FLOWERS SHOWING A LITTLE MORE.	OLIVIER: nothing even to throw away,
CU THREE PICTURES, FLOWERS EMERGING MORE.	OLIVIER: nothing to time.
CU THREE PICTURES, FLOWERS CONTINUE TO EMERGE.	MUSIC
CU THREE PICTURES, FLOWERS BECOMING CLEARER.	MUSIC
CU THREE PICTURES, FLOWERS MORE CLEAR.	OLIVIER: In minutes, you will have a finished photograph of such dazzling beauty
CU THREE PICTURES, FULLY PRINTED.	OLIVIER: that you will feel you are looking at the world for the first time.
XC FINISHED SINGLE PICTURE.	MUSIC
MCU OLIVIER HOLDING CAMERA OPENED.	OLIVIER: The new SX-70 Land Camera.
MCU OLIVIER HOLDING UP CAMERA CLOSED.	OLIVIER: From Polaroid.

Doyle Dane Bernbach Inc. for Polaroid Corporation

MERYL STREEP SCRIPT—For TV—30 Seconds

My baby will never have polio, diphtheria or measles.

We've cured them.

But one of the last major childhood diseases remains. Nuclear War. Deadlier than all the rest combined.

Please join Millions of Moms in sharing information about the prevention of nuclear war.

Send your name and address to MOM, Post Office Box B, Arlington, Massachusetts 02174.

You can help cure a major childhood disease.

Courtesy of Women's Action for Nuclear Disarmament Education Fund

An alternative to the traditional celebrity testimonial is the testimonial from the average man or woman—the worker, the homemaker, the person in the street with whom the viewer or listener at home can directly identify. Through such identification the viewer may more easily accept the existence of the common problem in a commonly experienced physical, economic, or vocational setting and, consequently, more readily accept the solution adopted by the person in the commercial—using the sponsor's product, service, or idea.

The following commercial follows this "everyperson" approach, but does not directly sell the sponsor's product. This is an *institutional* announcement, which creates good will for the sponsor and in general keeps the company name in the public consciousness in a highly positive setting.

60 SECONDS, RADIO

Hello, I'd like to tell you something about myself. I used to be a drunk, and a chronic drunk driver. In the ten years between my first arrest and having my license revoked I racked up 19 major traffic violations, I caused 6 serious accidents, injured 3 people besides myself and had my license suspended twice. I was still driving and drinking. Then one night I was driving home after work and I had a few and I hit this kid on a bicycle. He died before they could get him any help. He was just 11 and a little younger than my oldest boy. I'm living with that now. I was too drunk to see him then, but I can see him now ... and I remember.

ANNCR: This message was brought to you by The General Motors Corporation.

General Motors Corporation "Safer Driver Radio" series. Created by Robert Dunning, N.W. Ayer & Son, Inc., New York

Humor

Just as public attitudes toward humor change over the years, so do the humorous approaches in commercials. Humor is always an effective attention-getter, but successful humor must reflect current humorous trends. The gag or one-liner was once the staple of advertising humor, but has now been largely replaced by satire and parody. Most humor is used in conjunction with dramatization, tied to a story line or to character relationships.

Some humor is bizarre, but if part of a continuingly interesting gimmick, as in the Parkay commercial, it can be highly successful. Other humor can be gentle, almost with a tinge of pathos, as in the Southwestern Bell "Call Home" spot. And some humor is effective because of its incongruity or an unanticipated switch in thought, as in the Volkswagen ad.

30 SECONDS

VIDEO	AUDIO
1. OPEN ON LITTLE GIRL SITTING ON FRONT PORCH AT WICKER TABLE. BEGIN SLOW MOVE IN ON HER AS SHE SINGS.	KID: P-A-R-K-A-Y, P-A-R-K-A-Y.
2. CUP SPEAKS WITH LID.	CUP: Butter.
3. LITTLE GIRL PAUSES, THEN BEGINS SINGING AGAIN.	KID: (SIGH) P-A-R-K-A-Y, P-A-R ...
4. CUP SPEAKS WITH LID.	CUP: Butter
5. LITTLE GIRL PAUSES AGAIN, SIGHS, THEN LIFTS LID OF CUP & TASTES. SHE CONSIDERS THEN CHANGES HER LITTLE SONG.	KID: (SIGH) (TASTES) B-U-T-T-E-R, B-U-T-T-E-R.
6. CUP SPEAKS ONCE MORE WITH LID.	CUP: Parkay!
7. LITTLE GIRL PAUSES, CONSIDERS, THEN CHANGES SONG ONE LAST TIME.	KID: (SHRUGS) P-A-R-K-A-Y, P-A-R-K-A-Y.
8. CUT TO LIMBO SHOT OF SOFT PARKAY PACKAGES & SUPER: *PARKAY MARGARINE FROM KRAFT. THE FLAVOR SAYS BUTTER.*	ANNCR: Parkay Margarine from Kraft. The flavor says butter.

Permission for use of this material has been granted by Kraft, Inc. (Needham, Harper & Steers, Inc.)

"Call Home"—60 Seconds

ANNCR: Ever wonder what your parents do when you're away at school?

MUSIC: SAD VIOLIN UP & UNDER:

DAD: What would you like to do this evening, Dear?

MOM: Oh, I thought I'd sit by the phone again. Perhaps our son, Larry, will call this month.

DAD: Would you like the light on?

MOM: No, I'll just sit in the dark.

Continued

ANNCR:	You could've called, Larry. There's lots to talk about with your folks. Share with them why you changed your major to Recreation, explain what academic probation means or just ask 'em to send money.
	And It's so easy … call between 11 P.M. Friday and 5 P.M. Sunday when rates are lowest. You can even call collect. And you can bet they'll be glad to hear your voice.
SFX:	SFX: RING! RING!
MOM:	Hello …
LARRY:	Mom, it's me!
MUSIC:	DRAMATIC CRESCENDO
MOM:	Larry, is it really you?!
ANNCR:	This message has been brought to you as a public service on behalf of parents everywhere by Southwestern Bell Telephone.

Written and produced by D'Arcy MacManus Masius. Courtesy of Southwestern Bell Telephone.

VOLKSWAGEN COMMERCIAL—10 SECONDS

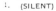

1. (SILENT) 2. ANNCR: (VO) If gas pains persist … 3. (SFX) 4. Try Volkswagen.

Doyle Dane Bernbach Inc. for Volkswagen of America

Music

The musical commercial has always been one of the most effective methods for predisposing an audience to remember a product. Many observers attribute the initial growth of Pepsi-Cola and its success in becoming a competitor to Coca-Cola to its 1930s radio musical jingle, "Pepsi-Cola hits the spot … nickel, nickel, nickel …" How many times have you listened to a song on radio or television, been caught up in its cadence, and then suddenly realized it was a commercial and not the latest hit tune?

Producer Susan Hamilton observed in *Broadcasting* magazine that "music is still basically an emotional thing. And the reason we are producing commercials that sound like recordings is to try and grab the listeners. We're always told that when a commercial comes on the radio kids immediately turn the dial. But when you make your spots sound like songs, there's a chance you may be able to reach those kids before they reach those dials."

Not only have many original tunes for commercials become popular hits, but many ads have used on a continuing basis already known pop songs, the latter, too, becoming associated in the public mind with the products. In fact, original and popular music both have been so effective in creating such associations that many people remember and identify the advertiser, such as Coca-Cola and McDonald's, first with the theme music and only secondarily with a particular sales message. The following script is an example.

60 SECONDS

VIDEO	AUDIO
	SONG:
CUT TO CU OF GIRL'S FACE AND SINGING. PB TO REVEAL GIRL SINGING WITH BOY AND GIRL WITH COKE BOTTLE ALSO SINGING.	I'd like to buy the world a home and furnish it with love. Grow apple trees and snow white turtle doves.
DISS TO PAN ACROSS OF BOYS AND GIRLS IN NATIVE DRESS WITH COKE BOTTLES IN HAND AND SINGING.	I'd like to teach the world to sing (sing with me) in perfect harmony (perfect harmony) and I'd like to buy the world a Coke and keep it company.
	It's the real thing.
DISS TO SIDE VIEW OF ROWS OF BOYS AND GIRLS IN NATIVE DRESS AND SINGING.	I'd like to teach the world to sing (what the world wants today)
DISS TO PAN ACROSS OF ROWS OF BOYS AND GIRLS IN NATIVE DRESS SINGING.	In perfect harmony (perfectly)
DISS TO PAN ACROSS OF COKE BOTTLES IN HANDS OF BOYS AND GIRLS.	I'd like to buy the world a Coke.
DISS TO CU OF GIRL'S FACE AND SINGING.	and keep it company
DOUBLE EXPOSE CU GIRL'S FACE.	It's the real thing (Coke is)
	What the world wants today Coca-Cola.
SINGING OVER CROWD SHOT TO PB TO REVEAL CROWDS OF BOYS AND GIRLS OF ALL NATIONS ON HILL WITH CRAWLING TITLE AND MATTE:	It's the real thing. What the world wants today Coke is.

Continued

VIDEO		AUDIO
SUPER:	ON A HILLTOP IN ITALY WE ASSEMBLED YOUNG PEOPLE FROM ALL OVER THE WORLD TO BRING YOU THIS MESSAGE FROM COCA-COLA BOTTLERS ALL OVER THE WORLD. IT'S THE REAL THING. COKE.	Coca-Cola.

Courtesy of The Coca-Cola Company. Words and music by Roger Cook, Roger Greenaway, William Becker, and Billy Davis. McCann-Erickson, Inc.

The approaches used in music videos have been adapted to commercials aimed at young audiences. MTV scenic, dance, prop, electronic, and sound techniques are staples of many television ads. *Broadcasting & Cable* magazine described these spots as "surrealistic and sex-oriented and distinguished by quick cuts, bands of light, bright colors, loud rock music, optical illusion, and a minimal amount of dialogue." The Levi's commercial shown on the next page is not the storyboard, but a series of photos of the completed spot. Note the use of angles, close-ups, and quick cuts, all in the rhythm of the contemporary music sound.

The Dramatization

The dramatization is, in effect, a short play, presented in 30 or 60 seconds. Most commercial dramatizations follow the standard play form (Chapter 10) that itself reflects the basic steps of persuasion—exposition, conflict, rising action, climax and, sometimes, resolution. In other words, the dramatization is a sequence that gets the audience's attention and interest, creates suspense, and solves the problem the character or characters are facing. AT&T has used the minidrama not only in individual commercials but also as part of a continuing series tracing crisis relationships among members of a family. Similar to a sitcom, these ads attracted many viewers who wanted to find out what was going to happen next to the characters.

Some dramatizations do not have a discernible play structure; they are simply bits of dialogue or action interspersed with direct or indirect information about the product. They reflect a nondramatic lifestyle. A straightforward dramatization is the Dunkin' Donuts "Wake Up Time" spot (see p. 90).

Dramatizations frequently combine elements of other commercial formats, such as humor or music. One example is the Coca-Cola ad (on page 104), which tells a visual drama narrated in song.

LEVI'S COMMERCIAL—30 SECONDS

SINGERS:
*Every late night morning
I put on my blues*

*Ooo bop bop
uh huh · ooo bop.*

Levi's button fly 501 blues.

Ooo bop bop oo bop.

*Well, they shrink down to fit
you and only you. They...*

*button fly. Don't it
make you wanna*

*ooo bop bop ooo bop.
That's the truth.
Ooo bop bop ooo bop.*

*Levi's 501 Blues.
Ooo bop bop ooo bop.*

Ooo bop bop.

Courtesy of Levi Strauss & Co.

60 SECONDS

	VISUAL	AUDIO
1.	COUNSELOR WALKING DOWN STEPS OF ROW HOUSE.	SONG: Hey, look at you lookin' at the sunrise …
2.	CU OF COUNSELOR TALKING TO BOY.	There's such a brighter …
3.	BOY BEING PULLED UP.	look in your …
4.	COUNSELOR AND BOY WALKING DOWN SIDEWALK, TALKING.	eyes.
5.	COUNSELOR AND BOY CROSSING STREET.	Now that I know you've felt the wind …

Continued

VISUAL	AUDIO
6. COUNSELOR AND THREE KIDS WALKING DOWN SIDEWALK.	that's blowing, reaching out …
7. PAN OF COUNSELOR AND KIDS.	and wanting life's good things.
8. LONG SHOT OF PLAYGROUND GATE OPENING AND KIDS WAITING.	Now that you're seein' …
9. OPEN GATE AND KIDS RUSHING IN.	All things grow.
10. CU OF COUNSELOR TURNING AROUND.	(MUSIC UP)
11. COUNSELOR PASSING BALL TO BOY.	
12. COUNSELOR JOGGING TO BOY BEHIND FENCE.	There is more love in …
13. CU OF JOSÉ.	you than anyone …
14. COUNSELOR ASKING BOY TO FOLLOW.	I know.
15. COUNSELOR WITH ARM AROUND JOSÉ, INTRODUCING HIM TO KIDS.	You take time for friends …
16. COUNSELOR PLAYING CHECKERS WITH KIDS, GIRL DRINKING COKE.	and simple talking …
17. CU OF COUNSELOR DRINKING COKE.	Sippin' Coke …
18. LS OF COUNSELOR SWINGING BOY AROUND.	enjoyin' life's …
19. PAN OF KIDS DRINKING COKE AGAINST FENCE.	good things. It's the Real Thing.
20. CU OF PRODUCT AGAINST FENCE.	Oh … Coca- Cola.
21. PAN OF KIDS AGAINST FENCE.	It's the Real Thing.
22. PRODUCT AGAINST FENCE.	Oh … Coca-Cola.
23. COUNSELOR GIVING JOSÉ A COKE.	It's the Real Thing.
24. PRODUCT AGAINST FENCE WITH SUPER: "It's the real thing, Coke."	Oh … Coca-Cola.
25. COUNSELOR WITH JOSÉ ARM IN ARM. SUPER: "It's the real thing. Coke."	It's the Real Thing.

Courtesy of The Coca-Cola Company. McCann-Erickson, Inc.

Some dramatizations use realistic settings or events as a base. They are, in effect, combinations of drama and news; rather than miniplays, they are **minidocumentaries.** Although the writer may be tempted to present serious information in a straightforward manner—narrated as in the straight sell format—the inclusion of a dramatic situation makes the presentation more interesting and holds the audience better. Note how the following ITT spot not only has the drama of the product solving a problem, but also includes the dramatic complication of a moment of crisis.

ITT COMMERCIAL—60 SECONDS

ANNCR. (VOICE OVER): With divers working a quarter mile down these days, how do you . . .

keep track of them without big, unmanageable cables.

In Britain, the Royal Navy is developing a monitoring system that uses optical fibers made by the people of ITT.

OFFICER: Give me a readout on No. 1 diver.
TECHNICIAN: Respiration and heart rate normal.

OFFICER: Ready No. 2 diver. Test for leaks and send him down.

ANNCR.: The ITT optical fibers are threads of glass that can be built . . .

right into the air hose — and over them, a laser beam can flash medical reports . . .

sixteen conditions that signal an emergency.

TECHNICIAN: Diver in distress.
OFFICER: What's the problem, Bob?
TECHNICIAN: EKG is unstable.

OFFICER (V.O.): Operate emergency procedure.
ANNCR.: Who knows how many lives this ITT cable will save —

once it's out of the laboratory.
OFFICER (V.O.): Not bad, chaps.

Courtesy of International Telephone and Telegraph Corporation (Needham, Harper & Steers, Inc.)

The good writer takes full advantage of the medium. For example, the creator of a television spot might concentrate on the visual elements that have the greatest impact. Too many announcements are interchanged between television and radio, which means they either are not using either medium fully or are shortchanging the impact in one of the media. One development in television is to use visuals with a minimum of dialogue. The "Cocaine" storyboard and script that follow are examples of a PSA with no dialogue, written by a student as an assignment in an Emerson College class on writing for the media.

"COCAINE" STORYBOARD

SFX Heartbeat—fade up and under. (Hands stay still)

Sneak up heartbeat a little (heart rate increases). Natural sound of gun as it's picked up. (hands wait a few seconds and pick up gun)

Sneak up heartbeat (heart rate increases). Natural sound of razor scraping on glass. (hand pickup up razor blade and begin separating cocaine)

Sneak up heartbeat (heart rate increases). Nat sound of chamber as it opens. (hands open chamber of gun)

Sneak up heartbeat (heart rate increases). Nat sound of scraping on glass. (hands separate cocaine into four lines)

Sneak up heartbeat (heart rate increases). Nat sound of bullet sliding into chamber. Nat sound of click as chamber closes. (hands load bullet into chamber and close)

Sneak up music (heart rate increases). Nat sound of straw scraping table. (hands pick up straw and bring straw close to camera)

Sneak up heartbeat to full level, heart rate increases. Lose all audio as gun faces camera. (Hands turn gun towards camera—end up aimed directly at camera)

SFX gunshot, as straw touches cocaine. (hands slowly lower straw to cocaine— camera follows—gun fires as straw touches cocaine)

VO—"Cocaine: it will blow your mind."

COCAINE: IT WILL BLOW YOUR MIND.

"COCAINE" SCRIPT

VIDEO	AUDIO
TALENT HANDS 1 OPEN SCENE WITH TALENT HANDS 1 (GLOVED) RESTING ON THE GLASS OF A TABLE (A) IN FRONT OF THE PILE OF COCAINE. FOLD HANDS FOR LENGTH OF SCENE.	PAIR OF HANDS RESTING ON A TABLE. INCLUDE ONLY HANDS AND TABLE SHOWING COCAINE, STRAW AND RAZOR BLADE. (over the shoulder shot) AUDIO: FADE UP HEARTBEAT WITH EST. SHOT.
TALENT HANDS 2 TALENT HANDS 2, (ALSO GLOVED TO BE VIEWED AS IDENTICAL TO TALENT HANDS 1), PICK UP GUN FROM TABLE (B), AND FACE GUN TO CAMERA LEFT, ALLOWING FULL LENGTH OF GUN TO BE SHOWN.	SWITCH TO PAIR OF HANDS HOLDING GUN SAME PERSPECTIVE AS ESTABLISHING SHOT.
TALENT HANDS 1 PICK UP RAZOR BLADE AND PLACE IN THE CENTER OF THE PILE OF COCAINE. BEGIN TO SEPARATE PILE IN HALF.	
TALENT HANDS 2 RELEASE REVOLVER CYLINDER, AND SLOWLY, TO EXAGGER-ATE ACTION, MOVE CYLINDER TO THE OPEN POSITION.	
TALENT HANDS 1 SLOWLY SEPARATE COCAINE INTO TWO DISTINCT LINES.	
TALENT HANDS 2 PLACE BULLET IN CHAMBER (IN FULL VIEW OF THE CAMERA). CLOSE CHAMBER.	
TALENT HANDS 1 PICK UP STRAW, AND HOLD IT ABOVE THE LINE OF COCAINE CLOSEST TO THE CAMERA (KEEPING STRAW ABOUT THREE INCHES ABOVE LINE).	
TALENT HANDS 2 TURN GUN TOWARDS SELF SLOWLY INDICATING INTENTION TO COMMIT SUICIDE.	AUDIO: FADE OUT HEARTBEAT AS GUN BEGINS TO TURN
TALENT HANDS 1 SLOWLY LOWER THE STRAW TO THE COCAINE AND PLACE THE END OF THIS STRAW TO THE BEGINNING OF THE COCAINE LINE CLOSEST TO THE CAMERA. FREEZE ACTION.	<u>SFX</u>: GUN EXPLOSION IS TO BE SIMULTANEOUS WITH STRAW TOUCHING COCAINE.
COCAINE IT <u>WILL</u> BLOW YOUR MIND	QUICK! FADE TO BLACK <u>CG</u>

Written by Edward Krasnow. Courtesy of Mr. Krasnow.

Format Combinations

Commercials and announcements usually combine more than one format, although one may predominate. An award-winning example of such a commercial, IBM "Skates," includes all the basic formats presented here. "Skates" is clearly a dramatization in which the principal character solves a problem. Music is used throughout much of the first part of the ad. The narration describing what the product can do employs straight sell. Humor, found in the Charlie Chaplin "Tramp" character's slapstick actions, prevails throughout. Can you determine the testimonial aspect of the spot? Although no live personality endorses the product, the ad ties the great actor, Charlie Chaplin, to the product, thus supplying the testimonial "ethical person" aspect. (The actor, who portrayed Chaplin in this commercial, which gave him a significant career boost, is Robert Downey, Jr.)

IBM "SKATES" COMMERCIAL

(MUSIC INTRO.)
ANNCR: VO
In today's rapidly changing world, *(1)*

even the brightest *(2)*

and best manager in the company *(3)*

may need more than a loyal staff *(4)*

(WALTZ MUSIC BEGINS)
and tried and true systems *(5)*

to oversee a
smooth running operation. *(6)*

Continued

Continued

Continued

Continued

Continued

Prepared by Lord, Geller, Federico, Einstein, Inc. Written by Bob Sarlin, art directed by Mary Morant, creative director Thomas Mabley. Courtesy of IBM.

Some commercials are, in effect, minidrama series, with one or more continuing characters encountering a different situation in each subsequent spot, with the advertiser's product the focal point of the playlet. One of the most effective and best-written of this type is the Sprint PCS series aired in 2002. A continuing character finds himself in different settings and problem situations. In each commercial, he shows the people involved how the Sprint PCS solves their problem. Note the excellent combination of drama and humor and the clear application of the problem-solution organizational approach in the following example from this commercial series. The script is followed by photos of the production sequence.

client	SPRINT	*date:*	JUNE 20, 2002	*page*	1 of 2
product	BRAND CLARITY				SWEM/MN
title	"LEMONS/REV1/MASTER BRAND"	*status*	AS PRODUCED		
length	:30 TV	*code*	YSTS 2377		
		no.			

art director _____ *creative director* _____ *proofreader* _____ *traffic* _____

copywriter _____ *account executive* _____ *product information* _____ *leg*

OPEN ON FIVE WOMEN (MID 30S) OUTSIDE ON THE CABIN LAWN PLAYING CARDS, READING MAGAZINES. BRIAN IS WITH THEM. ONE OF THE WOMEN EXPLAINS THE PROBLEM:

Continued

WOMAN 1: So I call her and I say, "Bring fresh lemons"…and she brings…

WE HEAR SOMEONE SAY "COME ON, LET ME IN" FROM A CANOE ON THE LAKE—THAT'S ALL BRIAN NEEDED TO HEAR. HE COCKS HIS HEAD AND RICHARD SIMMONS SAYS:

SIMMONS: I'll be so quiet…

BRIAN: Richard Simmons.

WOMAN 2: Give it a rest…

NOW WE SEE RICHARD ON A CANOE IN THE LAKE, SINGING A SONG AND DANCING. HE SINGS THROUGHOUT THE COMMERCIAL.

THE WOMAN CAN'T TAKE IT. SHE STANDS UP.

WOMAN 3: You know what…

WOMAN 3 STANDS UP, BUT BRIAN GETS BETWEEN HER AND THE LAKE.

BRIAN: It's not his fault. It's the cellular static. Here, Sprint built the largest all-digital, all-PCS nationwide network from the ground up, so calls are clear.

LEGAL: Nationwide network reaches more than 230 million people.

BRIAN HANDS HER A PCS PHONE, AND SHE RELAXES; ALL THE WOMEN THANK BRIAN.

WOMAN 3: Thanks

WOMAN 2: What about him?

BRIAN: Maybe some people shouldn't be heard.

RICHARD: Hey, I heard that…

TITLE CARD: THE PCS FREE & CLEAR PLANSM

4000 MINUTES FOR $39.99
NATIONWIDE LONG DISTANCE INCLUDED
WWW.SPRINTPCS.COM 1 800 480 4PCS

LEGAL: 350 ANYTIME MINUTES + 3,650 NIGHT & WEEKEND MINUTES.
REQUIRES 1-YEAR TERM AGREEMENT & CREDIT APPROVAL.
ACTIVATION & TERMINATION FEES APPLY.

SUPER: SPRINT PIN DROP.

TITLE CARD: SPRINT DIAMOND LOGO

4000 MINUTES FOR $39.99
NATIONWIDE LONG DISTANCE INCLUDED
WWW.SPRINTPCS.COM 1 800 480 4PCS

LEGAL: 350 ANYTIME MINUTES + 3,650 NIGHT & WEEKEND MINUTES.
REQUIRES 1-YEAR TERM AGREEMENT & CREDIT APPROVAL.
ACTIVATION & TERMINATON FEES APPLY.

VO TAG: 4,000 minutes for $39.99 from Sprint.

Courtesy of Publicis and Hal Riney, San Francisco

Internet Considerations

A most important thing to remember when preparing commercial or promotional material for the Internet is the links. The initial page must be attractive and, as in any announcement, get and hold the attention of the viewer. As noted by Professor Maurice Methot in Chapter 3, the design must be attractive, with appropriate size and type fonts and colors. Visual moving images and music or other sounds can enhance the home page. But to get the viewer to go further and learn more about the product or service and be convinced to patronize it, the viewer must be enticed to click on one or more links. The links should carry the viewer through the organizational elements of persuasion and end in convincing the viewer to take some kind of action: Buying a product online, supporting a cause, logging onto additional Web sites, or, as in the following example, listening to or viewing another medium.

Matt Ostrower, Web Promotions Manager for WBUR-FM, an NPR (National Public Radio) station in Boston, states his approach to WBUR.org online promotions:

> When we are promoting our content on-air the scripts always end with a specific call-to-action. There needs to be a compelling statement that will convince listeners to visit the Web site to learn more. The tone of the writing changes once they reach the site as our content strives to be in-depth and give a unique perspective on a particular topic. The text often includes hyperlinks to supplementary visual components such as photos, videos, and audio. In addition to supporting the radio broadcast, we view the Web as a vehicle that provides the user with an enhanced interactive experience that is only available online.

Following is the WBUR-FM Internet home page. Note the major links at the top: The forums, About the Show, Archives, Public Radio Store, and Join the Connection. The search option, too, entices the viewer into further exploration into WBUR. The viewer can also find out information about a favorite program—note "Top Ten Shows" links at the right. Special emphasis is given to WBUR's premier interview show, "The Connection."

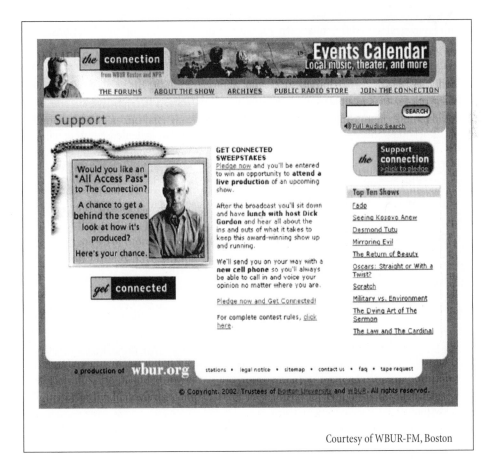

Courtesy of WBUR-FM, Boston

SPECIAL CONSIDERATIONS

Although most commercial writers are aware of ethical considerations, such as role stereotyping, many are not sensitive to the special characteristics of many segments of the population that determine those audiences' reactions to specific commercial stimuli. Audience analysis must go beyond the perception that all viewers or listeners of the same age, gender, economic, education, and geographical demographics, for example, will react the same way.

Dr. Cecil Hale, a communications professor and former president of the National Association of Television and Radio artists, believes there must be a common understanding, a mutual feeling between the writer, announcer, and audience for any broadcast material, including advertising spots, to be optimally effective. Hale thinks that the writer must find relationships among the character of the product, the character of the audience, and the character of the occasion. Commercials for the same product need to be different for different audiences because the audiences see the product differently. Not all people in a given ethnic or racial group are alike. Hale warns against stereotyping any segment of the audience. Two African American–oriented or Latino-oriented stations in the same community may deal with different audiences, just as would two white-oriented stations.

Caroline Jones, as creative director of the Black Creative Group, advising ad agencies dealing with the African American market, remarked in Joel Dreyfuss's *Washington Post* article, "Blacks and Television," that "they are getting blacks in ads, but they are not doing black ads. It's not black lifestyle." Referring to studies showing that African American women in general cook foods longer than do white women, and add more spices, stressing taste rather than speed, Jones said that an African American–oriented commercial, "instead of saying, 'You can cook it in a minute,' should say 'You will have more time to spend with your family.' I'm talking about why they use a product, why they buy it. They haven't researched it."

The same principles apply to all audiences, and the writer who analyzes the audience's distinct varying attitudes, backgrounds, and lifestyles will more accurately find the common ground between product and audience.

APPLICATION AND REVIEW

1 Choose a product, a television program, and a television station. Write a 30-second commercial script and storyboard for the product. Justify what you've prepared by stating (1) your audience analysis, (2) emotional and/or logical and/or ethical appeals, and (3) the steps of persuasion you used.

2 Write the same commercial for radio, considering the differences between the two media.

3 Using the same considerations, prepare a PSA for television and for radio.

4 Write an ID for a television and a radio station.

5 Write a promo for a television and a radio station.

■ *If your college or university has a television, FM radio, or carrier current station, arrange to do as many of the previous five exercises as possible as practical assignments for the stations.*

6 Bring to class a printout of any commercial on the Internet that features several links. Sketch out a similar commercial page for a different product or service.

■ *Discuss your completed commercials in class not only according to principles and techniques of ad writing, but especially in terms of ethical considerations, as well.*

5

News and Sports

NEWS

Any happening that might interest or have an effect on people is news. Anything from a cat up a tree to the outbreak of a war can be worthy of transmission to the mass media audience. The reporter is responsible for determining just what is newsworthy and selecting what to cover and report. The writer is responsible for taking that information and putting it into broadcast form.

The reporter and writer frequently are the same person. Except for network or large-station operations, where staff newswriters may be employed to take the reporter's notes and turn them into a script for the on-air anchors, the reporter usually writes his or her own script, providing the segment for the program as prerecorded sound-on-tape (SOT) or in a live remote. If the latter, the reporter frequently has not had time to prepare a written script and must extemporize.

Generally, the television or radio reporter gathers material for the story including sound or video **bites,** writes the script integrating the video and sound, and either presents the story as the talent or turns over the finished material to the studio for placement in the newscast. Sometimes the story is used as is, most often it is edited for time, and sometimes narration is written to go along with the video and audio reports.

Sources of News

The principal news source is the reporter-writer. If the reporter is a news-gatherer who collects the information, but does not write it up into final form and never gets on the air, a writer takes the information and prepares it or rewrites it for the on-air personalities.

Sometimes on-air personalities, particularly in small stations, do their own reporting and at least some of the writing. Information sometimes comes from a nonstation source, such as a citizen phoning in a tip or an observation, the police or fire department reporting a crime or a fire, the promotion or advertising offices of businesses and organizations, or press agents and public relations agencies—any source that officially deals with news-worthy events or that is being paid to make an event seem newsworthy. When you begin to put together the script from such nonreporter sources, you must be extra careful in judg-ing the validity of the material and the trustworthiness of the source.

Of course, if the material comes from a reporter in your own station, network, or broadcast news service, you will already know how complete and accurate that reporter is in gathering material. If the submission is not scripted (with visuals and audio) or not sufficient to provide a satisfactory story or if you have any question on the material's objectivity and veracity, you or another writer may have to do additional reporting, writing, and verification. You can obtain additional information through phone calls or personal on-the-spot newsgathering, if time permits.

To be considered complete, good news stories should inform the audience of the five Ws—who, what, when, where, and why. If you are missing one or more of the five Ws in an important story—for example, you know "what" happened, "when," "where," and to "whom"—you may have to dig out the "why." If you suspect a story has implications that go beyond the information available to you, you may need to do research on the back-ground of the story, including any five Ws of a previous story that might be relevant and any material you can find on the current event's importance for the future.

Another likely source of material is the "morgue" of all past stories that your station probably keeps. This morgue is similar to the files kept by newspapers, categorized by subject and person. The radio or television morgue will have audio or video material that can be reused; if none relating to the specifics of the story is available, **stock** footage can be helpful. You must make clear that any stock footage is not live or current material; don't mislead the viewer.

Clipping stories from local newspapers has provided newscasts for many radio stations, and even for some television stations that use only a newscaster with still visuals. If you adapt your news broadcast from the newspaper stories, keep in mind the styles and techniques of broadcast writing discussed later in this chapter that differentiate print from air news.

Have on hand those books that frequently help the broadcast newswriter, such as an encyclopedia, a world atlas, and history books—including those dealing with your region, state and local area. Most cities issue municipal directories that contain information on the city boards and offices. In many cities, the social service agency issues a manual of all social services offices and activities, including a list of nonprofit organizations. Many states issue directories or monographs with statistical data on the state, including population demographics. A city's chamber of commerce usually issues a directory that provides information on the area's business organizations, companies, and activities, including financial data such as sales, income, and advertising expenditures.

Several news agencies provide services to radio or television stations. These include the **Associated Press (AP); Reuters; British Broadcasting Corporation (BBC); World-wide Television News (WTN),** and **Cable News Network (CNN).** The larger networks have their own news divisions. Several organizations provide special news material, especially pictorial matter, for television. Almost all television and radio stations subscribe to at least one wire service.

Most smaller stations do not have separate news departments, so news broadcasts are prepared by available personnel, usually someone who has some news background, but has a different primary assignment at the station. If there is a continuity department, for example, the writer or writers in that office will be expected to prepare the local news reports. In radio the person on the air at the time of the news presentations—a disc jockey or a general staff announcer—may be required to prepare and present the news, usually in a one- or two-minute break. In some instances a writer with the station writes it; in others, the on-air person simply "rips and reads"—tears off the latest copy from a news wire and presents the news with little or no editing.

In sum, the most desirable news source is the writer/reporter himself or herself. Whenever possible, the writer/reporter should observe the event first-hand. Even if the report is not live, the taped story should contain the immediacy of the writer/reporter being on the scene. Most often, however, the reporter arrives after the occurrence—unless the event is preplanned or the reporter happens to be at a propitious place when an unexpected event occurs. Such a situation spurred the development of live news coverage in broadcasting. In 1937 Herb Morrison, a reporter for radio station WLS in Chicago, was testing a new disc recording machine at the landing of the German dirigible *Hindenberg* at Lakehurst, New Jersey. Usable tape recorders had not been invented yet. Unexpectedly, the *Hindenberg* burst into flames. Morrison's now-famous sobbing words, "This is one of the worst catastrophes in the world . . . oh, the humanity . . ." was carried—from the disc recording—by all three networks the next day and prompted the increased use of recordings and on-the-spot live news.

If the reporter can't be at the scene as the event happens, the next best thing is to get eyewitness, first-person accounts and, in television, shots of any continuing activity and any people involved. In some cases in radio—for example, a fire, a bombing, a festival—the continuing sounds at the scene should be recorded as background to enhance the narration and interviews that constitute the news broadcast.

Another source that can make the story more complete, accurate, or interesting, is recorded material: aural, visual, and in print.

Style

The news broadcast writer is first and foremost a reporter whose primary duty is to convey the news. The basic principles of news reporting apply to broadcasting as well as to print. But there are distinct differences between the two. For example, the traditional five Ws—who, what, when, where, and, if possible, why—always go into the opening, or **lead,** of the

newspaper story. Some broadcast newswriters advise doing the same in the opening seconds of the television or radio report; others warn against packing too much into the broadcast lead because an overload of information in a short time can confuse the audience. Yet, the broadcast newswriter must include as many details as possible within a much more limited presentation than that of the newspaper writer. The key focus is *condensation*.

Broadcast journalist Phyllis Haynes suggested several approaches for the writer-reporter:

> When James Joyce, the famous writer from the Emerald Isle, wrote in a stream of flowing words, the meanings were meant to be gleaned from deep within the writing. The traditions of the great novelists, poets, and mystery writers allow the reader to go on a long and winding journey. But the broadcast journalist has a different responsibility to the audience. He or she must get the listener and the viewer to understand an intricate plot of unfolding news within a matter of seconds. There can be no flighty adjectival clauses that allow the mind to linger. The broadcast journalist must reveal the plot immediately and have the audience understand upon the first run. But within this restriction there is also great art. The good broadcast journalist is a master of first impression. The old adage "less is more" is quite appropriate when writing for broadcast. One might say that a stone sculptor and a news writer come at their art with a similar problem. The sculptor must chip away at the hard rock to reveal the desired image. The sculptor must decide what is extraneous, but be careful not to chip away so much that the final rendering of the statue is faulty. So, too, the broadcast journalist must sort out the extraneous information and choose only the phrases and comments that bring the desired story moving forward in the mind's eye. The journalist, like the sculptor, must decide what is necessary and what is to be chipped away. There is always the danger of chipping away too much, leaving the audience confused or, worse, indifferent. But unlike the sculptor, the broadcast journalist is faced with the additional problem of time. Stories must get on the air by the broadcast deadline, usually leaving the journalist only a few hours, and sometimes much less, to complete the story. Time is not forgiving in this business. A great story can quickly become yesterday's news. No matter how marvelously crafted or well researched, if it's old, it's useless. Broadcast journalists write against the clock.

Further, the broadcast writer must find logical transitions between each segment of the newscast; the newspaper writer's stories are complete in themselves. Clarity, types of leads, use of quotes, objectivity, and verification of information apply to both print and air. The broadcast writer has to consider the additional factors of timing, visual and aural materials, and the personalities of the newscasters who will present the news.

Today, most young journalists have had some 12 years of print writing and literature by the time they graduate from high school, but little or no education in writing in or understanding the electronic media. Therefore, these journalists frequently think of journalistic writing in print terms. This book provides several reminders to help you learn the key differences between writing for print and writing for the visual and aural media.

One reminder is that the structure of the stories themselves can differ markedly. For example, newspaper stories usually provide all the five W information at the beginning, in the first or lead paragraph. The need to condense for radio or television may require eliminating

one or more of the five Ws in the opening statement or even inverting the order that seems logical for a full report. For instance, a radio or television news report, to avoid passive writing, might put the story source first, instead of later in the report. Note the following:

- *Newspaper:* "All the members of the City Council should be impeached for misuse of public funds," the president of a newly formed political activist group stated at the public meeting yesterday.
- *Radio or television:* A new political organization wants the members of the city council impeached for misuse of public funds.

(Sometimes, however, the broadcast story can have more of the five Ws than the print story, even in a shorter time. See the example in the next section.)

Leads

Begin the story with clear, precise information. The opening should be, as much as possible, a summary of the entire story. Be wary, however, of including too many details. Remember that the audience sees or hears the news only once and, unlike newspaper readers, cannot go back for clarification or better understanding of particular points. The broadcast audience must be able to grasp the story on the first hearing. Don't overload. The five Ws are as important in broadcast as in newspaper writing. Because they have to fit into 30, 60, or 90 seconds, broadcast news stories are sometimes little more than the equivalent of newspaper headlines, subheads, and the lead paragraph.

Compare the following openings for the same story, first in *Broadcasting & Cable* magazine and second on the AP news wire:

> Recreations—which have been subjected to considerable criticism when used to advance a news story or documentary—no longer figure in NBC News's plans. NBC News President Michael Gartner announced last week not only that the division will discontinue the use of actors portraying real-life characters for the purpose of conveying information, it will abandon the program on which it was used—"Yesterday, Today and Tomorrow." The concept of using recreations is being taken over by NBC's Entertainment division, without the news staff who have worked on the three segments that have been aired.
>
> (*Broadcasting & Cable*)

> NBC NEWS, FINDING THE USE OF NEWS RECREATIONS IN ITS "YESTERDAY, TODAY AND TOMORROW" SPECIALS TOO CONFUSING TO VIEWERS, SAID MONDAY IT WON'T USE THE TECHNIQUE ANYMORE. IT WON'T KEEP THE SHOW, EITHER.
>
> (AP)

Both stories present the five Ws—although the print story, which came out some days after the announcement, omitted the "when," while the broadcast story, even condensed severely, got all five Ws in, including the "when" because of its more timely presentation. Although a story in print may have a long lead, in effect summarizing the entire story in

the first sentence or two, the broadcast lead must be short. If necessary, save some of the five Ws for a second sentence or a follow-up visual.

Often the print story will have what is called a *second lead;* the second paragraph will contain the essential information that had to be left out of a first paragraph that became too lengthy in presenting only a few of the five Ws most important to the story. The broadcast presentation does the same, but only when the secondary Ws are considered essential to the viewers' or listeners' basic understanding of the story. Where the print story then elaborates on the lead or leads, the broadcast story usually ends. Any elaboration usually is confined to the active Ws—who, what, where, when. Rarely is there any time for the "why."

Following is a standard 30-second length television report, containing the essence of the story, including necessary video material.

VIDEO	AUDIO
DARL ON CAM	If you have been worried about the oil spill ruining any visit to Rhode Island beaches this holiday weekend, you can relax.
TAKE ENG/VO/NAT SOT	All the beaches have been re-opened except for Mackren Cove in Jamestown.
KEY: SATURDAY/R.I.	More may be learned tomorrow about last weekend's oil spill from a Greek-owned tanker.
	That's because federal immunity has been granted to the tanker's Helmsman and Chief Officer. The Captain faces federal criminal charges and fines up to six million dollars.
	420-thousand gallons of oil spilled into Narragansett Bay.

Courtesy of WLVI-TV, Boston

A more important story, or an equally important story for which there is more information and visuals, may get three times as much coverage and, if dramatic enough, as many as two or three minutes of the approximately ten minutes of hard news (excluding sports and weather) coverage in the half-hour show. The lead may be a **tease** or, as also called, a **soft lead**—a dramatic or human interest bit that will hold the audience's attention into the specific information of the **hard lead**. A second lead may follow, adding more depth, usually through significant visuals or interviews with participants or observers. The following script is such a story.

VIDEO	AUDIO
VO VTR	Rising tides … churning winds … boarded up buildings:
BRIAN	The signs of Hurricane Hugo are everywhere as this killer storm zeros in on the coastline from Florida to the Carolinas.
2S/VTR	Good evening. I'm Brian Leary.
SUSAN	And I'm Susan Wornick. Right now Hurricane Hugo is building strength and bearing down on the southeast coast of the United States. It should come ashore a little before midnight tonight.
BRIAN	New England could get a taste of this powerful storm as early as tomorrow night. But for now all attention is focused on the Southeast, where most people have boarded up and headed for higher ground.
	We now have a series of reports. First, our chief correspondent Martha Bradlee looks at preparations in the hurricane warning area.
SOT MARTHA	The mayor of Charleston said it is important that no one underestimate the danger of this hurricane. Mayor Joseph Riley said the storm could be the city's biggest since a 1938 tornado that killed 32 people and injured 100's.
SUSAN	Here in New England we could be feeling the effects of Hurricane Hugo by Saturday night. Let's go right to Dick Albert now for the latest on that.
ALBERT	[Weather report.]
BRIAN	The effects of Hugo are already being felt along the coast of Georgia and the Carolinas. Let's go to Wendy Chee-OH-gee of the Newstar Network … live in Savannah. Wendy … how's the weather?
LIVE NEWSTAR	[Live Newstar]
VTR CARIB DAMAGE SUSAN/VO	In the Caribbean … where Hugo has already left its mark … officials are still coping with water shortages … homelessness … and widespread looting. U.S. troops have arrived in the Virgin Islands. A government official just back from St. Croix says the situation there is out of control.
SOT	[SOT]
MORE V/O	But the governor of the Virgin Islands insists the looting is not as bad as it seems.
SOT MORE V/O	[SOT] In Puerto Rico the biggest worry is a scarcity of fresh water.

Continued

VIDEO	AUDIO
SUSAN	As expected, the President declared Puerto Rico a federal disaster area today. He did the same for the Virgin Islands yesterday. We will, of course, continue to monitor the path of Hurricane Hugo and bring you updated information throughout the evening.
	Courtesy of WCVB-TV, Boston

In sum, try to get the story into the first lead. If you can't, get it all in the second lead. Then, if the story has been given additional air time, elaborate on the lead or leads.

Hard Lead

The hard lead contains the most important of the five Ws, succinctly telling the crux of the story. For example, see the following script.

VIDEO	AUDIO
ENG/VO/SOT	Tonight almost one thousand students are under arrest in South Korea. Earlier today in Seoul, students on a university campus were demanding to be allowed to visit North Korea. Violence erupted after police stormed the campus with tear gas.
	Courtesy of WLVI-TV, Boston

Soft Lead

The soft lead tries to get drama into the story to attract and hold the audience's attention and follows this with the hard lead. Note the soft lead that opened the WLVI-TV newscast cited earlier in this chapter (and repeated here).

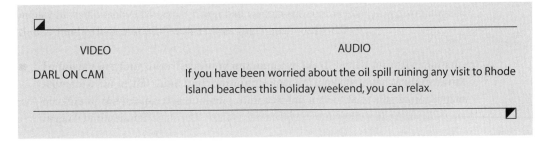

VIDEO	AUDIO
DARL ON CAM	If you have been worried about the oil spill ruining any visit to Rhode Island beaches this holiday weekend, you can relax.

Dennis White, a writer and producer of television news programs, advises students to forget the styles of writing they've learned in the past, except for writing the basic sentences. He noted that most students were taught to write long, involved sentences, but in broadcasting they must do just the opposite. "We must now recreate spoken language," he said. "It's much like writing a play." White stated,

> Our audience doesn't have the opportunity to go back and review what it has just heard. We only have one chance to grab our audience's attention. If we fail, our audience will be lost. Broadcast news writing has a simple structure but uses a high density of language. We must make every word count since we have a limited amount of time in which to tell our story.

White said that the news writer's first goal is to get the audience to listen:

> We usually top our story with a sentence of five to ten words that gives a general idea of the story. For example: "A five alarm fire destroyed a supermarket in Jamaica Plain this morning." The audience now has an idea of what happened and is ready to get more details about the story. In the subsequent sentences of the story we get more specific. Our final sentence brings some conclusion to the story.
>
> The best advice to someone writing a news story is to "tell" the story just like s/he would tell it to a friend. The first thing you would tell someone about the story is usually your first news writing sentence. Just finish this sentence "Did you hear about . . . ?" It works best if you say it out loud.
>
> A broadcast news writer must always remember that s/he is writing a story. It must have a beginning, middle, and end. The novice will very often just write a laundry list of facts. One sentence must lead into the next. One idea must lead us to the next.

Dramatic Action

Think of the news as a dramatic action. The story with an obvious conflict (war, a political campaign, a murder trial, a divorce case, the baseball pennant race) attracts immediate attention. Use direct statements rather than questions. Stress the immediacy of the conflict. For example, rather than beginning a story with the question, "Will America ignore world opinion and start a war in Iraq?," it is more dramatic to say, "The question in every country in the world tonight is, "Will American ignore world opinion and start a war in Iraq?" Keep the edge on the currency and excitement of the story. Avoid uninformed presentation of the news, but don't tell the audience you don't know, unless you use it as a tease for a later report that you know is in process. It is better to give whatever details are available without comment than to say, "This is an incomplete story, but . . . "

Technique

Probably the most difficult job for the television or radio news writer is to select out of the myriad details the most salient points and to present them in a very short time. Choose words as carefully as if you were conveying critical information in the limited space of a telegram or on a billboard.

Clarity

Use short, familiar words. You can be artistic without being verbose. Simple, direct language does not have to be dull. Read some works of Ernest Hemingway, who was a reporter before he became a novelist, for examples of such writing. You could begin a news story from South Africa like this:

> The title of a Charles Dickens novel might well be the hallmark of the majority of the South African people today as a new dawn blossomed over the long ravished and repressed land. "Great Expectations" surged through the valleys, hills, plains, and urban ghettos as new president Nelson Mandela was inaugurated, indicating a new governmental capacity for the nation's lion's share of the population.

But, if you write it the following way for broadcast, you will present more information more clearly in less time:

> South Africa's new president Nelson Mandela took the oath of office today pledging to create what he called a "new" nation. Mandela says he will accommodate all South Africans in the new government while providing new opportunity for the Black majority.

Nontechnical

Don't be ambiguous. Although you may be an expert in interpreting professional terms, scientific language, or statistics, your audience isn't. For example, if a forest fire destroyed 100 acres of timber, don't say, "One million square feet of wood went up in smoke." Say, "Enough timber went up in smoke to build 40 eight-room houses." Don't explain things in the abstract. Be concrete. Say exactly what you mean. Give specific examples.

Language

Writing should be simple, direct, and understandable. It can be colloquial in form. This does not imply using slang or illiterate expressions, but suggests *informality*. Avoid abstract expressions and words with double meanings. At the same time, don't overdo the simplicity or colloquialisms, or the viewers or listeners will think you're talking down to them.

The writing should be *conversational*. You want to enable the on-air talent to talk to the audience as if they were sitting in the audience's living rooms. *Empathize* with the individual members of your audience. *Personalize* the information. Put yourself in their place. What does the story mean to each of them? As a writer who has put together all the material gathered by the reporters, or perhaps also as a reporter, you know all about the story. Don't forget that for the audience it's brand new!

Use the *present tense.* Don't write, "When we spoke to the holdup victim he said he felt that the people who have been stealing to get drugs have been continuing to do so because there have been too many official coverups of drug-dealing in high places." Write, "The holdup victim blames the continuing rash of drug-related robberies on official coverups of drug-dealing in high places."

Use the *active voice and active verbs.* Don't say, "There were forty people taken to the hospital following a train derailment that occurred early this morning," but, "Forty people

are in the hospital as a result of an early morning train accident." Don't say, "The rushing water, churned by the hurricane winds, went over the town's river embankment," but rather, "Churned by the hurricane winds, the water rushed over the town's embankment."

News writer and news writing teacher Dennis White noted,

> When we tell stories we usually use the active voice. But for some unknown reason we often write in the passive voice. (At least that's my experience with writers who are new to broadcast copy.) Keep your copy active. Use simple verbs whenever possible. This helps to keep the copy moving and helps the audience follow the story.

White suggested a key way to determine the impact of the news writer's language on the audience:

> Since the broadcast writer is writing for the ear, s/he should read the story aloud to find out if it really works. You see this in newsrooms across the country: writers sitting alone at computers or typewriters reading their copy aloud. They are fine tuning the sound and feel of the copy. It is the only way to find out how the story works. Does it read well? Does it flow? Is the language simple and clear?

Spell out numbers. Although some writers, especially with close deadlines, save time by writing "people by the 100s descended on City Hall," it is easier for the on-air reporter to read "people by the hundreds descended on City Hall." Spell out in *phonetics* any uncommon names or pronunciations. Note in the Hurricane Hugo story, "Let's go to Wendy Chee-OH-gee of the Newstar Network live in Savannah." *Identify* all people clearly. If the person in the story is important, identify him or her with a job or title. It means more to the audience to learn that "Carla Johnston, State Democratic Committeewoman and former official in the Dukakis administration, today declared her candidacy for Congress," than "Carla Johnston, local political activist, today declared her candidacy for Congress."

Use style books. The *Associated Press Stylebook and Libel Manual* and the *United Press International Style Book* are both still available and are good sources for standard approaches to punctuation, spelling, use of numerals, use of capitals (upper case versus lower case), abbreviations, and how to state dates, ages, size, and capacity.

Objectivity

Although the Fairness Doctrine has been abolished, the writer, producer, or reporter with integrity aims for fairness and honesty in news reporting. The level of objectivity achieved is ultimately determined by (1) the policy of the station owner, (2) the political and social attitudes of the community, (3) pressures from advertisers, including a desire to avoid anything controversial, (4) personal biases of the news director, newswriters, and newscasters, (5) expediency in news reporting, and (6) *infotainment.*

Although the first four factors are determined largely by individual choice, the last two, expediency and infotainment, are part of the broadcasting business and frequently

justified as necessary for effective competition. Political campaigns are classic examples of expediency in reporting. By seeking easy coverage, radio and television news too often accept "sound bites" prepared by the candidates and interpretations given by the candidates' "spin doctors," and pay relatively little attention to the candidates' qualifications and the issues. Newswriters' acceptance of the easy-out "sound bites" instead of insistence on meaningful reporting exacerbate the media's inadequacies.

Because the news is potentially identical on all stations, especially the competing networks' national news shows, increasing emphasis is placed on the entertainment, rather than the news aspects, of the programs. Stations vie not with better-covered news or with news-in-depth, but with personalities. Increasingly less time is devoted to hard news and more to entertainment features. For example, while events in the former Yugoslavia were creating new schisms between Russia and the west and between western and Muslim countries, threatening an expanded conflict and even a world war, American television devoted proportionately more time to the O.J. Simpson trial than to the crises in the affected countries or to any other international issue.

The media hype their own stories. They did not hesitate to promote the O.J. Simpson trial as "the trial of the century" to attract more viewers. Over the years the media have called the Scopes "Monkey" trial, the Bruno Hauptmann trial for the kidnapping and murder of the Lindbergh baby, the Julius and Ethel Rosenberg trial, the Dr. Sam Sheppard trial, the Charles Manson trial, and others "the trial of the century" as each has taken place. Such exaggeration in labeling and coverage has caused some critics to take exception. In *Newsday,* television critic Tom Collins wrote that media coverage of Bernard Goetz, who shot four teenagers he believed threatened him in a New York subway, "has gone beyond circus and has crossed into carnival." And in the William Kennedy Smith alleged rape case, a television show paid a prosecution witness $40,000 to tell her story on the program before the trial was even over.

Media designation of the private lives of celebrities as "news" appears to change with the times. It does seem to coincide, however, with the increase in advertising and the direct relationship of increased media income to higher numbers of readers, listeners, and viewers. For example, in the 1920s, when one of Presidential-hopeful Warren Harding's several mistresses threatened to blackmail him and hurt his election chances, the Republican National Committee paid the blackmail. The media did not make it a cause célèbre. In the 1960s, when President John Kennedy openly had a steady stream of women, some of them high profile movie stars, visit him in the White House for extramarital sexual affairs, the media turned a blind eye. But more recently the media made a feeding frenzy out of President Bill Clinton's sexual encounters with a White House intern, not only exacerbating political opportunism for impeachment, but thrusting into the spotlight the intern and several other figures, creating for them the opportunity to make money as media celebrities and appear in more media stories and, coincidentally, generate more audiences and income for the media. In 2002, after a few months of concentration on the 9/11 attacks and their aftermath, it seemed like the media couldn't wait to get back to the lurid aspects of the Chandra Levy–Gary Condit story.

On one program in the television series *Lois and Clark: The New Adventures of Superman,* editor Perry says to reporter Lois: "Please tell me you're working on a story full of mayhem and scandal." Fiction is often a true representation of real life!

Proper and ethical promotion is necessary and expected. Deliberately misleading the public is something else. For example, CBS reporter Martha Teichner was asked to report, on the air, about Somalia during the U.S. military mission there. She stated in the *Columbia Journalism Review* that although she had done some research on Somalia, she had never been there. "Even if I'm correct and accurate," she said, "I'm superficial." Don Hewitt, executive producer of *60 Minutes,* warned "there is . . . a line that separates show biz from news biz. The trick is to walk up to it, touch it with your toe, but don't cross it."

Even local stations devote time to mostly inane banter between news anchors that could be used for better presentation of news stories.

"Infotainment" has replaced "information" on many news programs. The Roman writer Horace proclaimed, "Let fiction meant to please be very near the truth." Too many television newswriters and producers today seem to have reversed this advice and have attempted to let truth meant to please be very near fiction. Is this approach appropriate for reporting the news, or does it suggest a lessening of responsibility and values that will lead, as it did to the Roman Empire, to the downfall of broadcast news?

Accuracy

Write so that the viewer cannot possibly misunderstand. Even an unintentional careless or vague comment, or the integration of video or audio materials that distort the story because they are incomplete or out of context, can give the audience false impressions or incorrect assumptions concerning a given issue, person, or event. Make certain that the terminology used is correct. For example, don't refer to a figure in a story as a "car thief" if the person has not been convicted but is actually an "alleged car thief."

Be certain that all names are spelled correctly, with phonetic descriptions wherever necessary to guarantee that they are pronounced correctly by the on-air reporter. Be certain that all information about people mentioned in the story, such as age, occupation, and address, is correct.

Quotes, on videotape or audiotape or delivered by the newscaster, are most susceptible to distortion. Using quotes from the people involved—participants, eyewitnesses, or expert analysts—adds considerably to the immediacy of a news program. But any given interview is likely to be considerably longer than can be used on the air. Be careful that the segments you select to be used are not out of context or do not put undue emphasis on an aspect of the story that is, in fact, a minor part of it. One way to be sure that quotes are absolutely accurate is to record them verbatim. Don't allow any distortion of the facts, even if their enhancement makes the story more interesting.

One way to ensure objectivity and accuracy is through *verification* of any and all information gathered. If any segment of the material you are preparing for a script doesn't seem to ring true, double-check it with the reporter. If there is any further doubt, try to

reach the original source yourself. If you can't do that, determine with the producer whether or not the material should be used.

Personality

Write the news so that it fits the personality of (1) the network, if you're writing for a network or an affiliate; (2) the station, whether an affiliate or an independent; (3) the particular news program; and (4) the reporters or anchors presenting the news. The network or station may be promoting a particular image for itself, such as breezy, or serious, or fast and hard-hitting. The station may want to convey a different image for different news slots: the morning news as bright and entertaining, the evening news as world-shaking and in-depth.

Because personalities make the difference in attracting audiences to news programs that are essentially the same in content, write to fit the style of the newscaster(s). The words must be consistent with the vocabulary developed for the given newscaster; the sentence structure must reflect the rhythm and pace appropriate for that newscaster. You may be writing for the image of a dynamic, combative reporter, or a low-key friend who stops in to chat about the news, or a father or mother figure who conveys a sense of trustworthiness and authoritativeness. Many critics attribute the phenomenal success of Walter Cronkite to the latter. In this respect, the newswriter prepares dialogue the way the playwright does—consistent with the personality of the character who is delivering it.

Format

Formats vary from the writing of basic continuity to the more expansive and detailed demands of one- and two-column scriptwriting. In some instances, the writer may do little more than prepare the transitional continuity for the news program. Sometimes the on-air anchors extensively rewrite after the newswriter has done one or more drafts. When the final script reaches the on-air personality just before air time, he or she usually does little more than read through and change words or phrases, but not content, to better fit his or her air style. Some stations have a standard opening and closing for each short news report or break, with the broadcaster filling in the content with material from the wire services.

The final copy is meant to be read on the air and, therefore, must be as clear as possible. It must have no errors. Sometimes the writer should assume that the on-air personality reading the copy is a robot and will read exactly what is written, with no variation from the script. Although good on-air reporters go over every script carefully to be certain that they understand every word, phrase, and meaning, this is not necessarily true of all on-air newscasters. For clarity and ease of reading, several simple rules apply: no hyphenated words at the ends of lines, no split paragraphs (that is, no paragraphs carried over onto a subsequent page), words or names that might be difficult to pronounce spelled phonetically, and consistent use of upper case or lower case to help the reader to distinguish easily between directions and the material to be read on the air.

Although the script examples in this book are single-spaced to save space, copy should be double-spaced or even triple-spaced. That makes it much easier to edit and for the announcer or anchor to read.

Formats vary from station to station, but generally each story is given a *slug*—that is, a title. Usually the slug is at the top of the page and contains the title of the story, the date, the program on which it is to be presented, and the writer's name. Alternatively, the slug sometimes is placed in block form at the side of the page. Capitals or lower case can be used, as long as consistency in style is maintained. For example:

COUNCIL IMPEACHMENT — 2/16/03 — 6 P.M. News — J. Carter

or

Council Impeachment
2/16/03
6 P.M. News
J. Carter

Radio Rundowns

The basic radio news format has changed little over the years, except that on most stations the 15-minute news program has become 5 minutes or a 1-minute update. The following is the prepared format for a 10-minute-plus radio newscast.

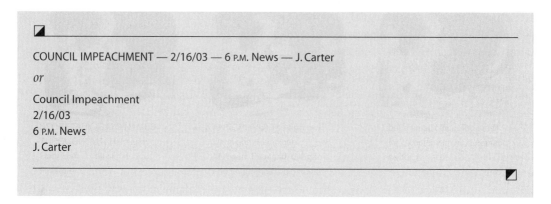

WBSM NEWS FORMAT

:30 BEFORE THE HOUR:
 ANN: (READ THREE SHORT HEADLINES) THESE STORIES AND MORE AFTER ABC REPORTS ON
 WORLD AND NATIONAL EVENTS. SET YOUR WATCH TO WBSM. THE TIME AT THE TONE IS
 _____ O'CLOCK.

:00 ABC NEWS (NETWORK)
:05 LOCAL NEWS (PLAY NEWS SOUNDER CART)
 ANN: IT'S _____ DEGREES AT _____(TIME)_____.
 I'M _____, WBSM TOTAL INFORMATION NEWS, BROUGHT TO YOU BY
 __(READ SPONSOR TAG)__.

Continued

```
:07   ANN:  WBSM NEWS TIME _____.
      (PLAY: COMMERCIAL :60)
:08   ANN:  (COMPLETE THE NEWS)
:10   ANN:  THE NEWS IS BROUGHT TO YOU BY ___(SPONSOR TAG)___. WBSM NEWS TIME
            _____. NORM MCDONALD'S WEATHER FORECAST IS NEXT.
      (PLAY :30 WEATHERCAST)
      ANN:  IT'S _____ DEGREES IN DOWNTOWN NEW BEDFORD. I'M
            _____, WBSM TOTAL INFORMATION NEWS. OUR NEXT NEWS AT
            _____ O'CLOCK.

NOTE:  WHEN GIVING TIME, USE "DIGITAL" TIME.
       EXAMPLE: FIVE MINUTES PAST FIVE IS "FIVE-OH-FIVE."
```

Courtesy of WBSM, New Bedford, Massachusetts

Some stations use the wire services almost exclusively for their news, adding only key local stories from local sources. Even so, they must have a prepared format containing opening, closing, and transitional lead-ins for specific organizational parts of the newscast, including the commercials. Here is such a format for a five-minute news program.

FIVE MINUTE NEWS FORMAT—SUSTAINING

```
OPEN:    Good (morning) (afternoon) (evening).
         The time is _____.
         In the news _____.
         (Note: use 4 stories ... mixing national, world and local by order of importance).*

ANNCR:   More news in just a moment.

TAPE:    COMMERCIAL (if logged)

ANNCR:   In other news _____.
         (NOTE: use 2 stories ... national, world and/or local.)

ANNCR:   WGAY weather for the Washington area _____.
         (NOTE: use complete forecast, including temperature, humidity and winds).

CLOSE:   That's news and weather ... I'm (anncr: name)
```

*Total local news content: 3 stories in entire newscast

Courtesy of WGAY, FM & AM, Washington and Silver Spring

Television Rundowns

The television news program follows the same basic format approach, except it is more detailed. Television news programs require a *rundown*—a listing of all stories and their sources—in preparation for organizing and writing the script. A network newscast can have several rundowns, beginning early in the day for an evening newscast. A local station may have only one rundown before the actual script is written.

Writing the script that appears over the air is only the final stage of a long, arduous, and frequently complicated process. For a program such as *CBS Evening News with Dan Rather,* the planning and development begin early. The first step is the "CBS Program Log," distributed early on the morning of the show, showing all the film pieces used on the CBS morning news, midday news, evening news, and even on the other network news programs from the previous day.

Second, written at about 6 or 7 A.M. and distributed at about 8:30 A.M., is a "CBS News Insights" sheet showing who is assigned to what coverage and what the planned assignments are for the day and containing a domestic and foreign "Who's Where" so that any staff member is reachable at all times.

Third, at about 11 A.M., a "Who Does What" rundown is distributed, showing which associate producers and which reporters are doing what and where.

Fourth, at about 11:15 A.M., a "Morning Line" is issued, with more information on the big stories and who is assigned to them.

Fifth, at about 12:30 or 1 P.M., a "Prelineup" is completed, providing a list of the stories expected to be used on the program.

Sixth, at about 3:30 P.M., the technical "Lineup" comes out, listing the stories that will be on, their sequence, and times.

Seventh, at about 5 P.M., an "Editorial Lineup" lists more exact information on where each story is. Until show time there are "Lineup Revisions" rundowns, incorporating any changes. The final rundown sheet and the final script are completed as close to air time as possible, to incorporate the latest breaking news.

The rundown form varies depending on the approach and organization of the given news department, but it should contain everything pertinent to the show. The following CNN rundown has a heading with the key data about the particular program, and it includes the number sequence of each story, the story title (or slug, as you will note at the top of the column), the form and identification of presentation, the graphics, and time lines.

Following the rundown are a few excerpts from the final on-air script. Match the appropriate rundown notation to its script segment to see how clear the matchup is as well as to note how each story meets the criteria for good television news writing presented in this chapter.

CNN HEADLINE NEWS RUNDOWN

SHOW	DAY	DATE	REV	PRODUCER	PHONE	ANCHOR		STATUS
3:30PM	WEDNESDAY	02/08		JIM BROYLES	EXT: 7-2627	CHUCK ROBERTS		READY

PG	SLUG	ANC	FORM	WR	VTR	TAPE#	GRAPHIC	TIME	TOTAL
E01	OPEN		OC MATTE		12	DAY OPEN	MATTE: HEADLINE NEWS		10
E02	SIMPSON TRIAL		OC MATTE	JG			MATTE: SIMPSON TRIAL		
			TBA TAPE		5	____			
			TBA TAPE		6	____			
			TBA TAPE		7	____			
			TBA TAPE		8	____			
E03	MARGUERITE SUBPOENA		OC BX	JG			BX MARGUERITE		
			TBA TAPE		9	____	THOMAS		
E04	BASEBALL STRIKE		OC BX	HZ			BX BASEBALL	25	350
			TK VO		5	6592	STRIKE		
	REICH SOT		PEEL SOT		6	6645		20	410
	CONE SOT		PEEL SOT		7	6725		15	425
E05	TAG BASEBALL		OC BX	HZ			BX B'BALL STRIKE	05	430
E06	WEIGHT RISKS		TK VO	11AE11	8	6481		20	450
E07	PASTA FAT		OC BX	HZ			BX PASTA	10	500
	O'NEIL PKG		TK PKG		9	____		150	650
E08	CLINTON-CIA		BN VO	MD	5	____	BN US GOVT	20	710
E09	SURGEON GENERAL		PUSH VO	3PA08	6	6652		25	735
E10	CLINTON-CRIME		PUSH VO	MD	7	6686		25	800
	-CONGRESS		PUSH VO		8	6695			
	SCHUMER SOT		PEEL SOT		9	6723		30	830
E11	TAG: CRIME BILL		OC BX	MD			BX CRIME BILL	05	835
E12	SUBWAY BOMBER/LEARY		TK VO	RB	5	6698		20	855
E13	TERROR TRIAL		PUSH VO	RB	6	6705		25	920
E14	ISRAEL-GAZA		PUSH VO	11AA10	7	6659R		25	945
E15	GREECE-TURKEY		OC BX	RB			BX GREECE-TURKEY	25	1010
			TK ADDA				ADDA: TURKEY/GREECE PLANE		
			PUSH VO		8	6720R			
E16	BRITAIN DIANA		OC BX	JB			BX PRINCESS DI	10	1020
	LOWRIE PKG		TK PKG		9	6712		155	1215
E17	SPACE SHUTTLE		BN VO	#3PA14	5	6722	BN SHUTTLE	20	1235
E18	TEASE		MATTE VO $	RB	12	$ MATTE			
	--PETOGRAPHY		DISS VO		6	6551			
			W/KEY		7	LATER KEY			
	WEATHER-HIGHS		DISS SOT		8	6641			
	WEATHER ROLL		DS VO		9	6670			

Continued

CNN HEADLINE NEWS RUNDOWN

SHOW	DAY	DATE	REV	PRODUCER	PHONE	ANCHOR	STATUS
3:30PM	WEDNESDAY	02/08		JIM BROYLES	EXT: 7-2627	CHUCK ROBERTS	READY

PG	SLUG	ANC	FORM	WR	VTR	TAPE#	GRAPHIC	TIME	TOTAL
F01	BIZ OPEN		UP ON SOT		12		BIZ OPEN-DAYS		
FXX	AX/TOSS BREAK		MATTE FRAME $		12		MATTE FRAME $	(60:83)	
	FACTOID BUMP F		EFF FONT/ADDA		11	CUBG	FACTOID F		
G01	SPORTS		UP ON OPEN		5		SPORTS OPEN		
			EFFECT PKG		6		SPORTS PKG		
H01	OPEN		CAM BUMP					05	5405
	PETOGRAPHY		ON CAM	RB				10	5415
	MOOS PKG		TK PKG		7	6548		315	5730
H02	H-SECTION TEASE		EFF/TZ OP	MD	8	TEASE OPEN		05	5735
	—SIMPSON TRIAL		EFF/VO		9	___		15	5750
	—CLINTON CRIME		EFF/VO		5	6686			
	—BRITAIN DIANA		EFF/VO		6	6657			
H03	CLOSE		MATTE VO		12	MTHN			
			CAM BUMP				GFX: COPYRIGHT		

CNN HEADLINE NEWS SCRIPT

PAGE	SLUG	SHOW	DATE	WRITER	ANCHOR	EDITOR	TIME S
E02	SIMPSON TRIAL	330P	2/8	guthriej	ROBERTS	tim	0:28R

*cg99 sx "Kato" the Akita takes center
stage at Simpson trial
DISS MATTE: simpson trial

TAKE VO: 6742
font:
*cg locator1
Los Angeles
TRT: 40
PEEL SOT: 6739

----ON CAM 2----
 HE'S FAR FROM THE COURTROOM, BUT
NICOLE BROWN SIMPSON'S DOG "KATO" IS AT THE
CENTER OF TESTIMONY TODAY IN O-J SIMPSON'S
MURDER TRIAL.
 WHEN THE TRIAL BROKE FOR LUNCH,
ABOUT HALF AN HOUR AGO, A MAN WHO LIVES
NEAR THE MURDER SCENE WAS TELLING WHAT
HAPPENED WHEN HE TRIED TO WALK HIS OWN
DOG THE NIGHT OF JUNE 12TH.
----SOT----

Continued

PAGE	SLUG	SHOW	DATE	WRITER	ANCHOR	EDITOR	TIME S
E02	MARGUERITE SIMPSON	330P	2/8	guthriej	ROBERTS	tim	0:33R

==

font:
*cg name2
Steven Schwab
prosecution witness
TRT : 57
DISS SOT: 6753
TRT: 50
ON CAM

*cg99 xs Simpson's first wife loses bid
to stay off stand
OC BX: MARGUERITE THOMAS

TAKE SOT: 6699
font:
*cg name2
Carl Jones
Simpson Thomas' Attorney
TRT: 34
OC BX: MARGUERITE THOMAS

OC: MAKE OF THAT

----SOT----
OC: BARK AT THEM
----ON-CAM TAG----
 SCHWAB SAYS THE AKITA HAD FRESH BLOOD
ON ALL FOUR PAWS, AND what appeared to be
EITHER DRIED BLOOD OR MUD ON ITS STOMACH
and chest
 THE DAY BEGAN WITH A FAILED ATTEMPT
BY SIMPSON'S FIRST WIFE TO STAY OFF THE
WITNESS STAND
 MARGUERITE SIMPSON THOMAS WAS
SUBPOENAED BY PROSECUTORS WHO WANT TO
KNOW WHETHER SIMPSON EVER BEAT "HER" … AND
WHAT THE TWO DISCUSSED IN TWO SEPARATE
PHONE CONVERSATIONS THE DAY SIMPSON WAS
ARRESTED.
 THOMAS' ATTORNEY INSISTED TO JUDGE
LANCE ITO THAT HIS CLIENT HAS NOTHING
RELEVANT TO SAY.
 HE ALSO WANTED THE SUBPOENA THROWN
OUT ON THE GROUNDS OF THE MANNER IN WHICH
IT WAS DELIVERED.
----SOT----
OC: THAT WAS
OUTRAGEOUS

----ON-CAM TAG----
 ITO DISAGREED THAT THE CONDUCT WAS
OUTRAGEOUS "ENOUGH" TO NULLIFY THE
SUMMONS.
 THOMAS IS TENTATIVELY SCHEDULED TO
TESTIFY MARCH THIRD.

* * *

Continued

PAGE	SLUG	SHOW	DATE	WRITER	ANCHOR	EDITOR	TIME S
E11N	CLINTON CRIME TAG	330P	2/8	maryd	ROBERTS	jf	0:08R

OC BX CRIME BILL

THE HOUSE TODAY PASSED ONE PROVISION IN THE REPUBLICANS' SIX-PART CRIME PACKAGE. IT ALLOWS UNLAWFULLY SEIZED EVIDENCE TO BE USED MORE OFTEN IN COURT.

* * *

PAGE	SLUG	SHOW	DATE	WRITER	ANCHOR	EDITOR	TIME S
E14	ISRAEL PALESTIN.	3PM	2/8	maryd	ROBERTS	jf	0:24R

*cg99 xs PLO police arrest suspected
militants
PUSH VO: 6659
*cg locator1
Gaza City, Gaza Strip
TRT: 40

P-L-O CHIEF YASSER ARAFAT IS TRYING TO MAKE GOOD ON HIS PROMISE TO REIN IN TERRORISTS.
PALESTINIAN POLICE ARRESTED 90 SUSPECTED MILITANTS IN THE GAZA STRIP, AND RAIDED THE OFFICE OF THE DEMOCRATIC FRONT FOR THE LIBERATION OF PALESTINE.
ARAFAT ALSO ORDERED THE CREATION OF A MILITARY COURT TO TRY SUSPECTED MILITANTS.
HE MEETS TOMORROW WITH ISRAELI PRIME MINISTER YITZHAK RABIN.
RABIN HAS DEMANDED ARAFAT DO MORE TO STOP TERRORIST ATTACKS IN ISRAEL.

* * *

PAGE	SLUG	SHOW	DATE	WRITER	ANCHOR	EDITOR	TIME S
E18	TEASE	3PM	2/08	burkard	ROBERTS		0:09R

ON CAMERA 2 MATTE SHOT: $$$$

---TURN TO CAMERA 2---

COMING UP NEXT IN DOLLARS AND SENSE: WHY U-S CHAIN STORES ARE SINGING THE BLUES IN MEXICO …

KEY LATER
VO 6551
TRT 1:00

AND LATER:
THE TRICKS OF THE TRADE, TO GET PICTURES OF PETS.

*cg99 xs Weather Forecast
DISS SOT 6641

---PKG---
OC: COOL FOR FLORIDA.

Continued

TRT :11 + :50 PAD

DISS WEATHER ROLL 6670 ---WEATHER ROLL---
TRT :28 + :20 PAD

PAGE	SLUG	SHOW	DATE	WRITER	ANCHOR	EDITOR	TIME S
F01	AX BIZ OPEN	345PM	2/8	f-cohen	ROBERTSJH	ld	0:09R

UP ON SOT

 THE STOCK MARKET TAKES INVESTORS ON A
BIT OF A ROLLER-COASTER RIDE ...
 AND THE MEXICAN CRISIS HITS U-S
BUSINESSES ...

OC MT FRAME JAN HOPKINS HAS ALL THE DAY'S BUSINESS
HIGHLIGHTS ...
 JAN ...?

PAGE	SLUG	SHOW	DATE	WRITER	ANCHOR	EDITOR	TIME S
F02	WALL STREET	345PM	2/8	f-cohen	HOPKINS	ld	0:16R

*cg99 xs Stock Prices Fluctuate THANKS, CHUCK.
in Afternoon Session. STOCK PRICES ARE LOWER THIS AFTERNOON
...AFTER GAINING 16 POINTS EARLIER.

*CG HOPKINS THE STOCK MARKET FOLLOWING A
OC CENTER DECLINE IN BOND PRICES.
TK VO B-4155 (FLOOR TRADING) RIGHT NOW THE DOW INDUSTRIALS ARE
TK VF DJIA _____ POINTS. .TO _____.
 TRADING IS _____. . AT
 _____ SHARES.

EFF VO B-BROADERS THE BROADER AND SECONDARY MARKETS
ARE _____ ...
 THE NASDAQ COMPOSITE _____.

PAGE	SLUG	SHOW	DATE	WRITER	ANCHOR	EDITOR	TIME S
F06	MEXICO BLUES	345PM	2/8	f-cohen	HOPKINSJH	LD	0:15R

*cg99 xs U-S Businesses in Mexico THEY HAD GRANDIOSE PLANS TO OPEN
Hurting From Peso Devaluation. NEW STORES AND STOCK THEIR SHELVES IN
OC BOX MEXICO MEXICO ...
 BUT SOME MAJOR U-S RETAILERS ARE
SMARTING FROM A LOWER PESO.

Continued

IT'S GOING MAKE BUSINESS TOUGHER. . AT
LEAST FOR THE TIME BEING.
LUCIA NEWMAN REPORTS.

TK PKG B-4157 (NEWMAN/SHORT) ---TK PKG---
TRT 1:43 LUCIA NEWMAN OC: CNN, MEXICO CITY
OC:" CNN, MEXICO"
SHORT
Fonts:
:00
*cg locator1
Mexico City, Mexico
//

* * *

PAGE	SLUG	SHOW	DATE	WRITER	ANCHOR	EDITOR	TIME S
H03	CLOSE	3PM	2/6		ROBERTS		0:08R

Oc matte hn ---turn---
 all the day's top stories are at the top of the
 hour.
 i'm chuck roberts,
 a whole day's news every half-hour,
camera shot this is headline news.
*cg ccopy

Courtesy of CNN Headline News

Script Forms

A radio news show has a relatively simple format compared with the television program. Radio news has a studio announcer or newscaster and, depending on the importance of news coverage to the station, will have live or taped narration, interviews, and voices and sounds of the event. Television news, however, ranges from the sophisticated, using all possible video and audio sources and techniques, to the simple "talking head" newscaster reading a script, with no visuals. The television writer must know the capabilities of the station in order to establish a format that will or will not use visuals chroma-keyed in back of the newscaster, visuals without sound, graphics, sound-on-tape (SOT), reporter or anchor voice-over (VO), or any of the other techniques discussed in Chapter 2.

The Radio Script

The radio script is usually the one-column form, with remotes, tape, or other sound sources written in. The first of the following scripts is an example from a half-hourly newsbreak update of radio station WBCN-FM, Boston.

The second script below is an example from a local radio station in Boston, Massachusetts, that does not have its own newsgathering service, but can nevertheless provide local as well as national and international news by adapting newswire materials.

Keep in mind that all radio scripts are double-spaced. They are single-spaced here only because of space considerations.

ANNCR: A new term begins for the U.S. Supreme Court … and the justices are expected to continue focusing their attention on abortion. Good morning. There are three abortion cases before the court … two having to do with parental consent or knowledge—the third an Illinois statute and regulations that required doctors' offices and abortion clinics to be equipped as if they were hospitals. That statute was declared unconstitutional by a federal appeals court.

TAPE: (Tribe: volcanic explosion)

ANNCR: Harvard law professor Lawrence Tribe says other matters before the court deal with the right to privacy and the right to die …

TAPE: (Tribe: the States)

ANNCR: The justices will also hear key desegregation cases from Kansas City, Missouri and Yonkers, New York. This past weekend saw a mass exodus of East Germans from Czechoslovakia and Poland to the west. And while East Germany says it will try to stop the flow of refugees from its borders, West Germany says it will do its part to make it continue. Carol Williams reports.

TAPE: (Williams)

ANNCR: November seventh is election day and in Cambridge and Brookline the issue on the ballot will be rent control. Patrick Murray has the first of two reports.

TAPE: (Murray)

Courtesy of WBCN-FM Radio, Boston

Good afternoon. I'm Ramona Parks with the 12 o'clock news update.

FOUR PEOPLE ARE DEAD FOLLOWING A HELICOPTER CRASH ALONG MEMORIAL DRIVE IN CAMBRIDGE SHORTLY AFTER 9 THIS MORNING.

A MASSACHUSETTS STATE POLICE HELICOPTER HAS CRASHED ON THE ROOF OF THE HARVARD UNIVERSITY SAILING PAVILION ALONG THE CHARLES RIVER.

Continued

AUTHORITIES BELIEVE THE HELICOPTER LEFT FROM THE NASHUA STREET HELIPAD IN BOSTON A SHORT TIME BEFORE IT LOST CONTROL.

POLICE SAY THE PAVILION ON MEMORIAL DRIVE WAS UNOCCUPIED AT THE TIME OF THE CRASH.

NO ONE ON THE GROUND WAS INJURED.

BOTH SIDES OF MEMORIAL DRIVE ARE CLOSED.

TRAFFIC IS BEING DIVERTED THROUGH LONGFELLOW BRIDGE AND DOWN MASS. AVE. IN CAMBRIDGE.

IT IS BEST TO AVOID THIS AREA.

* * *

THE U-S SUPREME COURT WILL DETERMINE WHETHER MASSACHUSETTS COURTS VIOLATED THE CONSTITUTION WHEN RULING THE SAINT PATRICK'S DAY PARADE IS OPEN TO THE PUBLIC.

THE SOUTH BOSTON ALLIED WAR VETERANS ARE TRYING TO BAN GAYS FROM MARCHING IN THE PARADE.

IRISH AMERICANS, LESBIAN, AND BISEXUAL GROUPS OF BOSTON ARE FIGHTING TO MARCH IN THE PARADE.

THE STATE COURTS SIDED WITH THE GAY ACTIVISTS PROMPTING THE SPONSORS TO CANCEL THE EVENT.

THE U-S SUPREME COURT WILL HEAR ORAL DEBATES ON THE ISSUE IN APRIL.

* * *

TURNING TO INTERNATIONAL NEWS ...

AN ENVIRONMENTAL GROUP SAYS IT WILL SUE SEVERAL COMPANIES FOR TRANSPORTING HIGHLY RADIOACTIVE WASTE.

GREENPEACE IS READY TO FILE SUIT AGAINST FRENCH, BRITISH, AND JAPANESE COMPANIES FOR SHIPPING WASTE THROUGH THE FRENCH CITY OF CHERBOURG (SHEHR BOORG).

THE BRITISH SHIP, PACIFIC PINTAIL, IS LOADED WITH FOURTEEN TONS OF RESIDUE FROM FRENCH REPROCESSING OF SPENT JAPANESE NUCLEAR FUEL.

THE SHIP LEAVES TOMORROW FOR JAPAN.

THE COMPANIES SAY THE SHIPMENT COMPLIES WITH INTERNATIONAL REGULATIONS, HOWEVER ENVIRONMENTALISTS DISAGREE.

THEY SAY THE VESSEL AND CONTAINER ARE NOT SUFFICIENTLY IMMUNE TO COLLISION OR INTENSE HEAT.

* * *

Continued

IN SPORTS LAST NIGHT THE CELTICS SHOCKED THE SUNS WITH A VICTORY OF 129 to 121.

IN TODAY'S WEATHER EXPECT A SUNNY BREAK THROUGH THE CLOUDS WITH A HIGH OF 38 degrees.

TONIGHT EXPECT FAIR SKIES WITH A HIGH OF 25.

TOMORROW CLOUDINESS WILL CONTINUE WITH SOME SNOW TURNING TO RAIN, WITH A HIGH OF 42.

RIGHT NOW OUTSIDE OUR BACK BAY STUDIOS IT'S 35 DEGREES.

THANKS FOR JOINING US. I'M RAMONA PARKS.

NOW BACK TO T.J. WITH JAZZ OASIS ON 88.9 WERS BOSTON.

Courtesy of the Associated Press and WERS

The Television Script

The television news script usually follows the standard two-column format, with the video at the left and the audio at the right. Following is a segment from the evening newscast of television station WLVI-TV, Boston.

VIDEO	AUDIO
JOE ON CAM BOX—FF—FLAG	Capitalism is the American way and one Great Barrington man has decided to cash in on this week's Supreme Court ruling on flag burning.
TAKE ENG/VO/NAT SO TUND:18 KEY:GREAT BARRINGTON:18	This flag has been fire-proofed with a flame retardant chemical. It is being sold for ten dollars by Skipp Porteous who publishes a newsletter called the Freedom Writer which seeks to preserve first amendment freedoms. Porteous thinks President Bush, who is against the court decision, will like his flags.
WIPE TO SEPARATE TAPE/SOT:14 KEY:PORTEOUS :00–:14	OQ: "We'll send him one."

Courtesy WLVI-TV, Boston

Approach

Each station and each news program aims for a distinctive style. Though the news in any given market may be the same, the ratings race requires the station to find an approach that is different enough from its competitors to draw an acceptable audience.

At the same time, there are still basic approaches common to writing and presenting the news in any station and any market, necessary for creating a news program of acceptable and, hopefully, high quality. The good writer tries to combine both of these considerations.

What does your station and program aim for? Which audience does it want to capture? Will the approach to news be consistent with the overall station format? Is the content primarily hard news? Soft news? Features? An emphasis on local happenings? Are you competing with other stations by playing up personalities rather than content and format?

Audience demographics are just as important to the news program as to any other broadcast format. The kinds of content and the level of presentation must be understood by and must appeal to the target viewers or listeners. Consider the time of day the broadcast is being presented. Is the audience at the dinner table? Seated comfortably in the living room? Rushing to get to work on time?

Suppose you want to establish an informal and friendly relationship with the audience? Obviously, you wouldn't lead off with antagonizing or shocking stories. Do you want to capture the immediate attention of the audience? Try leading off with an item that has personal meaning to the audience, written in dramatic terms.

For example, suppose a news report from Washington, D.C., shows that unemployment nationally rose from 5.5 percent to 5.8 percent during the previous month. You could simply give the statistics:

> The Department of Labor's monthly report, issued today in Washington, D.C., showed a rise in unemployment figures of three-tenths of a percent in November over October, to five-point-eight percent from five-point-five percent.

But a good writer would go further:

> Three hundred thousand more people are without jobs this month than last month, according to the latest figures from the Department of Labor. Unemployment in the United States went from five-point-five percent to five-point-eight percent—an estimated seven million, eight hundred thousand Americans out of work.

A writer sensitive to the local audience might say it this way:

> Four thousand more Center City residents are looking for work this month, according to figures released today by the U.S. Department of Labor. While the national rate for unemployment went up to five-point-eight percent in November compared with five-point-five percent in October, the rate for Center City went up from five-point-six percent to six-point-one percent, a marked increase, resulting in an estimated twenty-four thousand people in our town without jobs. Nationally . . .

The independent television station is likely to emphasize local news because its competitor affiliate stations have access to network feeds and better resources for regional coverage. Can the independent find local news approaches different from those used by the affiliate in its local news segments? A half-hour news show by an affiliate may have only a few minutes of local news. Keep in mind that a half-hour television news program may have only eight or nine minutes of actual hard news, the rest going for sports, weather, features, and commercials.

The local independent, spending less time on national and international reports, might carry a virtually identical lead as the affiliate on the unemployment statistics story, but then could add:

VIDEO	AUDIO
	Harriet Probing took our cameras to the Center City unemployment compensation office on River Street. Harriet:
Harriet: SOT :25 secs	

Electronic news gathering (ENG) permits greater immediacy in local news reporting. Local news has become even more people-oriented, more informal in nature. With a wider range of sources to choose from because of the mobility of the minicam, small stations do more and faster investigative reports, special reports on controversial issues, and features with good visuals. Small stations can more easily, as in the unemployment office example, localize the news for local audiences. Even a large market affiliate can localize news while stressing international, national, and regional stories.

Newspapers have done this, in reverse, for many years. Except for a few regional papers, such as the *New York Times,* the *Washington Post,* and the *Los Angeles Times,* newspapers have concentrated on the local news and added wider-ranging stories from various press services. The television affiliate takes the broader news from the network and adds its own local coverage. Some newspapers in some countries—England and Australia are good examples—have attempted to duplicate this approach with national editions that add local news for specific distribution regions. *USA Today,* distributed in the United States and abroad, has done the same.

As electronic media distribution modes increase, news coverage is likely to be oriented to more and more specialized audiences, similar to the approaches used by weekly newspapers and magazines as metropolitan dailies have disappeared. French historian Jacques Ellul, in his book *The Political Illusion,* expressed concern over electronic media approaches to news that stress information and ignore analysis. He argued that a political democracy cannot function effectively without people being able to analyze the errors of the past and to understand the present through that analysis. Ellul wrote, "Current news pre-empts the sense of continuity, prevents the use of memory, and leads to a constant falsification of past events when they are evoked again in the stream of news."

News programs must be careful not to confuse straight news with analysis or personal commentary. Some commentators editorialize in the guise of presenting information.

Distortion of stories or emphasis on only one side of a story can change a news report into a commentary. Incomplete statements and the excessive use of color words can do the same thing. For example, using the unemployment figures story:

> More than a quarter million additional American workers are unable to feed their families this month. They join over five-and-a-half million other Americans—more people than reside in our entire state—who were already out on the streets last month, as the Department of Labor unemployment statistics showed a whopping increase of over six percent from October to November.

The above report is not necessarily false or unjustified. The point is that the audience should know whether it is getting a hard news report or news with even subtle commentary.

Some newscasts sell sensationalism, similar to the magazines at supermarket checkout counters. Remember that the newscaster is coming into audiences' homes as a guest, almost like a personal visitor. The approach should be informal, friendly and, ideally, honest, if the newscaster is to be welcomed again.

The most common type of television and radio news broadcast is the straight news presentation, on radio usually in five-minute or one-minute newsbreak segments, and on television usually in half-hour programs. Some news personalities are known for their commentaries, rather than straight news, and the audience expects analysis or personal opinion, not hard news, from them. But sometimes commentaries are integrated into straight news shows. The recent trend has been toward some news analysis and a lot of feature stories and dramatic aspects of individual stories. Occasionally a network or station carries news specials that probe the news.

Following the continuing success of *60 Minutes,* other networks developed similar news shows, such as *Dateline, 48 Hours,* and *20/20* that tend toward minidocumentaries with more analysis than regular news programs—albeit these programs most often deal with human interest features or trivial subjects rather than with important events or issues.

At the other extreme is the use of *re-creations*—performers acting out a news sequence that the news team was unable to cover live or find **actuality** visuals for. Following criticism from many sources, including the public, networks, at least for now, have discontinued the use of re-creations.

In addition to *general news* programs, there are *straight news* shows devoted to specific topics, such as the international scene, financial reports, garden news, consumer affairs, educational or campus news, and similar areas. The approaches within each specialized category can vary, such as stressing the public service aspects or the human interest elements of the subject.

Although the straight news program is the most often used approach, some news programs provide in-depth reporting and obtain all the information possible on the particular story. In the unemployment figures example, using local interpolations of the statistics, following-up with comments from the workers affected, and interviewing employees and government officials provide an in-depth approach.

A third basic approach is the *interpretive* method, where the basic facts are analyzed for their immediate and future impact on the public through reporter commentary. The writer asks himself or herself: "What does this *really* mean to the audience?" In the unemployment figures story, the writer would include an analysis of the cost of the unemployment to the community, the effect on local and state taxes and services, the expected strength or weakness of the local economy, the effect of the lost income on local businesses, potential changes in school curricula to cope with an anticipated economic depression, possible solutions to the problem, and any other key areas that interpret the report's meaning for the viewers or listeners. Of course, the same interpretive approaches can be applied to reporting the national figures alone, without a local aspect, and international implications can be added.

The fourth basic approach is the kind we see mostly in movies and television shows and read in books about broadcast news: the *investigative* approach. The reporter or writer discovers and even *makes* the news by digging up material not available to the press in general and bringing to the public new and usually exclusive information on the subject. Investigative reporting covers all possible areas of news, from the classic work of Woodward and Bernstein in investigating and breaking the real story of the Watergate scandal to digging into the private life of Congressman Gary Condit after the disappearance of intern Chandra Levy, to the current journalistic investigations—at this writing—into what the George W. Bush administration did or didn't know about the plans for the 9/11 terrorist attacks in 2001 and what role the Bush administration's secret talks with Enron played in the energy company's economic collapse. Sometimes, the best-intentioned journalists hit a stone wall. For example, the media were denied access to vital information and documents and never did uncover the extent of White House involvement in the Iran-Contra scandal during the Reagan administration.

Any given news report can be a combination of these approaches. Basic investigation, for example, should be a factor in all good news reporting.

Advocacy News

Though news, ideally, should be objective and fair and should avoid any vested political, social, religious, economic, or other point-of-view, too often the news reflects the wishes of the network or station owner, the reporter, the advertiser, outside pressure groups, or other sources that want to mold public opinion. Given that the slanting of presumed objective news presents a serious ethical problem, some aspects of news reporting actually take a legitimate advocacy approach.

Editorials and commentaries are direct forms of advocacy news, presenting an overt point-of-view or personal opinion. Investigative writing and reporting, however, also frequently become advocacy news. The famous Watergate stories, for example, sought to root out corruption in the White House. Although few stations present specified editorial comments—and of those that do, most tend to be radio stations—many television and radio stations include investigative, advocacy news reports as part of their regular news

broadcasts or as special reports under the heading of news and public affairs. A principal difference between the advocacy of editorials and the advocacy of investigative reports is that the former usually represents special or vested interest points-of-view whereas the latter usually represents the interest of the public-at-large—the consumer.

Consumer Reports

A prime example of this kind of advocacy news is the consumer report. Paula Lyons is one of the country's leading consumer reporters. The purpose of her consumer news reports is to educate the public by investigating and revealing problems such as deceptive sales approaches, vendor scams, mislabelling and false advertising in the distribution of products and services, obtuse or misleading instructions or requirements from government or quasi-official agencies, and other practices that cheat or delude the consumer or that exploit a segment of the population. The writing for this kind of program should be direct, factual, and serious. That does not mean that humor, sometimes through satirizing the subject, cannot be used as a way of making the report attractive to the audience. The script should expose openly, and in as much detail as can be made clear in the limited air time, the specific ways in which the consumer can be duped and the specific ways in which the consumer can protect himself or herself.

Lyons suggests the following approaches to investigating and writing consumer news reports: The idea for any given report can come from various sources, and one key source is the writer-reporter herself or himself. Others include any information source that will help expose a problem in the marketplace or educate the consumer about something new, including individual consumers, consumer organizations, government agencies, and the media. For example, in the following script, "The Rugmark," the idea for the report came from the National Consumers League.

Once you have the subject, Lyons says, you must do the research. Where possible, travel to the site of the concern. Obtain all audio, video, and print materials available. Radio and television archives are helpful. In "The Rugmark," for example, Lyons incorporated some shots from a CNN documentary, "Faces of Slavery." Interviewing all parties is important, including consumers, retailers, manufacturers, consumer activists, and experts in the particular field. If the issue covered is controversial, talk with all sides before completing the script.

Lyons states that one technique for putting a consumer report together is to first line up all the best sounds—that is, the materials gotten on tape—and build the script around them. However, for a video program—Lyons's reports air on radio and television both— you must think visually. The pictures must tell the story, not simply be used as background. Avoid "video wallpaper." At the story beginning "tease" the audience—get its attention. Make the viewers or listeners stop what they are doing and pay attention because they are intrigued by the opening. The opening doesn't always have to be strong and dramatic, however. Lyons advises that a softer approach can be used, as in "The Rugmark," where the opening is on consumers shopping, to create an identification for the audience members with what they themselves have done.

THE RUGMARK

SONY:SOT 2:34

ANCHOR: LEDE

HAND WOVEN ORIENTAL CARPETS . . . THEY'RE LUXURIOUS AND BEAUTIFUL . . . BUT SOME COME WITH A HIDDEN PRICETAG . . . THE LIVES OF VERY YOUNG CHILDREN.

ILLEGAL CHILD LABOR . . . INDEED BONDED SERVITUDE IS A BIG PROBLEM IN THIS INDUSTRY. HOW CAN YOU AVOID BECOMING A SUPPORTER OF THAT?

CONSUMER EDITOR PAULA LYONS INVESTIGATES A PROGRAM CALLED "THE RUGMARK."

LEDE: PAULA

THE RUGMARK IS A LABEL THAT WILL SOON TURN UP ON SOME ORIENTAL CARPETS. SUPPORTERS SAY IT WILL MEAN THAT THE RUG WAS NOT MADE WITH CHILD LABOR. BUT CAN ANYONE GUARANTEE THAT? THE INDUSTRY HAS ITS DOUBTS.

SONY:SOT

nat:sot 25:23 "Beautiful, beautiful rug, what a combination of colors."

IF YOU'VE EVER SHOPPED FOR AN ORIENTAL RUG, IT IS EASY TO BE DAZZLED BY THEIR BEAUTY, OVERWHELMED BY THE MANY CHOICES, AND STUNNED BY THE COST OF SOME.

NAT:SOT . . . "Do you have anything like this (no) a little less expensive?"

BUT NOW THERE'S SOMETHING ELSE TO WORRY ABOUT . . . WHETHER OR NOT . . . THE RUG WAS MADE LIKE THIS . . . WITH THE LABOR OF CHILDREN.

IN INDIA, PAKISTAN AND NEPAL, SOME ESTIMATES SUGGEST THAT ONE MILLION CHILDREN UNDER 14 YRS. OF AGE, WORK LONG HOURS, IN MISERABLE CONDITIONS, WEAVING ORIENTAL RUGS FOR LITTLE OR NO PAY.

GRINDING POVERTY LITERALLY FORCES MANY FAMILIES TO SELL THEIR CHILDREN TO LOOM OWNERS.

:47 – :57
*CG TL
LINDA GOLODNER
Child Labor Coalition

SOT: 50:00 "The manufacturers just pay a pittance to the family to take these children away and then the children are fed at the loom, often they sleep at the loom. And it is virtually bonded slavery."

ACTIVISTS IN INDIA WHO HAVE BEEN RESCUING CHILDREN FROM THESE LOOMS HAVE JOINED FORCES WITH UNICEF, THE INTERNATIONAL LABOR ORGANIZATION AND THE CHILD LABOR

Continued

COALITION HERE IN THE UNITED STATES TO DRAW ATTENTION TO AND APPLY MARKET PRESSURE TO STOP THIS ABUSE OF CHILDREN.

SOT: 57:52 "What we want to do is educate consumers so that they can make the choice in the market place of choosing a carpet that was not made with child labor."

THEIR SOLUTION? THE RUGMARK ... A LABEL SOON TO APPEAR ON CARPETS CERTIFYING THAT THE LOOM OR FACTORY WHERE IT WAS MADE HAS BEEN INSPECTED AND FOUND FREE OF CHILD WORKERS.

SOT: STAND-UP All agree that the Rugmark is an excellent idea, laudable even. But local retailers are not sure it can really deliver on what it promises.

1:56 – 2:05

*CG TL
GREGORY HITES
Gregorian Rugs

SOT: GREGORY HITES, GREGORIAN RUG 35:35

"You are talking about an industry that is spread out over a very wide geographical area. It will require a tremendous amount of monitoring and also a lot of disciplined monitoring."

2:08 – 2:15*CG TL
STEPHEN BOODAKIAN
Koko Boodakian & Sons

SOT: STEPHEN BOODAKIAN, KOKO BOODAKIAN AND SONS

25:54 "To certify and visit the looms on a regular basis, and to do it and to know that it's being done without corruption, is extremely difficult."

BUT SUPPORTERS OF THE RUGMARK SAY THEY WILL CONTINUE TO PUT PRESSURE ON RETAILERS TO SUPPORT THE PROGRAM. THEY BELIEVE IN THE RUGMARK'S INTEGRITY AND SAY TO DO NOTHING ABOUT CHILD LABOR IN THIS INDUSTRY ... WOULD BE WORSE.

SOT: GOLODNER "There are a lot of people making money on the backs of these children."

SONY:SOT 2:34
"backs of these children."

TAG:

IT APPEARS THE SUCCESS OR FAILURE OF THIS EFFORT WILL DEPEND ON BUILDING TRUST. RIGHT NOW, LOCAL RETAILERS SAY THEY ARE MORE COMFORTABLE TRUSTING THEIR OWN SUPPLIERS' ASSURANCES THAT THE RUGS THEY SELL ARE NOT MADE BY CHILDREN, THAN THE ORGANIZERS OF THE RUGMARK WHO ARE UNKNOWN TO THEM.

NEVERTHELESS, THE RUGMARK IS HAVING AN IMPACT. ORGANIZERS SAY IT WILL START TO SHOW UP IN STORES IN THIS COUNTRY PERHAPS AS EARLY AS THIS COMING FALL.

Courtesy of Paula Lyons and WBZ, Boston

Input

Most news programs are a combination of live announcers—anchors and correspondents—plus film or tape for television and audio for radio. The various forms of video include sound-on-tape, tape-without-sound but with voice-over, video-on-tape without voice-over, various graphics, and other techniques. Simultaneous multiple pickups can come from various studios or the sites of the news events. Networks present news roundups from various parts of the country and throughout the world.

On-the-spot broadcasts that show the event as it is taking place are called **remotes.** The television reporter feeds the report live from the location of the event to the studio by **microwave.** Portable satellite uplink equipment allows the reporter to be in virtually any location and to send a signal to a satellite, which in turn beams it to the receiving dish at the station. *Satellite news gathering* (SNG) enables even a local independent station to carry a live report from almost anywhere in the world. Radio stations can use microwave or satellite feeds, but may also use the easier and cheaper telephone or cell phone. The live remote enables television and radio to make their most effective news contribution to the public: immediacy—coverage of the event as it is actually taking place, without the time delay that can make even a recent-hour SOT no longer of comparable importance.

Radio: Audio

Radio newswriting is closer to newspaper reporting than is television newswriting. Where the television report can show the event unfolding, the radio report has to include more descriptive writing—particularly verbal descriptions of scenes, people, and actions. The radio writer has to create word pictures, conveying through words clear and striking visual images. In television, the audience sees the persons being interviewed. In radio the voices in such interviews must be clearly identified. It is important in radio to integrate as much audio background—the sounds of the event and people associated with it, live or on tape—as possible into on-the-spot reports.

Television: Visuals

Remember: On television the *picture* is paramount. Don't waste the relatively few precious words you have in the average-length story by saying something the audience can see. In contrast with the radio newswriter, the television writer does not create word pictures, but emphasizes visual pictures. *Show* what is happening; don't *tell* about it.

Don't try to cover too much too quickly in the visuals. Even viewers used to television news's fast pace require some time to absorb the information. Generally, keep any picture on the screen at least three to five seconds—longer, of course, depending on its importance in the story; otherwise the audience gets more of a montage, an impression of a series of quick shots without a content focus. If you want to create a mood rather than to give information, then the montage approach will work.

When you put together the news story, you're working in a chicken-or-egg situation. You know at the outset what the story is from the reporter's written materials, but you can't begin to write the script, either dialogue or narration, without looking first at all the available visuals so you can determine which ones to use. After you've selected the visuals, you can write the narrative around them. Be careful not to use visuals for their own sake. They must be an integral part of the story and in themselves be able to tell the story. You may find some great tape or stills, but if they don't move the story along, don't use them.

Sometimes, especially in small independent stations with limited field resources, you can find yourself short on visuals for a given news show. Try to find additional visuals from some source, if you can't send a reporter out to get more. Stock footage, still pictures from the morgue, graphics created by a staff artist—all of these are better than a talking-head newscaster. You can write VO narration for such visuals, making sure you clearly identify them for what they are. If you use stock footage of a hurricane, for example, note that the shots of the hurricane are from a previous year in the same area, and that shots of the current hurricane are expected to be available for the next newscast.

Timing is important for the writer. Make sure you have the exact times for all visuals, especially those that are not self-contained as SOT. You don't want to write VO narration for a silent film or tape segment that runs longer or shorter than the visual itself. If the visual segment is shorter and if the extended narration is an essential part of the story, give the narration to one of the newscasters OC, either as a lead-in to or follow-up of the visual segment. The writer should prepare stories of different time lengths for the final story of the program, in case the program is running short or long. The alternatives may be different lengths for the same story or entirely different stories of different lengths.

Rewriting

One of the newswriter's duties, particularly on the local level, is *rewriting*. A smaller station without a news-gathering staff sometimes is totally dependent on the news wire. The announcer, given sufficient time and energy, edits those stories that can be adapted appropriately to include a local angle, evaluating the stories' impact on the community. In such cases the announcer rewrites the news.

The writer in any-size station tries to find a thread or angle that means something special to that station's viewers or listeners. That means rewriting the news that has not been gathered locally. For example, stories dealing with the national or state economy might be rewritten to reflect their relationship to the local economy, business conditions, or labor union concerns.

Probably the most common form of rewriting is updating. An important story doesn't disappear once it is used. Yet, to use exactly the same story in subsequent newscasts throughout the day is likely to turn away audience members who have heard it more than once; they might conclude that the station is carrying stale news.

Look for several major elements when you update news stories. First, determine if there is any further hard news, any factual information to add to the story. Second, if the

story is important enough, it is likely that some investigative reporting will have dug up some additional background information, if not new data, that was not available when the story was first aired.

Third, depending on the event's impact upon society, any number of people, from VIPs to ordinary citizens, will have commented since the story's initial release. Include these commentaries, preferably in SOT interviews. Fourth, a story by its very nature can relate to the day's other events. Your update can include new material showing those relationships.

Fifth, a story should be rewritten for the audience it is reaching. The person preparing for work, or listening to radio news during "drive time" on the way to work, may have different news interests than the person at home listening a few hours later; the early afternoon news on television reaches different audience interests than does the evening or late night news.

Finally, even if there is no additional information or any other angle that changes the content of the news story, rewrite simply to give it variety, to maintain a fresh news feeling for the station's image.

Following are examples of the same news story on one radio station's update reports.

6:00 A.M. Update: "It's the first Monday of October … and that means the U.S. Supreme Court begins a new session. The Court will hear three more cases concerning abortion. Harvard law professor Lawrence Tribe feels the Court may try to dismantle Roe versus Wade piece by piece." (TRIBE TAPE: "… volcanic eruption.")

7:00 Update: "It's the first Monday of October … and the Supreme Court begins its new term. The high court will look at three cases … each case is aimed at limiting a woman's right to an abortion." (TRIBE TAPE.)

7:30 Update: "A new term begins for the U.S. Supreme Court … and the justices are expected to continue focusing their attention on abortion. Good morning. There are three abortion cases before the Court … two having to do with parental consent or knowledge … the third an Illinois statute and regulations that required doctors' offices and abortion clinics to be equipped as if they were hospitals. That statute was declared unconstitutional by a Federal Appeals Court." (TRIBE TAPE.)

8:30 Update: "Abortion. The right to privacy and the right to die. Just three of the matters that go before the United States Supreme Court as it begins its new term. Good morning. Many observers are saying we'll see more of the Court's shifting to a more conservative bent. One of those observers is Harvard law professor Lawrence Tribe." (TRIBE TAPE: " … this term.") " … the Court will also look at the power of judges in desegregation cases. One concerns public housing in Yonkers, New York."

Courtesy of Sherman Whitman, WBCN-FM Radio, Boston

Internet Newswriting

Professor Bob Stepno of Emerson College, a 30-year veteran journalist on newspapers and Web news sites, is one of the country's experts on writing news for the Internet. He offers the following description of Web journalism and advice to the student on approaches and techniques for Web news writing:

> Writers creating material for news, information and entertainment sites on the World Wide Web use the same skills they use writing for other media—skills ranging from the basics—curiosity and love of language, to the other basics—grammar, spelling and punctuation.
>
> The Internet can deliver anything that can be converted to digital form: text, photos, animation, sound and full-motion video, as well as computer programs that let their active audience make choices, send messages, search databases and play games. It's all a matter of "bits," the ones and zeroes of computer code called "binary digits." Those bits, whether they represent sound or color, can flow through the same wires and fiber-optic cables, which means the Internet can and does deliver "media" of all kinds.
>
> These "digital media" aren't new. Most newspapers have set type using digital production systems for a quarter of a century. Hit recordings have been sold on digital CDs for almost as long. Full-length films are not only being distributed on home DVDs, but are being shot and edited in digital form, start to finish. Meanwhile, digital cameras and editing systems have hit the home market.
>
> Most treatments of "writing for the Web," however, still stress printed-text styles of writing, and with good reason. Until most people have high-speed "broadband" connections to the Internet, a sizeable part of the audience won't get the message at all without a text-and-still-images version. Television news organizations have realized this since their first online editions hit the Web in the mid-1990s, when very few home and office computers could handle video and audio. Online pioneers, including heavyweights like CNN and regional stations like WRAL-TV in Raleigh, N.C., all saw the need for "newspaper-style" writing on their Web sites. They added Associated Press wire stories, and they put editors to work converting TV scripts to a print-narrative format.
>
> For example, on television, a reporter can look into the camera and say "I asked the mayor why the meeting was cancelled . . . ," then cut to the video of her honor the mayor. The newspaper reporter covering the same story would keep himself out of the picture, leading with the facts and the mayor's answer:
>
> > A leaking roof at City Hall brought a quick end to Tuesday's City Council meeting. "We were concerned that the council chamber's ceiling was going to come down," Mayor Jane Brown said.
>
> A story's opening paragraph and its headline often appear as the index-entry of a Web site's main page, and Web "usability" experts recommend the newspaper conventions of headlines, summaries and the "inverted pyramid" story. They have learned from surveys (and common sense) that readers browse and skim their way around the Web—and may not get past the first paragraph without a clear invitation. Like newspaper page designs

that put the most important stories "above the fold," the essential information on a Web page should be visible as soon as the reader arrives, not out of sight at the bottom of a long scrolling window.

Given the discomforts of staring at text on a computer screen, there's a lot to be said for shorter stories and simple structures.

That doesn't mean a writer can't take a more "narrative" or "feature" approach to a story, or that a newspaper feature opening with a scene or anecdote can't be published online. The *Wall Street Journal* does it all the time, to name one home of the "anecdotal lead." Clever and informative headlines, pictures and separate summary paragraphs are among the ways to point readers to a story—and from there a well-written anecdote may be as inviting on the screen as it is in print.

The story or section summaries on that opening page also might be all the reader needs—or wants—to read. For that reason, they should be more than a "tease." Similarly, headings, subheadings, highlighted keywords and bulleted lists can help the rushed reader to get some information and move on, if that's his goal. Even if you have an ulterior motive—such as leading readers into a longer visit so that they will see multiple advertisements from companies that pay your salary—it's a fair bet that empty promises and P.R. puffery may convince them to go elsewhere.

"Choice" is just a mouse-click away, so writing for the Web should offer choices—a choice of short and long versions of a story, a choice of "entry points" or a choice of media. The original concept behind the Web is the word "hypertext," coined in the 1960s by Ted Nelson, a computers-for-the-people evangelist, to describe new non-linear or non-sequential forms of writing that computers would make possible someday. The Web doesn't reach his vision of global electronic publishing system, but it does offer some new ways to tell a story. Tim Berners-Lee, a computer scientist working at a European nuclear physics institute, created the first Web servers and browsers around 1991, drafting a hypertext protocol (HTTP) and a markup language (HTML) to make it easier to link documents across the Internet. By using the Internet to spread the word, Berners-Lee inspired other programmers to get involved, including a team at the University of Illinois that created browsers that could merge images and text on the same page. Audio and video systems came along soon after.

There were hypertext and multimedia systems before the Web—from computer program "help" pages to complex computer adventure games that linked pages with text or graphics. In the mid-1980s several experimental hypertext systems were developed, including one that is still in active use by authors of "hypertext fiction." Called "Storyspace," it was designed for new forms of writing where pages did not have to follow a single sequence, making the reader's choices part of the "writing" of the story. (Storyspace novels and other hypertexts are available from Eastgate Systems at http://www.eastgate.com)

Hypertext or not, "electronic books" and "electronic newspapers" have been predicted as "just around the corner" since the first home computers. Today's systems are much improved, but even the cheapest paperback novel or supermarket tabloid keeps "working" without a battery or a power plug.

The advantages of online publications are obvious—instant delivery, no dead trees, no inky fingertips. However, an on-screen document has its own limitations. It escapes the traditional print-media constraints of publication deadlines and available space, but the page

itself is somewhat unpredictable. Screens vary in size and quality, as does the compatibility of any one computer with the various programs that can edit or deliver the document.

The strength of hypertext—or "hypermedia" when you add audio and images—is its ability to provide choices that communicate with a wide variety of readers, making allowances for their differences in equipment, media habits, or personal preferences.

The online reporter (or re-write editor) has more room to work with than her TV or newspaper counterpart. The story could have sidebars about the City Hall maintenance budget, the mayor's past promises to fix the roof, or a link to a story about last year's rainy-season meeting when half the ceiling *did* collapse. In print, the writer might try to weave all of those elements into one piece. Online, they can be written as separate items linked to a central menu, and the reader can choose which to read first, or at all.

The same has been true in newspapers and magazines for years—a complicated story may have to be broken into a series, or shorter "sidebars" may be added to explain points that do not fit the main narrative. On the broad sheets of a newspaper, sidebars, boxes and photos give the eye multiple points to enter the page. On the smaller computer screen, a Web page's menus can do something similar.

If the story itself does not seem to fall into a natural narrative, then there's all the more reason to experiment with "chunking" the information into logical blocks, putting each block on a separate Web page and linking them together. The more complex such a hypertext document becomes, the more the Web developer should compensate by providing overviews, summaries, maps of all the pieces of the puzzle.

In "Literary Machines," his printed book about the possibilities of hypertext, Ted Nelson offered his readers a variety of choices. He divided some pages into three parts, suggesting that the reader could read down the page as usual, or read the top third of each page in a chapter, then go back to read the chapter again, focusing on the more detailed second and third sections.

In planning a Web publication, the writer also can plan to present information in layers of detail, or in layers of "media richness," to be chosen by visitors whose computer systems or browsing time can handle more pictures, audio or video.

Television and radio writers, even more than newspaper and magazine writers, have to "filter" the news and get to essentials. The audience is presented with an efficient package, but has to take it or leave it. On the Web, planning a story is not only a matter of deciding what to say, but choosing the form—or forms—in which to say it. Writers and producers of online sites get to make their own choices about which medium works best for the story at hand—text, still or moving image, sound or a combination.

Each medium has its strengths. Video captures people, emotion and action. Yes, aim a video camera at the people with tears in their eyes, the touchdown, the charging lion or the burning building. But you may want to use text instead of a reporter's "talking head" if you have to explain what's going on in the picture. Then use the Web's hypertext links to connect to background, more detail, and related stories. And use audio to deliver natural sound and the voices of people telling their own stories, not an announcer reading a script.

Even with relatively slow Web connections short video clips work—for pictures that really *are* worth 1,000 words—but sometimes even they can be replaced with lower-bandwidth techniques, such as a sequence of stop-action stills, or a still linked to a video

clip for viewers with sufficient bandwidth. Video can be turned into a series of still images with sound to cut down on the delivery time.

Creative multimedia storytellers have adopted the Macromedia Flash program because of its ability to merge text, visual effects, images, animation, sound and video—all in a relatively compact package. (As long as the user has installed the free Flash-player software.) One of my early favorites was a *New York Times* "Vietnam 25 Years After the War" piece by John Caserta (photographs and Flash) and Kelly McEvers (audio reporting).

http://www.nytimes.com/library/world/asia/vietnam-flash/index.html

Caserta uses Flash to pan across his large "Sunday magazine cover" color photographs of people and places on the smaller computer screen. Sometimes text-labels drift across the images, complementing McEvers' natural sound audio clips of interviews.

The writing is a combination of NPR-style script for McEvers' spoken introductions and newspaper techniques of headline-writing and choosing "lift-out" quotes.

When rescuers braved the North Atlantic to help an endangered whale tangled in fishing gear, the Providence (R.I.) *Journal*'s online edition tackled the story with interactive graphics and hypertext, building on the newspaper's four-day series of stories and photographs. The individual stories, each around 2,500 words, were written in newspaper style. The Web "glue" holding them together included a detailed drawing of the "right whale" with point-and-click pop-up text captions explaining everything from the inflatable rescue boat to the whale's "warts," an index page of headline-style summaries for the four main stories, and a 15-minute photos-and-audio piece compiled and narrated by a *Journal* staff photographer.

Web readers do tend to scan, so some of the best opportunities to reach them are in short bursts of writing: Headlines and sub-headings, photo captions, summaries and bulleted lists of key facts.

An award-winning Web project by the Quad-City *Times* of Davenport, Iowa, told the story of the Mississippi River floods of 2001 with words and pictures—including 199 individually captioned photographs (http://www.qctimes.com/flood2001/).

There has been a lot of debate about whether people will read longer texts on a computer screen. Fifteen years ago, the answer was an easy "no," given the early personal computers' low-resolution screens and cumbersome user interfaces and the fact that most people spent very little time looking at a computer screen. Now, with larger, brighter and more-detailed screens, and with thousands of people spending hours reading their email and instant messages, perhaps more people are willing to read thousands of words from the screen, especially if the writing itself is bright and engaging.

If readers' main online reading experience is email, that should give you some ideas about style and tone—personal and relaxed are good. However, emulating the grammar, spelling, punctuation and capitalization of casual email writers would not do much for your credibility as a professional communicator.

These "new media" really are "new." It is hard to predict how readers preferences and habits will develop, especially as screens get bigger, brighter, flatter and more detailed. As Ted Nelson said once, between discussions of hypertext, "If computers are the wave of the future, display screens are the surfboards."

Would the Web be any good at delivering a 28-day "to-be-continued-tomorrow" narrative, a true story that read like a novel? The answer is yes . . . and the story in question

was in 1997, before those fancy flat-panel screens. It was not only accompanied by a spin-off documentary film, but became a best-selling book, and then a major Hollywood feature. That's the true story of "Black Hawk Down," Mark Bowden's story about American soldiers fighting and dying in Somalia. It began as a newspaper series in the Philadelphia *Inquirer,* published simultaneously on its Web edition, *Philly Online.*

Up to 46,000 readers a day "hit" the story's online version, which ran along with the newspaper's series. Jennifer Musser and her *Philly Online* Web site team not only moved Bowden's text to the Web, but assembled a full multimedia treatment, with sound clips from the reporter's recorded interviews. Defense Department video, maps, photos, and a place for readers to correspond with Bowden, who answered scores of messages, made corrections when veterans pointed out errors, and made new contacts for the book version of the story.

"The technology of the Internet, paired with the creativeness of the editing team, meant that far more could be offered online to the reader than by the series in the newspaper," Bowden wrote later in Harvard's *Nieman Reports*. "On the Web site, the story became part illustrated book, part documentary film, part radio program. It was all these things and more, because it allowed readers (who at times became viewers) to explore the story and its source material in any way they chose."

The 1997 project is still online at http://inquirer.philly.com/packages/somalia/

Janet Wilson, executive assistant to the news director of television station WINK, Fort Myers, Florida, includes among her work contributions the rewriting of television news stories for the station's Web site. She describes some specific techniques and approaches she uses in writing news for the Internet, and some key differences between writing for the broadcast media and the Internet:

- *Approach:* TV news is visual. Often times the pictures tell the story. The writing can make it seem more important or less important to the viewer. When writing for the Web, it is all about the writing. On many Web sites, there are no visuals to enhance the story. The words have to tell the complete story and make it relevant to the reader.

- *Writing technique:* People tend to write in shorter sentences for TV news. Writing for the Web is different in that the sentences tend to be longer because they have to be more descriptive. It is probably a lot like writing for a newspaper or magazine.

- *Language:* Many times alliteration is used in TV news, either in the teases or the copy itself. Alliteration makes the sentences sound catchy or interesting to a listener. The written word on the Web page does not benefit from this technique. The Web writer has to remember there are different pronunciations for a single word. When a news anchor talks about a "lead investigator," the viewer should automatically know they are referring to the person in charge of an investigation. For the Web, this has to be clarified. It is not a person who investigates lead, a type of metal, but the head person in charge of an investigation. The Web writer should keep these several pronunciation possibilities in mind.

- *Use of visuals:* Our local Web page is not yet advanced enough to have a "snapshot" of video. The visuals on such Web sites have to be created with the writing. The newscast

is streamlined on the page, so the entire newscast can be viewed. The people who watch the streamlined webcast may not be the same people who read the individual stories on the Web. Not everyone's computer has the capability to watch a webcast, so the station needs to provide both options.

- *Length of story:* There is no minimum or maximum, at least on WINK-TV Web site. TV news writing is restricted to about a minute's time. The Web story could be endless. It does not have to fit into a particular format or size, like a newspaper story. The Web story's length is as long as needed to tell the story.

- *Interactive elements for the Web:* We can link our Web readers to an endless number of other sites. If the story is about a hurricane, for example, a Web reader can be linked to the National Hurricane Center or FEMA (Federal Emergency Management Administration) for more information. News people are not usually experts, but we can link the readers to experts.

- *TV and Internet differences:* In a TV news story a reporter can point to an object and say, "look at this document" or "look at this burned-out home." When writing for the Web, the object or event has to be described, if there are no visuals. If the Web site is an extension of the TV stations' news department, it is important to remind the audience that it is the TV station delivering the story. Where on the TV newscast the viewer would see a reporter doing an interview, on the Web we have to say something like, "a mother tells WINK-TV News her story." In rewriting a story for the Web, I change reporters' words if I can think of a more descriptive word to use. I also do not have the same strict time restrictions that a field reporter has and sometimes have a few extra moments to phrase things in a way that tells the story a little better.

 A reporter in the field also may write a story in a more relaxed speaking language, such as using contractions. For the Web page I like the more formal written language. In addition, field reporters do not always write in complete sentences. It is up to the Web writer to change that for the Internet story. Further, field reporters may not focus on correct spelling. Spelling is important on a Web page.

 In one of the stories I wrote [the 'Pastor' story on the following page, used as an example of a TV story rewritten for the Internet], the story was not posted until the station did a second televised story on the incident. For it to make sense to the readers, additional background information was added to the Web story. The Web story has to be a different entity from the story that aired on the TV news.

Janet Wilson advises writers of news for the Internet that "they need to get comfortable with a computer," although it is not necessary to be computer expert.

The following is an example of Wilson's adaptation of a TV story for the Internet. What changes do you find between the first script, that of the television broadcast, and the second script, the Web presentation?

P-PASTOR FOLO P-PATOR FOLO SHOW SLUG TAPE# DATE SOURCE 6p 7/3/01 P-PASTOR FOLO 390 07/04/01 08:44:54 PKG PRODUCTION CUES: SCRIPT:

((CG=PUNTA GORDA/MONDAY))

46-YEAR OLD PASTOR PAUL KING WAS JUST CHARGED WITH AGGRAVATED CHILD ABUSE …

BUT ACCORDING TO SHERIFF'S RECORDS … IT'S NOT THE FIRST TIME HE'S HAD CHARGES FILED AGAINST HIM.

LAST OCTOBER DOUGLAS POOLE … WHO IS A PARENT … FILED A BATTERY COMPLAINT AGAINST KING.

KING REPORTEDLY SHOVED POOLE, AFTER POOLE CONFRONTED HIM.

ACCORDING TO THE REPORT, KING ACCUSED POOLE'S CHILD OF CHEATING.

IN 1997 … ANOTHER SIMPLE BATTERY CASE WAS FILED AGAINST KING.

THIS TIME BY A MOTHER WHO SAYS SHE HAD TO SPANK HER OWN CHILD OR KING WOULD HAVE DONE IT HIMSELF.

THE WOMAN … WHO DOESN'T WANT TO BE IDENTIFIED … SAYS SHE TOO HAD TO SIGN A FORM THAT ALLOWS THE SCHOOL TO PUNISH STUDENTS AS SCHOOL OFFICIALS DEEM NECESSARY.

((CG=MOTHER OF FORMER STUDENT))

44:35 We do believe in spanking here. It doesn't happen often but then I found out it happens all the time and it has been unbelievable the abuse that has been reported to me from other parents.

MANY OF THE COMPLAINTS FILED … NEVER LED TO CHARGES.

AND THIS MOTHER SAYS … MANY PARENTS ARE AFRAID TO COME FORWARD TO BLAME KING.

SHE DOESN'T WANT ANOTHER CHILD HURT.

46:42 How he could even attempt to put his hands on another child even take the risk, that shows me there is a very serious problem.

PASTOR KING TOLD REPORTERS MONDAY … HE LOOKS FORWARD TO BEING VINDICATED IN COURT.

((CG=PASTOR PAUL KING/HARBORVIEW CHRISTIAN CHURCH))

11:13 No. None. I am a man of God and I will not agree to a lie.

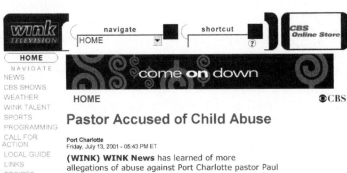

HOME ⊙CBS

NAVIGATE
NEWS
CBS SHOWS
WEATHER
WINK TALENT
SPORTS
PROGRAMMING
CALL FOR ACTION
LOCAL GUIDE
LINKS
RECIPES
MONEY
HEALTH
CBS KIDSHOW
SHOPPING
PRESS RELEASES
CONTACT US
JOBS AT WINK
UTILITIES
SITE MAP
FEEDBACK
CHANGE CITY
HELP

Pastor Accused of Child Abuse

Port Charlotte
Friday, July 13, 2001 - 05:43 PM ET

(WINK) WINK News has learned of more allegations of abuse against Port Charlotte pastor Paul King who was arrested and faces charges for paddling an 8-year-old girl with a wooden paddle. **WINK News** also learned that two other organizations, the Association of Christian Schools and the Department of Children and Families, are looking into the pastor's actions.

King was released from jail after posting a $20,000 bond Monday. King is director of Charlotte Regional Christian Academy and is a pastor at Harborview Christian Church.

Tammy Pipkin, the mother of the girl who was punished, says her daughter was severely beaten on May 11th. Pipkin took her daughter out of the school after the punishment.

WINK News also spoke with another parent who claims King abused her daughter and several other children 4 years ago. A search of Charlotte County records verified that the woman did file a report against King, but no charges were ever filed against King for the incident.

The mother, who did not want to be identified, tells **WINK News** she had to sign a form that allows the school to punish students as school officials deem necessary.

The unidentified mother says, **"We do believe in spanking here. It doesn't happen often, but then I found out it happens all the time. And it has been unbelievable the abuse that has has been reported to me from other parents."**

The mother believes many parents are afraid to come forward to say anything against King. **"How he could even attempt to put his hands on another child, even take the risk, shows me there is a very serious problem."**

Charlotte County Sheriff's records show another allegation against King. Last October, Douglas Poole, a parent, filed a battery complaint against the pastor. King reportedly shoved Poole after a confrontation. The report states that King accused Poole's child of cheating in 1997.

King tells **WINK News** that he looks forward to being vindicated in court. **"No plea bargain. None. I am a man of God and I will not agree to lie."**

Courtesy of Janet Wilson, WINK Television, Fort Myers, Florida

Professor Jack Lule notes in "The Power and Pitfalls of Journalism in the Hypertext Era," in *The Chronicle of Higher Education,* that "news differs in tone, tenor, depth, and style depending on whether it appears in a newspaper, in a magazine, on the radio, or on television. Online news is different from all of those media, and oddly, embraces them all." He explains that news on the Internet can have the depth that newspapers offer, the approach and orientation of a "smart-mouthed" magazine, talk radio's immediacy and call-in interactivity, and TV's visual impact. Lule gives an example of the Internet newswriter's obligation to "write a tightly woven main story with logical, independent links to other angles and topics." In writing an article about the murder of child model Jon-Benet Ramsey, the writer can go far beyond possibilities in any of the older media by including "links to transcripts of the sheriff's press conference, a three-dimensional map of the house, an exhaustive list of evidence, a detailed timeline of events, and profiles of defendants and prosecutors." Lule's example excellently represents the interactive nonlinear Internet writing approach. But, Lule cautions, in combining the most effective aspects of all these media into online news that uses the interactive potentials of chat rooms, forums, and email, the newswriter must give priority to ethics. As this book has pointed out in all formats, the writer must know the media and learn effective techniques, but the power of the writer and the media to affect the audiences' thinking and feelings requires a strong commitment to responsible ethical purpose and behavior.

Even with an ostensibly totally objective format—such as hard news—the write must be certain that all points of view and interpretations are available. If the older media are skewing the news—as they frequently do because of the advertiser, owner, or, sometimes, producer-writer control—the Internet offers the possibility of implementing the presentation of alternative viewpoints to popular thought and belief otherwise usually unavailable. A person might do extensive Web-browsing, but the writer can help orient the browser to sites that offset restricted attitudes and information.

Gatekeeping and Alternative Views

Probably the most important difference between news in the traditional media, such as radio and television, and news on the Internet is the issue of gatekeeping. A half-dozen multinational corporations control almost 90 percent of the international broadcasting and cable distribution and news dissemination. The corporate executives, as was demonstrated in the Worldcom and other media giant scandals in recent years, put their personal profits ahead of service to the public and manipulate and censor the news to serve their personal beliefs and corporate interests. They are the gatekeepers. We get only the news and views that they want us to get. The Internet, however, has challenged the international corporations' control of our information and ideas. Any group or individual can report news and views not found on the older media, without censorship or vested interest control. One such organization is FreeSpeech.org, which also provides a TV news service as Free Speech TV. With sources from all over the world, it provides written and visual coverage of corporate and governmental excesses not reported elsewhere, covers dissident

movements such as the 2002 and 2003 anti-war protests that the traditional media generally ignore or distort, and challenges and punctures sacred cows that established media, inasmuch as they are part of the sacred cow herd, praise.

The following is the home page from one of FreeSpeech.org's Internet news presentations. Note the links within a story to additional coverage in depth and to other stories.

Continued

tall-masted sailing ship to help create a culture of peace through the fundamental teaching of Sacred Ecology.

Peace Cards
We also feature two "Peace Cards" from: Anne Waldman, poet and co-founder of the Jack Kerouac School of Disembodied Poets; and Mayan spiritual leader, Apolonario Chile Pixtun who spoke to us at a Washington DC, *Prayer Vigil for the Earth* in September.

Indymedia Newsreal

December 2002

Denver Peace Rally
October 26, 2002
Tinderbox Productions
Anti-War March in San Francisco
October 26, 2002
Santa Cruz IMC
Anti-War Protest Denver
Amp & Margit Johansson
The First Ammendment Blues
Rochester Indymedia & Dawn Zuppelli
DC Anti-War Protest
October 26, 2002
North Carolina IMC & Brandon Jourdan

watch December Newsreal
Visit Newsreal Archives
Visit Newsreal Web site

working against war on a world wide scale.

Watch All the Programs in this Mobile-Eyes
Watch Mobile-Eyes Against Military Interventions
Visit Mobile-Eyes Archives

SPECIAL REPORT

America's Growing War in the Philippines

The Next Vietnam?

The US is dramatically increasing its military deployment. At first the rationale was to train Philippine troops to fight the Abu Sayaf, a bandit and kidnapping gang with ties to the Philippine military. But over the last several months the US advisors have gone from 160 to over 1000. And the US is putting a full-court press on the government of President Gloria Arroyo to permit reopening of Clark and Subic bases, which the US was forced to abandon in the early 80s in response to massive popular pressure.

We present two dramatic videos that show what is going on in that country now, and its implications for further US involvement *Basilan: The Next Afghanistan* reports on the work of an International Peace Mission to that island, led by anti-globalization activist Waldon Bello. The second video, *Basilan: Sparks of War* exposes the war on the Abu Sayaf as a pretext for mounting a full-fledged war against the peasant and urban movements fighting an elitist, neo-colonialist government in the Philippines. It examines the broader mass struggles for economic and social justice in this former US colony.

Watch Basilan: The Next Afghanistan?

Watch Basilan: Sparks of War

FSTV's website. If visitors you send our way order things from our store, you earn money (and so does FSTV).

Learn more

Web Hosting
Job Opening at FSTV
Website Director
Click here for details

FSTV–Noam Chomsky– War On Iraq–Listen to Internet Radio–Internet Radio –Dish Network

FSTV–Noam Chomsky– War On Iraq–Listen to Internet Radio–Internet Radio –Dish Network

Special Considerations

A most important concern of people of color, women, ethnic groups, and others not fully integrated into the American broadcasting mainstream is the lack of adequate news coverage pertaining to their special interests and needs. Many of the complaints to the FCC concerning failure of stations to serve community needs relate to both the quantity and quality of news items that affect or are about special groups. Many journalists, in both print and electronic media, say this is because it is difficult for a "nonminority" journalist to completely understand the concerns of people in "minority" groups.

Reporter Martha Bradlee, in an *op ed* piece on "Media's Racial Inequalities" in *The Boston Globe,* suggested that "perhaps in our largely white, middle-class newsrooms we have real empathy only for someone we can closely identify with . . . in my 10 years as a reporter in Boston, I remember only a handful of instances where we in the media have done background pieces of the 'what was he really like' variety on minority victims living in low-income, high-crime areas. We have, however, knocked on countless doors in the suburbs to try to humanize the white victim and show the pain of the victim's family."

Covering a nonmajority group requires a special sensitivity and empathy with the history, environment, culture, problems, and aspirations of that group. It has been suggested that being a member of that group is necessary for the understanding that results in the most effective story. Television news executive Robert Reid has been quoted as saying that reporters or writers from the "minority" group make a difference by providing perspectives that "majority" group professionals don't have. "Blacks in television tend to accord a more even treatment," Reid contended. "How often do you see a man-in-the-street interview and no Blacks are interviewed? The Black reporter is more likely to come back with some Blacks among those interviewed." The same has been said about the inclusion of women and other groups in news stories.

Closing this sensitivity gap requires a twofold approach: providing equal opportunity for reporter-writer jobs for all kinds of stories, and recognizing that a member of a particular group is likely to bring a sensitivity and perspective to covering a story relating to that group that nonmembers might not.

Like the commercial writer, the newswriter must be aware of the needs, attitudes, feelings, and motivations of the group covered, as well as those of the general audience watching or listening. The impact of a particular news event on a special group—and such impact, by the nature of our society, frequently is different than it is on the majority population—usually is ignored, except where the happening or issue directly and strongly relates to that specified group. The following example of how a general news story can be written to include or, depending on the audience, to be specifically oriented to a special group, is from the National Black Network (NBN) radio service:

November 5—8 P.M.—King

The administration's attitude toward Black unemployment is "cruel, cynical, and vicious . . ." I'm Ron King with World Wide News from the National Black Network in New

York. That biting and descriptive assessment of administration policies toward Black unemployment was given today by Black Maryland Congressman Parren Mitchell. Speaking before the Joint Economic Committee of Congress in Washington, following today's release of new unemployment figures, Mitchell blasted the administration for policies which have increased unemployment. Today's figures show a nationwide jump from 10.12 to 10.4 percent, with Black unemployment remaining at a staggering 20.2 percent. Congressman Mitchell says that's unconscionable.

Courtesy of National Black Network

Legal Considerations

Although the Communications Act of 1934, as amended, prohibits the FCC from censoring programs, another clause in the act gives the FCC authority to take action against what it interprets as indecency. Chapter 1 describes the status of this constraint.

The "freedom of the press" provision of the First Amendment applies differently to broadcasting than to print because of the electronic media's special nature. The number of printing presses that can be put into service to publish newspapers is unlimited, but the number of frequencies that can be used to broadcast news is limited. The crowding and chaos on the airwaves were the reasons for the Radio Act of 1927, which provided the first legal basis for airwave regulation.

Though the print media have virtually total freedom under the First Amendment to print what they want, the limited number of broadcast frequencies has resulted in the courts, including the Supreme Court, consistently applying the First Amendment differently to television and radio stations and affirming the regulation of broadcasting in the "public interest, convenience, and necessity" as stated in the Communications Act. Depending on the philosophy of the party in power, the FCC has either strongly enforced rules and concepts it believed best served the consumer—such as the now defunct Fairness Doctrine and Ascertainment of Community Needs—or has trusted the marketplace to decide and strongly deregulated broadcasting, as was done in the Telecommunications Act of 1996.

Nevertheless, many aspects of statute law (laws passed by a legislative body) and case law (established through court decisions) apply to both print and air, although sometimes in slightly different ways. One of the most important of these laws that apply to the broadcast writer is defamation.

Defaming a person's character or reputation in writing is called *libel;* when done through the spoken word, it is called *slander.* However, the term *libel* applies to broadcasting as well as to print because the courts have stated that television and radio news programs follow written scripts. Court decisions have made it extremely difficult to prove a case of libel. A plaintiff must satisfy five requirements: that he or she has, in fact, been defamed, that the broadcast clearly identified this person as the person being talked about or shown, that the defamatory material was actually broadcast, that the broadcaster stated the false information about the person either through negligence or through malice, and

that the plaintiff has suffered actual damages from the broadcast. As you can see, it is extremely difficult for someone to win a case of libel. Nevertheless, it does happen, and the writer should be careful that his or her script does not contain libel. If there is any question, check with the station's legal counsel.

One privilege the reporter in the United States has that is not available to the media in most countries is that of fair comment on public figures, including political leaders. Although a private person might win a libel case by proving negligence, a public figure almost always has to prove deliberate malice. In addition, U.S. journalists can make "fair comment" on any politician, even the president. Fair comment essentially means expressing any opinion about the political figure, no matter how damning or embarrassing—or even vicious. Personal attacks against presidents found in the U.S. media would land the journalists in jail in most countries.

Another area in which to be careful is the invasion of a person's privacy. Although courts usually consider public figures open to virtually any kind of press examination, intrusion on an ordinary citizen's private life by causing embarrassment through revelation of false or highly personal information can be the basis for a lawsuit. The courts have almost always, however, upheld the public interest or newsworthiness factor as a defense against such a suit. The courts do not look kindly, however, on invading a person's material space. Obtrusive spying on a person, unlawfully entering that person's premises, gaining entrance to private property to photograph that person's private behavior, and physical intrusion against that person are some areas in which journalists have been found guilty of invasion of privacy.

A comparable invasion of privacy concern is appropriating a person's likeness or speech for commercial purposes without that person's written permission. Other than in *bona fide* news coverage, make sure you get that consent.

Most states have what is called a *shield law,* protecting a reporter from having to divulge his or her confidential sources. No national law protects a reporter from having to divulge privileged information, however, and if your script contains material that you obtained by promising your informant that you wouldn't reveal the source, you may find yourself in a court case having to choose between naming the source or being held in contempt, fined, or sent to prison. The judge makes that determination in each individual case, deciding whether the reporter's privilege or the defendant's right to a fair trial is paramount.

A continuing confrontation between the courts and broadcast news reporters and writers is over cameras in the courtroom. Though a growing number of judges and legislators have accorded broadcast news the same privileges as print news, in most courtrooms and legislative assemblies cameras are not allowed, and not even microphones are permitted in many. To the degree that television writers use visual and aural material as part of their scripts, they can be more limited than are their newspaper counterparts in obtaining the news.

In most states, the individual judge in any given trial can decide whether cameras are allowed in his or her courtroom. Determination is made by balancing the media's First Amendment rights against the Sixth Amendment rights of the defendant to a fair trial.

Federal courts (but not the Supreme Court) have experimented with courtroom cameras, allowing individual judges to decide.

One of the most restrictive areas for reporters and writers is the federal government. Although 1974 and 1976 amendments to the Freedom of Information Act ostensibly allowed the press to report the government's actions, the Freedom of Information Act was restricted under the Reagan administration, and subsequently in the George W. Bush administration—aside from national security concerns—preventing journalists from reporting the peoples' business to the public. Material designated as pertaining to national security or to certain internal agency matters are exempt. A document can be arbitrarily classified as confidential, or kept secret on the grounds that it is necessary for law enforcement purposes or investigations.

One more legal issue directly affects your writing—the right to protect your work. You can protect your own scripts by **copyrighting** them (see Chapter 11 for details). Be sure that you don't use anyone else's copyrighted materials, whether words, visuals, music, or anything else, in your scripts without obtaining legal permission.

Sports

Writing sports is similar to writing news. The basic principles and techniques apply to both. The style, however, is different. If anything, sports broadcasts must be even more precise and direct than are news broadcasts. Peter Lund, when president of CBS Sports, noted the requirement for accuracy in preparing sports material: "Entry level people often are in the position of supplying information to producers and talent. It must be accurate, and available at a moment's notice."

The language of sports is more colloquial, and although technical terms should be avoided so the general audience won't be confused, sports jargon and expressions in common use relating to a specialized area of sports are not only acceptable, but necessary to establish expertise by the sportscaster and empathy between the sportscaster and the audience. The fan is interested in the competitive aspects of sports, in who wins and who loses. Keep in mind the dramatic elements when you write the sports script.

Although sports divisions usually are under news departments, the phenomenal growth of coverage of live athletic contests has resulted in independent status for sports at some networks and larger stations. The smaller the station, the more likely sports will be found under the direction of the news department. Though the newswriter is sometimes required to write the sports sections of the news script, the material usually is gathered and written by the sportscaster. In addition, all-sports cable channels have proliferated, with live coverage, sports news, interview shows, and sports features programs.

Internet Sports

An increasing number of Web sites deal with sports: features, history, personalities, and trivia, among other topics. The unlimited number of sites in cyberspace permits sports

afficionados to find even the narrowest area of interest in any given sport from almost anywhere in the world. As sports begin to stream from broadcast stations and cable systems onto the Internet and as the Internet itself begins to originate the kinds of sports programs now found on the older media, greater opportunities will open for the media sports writer (and announcer and producer). For the writer, the interactive aspects of the Internet will expand both the opportunities and requirements for Internet sports writing. The same principles that apply to cyberspace news writing, as delineated earlier in this chapter, apply to cyberspace sports writing, including the viewer's interactive opportunities such as calling up previous athletic contests or excerpts, athlete interviews and backgrounds, stadium or playing ground views and information, statistics, fan comments, press reports, and virtually any material relating to the sports event or program being presented.

Types of Sports Programs

The *straight sportscast* concentrates on summarizing the results of sports events and on news relating to sports in general. Some sportscasts are oriented solely to summaries of results, which can come from wire service reports or other sources. Material that is obtained from newspaper accounts or the wires should be rewritten to fit the particular program's purpose, the audience's interests, and the sportscaster's personality. Although there are occasional sports roundups of 15 and more minutes in length—usually as part of a network daylong coverage of athletic events or a late night special weekend wrap-up—most straight sports broadcasts are part of the daily evening and nightly news shows.

The sports *feature* program can include live or recorded interviews with sports personalities, anecdotes or dramatizations of happenings in sports, human interest or background stories on personalities or events, or remotes relating to sports but not in themselves an actual athletic contest (for example, the retirement ceremonies for a football coach).

Any sports program can amalgamate several approaches or, as in an after-event critique or summary, concentrate on one type alone. Many sports news shows are combinations of the straight report and the feature.

The most popular sports broadcast is, of course, the live athletic contest.

Organization

Sports broadcast formats parallel those for the regular news show. The most common approach is to give all the results and news of the top sport of the season and work down toward the least important sport. The most important story of the most important sport is given first, unless a special item from another sport overrides it.

Within each sport the general pattern in this organizational approach includes giving the results first, general news (such as a trade or injuries) next, and future events last. If the trade or injury is of a star player or the future event is more than routine, such as the signing for a heavyweight championship fight, then it becomes the lead story.

The local result or story is usually the lead within the given sports category at the local station, and the local sports scene ordinarily precedes all other sports news.

The sports segment of a typical late evening news show might look something like the following script.

VIDEO	AUDIO
COOPERSTOWN HALL OF FAME ANNCR: VO	Your favorite baseball cards come to life tomorrow at baseball's Hall of Fame in Cooperstown, New York, as three new diamond immortals are inducted.
	Commissioner I.M. Ownerowned will present the game's highest honor to catcher Roger Stamina who holds the record of 1562 straight games caught without an injury, first baseman Lefty Longarm, who won the Golden Glove award 16 straight times in his 20-year career, averaging only 1.667 errors per year, and outfielder Bill Ballsmasher, whose .324 batting average, average 37 homers per year, and the most doubles ever batting left-handed in rain-delayed night games in July led the Cincinnati Reds to an unprecedented four straight National League World Series titles. Bill Ballsmasher talked to us today about his illustrious career:

[Though numbers are usually spelled out in news reports, their preponderance in sports reports usually results in their use as ordinals.]

SOT: BALLSMASHER ANNCR: OC	The Boston Red Sox are still suffering from the late inning blues. They lost another one today to the Cleveland Indians in the ninth inning.
FENWAY TAPE ANNCR: VO	Leading 6–1 behind the powerful pitching of Jack Strongarm, the Sox dropped two straight fly balls in left field in the top of the ninth—there's left fielder Joe Weakhand missing the first one, and two pitches later he drops the second one in the same place—then allowed this towering home run over the Green Monster by Indians second baseman Harry Hurryup, then the first base on balls by Strongarm, followed by an error by third baseman Wayne Bobble, and the game-winning homer by Indians pinch-hitter Justin Time. Joe Weakhand tried to make up for his errors by this triple into the right field corner with one

Continued

VIDEO	AUDIO
	out in the last of the ninth, but the next two Sox struck out to end the game. Sox manager Hereford "Sticky" Notlong had this to say about the Sox fifth straight loss.
SOT: NOTLONG ANNCR: OC	
	Boston heads for Chicago now, the Sox going foot to foot with the Sox in a marathon of four games in three days, leading off with a twi-night double-header tomorrow. In other American League games today:
SCOREBOARD ANNCR: VO	Baltimore 2, Milwaukee 1 Detroit 8, Kansas City 4 Toronto 6, Seattle 0 and the Yankees and Texas Rangers play tonight.
ANNCR: OC	The sparse crowd of 6,149 who showed up at Vet Stadium in Philadelphia were treated to a rarity for Philly fans.
VET STADIUM ANNCR: VO	Veteran pitcher Robin Curve, obtained only last week on waivers from the Atlanta Braves, treated the fans to the first no-hitter at Vet Stadium in 14 years. He won 1–0 over the Arizona Diamondbacks on Mike Hitts 31st homer of the year in the third inning. Meanwhile Curve walked only one and struck out 14, including the last two batters of the game. Watch this strikeout curve—called—and this final one—swinging.
SCOREBOARD ANNCR: VO	Only two other National League games this afternoon, the New York Mets sinking the Los Angeles Dodgers 12–2 to move into a tie for first place in the East with the Braves, who dropped a squeaker to the San Diego Padres 5–4, in 11 innings.
ANNCR: OC	In golf today, Bernie Ems took an early lead in the Southern Open in Atlanta, birdying the last three holes to finish with a Flying Hand Country Club course record of 62. Five strokes behind was pre-tournament favorite Panther Forest, whose three bogies on the first nine prevented him from catching up despite a 30 on the back nine.
COUNTRY CLUB ANNCR: VO	Here's Ems sinking an 18-foot putt on the 18th hole.
SOT: DERBY	Sad news today for horse racing fans. Swift Stride, the last triple crown winner, died today at Raceway Farms, Kentucky, at the age of 22. Remember when Swift Stride nosed out Fast Legs to win the Derby?
ANNCR: OC	We'll be back at 11 with late sports.

The Live Contest

Newspaper and magazine cartoons showing a viewer glued to a television set for seven nights of baseball in the summer and seven nights of football, basketball, or hockey in the fall and winter are not exaggerations. The live athletic contest is the most exciting and popular sports program.

Although men traditionally have been the dominant audience for sports contests, the impact of Title IX, providing women in colleges and universities with equal opportunities in athletics, has led to the rise of women's professional sports, with women's teams and individuals getting increasing media coverage and, concomitantly, increasing the number of women watching sports programs.

The writer, as well as the producer and announcers, should determine at least the audience's general gender demographics for a given event to prepare continuity and filler material that are attractive and understandable to that audience. The importance of sports in television programming is demonstrated by *Monday Night Football* having been the male viewer's number one prime-time program since its inception in 1969. The prime-time sport most attractive to women has been figure-skating. Although advertisers on sports shows seem intent on attracting a young male audience as their primary target, studies show that older males are avid viewers as well, especially of sports that they continue to play, such as golf.

Although the jobs of the live event sportscasters differ in radio and television—the former are narrators, describing every detail of the action, whereas the latter are announcers, adding only explanations or color to what is being viewed—the writer's job is the same. The writer principally provides opening, transition, and closing material, plus enough color or filler material to keep every moment occupied. This background material includes information relating to pre-event action and color, statistics, form charts, material about the event's site and history, background about the participants, human interest stories related to the event and to its participants—anything that either heightens the audience's interest or helps clarify the action to the audience.

This material must be prepared in advance and must be available to the broadcaster for use immediately when needed. The writer's primary function for the live contest, therefore, is that of researcher and outliner. The script can be little more than an outline, a series of statistics, individual short unrelated bits of information, or short paragraphs providing some in-depth background, sometimes pregame and postgame segments, and opening, closing, and transition materials. Frequently, when the announcers have worked with the format for a while, they provide virtually all the continuity themselves, in many instances not even writing it out. They may work only from a rundown sheet, with a minimum of standard written continuity, as in the following example for a professional basketball game—a composite of rundown sheets from several major market stations.

Millnatti Giraffes Rundown Sheet

OPEN & BILLBOARD	STUDIO	1:00
TALENT ON CAMERA	REMOTE	1:20
1ST POSITION	STUDIO	2:00
ANTHEM, PLAYERS & TIPOFF	REMOTE	
START FIRST QUARTER		
2ND POSITION (AUDIO "A")	STUDIO	1:30
3RD POSITION (PROMO DROP #1)	STUDIO	1:30
END FIRST QUARTER		
4TH POSITION	STUDIO	2:00
START SECOND QUARTER		
5TH POSITION (AUDIO "B")	STUDIO	1:30
6TH POSITION (GIRAFFES PROMO #1)	STUDIO	1:30

<u>END SECOND QUARTER</u>

* * *

[Here a standard halftime format would be used, including, in this example, four promos, and a brief news segment. The transition continuity, written out for the talent, would be as follows:]

HALFTIME NEWS INTRO

At the half the score is _____.

When we come back, Norm Nonjock will be with you with a Channel 84 news update. Stay tuned.

* * *

START THIRD QUARTER		
11TH POSITION (GIRAFFES PROMO #2)	STUDIO	1:30
12TH POSITION (PROMO DROP #2)	STUDIO	1:30
END THIRD QUARTER		
13TH POSITION	STUDIO	1:30
START FOURTH QUARTER		
14TH POSITION (AUDIO "C")	STUDIO	1:30
15TH POSITION (PROMO DROP #3)	STUDIO	1:30
END OF GAME		
16TH POSITION	STUDIO	1:30

* * *

[Here usually is a promo for the next program on the channel. In this example it is the late news, the scheduled timing of which frequently fits in right after the game. The continuity would be as follows:]

Continued

<u>End of Game (News promo)</u>

With the final score _____.

We'll be back to wrap it up, but now let's go to Norm Nonjock and Jacqueline Jurnlist to find out what top stories you'll be seeing in tonight's news.

* * *

WRAP-UP FROM REMOTE

[Here is sample wrap-up continuity, as it would be written for the talent, the producer, and the director:]

VIDEO	AUDIO
TALENT ON CAMERA	AD-LIB RECAP (:30–1:00)
CHYRON NEXT GAME	So that's about it from here. Join us next Thursday night, November 15th at 8 o'clock when the Giraffes will take on the Philangeles Skywalkers right here in the Milnatti Sports Arena.
CHYRON PRODUCER	Giraffes basketball on channel 84 was produced by Jim Dropshot.
CHYRON FINAL SCORE	Once again, the final score is _____.
	This is Sam Slamdunk saying goodnight from the Sports Arena and we invite you to stay tuned for the channel 84 late news, to be followed by the Jay Scribbler Show. Goodnight.

The following outline, for professional hockey, is more complete than most, with the opening and closing format, the commercial format so the announcer knows when to break, and the lead-in script material for each commercial. Each page of the opening and closing formats is set up so that after the first page the announcements from network or local sponsors can be inserted without disrupting the continuity.

PROFESSIONAL HOCKEY—OPENING BILLBOARD

VIDEO	AUDIO
Up from black	Sneak theme
FILM	
PROFESSIONAL HOCKEY	ANNCR: Coming your way now is PROFESSIONAL HOCKEY, the
(Super)	fastest game in the world …

Continued

VIDEO	AUDIO
SUPER (NAME OF TEAMS)	and BIG match it is— the _____ against the _____. (Theme up and under)
CBS SPORTS (Super)	ANNCR: This is the _____ in a series of exciting matches that will be brought to you every Saturday afternoon during the season ...
BEST IN SPORTS (Super)	As part of the continuing effort of CBS SPORTS to present the BEST IN SPORTS all the year around. (Theme up and under)
NATIONAL LEAGUE HOCKEY (Super)	ANNCR: This is an important regular season contest in the National Hockey League ... hockey's MAJOR league ... being brought to you direct from famed _____ in _____.
NAME OF STADIUM (Super)	(Theme up and under) ANNCR: So now get ready to watch the match between the _____ and the _____ ... with
NAME OF TEAM	description by _____ and _____. Now let's go to (Name of Stadium) _____. (Theme up and hold)

CLOSING BILLBOARD

VIDEO	AUDIO
	You have just seen a presentation of fast-moving
PROFESSIONAL HOCKEY	PROFESSIONAL HOCKEY ... one of the big regular season matches of the NATIONAL
NATIONAL LEAGUE HOCKEY	HOCKEY LEAGUE ... the MAJOR league of hockey. (Theme up and under) Today's exciting contest was between the _____
NAME OF TEAMS	and the _____. Played on the _____ home ice, the famed
NAME OF STADIUM	_____ in _____. (Theme up and under) We invite you to join us again NEXT Saturday afternoon for
NEXT SATURDAY	another big Professional Hockey Match ... Next week's televised contest will bring together the (Name of
NAME OF TEAMS	Team) _____ and the (Name of Team) _____ at the (Name of Stadium) _____. (Theme up and under) The description of today's match has been provided by
NAMES OF SPORTSCASTERS	_____ and _____.

Continued

VIDEO	AUDIO
PROFESSIONAL HOCKEY is a CBS TELEVISION NETWORK Presentation PRODUCED BY CBS SPORTS	This presentation of PROFESSIONAL HOCKEY has been produced by CBS SPORTS. (Theme up and hold)

HOCKEY COMMERCIAL FORMAT

Before Opening Face-Off—"Very shortly play will be starting here at (Name of Arena) and we will have action for you."
(1 minute commercial)

First Period—During 1st period of play three 20 second commercials are to be inserted at the discretion of each co-op station. Audio Cue: "There's a whistle on the ice and the score is _____ & _____."

1st pause during play-by-play.	.20 seconds
2nd pause during play-by-play.	.20 seconds
3rd pause during play-by-play.	.20 seconds

End of First Period—"That is the end of the first period and the score is _____ & _____."

Middle First Intermission—"In just a moment, we are going to have more entertainment for you during this intermission."

Before Second Period Face-Off—"Very shortly, play will be starting in the second period at (name of arena) and we will have more action for you."
(1 minute commercial)

Second Period—During 2nd period of play three 20 second commercials are to be inserted at the direction of each co-op station. Audio Cue: "There's a whistle on the ice and score is _____ & _____."

Continued

1st pause during play-by-play. .20 seconds
2nd pause during play-by-play. .20 seconds
3rd pause during play-by-play. .20 seconds

End of Second Period—"That's the end of the second period and the score is _____ &
_____."
(1 minute commercial)

Middle Second Intermission—"In just a moment we are going to have more entertainment for you during this intermission."

Before Third Period Face-Off—"Very shortly play will be starting in the third period here at (Name of Arena) and we will have more action for you."
(1 minute commercial)

Third Period—During third period of play three 20 second commercials are to be inserted at the discretion of each co-op station. Audio Cue: "There's a whistle on the ice and the score is _____ & _____."

1st pause during play-by-play. .20 seconds
2nd pause during play-by-play. .20 seconds
3rd pause during play-by-play. .20 seconds

End of Third Period—"That is the end of the game and the score is _____ &
_____."
(1 minute commercial)

Statistical Wrap-up

Before Closing Billboard—"This wraps up another National Hockey League telecast. Final score _____ & _____."

By permission of CBS Television Sports

APPLICATION AND REVIEW

1. Using the front page stories from your daily newspaper, write the complete script for a 15-minute radio news program.

2. Take the same news material and write the script for a half-hour television news program, using film, tape, photos, graphics, and any other visuals you can justify as being appropriate and likely to be available.

3 Rewrite one of the news stories in exercises 1 and 2 for broadcast to a predominantly African-American, Latino, Asian-American, or Native American audience.

4 Rewrite one of the news stories in exercise 1 or 2 for the Internet, with appropriate links.

5 If your college or university has a radio or television station, arrange to write a news story for one of the news programs.

6 Write a news story around the following facts: (a) your college or university has just been purchased by the Toysan Company of Japan, a leading world manufacturer of electronic communication equipment; (b) the purchase price is $50 million if yours is a small institution, $50 billion if a large one; (c) the purchase becomes effective on January 1 of the coming year; (d) your institution's president has assured that "the purchase of this institution will not affect the high quality of our curriculum in any way; in fact, it will strengthen it with an immediate infusion of $10 million (if a small school, $1 billion if a large school) for new academic programs and faculty." What additional information and materials would you get to flesh out the story?

7 What athletic contest will take place at your college or university, or in your community, in the near future? Prepare a rundown, opening and closing, and transition continuity for that contest.

8 Prepare a five-minute straight sports summary of your institution's athletic contests, ostensibly for use on your college or university radio or television station, or for a local broadcast station.

6

Features and Documentaries

Features and documentaries usually are under the direction of the news department of the television or radio station or network. Features and documentaries deal with news and information and, frequently, opinion. They can relate to current or historical events or ideas. They can be academic, cultural, or even abstract, without apparent connection to any contemporary or major issue or concern.

Some practitioners and critics consider the *documentary* the highest form of the news and information art. Documentaries provide information and present a point of view (**POV**). A good documentary can have a profound influence on social, political, or economic developments and even on legislation in a city, region, or country.

Anything that deals with a nonfiction treatment of a subject in a format that is not straight news or interview or discussion is often called, interchangeably, a feature or a documentary. This book labels as "features" those productions that do not deal with a controversial issue or do not take a point of view toward the subject. Those that do are defined in this book as "documentaries." The writer—and producer—who wants to make a documentary that has substance and meaning should have a "fire in the belly," should be passionate enough about something to motivate the viewer or listener to take action on the issue.

The *feature,* as defined here, is a straightforward report on an event, situation, person, or idea, such as the life of someone in the community. If that person happens to be homeless and if the production makes a strong point about the community's obligation to do more to help homeless people, the piece crosses from feature to documentary. A production about the day-to-day operations of a new local industry is a feature; one that shows corporate executives inflating their companies' profits and then selling their stock options before their companies declare bankruptcy is a documentary. The feature can be simply a travelogue about the autumn leaves in New England, the local zoo, or a new beach

resort. The production that stresses acid rain or careless treatment of animals or cancer dangers from sun exposure or ecological dangers from global warming moves into the realm of the documentary. Both the feature and the documentary can be highly artistic; only the purpose of the content is different.

The *special event* sometimes is confused with the feature. Although the feature is a planned, scripted production, especially prepared for the network or station, the special event is part of the stream of life, usually a live happening planned by some source other than the media producer. The special event is closer to straight news than is the feature or documentary and is sometimes unanticipated, whereas the latter is always carefully preplanned.

The special event can be a visit to the city by a head of state, a holiday ceremony in front of city hall, the ground breaking for a housing complex, the local premier of a new film with one or more of its stars present, or even the opening of a new shopping mall. The feature, on the other hand, may deal with the work of a special community service health group such as an AIDS support organization, the operation of the local fire department or school board or of a national association of fire fighters or school boards, a how-to-do-it broadcast such as weatherproofing homes against hurricanes, or a behind-the-scenes story on any subject, from raising chickens to electing public officials. The documentary goes a step further and takes a point of view on the subject.

Don Hewitt, producer of *60 Minutes,* stated, "The key to *60 Minutes*'s success is a combination of good old-fashioned reporting and recognizing people who have an ability to tell stories rather than simply reporting an event." Telling a story goes beyond the news report. A good feature or documentary has what a special event does not: drama, depth, and empathy between the audience and the subject.

Special events have no set time limits, although networks and stations try to avoid open-ended coverage so they can preplan program time sales. Features can range from the following 30-second *We the People, New England* series to 30 minutes or even an hour in length.

We the People, New England #1
:30

Video	AUDIO	E.T.	R.T.
WE THE PEOPLE animation	WE THE PEOPLE music full	:03$^{1}/_{2}$	
dissolve to:	music under, Kate Sullivan:		
portrait of John Adams	"JOHN ADAMS IS BEST KNOWN AS THE SECOND PRESIDENT OF THE UNITED		
dissolve to exterior of homestead in Quincy	STATES, BUT ONE OF HIS GREATEST CONTRIBUTIONS TO HISTORY TOOK		

Continued

	PLACE HERE. . . . IN A SMALL LAW OFFICE IN MASSACHUSETTS.	:09	
dissolve to Kate Sullivan inside the law office	IT WAS HERE THAT ADAMS WROTE THE CONSTITUTION FOR <u>MASSACHUSETTS</u>, WHICH SERVED AS A MODEL FOR THE		
key Kate's name	<u>UNITED STATES</u> CONSTITUTION 8 YEARS LATER. SO ALTHOUGH HE WAS IN ENGLAND WHEN THE DOCUMENT WAS		
dissolve to second portrait of Adams	WRITTEN, JOHN ADAMS IS CONSIDERED BY MANY TO HAVE BEEN THE FOREMOST AUTHORITY ON THE UNITED STATES CONSTITUTION."	:14	
dissolve back to animation	music full	:03	:29½

Courtesy of WHDH-TV, Channel 7, Boston

Documentaries are rarely found on radio any more, and because full-length TV documentaries are costly to produce and usually don't draw competitive ratings, they have been made more palatable for television audiences by being presented in shorter or, as they are sometimes called, **minidocumentary** form. *60 Minutes* has been highly successful in popularizing *minifeatures* and *minidocs* of about 12 to 15 minutes in length and prompted minifeature and minidoc programs such as CBS's *48 Hours, Dateline NBC,* and ABC's *20/20.* Reflecting the exploitation/scandal mood of the lowest common denominator viewing public, these programs, by and large, concentrated on stories revolving around titillation, mayhem, scams, and personalities. Dianas, Monicas, and their counterparts seemed to dominate the subjects covered. Features and documentaries in the traditional informational and educational formats, however, both video and film, also grew on specialized cable channels such as A&E, Discovery, and the History Channel, frequently a full half-hour or hour in length.

Sometimes a highly dramatic news event can trigger a number of follow-up half-hour and even hour documentaries in prime time on the major networks. For example, the Littleton, Colorado, high school massacre in 1999 generated a series of full-length documentaries in the days immediately following the killings. The event lent itself to in-depth studies of several pertinent key issues, including the role of far right-wing political groups in influencing the students who did the killings; the availability of guns in facilitating the massacre and consequent changing attitudes in the country toward gun control and the glorification of a gun culture; the responsibility of parents in monitoring the psychological state and physical behavior of their children; the role of television and video games in motivating violent behavior; the insensitivity of young people, particularly in a school situation, by ostracizing and alienating classmates. The good writer

evaluates all significant news stories and explores in depth those aspects that lend themselves to good and meaningful documentaries. For the serious nonfiction content writer, there is a market out there!

Writing Techniques

Both the feature and the documentary require careful research, analysis, and evaluation of materials. Both can consist of many diverse forms: news, interviews, panel discussions, dramatizations, speeches, and music. Both follow an outline-to-script approach. After deciding on the subject and the approach, the writer outlines as fully as possible, developing a detailed *routine sheet* or *rundown*. After determining which of the anticipated materials— live interviews, stock footage, old recordings, family photographs and diaries, and other materials—are available, a preliminary script can be written. After the research is completed and all the material going into the show has been assembled, a final script is prepared.

Form

Both the feature and the documentary can be dramatic, but not the way a fictional play can. Each should be a faithful representation of a true situation. This is not to say, however, that all such programs are unimpeachably true. Although they contain factual, informational, and educational content, editing and narration can make any series of actual sequences seem other than what they really are.

For example, the semidocumentary or fictional documentary, frequently called the *docudrama,* has become relatively popular. It may take authentic characters, but fictionalize the events of their lives; it may present the events accurately but fictionalize the characters; it may take real people or real events and speculate as authentically as possible on what might have occurred to fill information gaps; it may take several situations and characters from life and create a semi-true composite picture.

Although both the feature and documentary deal with issues, people, and events of current, recent, or past times, neither are news stories as such. Both explore behind and beneath the obvious, with the documentary going more in-depth for a defined persuasive purpose. The feature principally should inform; the documentary principally should make the audience think and feel. The documentary explores as much as possible the reasons for what happened, for the attitudes and emotions of the people involved. Comments of experts and the reactions of other people who might be affected are used to assess the implications and significance of the subject for the whole of society.

Whereas the feature is more often oriented toward objectivity, the documentary is oriented toward interpretation and a point of view. A feature on a murder in a New York City park by a gang of youths may present fully all of the known factual material. A documentary on the same subject—such as the classic *Who Killed Michael Farmer?*—covers considerably more in background and character exploration and provides an understanding and an impact that otherwise would be missing.

Although some features and documentaries are prepared in a studio and depend largely on studio interviews and available stock materials, most are filmed or taped in the field. *Actualities*—the people and events recorded live—are essential for creating a credible program.

Approach

The feature and especially the documentary contain the real words of real persons (or their writings, published and unpublished, including letters, if they are not living or cannot be reached, or if no recording of their voices is obtainable), the moving pictures of their actions (or photos or drawings if film or tape is unavailable or they lived before motion pictures), and available sounds and visuals of the events. These materials, sometimes seemingly unrelated, must be put together into a dramatic, cohesive whole and edited according to the outline and the script.

How do you start? First, the writer must have an idea. The idea for the program frequently comes from the producer rather than from the writer. What subject of public interest is worthy of treatment? The attitudes of the ordinary Israelis and Palestinians toward the struggle that wreaked havoc on them all? The feelings of children, college students, poor people, and elderly about political legislation that threatens their lives and futures? The rampage of AIDS? Political and economic discrimination against people of color? Government corruption? Continuing nuclear testing? The deprivation of America's civil liberties under the "Patriot Act" of 2001? All of these have feature possibilities. By going further with each topic—Have the Western and Mideast powers done everything possible to establish bases for peace in the mideast? How can election laws be changed to make it possible for candidates to win on credentials and not principally on the largest campaign fund? How can the subjugation and virtual slavery of women in many countries be ended?—you have the makings of documentaries.

Process

First, determine the subject and point of view. Will this be an objective feature or a subjective documentary?

Second, prepare a tentative outline—not a road map, but a general direction.

Third, do thorough research: analyze library resources, make personal visits to people and places, determine what visual and aural materials are available and study them.

Fourth, prepare a more definitive outline, a detailed rundown sheet.

Fifth, work closely with the producer and director (in many instances the writer is also the producer, and sometimes also the director) to solidify the outline and prepare a full script. During this period the writer may suggest specific materials to be obtained, recommend the orientation of these materials, and even help gather them.

Sixth, prepare lead-ins, lead-outs, and interview background materials and question-answer outlines as the actualities are gathered, and other transition material as the script

begins to take shape. As the material comes in, the writer continually revises the outline, accommodating new, unexpected material and deleting anticipated material that is not obtainable.

Seventh, when most of the material is in, prepare a full script. Revise this script in conference with the producer and director.

Eighth, after all the material has been gathered, seen, and heard many times by the writer and the rest of the production team, write the final script, sometimes called the *working script.* This final version is used for selecting and organizing the material to be used in the final editing and timing of the program. The final working script and the *transcript*—the program as aired—should be virtually identical, with the transcript containing the actualities, interviews, and other material that cannot be scripted word for word beforehand. Some producers prepare their working scripts in detailed routine or rundown form, without the actualities. Some include the complete actualities, transcribed from the video or audio materials. Usually, much more material is obtained than can be used.

Sometimes an entire program can be developed from just a few minutes of tape available exclusively to one station or producer. The writer might decide that this material would make a unique beginning or ending and might build the remainder of the show around it. For example, a network might have an exclusive tape of a minute's duration of a secret meeting between the heads of two major world powers. From this tape, with the aid of stock footage, interviews, commentary, and further fieldwork not even necessarily directly related to the event, a complete program can be created.

Technique

Endowing a story with human interest is a key to good feature or documentary writing. Even if you want to present only facts, and even if the facts seem stilted and dry, you can make them dramatic. Develop them by embodying traits of the people they represent. Even if the subject is inanimate, such as a new mousetrap, toxic waste, a current fad, or a nuclear warhead, endow it with live attributes. Haven't we all run across machines that seem more alive than some people we have known?

Develop the script according to the same basic principles you use for writing the play and the commercial. Get attention. What is the problem or situation that requires the program to be made? For the documentary, especially, the conflict is important. Explore the people or characters involved with the subject. Develop the theme by revealing more information; in the documentary, build the conflict through the complications until it reaches a crisis point. Although major happenings create dramatic action, the little things, the human elements, are important in establishing empathy and holding the audience's interest.

A narrator almost always is used. But too much narration distracts. Don't let the program look or sound like a series of educational interviews or lectures. A narrator frequently can summarize information that is not obtainable through actualities. Make

the points clear and concise, and even if you are propounding one point of view, be certain to include all sides of the issue as the evidence presumably builds to support your position.

The Feature: Application

The feature often is a public service presentation, providing informational and educational content. But it doesn't have to be purely factual or academic in style. A variety show or drama format or elements of entertainment formats can make the feature more interesting to the audience. The feature can be oriented around a person, a thing, a situation, a problem, an idea, or an organization. The feature can be historical or current; it can explore concepts or show how to do something. The following example deals principally with an organization (the Red Cross), includes a problem (disaster work), a situation (life-saving), and how-to instruction (artificial respiration). This feature was originally produced live by a local commercial station as part of a public service series.

HOW RED CROSS DOES IT

VIDEO	AUDIO
CG: TRI-STATE STORY CG: RED CROSS EMBLEM	MUSIC: RECORD "RED CROSS SONG" IN AND OUT BEHIND STATION ANNOUNCER: As a public service, WEHT presents TRI-STATE STORY—a half hour prepared through the cooperation of the Springfield Chapter of the American Red Cross. Here to introduce our guests for this evening is Mr. John Smith, Director of Public Relations for the Springfield Red Cross. Mr. Smith:
CAMERA ON SMITH	(MR. SMITH THANKS ANNOUNCER AND INTRODUCES TWO GUESTS, MR. HARVEY AND MR. JONES. THEN ASKS MR. HARVEY TO SPEAK.)
CAMERA ON HARVEY CLOSEUP OF PHOTOS ON EASEL	(MR. HARVEY TELLS OF RECENT DISASTER WORK IN HARRISBURG AREA, SHOWING PHOTOGRAPHS OF SERVICE WORKERS. HE WILL RISE AND WALK TO THE EASEL.)
CAMERA ON SMITH AND JONES	(MR. SMITH INTRODUCES MR. JONES. THEY DISCUSS SUMMER SAFETY SCHOOL FOR SWIMMERS. JONES LEADS INTO FILM WITH FOLLOWING CUE): "Now I'd like our viewers to see a film that was made at Lake Roundwood during last year's Summer Safety School."

Continued

VIDEO	AUDIO
SPECIAL FILM CAMERA ON JONES	(8:35) (SILENT—JONES LIVE VOICE-OVER) (JONES INTRODUCES ARTIFICIAL RESPIRATION DEMONSTRATION.)
CAMERA ON TWO BOYS CAMERA ON SMITH	(JONES DESCRIBES METHODS OFF CAMERA.) (SMITH THANKS JONES AND HARVEY AND GIVES CONCLUDING REMARKS.)
SLIDE #3 TRI-STATE STORY	MUSIC: THEME IN AND UNDER
	STATION ANNOUNCER: Tri-State Story, a WEHT Public Service Presentation, is on the air each week at this time. Today's program was prepared through the cooperation of the Springfield Chapter of the American Red Cross.

By permission of American National Red Cross

The working script from CBS Radio's *The American Challenge* series is followed by a transcribed excerpt from that same program. Compare the designations of actuality content and time lengths in the working script with the aired material. A preliminary script would not contain the exact beginnings and ends of the interviewees' quotes and their timing, necessary in subsequent script versions for precise editing, but would indicate the people being interviewed and the anticipated gist of what they would say.

THE AMERICAN CHALLENGE

pgm 10 ward to live free

MUSIC THEME up 3 seconds then under for
 CRONKITE: The American Challenge. Thirty Special Reports this weekend brought to you by

_____.

THEME UP TO END AT :13
 CRONKITE: This is Walter Cronkite, CBS News, reporting on the CBS Radio Network. In a time when the relationship between Great Britain and the colonists in America was steadily growing worse, Thomas Jefferson wrote: "The God who gave us life gave us liberty at the same time; the hand of force may destroy, but cannot disjoin them."
 That's not true anymore. Drugs, electrical stimulation of the brain, the techniques of behavioral psychology can leave life, while taking liberty. An American Challenge, after this.

Continued

(COMMERCIAL INSERT)

Defining freedom is probably a job better left to philosophy students and the people who put dictionaries together. Historian Blanche Cook, a teacher at New York's John Jay College of Criminal Justice, believes it is easier to say what freedom is not.

In: You start looking at what …
Runs: :30
Out: …and stops this man.

Behavioral psychologist B. F. Skinner believes that a concern for freedom has outlived its time.

In: I think you can show …
Runs: :36
Out: …then the behavior will change.

Our very survival, says Dr. Skinner, depends upon controlling people. And the techniques for maintaining that control are available.

In: I think we have that …
Runs: :16
Out: …to use it.

For historian Cook, the problem is quite different.

In: We're using this really splendid …
Runs: :25
Out: …which could free us, really.

To find freedom and the limits of freedom. A matter for debate and an American Challenge; to make liberty more than a word stamped on our coins.

This is Walter Cronkite, CBS News.

#10—TO LIVE FREE

(MUSIC)

WALTER CRONKITE: THE AMERICAN CHALLENGE. Thirty special broadcasts this weekend. This is Walter Cronkite reporting on the CBS Radio Network.

In a time when the relationship between Great Britain and the colonists was steadily growing worse, Thomas Jefferson wrote, "The God who gave us life, gave us liberty at the same time. The hand of force may destroy, but cannot disjoin them."

That's not true anymore. Drugs, electrical stimulation of the brain, the techniques of behavioral psychology can leave life, while taking liberty. An American challenge, after this.

* * *

CRONKITE: Defining freedom is probably a job better left to philosophy students and the people who put dictionaries together. Historian Blanche Cook, a teacher at New York's John Jay College of Criminal Justice, believes it is easier to say what freedom is not.

BLANCHE COOK: You start looking at what the various police departments, for instance, have done with the technology that came out of Vietnam. The most bizarre thing of all is a fancy program: plant an electrode into somebody's brain who steals a lot, let's say, and gets arrested all the time. And he's going downtown to the supermarket, let's say, and all of a sudden the computer picks up that his

Continued

adrenalin is going fast, and his heartbeat is going fast, and they figure out, well, he's going to steal something. The computer programs a shock, and stops this man.

CRONKITE: Behavioral psychologist B. F. Skinner believes that a concern for freedom has outlived its time.

B. F. SKINNER: I think you can show that we are misguided in our insistence on the right of the individual, for example, to breed as he wants, or to consume more than a reasonable share of the resources of the world, to pollute the environment. These are not real freedoms, they are the products of our present culture. And if we can change that culture, then the behavior will change.

CRONKITE: Our very survival, says Doctor Skinner, depends upon controlling people, and the techniques for maintaining that control are available.

SKINNER: I think we have that. We have the rudiments of it. And we have to change our culture in such a way that we will be permitted to use it.

CRONKITE: For historian Cook, the problem is quite different.

COOK: We're using this really splendid technology, which could be used to feed people, you know, to really make our lives very comfortable, we're using it to control people. I think that's the really big challenge: how do we use the technology that we have, which could free us, really.

CRONKITE: To find freedom, and the limits of freedom, a matter for debate, and an American challenge, to make liberty more than a word stamped on our coins.

This is Walter Cronkite, CBS News.

Courtesy of CBS News

The following excerpts from a television working (or final) script, *Ave Maria: The Story of the Fisherman's Feast*, by Beth Harrington, illustrate many of the key elements that make a high-quality feature. As you read the script, note, in sequence, the following techniques of good writing:

1 The opening clearly establishes the locale. At the same time it obtains attention and interest by comparing and contrasting the old and the new, suggesting a dichotomy of change on one hand and no change on the other. The visuals of Boston Harbor become narrowed to the North End neighborhood, bringing the viewer closer to the action.

2 Although the feature is rooted in a historical event, the viewer can best identify with the current practice. The script makes the connection immediately.

3 As with most features and documentaries, the narrator plays a key role. In television, however, unless the narrator is a personality in his or her own right, like Dan Rather or Barbara Walters, he or she should remain in the background, and principally be a voice over visuals. Following the introduction, the narrator's comments in *Ave Maria* are V.O. a montage of historical photos.

4 Actualities are incorporated as soon as feasible, with a fishing captain, Ray Bono, the first key interviewee.

5 Although the interviewee may be telling a story and giving information, the writer does not let him or her become a "talking head" or substitute narrator. Use of visuals located during the research phase is important; for example, newsreel footage of the Boston fishing fleet in 1938 (six decades before the program) is run during the comments of the narrator and Captain Bono.

6 Again, the writer avoids the talking head problem in the Ray Geany interview, with Geany becoming a narrator over appropriate visuals. The same technique is used when the interviewee, band leader Guy Giarrafa, mentions Arthur Fiedler and a visual of Fiedler is inserted.

7 In several places dramatizations are used to enhance the commentary. For example, the feelings and beliefs of the people in the procession are made clearer through the interviews with Fathers #1 and #2 than if those attitudes had simply been described by the narrator. This technique is used again following comments that attendees are North Enders and visitors. Interviews with North Enders and visitors, including children, are developed to enhance human interest and viewer empathy.

8 Though not presenting a political or social point of view as a documentary would, *Ave Maria* nevertheless is sensitive to human aspects of the subject. For example, note Eddie Marino's comment about how the festival helped him overcome alcoholism, and several people telling how participation in the procession affected their personal lives.

9 Although concentrating on the festival's broad aspects, the script does not ignore the religious focus and includes dramatizations to emphasize its importance.

10 The ending is a clear linking, again, of past and present, stressing the event's continuity. We see what is happening, but, most important, we are taken behind the scenes for the human interest factors—a significant component of the good feature.

"AVE MARIA: THE STORY OF THE FISHERMAN'S FEAST"

VIDEO	AUDIO
	(music up and under the following:)
	NARRATOR:
Seagulls in flight, shots of Boston Harbor.	Change?
Changing face of the North End. Key in titles:	The North End has seen its share.
"The North End, Boston, Massachusetts."	From English colonists to Italian immigrants.

Continued

VIDEO	AUDIO
	Big change. It's like they say, the one thing you can count on is change. Pleasure boats crowd out the fishing boats. Tenements become condominiums.
Montage of shots of older North Enders, procession and neighborhood views.	But some things don't change. Like the Italian feasts. Oh sure, they're different now. But they continue. Thanks to a handful of dedicated people, they continue.
	There's one feast in particular that's—special. And this is its story. (fade music)
Fade to black. Fade up on collage intro of faces of feasts. Title: "Ave Maria: The Story of the Fisherman's Feast."	(Roma Band: Marcia Reale)
	NARRATOR:
Montage of historical photos of North End at turn of century, founders of society, etc.	At the turn of the century, Italian immigrants, like these men from Sciacca, Sicily, formed mutual aid societies—combination insurance agencies, support groups and social clubs.
	The Society of the Madonna del Soccorso took care of members' medical needs, provided for burial, and—most importantly—ran the annual feast in honor of their patroness.
	The feast was a tradition dating back to sixteenth century Italy.
Universal Newsreel footage of Boston fishing docks.	But there was a second level of tradition at work here. For generations, the members of the society had been fishermen.
LS of "St. Jude" (fishing boat) going out to sea.	Today, Captain Ray Bono is the grand marshall of the Fisherman's Feast, one of the last in a long line determined to continue the tradition.
	RAY BONO:
MS of Captain Ray Bono.	In my particular family, I'm the only one that's left fishing.
	There may have been maybe 150 boats years ago. Now there might be 20 and most of the 150 boats were more or less family boats. So you were fishing with your cousins, your father, your uncle, your brother, your brother-in-law. Today you haven't got that. Today it's just crews.

Continued

VIDEO	AUDIO
	You might have a couple of boats with a brother on board or something like that. But not many of them are related like years ago.
	NARRATOR:
Universal Newsreel footage of Boston fishing boats at sea in winter. Key in title: "Boston Fishing Fleet, 1938"	The fishermen didn't have it easy. Atlantic winters were hard and the good weather was no picnic either. Then and now, these men put their trust in the Madonna. Ray carries a picture of her on board.
	RAY BONO:
Cut back to Ray Bono in MS.	The boat was sinking. We were waiting for the Coast Guard to come and get us. We threw the life raft overboard. And as we threw it overboard, it deflated. Now we were all alone. The closest boat was 12 miles from us. And I turned to that picture and said, "Save us and the boys." And we got hauled off in the helicopter. And that was the most that I really felt . . . felt for her at that time.
	NARRATOR:
North Enders coming out of church.	The descendants of the fishermen have their own reasons for taking part in the feast.
	RAY GEANY:
CU of Ray Geany. Key in name and title: President, Madonna del Soccorso Society.	As a kid, I never missed a feast. Granted, my father wasn't a fisherman. My father wasn't even Sicilian! But we were brought up with a tradition from my mother's family that this was a major event and we grew up in the feast. Every year we'd come and see the feast and we'd be part of it. Whether we were on a float, or carrying a sheet, we were always part of it. Carrying a flag. As soon as you got a little taller and pestered the committee enough, you carried the saint.
Cutaway to statue of the Madonna.	Joining the society once we reached 18 was very important because we were carrying on a tradition. I didn't get very involved personally to the extent my brother did until . . . my grandmother died. One of her wishes was that we continue the feast. That was important to her. On her bedroom walls, she always had a picture of the Madonna with a candle in front of it. She
Cut back to CU of Ray Geany.	

Continued

VIDEO	AUDIO
	was very devoted. She wanted to see to it that her grandchildren played a role in continuing the society, continuing the feast.
	* * *
Shot of Roma Band playing, zoom onto Guy Giarraffa.	NARRATOR: What would a North End feast be without music? Tarantellas, marches, hymns? The Roma Band began in 1919 and since then has played at nearly every feast.
MS of Guy with name and title: "Guy Giarraffa, Maestro, Roma Band."	GUY GIARRAFFA: The Fisherman's Feast, in my opinion, is Number One, colorful. It's excitement. Why? Because they're Sicilians and I'm Sicilian, too. And we're excited. Around 1970, I remember, I'm laughing, I was directing the Roma Band on North Street. Somebody spotted Mr. Arthur Fiedler, the late Arthur Fiedler walking down the street. So they said, "Guy, it's Maestro Arthur Fiedler." And I said, "So what?" (laughs) He said, "Whaddya mean, 'so what!'?" And I said, "Well, whaddya want to do?" "Shall I tell him to come up?" I said, "Go ahead." So this musician goes down and he begs him. He says, "I belong to the union, I can't." We say, "C'mon, forget
Cut to photo of Arthur Fiedler conducting the Roma Band.	about the union." So he comes over and he directs a march or two. They took pictures and the next day I understand the picture went all over the world, Hawaii, Europe, everywhere. It was a great honor.
Shots of procession as it wends its way through the North End.	NARRATOR: Sunday's procession is an all-day affair. The statue of the Madonna is carried through the streets of the North End.
	(Music under)
	(Music out)
Three-shot of fathers with super: "Angels' fathers."	FATHER #1: I don't count my years by New Year. I'm serious. My year doesn't end or start on New Year's. My year begins and ends with this feast.

Continued

VIDEO	AUDIO
CU of second father.	**FATHER #2:** We used to look forward to this the way other kids looked forward to Christmas. And I remember our parents used to go out a couple of months before the feast and buy us new clothes—new shoes, new slacks, new shirts—We all had to look perfect for the feast.
Montage of money-collecting shots.	**RAY GEANY:** The primary purpose of raising money during the feast is to pay for the feast. As far as being money-making, unfortunately, that's the one thing people see. They see money coming out of the windows, and they look at all that mnoney. Well, you can get a lot of one dollar bills, stack 'em up very high and it looks very impressive. But when you count 'em and you have bills totalling anywhere from $25- to $35,000 dollars, you need a lot of one dollar bills to pay for it. If any businesses was run the way the feasts were run, they'd probably go under in a year.

* * *

	(music up and under the following)
Montage of shots of vendors, visitors and North Enders.	**VENDOR:** During the summertime, you don't have to be Italian to be Italian. Everybody can come down here and be Italian.
	VISITOR: I'm proud to swap my Galway hat for my lovely Italian hat. And God bless everyone.
	NORTH ENDER: It's everyday living. It's just people get together and show their emotions for each other and they're happy.
	NORTH ENDER: It's very good. I like it very much.
	NORTH ENDER: I got to dance three times a week. I gonna dance all my life. Some days I no dance, I'm not feelin' good, I feel sick. I dance, I feel alright.

Continued

VIDEO	AUDIO
	VISITOR: We used to have relatives here. I'm of Italian-American extraction, so we just come down, bring the kids down and try to keep in touch with their heritage. That's basically what it is. You know, you get out to the suburbs, and you become kind of homogenized after a while. You kind of lose some of your ethnic connection, so to speak.
	[INTERVIEWER: What do you guys think of it?]
	KID: It's great!
	[What's your favorite part?]
	KIDS: The food!
	VENDOR: We have fried calamari, the onion ring that tastes like a clam. It's delicious. It's nutritious. Who wants some?
	VENDOR: Who wants one here? Do you want one?
Eddie Marino in his stocking feet, followed by Eddie reciting a prayer to the Madonna.	NARRATOR: As a devotion, Eddie Marino walks the procession each year in his stocking feet. He says his faith in the Madonna helped him overcome alcoholism.
	EDDIE MARINO (V.O.): I was on skid row and I turned to her when she was coming out. I stopped in the street and knelt down in front of her and said, "You make me or you break me." I prayed so much to her I got my wish. (SFX: Eddie's prayer)
Eddie and Jim Geany two-shot, followed by more procession footage of Eddie.	JIMMY GEANY: Eddie, here, I guess you could say is our mascot of the Fisherman's Feast. He is our inspirational leader actually. Of course, we're all dedicated, but I don't think there is anyone more emotionally involved with the Blessed Mother and the feast of the Madonna del Soccorso than Eddie right here.

Continued

VIDEO	AUDIO
Cut back to Jim Geany interview.	Another favorite part of the feast is the angel, what we call the angel ceremony. That's what sets the Fisherman's Feast apart from the other feasts in the North End. It's something special to all the Sciaccadanis.

* * *

VIDEO	AUDIO
	[INTERVIEWER:
Cut to interview with North End woman, key in title: "Ex-Angel."	Tell us about the fact that you were an angel? Can you describe it as you remember it?]
	NORTH ENDER: Well, I would say it was the biggest thrill of my life. I don't know how else to describe it. Except that it's a big honor and it's been traditional. My daughter has done it, my granddaughter, so have all my relatives, my cousins, nieces and so on.
	ANDREA:
Cut back to interview with first angel.	It's uncomfortable because you're on your stomach and all your weight's on the belt and when you're hanging there it's hard to get enough air to say the speech and then it's like I said, the air's hard to get a lot of air in. And some lines you have to put all your air in 'til your next line. It's pretty hard.
Shots of angel getting ready for her "flight," followed by street scenes just prior to ceremony.	(Music up and under the sequence, then out.)
	NARRATOR:
Shots of other angels reciting prayers.	The Madonna has arrived. The angel ceremony begins.
Angel "flight" sequence from start to finish.	(Music up and under the sequence.)
	JIMMY GEANY (V.O.): I guess I do the work I do because I like to think that somewhere up there in heaven my grandfather is looking down at me—who was a fisherman and a charter member of the society—and up there he's smiling somewhere and he's proud.
Fade to black. Credits.	(Music out)

Written by Beth Harrington; courtesy of Ms. Harrington.

DOCUMENTARIES

Next to the drama, the documentary is said to be the highest form of television and radio art. Many broadcast news personnel say that the documentary, combining as it does news, special events, features, music, and drama, *is* the highest form. At its best the documentary synthesizes the creative arts of the broadcast media and makes a signal contribution to public understanding by interpreting the past, analyzing the present, or anticipating the future. Sometimes this all happens in a single program, in a highly dramatic form that combines intellectual and emotional meaning.

Types

Robert Flaherty is a seminal figure in modern documentary development. His *Nanook of the North,* completed in 1922, set a pattern for a special type of documentary film. This type went beneath the exterior of life and carefully selected those elements that dramatized people's relationships to the outer and inner facets of their world. Flaherty started with an attitude toward people: He eulogized their strength and nobility in a hostile or, at the very least, difficult environment.

Pare Lorentz, noted for his productions of *The Plow That Broke the Plains* and *The River* under Franklin D. Roosevelt's administration in the 1930s, forwarded another type of documentary: Presenting a problem that affects numerous people and the ways in which the problem might be solved. Lorentz's documentary type called for positive action by the viewer to remedy an unfortunate or ugly situation. A third documentary or feature type is exemplified by the British film *Night Mail,* produced by innovator John Grierson. The details of ordinary, everyday existence—in this instance the delivery in Britain of the night mail—are presented in a dramatic but nonsensational manner. In this type we see people or things as they really are; we receive factual information without a special attitude or point of view expressed or stimulated.

These types (the documentary writing student is urged to view these films) provide the bases for writing the television documentary today. The documentary can use one of these approaches or—and this frequently is the case—combine two or more types in varying degrees.

Point of View (POV)

Good documentaries have a point of view. What is the *purpose* of the particular documentary you are preparing? To present an objective, many-sided view of a community's traditions and problems? To present solutions to one or more of those problems? By lack of criticism, to justify violence as a means for international political gain? To show the effects of pollution on our natural environment? To carry it a step further and show how the audience can stop the pollution? To show the courage of a particular group—people of color fighting "profiling," women who want control of their own bodies, victims of AIDS—in a

hostile political or social environment? To show that the only way to find true physical and spiritual rejuvenation is to spend one's vacation time in encounter groups (or health clubs, dude ranches, or hot tubs) in southern California? To what degree will the writer's personal beliefs (or those of the producer, network executive, agency representatives, or sponsor) determine program content and orientation?

A point of view is important, whether the program is prepared for a small station with little money or for a network with a big budget. A documentary can be produced with a minimum of equipment: a field camera, tape, and access to an editing room for television; or a couple of tape recorders and some tape for radio. One such documentary, produced as a course project in a radio class at the University of North Carolina at Chapel Hill and winner of a national award for public service reporting, illustrates how simple and direct the documentary-making process can be.

First, the class decided on a subject: the problems of the small farmer in North Carolina's Piedmont region (where the university is located) and the possible relationships of these problems to politics.

The three major documentary types were combined in the purpose of the documentary: to present information in a straightforward, unbiased manner; to show by implication the problem that had to be solved and to indicate several possible solutions; and to present the farmer as a persevering person in a difficult economic environment. The class decided that not only farmers, but also experts from the university should be interviewed and their tapes edited in a sort of counterpoint fashion.

Research was the next step, with as much material as could be found on the problem gathered from an examination of all available literature and from preliminary talks with farmers and persons familiar with the farm problem. The subject and purpose were clarified further and, on the basis of the documentary's projected findings, specific interviewees were chosen—farmers for the size, location, and crop of the farms, and experts for their academic departments and special areas of study.

A careful distillation of material already gathered led to a series of pertinent and interrelated questions to be asked of the farmers and the experts. After the interviews were completed, a script containing the narration and a description of the taped material to be inserted was developed from all the material, including tapes, library research, and personal interviews. A script analysis indicated places that were weak, some because of the lack of material and others because of excess material. Further field work and the addition and pruning of material resulted in a final script, ready for the editing process.

The following are excerpts from a composite of the script and a verbatim transcript of the program. The final script is shown in capitals; the material in parentheses is that actually recorded and incorporated into the program with the narration. Note here the use of numbers indicating the tape and **cut** to be used, with the first and last words of each cut to help the editor.

- *One criticism of this script may be that it tries to cover too many subjects. Another may be that it is not sufficiently dramatic. Take the material contained in the*

script and other material that you can get through your personal research, and rewrite this documentary in outline form, improving it as you think necessary.

THE PIEDMONT, NORTH CAROLINA FARMER AND POLITICS

OPEN COLD: TAPE #1, CUT 1, DUPREE SMITH: "I WOULD LIKE VERY MUCH … BEST PLACE TO WORK."
(I would like very much to spend my entire life here on the farm because I feel like being near the land and being near the soil and seeing the operation of God on this earth is the best place to live and the best place to work.)

MUSIC: IN, UP, AND UNDER

NARRATOR: THIS IS THE SMALL FARMER IN THE PIEDMONT OF NORTH CAROLINA.

MUSIC: UP AND OUT

NARRATOR: YOU ARE LISTENING TO "THE PIEDMONT, NORTH CAROLINA FARMER AND POLITICS." THE VOICE YOU JUST HEARD WAS THAT OF DUPREE SMITH, A FARMER IN PIEDMONT, NORTH CAROLINA. IN RURAL AMERICA A CENTURY AGO THE FARM PROBLEM WAS AN INDIVIDUAL ONE OF DIGGING A LIVING OUT OF THE LAND. EACH FARMER SOLVED HIS OWN INDIVIDUAL PROBLEMS WITHOUT GOVERNMENT AID. NEARLY EVERYONE FARMED. TODAY, BECAUSE OF INCREASING COST OF MAINTAINING CROPS, LARGER SURPLUSES, HEAVIER STORAGE COSTS AND LOWER FARM INCOME, THE SMALL FARMER IN NORTH CAROLINA, AS WELL AS ACROSS THE NATION, HAS BEEN UNABLE TO DEPEND ON HIS LAND FOR A LIVING. PRODUCTION CONTINUED TO GROW, SURPLUSES MOUNTED. FARM INCOMES FELL AND THE GOVERNMENT SUBSIDIES NECESSARILY GREW.

PROFESSOR KOVENOCK: TAPE #2, CUT 1: "THE COMMON PROBLEMS … ARE THESE."
(The common problems shared by almost all national farmers today and, at the same time, most North Carolina farmers, are these.)

NARRATOR: YOU ARE LISTENING TO PROFESSOR DAVID KOVENOCK OF THE POLITICAL SCIENCE DEPARTMENT OF THE UNIVERSITY OF NORTH CAROLINA.

KOVENOCK: TAPE #2, CUT 2: "FIRST OF ALL … SHELTER FOR HIS FAMILY."
(First of all, a decline in the income going to the farmer—a problem of—this is particularly for, let us say, the marginal farmer, the farmer with a small operation in North Carolina and the rest of the country—the problem of obtaining employment off the farm, that is, some relatively attractive alternative to continuing an operation on the farm that is becoming insufficient for feeding, clothing, and buying shelter for his family.)

NARRATOR: THIS IS DUPREE SMITH'S PROBLEM.

Continued

SMITH: TAPE #1, CUT 2:"YES, THAT WAS MY DESIRE ... PART TIME AND WORKING."
(Yes, that was my desire after returning from service, was to go back to nature and live and raise a family where I felt that I would enjoy living to the fullest. For several years, on this same amount of land, I was able to support my family and myself adequately. For the last year or two, this has been on the decrease. The decline has been to such an extent, that I've had to go into other fields—my wife helping part time and working.)

NARRATOR: WHAT SPECIFICALLY ARE DUPREE SMITH'S PROBLEMS?

KOVENOCK: TAPE #2, CUT 3:"THE COMMON PROBLEM ... OCCUPATIONAL PURSUIT?"
(The common problem shared by the North Carolina farmer and by the national farmer would be, first of all, the condition of agriculture, the relationship of the supply of agricultural commodities to the demand and, of course, consequently, the price that the farmer receives which, of course, now is somewhat depressed. The second major problem is the condition of the rest of the economy as a whole—that is, is it sufficiently good so that the farmer has some alternatives to continuing his, currently, rather unsatisfactory occupational pursuit?)

NARRATOR: FARMERS ARE MARKETING MORE, BUT ARE RECEIVING LOWER PRICES FOR THEIR CROPS AND PRODUCE. DR. PHILLIPS RUSSELL, A FORMER COLLEGE PROFESSOR AND RETIRED FARMER, HAS THIS TO SAY:

PHILLIPS RUSSELL: TAPE#3, CUT 1:"THE FARMER HAS BEEN LOSING ... IN AN UNPROTECTED MARKET."
(The farmer has been losing out everywhere, because he has to buy the things that he needs in a protected market and he has to sell in an unprotected market.)

NARRATOR: WHAT IS THE FARMER'S ANSWER TO THIS PROBLEM? FARMING HAS BECOME A BUSINESS INSTEAD OF A WAY OF LIFE. THE FARMER IS FORCED TO CURTAIL HIS ACTIVITIES ON THE FARM IN ORDER TO SUPPORT HIS FAMILY. DR. RUSSELL SAYS:

RUSSELL: TAPE #3, CUT 2:"THAT'S THE ONLY WAY ... 24-HOUR FARMER."
(That's the only way that a man can continue in farming—is to make some extra money in town to spend it out in the country because he's losing everywhere as a 24-hour farmer.)

NARRATOR: FARMER HARRY WOODS COMMENTS:

HARRY WOODS: TAPE #4, CUT 1:"I WOULD HATE ... AT THIS TIME."
(I would hate to have to try—let's put it that way—right at this time.)

INTERVIEWER: TAPE #1, CUT 1 (CONT.):"WOULD YOU LIKE ... IT FULL TIME?"
(Would you like to be able to work it full time?)

WOODS: TAPE #4, CUT 1 (CONT.):"WELL, I ENJOY ... IT'S PRETTY ROUGH."
(Well, I enjoy farming. I enjoy it, but as far as actually making a living out of it, I would hate to think that I had to do it, because it's pretty rough.)

Continued

NARRATOR: MANY BELIEVE THAT THE BASIS FOR SOLVING THE PROBLEM LIES AT THE FEDERAL GOVERNMENT LEVEL. HARDEST HIT IS THE FARMER WHO CAN LEAST AFFORD IT, THE SMALL COMMERCIAL FARMERS WORKING INFERIOR LAND. THEY LACK ADEQUATE CAPITAL TO IMPROVE THEIR HOMES. MUCH OF THEIR EFFORT GOES INTO PRODUCING THEIR OWN FOOD. OFTEN THEY DON'T HAVE THE MECHANICAL AIDS TO MAKE THEM MORE EFFICIENT. THEY ALSO GET LITTLE BENEFIT FROM THE SUBSIDIES AND HIGH SUPPORTS BECAUSE THEIR YIELD IS LOW AND THEY CAN'T AFFORD TO STORE UNTIL THE GOVERNMENT MAKES PAYMENT.

RUSSELL: TAPE #3, CUT 3: "IF FARMING ... THAT'D BE FATAL."
(If farming is to be continued, and the country still has to rely on the farms for three very important things: food, feed, and fiber, and if the farming system collapses, we won't have enough fiber, and in case of war, that'd be fatal.)

* * *

NARRATOR: BESIDES PRICE SUPPORTS, STORAGE AND SOIL BANKS, THE GOVERNMENT SPENDS SOME TWO AND A HALF BILLION DOLLARS TO OPERATE ITS OTHER FUNCTIONS FOR THE IMPROVEMENT OF FARMING. THERE IS LITTLE AGREEMENT AS TO JUST WHAT ROLE GOVERNMENT SHOULD PLAY IN ASSISTING THE FARMER. FARMER HARRY WOODS HAD THIS TO SAY:

WOODS: TAPE #4, CUT 2: "THE FARM PROBLEM ... TO HAVE THEM."
(The farm problem has been with us ever since I've known anything about the farm, and there have been both sides in, and it's never been solved yet. Until they really get down to business and want to solve it, why, it never will be. Now, you said something about politics, why, you know, and I think that everybody else realizes that there is politics in the farm program as they are administered. By the time that they go into the Congress and come out, you know what happens, and, it's difficult to ever work out something that, well, that is workable. But, as far as Republicans or Democrats, why, we've had farm problems under both parties, and I think we'll continue to have them.)

KOVENOCK: TAPE #2, CUT 4: "THERE'S COMMON AGREEMENT ... THIRTY-EIGHT CENTS."
(There's common agreement, common ground for agreement, that during the last seven or eight years that farm income has gone down roughly twenty-five percent. The farm purchasing power is at the lowest point since sometime during the 1930s. Further, we have relatively great social dislocation among farmers and non-farmers in rural America due to the relative decline of the position of the farmer in the economic sphere. We now have more employees in the Department of Agriculture than we've ever had before, and, of course, they are serving fewer farmers. The size of the surplus is, of course, grounds for common agreement. It's multiplied six or seven times; it's now worth, roughly, seven billion dollars. And, of course, the farmer's share of the dollars that we spend in the grocery store has declined now to a low point of thirty-eight cents.)

* * *

Continued

MUSIC:	IN AND UNDER
NARRATOR:	THESE ARE THE PROBLEMS.
MUSIC:	FADE OUT
NARRATOR:	THE ANSWERS ARE NOT APPARENT. THE FARM INCOME DILEMMA SPELLS TROUBLE, NOT ONLY FOR THE FARMERS, BUT FOR THE PEOPLE WHO DO BUSINESS WITH THEM, POLITICIANS, GOVERNMENT OFFICIALS AND TAX PAYERS ALIKE. WHAT DOES THE FARMER, AS A MEMBER OF THE AMERICAN SOCIETY, DESERVE? PROFESSOR S. H. HOBBS OF THE SOCIOLOGY DEPARTMENT OF THE UNIVERSITY OF NORTH CAROLINA HAD THIS TO SAY:
HOBBS:	TAPE #5, CUT 1: "ONE IS THE PROBLEM … ECONOMIC SYSTEM." (One is the problem of maintaining income adequate to maintain a level of living comparable with other groups. This does not mean that farmers deserve an income equal to that of any other group, but he does deserve to have an income that enables him to live comfortably in the American economic system.)
NARRATOR:	IN A REGULATED, PROTECTED, AND PARTIALLY SUBSIDIZED ECONOMY SUCH AS OURS, THE FARMER REQUIRES CONSIDERABLE PROTECTION. THE TASK IS TO DEVISE NEW METHODS WHICH WILL PROVIDE HIM WITH AN ADEQUATE INCOME FOR THE VITAL FOOD WHICH HE PRODUCES.
SMITH:	TAPE #1, CUT 1: "I WOULD LIKE … PLACE TO WORK." (I would like very much to spend my entire life here on the farm because I feel like being near the land and being near the soil and seeing the operation of God on this earth is the best place to live and the best place to work.)
MUSIC:	IN, UP, HOLD, UNDER.
NARRATOR:	YOU HAVE BEEN LISTENING TO "THE PIEDMONT, NORTH CAROLINA FARMER AND POLITICS." THIS PROGRAM WAS A STUDENT PRODUCTION OF THE RADIO PRODUCTION CLASS IN THE DEPARTMENT OF RADIO, TELEVISION AND MOTION PICTURES OF THE UNIVERSITY OF NORTH CAROLINA. ASSOCIATED WITH THE PRODUCTION WERE BUD CARTER, YOSHI CHINEN, JIM CLARK, WILLIAM GAY, ROGER KOONCE, JOHN MOORE, ANITA ROSEFIELD, ALEX WARREN, ANNE WILLIAMS, STEVE SILVERSTEIN AS ENGINEER, AND WAYNE UPCHURCH, YOUR ANNOUNCER.
MUSIC:	UP AND OUT

Structure

Edward R. Murrow's "Who Killed Michael Farmer?" was one of broadcasting's classic documentaries. Although produced for radio, which now rarely does any documentaries, its approaches and techniques influenced video documentaries. Here are some key structural elements in "Michael Farmer" that apply to television as well as radio:

- Select carefully from the mass of taped material several short statements by persons involved and present them immediately to get the audience's attention and interest as well as to tell, sharply and concretely, what the program is about. The stark nature of opening cold—that is, no introduction, no music, simply the statements—can lend force to an opening. Early on let the audience know the approach that the documentary will take. In "Michael Farmer," the narrator says, "But there is more to be said. More is involved here…the roots of this crime go back a long ways." Clearly the event and people will be explored in depth, a problem will be presented, and solutions will be sought.

- Suspense is an important documentary ingredient. But it is not necessarily only the suspense of finding out what is going to happen. Because the documentary is based on fact, we already know what is going to happen in many cases. The suspense can be in learning the motivations, the inner feelings, and the attitudes of the people involved even as the actual event is retold.

- Video documentary makers should be familiar with the techniques D. W. Griffith pioneered for film. One important technique that can be applied to video is dynamic cutting: switching back and forth between two or more settings and two or more persons or groups of people who are following parallel courses in time and in action.

- Various physical and emotional viewpoints are presented in increasingly dramatic order until a climax is reached—much as in writing a play. All of these elements should relate to each other, build on one another, and concomitantly carry the suspense into an ultimate explosion. The audience should be put into the center of the action, feeling it perhaps even more strongly than if the incident or action were fictionalized.

- When the script has almost completed telling what happened, don't be tempted to end it there, as if the documentary's purpose has been accomplished. The script should imply, through the interviews and the narrative, that there is more to the story than "who, what, when, and where." The script can begin to explore motivation, to get behind the problem.

- In getting to the "why," the script can go beyond the actual participants and, where feasible, seek out experts to analyze and comment on the problem.

- In addition to presenting, where available, the solutions to the problem already tried, the script can suggest solutions that are still to come.

BIOGRAPHIES

The biography is a frequently produced documentary/feature type. One of cable television's premier programs has been the A&E network's series entitled *Biography*. This kind of show is sometimes called a "compilation documentary." Nat Segaloff is one of the writers and producers of *Biography*. Segaloff—whose biography production subjects include John Belushi, Shari Lewis, Darryl F. Zanuck, Larry King, and Stan Lee—described the process of writing and producing for this format:

Biography, on the A&E Network, is the heir to the honorable tradition of the compilation documentary. Its creative fathers include David L. Wolper, Mel Stuart, Donald B. Hyatt, Jack Haley, Jr., Robert Youngson, Isaac Kleinerman, and Saul J. Turrell. In fact, it was Wolper and Haley who, from 1961–1964, produced 91 half-hour *Biography* series which A&E licensed and, in 1979, began replacing with their own updated productions.

Unlike the seminal documentaries of Robert Flaherty and John Grierson, the compilation documentary does not attempt to present reality as much as entertain and, on occasion, editorialize. The discipline is to construct a film almost entirely out of previously existing footage linked with narration and interviews that add resonance. Compilation documentaries can be dry ("That War in Korea," NBC, "Project XX," Donald B. Hyatt), electric ("Hearts and Minds," Peter Davis) or entertaining ("That's Entertainment!," Jack Haley, Jr.), but they all have one thing in common: they couldn't exist if somebody else hadn't made another movie first.

Essentially, the producer of a compilation documentary is stuck with somebody else's footage; the trick is giving it a new twist. Within the constraints of its format, *Biography* has a lot of creative space:

1. Tell a person's story in strict chronology;
2. Narrate it in the past tense (even if the subject is still alive, which can be alternately awkward and ghoulish);
3. Have mostly other people tell the subject's story ("It's called 'Biography,' not 'Autobiography'" is the credo) even if the subject is still alive.

Fortunately for "Stan Lee: The ComiX-MAN" (the network's title, geared to capitalize on the popularity of *The X-Men* TV show), Stan was very much alive and we enjoyed the full support of Marvel Comics, which allowed us rare access to artwork, characters, films and personnel—within the limits, however, of a cable TV budget (roughly one-fourth of a network budget).

The complexity of researching, booking, shooting, and editing a one-hour show (actual time without commercials: 43:30) strains that budget.

I like to describe the drill as "an eight-week show that takes 16 weeks to do." Each profile includes between 8 and 12 interviews, 5 to 7 minutes of licensed action material (film clips, music videos, etc.) and between 100 and 200 photographs or supportive action footage (called "B-Roll"). Typically, the interviews are conducted in hotel rooms or private homes. The producer asks the questions, but the subject is directed to give self-contained answers so the producer can be edited out.

The process is to weave a compelling narrative out of these recollections. Sometimes the subjects' stories advance the "plot" of the person's life; other times two, three, or even four people will give separate versions of the same event and the producer and editor must string them together as though they were one continuous tale.

The effect of this interwoven narrative enlivens even the most mundane story— provided it has a good punch line. A voice-over narrator bridges the gaps.

Where TV magazines involve the producer shooting tapes in the field and then throwing them at the editor to finish, *Biography* shows compel the producer to stick with a single story from inception to mix. This is financially inefficient (I don't know of anybody who can do more than four a year), but can be tremendously satisfying work.

The difference is the venue. A&E is enlightened; they recognize that the viewer isn't an idiot. Best of all, since the shows are about real people caught up in real quandaries, it's possible to address complex social and political issues within the framework of a person's personal story.

In an age where documentaries have the reputation of being boring, A&E has the key to making and showing truly subversive television. Don't let this get around.

Getting all viewpoints and all sides and organizing them into a comprehensive whole creates a rounded, complete picture of the person being studied. Segaloff pointed to an example in his biography of "Stan Lee: The ComiX-MAN": the description of how Stan Lee and his wife, Joan Lee, met. Segaloff noted that the following excerpts from the unedited script "show how editing can intertwine two separate recollections of the same incident into the appearance of a single cohesive story…of course, this is planned when we do the interview, but it always works (unless the story tellers have differing memories of the same event)." [In 2002 Stan Lee produced the blockbuster film of one his comic book characters, Spider-Man.]

Stan Lee unedited transcript

NS [INTERVIEWER Nat Segaloff]:
I want to ask you about the most animated person in your life, I'm looking for a segue, that is of course, Joan. You married her on December 5, 1947, but as I understand it according to legend, was that you visualized what she would look like before you even met her?

SL [Stan Lee]:
Well, its a funny thing about how I met my wife. You know, I used to draw cartoons when I was very young, little drawings. Almost everybody who draws, every guy I guess, you, you like to draw girls and you usually draw your idealized girl's face. And it has been the same face that I had been drawing all the time, you know, I, I, big beautiful eyes and a turned up nose, and nice lips and I had gotten real good at drawing this face. And one day, a friend of mine told me that he had arranged this blind date for me, there was a model, at a hat showroom somewhere. In those days, the hat models were the most beautiful girls ever, because they were just taking photos of their faces all the time, for the hats. So I was thrilled about that and I went up the, to this place. Joan opened the door—she was not the girl that I was supposed to meet. She was the head model there and she was one and she opened the door and she's English, so the English accent, you know, may I help you?, and I took one look at her and it was the face I had been drawing all my life. And I think I said something stupid like, I love you, and anyway, that's how we met. I didn't date the other girl, I started dating Joan.

* * *

Interview with Joan Lee

NS:
The classic story of your first meeting with Stan, uh, where you were modeling hats, I'm looking to go back and forth through the stories. You weren't expecting to meet him, as I gather.

Continued

JL [Joan Lee]:

No, not at all. We were having a Christmas party, as a matter of fact. A Christmas party, and there was a little girl called Betty Sue—blonde and very pretty. And Stan was supposed to have a date with her. And I remember it very clearly, he came to the door (laughs) and he had his raincoat thrown over his shoulder. It had to be like this, you know, and a scarf or some- like a cravat. And he said press the doorbell and it was on Fifth Avenue and 37th Street and busy (garbled) called Latham hats. Press the door and I opened it and said hellllo. And he said, hello, I think I'm going to fall in love with you. And I thought this is one I can't let get away. And I was a terrible flirt in those days, too, so I ushered him in, and talked to—I think he took Betty Sue out that night, that was it. And then I think he called a week later, . . . we had lunch and I think it was then he told me he was a writer. I think he did carry a briefcase too. I remember thinking, well, what are you writing? This is wonderful. This is so romantic. This is divine. I mean, we are both so young. And he said, well, I write—I'm editor for a comic book. And I said, oh, comic books, oh, we don't have comic books in England, we don't read comic books. And then he did all those things and I thought he was the most interesting man I have ever met in my life. So, that was it. I decided, the truth, that I absolutely could not let him go. I think it was 8 weeks longer, I was in Reno and we were married and there you go.

To show how the approaches Segaloff described are implemented, following are excerpts from Acts I and V of the program, "Stan Lee: The ComiX-Man," (© A&E Television Networks). This is written in one-column drama form. Segaloff explained that scripts are usually in the two-column television format, but when he was writing this his computer software was not cooperative. Note, however, that the format used is consistent.

"Stan Lee: The ComiX-MAN!"

INTRO — HOST IN STUDIO

 HOST

 Hello. I'm (Peter Graves) (Jack Perkins) and welcome to "Biography." What do "Spider-Man," "The Incredible Hulk" and "X-Men" have in common? If you said "comic book heroes" you'd be on the right track. If you said "Stan Lee" you probably have a closet full of his work. Stan Lee is the man behind the incredible popularity of Marvel Comics. Beginning in the 1960s, he virtually re-invented comic books—and his own life story is as iconoclastic as any of the classic super heroes he helped create.

 FADE OUT

Continued

ACT ONE
FADE IN: Clip: "Spider-Man" (animated)

DISSOLVE TO:

Simmons (3)
04:06:54

GENE SIMMONS
Spider-Man, The Hulk—there's not a, there's not a country
in the world that doesn't know those names.

CUT TO:

Yet more LIGHTNING, then

CUT TO:

Clip: "The Incredible Hulk"

DISSOLVE TO:

Ferrigno (1)
00:08:12

LOU FERRIGNO
When you meet Stan, he to me is the only living Marvel comic
hero on earth.

CUT TO:

Clip: "The Fantastic Four"

DISSOLVE TO:

John Semper
01:48:54

JOHN SEMPER
Think about it: this man took, um, a few short years to lay down
the framework for characters and a popular mythology that
would last for thirty years.

CUT TO:

Even more LIGHTNING, then

CUT TO:

Clip: "The X-Men"

DISSOLVE TO:

Ritter (2)
02:26:14

JOHN RITTER
That's something about Stan Lee: you have the feeling
that, uh, he doesn't want to be bored and he doesn't want
to bore you and, consequently, everything is new and exciting.

Music changes to heraldic Wagnerian themes as we

IRIS TO:

Stan's story told in comic book panels that illustrate the narrative that's to come.

Continued

<div style="text-align:center">NARRATOR (V.O.)</div>

Stanley Martin Lieber—writer—editor. His dream stifled by a boss devoid of vision. Then, one night, he is seized by all-consuming originality. Forsaking his job security, he vents his creative spirit—and revolutionizes an industry to become: Stan Lee: The ComiX-MAN!

<div style="text-align:right">END ON:</div>

The comic book closes to reveal the cover: John Romita's caricature of Stan Lee as Spider-Man. We SUPERIMPOSE the main title:

<div style="text-align:center">Stan Lee: The ComiX-MAN!</div>

Music change to Jazz-era themes as we

<div style="text-align:right">IRIS TO:</div>

Tilt-down a huge collage of comic book covers.

<div style="text-align:center">NARRATOR (V.O.)</div>

The life of Stan Lee is really two stories, and it begins—not with Stan Lee—but with comic books.

<div style="text-align:right">CIRCLE WIPE TO:</div>

<div style="text-align:center">NARRATOR (V.O.)</div>

newspaper strips
"Yellow Kid"

Comic <u>books</u>, as they're known today, evolved from comic <u>strips</u> in daily newspapers of the 1890s. One reason for their popularity was color, and the first to exploit it was Richard Outcault. His 1897 strip, "The Yellow Kid," was so valuable that it sparked a circulation war. The reason: comics sold papers. And when the movies were invented, <u>animated</u> comics—cartoons—began appearing on screen.

Clip: Classic Winsor McKay early animated film (c. 1911) with piano and small combo.

<div style="text-align:center">NARRATOR (V.O.)</div>

In 1933 a printing company salesman named M.C. Gaines conjured a way to keep his presses running on weekends by reprinting daily strips as comic "books." The gambit was sound, but needed a hero.
<div style="text-align:center">(Music change)</div>

<div style="text-align:center">NARRATOR (V.O.)</div>

Superman, published in 1938 by DC Comics, heralded the Golden Age of Comics. Then, two years later, at competing Timely Comics, Joe Simon and Jack Kirby created Captain America—confirming the popularity of comic books. And that brings us to:

<div style="text-align:right">*Continued*</div>

Photo of Stan;
Stock shots NYC c. 1930
and photos

NARRATOR (V.O.)

Stan Lee. He was born in upper Manhattan on December 28, 1922—
as Stanley Martin Lieber. The son of Jack and Celia Lieber, Stan was
precocious, skipping grades and winning the New York Herald
Tribune essay contest three weeks running. Unlike his peers, who devoured
comics, young Stan preferred books: the classics of
Edgar Rice Burroughs, Mark Twain, Arthur Conan Doyle and more.
He also loved movies, and spent his free time at the local
theatre, absorbed in their tales of action and adventure.

SEQUENCE of movie swashbucklers, chases, etc.

* * *

NARRATOR (V.O.)

After graduating high school in 1939, Stan looked for full-time work. A distant
relative, magazine publisher Martin Goodman, needed a helper at one of his
companies, Timely Comics. Stan arrived at Timely's cramped Manhattan
offices just as editor Joe Simon and art director Jack Kirby were creating
Captain America—and preparing to leave.

EVANIER (02:09:00)

[Ah] after ten issues they quit over a financial dispute, ah, starting another
precedent in the industry, but by that time an office boy named Stan Lee
had been brought in. [edit]

NARRATOR (V.O.)

Not taking comics seriously, Goodman gave his 18-year-old office
boy a free hand. This capricious decision would soon change an
entire industry: from 1941 on, Stan Lee and the history of comics
books are one and the same.

EVANIER (02:09:15)

I think Stan's first published story was in Captain America number
three, a little text piece on Captain America written by Stan Lee. It's bylined,
one of the first bylines in comics.

WAR FOOTAGE—recruits in basic training.

NARRATOR (V.O.)

World War Two interrupted the Golden Age of comics and
punctuated the career of Stan Lee, who enlisted in 1942. The Army
posted him stateside with the unusual classification of "playwright."

Continued

NARRATOR (V.O.)

After the war Stan returned to writing and editing comics, which by 1945 had become an industry without a focus.

EVANIER (08:03:04)

The modus operandi of Marvel Comics, or Timely Comics or Atlas Comics was: find out what other people have got that's selling and strip-mine the market. Put out knockoffs of it.

STAN (04:49:10)

We did war stories, romance stories, humor stories, um, horror stories, monster stories, um, little funny animal, animated comic stories. Whatever was the trend at the moment, that's what we did.

NARRATOR (V.O.)

It was also an industry without prestige.

ELLISON (05:08:30)

When they started out, they were considered for kids because, like all native arts, they're demeaned at the outset, whether it's Grandma Moses's painting or the, or the, or the, or the, ah, ah, banjo, or the mystery stories, all of which are singularly American constructs. There're only, there're only about five real American folk arts and comic books is one of them.

STAN (04:55:15)

In those days comics weren't thought of very highly. And I remember when we would go to parties, people would walk over to me and say, What do you do? And I tried not to say it—Oh, I'm a writer, and walk away. But the person would follow me, Well what do you write? Oh, stories for young people. Walk away further, they'd follow me. What kind of stories? Magazine stories. Well, what magazine? At some point I had to say comic books and the person who had been interrogating me would say, Oh, I see, and turn around and leave me, you know.

NARRATOR (V.O.)

One person he met at a party didn't walk away. She was actress- writer Joan Clayton Boocock. They met by accident, and also by Fate, at a social gathering.

STAN (04:49:41)

Well, it's a funny thing about how I met my wife. You know, I used to draw cartoons when I was very young, little, little drawings. Almost everybody who draws, every guy I guess, you, you like to draw girls and you usually draw your idealized girl's face. And there had been one face that I had been drawing all the time …

Continued

JOAN (05:44:35)

And I remember it very clearly: he came to the door and he had his raincoat thrown over his shoulder.

STAN (04:50:35)

Joan opened the door. She was not the girl that I was supposed to meet. She was the head model there and she was the one I had been drawing all my life! And I said ...

JOAN (05:44:58)

—helllllloo. And he said Hello, I think I'm going to fall in love with you—

STAN (04:50:48)

And I took one look at her and it was like the face I had been drawing all my life. And I think I said something stupid like, I love you—

JOAN (05:45:10)

—and I thought this is one I can't let get away.

NARRATOR (V.O.)

Joan and Stan were married in time for Christmas, 1947.

Harsh music under

NARRATOR (V.O.)

By the 1950s, comics returned with a vengeance—literally. Lurid, often violent books captured the imagination of kids—and ignited the ire of their parents. In 1954 the Senate Subcommittee on Juvenile Delinquency investigated the comics.

First commercial break

* * *

Act Five

CLIP: "The X-Men" (SOT under).

NARRATOR (V.O.)

It only took them thirty years to get from newsprint to celluloid, but "The X-Men" captured Saturday morning TV in 1962—and three years later went six days a week.

Scenes of print X-men: Angel, Iceman, Marvel Girl, Cyclops and Beast.

NARRATOR (V.O.)

Originally, they were rebellious mutant teenagers with super-powers: Angel, Iceman, Marvel Girl, Cyclops and Beast. Over the years, and on TV, they became older, but they're still mutants, and still rebellious.

Continued

CLIP:"The X-Men" (SOT under; use other music to show characters)

NARRATOR (V.O.)

"The X-Men"'s enduring appeal comes from their ever-changing composition. Like "The Fantastic Four," who would occasionally take on extra help, "The X-Men" themselves adapted. Over the years they added "Wolverine," "Storm," "Nightcrawler"—new heroes meeting new challenges, but still mutants facing old prejudices.

NARRATOR (V.O.)

In 1994: "Spider-Man." This was actually Spidey's fourth time out: three earlier attempts had been made—by others. This time Stan vowed to get it right, and brought in the experts.

* * *

NARRATOR (V.O.)

Today, comics are a valuable part of culture. That value stems, in part, from their rarity. And that rarity stems from—mothers.

STAN (23:15:40)

I don't know what it is about comics. It seems that every young person in the country or every adult, at some time or other, had his or her mother throw the comic books away.

EVANIER (09:05:06)

The job of mothers is to throw away comic books. The number one, the three things mothers are supposed to do is give birth to you, make sure that you're fed and to, uh, throw away your comic books before they become valuable.

ELLISON (05:09:33)

The idea that they were for kids was promulgated for a long, long time. That's why everybody's mother threw out their comics which are now worth 40 million dollars apiece and everybody cries and gashris about it.

BARNES (20:01:00)

[edit] Now I see those comics that were going for 65 cents, you know, for $20. And I had like a thousand, you know.

SIMMONS (03:27:15)

My mother used to throw out my, you know, comic books and to bring home that first issue of KISS and show her, Remember those comic books you threw out? I'm one of them now.

Continued

FERRIGNO (00:09:15)

[close edit] I probably could have bought another house with the money I could have made.

STAN (23:15:55)

A day doesn't go by that I don't hear that at least once from somebody I meet.

FADE OUT

* * *

Music transition; Stan signing autographs at ComiCon

NARRATOR (V.O.)

Today, Stan Lee's undiminished energy is focused on expanding the Marvel Universe, including his own label called Excelsior. His future is the uncharted realm of fantasy—explored every time a kid, of any age, finds adventure in the pages of a comic book. And, yes—he finally has respect.

STEWART (06:14:42)

I think Stan's efforts were instrumental in creating something that was very contemporary and something that could be respected as an art form as an entertainment form that allowed more people to enjoy it and that by, in and by itself raised it to the level that it is today.

LIEBER (07:29:50)
NEW BITE

What he did to it is what gave it life. Uh, by putting in humor, by having those characters, by the way he did, by, he just wrote it very well and very personal and it, and it took off, and, um, it just grew from them.

ELLISON (05:29:12)
NEW BITE

In my dealings with him, and I'm not an easy guy as you may gather, Stan Lee has always been absolutely four square. Absolutely straight. He has never lied to me. If he made me a promise, he did it.

ASNER (20:17:26)

He's more youthful now than when he began. Uh, he's to be admired. And uh—bottom line—he's a terribly decent chap.

JOAN (05:56:17)

And he's healthy and energetic and talented and very happy being Stan Lee.

Continued

STAN (21:03:33)

When I was a kid, I used to draw a lot, so I figured, hey, I'm gonna try this for a while. I'll get some experience and then I'll get out into the real world and get a real job. I never thought it would be permanent.

Dissolve to head shot of Stan Lee smiling.

FADE OUT

OUTRO: Host in studio

HOST

Like his super-heroes, Stan Lee is down-to-earth and endearingly human. Hollywood filmmakers court him seeking fresh ideas; he travels the country as Marvel's goodwill ambassador. But, with all his success, he still has the optimism that he started with more than thirty years ago. And he shares it with his readers—of all ages. Now here's a look at our next "Biography"

####

"Stan Lee: The ComiX-MAN," Produced by Nat Segaloff.
© A&E Television Networks. All Rights Reserved. Courtesy of Mr. Segaloff.

MINIDOCUMENTARIES

The success of *60 Minutes* prompted the growth of the minidocumentary, or minifeature in a magazine format. The *60 Minutes* hour-length program permits 15–20 minutes per segment, but the half-hour length of magazine shows such as the syndicated *Chronicle* series allows segments of only about 7 minutes per story. The writer must be concise, and, because many minidocs bridge early evening periods between news and entertainment programs, must combine both news and entertainment.

Ron Blau, filmmaker and television writer-producer, has written documentary films, full-length television documentaries, and dozens of minidocumentaries ranging from four to ten minutes each. He believes that the standard documentary and minidocumentary are essentially the same except for the obvious difference: The longer show has more time in which to present information and develop ideas.

Most minidoc writers work through the same chronological process. First is selecting the topic or theme, which can come from any source: the executive producer, the field producer, newspaper stories, and, less frequently, the freelance writer-producer. After the topic is determined, the writer must do appropriate research; some can be done in libraries, some on site, and some through interviews.

Following initial research, an outline is prepared, somewhat similar to a rundown sheet. The outline remains flexible because the writer does not yet know who is going to

say what or what kinds of visual or aural material will be available. Blau advocates outlining a fairly simple structure because there is not enough time in a minidoc for anything complicated. He explained that there are three principal types of material to look for: voice-over, *bites* or quotes, and what he terms "breathing" visuals—video, film, or stills of background, actions, or persons without voice. Room should be left for music, too. The final outline becomes the basis for shooting.

Following shooting, the screening of all materials permits the writer to prepare the final script. According to Blau, most writers structure the piece from the bites and the voice-overs. He advises that the piece be allowed to breathe: A piece on dance could have dance itself shown without any voice-over, and a piece on housing could have film or tape of the neighborhood or of interiors without voice. The latter approach is sometimes referred to as using the **B roll,** arising from the practice of putting interview material on one projector and non-interview visuals on a second or B projector.

Most documentary writers practice the basic principles of journalism: start with a strong topic opening giving the essence of the piece, follow immediately with the five Ws, then fill in the details in whatever time is left. Some writers structure the piece around voice-overs and fill in with the bites and breathing shots. Ron Blau's approach is to begin with something attention-getting that is of special interest to the audience, then fill in the basic structure with field materials, and, finally, add the voice-overs.

With the numerous pieces needed for a given program series (sometimes at least three for every half-hour show), and the limited time available to produce them (sometimes less than a week per segment), you need either to have a large staff or to take extra care to see that all the information is accurate. Be careful not to take liberties with the facts if you find that time and staff haven't permitted you to get all pertinent information. Write from what you have. Don't make up facts to fill in. Many minidocs essentially repeat what has been covered in the press, and you may be tempted to embellish to give the story a new look. Where do you draw the line between factual documentary and fictional documentary? *New York Times* critic John J. O'Connor referred to the result of the failure to make the distinction as the "questionable craft of 'docudrama.'" Don't pass off fiction as fact.

■ *Following are excerpts from two short sequences from one of Ron Blau's mini-documentary scripts,* **Prodigies.** *Analyze where and how they follow Blau's writing approach.*

◤

PRODIGIES
Intro

VIDEO	AUDIO
KIDS	MUSIC: In, up, and under.

Continued

VIDEO	AUDIO
Pix from Josh's nursery school without Josh in shots.	NARRATOR (V.O.): Until now we have been looking at forces which shape a child's mind at close range: like gifts a child is born with … and the family's effect.
Exterior with kids.	But some forces are as big as America itself.
	These forces are cultural influences—which push some ethnic groups to the top—which allow more boys than girls to shine in some fields—which limit the progress of other groups.
	America may seem like a great melting pot, but within her borders cultural pressures still encourage some of her people more than others to travel paths of giftedness.
End of Intro	
Exterior: Wei-Jing's school.	MUSIC: Rap music, in and up.
Interior: Hallways.	SFX: Natural sounds. Music out.
	NARRATOR (V.O.): Each year the Westinghouse Science Talent search rewards a few outstanding high school students with the largest no-strings-attached scholarships in the country: up to $20,000! Recently, the top five awards <u>all</u> went to a single ethnic group.
Math Club	SFX: Natural sounds, then V.O.
Wei-Jing at computer SOT	WEI-JING: Normally in class I try to comprehend what's going on. And most of the time I remember everything. And so when a test time comes, it's just like a normal day. And I really look forward to tests since when there's a test that means there's less homework.
Frisbee	NARRATOR (V.O.): Wei-Jing, who's a descendent of the first emperor of the Ming Dynasty, is now headed for Harvard.
Wei-Jing SOT	WEI-JING: I'm hardworking in the sense that I am very, very inquisitive and curious about things and like to find out the why's and how's in nature and … well … I'm just very curious about things. And also I like to find competitions that I can enter. For example, I enter all the math contests.
Benjamin Bloom SOT	BLOOM: We study parents in Japan, Hong Kong, and in other countries and ask the parents, "How would you explain your child doing poorly in school?" The Asiatic parents explain it in terms of the amount of effort the child puts in. In the United States, when we ask the parents, for example, "Why is your child doing poorly in arithmetic?" the mother says, "Well, I was never good at arithmetic." They reply that this is an inherited defect.
Japanese file footage.	
American school.	

Continued

VIDEO	AUDIO
Japanese file footage.	NARRATOR (V.O.): Asia, of course, is an entire continent, with an enormous density of people. These children are from Tokyo … but they share with children in Beijing and Phnom Penh an ancient tradition of discipline, of respect for learning, and of status based on educational achievement.
Wei-Jing SOT	WEI-JING: I guess the major factor is that the Asian people … like the families … are really hard and demanding in what their sons and daughters achieve. They are expecting very high achievements from their children. And I guess that's the major factor.
End with Frisbee shot.	
End of Wei-Jing segment.	
Edith doing math at blackboard with friend Carlos.	SFX: Natural sound—conversation—5 seconds.
Edith SOT	EDITH: I think it started when I got into high school and they had a math team and I'd never heard of such a thing. The idea of being able to go out and do math problems for fun and for competition was terrific.
	NARRATOR: The "Math Olympiad" is a competition to find the top eight high school math students in America. In the history of the Olympiad, Harvard student Edith Starr is the only <u>woman</u> ever to win. Altogether, only a small fraction of mathematicians are female.
	Why are women a rarity in some fields? We noticed only three in a chess match we covered with Ilya Gurevich … out of a field of 142 players. We were told this is typical.
	It's <u>possible</u> that genes play some part in this imbalance; no one's proved otherwise. But most experts point to <u>cultural</u> forces.
Ruth Feldman SOT	FELDMAN: Even today I think girls grow up thinking that somebody is going to take care of them. That they're going to be wives and mothers and maybe they are going to have careers for a while, but they can always fall back on a man. So I think with gifted girls, particularly, it's important to give them the idea that they really can make their own decisions. They can choose a career if they want to, they can choose home and motherhood if they want to. These options need to be available to girls.

Continued

VIDEO	AUDIO
Edith walking.	NARRATOR (V.O.): So, Edith Starr is an exception who can light the way for others. She feels she's successful in math because she was not brought up like most other girls.
Edith SOT	EDITH: My parents encouraged me although they didn't push it on me in any way. But they were always happy when I did well. And I guess they always encouraged mind puzzles, word games. I had a lot of teachers, as well as my parents, who encouraged me in everything I did without pushing me.
	NARRATOR: Regardless of the field, fewer girls than boys get identified as prodigies. But this imbalance may someday disappear.
Feldman SOT	FELDMAN: Once the culture begins to entertain the possibility that the same kinds of extraordinary possibilities exist in girls as in boys, you'll start seeing girl prodigies. It's
End with pix of girls.	as simple as that.

Courtesy of Ron Blau and WBZ-TV, Boston

Special Considerations

Features and documentaries are especially adaptable to programming for ethnic and racial groups. Some critics have suggested that unless you belong to the group being presented in the feature or documentary, you may not have sufficient firsthand knowledge and emotional understanding of that group to write about it accurately, perceptively, and with depth—even with the best will in the world.

Loraine Misiaszek, who was director of Advocates for Indian Education and a producer of radio and television programs by, about, and for Native Americans, found that non-Indian writers frequently use words such as "squaw" and "breed," not realizing how derogatory they are. She also expressed concern with programs about Native Americans that are "put-downs," that editorialize instead of presenting the facts, and influence listeners into drawing conclusions that judge Native American actions as "bad," whereas an outside objective view might find them to be "good." "Anyone concerned with scriptwriting for radio or television," Misiaszek warned, "ought to be aware of this problem. It is not necessarily intentional, but it happens because of the general conditioning in our society that causes people to think of Indians in terms of stereotypes."

The same viewpoint was expressed by Thomas Crawford, who wrote and produced Native American programs. The writer "must first of all become familiar with idioms,

patterns of expression, turns of thought, and pronunciations of the particular Indian community with which one is dealing," Crawford stated. "This kind of background will enable a scriptwriter to deal with the subject in a way that will interest and be appropriate to the people." Crawford stressed the need for personal experience and empathy by the writer. "The complexities of writing a program for or about Native Americans on a national level would be nearly prohibitive for the non-Indian. An Indian writer can present idioms and viewpoints as a valid part of the Native American scene in the United States."

These concepts can be applied to almost every racial, ethnic, and other special group, especially when you are writing a feature or documentary, which requires you to be knowledgeable about the subject. One example is the following radio documentary about Native Americans, *Who Has the Right?*

Begin with Intro music (stick-game song played and sung with guitar). Fade into Narrator: Who has the right? The first in a series of programs on The Kootenais: Their Political Power in Northwestern Montana.

The Kootenai people have occupied northwestern Montana since "time immemorial." Before white men came the Kootenais hunted bison, deer and elk, and thrived on the local berries and herbs which at that time were abundant. Aside from occasional conflicts with the Blackfeet, they lived peacefully and controlled their own lives.

Today it is a different story. The United States Government has included them in the Confederated Salish and Kootenai Tribes of the Flathead Reservation; the Kootenais number roughly 1/10 of this confederation. Of the ten members of the tribal council, the Kootenais have one representative. They also find themselves heavily outnumbered by the non-Indian people of Lake County, where most of the Kootenais live. Even in Elmo, a town on the northern end of the Flathead Reservation which is 90 percent Kootenai, the two stores, the grade school and the water commission are all run by non-Kootenais. This situation existed for many years, and has created a certain amount of frustration among Kootenai people. Lyllis Waylett, tribal development specialist of Pend d'Oreille descent, put it this way:

> I would say that the Kootenai area people have been isolated or remote from the focal point of our tribal government and I think that they've been disadvantaged because of it. I don't think that they've seen good things—if indeed there have ever been any good things flow from the government to the Indian people, the Kootenais and their primary area of residence on our place. I feel that this has strained relationships."

NARRATOR: Residents of the Elmo area express their difficulties with the present situation:

> "It seems like so many other people around here try to run the place. They don't give us minority a chance to really speak our piece." (G. Crew)

Continued

"Do you think the Kootenais have a strong voice in council affairs? No, because of the fact that we, the Kootenais, have only one Kootenai in the council." (B. Kenmille)

"Well, we went across to that island, we circled the island. We found ten deer—ten deer dead. Whoever killed them or whatever killed them took the head. It was sawed off, we could tell it was sawed off.... I think it must be the white guys did it because they wanted the head and the horn. If an Indian did it, they would have took the whole deer. An Indian would have took the whole deer. They use every part of the deer." (F. Burke)

"When the people come out from Washington, D.C. and ask how the Indians been treated they take them to these new houses where these people are well off. They don't take them around to these lower grades of Indians, or show the all tore-up houses.... They really should take them around right here in Elmo here. Because I know there's a lot of people that really need help." (L. Stasso)

* * *

Within a social structure, one can often tell which group feels in control and which group feels that it has no power by asking the simple question, "What are the needs of this area?" Those who feel in control will probably see few if any needs. Kootenai Communications found that while non-Kootenais by and large saw no great needs in the Flathead Valley area, Kootenai people saw some very immediate ones.

* * *

To understand the wisdom of the Kootenais, one must first understand their history. This history goes back many centuries. It begins with the Kootenai as a plains people, occupying much of the land now held by the Blackfeet, the Assiniboine, and other present-day tribes of the northern plains.

Maulouf, 395 ("Going back ...") to 487 ("other side of the divide")

The Kootenai organized themselves into regional bands, each with its chief and subchiefs, each with its own government, yet all sharing the Kootenai blood, language, and way of life.

Malouf, 20 ("Of course, the Kootenai had ...") to 70 ("one of their most ancient important centers")

When the Kootenais were invited to join the Salish and Pend d'Oreille at Council Groves to make a treaty with the whites, they saw no reason to come. They had seen few of the whites and were certainly not threatened by them.

* * *

Throughout the century following Council Groves, this question would plague the Kootenais: What right, after all, did the whites have to make decisions for them, to control their lives? Next week we

Continued

will historically trace some of the economic and social problems which resulted from the decision to place the Kootenais on the Flathead Reservation.

(Fade-in with theme music)

NARRATOR: This program was produced by Kootenai Communications with the help of a grant from the Montana Committee for the Humanities. The views expressed here do not necessarily reflect those of the Committee.

Written by Tom Crawford, Advocates for Indian Education and KPBX-FM, Spokane, and Tony Grant, Kootenai Communications, Elmo, Montana. Broadcast on KOFI-AM, Kalispell, and KUEM-FM, Missoula.

APPLICATION AND REVIEW

1 Write a routine sheet for a how-to-do-it *radio* feature. The subject should be important to a professional or vocational group in your community.

2 Write a script for a behind-the-scenes human interest *television* feature. The purpose should be to persuade as well as to inform. Try a public health or social welfare subject or a biography.

3 Write a documentary script for television *or* radio, using one or a combination of the basic documentary types. Choose a subject that is vital to the welfare and continued existence of humanity, and that is controversial in your community as well as nationally.

4 Write a documentary script for the medium not used in exercise 3. Choose a subject that is relatively unimportant and not of vital interest to humanity. Can you, even so, incorporate a point of view that makes the documentary pertinent to your community?

5 Outline a 15-minute segment that might be appropriate for *60 Minutes* and a 7-minute segment for a TV magazine program.

6 Analyze one script you have written for exercises 1–5. Does it give equal consideration to the status and viewpoints of both genders? If women or racial or ethnic minorities are part of the subject covered, are they presented objectively and honestly?

7

Interview and Talk Programs

The term *talk programs* encompasses the major program types that are not news, documentaries, drama, music, features, game shows, education and training programs, or commercials. That leaves interviews, discussions, and speeches. In the 1990s the "talk" show phenomenon swept radio and into television. Talk hosts and hostesses dominated nonmusic radio stations, and even many music stations added talk programs to boost ratings, especially in the evening and late night hours when television dominates the airwaves. The tenor of the times affected and was reflected in talk program growth, the nation's political conservatism spawning commentators such as Rush Limbaugh; there were relatively few liberal commentators. Some talk shows are editorial commentaries; some are interview or discussion programs. A guest is either interviewed or engages in a discussion of specified issues with the program personality. Often, call-in lines permit the public-at-large to participate as discussants and, occasionally, as interviewees. Such political talk shows are principally on radio, but some are found on television and cable, such as *Larry King Live,* which follows this pattern and was developed in King's radio show that preceded his television program.

Purely entertainment talk shows that only sporadically go into the serious political or social sphere also proliferated. *Oprah*'s success in airing not only ideas and attitudes, but also emotional and physical—principally sexual—feelings and experiences has led to many similar shows on television and radio. These also are essentially interview shows.

None of these formats require fully prepared scripts. Interview and discussion shows are outlined, either in *rundown* or *routine sheet* form. The principal reason they cannot be fully scripted is that the interplay of ideas and, sometimes, feelings among the participants requires extemporaneity. Another reason is that the participants, excluding the interviewer or moderator, usually are not professionals and cannot memorize or read a prepared script

without seeming strained or stilted. The speech, of course, is fully prepared, including the intro and outro.

Nevertheless, the writer should complete as much of the script as necessary and possible. Why take a chance with an unprepared question or unanticipated answer or an irrelevant series of comments when the chances of success are better with prepared material? Some talk programs that have long-established formats and experienced questioners or moderators may need only a **rundown sheet**—a detailed list of all program sequences with the elapsed time, if known, for each item.

The more detailed **routine sheet** contains as much of the actual dialogue and action as can be prepared, including remarks that are designed to appear as ad-libs to the audience. The improvised nature of talk shows makes them more open to mistakes, slow action, dullness, and the other afflictions that mark unscripted, unrehearsed programs. Good writers (and producers, directors, and performers) want as much preparation as possible.

Because broadcasting operates on a split-second schedule, the final version of the rundown or routine sheet must be adhered to as meticulously as if it were a fully scripted program that had been rehearsed down to the exact second of playing time. Sometimes alternate endings of different lengths are included so that the director can choose the right one, especially in live shows, to make the program end on time.

THE INTERVIEW

Interviews are used in many programs, especially news, documentaries, features, corporate and educational programs, and, of course, interview shows. The basic approaches for the interview are essentially the same for all these formats.

Types

The three major interview types are the opinion interview, the information interview, and the personality interview. Any given interview can combine elements of all three.

The Opinion Interview

Any interview that concentrates on the beliefs of an individual can be an opinion interview. Because many of these interviews are with prominent people, usually experts in their fields, such interviews are often information and even personality interviews as well. Even in the completely ad-lib street interview, the interviewer should have an introduction, a question, and follow-up questions developed for possible answers. Prospective interviewees can be briefed before the program is taped or goes on the air live.

The Information Interview

The information interview usually is the public service type. The information can be delivered by a relatively unknown figure or by a prominent person in the field. Because the main objective is the communication of information, sometimes a complete script will be

prepared. The interviewee can provide direct factual material, deliver information oriented toward a cause or purpose, or combine information with personal belief. If a script is written, the speaker's personality should be considered. If the interviewee is not likely to be a performer—a good "reader"—then it is better to prepare a detailed outline and to rehearse the program as an extemporaneous presentation.

The Personality Interview

This is the human interest, feature story interview. The program format can be oriented toward one purpose—to probe, embarrass, or flatter—or it can be flexible, combining and interweaving these various facets. The most successful recent personality interview programs seem to be oriented toward a combination of probing for personal attitudes and revelation of personal beliefs and actions. To prepare pertinent questions for the personality interview, obtain full background information on the interviewee. Outline the questions and talk with the interviewee before the program to prepare the in-depth questions and the logical order of questioning.

Preparation

The television or radio interview may be prepared completely, with a finished script for the interviewer and interviewee. It may be oriented around an outline, where the general line of questioning and answering is prepared, but the exact words used are improvised. Or it may be completely unprepared, or ad lib.

Very rarely are interviews either completely scripted or completely ad lib. The full script usually results in a stilted, monotonous presentation except where both the interviewer and interviewee are skilled performers who can make a written line sound impromptu, a situation that does not often occur. On the other hand, the totally unprepared interview is too risky, with the interviewee likely to be too talkative, embarrassing or embarrassed, or just plain dull, and the interviewer faced with the almost impossible task of organizing and preparing appropriate questions on the spot.

Most interview scripts are written in outline form. First, the producer, interviewer, and writer prepare a broad outline of the purpose and form of questioning. Following intensive and extensive research, they prepare appropriate questions. To be ready to ask meaningful questions in a logical order, the interviewer must have an idea of the possible answers to the major questions already developed. For this purpose, a preliminary conference, or **pre-interview,** is held whenever possible. The interviewee is briefed, sometimes lightly, sometimes fully, on the questions to be asked. The interviewee indicates the general line of answering. Then the writer develops follow-up and probe questions and arranges them in the most logical and dramatic order. The rundown or routine sheet lists the actual questions to be asked, the probable answers, and follow-up questions based on those answers.

Sometimes, of course, the interviewee is not available for a pre-interview, and the writer must guess at the probable answers. If the research on the interviewee has been thorough and accurate, a certain consistency can be correctly anticipated. Sometimes the

interviewee who can't be pre-interviewed can be persuaded to come to the studio before the program is to be aired or taped for a brief discussion or rehearsal. In such cases the writer works closely with the producer and interviewer to revise the material already prepared, right up to the last minute. When the interviewee cooperates by permitting both a pre-interview and a pre-show meeting, the writer's opportunity for developing an excellent script is greatly enhanced.

The key to the successful interview is preparation. The writer/researcher must dig deeply, and the interviewer should be equally familiar with the interviewee's background, attitudes, and feelings. We've all seen too many interviewers who are obviously poorly prepared. Michael McLaughlin, author of *Screw,* a controversial book about the prison system, appeared on many talk/interview shows on radio and television and insists that there is a big quality difference in the programs where the interviewer has taken the time and effort to actually read the book: "When the interviewers have done their homework, know the book, have prepared good questions, and can follow-up with an intelligent discussion based on the book, the shows are much livelier and more interesting."

Phyllis Haynes, writer, producer, and host of interview shows on national, regional, and local television, also advocates good "homework." Although interviewer approaches vary—Barbara Walters's conversational empathic approach, Ted Koppel's academic approach, Oprah Winfrey's enthusiastic probing with questions the average viewer might ask—preparation is the key. "Reading about the guest, reading what the guest has written, preparing questions that reveal a deep level of understanding and concentration," Haynes states, are key ingredients of good interviews.

One of the most successful interviewers in television history, Barbara Walters has conducted interviews combining all three interview types: opinion, information, and personality. She always comes across as confident and comfortable in questioning interviewees in all of these areas and talking in depth with them, often eliciting information and feelings not previously revealed. Some of her interviews with political leaders result in headline-making statements affecting world affairs. How does she do it? Through intensive research and preparation.

Neophyte interviewers and writers who learn that Barbara Walters's shows have no formal prepared scripts sometimes assume that there has been no preparation. Actually, the detailed research reports and extensive lists of questions Walters requires of her staff frequently entail more work than the writer might do for many other formats with full scripts. For example, for an interview with Carol Burnett, Walters worked from a 38-page research report that provided chronological facts about Burnett's life, quotes from various sources about her personal, as well as professional background and beliefs. From the research report Walters developed a list of more than 100 probe questions, only a fraction of which could be used in the actual interview.

The following are excerpts from the Burnett interview research report. Note especially the categories of questions; these and others not included in the excerpts cover all possible areas of thought and experience.

CHRONOLOGY

4/26/34	Carol Burnett born in San Antonio, Texas
1938 or 1939	Parents move to Los Angeles
1940	Carol and Grandmother move to Los Angeles
Dec. 1944	Sister Christine born
1946	Parents divorce
June 1952	Carol graduates Hollywood High School
1952–1954	Carol attends UCLA
1954	Carol's father, Jody, dies
August 1954	Carol goes to New York
1955	Carol appears 13 weeks, Paul Winchell's television show
	Marries Don Saroyan
Sept. 1956	Begins as regular on TV show "Stanley"
11/9/56	First appearance on Garry Moore morning show
March 1957	"Stanley" cancelled
July 1957	First nightclub appearance, Blue Angel
	Sings "I Made a Fool of Myself Over John Foster Dulles"
Dec. 1957	Visits L.A. Brings sister back to New York
1/10/58	Mother dies
1958–1959	Regular "Pantomime Quiz," ABC
1959	Separates from Don Saroyan
May 1959	Off-Broadway show, "Once Upon a Mattress" later moves to Broadway

* * *

CHILDHOOD - FAMILY - EDUCATION

Carol Burnett was born in San Antonio, Texas, April 26, 1934.

"I'm a lot Irish, and I'm part Indian . . . we were Irish and English and there was Cherokee blood."
Esquire, June 1972

Carol's father, Jody Burnett, was a movie theater manager in San Antonio. She says that he was a charming man, but weak-willed, more interested in drinking than working.

"He was a lanky six feet two and a half inches tall—and not unlike Jimmy Stewart in speech and mannerisms."
Good Housekeeping, December 1970

Carol's mother's name was Louise Creighton Burnett.
"Mama was short, fiery, quick-witted and quick-tempered, but basically kind."
Good Housekeeping, December 1970

Continued

"I got my sense of humor from my mother. I'd tell her my tragedies. She'd make me laugh. She said comedy was tragedy plus time."
TV Guide 7/1/72

Sometimes in the late 1930s, Carol's parents left her in Texas with her grandmother, Mae White, and moved to Los Angeles. In 1940, Carol and "Nanny" joined them.

Jody and Louise fought a lot and were frequently separated. Christine was born in December 1944, after one of their brief reunions.

* * *

CAREER

Carol used to say that she left California because
"To succeed in the movies, you have to look like Marilyn Monroe or Tony Curtis. Unfortunately, I look more like Tony Curtis."
Current Biography, 1962

Carol arrived in New York, August 1954, and Don Saroyan followed a month later. Carol moved into the Rehearsal Club, a hotel for aspiring actresses, made famous in the stage play and movie, "Stage Door." Her first job was checking hats in a restaurant in the Rockefeller Center area.

"The one thing I can tell (aspiring actors) is, Get a part-time job. So when you see a producer you don't have that desperate starved, I'm-going-to-kill-myself look."
Current Biography, 1962

She made the rounds of producers and agents and got the same old story, I can't give you a job until I see your work. Finally, one person suggested she put on her own show.

* * *

PERSONAL

Sometime in the early 1970s, Carol lost a lot of weight, going from a size 14 to a size 8. About the same time, she quit smoking, gave up coffee and became a vegetarian. She eats no red meat, but it goes further than that.

"I don't eat any canned foods, any frozen foods."
TV Guide 4/14/79

* * *

QUESTIONS—CAROL BURNETT

1. Right now, this minute, how is your life?
2. If your life was a movie, can you give us a synopsis of the plot?
3. How would you describe Carol Burnett?

Childhood
1. What is your strongest childhood memory?

Continued

5. What kind of person was your mother?

5A. You've said that your mother "cuffed you around." Was it, although you may not have realized it then, a case of child abuse?

6. Did you feel you were pretty? Did she?

7. What kind of person was your father?

* * *

Youth

22. From everything I've read about you, for much of your life you had little confidence, yet you became an enormous success. What kept you believing in yourself?

23. You were only 23 years old when you decided to bring your 12-year-old sister to New York to live with you. Wasn't that a lot to take on then ... your career was barely under way ... then your mother died.

24. I read that you were able to go to UCLA because someone anonymously left the tuition money in an envelope for you. Is that true?

* * *

Career

30. You did the Carol Burnett Show for eleven years. Will you ever do another television series?

* * *

37. Do you have any political involvements?

* * *

Meditation/ Reincarnation

76. I understand you meditate. Do you do it regularly? What does it do for you?

77. Are you religious?

78. I read that you believe in reincarnation. Do you have any feelings about who you were in other lives?

Courtesy of Barbara Walters and the American Broadcasting Company

Research

The volume of material for the Carol Burnett interview clearly shows that research is the key to effective preparation. Find out everything possible about the interviewee (or for a noninterview script, about the subject matter). What has the interviewee written? Are there any biographical materials, either in a complete book or in magazine articles, such as music, film, theatre, art, dance, business, or scandal magazines. The same is true for political figures, business executives, and other professions as well. *Who's Whos* are a good source for initial background information.

Sources for information include the Internet, libraries, and the archives and morgues of stations and newspapers. Helpful documents may be on file in government offices if the interviewee (or subject matter) has been in any way connected with the government. A politician or political subject? Talk to political organizations; ask to see available files. Citizen-activist or public interest matters such as pollution, welfare, health care, housing, and similar areas? Try civic associations. Physician? Educator? Attorney? Architect? Psychologist? Professional associations cover virtually every field. An increasing number of celebrities, principally political figures, have Web pages on the Internet.

Don't hesitate to contact experts in the field of the interviewee or subject matter. If you dig hard enough you'll find more than one expert familiar with the interviewee or with even the narrowest topic. Become so thoroughly familiar with the person or subject that the questions you prepare are intelligent and meaningful. Don't waste your time and theirs with innocuous questions or ones to which answers are available elsewhere. Make the most of the time you have with the interviewee.

Get the information you need for the interview, the feature, or the news story firsthand. Often you can find secondhand or thirdhand sources who are completely trustworthy. However, the information may already have been distorted when it reached them. Talk to people first who personally know or knew the interviewee, who have worked with the subject or actually participated in the event. Talk with eyewitnesses, with the people directly and actively involved. Only after that should you talk with people who know *about* the person or topic.

Be sure your research is accurate by choosing your sources carefully and correctly, and by evaluating what your sources tell you. Be careful of individual points of view. You want the facts first; interpretation comes later. Don't confuse the two. Repeat questions if you are not sure you heard the entire answer or heard it all clearly. Unless you have a photographic memory, don't trust that you will remember everything accurately. Write the information in a notebook or on file cards or, if your research source is a person, make a tape recording.

Don't forget audience research, which is as essential for the talk show, including the interview, as for any other type of program. How much might the audience already know about the topic and the person being interviewed? What are the audience's likely attitudes toward the topic and the interviewee? You can't prepare the interview orientation or the specific questions until you know the probable answers.

Format

In all interviews—prepared, extemporaneous, ad-lib—the writer prepares at least the opening and closing continuity, introductory material about the interviewee, and for each section of the program, lead-ins and lead-outs for commercial breaks. And, of course, there are the questions to be asked and, if possible, the probable answers.

The closing continuity should be of varying lengths in case the program runs short or long. Without a script that can be rehearsed for time, such flexibility is necessary.

Each interview program has its own organization, and the writer must write for that particular format. Some interview shows open with an introduction of the program, note the topic or approach, and then introduce the guest. Others open cold, with the interview already under way, to get and hold the audience's attention, and then bring in the standard introductory material.

The following format rundowns from *Face the Nation* are simple, clear, and classic program approaches, illustrating both kinds noted earlier. First, the script for CBS Television features an announcer introducing the show and a follow-up billboard and then the interview, followed by standard closing material. Next, the CBS Radio script opens with the interview in progress, then cuts away for the standard introduction. Following the interview is the standard close.

CBS TELEVISION
Face the Nation

HERMAN TEASE QUESTION _____
SENATOR _____ ANSWERS _____

(ANNCR: V.O.)

FROM CBS NEWS WASHINGTON . . . A SPONTANEOUS AND UNREHEARSED NEWS INTERVIEW ON "FACE THE NATION" WITH SENATOR _____. SENATOR _____ WILL BE QUESTIONED BY CBS NEWS DIPLOMATIC CORRESPONDENT MARVIN KALB, DAVID S. BRODER, NATIONAL POLITICAL CORRESPONDENT FOR THE WASHINGTON POST, AND CBS NEWS CORRESPONDENT GEORGE HERMAN. "FACE THE NATION" IS PRODUCED BY CBS NEWS, WHICH IS SOLELY RESPONSIBLE FOR THE SELECTION OF TODAY'S GUEST AND PANEL.

BILLBOARD _____ 10 sec. _____
COMMERCIAL _____ 1:40 _____

(HERMAN CLOSING)

I'M SORRY GENTLEMEN, BUT OUR TIME IS UP. THANK YOU VERY MUCH FOR BEING HERE TO "FACE THE NATION."

COMMERCIAL _____ 30 SEC. _____

(ANNCR: V.O.)

TODAY ON "FACE THE NATION" SENATOR _____ WAS INTERVIEWED BY CBS NEWS DIPLOMATIC CORRESPONDENT MARVIN KALB, DAVID S. BRODER, NATIONAL POLITICAL CORRESPONDENT FOR THE WASHINGTON POST, AND CBS NEWS CORRESPONDENT GEORGE HERMAN.

BILLBOARD _____ 6 SEC. _____

"FACE THE NATION" HAS BEEN SPONSORED BY IBM.

Continued

(ANNCR: V.O. CREDITS)

NEXT WEEK ANOTHER PROMINENT FIGURE IN THE NEWS WILL "FACE THE NATION."
THIS BROADCAST WAS PRODUCED BY CBS NEWS. "FACE THE NATION" ORIGINATED FROM
WASHINGTON, D.C.

CBS RADIO
Face the Nation

12:30:00–12:58:55 P.M. _____
(Date)

OPENING: Radio takes audio (Herman asks tease question, guest(s) answer(s)). Before TV
announcer comes in, Radio cutaway as follows:

SOUND: RADIO "PUBLIC AFFAIRS SOUNDER"

ANNOUNCER: From CBS News, Washington ... "Face the Nation" ... on the CBS Radio Network ... a
spontaneous and unrehearsed news interview with Senator _____.
Senator _____ will be questioned by CBS News Diplomatic
Correspondent Marvin Kalb, David S. Broder, National Political Correspondent for
the Washington Post, and by CBS News Correspondent George Herman. We shall
resume the interview in a moment. But first, here is George Herman.

(2:00 Herman Tape)

ANNOUNCER: And now, we continue with "Face the Nation."

INTERVIEW

CLOSING: Radio cuts away from TV audio on Herman's cue. (" ... Thank you very much for
being here to "Face the Nation." A word about next week's guest in a moment.")

(PAUSE: :02 PROMO _____)

ANNOUNCER: Today on "Face the Nation," Senator _____ was interviewed by CBS
Diplomatic Correspondent Marvin Kalb, David S. Broder, National Political Correspondent
for the Washington Post, and CBS News Correspondent George Herman.

Next week, (another prominent figure in the news), (_____), will "Face
the Nation."

Today's broadcast was recorded earlier today in Washington and was produced by
Sylvia Westerman and Mary O. Yates. Robert Vitarelli is the director. "Face the
Nation" is a production of CBS News.

SOUND: CLOSING "PUBLIC AFFAIRS SOUNDER"

Some interviewers want to be certain that full and reasoned information and commentary are presented to the audience, and they prepare clear informational promos for use before the given program and well-researched and well-written extensive *intros*—that is, openings. One program using this approach is "The Connection" a public radio show originating at WBUR-FM, Boston, and heard on a number of stations. Following is the promo and the opening for one of the shows aired in 2002 that dealt with a critical public issue.

From WBUR Boston and NPR

I'm Dick Gordon. This is The Connection.

"There are terrorists living among us …" so says a coalition of interest groups including loggers, miners, farmers and developers who regularly confront environmental activists. But are they? Are they terrorists? According to new legislation, the brazen confrontations of the suffragists and the principled disobedience of the civil rights movement could all be termed—terrorism. This week in California—the definition will be tested in court. The Star Wars 17, Greenpeace activists facing felony charges for interfering with missile tests, are going to trial—in a nation where the old rules of "what was acceptable" are out—amidst a new atmosphere of "what won't be tolerated." Environmental Protest, the Patriot Act and what, if anything, is still civil in disobedience—next on The Connection. First this news.

* * *

I'm Dick Gordon. This is The Connection.

America has always had a tradition of dissent: The Boston Tea Party is still celebrated, as are the underground railroad and 1950s lunch counter occupations. And protest always involves making noise—whether at Main Street marches or sidewalk sit-ins—ruffling feathers is par for the course—often essential—in demanding change. But the concept—and maybe even the cache—of civil disobedience is changing in the wake of September 11th. With the birth of the Patriot Act, free speech and political action could be facing higher stakes … look at the environmental movement. When ecotactics go beyond bumperstickers for "saving the whales" and into burning ski resorts, the line between activism and what's called Ecoterrorism blurs. Tomorrow, Greenpeace activists are in court, facing up to six years in prison for protesting the US Missile Defense System. Greenpeace says it's concerned that it may not be possible to have fair trial amidst America's New War … Connection listeners, in the wake of September 11th, how's the debate changing over civil disobedience, saving the forests, freeing the mink, and uprooting experimental crops? When is "Making a point" just making a mess? Call us at 1-800-423-8255, that's 1-800-423-TALK. With me today is Mara Verheyden-Hilliard, attorney and co-founder of Partnership for Civil Justice in Washington, DC; Teresa Platt, Executive Director for Fur Commission USA, and Andrea Durbin, National Campaign Director for Greenpeace.…

Courtsy of "The Connection," WBUR-FM, Boston

Program formats frequently develop out of the interviewer's personal approaches and techniques, especially when the interviewer is also the show's writer and producer. Duncan MacDonald was all three for the interview program she conducted on WQXR, New York. After a while she did not need a written opening, closing, and transitions. She concentrated on the content. One of her keys was to be certain that under each major question there were enough follow-up or probe questions, so that she was never faced with the possibility of getting single-phrase answers and running out of topics and questions in a short time. The following is a rundown outline she used for one 30-minute interview program.

Today is the anniversary of the signing of the United Nations Charter in San Francisco. In observance of this anniversary our guest today is Dr. Rodolphe L. Coigney, Director of the World Health Organization liaison office with the UN in New York City.

Dr. Coigney was born and educated in Paris. He began his career in international health and became director of health for the International Refugee Organization. In his present post at the UN he represents WHO—the World Health Organization—at Economic and Social council meetings, the Committee of the UN General Assembly, and other bodies of the UN.

1) Dr. Coigney, as one of the 10 specialized agencies of the UN, what is WHO's specific function?
 a) Is it included in the Charter of the UN?
 b) Active/passive purpose?
 c) Is WHO affected by various crises within the UN?
 Financial/political? Your own crises in health?
 d) Do you have specific long-term goals, or do you respond only to crises in health?
 Earthquakes/Floods/Epidemics?

2) How does the work of WHO tie in with other UN organizations?
 UNICEF/ILO/Food and Agriculture/UNESCO/International Civil Aviation/International Bank/Reconstruction and Development/International Monetary Fund/Universal Postal/International Communications/World Meteorological.

3) Background of WHO.
 a) How started? Switzerland?
 b) Headquarters for all international organizations?

4) How much would the work of WHO differ in a country medically advanced, such as Sweden, as opposed to developing countries: Africa, Far East?
 a) Religious or social taboos?
 b) Witch doctors?
 c) Birth control?

5) Can you give an example of a decision made at Headquarters and then carried out in some remote area of the world?

Continued

6) What do you consider WHO's greatest success story in fighting a specific disease: malaria, yaws?

 a) Ramifications of disease? Economic/Disability for work?

7) Your secretary mentioned on the phone that you were going to Latin America. What specifically takes you there now?

8) How does a country get WHO assistance?

 a) Invited?

 b) Matching funds?

9) We are aware of the shortage of doctors and nurses in the United States. What is the situation world-wide?

 a) Do you think Public Health is an important career for young people? Now? For the future?

Courtesy of Duncan MacDonald

Structure

The beginning of the interview should clearly establish who the interviewee is. You'd be surprised how many neophyte writers forget that much of the audience may not recognize even the most famous or infamous person. Something as obvious as giving the name of the person is sometimes overlooked.

If the person has a specific profession, title, or accomplishment that warrants the interview, identify what it is immediately to establish the interviewee's credibility (although not necessarily honesty) for the interview.

Early on make clear the reason for the interview. What is the purpose? What should the audience be looking for throughout the interview and especially at the end? From a simple personality interview the audience may learn no more than what the interviewee does on his or her vacations. But if the interviewee is a movie star or a rock idol, that may be sufficient for much of the audience. Figure out what the audience wants to know and prepare questions to get those answers.

Don't start with hard, controversial questions. That will only put the interviewee on the defensive and could lead to evasion or stonewalling. Begin the interview with background questions that establish the interviewee's expertise and position and set him or her at ease. You can begin with questions of a human interest nature, so that the audience gets to know something about the guest's personality before the interview is too far along. Even with a well-known personality, this is desirable to give a sense of the real person as differentiated from the public image. In the strictly informational, news-type interview this approach could be distracting, although even in such programs the interviewer sometimes asks personality questions.

Avoid questions that don't go anywhere. They may have some entertainment value, but they tend to slow the entire interview and keep both the interviewer and the interviewee from getting into the interview's purpose.

Remember that it is an interview, not a monologue by either the interviewee or interviewer. How many times have you seen or heard an interview in which the interviewer seems to do most of the talking and sometimes doesn't even give the interviewee an opportunity to finish an answer? Write questions, not commentary, for the interviewer.

Seek depth in the interview. It is not enough to discuss only who, what, where, when, and how; you want to find out why—and that applies to a full-length interview as well as to a news story interview. For example, if you were interviewing a former president about a scandal in the Department of Commerce in his administration, you need to ask not only "*How* did Commerce keep the scandal quiet for so long?" but also "*Why* didn't the White House act on the scandal?"

Be careful of boring or distracting repetition in the questions and in the possible answers. For instance, know enough about the interviewee to avoid asking, "Did you find that making that movie was the most exhilarating artistic experience in your career?" if the answer is likely to be, "Oh, yes, making that movie was the most exhilarating artistic experience of my career." In other words, don't put words in the interviewee's mouth if there is a chance they will come right back at you. Ask questions that will prompt original answers, such as "How do you rate making that movie among your career experiences?" An interview that is too controlled comes across to the audience as stilted or manipulated.

As with any good show, build to a climax—to the most dramatic or confrontational questions.

In all interviews, regardless of the format or orientation, some basic structural standards, if not rules, apply:

1 Establish the purpose of the interview.

2 Establish the type of interview approach to be used.

3 Establish who the interviewee is.

4 Establish the interviewee's background in relation to the particular interview or news story.

5 Establish the setting: the subject's home, a studio, an event such as a new movie opening or an award ceremony, a political meeting, a divorce court.

6 Create a rising action; increase interest after you've got the audience's attention through effective questions and follow-up.

7 Summarize at the end.

Technique

Some key points to remember when working on the final script:

1 Research thoroughly; the writer's most important job for the interview program is research. Get all the background possible on the subject, whether inanimate or a person.

2 Know the probable answers so you can prepare appropriate probe questions.

3 Double-check all the facts, particularly the interviewer's statements. Nothing is as embarrassing as the interviewee stating on the air that the interviewer has made an incorrect statement, when the interviewer has no concrete data to back it up.

4 Write copy that fits the program's style. What is the principal approach: to attack guests? to goad guests? to praise guests? If the latter, is it the backpatting puff-piece kind? Is information, opinion, or personality to be stressed? A combination? Which is dominant? Does the particular interview have a religious orientation? A political orientation? A sexual orientation?

5 Be specific with the questions so there is no doubt about the information or ideas you are seeking. If you have a generalized or open-ended question, be sure that the interviewee is likely to feel free to talk on the subject.

6 Repeat follow-up, probing questions in different forms if the interviewee tries to evade them. With sufficient research, you will know which questions the interviewee might try to stonewall, and you can prepare additional questions accordingly.

FORMAT TIPS

The Entertainment Interview

The entertainment interview has become a staple of the late-night show, exemplified in *The Tonight Show with Jay Leno*, and *The David Letterman* show. Although entertainment and personality revelation, rather than information and opinion, are the key elements in these interviews, the latter frequently emerge. The content varies with the show's orientation and interviewer. The early morning counterpart shows tend more toward news and information interviews, but they have their share of entertainment interviews.

Formats and scripting for such shows are similar. The principal written preparation is the rundown sheet, listing all segments and their running times. Specific dialogue can be prepared by several writers: the personal writers of the show's guests, to be certain that the anecdotes, responses, and ad-libs are in the style and reflect the best image of the given performer; personal writers of the show's star; and writers working for the producer, to provide transitions and shore up any weak material of a guest.

Writers frequently work on extemporaneous and ad-lib dialogue during rehearsals, when they and the producer can judge how well any given segment is shaping up. Sometimes the producer, director, and host do much of the writing themselves, their closeness to the program giving them a special sense of what will and won't work. The rehearsal period offers the show's participants an opportunity to make notes for their own dialogue during the live taping.

The News Interview

Although news and sports are covered in Chapter 5, the basic concepts of the interview discussed here also apply to those formats. The essential differences between the interview for the interview show and the news or sports program relate to time and condensation.

The broadcast news interview is very brief, anywhere from a few seconds to rarely more than a minute. The newspaper or print news story can have several interviews, presenting varied and even contradictory viewpoints, but the broadcast news story does not have time for more than one or two interviews. Those used must be as representative and accurate as possible in conveying the story's essence.

The interviewer has to get the interviewee to make a statement that gets across the idea quickly. The writer's elicitive phrasing of the questions is the key to conveying this effectively. For example, suppose the interview is with a former member of the administration about the Department of Commerce scandal. You could phrase a general question, "What do you think about the Commerce scandal?" and hope for a concrete answer. But no politician from the guilty political party is likely to give one. A more succinct question, perhaps as a follow-up to the first one, is, "Who was responsible for the Commerce scandal?" Even that, however, allows an evasive answer. More specific is the following: "Do you think that the president knew about and condoned the corruption in Commerce?" But that still doesn't require the interviewee to give the specific information you want. You need more than a "yes" or "no" answer.

If the answer is "yes," be prepared with follow-up questions that ask "Why do you think he did nothing about it?" "Was the White House itself involved in the scandal?" If the answer is "no," be prepared to ask: "These were his appointees. Did he not keep tabs on them?" And "He had frequent cabinet meetings with the secretary of Commerce. Was he deliberately kept in the dark?" And: "Why didn't the president comment on the scandal after it broke?" In other words, decide what interview information is essential to the point of the news story and be certain that questions are prepared to elicit that information.

Give the interviewee the opportunity to say what he or she thinks. Even if the interviewer is the focal point of the show and might even know more about a given subject than the guest, it is important to get the guest to talk as much in depth as possible and to deal directly with controversial issues, with the interviewer hopping in with the next prepared question only if the interviewee moves too far away from the topic or becomes repetitious or boring. For example, in 1999 during the U.S.-led NATO action in Kosovo, Yugoslavia, Larry King had several prominent critics and government officials on one of his live CNN

shows. The mood of the country at that time generally was supportive of the bombing of Yugoslavia; those who opposed it had their motives and even loyalty questioned. Venerable video journalist Walter Cronkite, however, was not to be put off and seriously and sharply criticized the media for allowing the military to censor them and for reporting incomplete and even inaccurate information from the war zone. Larry King allowed him to continue his criticism of the military and government for not providing a clear and substantial reason for the bombings, noting a number of possible self-serving scenarios having little to do with humanitarian purposes. This kind of maverick interviewee commentary, allowed and encouraged, makes for good broadcast interviews.

Be accurate and honest. Don't take quotes out of context and don't edit them so that the interviewee's comment is distorted. The same holds true for narration prepared for the on-air reporter. Give full information. It would be false reporting to have the reporter say, "The president told this reporter on the presidential plane today that he is going to immediately end corruption in government," when what should have been written was, "The president told reporters at a press interview today aboard presidential plane Air Force I when it arrived at Andrews Air Force Base—and I quote: 'Any further revelations of corruption in government will get the immediate attention of the Oval Office.'"

Though the so-called person-in-the-street interview can sometimes provide good feature material, accuracy and meaning in the news story necessitates interviews with people who are (1) experts, (2) observers, or (3) participants, either directly or indirectly, in the news story.

For example, after a number of accidental airplane crashes, who would you have sought out to interview for your news story? You have many choices of experts, including an aeronautics engineer, the plane's manufacturer, a Federal Aviation Administration official, and an experienced air traffic controller.

Observers would include people who saw the plane in trouble, or exploding, or actually crashing. Participants would include, of course, any survivors among the passengers or crew, as well as current air controllers and others involved in monitoring the plane's flight. Be certain that your interviewee does have an actual connection with the plane in the appropriate category and is willing to talk about it.

Especially with nonprofessionals, be careful of leading the interviewee to give the answers you want, rather than what the interviewee actually knows or thinks. This is important in both the reporter's commentary and the interview questions. As an illustration, if the anchor's script reads, "Joe Eyewitness described the plane crash as a fiery ball dropped from the sky, exploding as it hit the earth," and the interview tape follows with Joe Eyewitness saying, "I saw the plane crash. It was like a fiery ball dropped from the sky, exploding when it hit the earth," then the writer/producer has dropped the ball, too.

And don't forget to identify the interviewee. If the interviewee who saw the plane crash is not identified by name in the news interview itself, use the CG to put the name, title, position, or reason for being interviewed on the screen—"Joe Eyewitness" or "plane crash eyewitness."

The good interview script, even for the short newsbite, requires extensive research and effective writing. Sometimes, however, especially for the short interview, the writer may provide

no more than an intro and outro, with all the rest of the preparation done by the reporter. Of course, in such cases, the reporter must also be an experienced and competent writer.

Most often, news interviews are in the field, and, if not live, the reporter tapes as much as possible for editing to the time allotted on the newscast. The preparation is similar to that for the longer interview, except that the brief time allowed requires identification of only the most important questions and possible answers before the interview. The following script is an example.

Tuesday, October 27
SOT :30 State housing director E.Z. Skimmer

Grand jury handed up indictment today charging Skimmer with misappropriation of $500,000 of housing funds for his personal use.

Q: Do you intend to resign? (No.)

Q: Are you saying the charges are untrue?
 Follow-up: ask specific denials to each count of the indictments; misappropriated from Jan. 10–Sept. 25; books show shortages on eight different occasions; deposits in personal bank accounts $400,000 during that period.

Q: If you didn't take the money, who did?
 Follow-up: Aren't you responsible for continuing audits of the books? Why didn't you know?

Q: How do you account for the $400,000 in deposits in your personal bank accounts in eight months on a salary of $75,000 per year?

Discussion Programs

Discussion programs are aimed toward an exchange of opinions and information and, to some degree, toward the arriving at solutions, actual or implied, on important questions or problems. They should not be confused with the interview, in which the purpose is to elicit, not to exchange, information.

Approach

The discussion program writer has to walk a thin line between too much and not enough preparation. You cannot write a complete script, partially because the participants can't

know specifically in advance what their precise attitudes or comments might be before they have heard a given issue or statement that might be brought up in the discussion. On the other hand, a complete lack of preparation would likely result in a program in which the participants would ramble; the moderator would have the impossible task of getting everybody someplace without knowing where they were going. To achieve spontaneity, it is better to plan only an outline, indicating the general form and organization of the discussion. This is, of course, in addition to whatever standard opening, closing, and transitions are used in the program. The outline might include opening and closing statements for the moderator, participant introductions, and general summaries the moderator can use in various places throughout the program.

The discussion outline should be distributed to all participants in advance so that they can plan their own contributions, such as necessary research, in accordance with the general format. The writer should indicate the issues to be discussed, the order in which the discussion will take place, and, where feasible, the time allotted for each point for each participant. If possible, the participants, in consultation with the writer (or producer or director), should prepare brief statements of their general views so that there can be a pre-program exchange of ideas and a coordination of all participants' contributions toward a smooth, well-integrated program. Just as too much preparation can result in a dull program, too little preparation can result in participants being unable to cope with the needs of a spontaneous program. In addition, lack of preplanning with the participants can cause unnecessary duplication of material. A program in which everyone agrees on everything can become quite boring; preplanning should ensure, for incorporation in the rundown or routine sheet, that all points of view on the given issue receive adequate representation—unless, of course, the program is deliberately oriented toward a particular, nonobjective viewpoint. Some discussion programs, such as the *Jerry Springer Show*, deliberately encourage interruptions and spurious, even physical arguments among the participants, aimed not at informing or mentally stimulating, but at "infotaining."

A decision should be made during early planning whether to use a controversial topic, certainly a good way to achieve vitality and excitement in the program, and whether to promote or avoid disagreement among the participants. The topics should be presented as questions, thus provoking investigation and thought. In addition, the topics should be broadly oriented, preferably toward general policy, and should not be so narrow that they can be answered with a yes or no response or with obvious statements of fact.

In the extemporaneous discussion program the same principles apply as in the interview. Opening and closing remarks and introductions should be written out. If possible, general summaries should be prepared for the moderator. In some instances, depending, as in the interview program, on format and approach, a brief outline or routine sheet consisting of a summary of the program's action and a listing of the topics to be covered, or a rundown sheet, may be sufficient.

In television, visual elements should be incorporated. The setting should, if possible, relate to the topic. The visual element can be relatively simple, but should help to convey a feeling of excitement and challenge for the topic under consideration.

Types

The major types of discussion programs are the panel, the symposium, the group discussion, and the debate.

Panel

The panel discussion—not to be confused with the quiz-type or interview-type panel—is the most often used and the most flexible. Several people in a roundtable situation exchange ideas on some topic of interest. There is no set pattern or time limit on individual contributions and sometimes not even a limitation on the matters to be discussed. The participants usually do not have prepared statements, but have done whatever background preparation each individual has deemed necessary. A moderator, who usually does not participate, attempts to guide the discussion and to see that it does not get out of hand or too far from the topic.

The approach is informal, with the participants offering personal comments and evaluations at will. On occasion the discussion may become heated between two or more participants. The moderator tries to see that the discussion is not dominated by just one or two persons. No solution to the problem being discussed is necessarily reached, although the moderator frequently summarizes to pull the discussion together and to clarify for the audience—and the participants—the point at which the panelists have arrived.

A routine sheet usually consists of the moderator's opening remarks, introduction of the panel members, statement of the problem, flexible outline of subtopics to be discussed under the main topic (the outline should be given to each panel member sometime before the program, preferably in time for them to prepare materials if they wish), and the closing. As you read the following beginning and end of a script routine sheet prepared for a panel discussion program, note the careful and liberal insertion of subtopics. The complete script repeats the principal question and the subtopics several times in the one-hour show.

■ *Apply to this script the following questions (which you should apply to any discussion script that you subsequently write): Do you feel that the phrasing of the subtopics provides the essentials for a good discussion? Is the topic development too limited or is there opportunity for the clear presentation of varied opinions, attitudes, and information? Does the program organization seem to move logically toward a climax? Does there seem to be a logical interrelationship among the various parts of the discussion? Are the participants properly introduced? Does the structure permit periodic summarizing? (See exercise 7 in the "Application and Review" section at the end of this chapter.)*

WTAK ROUNDTABLE

Bosnia

Thursday, 7–8 P.M.

MODERATOR: (OPEN COLD) Bosnia—to be or not to be? This question has been reiterated thousands of times by the peoples of the world. Bosnia has become a symbol of the religious and ideological conflict that threatens to tear apart almost all the countries in former Yugoslavia.

This is your Moderator, Tom Guide, welcoming you to another "WTAK Roundtable."

All of us by now are fearfully aware of the critical importance of finding peace in former Yugoslavia, specifically among the states of Bosnia-Herzegovina, Croatia, and Serbia. Is peace possible? Will old nationalistic enmities prevail? Will Muslim and Christian religious fundamentalism prevent any accommodation? What role will Serbia play in relation to the Bosnian Serbs? Will outside pressure, including United Nations intervention and peacemaking negotiations by the United States President, lead to a solution? Are there any areas of compromise that will be satisfactory to all parties?

This evening, with the aid of our guests, we will attempt to seek some answers to these questions.

Dr. Robert Charlton is a professor of political science at Yalvard University and an authority on Yugoslavia. Dr. Charlton teaches European government and modern political theory. He recently spent several months in the former Yugoslavia studying the situation there. Good evening to Dr. Charlton.

CHARLTON: Response

MODERATOR: Dr. Brno Zdislaw is an associate professor of religion at Missitucky State University. He has written extensively on the rapid expansion of Islam as the state religion in a number of countries. He has observed first-hand the establishment and practice of the Moslem religion in several mid-east nations. Good evening, Dr. Zdislaw.

ZDISLAW: Response

MODERATOR: Our third panelist is Dr. Arthur Stone, professor of history and economics at Kings College. He specializes in United States foreign policy and international politics. He has served as cultural attache with the U.S. State Department in embassies in eastern Europe. Good evening, Dr. Stone.

STONE: Response

MODERATOR: I'd like to remind our participants and our listeners that questions are encouraged from our listening audience. Anyone having a question for any or all of our panel members is invited to phone the WTAK studios at 555-3296. Your question will be

Continued

asked directly of the panel, if pertinent to the specific discussion in progress, or taped and played back for our panel to answer at the first appropriate opportunity. That's 555-3296.

In view of the horrors perpetrated by all participants in the conflict, including genocidal ethnic cleansing, do you think there is any chance of any peace accord and, if so, would it be likely to last longer than a few weeks or months? Dr. Stone, would you start the discussion on this question?

(BRING IN OTHER PANELISTS ON THIS QUESTION. DETERMINE TENTATIVE AGREEMENT ON SOME AREAS, AS BELOW.)

1. Sharing of territory and political power, as proposed, with degree of sovereignty within the political structure of each group?

2. Accommodation of all religions without any one seeking to impose its beliefs and practices on the others?

3. Containing the continuing enmity between the Serbs, who supported the Allies during World War II, and the Bosnians and Croats, who supported Hitler? (Historical differences play an important role in Europe.)

4. United Nations peacekeeping force and economic assistance as a stabilizing factor?

5. Continued U.S. mediation to negotiate continuing problems?

MODERATOR: (REMINDER TO AUDIENCE ON PHONE CALLS)

* * *

MODERATOR: (IF ABOVE TOPICS NOT CONCLUDED BY 8 MINUTES BEFORE THE END OF THE PROGRAM, SKIP TO FOLLOWING): Of all the possibilities discussed on the program, which, if any, do you think has the most chance of succeeding?

MODERATOR: (SUMMARY AT 8 MINUTE MARK)

1. Sharing of territory.

2. Accommodation of all religions.

3. World War II legacy.

4. U.N. peacekeeping force.

5. Continuing U.S. role.

MODERATOR: (AT 1 MINUTE MARK) Dr. Robert Charlton, Dr. Brno Zdislaw, and Dr. Arthur Stone, we thank you for being our guests tonight on this WTAK Roundtable discussion on the possible solutions to the problems in former Yugoslavia, specifically Bosnia-Herzegovina.

Continued

GUESTS: (MASS RESPONSE OF GOOD NIGHT, ETC.)

MODERATOR: We thank you all for listening and invite you to join us next week at this same time when "WTAK Roundtable's" guests, _____, and _____ will discuss _____.

This has been a presentation of WTAK, the FM radio station of stimulating talk, New Concord.

Even when a panel discussion program is known for its extemporaneous approach, some key continuity must be prepared. *The McLaughlin Group* is a panel talk show with newsmakers oriented to strongly conservative views. Guests in the studio and by remote join in free-form discussion on headline issues and events of the day. Note, in the opening below, that in addition to the introduction the script includes a topics list and the initial question(s) to get the discussion going. The end has a standard outro, as well as an advisory of the next program's topic.

THE MCLAUGHLIN GROUP
HOST: JOHN MCLAUGHLIN
JOINED BY: ELEANOR CLIFT, FRED BARNES, JAY CARNEY AND MORTON KONDRACKE
WASHINGTON, DC 20045

ANNOUNCER: From the nation's capital, "The McLaughlin Group," an unrehearsed program, presenting inside opinions and forecasts on major issues of the day. GE is proud to support "The McLaughlin Group." From information services to locomotives, GE. We bring good things to life.
Here's the host, John McLaughlin.

MR. MCLAUGHLIN: Issue one: Farewell, welfare.

SEN. BOB DOLE: (From videotape.) We're closing the books on a six-decade-long story of a system that may have been well-intentioned, but a system that failed the American public.

CLINTON: (From videotape.) If welfare reform remains a bipartisan effort to promote work, protect children and collect child support from people who ought to pay it, we will have welfare reform this year and it will be a very great thing.

MR. MCLAUGHLIN: The U.S. Senate this week passed landmark reform of the nation's welfare system. The historic legislation ends 60 years of welfare entitlement. The proposal eliminates the current federal welfare probably as we know it.

Continued

Block grants will be the new system, lump-sum payments to the states to spend on benefits to their poor as the states see fit. Key features of the historic overhaul include:

1. Time limits. Welfare recipients are limited to two consecutive years of assistance, five years over a lifetime.
2. Work requirements. State governments must move half of their welfare recipients into jobs within five years.
3. No aid for non-citizen immigrants. States can deny aid to all immigrants who have not become citizens.
4. Food stamps. States may choose to get food stamp funds in the form of block grants.

The Senate bill now goes to conference, where it must be reconciled with the more conservative House version, which includes cutting off cash to unwed mothers under 18 and denying additional benefits to mothers who continue to have more children while on welfare.

Question: When the welfare reform plan comes out of conference....

* * *

MR. MCLAUGHLIN: Well, we have just a few more seconds…Next week: the investigation of the Ruby Ridge tragedy focuses on the highest levels of the FBI. Bye-bye.

ANNOUNCER: "The McLaughlin Group." GE is proud to support "The McLaughlin Group." From information services to locomotives, GE, we bring good things to life.

Courtesy Federal News Service

Speeches

Most speeches are prepared outside the station, and the staff writer usually has no concern with them except to write the opening and closing material for the station announcer, which can include introductory comments about the speaker, depending on how well known the latter is. It is improper to go beyond: "Ladies and gentlemen, the president of the United States." If the president is speaking at a special occasion or for a special public purpose, however, prespeech commentary would describe the occasion and purpose, with appropriate background material. Commentary and analysis can also follow a speech.

If the speaker is not well known—for example, a spokesperson responding to a station's editorial—information about that person's position and qualifications as a spokesperson on the issue should be presented, as well as the reason for his or her appearance. A good rule to remember is that the better known the speaker, the less introduction needed.

In some instances, usually on the local level, speakers unfamiliar with radio and television time requirements may have to be advised how and where to trim their speeches so they are not cut off before they finish. Speakers unfamiliar with television and radio techniques frequently do not realize the need for split-second scheduling and their speeches may run too long or, sometimes, too short, leaving unfilled program time. In other instances it may be necessary to remind (or even help) the speaker to rewrite in order to adhere to legal, FCC, or station policy concerning statements made over the air, including slander and obscenity or indecency.

If a speech is prepared by the station's writer, it must, of course, be done in collaboration with the speaker. First, determine the format. Will it be a straight speech? Will a panel or interviewer be included? Will the audience be able to ask questions? Will the speech be read from a desk or a lectern, memorized, or put on a teleprompter? At all times the speech must fit the speaker's personality.

Occasionally, the televised speech can be developed into more than simple verbal presentation and can include film, tape, photos, and other visuals. Such speeches are, however, more like illustrated talks or lectures and, if so, would likely be prepared as features.

A simple, basic format, containing intro, outro, and transitions, is the following, used for speeches during a political campaign.

ANNCR: To better acquaint Virginia voters with the candidates and issues in the upcoming
 general election . . . the WGAY Public Affairs Department presents . . . "Platform" . . .

 Now . . . here is _____
 _____.

 (play cart)
 You've just heard _____
 _____.

 Now . . . here is _____
 _____.

 (play cart)
 You've just heard _____
 _____.

 In the public interest, WGAY has presented "Platform" . . . a look at Virginia general election
 candidates and issues. The opinions expressed are those of the candidates and do not
 necessarily reflect the feelings of WGAY or its sponsors. Stay tuned for other candidates
 and their views throughout the campaign. (PAUSE)

 From atop the World Building . . . WGAY FM & AM, Washington & Silver Spring. (WGAY-FM
 in Washington)

SPECIAL CONSIDERATIONS

Although many talk shows, documentaries, and features deal with people of color, minority ethnic groups, women, and other constituencies that traditionally have been denied equal opportunity in employment and equal dignity through nonstereotyped program portrayals, many members of these groups still have a strong perception of insensitivity by the electronic media. The talk program offers a special opportunity to focus on a person, problem, or idea relating to special groups or subjects. The feature and documentary, the commercial, and the play offer excellent opportunities to deal with these special considerations directly and candidly.

Women's Programs

Changes in media programming for women coincided with the feminist movement's initial gains in the 1970s, including its overt efforts to abolish negative images of women in the media. The media not only reinforce and create attitudes toward women, but can also serve as a direct means for women to improve their status in a male-dominated society. Romy Medeiros de Fonseca, an early women's rights movement leader in Brazil, noted that television "is the first means of education from which Brazilian men have not been able to bar women. They stopped them from going to school, stopped them from studying, kept them at home and cut off all contact with the world. But once that television set is turned on there is nothing to stop women from soaking up every piece of information it sends out. They soak it up like a sponge, and they don't need to be able to read a word."

For decades conventional wisdom in the media dictated that women's programs were those that primarily attracted women viewers and listeners because of the times of day they were presented and that carried content traditionally deemed of interest primarily or solely to women. Such programs consisted largely of noncontroversial, stereotyped material such as club meeting announcements, advice on interior decorating, cooking hints, information on fashion and make-up, and interviews with local personalities who provided advice, products, or services that presumably met women's needs.

Most of these programs have evolved into serious considerations of drugs, youth violence, consumer rights, environmental pollution, television's impact on children, local education problems, and similar subjects. Topics vital to women that affect the entire population and provide women with information and tools for equal rights and opportunities have replaced the cooking- and cosmetic-oriented format.

The effects of nuclear power plants on community health, acid rain, toxic waste dumping, rape, abortion, birth control, job training, financial dependence and independence, and legal discrimination against women and its remedies are some topics one finds today on the so-called woman's show. Many of these programs serve as consciousness-raising tools for both women and men. Interview shows in particular can provide younger women with role models and younger men with new, positive views of women.

Barbara Walters—a pioneer in establishing the acceptance of a woman interviewer-commentator on talk programs, features, and documentaries—believes that information-education programs that appeal to both women and men should be developed on daytime television. "To say a show is just for women is to put down women," she emphasized.

Writing the woman's program is not appreciably different from writing other program types, as far as the basic form is concerned. But these programs should be sensitive to women's status, contributions, achievements, aspirations, and needs in the same way they are to men's. Sexism that is not deliberate is still sexism, and special sensitivity is required by the writer who has not experienced the discrimination or stereotyping that women face.

Cable has expanded the programming oriented to women and to other special considerations and groups. Cable channels such as WE, Oxygen, and Lifetime program materials that recognize women's needs and views. Talk shows oriented to women's roles and potentials in society are increasing on cable, where the large number of channels and freedom from dependence on individual program ratings (cable systems use cumulative ratings over a given time period) free cable from some of broadcasting's bottom line dictates. The following script is from such a program that has been syndicated on local cable origination channels.

WOMEN ALIVE

Hostess: Ina Young; Guests: Marsha Della-Giustina, free-lance news producer and professor of mass communication, Emerson College, and Debby Sinay, vice-president of sales, WCVB-TV, Boston.

Feature	Time Segment	Total Time
Introduction by Ina Young	01:00	01:00
Two Commercials (1 minute each)	02:00	03:00
Interview with Marsha Della-Giustina	10:30	13:30
Two Commercials (1 minute each)	02:00	15:30
First Part of Interview with Debby Sinay	05:30	21:00
Two Commercials (1 minute each)	02:00	23:00
Second Part of Sinay Interview	05:00	28:00
Thanks and Outro by Ina Young	01:00	29:00
Credits	01:00	30:00

INTRODUCTION:

INA: This is WOMEN ALIVE and I am your hostess, Ina Young. Television is considered to be a very glamorous, often high-paying profession. One successful series can

Continued

make instant stars of previous virtual unknowns. Yet, for every Barbara Walters and Connie Chung there are thousands of women working industriously behind the cameras in television offices and studios.

Today on WOMEN ALIVE we will be looking at "Television Broadcasting from the Woman's Viewpoint" and our two guests are two talented TV women. Marsha Della-Giustina is a freelance news producer and director of broadcast journalism and associate professor at Emerson College, Boston. Debby Sinay is vice president of Channel 5, WCVB-TV, in Needham, Massachusetts. So stay with us here on WOMEN ALIVE and we will be back with a behind-the-scenes look at "Television Broadcasting from the Woman's Viewpoint."

COMMERCIAL BREAK

INA: Today on WOMEN ALIVE we are going to take a look behind the glamour and the glitter of television. We are all familiar with the high-paid, highly visible news anchorperson. But what do we know of the men and women who ferret out the news and prepare it for television delivery? We know the stars of popular series, but are we aware of the television sales staff that keeps each station a productive and flourishing business? Our first guest is Marsha Della-Giustina, freelance news producer and professor at Emerson College. Welcome to WOMEN ALIVE, Marsha.

[The initial questions relate to the process of news gathering, processing, preparation, and reporting, regardless of gender. After the credentials and knowledge of the interviewee are established, again regardless of gender, questions relating to women are introduced, such as the following.]

INA: Marsha, at Channel 5, where you do freelance producing, how big is the news staff? How many men, how many women? What are the approximate ages? Which seem more appreciated by management?

* * *

When a station changes ownership, such as recently happened at Channel 5 when Metromedia purchased it, there is a great turnover, staff leaving, fired or replaced. Is there any pattern now at Channel 5, in relation to women and minorities?

* * *

What kinds of advantages and obstacles can a woman with a career behind the camera in TV broadcasting expect? What do you foresee in the immediate future for women—and men—in this profession?

[The second interview, with Debby Sinay, followed the same format.]

INA: We are back again with WOMEN ALIVE and our second guest today is Debby Sinay, vice president of sales at Channel 5 in Needham, Massachusetts. I am delighted to have you on the show, Debby.

* * *

Continued

As vice-president at a major television station, could you give our viewers an idea of what that entails?

* * *

How big a staff do you have? How many males, how many females? Do females bring different qualities to the job than males? Is one sex better than the other? Which responds better to taking orders from you, a female boss?

* * *

Do you think that being female helped or hindered you in your climb up the corporate ladder?

Written and produced by Ina Young, Essex Video Enterprises, Inc.

Ethnic Programs

The same sensitivity applies to African-American, Latino, Asian-American, and Native American programming, among others. The growth of Black-owned and Black-oriented stations and Spanish-language networks has resulted in talk shows and other programs specifically oriented toward African American and Latino and Latina audiences. Other racial and ethnic groups have had fewer media outlets oriented toward their concerns. The traditional outlets rarely program for these groups.

In Chapter 6 of this book, "Features and Documentaries," examples of writing for these special audiences are presented. In all cases the question of language and terminology is important. The special background and history as well as the immediate needs of a particular group help determine the writing approach.

A program designed for listeners or viewers from that special group would be written differently than the same program designed for a white majority audience. The vocabulary or dialogue that refers to sections of a given community or to events frequently has explicit meaning only to the targeted audience.

For example, one program produced on radio by the Chinese Affirmative Action Media Committee in San Francisco combined news, commentary, and satire. The writers were scholars of Chinese American history and people in the arts, as well as reporters and media experts. The materials reflected perspectives and viewpoints of the Chinese American not usually heard on the air.

The program's producer, Russ Lowe, cited a historical skit that tells of the tax collectors during the Gold Rush days going through the mining camps for the $2.50 monthly tax on miners—but trying to collect it only from the Chinese miners.

The standard opening for the DuPont Guy news-commentary-satire talk show:

NARRATOR: Welcome friends and tourists to DUPONT GUY, a listening trip through Chinese America. Brought to you by the DUPONT GUY COLLECTIVE of Chinatown Saaan Fraanciscooooo.

The name DUPONT GUY comes from the original name of Grant Avenue, Dupont Street. After the 1906 Earthquake, City redevelopers decided to take over Chinatown and changed Dupont Guy to Grant Avenue. Of course, when the Chinese returned to claim their homes, they continued to call their main drag Dupont Guy.

In this spirit of truth and defiance, we commence our program of community news and commentary, of music, poetry and satire.

And a skit from the program:

RUSS: And now we bring you the KOW BEE SEE Network brain show, College Bowel. On today's team we have Mr. Cally Flower of Podunk U. facing Yu Fong of Choy-Lai's School of Chinese American history. Before we begin, let me offer my regrets to you Yu Fong on the impending threat of your school's obliteration. I know there has been activity prevailing in some of our great universities to eliminate Asian American studies. But let us see if you can show us what you've learned in today's match of COLLEGE BOWEL. Are you ready, Cally Flower?

BREEN: Uh, yeah, sure.

RUSS: Yu Fong, are you ready?

CONNIE: SHR!

RUSS: All right, tell me the answer to this question . . . When did the first Chinese arrive in the United States?

BREEN: Oh, that's easy! Everyone knows they came after the California gold rush in 1849.

RUSS: That is absolutely . . . WRONG! Yu Fong, do you have an answer?

CONNIE: In 1785, three Chinese, Ah Sing, Ah Chyun, and Ah Coun were in Baltimore. Their presence was noted by the Continental Congress.

In 1796, five Chinese were brought to Philadelphia to be servants for Andreas Evarfdus Van Braan Houckgeest.

In 1807, Pung-hua Wing Chong arrived in New York to collect his father's debts.

In 1815, Ah Nam, the cook to Governor de Sola of California was confirmed a Christian at Monterey.

In 1818, Wong Arce attended the Foreign Mission School at Cornwall, Connecticut, with Ah Lan and Ah Lum and Lieau Ah See.

Continued

In 1847, the Chinese junk "Ye King" sailed into New York harbor with an all Chinese crew.

In 1847, Yung Wing, Wing Foon and Wong Sing enrolled at Monson Academy at Monson, Massachusetts. Yung Wing went on to Yale and became the first Chinese to graduate from a U.S. university, in 1854. In 1852, Yung Wing became a citizen.

BREEN: Gee whiz, they never taught me that at Podunk U.

Dupont Guy Collective, Chinatown, San Francisco

Using the media as an integrating tool is an approach taken by many producers of programs for or about special groups. Dr. Palma Martinez-Knoll, who wrote and produced a Latino program in Detroit, is one of those producers.

Martinez-Knoll's program, *Mundo Hispano*, consisted of a variety of formats including cultural presentations, interviews, different kinds of music, information for women, news, features, documentaries, commercials, and PSAs—similar to the formats of many other ethnic programs. *Mundo Hispano* also included a weekly editorial. "Like the rest of the program," Martinez-Knoll noted, "the editorial shows that the American Hispanic community is an offshoot of the Spanish-speaking community all over the world. It is not a Chicano here, a Puerto Rican here, but an entire linguistic community who face a common problem. It is the entire community that must communicate with the majority society."

The following example of the beginning of one program's editorial illustrates this approach.

About 1 of every 15 Americans has a Spanish-speaking heritage. In other words, there are about 20 million Americans with a Spanish-speaking heritage in the mainland United States.

Yet, the Spanish-speaking have had a long-standing problem in the area of equal employment opportunity, which only recently has become the focus of national attention and action. In addition, the Spanish-speaking population has had to face problems of social and economic deprivation as well as its own particular problem of a language barrier.

Working to help the Spanish-speaking peoples is not as easy as it may appear. The reason for the difficulty is that those with Spanish heritage are a heterogenous group despite their shared Spanish-language background. In fact, they represent a microcosm of American ethnic diversity.

Interestingly, not all those with Spanish heritage speak Spanish, although most of them do, and all have ancestors who did. Some of these people are recent immigrants or are first generation citizens while others come from families that were living in the Southwest or Puerto Rico. But by far the

Continued

largest group are of Mexican origin or descent. The next largest group would be those from Puerto Rico followed by a large group from Cuba. Others can trace their families to Central or South America. Thus, it is evident that the Spanish-speaking community is made up of groups from different areas with different backgrounds and cultures.

These groups are located in different parts of the country. For example, most Mexican-Americans live in the Southwest; the Puerto Ricans live largely in New York City and the majority of Cubans live in Florida. Of course, there are smaller concentrations of these various groups in large metropolitan areas such as Detroit.

Within these metropolitan centers, many of the Spanish-speaking have moved into distinct, close-knit neighborhoods, either by choice or because they cannot afford or are barred from housing elsewhere. Unfortunately, these neighborhoods are sometimes in city slums or in poverty stricken "barrios" on the fringes of metropolitan centers.

Partly because of these concentrations of Spanish-speaking peoples into separate urban areas, they continue to have English language problems. At times, the language barrier may not even be overcome during the second generation. There is also the frequent movement of people back and forth between Puerto Rico and the mainland which tends to reinforce the language barrier.

All of these factors have had the effect of culturally isolating the Spanish-speaking from the mainstream of the population. Of course it hasn't helped that ethnic prejudice and discrimination exist in some communities, creating additional barriers to the assimilation of the Spanish-speaking into the community.

In addition, for Spanish-speaking adults there is often a lack of education along with the lack of knowledge about the English language. Both work toward preventing the individual from obtaining a well-paying job. However, the relative number of Spanish-speaking youth with a high school education or better has been rising.

* * *

The problems of the Spanish-speaking in this country are not going unnoticed. Manpower and related programs have been developed to deal with the problems of joblessness and low-level employment. The goal of these programs is to help Spanish-speaking workers qualify for and enter more skilled occupations, offering both higher wages and promise of steady work.

These programs will not lead to any overnight successes, but they are part of a mounting effort to help the Spanish-speaking and all other minority groups.

Courtesy of Palma Martinez-Knoll, *Mundo Hispano* Latino Hour

APPLICATION AND REVIEW

1 Prepare an outline, rundown, and routine sheet for an opinion interview, a personality interview, and an information interview. Each interview should be with a *different person* of local importance.

2 Do the same exercise, using the *same person* as the subject for all three interview types.

3 Prepare an outline, rundown, and routine sheet for a panel discussion program on a highly controversial subject, first for radio, then for television.

4 You are the writer-interviewer for an interview show. Choose a book written by someone on your college or university faculty. Prepare a script outline, with intro, transitions, outro, appropriate questions, and follow-up questions for a 15-minute interview with the author about the book. If possible, produce the interview in conjunction with a radio or television production course or for your institution's radio or television station or organization.

5 Prepare the format for a talk show on your college radio station or a local radio station that is oriented toward African Americans, Latinos, Asian Americans, or Native Americans.

6 Develop a format for a television or cable women's talk show that provides to both men and women a service not now seen on network television.

7 Prepare the outline and continuity (containing at least the intro, transitions, and outro) for a panel discussion program on a topic that is currently in the headlines of the print or electronic press.

8

Music, Variety, and Comedy

lthough talk and other nonmusic specialized formats have recently increased on radio, radio programming today is principally music. Stations rely primarily on recorded music for content. Those affiliated with one or more of the many radio network services receive news and feature **feeds** to integrate into an otherwise all-music format.

In the 1930s, Martin Block successfully developed the concept of a radio announcer playing records separated by comment and commercials, yet conveying the feeling that the performances were live in the studio. Since then, the disk jockey and record/tape/disc show have become national institutions. Before television drew almost all the major live talent away from radio, live studio musical programs featured symphony orchestras, popular singers, jazz bands, opera stars, dance orchestras, and other musical soloists and groups. Virtually all such programs gradually disappeared from radio; some radio programs with music, particularly comedy and variety programs, made the transition to television.

Over the years, a number of television series starring musical personalities, groups, and orchestras were highly successful. Dick Clark's original record and dance show in Philadelphia, *American Bandstand,* evolved into a national institution on television. Generally, singers have fared better on television with variety formats than with strictly musical ones. Similarly, individual musical groups occasionally appear on television in specials or as separate acts on nonmusical shows such as *Saturday Night Live* and the Jay Leno and David Letterman programs. Continuing music specials have proven popular with some audiences, especially on public broadcasting, including operas and Boston Pops concerts, but have not otherwise found broad popular appeal. The advent of MTV in the early 1980s moved television music shows into a new dimension. The growth of cable allowed MTV, the first 24-hour music service, to prosper and spawn other services that feature popular

groups whose music and personalities blend into highly visual, often dramatic, energetic formats viewed by a wide audience.

Other than scripting the music video, the scriptwriter's job in music is principally to prepare continuity—intros, outros, and transitions—and the rundown or outline for the show. Very few radio disk jockey shows have prepared scripts anymore. Most often, the deejay works from a playlist and develops his or her own continuity—in script form, in notes, or in his or her head.

A professional never takes a chance on making a mistake if it can be avoided. The top pros have a program's every detail worked out in advance. The deejays who insist that everything they do is ad-lib, with no preparation, are, with few exceptions, either pretending, or are amateurs who won't last very long.

Writing the variety show, with the comedy that it requires, is a special talent that cannot be taught—and this book doesn't attempt to do so. This book does present some basic principles for formulating the variety show format and some basic techniques for writing comedy.

MUSIC: RADIO

A music program must have organic continuity: a clear, specified format, a central program idea, a focal point around which all the material is organized and from which the show grows and develops. Although most disc jockeys are spontaneous with their continuity, the music content of most of their programs is carefully planned and organized.

Each program's format preparation reflects the format of the station as a whole. Specialization is the cardinal principle of most stations' programming and image. Some stations combine several programming types—two or more types of music plus news, talks, and features—and are known as **full-service stations.** Originally FM was equated with "good" music, especially classical music, and had a smaller audience than did AM. Today most music listeners choose the FM band. Virtually every format and music type is found on FM, but popular music is the prevailing category. Definitions of types of music are constantly changing and music formats change accordingly. Contemporary music means that of living composers to some programmers, but is limited to current popular hit songs by others.

Irrespective of how *contemporary* or *pop music* is precisely defined, music both reflects culture and builds it. Contemporary music is the dialogue of youth, providing a sense of psychological freedom for the listener and a sense of artistic freedom for the performer. Pop music is a sociological phenomenon, partly because it reflects the flexibility, growth, and change of society, particularly young society. The Beatles changed not only the face of popular music but also the attitudes and behavior of youth. The Beatles motivated an escape from the traditional formulas, and their music was not music alone of bodily rhythm, but music of ideas, communicating unspoken and spoken meanings that were vital and forceful to the young people who eagerly pursued them. The basic concept was not new, but the music was. Combined with the inexpensive availability of

the transistor radio receiver, it made radio the link between creative artistry and creative reception as never before. At the beginning of the twenty-first century, new music fads such as "rap," "hip-hop," "fusion," and "alternative" were the popular formats.

Recording companies and radio stations believe that radio record music is a democratizing tool, serving the desires of the public. Occasionally, the question can arise, of course, whether wants are the same as needs and whether the *democratic denominator* is merely a euphemism for *lowest common denominator (lcd)*. In any event, recording companies and radio stations have found that the terms *democratic* or *lcd* are broad in scope and that a station cannot be all things to all listeners. Thus, the trend is toward specialization and development of numerous major formats, with individual stations in individual communities tending to exclusivity within any given type.

Format Types

In the late 1940s, radio needed a new approach. Postwar growth in the number of stations was almost completely local, and local revenues began to exceed those of the networks. Music programs on local stations had affinity blocks—15-minute or half-hour segments devoted to a particular band or vocalist. Format was what was decided on each day by the program director, disc jockey, or music librarian; the latter frequently prepared the actual continuity. In many local stations the disc jockey would sign on in the morning with piles of records already waiting, prepared for each show for that day by the music librarian the night before. The disc jockey might not even know what the music for each show was before it was played.

Then came top-40, an attempt to reflect and appeal to the listeners' tastes by choosing records based on popularity as judged by sales charts, juke box surveys, and record store reports. Top-40, at its beginning, was eclectic, with several stations playing the same 40 most popular selections and the disc jockey's personality providing the principal difference between station images. Soon, however, many stations began to seek specialized audiences and concentrated on certain types of top-40 music, such as country and western, rock and roll, and other forms. By the late 1960s, many top-40 stations had become almost mechanical, with virtually no disc jockey patter, a playlist of only the most popular records, and quick segues from record to record. From time to time top-40 stations rejuvenated themselves by bringing back emphasis on the disc jockey, providing "warmth" between records and more flexibility in format. When personality becomes important, deejays spend more time on continuity.

In the 1990s, adult contemporary stations took over where **MOR** (middle-of-the-road) stations left off in the 1970s. The sound is still essentially the same—"adult" music without extremes in volume, timing, rhythm, or technique. To one generation this is Frank Sinatra, Peggy Lee, and Nat King Cole; to a later one the Rolling Stones, the Police, U2, and Billy Joel; to another Tracy Chapman, Madonna, Michael Jackson, and the B-52s, and to a still later one Pearl Jam, AC/DC, Britney Spears, and Mariah Carey. Adult contem-

porary stations are personality oriented, and announcer-deejays frequently become local and even regional celebrities.

Another significant adult format is "classic rock," featuring highly successful hit music of 15- to 30-year vintage and reflecting rock's dominance as the period's prevailing music.

Rock was easy to categorize when it was new. Hard rock, underground rock, acid rock, and other rock offshoots required flexibility in rock station formats. The sociopolitical nature of some 1960s rock lyrics required a soft sound, compared with emphasis on tempo and volume alone. Jazz and folk rock have led many artists into combinations of country and rock. Specialized subtypes of rock emerged, and by the 1990s new evolutions of what the Beatles started dominated the airwaves. As young people in the 1990s began to rebel against the inequities and insensitivities of the 1980s, contemporary music again reflected political overtones, but the sound was louder, harder, and called rap.

"Easy listening" (formerly called "beautiful music" on many stations and featuring traditional string music of Mantovani, Percy Faith, André Kostelanetz, and others) is still a popular format, but today often is also a mixture of instrumental, specially performed studio versions of popular vocal songs, light jazz, and soft rock vocals. Easy listening music is chosen carefully to fit the moods and tempos of different times of the day.

Country and western music emerged as a major radio format with spectacular growth in the 1970s, capturing surprising success in urban as well as smaller markets. In the 1980s, a revival of jazz and the Big Band sound brought a return of these formats. Most radio stations have narrow-based formats so they will appeal to a well-defined and loyal audience, such as "nostalgia," "oldies," "classic rock," and "album rock." As you read this, tastes undoubtedly have changed again, by the year or by the month, and some entirely new major format may currently be popular. Even within each format there are many variations and adaptations to the individual station's market and listening audience.

Theme

Some music programs, in addition to being made cohesive through a type of music, are developed around a central theme: a personality, an event, a locality—anything that can give it unity. The writer—the person who prepares the script or rundown sheet continuity—can find ideas for central themes in many places: Special days, national holidays, the anniversary of a composer's birth, a new film by a popular singing star, a national or international event that suggests a certain theme such as love, war, the jungle, adventure, corruption, drugs, and so forth. The musical selections themselves should have a clear relationship to each other, and the nonmusical transitions should indicate this relationship.

The following program, one of a series sent to RCA Victor subscriber stations, illustrates continuity for the classical recorded music program built around a theme. Note that a listing of records according to catalogue number and playing time precedes the script, thus providing a simple rundown sheet.

MUSIC YOU WANT

LM-6026	Catalini: LORELEI: DANCE OF THE WATER NYMPHS	
	NBC Symphony Orchestra, Arturo Toscanini, conductor	
SIDE 3:	Band 4	6:23
LM-1913	Delibes: COPPELIA: EXCERPTS	
	Boston Symphony Orchestra, Pierre Monteux, conductor	
SIDE 2:	Entire	25:31
LM-2150	Stravinsky: SONG OF THE NIGHTINGALE	
	Chicago Symphony Orchestra, Fritz Reiner, conductor	
SIDE 2:	Entire	22:13

G07L-0783 AIR FOR G STRING (fading after 20 seconds)

ANNCR: (Sponsor or) His Master's Voice is on the air with THE MUSIC YOU WANT WHEN YOU WANT IT, a program of RCA Victor High Fidelity Red Seal records.

G07L-0783 AIR FOR G STRING (Up 5 seconds and fade out)

ANNCR: Today's program is devoted to musical works that deal with the supernatural. One of the three selections is from an opera, one is a suite from a ballet, and the third—from a new RCA Victor album—is a symphonic poem, later used for a ballet.
The supernatural has always had a strong hold on people's imaginations. The unknown and the unusual, with the laws of nature in a distorted or suspended state, has occupied story-tellers from their earliest days. It is only natural that this strong impulse, throughout time and all races, should attract composers as suitable subject matter. Our three works today deal with three separate types of the supernatural: mythological creatures who are portents of evil for mankind—a mechanical doll with complete but superficial resemblance to living beings—and animals with human characteristics and traits.

We open with a selection from Catalani's opera *Lorelei*. The opera deals with maidens who inhabit a rock in the middle of the Rhine River and lure sailors to destruction. We hear the "Dance of the Water Nymphs," in a performance by Arturo Toscanini and the NBC Symphony Orchestra.

LM-6026
SIDE 3:
BAND 4 Catalani: LORELEI: DANCE OF THE WATER NYMPHS 8:05

ANNCR: We have opened today's program with the "Dance of the Water Nymphs" from the opera *Lorelei* by Catalani. Arturo Toscanini led the NBC Symphony Orchestra in our performance.

Continued

Our second selection devoted to the supernatural in music is the suite from the ballet *Coppelia* (Coe-pay-lyah), or the Girl with the Enamel Eyes, by Leo Delibes (Lay-oh Duh-leeb). *Coppelia,* one of the most popular of all evening-length ballets, had its first performance at the Paris Opera in May, 1870.

The dominant figure in the story is Coppelia, an almost human mechanical doll. The youth Frantz falls in love with her, much to the chagrin of his lively fiancee Swanhilde. But all ends happily, and in the final act the betrothal of Frantz and Swanhilde is celebrated. The selections we are to hear from *Coppelia* are as follows: "Prelude"— "Swanhilde's Scene and Waltz"—"Czardas"—"The Doll's Scene and Waltz"— "Ballade"—and "Slavic Theme and Variations." We hear *Coppelia* in a performance by members of the Boston Symphony Orchestra under the direction of the veteran French composer, Pierre Monteux. Selections from the ballet *Coppelia* by Leo Delibes.

LM-1913 SIDE 2: Entire	Delibes: COPPELIA	34:52

ANNCR: Members of the Boston Symphony Orchestra under the direction of Pierre Monteux have just been heard in selections from the ballet *Coppelia* by Leo Delibes.

Animals with human traits and emotions are at least as old as Aesop. Igor Stravinsky, before composing his ballet *The Firebird,* wrote the first act of an opera, *The Nightingale,* which—for a number of years—remained unfinished. The opera was to deal with a nightingale who, moved by pity, returns to save the life of a man who previously rejected it. Stravinsky was prevailed upon to finish his score after the composition of his revolutionary *Le Sacre du Printemps.* Naturally, he was a different composer at that time, disparities of musical style resulted, and Stravinsky remained dissatisfied with the opera. He took the later selections of *The Nightingale* and turned them into a symphonic poem, changing the title to *The Song of the Nightingale.* Like most of his works, this symphonic poem became the basis for a ballet.

The Song of the Nightingale concerns the Emperor of China who shifts his affection from a live nightingale to a mechanical one, a present from the Emperor of Japan. He falls ill and is on his deathbed. The real nightingale, contrite at having deserted the Emperor after his change-of-heart, returns to sing to him and restores him to health. *The Song of the Nightingale,* a symphonic poem by Igor Stravinsky, in an RCA Victor recording by Fritz Reiner and the Chicago Symphony Orchestra.

LM-2150 SIDE 2: Entire	Stravinsky: THE SONG OF THE NIGHTINGALE	58:33

ANNCR: Fritz Reiner and the Chicago Symphony Orchestra have just played Stravinsky's *Song of the Nightingale*.

STANDARD CLOSE
Next Program (Premiere)—Monteux interprets Tchaikovsky's *Sleeping Beauty* Ballet.

G07L-0783 THEME UP TO END OF BROADCAST PERIOD.

Continued

[Examples of further central themes types are evident in the following excerpts:]

ANNCR: The three greatest masters of the Viennese classical school are Ludwig von Beethoven, Wolfgang Amadeus Mozart and Franz Joseph Haydn. Today we will hear works by each of these three masters.)

ANNCR: Our program today offers Russian music of the 19th century. We open with Borodin's atmospheric orchestral sketch, "On the Steppes of Central Asia." Leopold Stokowski leads his orchestra in this performance.

Organization and Technique

Variety is important in any musical program, which should reflect the elements of any good entertainment program. Open with something that gets the audience's attention, relax a bit, then build to a climax. Offer the listener a change of pace throughout; after each high point give the audience a rest and then move on to a higher point.

The deejay-producer-writer must analyze the potential audience—just as do the producers and writers of commercials. Though the audience is given the music that interests it—the station format and image are created for a particular audience—the program should not play down to the audience or pander to a low level of taste. The deejay-producer-writer, to a great degree, molds and determines the tastes in popular music. No matter what type of music is used, present the best of that type.

Never forget that the audience tunes in to a program because it likes that particular musical format. Reasons for listening may differ: for relaxing, thinking, learning, dancing, background while working, reinforcement while playing, or many other purposes. This suggests adhering to a single music type. Although there are exceptions, mixing Beethoven with country or rap with string quartets is not likely the most effective way to reach and hold an audience. In addition, the program organization and continuity should fit the performers' personalities, whether an orchestra, a vocalist, or a disc jockey.

Continuity sometimes seems to be limited to orchestras that "render," singers who give "vocal renditions of," pianists who have "impromptu meanderings" and are playing "on the eighty-eight," and songs that are "hot," "cool," "mellow," "explosive," "ever-popular," or "scintillating." The trite joke or play on words for transitions and lead-ins has become an overused device. Phrases such as "For our next number" and "Next on the cart" have long ceased to serve a worthwhile purpose. Perhaps that doesn't leave much choice? If you can't think of something new and fresh and not trite, keep it simple.

The timing of the show has to be exact, with the combination of musical selections, continuity, and commercials coming out to the program length. You do this by outlining all

these elements on a rundown sheet. Each record or tape cut has a specific time length indicated. Each commercial is written for a specified time. Don't forget to leave time in between for transitions and lead-ins. Rundown sheets such as the following are frequently used.

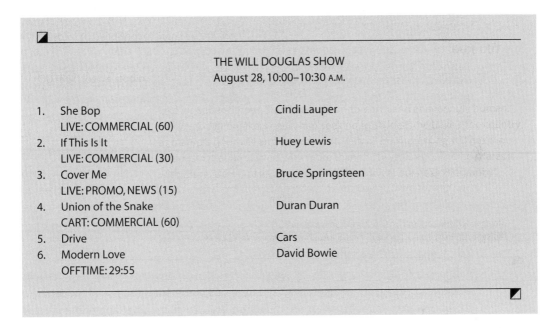

THE WILL DOUGLAS SHOW
August 28, 10:00–10:30 A.M.

1.	She Bop	Cindi Lauper
	LIVE: COMMERCIAL (60)	
2.	If This Is It	Huey Lewis
	LIVE: COMMERCIAL (30)	
3.	Cover Me	Bruce Springsteen
	LIVE: PROMO, NEWS (15)	
4.	Union of the Snake	Duran Duran
	CART: COMMERCIAL (60)	
5.	Drive	Cars
6.	Modern Love	David Bowie
	OFFTIME: 29:55	

A rundown or format sheet can be prepared for an entire evening's schedule, containing the timing for each musical piece and the listing of nonmusical program segments, as in the following example.

9:00	Fantasy/Mariah Carey	4:00
	Gangsta's Paradise/Coolio Featuring LV	3:50
	Runaway/Janet Jackson	4:17
	news	2:00
	Kiss From A Rose/Seal	3:07
	You Are Not Alone/Michael Jackson	3:32
	Only Wanna Be With You/Hootie & Blowfish	3:14
9:30	Waterfalls/TLC	4:30
	I'll Be There for You/The Rembrandts	3:45

Continued

	As I Lay Me Down/Sophie B. Hawkins	4:39
	Boombastic/Shaggy	4:10
	news	2:00
	Run-Around/Blues Traveler	3:08
	He's Mine/Monkenstef	3:10
10:00	'Til You Do Me Right/After 7	3:53
	Tell Me/Groove Theory	3:35
	Roll To Me/Del Amitri	5:04
	news	2:00
	Brokenhearted/Brandy	4:30
	Here Comes Trouble/Small Town No Airport	4:10
	Colors of the Wind/Vanessa Williams	3:02

The Pop Music Program

Although very few pop music deejay shows have written continuity, it doesn't mean that no preparation is done. Every show has to have some kind of rundown or outline to make certain that commercials and other announcements are included at appropriate places within the program's specified running time. At the very least, a pop music program will have a playlist from which to work, usually a tabulation of the most popular songs of the past week, from which the deejay, traffic manager, or librarian chooses those numbers that fit the musical format of the given show.

Few disk jockeys can come to the studio without any preparation for the specific program, pick up a batch of records or carts, and come up with a good, professional show. Some personalities can recall, organize, interrelate, and present ideas correlated with musical numbers with speed and fluency. Unfortunately, too many deejays who think they can, actually can't. Ad-libbing usually becomes boring and repetitious or embarrassing. Successful deejays rarely take a chance with complete ad-libbing. Why be half-safe when you can be more sure with some preparation?

Harold Green, when general manager of WMAL, Washington, D.C., detailed the preparation required for his music programs, including the gathering and development of material to be used as continuity:

> The day of the "limited" announcer is about over. Just a beautiful voice, or just a snappy, witty or attractive personality is not enough for today's successful radio station. All the tricks, gimmicks, formats, points of view have been tried in one form or another. Some are quite successful in a limited way. The danger that the individual suffers is the strong possibility that he will remain submerged or anonymous. This is particularly true in a station that depends strongly on a particular "format." We feel that the stations that matter in the community don't

limit themselves to a format or other gimmick. The key is community involvement—information with a purpose—and a continuity of sound (in music and personality) that will continually serve, and please, the audience that particular station has cultivated.

Our announcers go on the air each day with a thick folder of clippings, personal observations, letters from listeners, and tears [reports taken off the wire service machines] from all the news and sports wires. By the time our announcers go on the air each day, they are fully briefed on all that is happening that is significant in the news, in sports, special events in the community, special broadcasts of more than routine interest scheduled for that day and week, or anything else that amounts to information *with a purpose.* They have spent a minimum of two hours in the music library. Generally, each day's music preparation time amounts to approximately 50% of air time. A four-hour program requires about two hours to prepare musically. This is for one who is thoroughly familiar with the library. Otherwise it becomes a 1:1 ratio, or even longer. This is because the music list must reflect variety and balance: up-tempo music, boy vocal, lush orchestral, girl vocal, combo or variety, group vocal, and back around again. Specialty, novelty, or other types that break the pattern must be showcased by the D.J. There must be a reason for playing these "extras," and it must be explained.

It is safe to say that when a person does a smooth, informative, professional four-hour show—and one that teased the imagination and piqued the curiosity—he or she did an equal four hours of preparation. If they don't, they'll know it in about an hour. I'll know it in about an hour and a half, and the listener will know it before noon the next day.

Without preparation, background, genuine interest in the world, and diligent attention to getting informed and staying informed, broadcasters sink instantly into mediocrity. They are then relying on tricks. . . . They are ordinary. . . . They are short-changing the audience.

They won't last long.

The music library is of great importance. Know its content. Recordings should be auditioned, timed, and catalogued when received. Cross-indexing is desirable, with separate indices for theme, performer, composer, and any other area that can help the program's organization. Be conscious of the changing fads and fancies in popular music. Do not assume that because popular music is not in the same aesthetic league with classical music that it is not serious music to its listeners.

In specific pop music forms, such as rock, fusion, and rap, the deejay is expected to be highly knowledgeable. Standard selection sources for pop music programs are trade magazines. *Radio and Records, Cash Box, Billboard, Record World,* and *Variety* provide information about the best-selling records and tapes, including rank in sales and type of music. In addition, these publications frequently give background information and carry news and features about the artists. For a top-40 show, the ranking list is indispensable. But for all formats the information obtained from the trade journals makes it possible to organize a program and, where feasible, to write meaningful continuity.

Michael C. Keith, longtime radio programmer, professor, and author of many books on the medium, describes three principal copy types for the pop music show, besides commercial and PSA scripting: "liners," "positioners," and "promos."

Liners are specific statements that announcers or deejays make about the programming. For example:

KISS 108 ACCUTIME ...
MORE Q-ROCK POWER HITS ...
A LITE 92 FM MUSIC SWEEP ...

Positioners tell the listener exactly what the station is all about—its place on the radio dial. For example:

BOSTON'S BEST MODERN ROCK STATION ...
THE EASIEST SOUND IN THE BAY CITY ...

Promos are just that. They promote the station. For example:

HITS 96 GIVES YOU 96 DOLLARS EVERY 96 MINUTES ...
EVERY NITE AT 9 THE BEST IN SPORTS TALK ON AM 1080 ...

Keith stresses that economy is very important in writing this kind of continuity. The writer must consider time and space limits. The writer should create simple, declarative statements, no more than a sentence for each, that should be pertinent and direct. These statements are used between program elements and are called "drop-ins." The deejay will talk until the lead or post (the beginning) of a song—read a liner right until that point. Highly formatted and planned shows, Keith notes, have no ad-libbing, no extemporaneous material. The deejay must read the liners as they are written and where they are placed, with no deviation. The continuity writer, therefore, is a very important part of the pop music program.

The Classical Music Program

Very few radio music programs have prepared scripts, and these usually are limited to classical shows. The classical music audience expects more than a cursory introduction, and more continuity is needed than in the pop program. The listener already is likely to know something about the music to be presented and to expect intelligent and informational background material and, frequently, aesthetic comment and interpretation. The expert analysis must be presented thoroughly. It is not sufficient to say, "This is the finest example of chamber music written in the twentieth century." Give the reasons why.

Classical music continuity can be oriented toward special areas; for example, a concentration on symphonies, chamber music, or operatic excerpts. Note how the program outlined earlier in this chapter dealing with the supernatural combined opera, symphony, and ballet within its central theme.

MUSIC: TELEVISION

As the 1990s moved into the twenty-first century, music television networks continued to explode—with literally 20 and more vying for places on the cable dial. Like radio, many

music television networks tended toward specialization to reach specific demographic audiences. Although most still maintained a mix of music, some featured one music type more than others, and some networks were principally or exclusively oriented to a given music, including jazz, country, MOR, rock, pop, alternative, rap, metal, and reggae. Some oriented their nonmusic materials to a specific topic, such as sports, drugs, health, and dating. Some, such as the Spanish language network and the Christian music network, aimed at designated audiences. In addition, there seemed to be a trend toward more music on traditional channels, such as classical music on PBS.

Without visual action and attractiveness, the music program on television might just as well be listened to on radio. Although the music must be the audience's primary focal point, the visuals must be integrated effectively enough to hold the audience's attention and interest. The success of music videos illustrates the importance of visual action.

The first thing the writer must ask is, "What will the picture add to the sound?" Gimmicks, strange angles, and bizarre shots are not justified for their own sakes; they must have an integral relationship with the music and the performer. You can discover ideas in a locale related to the musical number, the mood expressed by the song, the idea or story presented in the lyrics, and the origin or image of the performing group, among other things.

For many years simplicity was the key: Visual concentration on different sections or members of the orchestra, on the rock performer's gyrations, on the ballad singer's facial expressions. This worked well to a point, but for a performance lasting longer than one or two numbers the visual coverage became repetitious and boring. Music videos broke the mold, incorporating abstracts, free forms, dramatic situations, drawings and paintings, architectural compositions, combinations of colors and angles, and a kaleidoscope of the television camera's and effects board's potentials.

Other art forms, such as pantomime and dance, can provide interpretive visualizations of the music. Inanimate objects and forms can illustrate realistic and nonrealistic content and feeling. Landscapes, people, places, actions, and events can indicate various environmental, fantasy, and psychological meanings and moods for the music.

According to Patrick Kirwinek, a music video producer and teacher, experienced producers do not need to submit scripts or storyboards, but operate from ideas created from the essence of the musical number to be videoed. Established directors "wing it from the edge of a martini glass," noted Kirwinek.

Although the young, beginning writer-producer may be asked to follow a proposal acceptance with a script or storyboard, the key is the proposal—that is, the *treatment*. Producer Joel D. Hinman, of Scorched Earth Productions, advises that in his "long experience the more successful treatments have relied on visually specific language. An artist, for instance, will want to know what they are wearing. If you have a choice, be specific."

Music video writer Ernie Fritz advised the beginning writer to determine first what the recording company's purpose is for the video. "If the song is already getting air play," Fritz said, "they're not looking for innovative video art. They want the video for support. Sometimes, however, they want you to make the video predominant because the song isn't getting much air play and they want the video to generate it." For writing technique, Fritz stressed

the importance of listening to the song very carefully before preparing a video treatment. "Understand it emotionally as well as intellectually, what the music says as well as what the lyrics say," Fritz stated. "Sometimes the music is going in a different direction than the lyrical content. Capture the feeling as well as the narrative of both the music and lyrics."

The following treatment, written by Ernie Fritz for Scorched Earth Productions, dramatizes the rap song "Cappucino" with the artist MC Lyte.

- *What elements can you find in the following treatment that are mentioned in the preceding paragraphs? What additional elements can you find that were not noted?*

It is pretty evident that we should follow the narrative of the song and portray some of the incidents described. I feel however that the bulk of the clip should be kept in a present state as if MC LYTE were recounting it to some friends. She would also present evidence of the event in the form of napkins, stains on her shirt, and other items from the story.

The video would start out on a street full of people walking around, driving by in cars, eating ice cream . . . hanging out. The camera would travel down the street until it rests on MC LYTE with a group of friends around her. MC LYTE would begin to tell her saga which, for the opening, would be inter-cut with illustrations of maps indicating the location of this adventure. The maps would be of different countries and different towns, and each time would lead us a bit closer to the real locale.

The shoot out would all take place in four shots. MC LYTE placing her order, a gunman grabbing her from the back, other bandits demanding all the cappucinos in the place, and a shot of something aiming at her back. MC LYTE would recount the rest of the incident combined with shots of her friends reacting and K-ROCK confirming her story. *"I got shot in a shootout"* would be covered with stock footage from a 1930s black and white gangster movie.

The ascent to "heaven" would be covered with a blue screen shot of MC LYTE floating in the sky looking down on the city. She wonders to herself "Why did I need cappucino?" In this ascent, we would also use a shot of a clock ticking by time floating past her.

As we get to heaven MC LYTE will continue her float, passing all her "friends and acquaintances" who will also be floating in space. Each person she passes will look at her and they will exchange greetings. Hanna Smith will be shown in a photo with her name written across it.

MC LYTE awakens in her bed screaming and quickly checks in the mirror to see that she is really alive. In fast cuts we will go through all the incidents that have occurred so far until we get back to the street scene where she reveals to her friends the spot of cappucino on her shirt.

We will then proceed to a quasi-documentary on the making of cappucinos, from the making of the coffee to the foaming of the milk. . . . This will be done in a 1950s "industrial" look.

Continued

The "documentary" will end with MC LYTE sitting at a counter with 418 empty cappucino cups in front of her in what will appear to be a day of deranged cappucino drinking. Her hair will be teased up in the air and an extreme close up of her eyes will reveal a scene of spinning coffee cups. By this time MC LYTE will be waving a white surrender flag. The finale will consist of another roundabout look at the places that we have been to so far. Also, in this end section, we will focus on K-ROCK, other musicians, and MC LYTE's friends (from the first scene) who will be shocked and incredulous of the story that they have just been told. MC LYTE will get up and leave the setting as we are left behind to wonder the veracity of her story.

Written and copyrighted by Ernie Fritz; courtesy of Ernie Fritz and Scorched Earth Productions, New York

The following is an example of the written material for another kind of contemporary music program—the variety, anthology, or medley—comparable to the radio disc jockey program in which a series of numbers are performed. Produced by broadcasting majors from colleges in New England on a commercial station, "Nightshift" alternated among various formats, including music, drama, variety, and interview shows.

NIGHTSHIFT # _____ TAPE DATE <u>12/12</u> AIR DATE <u>12/14</u>
PROGRAM TITLE <u>"AN EVENING WITH THE RON GILL AND MANNY WILLIAMS TRIO"</u>
SCHOOL <u>EMERSON COLLEGE</u>
PRODUCER <u>RICHARD BUXENBAUM</u>
DIRECTOR <u>ISAAC LAUGHINGHOUSE</u>

ITEM #	VIDEO	AUDIO	SEGMENT TIME	RUNNING TIME
	SLIDE 1,2,3,4,5,6 (OPENING)	"WHEN THE MORNING COMES"	:30	00:00
	SLIDE ¢ w/EFFX (mix, card)			
	SLIDE 7–24			
	SLIDE 25			00:30
	DISSOLVE TO EXCU (cymbal, matching shot) STUDIO		5:30	
	ZO—CS (wide shot)			00:32

Continued

ITEM #	VIDEO	AUDIO	SEGMENT TIME	RUNNING TIME
	FILM CART I	w/sound, MUSIC UNDER	00:47	06:00
	LONG CS (with Ronnie's back facing camera)	"WONDER WHY"	03:00	06:48
	MA (MANNY)	(PIANO INTERLUDE)	01:00	09:50
	M2S (RONNIE, MANNY)	"SADNESS"	05:05	10:50
	FILM #2	w/sound MUSIC UNDER	00:42	15:56
	KNEELING HAND CAM LOOKS UP RONNIE	"PHOTOGRAPH"	04:00	16:38
	EXCU RON, CU PIANO KEYS MIX	"RAINING OUTSIDE"	04:40	20:38
	2S BASS DRUMS	"WAY OUT THERE"	03:00	25:18
	FILM #3	MUSIC UNDER w/sound	01:33	28:18
	SLIDE: WRITE . . .	Cart #7	00:09	29:51
	BLACK			30:00

Courtesy of WCVB, Boston

The more formal, more serious musical program tends to be less visually innovative than the contemporary pop music program. This may be because the audience's educational and aesthetic levels are likely to be fairly high: The audience concentrates principally on the music.

- *The following script is for one of the* Evening at Pops *programs on public television. What techniques would you add to make the program more visually informative as well as entertaining, but still keep within the tone of the presentation and the orientation of the audience?*

EVENING AT POPS

Tonight, Broadway and film star Bernadette Peters. With music from Broadway and Hollywood, movie star and entertainer Bernadette Peters joins John Williams and the Boston Pops, tonight on Evening at Pops.

And now to get this evening's concert started, here is John Williams for Leonard Bernstein's Divertimento for Orchestra. The Divertimento is in eight parts and tonight John Williams has made a selection of four—Sennets and Tuckets, Waltz, Mazurka, and March: The BSO Forever.

out by: THE DIVERTIMENTO
 The Divertimento for Orchestra by Leonard Bernstein. John Williams conducted the Boston Pops. The Divertimento was commissioned by the Boston Symphony in celebration of its centennial year.

cue: And now tonight's guest Bernadette Peters.
 Ms. Peters has chosen a program that includes a medley "We're in the Money" and "Pennies from Heaven," "If You Were the Only Boy," "Broadway Baby," "Other Lady," and a medley of Harold Arlen tunes. (pause) Here is Bernadette Peters with John Williams and the Boston Pops. To start—"We're in the Money."

cut by: PENNIES FROM HEAVEN
 IF YOU WERE THE ONLY BOY
 BROADWAY BABY
 OTHER LADY
 HAROLD ARLEN
 A medley of Harold Arlen tunes with tonight's guest Bernadette Peters; John Williams conducted the Boston Pops. With Miss Peters were pianist Marvin Laird and Cubby O'Brien on drums. Bernadette Peters' first starring part was in the off-Broadway musical "Dames at Sea." That part led to starring roles in the Broadway musicals "George M," "On the Town," and "Mack and Mabel." Her movie appearances include "The Longest Yard," "Silent Movie," and most recently, "Pennies from Heaven" and "Annie."
 In just a moment John Williams and the Boston Pops for *Overture to Candide* by Leonard Bernstein.

out by: CANDIDE
 Overture to Candide by Leonard Bernstein. John Williams conducted the Boston Pops. In just a moment "Tara's Theme" by Max Steiner from the film "Gone with the Wind."

out by: TARA
 "Tara's Theme" by Max Steiner from the film "Gone with the Wind." John Williams conducted the Boston Pops. And now another tune from the movies, "Raiders of the Lost Ark March," composed by Boston Pops conductor John Williams.

Continued

out by:	RAIDERS OF THE LOST ARK
	"Raiders of the Lost Ark March," composed and conducted by John Williams. And now to close this evening's program, from the film E.T. "The Flying Theme" composed by John Williams.

out by:	E.T.
	"The Flying Theme" from E.T. by John Williams.
	This brings us to the end of tonight's Evening at Pops with John Williams and the Boston Pops Orchestra. Tonight's special guest was Bernadette Peters. Major funding for Evening at Pops was provided by Public Television Stations. Additional funding was provided by Digital Equipment Corporation. This is William Pierce inviting you to join us again for our next Evening at Pops.

Courtesy of William Cosel Productions

MUSIC ON THE INTERNET

Music on the Internet has led to laws and litigation reminiscent of the early 1920s when the American Society of Authors, Composers and Publishers (ASCAP) won a court case against the nascent radio stations, litigation that affirmed ASCAP members' ownership of music they had copyrighted. The radio stations played records and used sheet music for live shows that had been copyrighted by members of ASCAP without getting permission or paying any fees. In other words, they pirated the intellectual property of others, similar to production companies producing a script you wrote without paying you for it or getting your okay to do so. Since then ASCAP and the National Association of Broadcasters (NAB) periodically negotiate a contract in which each station pays a statutory fee (a fixed amount based on the station's market) for unlimited use of ASCAP's music inventory.

In the past decade, various Web sites on the Internet have done the same thing, with Napster being the most prominent pirate. Napster's file-sharing system permitted Internet users to create MP3s, a digital form of audio recording, which allowed storage of music on hard drives. Users could exchange copies of their MP3s. The problem was that Napster did this without paying fees, thus turning all its users into pirates as well. Napster was successfully sued for copyright infringement. Before you use any music on the Internet, be sure you are ethically and legally clean and get proper clearances. A new copyright royalty fee to record companies, as well as to songwriter organizations, which went into effect in 2002, forced hundreds of Internet "pirate" radio stations to close. Online music services such as Listen, Pressplay, and RealOneMusicPass, however, began to grow, replacing Napster by paying legal fees to artists for their music. As critic Jefferson Graham writes in *USA Today,* these services are among those "in the race to become the great celestial jukebox that could someday make the universe of music available anywhere, any-

time, at the click of a mouse." As this is written, Congress is considering legislation that would require computer and consumer electronics makers to incorporate technology into their products that would prevent anyone from downloading a particular piece of music or film that has been copyrighted.

More and more people are listening to and even purchasing music on the Internet. Live broadcasts with interactive sidebars have begun to create new audiences for the radio, audio, and music industries. Listeners can select specific artists or music styles at any time. Listeners can establish their own playlists for as many selections and as long a time as they want. The Internet also permits less restrictive music formats, enabling receptors to go to sites with background information on artists, reviews of albums, history of the type of music, and similar data previously not easily available. With listeners able to respond directly and in-depth to the deejay or program producer, Internet radio stations can more accurately serve audience needs than can traditional radio stations, including those that stream their signal onto the Internet. The ultimate flexibility is the music radio Internet service with multiple channels or the service with multiple links and sites that lets the listener set up his or her own personal radio station. The writer can set up interactive choices that give the listeners complete control over what they hear, including the type of musical style, choice of artist, and specific musical numbers. The computer uses this information to establish a playlist and every time that listener logs on it offers a new rotation of selections.

Some audio programmers have taken music on the Internet a step further and have integrated the music with graphics, not quite the same as music videos, given the Internet's limited bandwidth, but the kaleidoscopes of colors prompt some observers to make analogies to safe drug highs.

If you've not yet logged on to one of the Internet music services, do so and note the links to the many services that most of the companies provide, going beyond the music alone and including subsets regarding individual performers and pieces of music.

VARIETY AND COMEDY

Reading a chapter of a book or reading a dozen books will not give a writer the comedy writing skills of Goodman Ace, Carl Reiner, Norman Lear, Neil Simon, or Woody Allen. But the writer can learn some basic approaches to organizing the variety program and writing humor—including elements of drama and music as well as comedy.

Program Types

By the 1980s, variety shows had all but disappeared from television. What were once among the most popular shows were reduced to occasional specials. Elements of the variety show are still found in late evening entertainment programs such as *The Tonight Show with Jay Leno* and *The David Letterman Show*. Whether variety shows will resurge in the near future is anybody's guess—but the broadcast writer should be prepared.

The term *variety* implies a combination of two or more elements of entertainment and art: a singer, dancer, stand-up comic, comedy skit, Shakespearean actor, puppeteer, ventriloquist, pianist, rock group. Depending on the program's principal figure, several of these elements would be incorporated in a manner that shows off the star to the best advantage. Catchall, nonstar variety shows are rare.

The basic variety show types are the vaudeville show, the music hall variety, the revue, the comic-dominated show, the personality (usually singer or dancer) program with guests, the musical comedy approach, and the solo performance. Although all of these forms have been on television from time to time over the years, they have varied in popularity.

The variety show is not a haphazard conglomeration of different acts. Even the vaudeville show—exemplified in television history by the *Ed Sullivan Show*—carefully integrates and relates its various acts and frequently focuses on a clear central theme. Vaudeville and music hall variety are basically the same, oriented around specialty acts of different kinds. The revue is organized primarily around music and dance, with comedians frequently providing the continuity and transitions between musical numbers.

The comic-dominated show can consist of a comedian as the central performer, with various guests or standard acts. A singing personality can mix his or her songs with participation in comic skits (a comic could add the songs), with contributions from guests, creating what is in essence a revue centered on one performer. When such shows have a thread of continuity, no matter how thin, they become musical revues. The thread can be any kind of theme: the songs of one composer, a national holiday, a historical happening, the biography of a famous entertainer, a locale—almost anything can serve.

An adaptation of the vaudeville variety show has been successful on American television, substituting a host or hostess who rarely participates in the overt performing and who introduces and interviews various guest entertainers. Because much of the program is banter between host and guest (and in these segments the host or hostess is a principal entertainer), these are frequently called talk or interview shows, most notably exemplified by the late night programs already noted. There can, of course, be combinations of various performance types and variety forms on any given program.

Some of these programs have become even more sophisticated through the Internet. As early as 1998, NBC was providing interactive access for *The Tonight Show with Jay Leno*, in which viewers could click on sidebar icons for background information on Leno's guests.

Approach and Organization

The most important thing for the variety show writer to remember is that there must be a peg on which to hang a show. You must develop a clear central theme, capable of being organized into a sound structure, with a unity that holds all the parts of the program together. Otherwise, each number will be a number in itself, and unless the audience knows what the next act is and especially wants to watch it, the audience feels free at any time to tune in another station. The theme could be a distinct one or the continuity factor

could simply be the personality of the host, comedian, or singer. An exception is the vaudeville or music hall type of presentation. In these shows the audience is held by frequent reminders of the special act still to come.

Within each separate variety show type, distinct orientations must be determined by the writer. Will the musical portions stress popular or novelty numbers? Will the dances be classical in style? Modern? Presentational? Representational? Interpretive? The comedy must be written to fit the comic's personality and must contain a sufficient amount of ad-lib material to enhance the public concept of the comic's spontaneous talents. What kind of comedy will be emphasized? Simple good humor? Wit? Satire? Slapstick? Will it combine elements of several types? Will it go into special areas of farce, sophisticated humor, irrelevancy, or irreverence? Does the comedian's style require material oriented toward broad, physical gags? Sophisticated wit? The intellectual approach? Irreverent satire? *Laugh-In* and, later, *Saturday Night Live* started with satire, but ultimately overlaid it with other forms of comedy to fit the personalities of the particular performers.

When planning a variety show, consider the intrinsic meaning of the term *variety.* You must differentiate between each successive number and among the various program segments. Contrast is important—not so much that the viewers are disturbed, but enough so that there can be no feeling of sameness, a feeling too easily transferred into boredom. Musical number should not follow musical number; comedy routine should not follow comedy routine. Even in a show featuring a popular singer, the continuity is broken up with an occasional skit or a guest performer. A comedy program such as *Saturday Night Live* provides variety to the comedy with segments by musical groups. The suspense created by a juggler who balances an unbelievable number of fiery hoops on the end of his or her nose should not be followed directly by the similar suspense of acrobats balancing one another on each other's noses.

In programs that use outside acts—those that cannot be scripted and timed exactly, as with late night talk or variety programs—the final number or act should have two versions, a short one and long one. The proper one can be called for depending on the time remaining when the act is about to begin.

Comedy

Although many books contain hundreds of comedy situations and thousands of one-liners, few books do more than give you ideas for comedy or overviews of comedy approaches. You can't learn to be a comedy writer from a book. Each comedian has his or her own "shtick." You can learn individual techniques by watching them. And some books delve into principles of comedy writing that you may be able to apply, depending on your own type of humor.

Comedy writer Hal Rothberg, writing in *Audio-Visual Communications,* advised that "to write funny, you have to think funny." He offered several guidelines for the comedy writer:

1 "Understand your audience." Are audience members the type who will laugh at slapstick or prefer more sophisticated humor? Situation comedy or one-liners?

2 "Make the humor spring from the characters or situation." As with writing any action, the characters and the situation must first be believable to the audience before you can move into comedy, satire, or farce.

3 "Use all your tools." Don't forget that humor can be presented both aurally and visually. On television, you can use films, cartoons, and other visuals alone or with live performers. On radio, sound effects (as in the old Jack Benny script in Chapter 2) have always been useful tools.

4 "Watch the budget." Neophyte writers sometimes think that far-out situations that are very expensive to produce automatically will be funny. A relatively low-budget show like *Saturday Night Live* demonstrates how creativity is more effective than costliness alone.

5 "Keep it clean." In some situations blue humor may fit, but on television one must be careful while being clever. Most nightclub stand-up comedians have visions of being Lenny Bruce or Eddie Murphy and resort to sophomoric bathroom humor and four-letter words as substitutes for comic ideas. Too many young comedy writers substitute shock for stimulation.

6 "Don't beat a joke to death." Except for the running gag, don't repeat something, even if you think it's good. It works only once.

7 "Mix 'em up." Use a variety of ways to get laughs. Surprise your audience. Varying camera perspective or the music mood can be just as effective as a punch line.

8 "Keep it fun." In most situations, the audience wants to see only the bright side of life. Heavy humor is risky for the mass television and radio audience. That doesn't mean meaningful humor will not work. Mark Twain and Will Rogers were superb satirists of society. Mark Russell has been successful with political satire. Jerry Seinfeld has made gentle humor and commentary on everyday foibles work on television.

9 "Try it out, but don't be discouraged." Before you sell or give it to your agent or client, try it out on friends, strangers, anyone from whom you can get a reaction; then cut, fix, and rewrite.

10 "Don't expect to be loved." The people you sell your comedy writing to are likely to be skeptical; until your material is getting laughs from an audience, don't expect much applause.

11 "Read a little." To write humor, you have to keep up with what is happening to people and the world. Find out what other comedy writers are producing and what is working.

12 "Are you communicating?" What is the purpose of your humor? Is there a goal besides simply making people laugh?

As Rothberg said, "First and foremost, communicate."

APPLICATION AND REVIEW

1 Prepare rundown sheets for three different local disc jockey pop music radio shows, each with a different music format.

2 Write the complete script for a half-hour radio classical music show, to be distributed on a national basis to local stations.

3 With other members of a writing team (for example, several other members of your class) prepare the rundown and continuity for an hour special featuring the pop music group or personality currently at the top of the sales charts.

4 As part of a writing team, write a treatment for a five-minute music video. Write one alone.

5 Mock up a preliminary home page for a new Internet music provider.

9

Corporate, Educational, and Children's Programs

According to *Writer's Market,* corporate and educational films and tapes, including advertising, informational, and training programs, are bigger business than Hollywood. Corporate media programming—or, as it is still frequently called, industrial programming—includes virtually all the formats covered thus far in this book.

Examples of corporate media programming include "talk" programs that feature managers or subject area experts discussing new sales approaches, manufacturing processes, or organizational changes, among other topics; **teleconferencing,** small or large meetings connecting two or more sites via television; executives giving speeches to employees or to the public at large; company leadership being interviewed for internal or external distribution; and formal education and training programs.

Feature and documentary formats provide historical, scientific, public service, operational, or other background regarding the company that will enhance its institutional image. News formats convey information about the company on a periodic, sometimes daily, basis.

All companies use commercials and announcements. News, features, and commercials have been merged into a format that has grown in recent years, sometimes called "infomercials." These range from short commercial spots, usually about 30 seconds, that combine public service information, such as consumer data, with a commercial message, to 15- and 30-minute and longer programs that sell a product or service.

The feature/documentary and commercial have been united for public relations programs. For example, if the company wanted to expand onto some property that was going to be used for low-income housing, a feature-type commercial showing how the company's expansion will provide jobs for low-income families, below market-rate loans for worker home-ownership, and another equivalent suitable site for housing could defuse opposition to expansion and gain increased support for the company and its products.

Perhaps the most widely served corporate purpose is education and training. Video training programs are produced internally by many companies. Some have highly sophisticated production centers and a staff of producers and writers (usually, the producer and writer are the same person—an important consideration for students who are studying production but neglecting writing courses). Training videos are produced for all corporate levels and for all purposes. Programs run the gamut from introducing the physical surroundings in which new employees will work to more sophisticated requirements such as filing procedures for entry-level office personnel, to more complex procedures such as operating a given mass production machine, to an even higher level such as introducing the development of a new company product based on a recently invented scientific process.

Videos can teach new secretaries basic grammar skills and vice-presidents how to make speeches to employee groups. Programs are produced to introduce new products, new selling techniques for old products, new operational systems, new reporting procedures, and new budget and financial processes to a relatively few or a few hundred people at one site, or to literally thousands of employees scattered all over the world for a multinational corporation.

Another area of corporate video is *point-of-purchase (POP)* television. These are monitors at retail outlets where the video is designed to influence undecided customers to purchase a given product. Though a small store with many products could not show its many items effectively in a video, a store with one or a few major products could, as can department stores that have specialized areas or counters. Although many of these videos are straight sales pitches, others use a combination of formats to create infomercials and MTV-type entertainment.

The writer pitches these videos principally to the customer, but many stores find a secondary use for them: to inform employees about the products and to train employees how to sell products most effectively. Some stores contract for videos for the latter purpose only. This means the writer must creatively combine commercial and training objectives.

Although writing any format is essentially the same for all media distribution situations, remember that corporate media's bottom line may not relate directly to selling the product. The company's purpose with any given video, **slide show,** or audiotape can vary greatly: to enhance employee morale, obtain good public relations, sell, persuade colleagues, or educate and train. The writer must determine the company's specific purpose for any given corporate media program. All of these corporate purposes were for some years served by video, audio, and film distribution. As this new century began, the new medium, cyberspace, became increasingly important for corporate use; the Internet is more and more becoming the medium of choice.

Corporate media writing is not confined to industry. Though widely used in industry, corporate media refers as well to media use by government offices, educational systems and institutions, and professional and citizen associations and organizations—in other words, by any group that wants to inform, persuade, or educate, internally and externally.

Corporate Programs Procedure

Objectives

To develop an idea for a program, the writer must know the program's purpose. Usually, there are two major objectives: that of the client or management and that of the target audience. It generally is easier to determine the purposes of an in-house production because management usually is precise about what it wants the media program to accomplish.

The writer must determine, as well, the purposes of the audience. If a training program is aimed at company employees, as most corporate media programs are, how is the intended audience going to be motivated to watch and pay attention to the program and to actually learn from it and follow through on the management goals inherent in it?

Demographics are important here for two major reasons. The first, and perhaps most obvious, reason is the same as that for writing commercials: determining what kinds of program materials will appeal to the viewers or listeners, get their attention, keep their interest, and persuade them to do whatever it is management wants them to do. The second relates to motivation: determining why the viewer or listener should take the program seriously. Every member of the audience must be made aware of what is in it for him or her. Will learning the new production technique and using it successfully earn a raise or a promotion? Is proper use of the new computer system necessary for keeping one's job? Will expanded sales of the new product result in escalated commissions? Does learning how to make good speeches, to increase participation as a middle manager in community affairs, result in higher bonuses? If the production is for public consumption, such as an institutional feature or an infomercial, the writer uses the public demographics of the target community.

A good example of combining management's purpose with motivating the audience both to watch and learn is "The Hantel Advantage" script later in this chapter. Writer-producer Frank R. King knew what management wanted: increased productivity through faster interoffice communications. The employees scheduled to see the video at regional conferences were forced, however, to take time from their commission-earning routes to attend the meeting and had to get up early in the morning to watch the program.

King used two key motivations in the script. First, he tried to convince the employees that by using the new Hantel computer system they would require less time for any given client transaction, thus saving them hours per week in which they could sell more insurance and make more money or, if they wished, have more leisure time. Second, so the employees would not ignore the video because they were both tired and angry from having to get up early to see it, he included broad, almost farcical humor in an attempt to motivate a happy attitude toward the video, as well as to the workshop that followed. Entertainment became an integral part of learning motivation.

Roger Sullivan, when director of education for the Commercial Union Assurance Companies, offered the following advice for developing effective corporate video scripts:

It is very important that business video program writers understand the objectives of the particular video being produced. For example, when we develop a video for the business adult education community, we have, in truth, two audiences: the organization for which the video is being developed, which wants a program that provides employees with the practical knowledge and skills they need to carry out successfully one or more particular predefined performance functions on the job; and the employee, who seeks personal growth and the ability to carry out a performance function as confidently and competently as possible. Both audiences want to have the learning completed in as short a time as possible and within reasonable cost limits. The business video production begins with a detailed agreement about the objectives, the performance which the employee can be expected to demonstrate as a result of the learning. The complete scenario is a series of interrelated modules of skills or knowledge leading to the final ability to perform the objectives. The most effective visual presentation for each module is developed. The emphasis is on the practical—how to do it. The theoretical—why—is secondary. Once your audience and objectives are well-defined and the modular building blocks assembled, then the scenario may be fleshed out.

Client/Management Conferences

If you are an out-of-house writer, that is, an independent writer or writer-producer, it will take longer to determine management purposes and target audience demographics and motivations. Although no rule-of-thumb works in all cases, many independent production organizations allocate about two-thirds of the total production schedule to writing the script and one-third to actual production. The more complete the preparatory work, including finalizing the script, the less time is needed for shooting. If the entire production is in-house, the same time ratios generally are true, except the total time allotted to the project may be far shorter. Management often forgets that creativity takes time and expects its audio-visual unit to produce a product as quickly as it expects its accountant to provide last week's sales figures.

Whether working within a long or short time frame, the writer must meet with management and with target audience employees. Frequently, the program is produced in-house, but is scripted by a freelance writer. That situation calls for the writer to consult with the in-house producer as well as with other offices and personnel in the company who may be affected by the program's purpose or content. During the initial meeting between writer and client (or if in-house, writer and management), clear agreement should be reached about the program's purpose and form.

Budget and Resources

As soon as possible the writer must gain a clear understanding of budget limitations. If, as is frequently the case, the writer is also the producer, a budget should be determined with the client/management at the first meeting. A client may have in mind a program that, from the writer-producer's expert viewpoint, requires a budget of $150,000. The client, on the other hand, may have allocated a budget of $50,000 for that particular project. Make clear immediately the kind of program that can be prepared with the available budget to avoid not only wasted time and resources, but also misunderstanding and recrimination.

When initially discussing the project, the writer must determine whether its purposes can be accomplished in one program and, if so, the optimum program length, whether several shows will be required, or whether a lengthy series is necessary. The purposes, budget, and resources also determine the media form. Video on tape or film? Voice-over slides? Audio alone? Streaming video for the Internet?

If you are employed in-house, or by an independent production company, you already know the production resources. If, however, you are employed on a freelance basis to write that particular script, you must determine the company's production capabilities or those of the outside organization the company will hire, before preparing an outline.

Treatment or Outline

The treatment is important as the next step in maintaining agreement between writer and client/management during the preparation and production period. It might well cost the writer time and money, and perhaps even the job itself, for the client/management to look at a script several weeks after the beginning of the process and object that it is not at all what the client had in mind, wanted, or expected to get. Therefore, soon after the initial meeting, the writer should prepare an outline and get client/management approval before beginning a detailed treatment, which in turn needs approval before the preliminary script is written. That, as well, should be approved before the final script is prepared. In other words, the writer should be certain that his or her work is on target during every phase of the project.

There are exceptions. Some in-house and independent writers have worked sufficiently long and successfully for the company that their judgment and proficiency are trusted. These writers may be given the project purpose at an initial meeting and told to come back with a completed script in a specified time period. Experienced writers-producers such as Ralph De Jong, whose script is used as an illustration of good writing later in this chapter, are frequently in that position. As you read De Jong's advice to young writers, note that despite his prerogatives he takes the steps necessary to be certain that both he and the client agree all the way.

Research

In most cases research takes the longest time, unless the writer happens to be an expert in the subject being scripted. Although the program should be entertaining as well as educational, it is not an entertainment program. Its purpose is to convey specific ideas and information. It must be totally accurate. To make it interesting, the writer must become familiar with all aspects of the subject, whether the company history or the technical operation of a scientific process. Only then can the writer have enough material to choose the options that will result in the most effective script. Depending on the subject, the writer will do library research, computer research on the Internet, pick the brains of experts, and talk with the employees who are the targets of the program and with the

management officials who decided on the objectives. Roger Sullivan advised the writer to "work closely with subject matter experts and rely on their comments, as well as on your own imagination."

When possible, the writer seeks real-life experience with the subject, such as going into the field with an insurance salesperson and applying the new method promoted in the program, working on the assembly line with the new machine, or accompanying the vice-presidents who are promoting the company's image at community affairs.

Production

When the final script is prepared and approved, production starts. In the corporate situation, unlike many broadcast or cable circumstances, the writer's job usually does not end with the completed script, but can continue through the editing and screening or web-casting process. There is always the chance that the company president, seeing for the first time a program that has been approved every step of the way by a cadre of vice-presidents, will ask for some changes before the program is used.

Evaluation

A final step takes place after the program is used: evaluation. Has the program been effective? Did it accomplish management's purposes? Were the audience's needs satisfied? The writer should participate in measuring the program's effects, usually through traditional educational tools of testing and interviewing, to know how to write the next program or series, or new version of that program or series, more effectively.

De Jong summarized some of these procedures from his own experience writing and producing award-winning programs for government and industry:

> Industrial or corporate films offer the writer an opportunity to bring into play any one or a combination of several conventional storytelling approaches and techniques. But unlike the typical entertainment film, the corporate film demands that the writer be acutely aware of the relationships between people, procedures, processes, equipment and institutional philosophies and goals.
>
> Most corporate films are relatively short, running anywhere between 10 and 30 minutes, with an average running time of 15 minutes. Since corporate films are proprietary, the scriptwriter needs to determine a client's objectives and purpose of the film and then conduct sufficient research on the subject so that the final product will convey its message succinctly and with authority, credibility, and integrity.
>
> In addition to running-time constraints, most corporate films have tight budgets and protracted deadlines. Since the scriptwriter is very often the first person to be involved with a film project, it is essential that he or she have a thorough understanding of production techniques in the three basic audiovisual formats: film, video, and slide-sound. Armed with this knowledge the scriptwriter can utilize various aspects of these formats to create a production that can be completed within budget and on time

while meeting its objectives in an interesting, informative and entertaining way. Where the typical entertainment film is geared for a general audience, most corporate films are designed for a specific viewership. To ensure that the film meets its objectives the scriptwriter must identify the target audience and develop a profile of its interests and familiarity with the subject matter so that the film will satisfy both the needs of the audience and the client.

WRITING TECHNIQUES

Donald S. Schaal, as television producer-director for Control Data Corporation Television Communications Services, observed in *Educational and Industrial Television* that "when you come to grips with scripting for industrial television, for the most part you might just as well throw all your preconceived ideas about creative/dramatic and technical writing in the circular file." Schaal recalled that his initial attempts to transfer the classroom teacher to television failed and that "unfamiliarity with what television could or could not do . . . resulted in a product which left just about everything to be desired. It lacked organization, continuity, a smooth succession of transitions and, in many cases, many of the pertinent details. . . . Since we think so-called 'training' tapes should *augment* classroom material and not supplant it, we soon realized that we could gain little but could lose everything by merely turning an instructor loose in front of the tube to do exactly what he does in person in the classroom. . . . The videotape he needs for his classroom *must* provide something he cannot conveniently offer his students in person."

Schaal's solution to the problem was to use professionals to do the voice tracks describing electromechanical and electronic equipment. He found, however, that this created a further problem: Although the teacher who knows the equipment doesn't usually know how to present it effectively on television, the professional who can make a good presentation doesn't usually know much about the equipment. Schaal said that "the solution, of course, is the professional must *sound* as though he invented every part of the machine and painstakingly handtooled it out of solid gold. To accomplish this effect, you must contrive what I like to call a 'shadow' script."

The shadow script, according to Schaal, is a transcription of the classroom teacher's presentation of a particular subject and a minimum rewriting of the transcription for smoother continuity and subsequent voice-over recording by a professional. Schaal encountered two distinct difficulties because the classroom instructor tended to reflect the classroom teaching approach: a lack of concise, clear continuity and the accidental omission of pertinent material. Schaal was forced to reevaluate his procedure.

> Now an instructor who comes into our shop to make such a tape arrives with at least a very detailed, topical outline prepared with television in mind. In many cases, he is actually provided with a detailed rough shooting script from which he reads for the benefit of the audio track. These outlines and scripts are provided by the curriculum people of the school and tend to confine the instructor to an orderly and complete description of the equipment. . . .

Had we gone the route of preparing formal scripts in the technical writing style (which would have been the most appropriate in this case), dropped the instructor out of the loop completely by telling him he was a clod on television and showing him the door, and refused to cooperate with the curriculum people because they didn't think in terms of television at first, we not only would have alienated a lot of people, but also I doubt if we would have produced a completely usable tape . . .

The moral, as I see it, is that corporate television scripts must be tailored to meet the situation. I have talked of only one aspect of industrial scripting—the description of equipment for training people on how to use and maintain it. For this type of script, I feel it is very important to retain the credibility of the person who knows the equipment the best, even though his voice does not appear on the finished product.

For this reason, I confine my rewrites to removing bad grammar and clarifying hazy or badly worded description. I make no attempt at restructuring mainly because the pictures are already on the tape. If I do see continuity problems, however, I call them to the attention of the curriculum people involved and let them make the decisions. I do make every attempt to keep the narrative as conversational as possible without lapsing into the creative/dramatic vein. All such scripts must be straightforward, sound natural, and contain a minimum of slang. Rarely is anything flippant allowed to survive the waste basket. Cliches and stylized narrative are avoided like the plague.

Many corporate scripts, whether for video or film, use the drama format, creating suspense that holds the audience and a conflict whose solution achieves the presentation's objective. Corporate film writer-director Richard Bruner, who effectively used dramatic dialogue and action rather than the voice-over narration and lecture-type dialogue that dominate many corporate videos, offered some advice in an article in *Audio-Visual Communications* by Thomas C. Hunter. Bruner explained that when the purpose of the program is simply conveying expository information, narration can do a good job. But "for a film to have dramatic impact," he advised a dramatic format. "The audience must be convinced that something important is at stake. The protagonist must have a stake in the outcome of the conflict."

Bruner warned, however, that clients sometimes get uneasy with the dramatic approach "because to have a conflict, everything can't be rosy." The writer must remember that the corporate client, by nature, tends to be conservative. That attitude applies to the artistic as well as content elements of a script. Even a mildly different creative approach might give the impression of rocking the boat. The writer sometimes has to convince the client that without the creative factors necessary to make the script entertaining enough to be watched or heard, the program could turn out to be dull and boring and not fulfill the corporate objectives. Bruner cautioned, however, that creativity for its own sake can be overworked and that the writer must avoid a profusion of special effects and "razzle-dazzle."

The "talking head" and "straight sell narrative" rarely work well in the corporate training script and are to be avoided in most situations. How then does the writer convey the system, routine, procedure, or ideas that result in effective learning? Corporate training scripts rely on two major approaches: the right-way–wrong-way demonstration and the step-by-step demonstration.

In the right-way–wrong-way demonstration, a character uses the system or machine incorrectly, with unwanted and unhappy consequences. This is followed by a character doing it the right way. The process can be shown step-by-step, if desired, so that every stage is absolutely clear. For example, a restaurant chain may contract for a video that teaches new personnel how to serve wine. In one sequence the novice manages to push the cork *into* the bottle; put a *red* wine bottle into an ice bucket; pour the wine without showing the wine label, offering the cork for odor, or providing a preliminary taste; fill each glass to the top; and then, of course, spill the wine onto the table cloth and the customers' clothes. Treated with humor, and followed by a demonstration of how to serve wine correctly, the sequences show the correct procedure and the common mistakes to avoid.

Humor is an effective device for most script formats; it's risky, however, in the corporate script. Many writers have found that a sense of humor often is not appreciated. Some corporate executives seem to equate humor in the script with making fun or light of their product or service. Further, comedy writing is extremely difficult. Many writers *think* they are funny, but often they are guilty of sophomoric humor. Corporate producers will tell you that they've rarely seen humor work in corporate scripts.

A second major approach for effective learning in the training script is step-by-step demonstration. The expert, office manager, or production unit chief can demonstrate point-by-point how to do the particular task. The demonstration can be reinforced by slow-motion, close-ups, repetition, and key scripted questions from the character or characters playing the learning-employee roles. When the demonstration is completed, the person playing the learner may then be asked to go over the process point-by-point.

Reinforcement and repetition are extremely important. Tell the audience what you are going to tell them, tell them, and then tell them what you've told them. Sum up after each learning module, and sum up at the end of the program. Complex processes should be repeated slowly enough for each aspect to be made clear. Visual action, voice and sound effects, music, written words—usually in large block letters—and diagrams—in color where possible and always clear and precise—are good supports.

Because the corporate script is more formal than most entertainment scripts, it is especially important to apply the principles in the style section in Chapter 3, "Format and Style." Several key points are the following:

1 *Use the active voice instead of the passive whenever possible.* Many writers tend to use the words "there are"—the passive voice—rather than stating the facts or ideas directly and actively; for example, "There are eleven chapters in this book" instead of "This book contains eleven chapters."

2 *Use simple, colloquial language, suited to the level of the audience.* You are not writing print literature, but visual and aural presentations. Conform the rhythm and pace of the language in the script to the subject matter and temper of the program. Keep sentences short, especially with how-to demonstrations. Don't try to cram too many ideas into a short time period. A principal drawback in most neophyte scripts is the

overload of information, making it difficult for the audience to keep up with, much less remember, everything presented.

3 *Be exact. Be precise.* The audience should have no doubt about what is being said or shown, or what it should be learning. Don't assume that all the audience members understand all the technical language just because the audience is an employee group. Explain and define all technical terms. On the other hand, you should determine what specialized words or terms are common knowledge for that audience and include them as a means of establishing empathy with the audience and, where appropriate, in place of more formal terms that might need more explanation.

4 *Use the right word and spell it correctly.* Just as you should do for all writing in any situation, don't hesitate to use your dictionary and thesaurus.

5 *Be direct in training programs.* For example, when instructing the audience about how to use a new machine, don't have the demonstrator say, "Next, you should release the thingamabob, and then you should spin it through the fragamaran . . ."; simply write: "Next, release the thingamabob and spin it through the fragamaran . . ."

6 *Think visually, write visually, and revise visually.* Most corporate scripts are visual— either filmed or taped video or slides or Web video-streaming. Many writers have a tendency to think of instructional writing as print writing because most of their experience with such learning is with textbooks.

7 *Be neat.* Neatness counts. Make a good impression with what you submit. If your script looks sloppy, the people deciding whether to hire you may assume that your work in general is sloppy. The corporate world has little patience with artistic bohemianism.

APPLICATION: VIDEO—INTERNAL TRAINING

Frank R. King, when director of video training for the John Hancock Mutual Life Insurance Company, was asked to produce a video program to introduce agents in 430 locations throughout the country to a new companywide computer system, HANcock TELecommunications. The video was to lead off day-long meetings in which agents were to learn about HANTEL. The script objectives were to (1) kick off each regional meeting with a positive feeling, (2) convince managers that if they did not use the new computer system the company wouldn't save the money that prompted its installation, and (3) make clear the personal benefits of the system to each individual manager and agent.

King chose a dramatic format that would lend itself more easily to humor than would a narrative or discussion format. He had to motivate the audience to accept the content and to pay attention to the video at an early morning hour. King condensed the informational or specific learning objectives to four that would show as well as tell managers how and why HANTEL should be used: (1) to train agents, (2) to facilitate sales,

(3) to create a more efficient sales proposal system, (4) to strengthen administrative processes. He titled the script "The Hantel Advantage." As producer as well as writer, King hired professional talent for some of the lead roles and used selected John Hancock employees in minor parts.

■ *As you study the first part of "The Hantel Advantage" shooting script, which follows, note how it reflects some of the techniques discussed earlier, including the right-way–wrong-way approach, as shown in the comparison of the fictional insurance company without a computer and the John Hancock Company with HANTEL. King stays with the play format, concentrating on motivating dialogue rather than on expository monologue. The contrasts between the old and the new are exaggerated sufficiently to provide visual humor and entertainment for the viewer.*

THE HANTEL ADVANTAGE

AUDIO	VIDEO
	JHVN LOGO
	Fade up: Opening Title:
	THE HANTEL ADVANTAGE
	Fade to Black
NARRATOR: (Music under):	Fade up on: LS
	Aerial photo, small town.
Our story takes place in a small town. Like any other American town, there are a number of businesses here, including two life insurance companies.	Slow zoom in.
Now, most people think that life insurance companies are all the same. But there's one person in this town who knows better. That's Bob Shields. Bob's brother is an insurance agent himself, and now Bob's decided to become an agent too. He's made plans today to learn a little bit about how the 2 companies in town operate.	Dissolve to: Exteriors: Olde Fashioned Life and John Hancock, with signs. The first is old, decrepit; JH is modern, clean.
	Cut to: Pan and follow one pedestrian, Bob Shields, walking through light crowd. Late 20s, well-dressed, whistling tune.
(MUSIC OUT)	Bob walks into door of Olde Fashioned Life.
	Zoom into sign.

Continued

AUDIO	VIDEO
BOB: Er . . . excuse me . . .	Interior, reception area. Receptionist is sleeping in her chair.
	She is snoring.
Uh . . . miss . . .	Bob tries waking her, getting louder and louder, finally succeeds with a shout.
HELLO?!!?	
RECEPTIONIST: (Waking suddenly) OH! What . . . what is it? (She looks around anxiously) (Sees Bob. Angrily:) Who are you? What do you want, anyway?	
BOB: Sorry, miss. My name is Bob Shields, and . . .	
RECEPTIONIST: (Interrupts) Well, Bob Shields, do you always shout at people? Can't you see this is a place of business?	Bob peers over her shoulder into clerical area. We see several clerks, all sleeping in their seats.
BOB: Well, I'm really very sorry. I have a 10:00 appointment with Mr. Hindenburg.	
RECEPTIONIST: Well, just find a seat over there and he'll be with you soon.	
	Bob finds waiting area, sits down. Looks around for reading material. Finds a copy of *Liberty* or other defunct magazine, circa WWII. Reacts with surprise. Starts to read.
	A kindly, frail woman about 40 enters office and goes to receptionist. Bob watches . . .
RECEPTIONIST: (Gruff tone) Yeah!	
WOMAN: (Taken aback slightly) Uh . . . How do you do? I wonder if someone can help me?	
RECEPTIONIST: Could be. What's your problem, honey?	
WOMAN: Well, my husband and I just moved here a few weeks ago from Minnesota . . . You see, our moving expenses were a bit higher than we expected, and we were hoping we might be able to get some money out of an Olde Fashioned policy my husband bought in 1979?	

Continued

AUDIO	VIDEO
RECEPTIONIST: Well, it's not that easy, you know. We can't do that *here*. First, you've got to fill out these change of address forms. (She slaps on the counter a pile of papers.) Then you've got to complete these "Intent to Raid the Nonforfeiture Value" forms (more papers). After that, there's this one: "Declaration of Anticipated Financial Status for the Next 35 Years" (more papers). And if the amount you want is over $15, we need your fingerprints, passport information, police record, and grammar school history on these (a last huge bunch of papers).	From receptionist's viewpoint: only the very top of woman's head now shows above the huge pile of papers.
WOMAN: Thank you. How soon will I get my money?	
RECEPTIONIST: (Looking at calendar) Well, this is November . . . with any luck around Easter.	
WOMAN: THANK YOU.	As she struggles to take the papers off the counter, dropping many . . .
Fade to Black	
(MUSIC UNDER)	TITLE: That afternoon . . .
	Wipe to: Bob enters *JH* office. Goes to receptionist. Office is bright, neat, receptionist is attractive young woman.
(MUSIC OUT)	
RECEPTIONIST: Hello, may I help you?	
BOB: Yes, thanks. My name is Bob Shields. I have a 2 o'clock appointment with Mr. Davis.	
RECEPTIONIST: Oh yes, Mr. Shields. Mr. Davis is expecting you. If you'll have a seat I'll tell him you're here.	
	BOB sits, notices a small sign on end table or wall that reads:
	ASK US ABOUT THE HANTEL ADVANTAGE!

Continued

AUDIO	VIDEO
	Same woman enters office, goes to receptionist. She looks haggard from her ordeal that morning.
RECEPTIONIST: Yes, Ma'am. What can I do for you?	
WOMAN: I *hope* you can help me. It's about a John Hancock insurance policy my husband has. I'd like to get a loan through the policy . . . if that's not asking too much?	
RECEPTIONIST: I'm sure we can help. Let me get one of our representatives to take care of you.	
DAVIS: Mr. Shields?	DAVIS enters waiting area. Walks over to Bob.
SHIELDS: Yes.	
DAVIS: I'm Herb Davis. Glad you could make it today.	
SHIELDS: It's nice to meet you, Mr. Davis. I appreciate your taking the time for me today.	
DAVIS: My pleasure.	
SHIELDS: I've got a lot of questions—but first of all, tell me—what's this (pointing to sign) about a HANTEL advantage?	
DAVIS: Well, before we talk about your aptitude test or anything else—that's a pretty good place to start, because HANTEL has really become the *heart* of our agency. If you'll come with me, I think I can *show* you what HANTEL's all about.	DAVIS & BOB peer into agent's office. We see AGENT, about 45, with WOMAN.
AGENT: Mrs. Bingham, by any chance do you know the number of the policy?	
WOMAN: No, I'm afraid not—but I think I have the last bill John Hancock sent me. Would that help? (Goes into purse.)	
AGENT: Yes, that'll give me just what I need.	
WOMAN: (Hands bill to agent)	

Continued

AUDIO	VIDEO
AGENT: (Writing it down) OK. Now the 1st thing we should do is make sure we get that new address.	
WOMAN: Oh, yes. It's 506 Whitman Rd.	
AGENT: Fine (writing). Now if you'll be kind enough to wait here for just a moment I'll be right back.	Agent exits, DAVIS & BOB watch him go.
DAVIS: You see, Bob, HANTEL stands for HANCOCK *TELE*COMMUNICATIONS. Right here in this office, we have a direct link to the computer system in our Boston Home Office. It's really a whole new way of doing business in the insurance industry.	
DAVIS: (V/O) For example, Bob, with HANTEL our agents have instant access to a wide range of information contained in literally millions of John Hancock policies. We can do a lot of things in just seconds now that used to take us days through the mail. We can make necessary changes in policy information . . . and we can find out policy values that are up-to-the-minute!	AGENT arrives at clerical window . . . Gives request, info to HANTEL operator . . . HANTEL operator, on terminal: changes address to 506 Whitman Road. Calls up value screen and points to Cash Value, Accumulated Dividends figure and writes these down. Gives to Office Manager. CU: Check being written by OM (young male).
DAVIS: The machinery is something, Bob, but I'll tell you—Hantel's *real* value is the better service our clients get—and it sure helps the agents sell!	DAVIS & BOB AGENT'S OFFICE. Agent returns.
AGENT: OK, Mrs. Bingham, here's that money you needed (hands her check). We took it out of your dividends. You had plenty to spare.	
WOMAN: So soon? That's marvelous! *Thank* you *very* much!	
AGENT: Not at all. We're happy to help. While you're here, Mrs. Bingham, tell me about this new house of yours. Have you and your husband taken any steps to protect your mortgage?	

Continued

AUDIO	VIDEO
WOMAN: Well, I don't think we've done anything about that, no.	
AGENT: The biggest single investment most people make is in a home. Don't you agree?	
WOMAN: Oh, definitely.	
AGENT (V/O): Your home is important to your husband and yourself. I'd like the chance to talk to both of you together about making sure your options are left open . . .	CU, BOB, nodding in appreciation at this scene.
(fade out)	
WIPE TO: (FAST-MOVING SCENE)	Waiting room of Olde Fashioned Life. Bob reading magazine. Hindenburg enters. He is about 45 or older, short, rotund, smokes cigar, conservatively dressed, looks old-fashioned: belt and suspenders, hair parted down center & slicked back, handlebar moustache, 1890's look.
HINDENBURG: Shields?	
BOB: Uh—yes.	
HINDENBURG: Harry Hindenburg's the name—insurance is my game! How ya doin!	
BOB: Pretty good, thank you . . .	
HINDENBURG: (Slaps Bob on back, knocking him over) That's great! Glad to hear it! You wanna be an agent with us, right!	
BOB: Well, I'd like to become an agent, yes, but I haven't decided which company to go with quite yet.	
HINDENBURG: (Blowing smoke in Bob's face as he talks) Oh, a comparison shopper eh? Very smart, kid. I like your style.	
BOB: (Coughing) Um . . . thanks. Where do you think we should start?	
HINDENBURG: Well . . . (thinking; suddenly, he grabs Bob's shoulder, startling him). Come with me! We've got the very latest in *communications*! State-of-the-art stuff, you know what I mean? Josephine, would you send that letter I gave you to the Home Office now?	

Continued

AUDIO	VIDEO
JOSEPHINE: Sure, Mr. H.	Josephine takes letter on her desk, folds it into tiny square, opens bottom drawer of desk, removes carrier pigeon, attaches letter to leg, and throws bird out window.
HINDENBURG: (to Bob): Our company uses *only* the fastest birds.	
BOB: Oh. where's your Home Office?	
HINDENBURG: Ottawa.	
BOB: How long will it be before you get an answer?	
HINDENBURG: Well, usually about two months, but this is the mating season. Might take a little longer.	
WIPE TO:	Clerical area, JH. Bob & Davis talking. Davis holds folder.
DAVIS: You know, Bob, *we* try to organize our office to accomplish two things: to help our agents sell insurance, and to give our clients the quickest, most courteous service possible. Believe me, HANTEL has really made that easy.	
The basic things are much simpler—like getting in touch with our Home Office. Before, it was either wait for the mail to go to Boston and back, or try to get through by phone. *Now*—well, watch this . . .	
(TO HANTEL OPERATOR) Kathy, will you send this message? (Takes paper from folder, gives to her.)	2S: Davis and operator
	Operator sends message: (CU, HANTEL CRT:)
	"TO: MARKETING/EDUCATION: PLEASE SEND FIVE COPIES OF CLU material 'Getting Started' and 'Action Information.' Needed by the 24th. Please confirm."
(V/O): In a sense, HANTEL is really like having our own private telegram system, but it costs much less. We can even communicate with	

Continued

AUDIO	VIDEO
any other Hancock office across the country. (Pause). That's it! They've heard me in Boston!	
It's a funny thing—I guess old habits are hard to shake. I still like to have a hard copy of my messages. Kathy, would you mind?	DAVIS & BOB.
	Operator has printer deliver printed copy of message.
If things go as usual, I'll have a response to this late today or first thing tomorrow.	Davis rips it off.
BOB: Hey, that's really something!	

[The end of the program describes the actual working of HANTEL as it relates to specific insurance operations and procedures.]

"The Hantel Advantage" written by Frank King, Director, John Hancock Video Network, John Hancock Companies

◣

APPLICATION: SLIDES AND AUDIO—INTERNAL TRAINING

Although the use of *slides* virtually disappeared in television writing and production after the character generator and similar devices were developed, slides continue to be a key medium for educational and training programs. First, a slide program is considerably cheaper to produce than a video. Second, at certain levels of learning, visual motion is unnecessary and still pictures can be more effective. The following slide with audio script illustrates the how-to approach with narration. The program objective is to help employees learn why and how to use charts and graphs. The use of charts and graphs— still pictures—to teach the information is, therefore, especially appropriate.

■ *The format of the script on the following pages, "Data Analysis and Display," written by David Brandt for use in manufacturing training by Avco Systems TEXTRON, follows the usual format of visual information to the left, audio to the right. This script also contains an "instructional design" or "I.D." column— illustrations of the learning cues. Analyze the script for these cues, noting the sequence of modules relating to the presentation and reinforcement of information, including repetition, simplicity, and clarity. What elements do you find that motivate the employee to learn the material presented?*

Project ___Data Display___
Page ___1___

C.T.	SLIDE	AUDIO	I.D. CUE
:00	DATA ANALYSIS AND DISPLAY /1/	MUSIC MUSIC UNDER NARRATOR: In this lesson you will learn why we analyze data and how to use charts and graphs.	Directing and preparing the learner
:17	WHY ANALYZE DATA? — VERIFY MOST PROBABLE CAUSES — CREATE A BASE FOR BRAINSTORMING POSSIBLE SOLUTIONS — DETERMINE YOUR NEXT STEPS /2/	We analyze data to verify the most probable causes, to create a base for brainstorming possible solutions and to determine the next steps toward the solution.	
:30	SCENE OF CIRCLE MEMBERS WITH CHARTS AND GRAPHS /3/	Charts and graphs will help you show your data effectively and communicate your message clearly. But first, it is necessary to understand why we use charts and graphs.	
:41	CHARTS AND GRAPHS /4/	Charts and graphs dramatically show information so that it is easier to analyze your data and to draw conclusions from them. In some cases data which have important information may otherwise go unnoticed if not displayed properly.	Presenting the concept
:55	SCENE OF CIRCLE PRESENTATION WITH CHARTS AND GRAPHS /5/	Also, charts and graphs are useful because they tell a story quickly and clearly. A common problem with displaying data is that the audience cannot easily understand the information being presented and may 'tune-out.' When properly used, charts and graphs can eliminate this problem.	

Continued

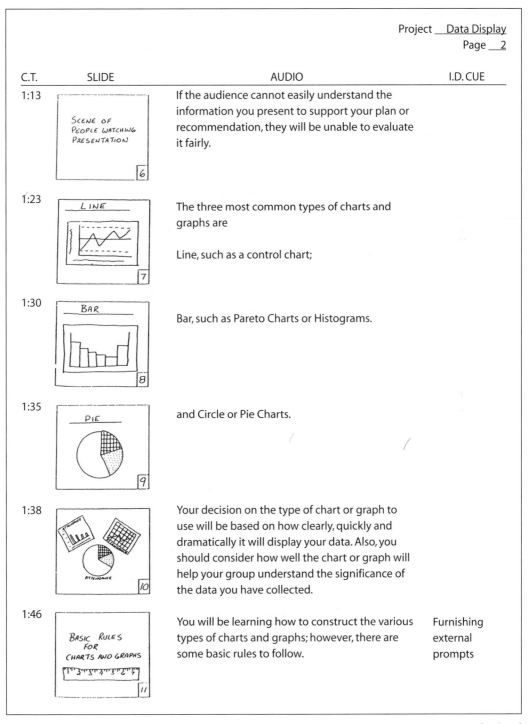

Project __Data Display__
Page __2__

C.T.	SLIDE	AUDIO	I.D. CUE
1:13	SCENE OF PEOPLE WATCHING PRESENTATION [6]	If the audience cannot easily understand the information you present to support your plan or recommendation, they will be unable to evaluate it fairly.	
1:23	LINE [7]	The three most common types of charts and graphs are Line, such as a control chart;	
1:30	BAR [8]	Bar, such as Pareto Charts or Histograms.	
1:35	PIE [9]	and Circle or Pie Charts.	
1:38	[10]	Your decision on the type of chart or graph to use will be based on how clearly, quickly and dramatically it will display your data. Also, you should consider how well the chart or graph will help your group understand the significance of the data you have collected.	
1:46	BASIC RULES FOR CHARTS AND GRAPHS [11]	You will be learning how to construct the various types of charts and graphs; however, there are some basic rules to follow.	Furnishing external prompts

Continued

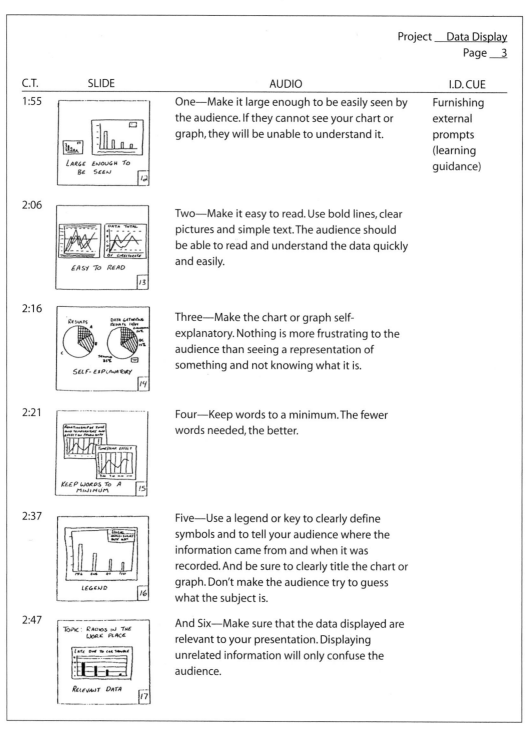

Project __Data Display__

Page __3__

C.T.	SLIDE	AUDIO	I.D. CUE
1:55	LARGE ENOUGH TO BE SEEN 12	One—Make it large enough to be easily seen by the audience. If they cannot see your chart or graph, they will be unable to understand it.	Furnishing external prompts (learning guidance)
2:06	EASY TO READ 13	Two—Make it easy to read. Use bold lines, clear pictures and simple text. The audience should be able to read and understand the data quickly and easily.	
2:16	SELF-EXPLANATORY 14	Three—Make the chart or graph self-explanatory. Nothing is more frustrating to the audience than seeing a representation of something and not knowing what it is.	
2:21	KEEP WORDS TO A MINIMUM 15	Four—Keep words to a minimum. The fewer words needed, the better.	
2:37	LEGEND 16	Five—Use a legend or key to clearly define symbols and to tell your audience where the information came from and when it was recorded. And be sure to clearly title the chart or graph. Don't make the audience try to guess what the subject is.	
2:47	RELEVANT DATA 17	And Six—Make sure that the data displayed are relevant to your presentation. Displaying unrelated information will only confuse the audience.	

Continued

Project __Data Display__
Page __4__

C.T.	SLIDE	AUDIO	I.D. CUE

3:08 — [REPEAT OF SLIDE #10] 18

One final caution to keep in mind when preparing any type of chart or graph; be careful not to mislead the audience. The size and shape of your chart or graph can create a misunderstanding on the part of the audience. These three charts all display the same information, but each one leaves a different impression.

3:21 — [REPEAT OF SLIDE #2] 19

Let's review. We analyze data to verify the most probable causes, to create a base for brainstorming possible solutions and to determine the steps toward those solutions.

Repetition

3:28 — [REPEAT OF SLIDE #3] 20

Charts and graphs display data so that it is easier to analyze and to draw conclusions from them.

3:36 — [REPEAT OF SLIDE #6] 21

Also, charts and graphs are used to present information to your audience so it can understand it quickly and easily.

3:42 — [REPEAT OF SLIDE #7] 22

The three most common types of charts and graphs are:

Line, such as a control chart;

3:47 — [REPEAT OF SLIDE #8] 23

Bar, such as Pareto Charts or Histograms;

Continued

			Project __Data Display__	
			Page __5__	

C.T.	SLIDE	AUDIO	I.D. CUE
3:51	[REPEAT OF SLIDE # 9] 24	and Circle or Pie Charts.	
3:56	[REPEAT OF SLIDE # 12] 25	These are the characteristics of a good chart or graph: Large enough to see;	Furnishing a model of expected performance
4:01	[REPEAT OF SLIDE # 13] 26	Easy to read;	
4:05	[REPEAT OF SLIDE # 14] 27	Self-explanatory;	
4:09	[REPEAT OF SLIDE # 15] 28	Words are kept to a minimum;	
4:13	[REPEAT OF SLIDE # 16] 29	A legend or key to explain symbols;	

Continued

C.T.	SLIDE	AUDIO	I.D. CUE

Project Data Display
Page 6

4:18

[REPEAT OF SLIDE # 17]

30

Relevant information;

And it does not mislead the audience.

4:38

SCENE OF CIRCLE WITH CHARTS AND GRAPHS

31

MUSIC UNDER
Good data display techniques will make it easier to analyze your data and will help you make a clear, concise and effective presentation to management.

Assessing attainment

5:08

LOGO

32

MUSIC UP FULL TO END

Written by David Brandt for Avco Systems TEXTRON

Application: Video and Film—External Professional

The following script by Ralph De Jong was designed to inform and instruct cardiovascular radiologists about a new medical device while serving as a promotional vehicle for the product. The script was not intended to train the employees of the manufacturing firm that ordered the program, nor was it intended for the general public. De Jong obviously did considerable research and obtained the aid of many experts to achieve accuracy in such a specialized subject area. The tendency for many writers preparing a program with a subject and target audience such as this one would be to create a straightforward how-to demonstration. De Jong made the material more interesting and viewable by incorporating elements of the drama, discussion, interview, and feature.

- *What principal differences and similarities do you find in technique between this script and the John Hancock and Avco Systems scripts? "An idea I had,"
writer-producer De Jong stated, "was to include a 3-minute segment that could*

be lifted in toto and put into a continuous loop for screening in a convention display booth." Do you find this loop complete in itself? Does it maintain the continuity of the larger script? Though not designed for a retail store, it serves the same purpose as POP (point-of-purchase) videos by attempting to convince buyers seeing the product at professional convention sales booths to order it.

THE MINI-BALLOON APPROACH TO INTRAVASCULAR OCCLUSION

VISUAL	AUDIO
<u>TEASE</u>	
Angiography—Catheter Lab area: Johns Hopkins Hospital, Baltimore.	(SFX: AMBIENT SOUNDS/VOICES.)
LS: Personnel coming and going through double entry doors. A patient or two being wheeled in/out of lab area. Elevator to right in middle distance.	
Elevator doors open and several passengers emerge. Among them are a man and a woman. (Man is patient coming in for a varicocele procedure using the B-D MINI-BALLOON.)	
Man and woman take a few steps and encounter Robert White, MD, who has entered scene walking from behind camera-left. White is dressed in surgical gown, mask loose around neck. He is on his way to cat lab.	(SFX: WHITE, PATIENT, WOMAN EXCHANGE A FEW WORDS OF GREETING. WHITE ASKS PATIENT HOW HE FEELS, ETC. WHITE TELLS PATIENT HE WILL SEE HIM SHORTLY.)
Patient and woman walk off-camera. White heads for cat lab.	
Camera follows as White passes through entry doors. White full frame.	
White joins several other MDs who are examining radiographs depicting a pulmonary arteriovenous fistual-malformation or other condition suitable for MINI-BALLOON occlusion.	
Close in slowly on MD group.	(SFX: CONVERSATION AMONG MDs IS HEARD MOMENTARILY AS THEY DISCUSS MEDICAL

Continued

VISUAL	AUDIO
	PROBLEM SEEN, THEN FADES UNDER AS NARRATOR SPEAKS.)
	<u>NARRATOR V/O</u>
	These radiologists are discussing a nonsurgical technique for occluding blood vessels—a technique that can be performed with local anesthesia—and, generally, with less patient risk than that associated with the injection of particulate embolic material.
Continue moving in, focusing on pulmonary AVM radiograph displayed on light box.	The procedure about to be performed on this patient is also suitable as the therapy of choice for other vascular conditions that may exist in various parts of the body . . .
Begin series of cuts of diagnostic radiographs, matched to narrative.	
Carotid cavernous fistula.	. . . carotid cavernous fistula . . .
Bronchial pulmonary artery fistula.	. . . bronchial pulmonary artery fistula . . .
Hemobilia.	. . . hemobilia . . .
Renal traumatic aneurysm.	. . . renal traumatic aneurysm . . .
Varicocele.	. . . variocele . . .
Show two or three other conditions suitable for MINI-BALLOON occlusion; i.e., vascular head and neck neoplasm/hepatic artery branch/traumatic fistual or aneurysms of non-essential branch/or dry field surgery. Shots should be tight enough and on long enough for relatively experienced eye to identify problem.	. . . and others . . . (NO COMMENTARY)
Final diagnostic radiograph serves as freeze-frame which becomes live-action cine of MINI-BALLOON procedure in progress: dye being injected and balloon catheter coming on-screen—for positioning.	(SFX: FADE IN MUSIC LOW, THEN UNDER.) <u>NARRATOR V/O</u>
[LOOP SECTION BEGINS]	This is balloon embolotherapy—a proven technique for transcatheter vascular occlusion. The procedure seen here centers on the use of a detachable balloon system—a system that provides control, reversibility and precise placement at the desired point of occlusion.

Continued

VISUAL	AUDIO
Cine continues: MINI-BALLOON seen being reversed, positioned, inflated and detached as Main Title crawls.	
MAIN TITLE	
THE MINI-BALLOON APPROACH TO INTRAVASCULAR OCCLUSION Presented by BECTON-DICKINSON AND COMPANY	
Cine continues briefly after titles, then go to brief lap dissolve of slightly elevated, moderate wide-angle pull-back revealing preceding cine on portable viewer screen: angled OTS of radiologist's POV. (RADIOLOGY LIBRARY) Radiologist seen at portable viewer, looking at screen.	(SFX: CROSSFADE TO RADIOLOGY LIBRARY AMBIENCE.)
Continue pull-back to reveal radiologist and narrator in library.	
During pull-back, narrator, with medical journal in hand, walks from bookstacks to portable viewer, glances at screen, then speaks on-camera. (Narrator dressed in casual attire: somewhat tweedy jacket, tie, etc.)	
	NARRATOR (ON-CAMERA)
	Until the 1930s, surgical ligation was the only technique available for occluding a specific blood vessel.
MS.	Then, in that year, a minute particle of muscle tissue was implanted percutaneously to embolize a carotid cavernous fistula.
MCU.	While the procedure was successful, it was not until the early 1960s that advances in medical technology made it possible for intravascular occlusion techniques to be explored and developed more extensively.
Camera follows as narrator walks to library table.	Since then different types of particulate material and mechanical devices have been

Continued

VISUAL	AUDIO
	injected—by way of a catheter—to promote vascular occlusion.
Cut to CU L-R pan: assorted embolic/occlusion materials and devices, ending with B-D MINI-BALLOON system.	(NO COMMENTARY THROUGH PAN.)
Cut to table-top MS: Narrator in background, half-seated at end of library table top. Embolic/occluding devices in foreground. MINI-BALLOON system closest to narrator. Narrator gestures toward materials while speaking.	Today, each of these is used for intravascular occlusion. When they are used and how they are used depends on the medical problem involved, the condition of the patient, and the skill and experience of the physician.
Move slowly over devices toward narrator, stopping as narrator picks up MINI-BALLOON catheter.	Of these, only one provides permanent vessel occlusion where you want it—when you want it.
Cut to OTS: MINI-BALLOON catheter in narrator's hands.	NARRATOR (ON-CAMERA) This is the Becton-Dickinson detachable MINI-BALLOON system.
Slow zoom toward MINI-BALLOON, going to out-of-focus and dissolving to:	When the MINI-BALLOON is injected into a vessel by way of a catheter . . . it becomes flow-directed.
ANIMATION: Flow-direction feature of MINI-BALLOON.	(SFX: FADE OUT LIBRARY AMBIENCE TO DEAD AIR.)
ANIMATION: Positioning of MINI-BALLOON in vessel.	And, because it is tethered, the MINI-BALLOON is completely controllable—it can be guided forward or backward so that it can be placed precisely at the desired point of occlusion.
ANIMATION: MINI-BALLOON inflation and detachment.	Once in position, the MINI-BALLOON is inflated . . . and detached.
ANIMATION: hold momentarily on detached balloon in vessel.	
[LOOP SECTION ENDS]	
Dissolve to MLS: cat lab corridor.	(SFX: FADE IN CAT LAB AREA AMBIENCE.)
Move in to MS, then to MCU of White and two other physicians seen at left studying radiographs of varicocele.	WHITE AND COLLEAGUES (PICK UP BRIEFLY ON CONVERSATION AMONG WHITE AND COLLEAGUES DISCUSSING

Continued

VISUAL	AUDIO
	VARICOCELE CONDITION SEEN ON RADIOGRAPH. COMMENTS CENTERING ON PROBLEM AND WHAT NEEDS TO BE DONE.)

* * *

VISUAL	AUDIO
XCU: Syringe in hand, smooth injection.	WHITE Once you have blood back and a good seal, then we simply give a nice smooth injection . . . until the balloon catheter is well beyond where you want to send it.
Dissolve to cine: balloon injection. NOTE: From here, visuals are combo of live action and cine. Included are: balloon positioning, flow-directability, reversibility, inflation, deflation to reposition, re-inflation and final positioning, detachment and catheter removal. During this sequence, use modified split-screen with circular cine inserted with live action.	(PAUSE)
	(NOTE: WHITE'S COMMENTS FROM HERE TO INCLUDE BALLOON MANIPULATION, FLOW DIRECTION, REVERSIBILITY, INFLATION, DEFLATION TO REPOSITION, RE-INFLATION AND FINAL POSITIONING, BALLOON DETACHMENT AND CATHETER REMOVAL. ALSO INCLUDE TEST INJECTION TO SEE BRIDGING COLLATERALS.)
Final cat lab sequence: circular cine inserted with live action. Cine shows balloon in position. Slowly expand cine insert to full-screen, then slowly dissolve to CU of White removing catheter and begin lazy pull-back to MLS of procedure wrap-up. White, tech(s) and patient; then patient being wheeled out of lab. White and tech(s) having conversation, relaxed.	WHITE (AFTER FINAL COMMENTS REGARDING PROCEDURE, TALKS BRIEFLY CITING PERSONAL EXPERIENCE WITH MINI-BALLOON PROCEDURE (STRAIGHT, NO HARD SELL) AND THE TECHNIQUE, GIVING SUGGESTION ON APPROPRIATE MEDICAL CONDITIONS TO BEGIN WITH AND SOME TO WORK UP TO, THEN SHIFTS TO BRIEF CHAT WITH PATIENT, WITH PATIENT RESPONDING.) (CONVERSATION WITH TECH(S) UP MOMENTARILY, THEN SLOWLY CROSS-FADING

Continued

VISUAL	AUDIO
	TO MUSIC LOW AND UNDER, COMING IN WITH RADIOGRAPH REPRISE.)
MLS: White and tech(s) talking, patient being wheeled out of cat lab.	<u>NARRATOR V/O</u> MINI-BALLOON embolotherapy—a nonsurgical approach to intravascular occlusion.
Insert dissolve cuts: reprise of opening diagnostic radiographs.	A proven technique suitable as the therapy of choice for a wide range of vascular conditions . . .
Dissolve in complete ANIMATION sequence.	. . . a procedure that centers on the use of a detachable balloon system—a system that provides control . . . reversibility . . . and precise placement at the desired point of occlusion.
Dissolve to full-screen cine: reprise of footage appearing behind Main Title as end credits crawl.	(SFX: MUSIC UP THEN FADE OUT.)

Courtesy of Ralph J. De Jong, President, WORDSYNC, Harpers Ferry, W. Va.

APPLICATION: VIDEO—TRAINING AND INFORMATION SERIES

Leslie O'Flaherty is a writer, producer, and teacher of corporate media. She summarized her approach to writing a corporate script and described the application of writing techniques to a specific series she worked on:

> The process of writing a corporate script is very similar to that of writing a feature. A writer can use the same narrative techniques to teach or illustrate a process for a specific group as those used to entertain and move a general audience. All stories begin with a particular character in a particular situation. This character moves through the situations presented to another point. Along this path, the writer needs to establish setting and character; provide conflict and continuity; and dramatically move the story to a logical conclusion.
>
> A corporate script starts with the client's need to illustrate an issue. Focusing on the particular people involved in the situation will usually yield a starting point. Find this and a writer will find the story. The story can then be told in a dramatic rather than a static way, avoiding the "talking head" syndrome.
>
> In this particular case, the company hired me and my writing partner to write a series of four video scripts. This series targeted alcohol and drug counselors who work in the mental health field. They needed to identify the mental health problems of their addicted patients so that the counselors can refer their patients to the proper people for additional help.

Our challenge was to dramatize these problems. We were given the characters of the patients and each of their particular issues. We were also given the characters of the counselors who worked with each of these patients. In addition, we had to include the teaching psychiatrist who was training the counselors.

For each of these givens, we took specific steps. To illustrate the patients' mental health issues, we chose to show the environment from which the issues stemmed. In the example, Ann Smith, a patient, with a prescription drug addiction, is having family problems with her husband, Frank. Spousal abuse is suspected. Her story was in the final script, but we needed to introduce her early in the series so the counselors were aware of the specific issue being presented. We set it up by having Frank kick a child's toy so hard that it bounced off a cabinet by her head. Neither one says a word. While providing for the clients' need to address the particular mental health issue, showing the issue in this way provided two narrative needs. First, the characters were introduced early, letting the audience know they would be back. Second, by creating this particular situation, we provided sympathy for Ann and antipathy for Frank. Both were done without saying a word. The narrative's power was in the action.

Having a set group of counselors was a convenient way to develop continuity. Three of them, Janice, Susan, and Bill, attended a seminar led by the teaching psychiatrist, Simon Budman. In addition, all four were present in each group training scene. The audience gets used to seeing the same people throughout the series. This way, in each script less time was taken in establishing character and more time was available for character development and for focusing on the issue being examined. To introduce the counselors' characters, we created a car pool. Nothing like having people trapped in a small space for character interaction! Susan picks up her cohorts and they all drive to the seminar together. Along the way, they all deal with Bill's difficulty in quitting smoking. The audience becomes familiar with the counselors as people, before seeing them at work. Creating empathy between the audience and the characters is key in holding the audiences' attention.

To provide background and to take less time with exposition, we created an established relationship between Ann and Janice, her counselor. Janice had helped Ann get clean of drugs six months earlier. By having Ann return for more counseling, we focused on revealing the spousal abuse. We didn't need to take time to develop a relationship. We also had to show abuse without relying on depicting physical violence. Emotional abuse takes many forms. We already showed Ann scared, we had to show the extent of her fear. We created a situation for Ann and her husband that would illustrate escalating violence and generate fear. We went back to the car. And we got a very dramatic, dynamic scene.

Finally, we had a challenge in providing a sense of connection between the various elements: the training sessions and the counseling sessions. How could we move easily between them? We found a device with which everyone is familiar and comfortable. Because counseling sessions were taped, we used the monitor to move in and out of the counseling sessions as a way of creating a smooth transition between scenes and locations.

The final product met everyone's needs. The scripts provided for the client's teaching needs. The actors were grateful to be given characters with depth. The director got some great shots and locations. And as writers, we could be proud of the stories we created.

The following is the first part of O'Flaherty's script. Note that it is written in film form.

▰

SCRIPT #4—INNOVATIVE TRAINING SYSTEMS—FAMILY

CAST OF CHARACTERS

Ann Smith	In her thirties. A recently recovered drug addict.
Frank Smith	Ann's husband, 30s. Hostile and verbally abusive.
Max Smith	Ann and Frank's two-year-old son.
Janice Peters	African-American in her thirties, a counselor for Eastlake Mental Health Center.
Simon Budman, Ph.D.	Clinical psychologist who teaches a seminar on the Prochaska Change Model.
Susan Oliver	Fiftyish, experienced counselor for Eastlake Mental Health Center. A recovering alcoholic.
Bill Roper	Experienced substance abuse counselor for Eastlake Mental Health Center. A smoker.
Jim Craddock	A substance abuse counselor for Eastlake Mental Health Center. Attending the Budman seminar.
Penny Tracey	A substance abuse counselor for Eastlake Mental Health Center. Attending the Budman seminar.
Mimi Kitano	Japanese American substance abuse counselor for Eastlake Mental Health Center. Attending the Budman seminar.
Extras	Rush hour drivers and passengers.

SCENE 1	Waiting Room at Eastlake Mental Health Center
SCENE 2	Janice Peters' Office at Eastlake Mental Health Center
SCENE 3	City street. Ann Smith's Car
SCENE 4	Office Building
SCENE 5	Ann's Car
SCENE 6	Office Building
SCENE 7	Ann's Car
SCENE 8	Ann's Car
SCENE 9	City Street
SCENE 10	Ann's Car
SCENE 11	City Street
SCENE 12	Ann's Car
SCENE 13	Conference Room at Eastlake Mental Health Center
SCENE 14	Janice Peters' Office at Eastlake Mental Health Center
SCENE 15	Conference Room at Eastlake Mental Health Center

Continued

1 INT WAITING ROOM EMHC AFTER THE PROCHASKA SEMINAR 1

ANN is sitting alone in the waiting room after the other patients have been called into the offices. JANICE enters the area from her office.

> JANICE
>
> Ann?

> ANN
>
> Yes?

She hurriedly gets to her feet.

> JANICE
>
> Don't rush. We're not running late. Why don't you come on in?

> ANN
>
> OK.

The two women walk toward Janice's office.

2 INT EMHC JANICE'S OFFICE THE SAME DAY 2

Ann and Janice take their respective seats in the office. Janice refers to Ann's file which is on her desk.

> JANICE
>
> Well, it's nice to see you again.

> ANN
>
> Nice to see you too.

> JANICE
>
> Let's see . . . it's been about three months since I last saw you. How are things going?

> ANN
>
> Oh, fine, I guess.

> JANICE
>
> Still clean and sober?

> ANN
>
> Yup, I've got three months now.

Continued

JANICE

Congratulations. That's a long time.

ANN

You're telling me . . .

JANICE

Is it hard for you? Not using the pills?

ANN

Not really . . . I guess . . . I don't know, I guess it's tough.

JANICE

How is it difficult?

ANN

Oh, I don't know . . . being clean is not what I thought it would be.

JANICE

Well, you can't expect it to be easy right off the bat. There's a lot that needs to go on. Just not using takes a great deal of energy and focus. It's a big change for you.

ANN

You can say that again, I'm exhausted.

JANICE

Do you go to meetings?

ANN

Well, I pretty much went to ninety meetings in ninety days, like they say to do.

JANICE

And did that help?

ANN

It's getting harder, though. I missed my home group the other night. That's the one I like the most.

JANICE

What happened?

Continued

ANN

Well, my husband made plans to go out and I didn't get a sitter, so I had to stay home with Max.

JANICE

Why didn't you get a sitter?

ANN

I guess I didn't remember him telling me he had to go out. He said he did, but I don't remember it.

JANICE

Sometimes, there's a lot of confusion in early recovery.

ANN

That's true . . .

JANICE

So you had to stay home with Max. How old is he?

ANN

He just turned two last month.

JANICE

Oh boy, the terrible twos.

ANN

Yeah . . .

JANICE

You couldn't bring Max to the meeting?

ANN

It's hard to watch out for him and get something out of the meetings, too. And, well, Frank doesn't want him to go to meetings with me.

JANICE

You do need to focus on yourself now and not get distracted. You also have to make sure you get to enough meetings, especially your home group. Why didn't Frank take Max with him?

ANN

He was out at a bar with the office softball team.

Continued

JANICE

There might be meetings around here with day care. You should look for those.

ANN

Yeah, OK . . .

JANICE

Now's the time to be a little selfish. You need to stay in recovery.

ANN

Well, Frank has stayed home with Max for nearly 3 months. Maybe he's getting sick of it. But I feel like he doesn't want me to go to meetings these days.

JANICE

What Frank wants isn't important. Concentrate on your own recovery right now.

ANN

It's just so hard . . .

JANICE

It's hard for everyone in early recovery.

ANN

I guess . . .

JANICE

It'll take all you have to keep this going.

ANN

It's just that I've been dealing with this for so long.

JANICE

So has Frank and Max . . .

ANN

I don't think you understand what I'm saying.

JANICE

I think I do. It's hard to get to meetings; it's hard to focus on yourself; your husband is tired of staying home with Max all the time.

Continued

ANN

It's not just that . . . Frank . . .

JANICE

Let Frank find his own recovery. Addiction is a family disease. Encourage him to go to his own meetings. That way you can each focus on yourselves.

ANN

Yeah, OK . . . if that's what you think I should do . . .

JANICE

It's a difficult time.

ANN

It's just that this is not how I thought it would be.

JANICE

How did you think it would be?

ANN

I thought things would be easier. They're not.

JANICE

What things?

ANN

Everything . . .

JANICE

Can you explain that?

ANN

Oh, life . . . marriage . . . dealing with my son—everything.

JANICE

You can't deal with "everything" all at once. You need to take this a step at a time. And the first step is to stay clean. That's the most important thing right now.

ANN

I guess . . .

Courtesy of the authors, Leslie O'Flaherty and Robert Deveau

APPLICATION: VIDEO—EXTERNAL INFORMATION AND PUBLIC RELATIONS

Well Aware was a series written, produced, and directed by Barbara Allen for Memorial Hospital in York, Pennsylvania. Shown principally on cable, the series had several objectives: to inform the public about common medical problems; to teach the public how to deal with those problems—in some instances through personal treatment, exercise, diet, and similar approaches not requiring medical supervision and in other instances by consulting a physician; and to create positive feelings about Memorial Hospital through this public service program.

Using her background as a documentary writer-producer for broadcast and nonbroadcast television, Allen incorporated several techniques, including interviews, demonstration, and feature material. Though informational, this program has a lighter approach than the training program. Because it seeks a general audience in the community, it must be entertaining as well as informative to attract and keep the viewer.

The following description and analysis of her work as a writer for the series was especially prepared by Allen for this book.

What does a writer have to know when he or she also wears the hats of director, co-host, and, sometimes, editor? This is how it works for me.

Well Aware is produced entirely on location, of necessity. The hospital is not equipped with a television studio. A professional videographer and grip, or sound person, are hired. The hospital's PR manager and executive producer of *Well Aware,* Sheryl Randol, serves as co-host. The budget is a very modest one, and taping is limited to one-and-a-half to two days.

It's important for the writer to be "well aware" of all of these factors in order to

1. Limit taping locations to fit into the time schedule and budget, while seeking the most varied backgrounds within each location. It's amazing what you can do with a few plants, some colored gels, a different angle and some well chosen wall hangings. Every time you have to pick up and move lights and other equipment it takes about a half hour to set up and another half hour to tear down, plus travel time.

2. Be prepared to switch to a pre-arranged indoor location for a scheduled outdoor shoot cancelled by rain or snow.

To accomplish these, the writer must have a thorough knowledge of production techniques. It also helps to be patient, very flexible, and have a great sense of humor.

The producer of *Well Aware* makes all arrangements for crew, participants and locations. Therefore, I must tell her what categories of people or experts are needed, what kinds of locations, the activities to be taped at those locations and any special equipment or props that might not ordinarily be available at those locations. All of this information saves time and money.

Using one camera helps, too. But we try to make it look like three by careful shot planning and editing. In interviews two shots are interspersed with individual closeups and medium closeups of each participant, as well as over the shoulder shots.

After the interview is finished, we tape each participant "listening" and "nodding" in agreement. See *60 Minutes* or *20/20* any week for examples of how these passive responses are used to avoid jump shots when editing out pieces of guests' remarks.

We also re-tape all of the interviewer's questions with the camera on the interviewer who is looking in the direction of the guest. This includes spontaneous questions not in the script. To remember all of these questions and get a rapid playback of them, we audiotape all questions on a microcassette recorder as the interview is in progress, and then play them back for the interviewer to re-tape.

By combining these reverse questions with other shots, there is the effect of three cameras; one on the interviewer, one on a two shot of some kind, and one on the guest(s).

Other cutaways to be taped include closeups of items or actions discussed during interviews, for example, in the back pain script; a string of large wooden beads, a list of remedies, a skeleton, physical therapy equipment and techniques, as well as material used under narration.

It is the writer's job to plan for these, not only to make the final program more interesting, but also as self-protection to cover errors, omissions or awkward moments that occur during taping.

When the taping is finished the videographer/editor makes up a set of half inch VHS tapes for me, with a burned-in time code. The secretary in the PR office transcribes all spoken material.

Using both of these I prepare a very specific, second-to-second editing script, with all shot selections shown, as well as dissolves, fades, pushes, music selections and other special instructions.

Then my job is done ... until the next program ... and the videographer/editor prepares the master tape.

■ *Following is the first segment of the taping script of one half-hour* **Well Aware** *program. It is followed by the final minutes of the program, in which the institutional public relations aspect is included. Note the listing of the address of Memorial Hospital for obtaining written material on the program's subject, and the lines "Memorial Hospital wants you well ... and well aware of everything that affects your health. Won't you tell your neighbors and friends about us?" At the beginning of the script is a needs-assessment listing prepared by the writer for the producer. At the end is a sample list of questions prepared by the writer for one of the interviews.*

The finished working script is reproduced here with the writer-director's notes and check marks included.

WELL AWARE- Taping Needs- LOW BACK PAIN

PEOPLE	PLACES	ACTIVITIES	EQUIP/PROPS
TEASE			
Person #1	Outside, driveway,	Lifting grocery bags out of trunk	Car, 2 brown bags with stuffing; some groceries on top
Person #2	Doorway, PR house	Bending to pick up newspaper	Newspaper
Person #3	At window, PR house	Washing window	Bucket, water, long handled squeegee, ladder
OPEN AND CLOSE	Children's playground	Comments	
BA			
SEGMENT #1			
Reporter #1	Empty room for demos.	Demos.	See script, Pg. 3,4
Orthopod	Clinical setting	Interview	Skeleton, part of spine from PT, poss. slides
SEGMENT #2			
BA			
Orthopod	Different clinical setting; office?	Interview	
Gloria Miller, PT	PT dept.	Interview and demos. hot pack, ultra sound, massage, Back Trac etc.	Those needed for activities
2 real patients, if poss.	.		
SEGMENT #3			
Sheryl	Empty room	Demo. exercises and tips	See script, pg. 7,8
Gloria			
2 people to demonstrate			

NOTE: PERSONS IN TEASE AND PEOPLE TO DEMONSTRATE MAY BE SAME PEOPLE

Continued

TAPING SCRIPT - Well Aware LOW BACK PAIN Page 1

TEASE

VIDEO	AUDIO
	MUSIC UNDER SILENT ACTION
PERSON LIFTING GROCERY BAGS FROM CAR TRUNK.. PAINED!	
PERSON REACHING DOWN TO PICK UP NEWSPAPER AT DOOR...PAIN!	
PERSON ON LADDER STRETCHING DOWN, THEN UP TO WASH WINDOW...PAIN!	
	BA- Ohhh...their aching backs! If back pain has you in a bind, we have some help for you. Coming up next...on Well Aware.
GENERIC OPEN	GENERIC OPEN

Continued

TAPING SCRIPT - Well Aware LOW BACK PAIN Page 2

VIDEO	AUDIO
	__OPEN__
WS BA AT SWINGS *or other* *playground equip.*	✓ BA- Welcome to Well Aware, Memorial Hospital's monthly program devoted to you, your family and your health.
	I'm Barbara Allen, host for this month, and I have a confession to make. Today's topic is really close to my...back. Remember when we were little and used to flip and twist and hang and swing on equipment like this? Not anymore.
MS ANOTHER ANGLE	My back problems started over 25 years ago when I helped a friend lift and pull a heavy steamer trunk up a long flight of concrete steps and into a house.
	It was a stupid thing to do, but I felt invulnerable then. Now.... after years of recurring back problems, I don't feel invulnerable anymore.

Continued

TAPING SCRIPT - Well Aware LOW BACK PAIN Page 3

VIDEO	AUDIO
CU BA	Today we're going to be looking at some of the causes of low back pain...why it happens, how to treat it, and, perhaps most important, how to prevent it from happening again. Joanne Reeser gets us started.
MCU JOANNE IN DR. N's OFFICE ✔	JOANNE- Here's a quick test for you on the causes of back pain. Which of the following are true?
✔DEMOS	Back pain can be caused by: 1) lifting heavy boxes without bending your knees; 2) turning on a lamp 3) pulling your boots off 4) sneezing
JOANNE	If you said TRUE to the first two, you're right. If you also said TRUE to 3 and 4, you are 100% right.
2 SHOT	Dr. Dean Nachtigall specializes in orthopedics, or the skeletal and muscular structure of your body.

Continued

TAPING SCRIPT - Well Aware LOW BACK PAIN Page 4

VIDEO	AUDIO
REPEAT DEMOS VARY 2 SHOT AND CUs ✓ *skeleton or slides* *RepEAT DEMO*	Dr. Nachtigall, I read that back pain strikes 60-80% of us and that low back pain is the price we pay for upright posture. Is that true? ...Why? Let's go back to some of the causes in our true-false test. Heavy lifting without bending the knees is clearly a cause, but turning on a lamp?...and pulling your boots off?.... *What happened to that flexible little body that used to swing on jungle gyms?* What is it about our spine that makes us so vulnerable to injury and pain?(slipped or bulging disc?) Getting back to our true/false test, why can sneezing be bad?.. What are some of the other common causes?(high-heeled shoes, restrictive clothing, drafts, dampness, low calcium levels, lack of exercise, kidney infections, psychological tension) Can we inherit the tendency to back problems?(arthritis, osteo-porosis, structural problems, muscle weakness)

Continued

TAPING SCRIPT - Well Aware LOW BACK PAIN Page 5

VIDEO	AUDIO
CU JOANNE	JOANNE- Whatever the cause, when you injure your back, the odds are the pain won't go away by itself. What can you do at home, and where do you go from there to get relief? Coming up next...with Barbara Allen, right after this message from Memorial Hospital, sponsor of Well Aware.
LOGO	

	SEGMENT #3
GLORIA AND SHERYL DO EXERCISES AND GIVE TIPS *DEMOS on all tips*	*Mention giving address for exercises & tips at end of program.* (AT END OF SEGMENT) Sheryl- Have you been listening, Barbara?

Continued

TAPING SCRIPT - Well Aware LOW BACK PAIN Page 10

VIDEO	AUDIO
BA AT TOP OF CHILD'S SLIDE ON PLAYGROUND BUT YOU CAN'T SEE SLIDE ADDRESS ON CHAR. GEN.	BA- You bet I have Sheryl. And here's how YOU can get copies of these exercises as well as the tips. Write to: Well Aware- Low back pain Public Relations Department Memorial Hospital P.O. Box M-118 York, PA 17405 I'll repeat that in a moment. I can remember a college health teacher who, in teaching good posture, would parade us around in a circle while she proclaimed, "Hitch your sternum to a star." It was funny then....It's not funny anymore. She was right! As simple a thing as standing and sitting properly can help keep back problems away for years to come. If I had to give one piece of advice to people who have never had back problems, it would be..

Continued

TAPING SCRIPT - Well Aware LOW BACK PAIN Page 11

VIDEO	AUDIO
CHAR. GEN. *Repeat*	BA- Don't press your luck.
	Once they start, it seems they
	can be with you, off and on, for the
	rest of your life.
	SO...here's that address again
	for the exercises and tips.
	Remember...what's important
	before you begin any exercise program,
	be sure to check with your doctor
	first.
	Memorial Hospital wants you well...
	and wellaware of everything that
	affects your health. *Won't you tell your neighbors and friends about us?*
SLOW ZOOM OUT TO SHOW	Until next time, I'm Barbara
BA STANDING AT TOP OF	Allen wishing you the very BEST
CHILDREN'S SLIDE	of health!
SHE BENDS, AND PUTS ONE LEG	Maybe just once?
STRAIGHT OUT AS IF TO	
SLIDE DOWN	
FADE TO BLUE	
CREDITS	CLOSING MUSIC

Written by Barbara Allen. Courtesy Ms. Allen and Memorial Hospital, York, PA.

THE INTERNET

One of the leaders in writing and producing corporate materials on the Internet is the Pangaea Multimedia Communications Corporation. Its president, Eric Johnston, notes that traditional media are giving way to cyberspace and that Pangaea writes and produces corporate materials ranging from training programs to public relations presentations to informational projects to conferences on the Internet. One such production, entitled "Streaming Video on the Internet," written by Steve LaRochelle, is an example of a corporate script for the Internet and a seminar on writing and creating an interactive Web site. As you carefully read it, the "Notes:" column will give you additional explanations of writing and producing purposes and techniques. When you have finished studying this script, check the Pangaea Web site for sample templates used for Internet scripts, at www.pmcc.com/templates.

INTERACTIVE STREAMING VIDEO FOR THE WEB

Seminar on Demand
Post on web target: January 15, 2000

AUDIO	VIDEO	GRAPHICS URL FLIPS	NOTES
WORKFLOW **Workflow.mov** SL-OC: Welcome to the Interactive Streaming Seminar on Demand. My name is Steve. And my name is Tara. We are going to give a behind-the-scene look at what it takes to create an interactive Web site using video to drive all the interactivity. TB-OC: Just click on the word "Introduction" to start the seminar.	MS: Informal shot ... Tara and Steve sitting on couch. Rich blue light in background.... 20/20 look Video fades to black	none	**We want to keep this video very short so the download time is kept to a minimum.** Video will automatically play. All video will only fade to black at the end. NO fade up from black.

Continued

AUDIO	VIDEO	GRAPHICS URL FLIPS	NOTES
INTRODUCTION **Introduction.mov**			Have to click on "Site Overview" to start video.
TB-OC: The video you are watching now will *automatically* open different graphics and flash animations in the frame below. And any time you see a glow around an object, such as the one you see over my shoulder, you can click on it for more information.	MS: Informal shot … Tara and Steve sitting on couch. Rich blue light in background.… 20/20 look	Graphic— Company Inc. EStream Technology Graphic hotspot— camcorder Graphic: Freeze frame of Ski Site	
SL-OC: After you watch this seminar, you'll have a good idea of what it takes to put together an interactive Web site. We are going to use a *waterskiing* Web site that we produced to demonstrate some of the interactivity. To see the waterskiing Web site at any time, click on the link "example site" located in the top left corner of the sliding menu.			
TB: At this point please go to the water ski site and check out some of the interactivity, then come back here learn how we put the site together.			
TB & SL: See you in a few minutes.	Video fades to black		
CAPTURE—Viewer has to click on Design, Shoot or Capture to start the video. **Design: Design.mov**			
SL-VO: The first thing we did was come up with a objective for the site. In our case this waterskiing club wanted to document the season finals. Our objective was to create an interactive site that allows *individual*	Misc shot of event	Graphic: freeze frame of skier	

Continued

AUDIO	VIDEO	GRAPHICS URL FLIPS	NOTES
skiers to see specific runs without having to look at a very long videotape.			
TB-VO: Steve and I had to figure out how we were going to show the skiers and add interactivity. So we started to *sketch* out the design of the Web site. A little later in the workflow you will see why planning the functionality of the site is very important to work out early in the process.	SL and TB in edit suite with pad of paper sketching design … use CU and MS shots	Graphic: sketches from paper Frame set sample	Need to videotape paper—use as graphic
Shoot: shoot.mov			
SL-VO: We used *three* cameras for the shoot, one on the beach, one from the edge of the woods on the lake, and one in a boat. You'll get the best results for your Web video if you *use* a tripod and turn off the auto focus control.	Footage from beach, shore, boat. Same shot … End with 3 cameras in video. USE PAUSE EVENT. Glow around each camera. Click on:	Graphic: Diagram of lake. Cameras in position … shore, woods, boat Graphic: Camera on tripod, text— "Auto focus—off"	
TEXT—**XL 1**—Steve says, "This is an excellent 3 chip camera. The size of the camera makes it easy to balance on your shoulder."	XL1—see URL flip	Graphic—XL1 with text comment & specs	
Elura—Tara notes, "I can't believe the quality of video you can get with a video camera that fits in the palm of your hand."	Elura—see URL flip	Graphic—Elura with text comment & specs	
Optura—Steve says, "The flip out screen is great for review of your shots. Tara says, "With the easy to use menu I could quickly adjust for different exposures and fast action."	Optura—see URL flip	Graphic—Optura with text comment & specs	

Continued

AUDIO	VIDEO	GRAPHICS URL FLIPS	NOTES
Capture: capture.mov			
TB-VO: With all the planning and taping complete, we need to *capture* our video. In our case we used Company connected to a DV deck with an SDI option. With Company products, Mac or *Windows* based, you have the flexibility to capture your video via analog or digital connectors.	TB capturing video. Insert tape, control deck with app, insert another tape, move mouse, etc … PAUSE COMMAND AT END OF VIDEO Have a Cleaner 5 box in the shot … Have glow around box. (Box is hot spot.) GO TO COMMAND on hot spot	Graphic: Junction box, computer and deck connected to MAC Graphic: Same as above but iFinish	Hot spot on the C5 box
GO TO … SL-OC—You found the hot spot. You can capture directly to Cleaner as long as your Mac or PC has a Firewire connector. Cleaner 5 used MotoDV software for capturing video	SL on camera. Video fades to black	Hot spot trigger. Cleaner 5 application Show capture menu item. Graphic of deck connected to PC or Mac	
Edit: must click Company I or iFinish 4 to start video **Company i: editm100.mov**			
TB-OC: For the waterski site we used Company i to edit the video together. Once we had the video on the hard drive, we could *see* picture icons of the media in the bin window. We would trim the *video* in the edit suite and then bring the *video* to the program time line. While using the timeline, we *matched* the action between the three different cameras. We also decided to strip the natural sound and add music. If you are new to video editing, you'll find the interface very intuitive and the system very responsive.	TB—Talking to camera sitting in front of Mac system in edit suite.	Flash— **editm100.swf** Start with WS of bin, edit suite & program. Enlarge & shrink bin shot. Enlarge & shrink edit suite. Enlarge time line. Slide timeline down & shrink. Add three clips. Open slip window. Video in slip window will	

Continued

AUDIO	VIDEO	GRAPHICS URL FLIPS	NOTES
		show matched action between different camera angles. **Pop on text** …match action with "Slip and Slide"	
iFinish 4: editfinish.mov			
SL: The video you are *watching* now was edited using iFinish 4. This, too, was shot in the DV format. iFinish 4 has the same interface as Company i. One additional feature in iFinish 4 is the ability to *master* to MPEG right from the timeline. You can bring these MPEG files right into an DVD authoring package such as Sonic Solutions DVDit! PE for creating interactive DVDs.		Flash— **editfinish.swf** WS of interface. Master to MPEG selection MPEG mastering window **Pop on text** … MPEG 1, MPEG 2, system, program and elementary streams Data rates up to 50 megabits, 4:2:1 I Frame	Note: This could be graphic url flips instead of flash
Effects—must click compositing to start video **Compositing: composite.mov**			
SL-VO: The waterski site does not have any layers of video or composite effects. However, if we wanted to *create* some special effects we could use the composite feature found in Company i or iFinsh 4. The composition clip will automatically access Boris FX. Here you have direct *access* to your bins and unlimited layers. When your composite is complete, you'll notice you take up only one layer in your timeline. This feature gives you the	MS—over the shoulder of Steve. Glow around Boris box. Cut to composite examples created in Boris FX (or composited waterski clip.) End with over the shoulder shot. In each shot put glow around Boris document box.	Graphic: **composite.swf** Timeline with comp clip being stretched out. Boris window comes out of comp clip. Bin pops open. Close bin. Dissolve on many layers. Close Boris. Show time-line with comp clip.	Could use a Boris demo here or create a composite of water ski stuff. If create new piece, then make link from Ossipee main title to the

Continued

AUDIO	VIDEO	GRAPHICS URL FLIPS	NOTES
power to create what you think and keep your timeline organized.	Fade to black		newly created composited piece.
GO TO on Boris Box Music under video	Go To video More "Boris" examples	**Hotspot Graphic: borisbox.gif** Boris Box and text with some features, functions and benefits	

Character Generation: cg.mov

TB-VO: In the waterskiing video we created three buttons using the character generator. Just create the length of your title in the graphics track, then access the character generator. In this part of the application it's easy to create button with text over the top. You also have the ability to animate these titles and create 3D text. Company i uses Graffiti and iFinish 4 uses Inscriber.	Water ski video with buttons. Dip to black. Show water ski video again, but buttons with text tumble on. Dip to black. Buttons tumble on, then 3D text tumbles on.	Graphic: **cg.swf** Timeline stretch out graphic. Boris interface flies out of graphic clip. Cut to completed "text over video" In Graffiti window. Dissolve off Boris window dissolve on Inscriber window.... iFinish 4 text on screen.	

Test Your Knowledge: tyn.mov

TB-VO: When creating an interactive video, what is the first task you should do?	Graphic Video with hot spot on answers. See audio for text applied to screen.		
A. Shoot the video B. Edit the video C. Design the interactivity D. Order a pizza			
"GO TO VIDEO....	TB on-camera: "Questions" hot spot Back button on video.		
A. This is not correct. How do you know what to shoot if you don't know what you are creating? Go back and try again.	Read answer. Fade to black		

Continued

AUDIO	VIDEO	GRAPHICS URL FLIPS	NOTES
B. Edit the video? You need to shoot it first. Go back and try again.	Read answer. Fade to black		
C. You are correct. It's always a good idea to sketch out your ideas before you start spending money on tape stock and hiring any production personnel.	Read answer. And so on …	1. no url flip 2. no url flip 3. url flip—ideas, design, write, shoot, edit, author, encode, post	
D. Eating pizza can foster new ideas, but it is not necessarily the first thing you want to do. Go back and try again.		4. no url flip	

Author
HTML: authorhtml.mov

TB & SL—OC—When Steve and I produced the waterski site we started by creating an html document which was a frame set. The key element for us at this point is to name our frames … these are called "Target names."	TB & SL OC—… next to system—edit suite. GoLive and Dream-weaver box in background, but no glow.	Graphics—**authorhtml.swf** Show Dream-weaver and GoLive box. Text—"Drag and drop HTML editors." Dissolve on frame set graphic. Point out target name. Three little "html docs." Slide docs, one at a time, into a frame.	**This will be the most compli-cated flash animation of the en-tire project. Good luck.**
SL—Individual graphic, text and movie html documents are created. When the video plays, our embedded triggers will call up the appropriate html document. Then open it in the proper frame.			
TB—For example, let's say we wanted a graphic to open in the frame below us. And that frame is called "Content." First we would open a blank html document. Then we would drop a graphic plug-in on that document. Next we would link a document or piece of media to that plug-in. Finally, we would save that html document in a folder called pages. When the video plays it will		Text at top of frame "Content." Blank html doc & Palette. Animate plug-in to html doc Show Frame Inspector. Pop on file name.	

Continued

AUDIO	VIDEO	GRAPHICS URL FLIPS	NOTES
look to the Pages folder. Find the html document. Then open that document in the Content frame below us.		Have that page push back into a "Pages" folder. Graphic of Company logo opens in Content frame.	
SL—The graphic you are looking at right now was triggered by this video. To keep all of our files organized, we put all of our media in a folder called Media and all of our html documents in a folder called Pages. If you click on one of these objects that glow, you'll see a hotspot trigger. Check out the eStream section for more details.	Two hot spots appear— GoLive and Dreamweaver boxes have glow. Action is URL flip of each package	**HOT SPOT GRAPHIC:** Dreamweaver— **Dream.html—box with features, function benefits in text** GoLive— **Golive.html** GoLive box with feature, function, benefit in text.	
	Fade to black		
EStream: authorstream.mov			
SL—OC—To create the triggers you saw in the water ski video, we'll focus on one water skier, Stephanie Krebs. If you click on her you will see the ski she is using and the wet suit that she is wearing. To create the hot spot we used the following steps.	Next video will cut between SL and TB. SL—OC	Graphic— **authors.swf** Freeze frame of Stephaine	
TB—If you look at the skier you'll notice that she stays in a certain area of the screen for almost the entire video. So we placed an event mark near the beginning of the video. We defined the event as hot spot. Next we created the area which remains hot. We also defined the duration of that hot spot.		Fade on timeline EStream window shot hot spot area Action window show URL and target	
SL—Now we need to define the action of the hot spot. So we type in the location of the graphic file we			

Continued

AUDIO	VIDEO	GRAPHICS URL FLIPS	NOTES
wanted triggered and the target frame. In this case the target frame is called Leftcontent.			
TB—The next step is to encode the video using Cleaner 5. We cover the details in the Encode section of this seminar.	Fade to black		

Written by Steve LaRochelle for Pangaea Multimedia Communications Corporation, Cambridge, Massachusetts, USA www.pmcc.com

FORMAL EDUCATION PROGRAMS

The formal lesson designed for classroom use is a principal form of the educational television or radio program. The formal instructional program writer is, to a great degree, a planner. Writing the program begins with the cooperative planning of the curriculum coordinator, the studio teacher, the classroom teacher, the educational administrator, the producer, the television or radio specialist, and the writer. The writer must accept from the educational experts the purposes and contents of each program. However, he or she should stand firm on the manner of presentation. Many educators are prone to use the media as a classroom extension, incorporating into the programs techniques that might work well in the classroom, but are ineffective for the media.

Most important, the writer should avoid the "talking head"—presenting the learning materials the same way it is done by the teacher in the classroom. The media should be used to do what renowned educator John Dewey advocated as a key to good education: bring the classroom to the world and the world to the classroom. An effective television or Internet lesson does not necessarily require a teacher on screen. Good instruction must be wedded to good video and audio production.

Approach

First, the writer must determine the learning goals and contents and the lengths of the individual programs. After that he or she can begin outlining each segment. The outline should carefully follow the lesson plan for each unit as developed by the educational experts. Stress important topics; play down unimportant ones. Some instructional programs are not fully scripted, but are produced from detailed outlines or rundowns. For example, a program that uses tape or film from the field, demonstrations at professional

sites, or interviews cannot be fully scripted. Script preparation is similar to that done for the comparable feature, interview, or corporate program.

Most instructional programs have studio teachers—teachers who conduct the media lesson. Some excellent classroom teachers are poor on camera; and some teachers who do not come across well in the classroom are excellent on television. Sometimes a professional performer is hired to play the role of the teacher. The detail in the script can vary depending on the competence of the on-camera instructor.

Even in the outline stage the writer should explore the given medium's special qualities that can present the content more effectively than in the classroom. Infuse creativity and entertainment into the learning materials. The instructional writer needs to stimulate the viewer-learner and relate the material to the student's real-life experiences.

Use humor, drama, and suspense, borrowing liberally from the most effective aspects of entertainment programs. *Sesame Street,* though not a formal instructional program, is used in many classrooms and combines the best television techniques and forms, from animation to commercials.

Don't be afraid of a liberal infusion of visuals and sounds. Good use of visual writing permits more concrete explanation of what is presented than in the traditional classroom. You can show the real person, place, thing, or event being studied.

Two-way audio and two-way video are useful. Even with one-way video, voice communication from the classroom to the studio teacher, if the production is live, permits questions-and-answers and discussions. Discussions can take place among several classes taking the same subject at the same time. Evaluation, or testing, can be done during the live media lesson through talkback. The studio teacher and the instructional team planning the lessons know what kinds of questions the students will ask and should build in information on those questions and appropriate times during the lesson for questions and answers. Commercial broadcasters have an inordinate fear of dead air time, but good instructional programs build in such time for the classroom teacher to review what the studio teacher has presented and to establish appropriate interaction among the students and the classroom teacher as well as with the studio teacher. With the use of the Internet for formal instruction, interactive teaching and learning is built in.

Classroom teachers do not work in a vacuum. Every instructional series should have a written teacher's guide that details the purposes, level, content, and evaluation for each media lesson. The guide includes preparatory and follow-up recommendations. Sometimes the guide is prepared after the series is completed; sometimes it is written as the series develops, in which case the guide provides the writer with an excellent outline base for each script.

Techniques

1 *Follow a logical sequence in every script.* Begin with a review and preparation for the day's materials and conclude with classroom follow-up materials such as research, field projects, and individual study.

2 *Motivate the learner with stimulating material.* Make the learning experience exciting for the child in the elementary grade, the adult in the professional school, or the employee in the workplace. Include imaginative visual or aural stimuli and attention-getting material that will retain the viewer's interest.

3 *Target the script to the specific audience.* Determine whether the program is designed for one school, a school system, an entire state, or for national distribution. Determine the backgrounds and interests of the students who will be watching the program.

4 *Write at the appropriate level.* Determine, with the help of the educational experts, the desired complexity of the material based on how much the students are likely to know already and the language level the students in that grade level require for optimum comprehension.

5 *Encourage students to create new ideas through their own thinking.*

6 *Follow the principles of good commercial writing.* Get the students' attention, keep their interest, impart information, plant an idea, and get them to take action by evaluating and following-up on what they have learned.

7 *Follow the principles of good playwriting.* Begin with background or exposition; follow with conflict and suspense about what will happen to the idea, characters, or situation; incorporate as complications the problems or methods of what is being learned; move the students toward reaching a climax through their findings. Most effective learning takes place when the student is given alternatives and reaches a solution through his or her own thinking. Drama is an excellent technique to use in teaching. For instance, many critics and researchers believe that the dramatists have educated us with deeper insights and feelings about the relationships among people and between people and their environment than have historians or social scientists. As an example, Shakespeare's plays give us more understanding of the motivations and interpersonal relationships of England's kings than do most history books.

8 *Be creative.* Do not simply present information. Make the form of presentation interesting. For example, one of the most effective devices for teaching history is the "You Are There" approach that was popular on commercial television and radio for many years. The script is written as though a team of on-the-spot reporters were at the historical place and time bringing the audience the news through narrative pictures, sounds, words, interviews with the historical figures involved, and comments on the significance of what is occurring. Of course, the settings and the performers' costumes are as accurate as possible. The content is factual, but the form has the interest of the historical drama.

Another often-used approach, especially in science programs, is costumed performers playing the inanimate subjects being studied. For example, an AIDS antibody can be the guide on a tour of how the AIDS virus enters and destroys the body. Although such

imaginative approaches are highly learning-effective, the more complex the program, the higher the cost.

■ *One of the simplest and most popular formats is directly presenting views and sounds of people, places, and things that otherwise would not be available in the traditional classroom. Science experiments, biographical interviews, artistic performances, and geographical information are among the areas that fall into this category. The television program using this approach can resemble a travelogue, with the television teacher providing voice-over commentary. An example of this kind of script is the following beginning and ending of one lesson of a series designed for fourth-grade social studies. As you read this script, think about how you would adapt it for interactive presentation on the Internet.*

LANDS AND PEOPLE OF OUR WORLD

Lesson Number: 29	Lesson Title: Japan

FILM—1 min.

MUSIC—1 min.

CG—"Lands and People of Our World"

CG—Donna Matson	Legend says that the Sun Goddess founded the islands of Japan, and for many years only tribespeople inhabited the land of the rising sun. Then Chinese traders and other foreigners began visiting Japan; they brought new ideas and culture. But the rulers of Japan didn't want any changes, so they closed their gates, allowing no one to enter and no one to leave. For nearly 200 years Japan and her people remained isolated from the outside world.
	Then, in 1853, Commodore Perry of the United States Navy sailed his warships into Tokyo Bay and persuaded the Japanese to open two of their ports to U.S. Trade.
	The Japanese quickly learned the ways of the modern world, and today they are one of the greatest industrial nations in the world.
ON DONNA	Hello, boys and girls. Our lesson today is about Japan, one of the most amazing countries in the world today.
PIX #1 MAP—ASIA	Japan is a group of islands, located in Asia, off the East Coasts of Russia, Korea and China, in the Western part of the Pacific Ocean.

Continued

Japan consists of four main islands: Hokkaido, Honshu, Kyushu, and Shikoku, plus about 3,000 smaller islands. All together they about equal the size of the State of California. The islands of Japan stretch from North to Southwest for a distance of about 1200 miles.

FILM—3 min.

MUSIC

Mount Fujiyama, a volcanic mountain, over 12,000 feet high, is the highest point in Japan. The islands of Japan are actually the tops of mountains which are still growing.

Japan is located in the Pacific Great Circle of Fire, and has about 1500 earthquakes each year, but most of them cause little damage.

Japan has a wide variety of climates ranging from tropical on the southern islands to cool summers and snowy winters on the northern islands.

Tokyo

More than 120 million people live on the islands of Japan, and two out of three live in cities.

Tokyo, Japan's capital city, is the largest city in the world, with a population of more than 12 million people. Osaka, Kyoto, and Yokohama are also large cities, with populations of more than two million each.

The city of Tokyo has been rebuilt twice in the last 60 years, once after an earthquake, and again after the air raids of World War II.

Today it is very much like an American city, with wide paved streets, tall modern buildings, and heavy traffic. Tokyo has been able to grow so fast mainly because of its very modern railroads that carry more than one million people into work each day.

Most Japanese homes are made of wood panels and sliding doors. They withstand earthquakes well, but not fires. Many homes have beautiful gardens. The floors of the homes are like thick cushions and the Japanese people kneel on the floor while eating off low tables. They sleep on the soft floors in comforters and blankets that they roll up during the day. And to keep these floors clean, they always remove their shoes before entering their houses. The Japanese are some of the cleanest people I've ever met in the world.

Students

In Japan, all boys and girls must go to school for nine years. That's grade one to nine. And they have at least two hours of homework each night, and homework assignments all summer long. All students in Japan are required to study English. There are more than 60 universities and colleges in Tokyo.

Continued

Mother and Child	Japanese children are very respectful and polite to their parents and grandparents, and try very hard never to bring shame to their family in any way.
Harbor	Japan is an island nation, and island nations need ships. Japan is a leader in the world in ship building, plastics, electronics, and auto making. Japan imports much steel from us, manufactures trucks, autos and machinery, and exports it to the United States and other countries.
	People travel mainly on electric trains and buses. There just wouldn't be enough room if many people had cars. Space is a problem. . . .
	Japan is also the world's largest exporter of ceramic tableware, cameras, lenses, electronic equipment and motorcycles.
Film Ends (3 min.)	
ON DONNA	As a matter of fact, here are some of the things I own that are manufactured in Japan. My camera, tape recorder and ceramic tableware.
FILM—7½ min.	The textile industry is another important industry in Japan. Japan produces more than half the world's supply of raw silk. Silk, remember, comes from cocoons of the silkworms.
Fishing	Japan is one of the world's greatest fishing countries. It has over 400,000 fishing boats. That's more than any other nation.
	* * *
FILM	For over 1,000 years Japan was ruled by an Emperor who had great powers over the people. Today his duties are mainly ceremonial. Here we see the Emperor of Japan greeting his people on New Year's Day at the Imperial Palace Grounds in Tokyo.
	After World War II, the United States helped Japan set up a democratic form of government, and the head of their government is the Prime Minister, who is chosen by the Diet. The Diet is like our Congress, with a House of Representatives and a House of Councilors who are elected by the people of Japan.
	Hibatchi, food, toys, dolls, kite.
ON DONNA MUSIC—15 sec. ON KITE CG—Consultant CG—Western ITV	Closing

Courtesy of Western Instructional Television

CHILDREN'S PROGRAMS

Informal educational programs include those for children. At one time a number of television programs combined information, ideas, morals, and entertainment for young viewers, just as radio did in a previous era. Today, however, with the exception of cartoons, few children's programs remain on television. Networks occasionally do children's specials, several individual stations produce local programs for children, and public television and some commercial stations carry *Sesame Street.* But the day of nonexploitative drama for children is past. Cartoons may have dramatic plots or sequences, but they are by and large written on a very low level, filled with violence and sexism, and in many cases are merely program-length commercials with the entire cartoon centered around the toy that the advertiser is trying to sell to the children.

Some basic principles and techniques apply to writing for children. The foremost principle is to remember the effect television has on the vulnerable minds and emotions of young viewers. One hopes that writers of children's programs will exercise their consciences and discuss new program ideas with child experts and child advocates before writing scripts that may prove harmful to youngsters.

Approach

Imagination is the key to preparing and writing programs for children. The imaginations of children are broad, exciting, stimulating. Only when we are forced into the conformity of the formal educational system and, later on, when we near adulthood, do our thoughts and imaginations become restricted. Children can release themselves to be led into almost any fantasy, *provided a valid, believable base exists.* The same principle applies to adult farce or comedy. As long as the characters, situation, and environment are believable and the plot is developed logically, the actions and events will be accepted.

Format

Certain age levels respond best to certain kinds of content. The child in the early elementary grades can relate to material containing beginning elements of logical thinking. Sketches with simple plots and fairy tales are appealing. Activities the child can get involved in, if not too complicated, are effective. The child older than eight or nine can respond to accounts of the outside world. Drama is effective, especially stories of adventure where the child can identify with the hero or heroine. Children in upper elementary grades have begun to read parts of the daily newspaper and to watch news and documentary programs, as well as cartoons and sitcoms, on television. They can respond to ideas and real-life events. British children's television producer Lucinda Whitely stated in *Spectrum* magazine that "You don't want all the programming to be sweet and lovely . . . it has to be challenging and deal with issues pertinent to kids today." Whitely also stressed the need for audience participation and feedback.

Writing Techniques

Reach the child viewer in a direct manner. The presentational approach is good, with the narrator or character relating directly to the child. Be simple and clear, but not condescending or patronizing. Too much dialogue is not advisable. Action—vivid, colorful presentation of ideas—is more effective. In a story, stick to a simple plot. Don't present too much at once, and don't draw it out; children don't have very long attention spans. Avoid using material that the child may have seen or studied in school, unless you can build on it and take the child to the next level of learning. Stimulate the child with new experiences and ideas. Don't pad the program. Don't be confusing. If a moral is presented, make it definite and clear.

In any drama form, suspense is a prime ingredient. Just as with the play for adults, children should be caught up in a conflict, no matter how simple it is, and should want to know what is going to happen. A good technique is to let children in on a secret that certain characters in the play do not know.

Especially in a program oriented to learning—information, a skill, an art—the writer has to involve and challenge the child viewer. Neil Buchanan, writer and producer of the highly successful children's art show on British television, "Art Attack," stated in *Spectrum* that "you can't say to a kid nowadays, 'hello children and welcome to drawing time.' They'll reject it. They won't buy innocence from you, but if you tap into it, you'll see their faces light up. It's still there. The skill is to get to it."

The Manuscript

Some children's shows are written out completely, with all the dialogue and directions. Some use detailed routine or rundown sheets, especially in nondramatic, host-conducted shows. *Sesame Street* has combined educational television with the techniques of commercial television by integrating various elements such as live performers, puppets, music, graphics, visual and aural special effects, and other resources that attract the attention and hold the interest of young viewers. Here is a classic example of a *Sesame Street* script.

CHILDREN'S TELEVISION WORKSHOP

SESAME STREET

AIR: MARCH 15
Final Air Version

1. Film: Show Identification :15

2. Film: Opening Sesame Street Theme :50

Continued

3. DAVID IS STUDYING (SOCIAL ATTITUDES) 2:02

HOOPER DRESSED IN DAY OFF OUTFIT ENTERS NEAR FIXIT SHOP. HE GREETS AND THEN GOES INTO STORE. DAVID IS BEHIND COUNTER. HE IS READING A BOOK AND TAKING NOTES.

HOOPER: Hello David.

DAVID: Oh hi Mr. Hooper. What are you doing here? This is your day off.

HOOPER: I know but I just happened to be in the neighborhood and I thought I'd drop by.

(NOTICES DAVID WAS READING) Reading huh?

DAVID: Uh . . . yeah I was.

HOOPER: (LOOKS MIFFED) Reading on the job?

DAVID: Hey wait a minute. I know this looks bad . . . but there were no customers in the store and I just . . .

HOOPER: (CUTS HIM OFF) Yes I know . . . but the floors could use a sweeping . . . and shelves could be straightened. I don't know . . . in my day when I was young like you . . . when I worked . . . I worked.

DAVID: (A LITTLE MIFFED) Listen Mr. Hooper. I know I shouldn't be reading when you're paying me to work, but I wasn't just reading. I was studying.

HOOPER: Studying?

DAVID: Yeah, I have a big law school test tonight.

HOOPER: A test? Why didn't you say so? Studying is very important. It's a good thing I came by. You shouldn't be here in the first place. (STARTS USHERING DAVID OUT OF THE BACK INTO THE ARBOR) Come on come on. You gotta study. I'll work today.

THEY GET TO ARBOR . . .

DAVID: Wait, Mr. Hooper. That's not fair to you. It's your day off.

HOOPER: So you'll work on your day off and make it up. You want to be a big lawyer some day no?

DAVID: O.K. If you say so. Thanks a lot, Mr. Hooper, I appreciate it. (SITS AND STARTS TO READ, AT TABLE)

HOOPER: My pleasure, Mr. Lawyer, my pleasure.

SCENIC: Street, Arbor, Store
TALENT: David, Hooper
PROPS: Constitutional Law Book, note book, pencil

Continued

COSTUMES: Hooper in regular clothes

4. VTR: BEAT THE TIME-TRAIN (GUY, CM, AM) (446) (33a) 3:03

5. BB STUDIES WITH DAVID 3:03

BB ENTERS ARBOR AREA CARRYING A SCHOOL BAG. DAVID IS STUDYING. THERE IS A STOOL AT TABLE OPPOSITE DAVID.

BB: Hi David. Do you mind if I study with you?

DAVID: What are you gonna study BB?

BB: (REACHES INTO SCHOOL BAG AND TAKES OUT LETTER "U" AND PUTS IT ON TABLE)

The letter "U." It takes a lot of study you know.

DAVID: O.K. BB go ahead. (GOES BACK TO READING)

BB: (GETS CLOSE TO LETTER) U . . . U . . .

DAVID: (LOOKS UP) BB quietly.

BB: Oh sorry David. (TAKES A UKELELE OUT OF SCHOOL BAG, PUTS IT NOISILY ON TABLE THEN DOES THE SAME WITH AN UMBRELLA.

DAVID: BB what now?

BB: Oh these are just some things that begin with the letter "U." A ukelele and an umbrella. See it makes it easier to learn a letter if you know a word that begins with that letter.

DAVID: I know . . . I know. But listen BB. You can't be putting all kinds of things on the table. It bothers me.

BB: Oh sorry Dave. Well then how about if I do something that begins with the letter "U"?

DAVID: (WILLING TO AGREE TO ANYTHING BY NOW). O.K. Sure. As long as you're quiet.

BB: I'll be quiet.

DAVID GOES BACK TO READING.

BB: (GETS UP AND TIPTOES TO SIDE OF TABLE . . . BENDS OVER AND PUTS HIS HEAD UNDER THE TABLE AND TRIES TO GO UNDER IT . . . POSSIBLY KNOCKING IT OVER)

DAVID: BB what now?

BB: I was going under the table. Under starts with the letter "U."

DAVID: BB you're driving me crazy.

BB: Gee it's not my fault the letter "U" is a noisy letter to study. Well anyway I'm finished studying it.

Continued

DAVID: Good.

BB: Are you finished studying your law book?

DAVID: No.

BB: Well don't feel bad. Not everybody is as fast a learner as me. (STARTS GATHERING HIS STUFF TOGETHER)

DAVID: (BURN)

SCENIC: Arbor
TALENT: BB, David
PROPS: BB school bag, letter "U", a ukulele, umbrella

6.	FILM: U IS FOR UP	:34
7.	FILM: DOLL HOUSE #2	1:32
8.	FILM: U CAPITAL	:46
9.	BB AND SNUFFY STUDY WITH DAVID.	2:57

BB AND SNUFF NEAR 123. BB HAS A #2.

BB: O.K. Mr. Snuffleupagus, are you all set to go study with David?

SNUFF: Sure Bird. I'm ready. What are we gonna study?

BB: The number two. (HOLDS UP NUMBER)

SNUFF: Oh goody, let's go.

BB: O.K. But be very quiet. Don't make a sound. We mustn't bother David.

SNUFF: O.K. Bird. I won't even say a word.

THEY GO TO ARBOR . . . SNUFF SITS IN BACK OF DAVID WHO IS READING INTENTLY . . . BB GOES TO STOOL OPPOSITE DAVID.

DAVID: (LOOKS UP) Oh no, BB. I thought you were finished studying.

BB: I was finished studying the letter "U" . . . now we're gonna study the number two.

(PUTS "2" ON TABLE)

DAVID: BB you've got to be quiet.

BB: Oh we will. We won't make a sound. We promise.

DAVID: Good. (GOES BACK TO READING THEN LOOKS UP) Who's we?

BB: Me and Mr. Snuffleupagus.

Continued

DAVID: You and Mr. Snuffle . . . ? Oh not again with that imaginary friend.

BB: He's not imaginary. He's right behind you.

DAVID: O.K. . . . I don't have time. Just be quiet. (GOES BACK TO READING)

BB: We will. O.K., Mr. Snuffleupagus. Let's study the number two.

BB AND SNUFF STARE INTENTLY AT NUMBER 2. SNUFF GETS AS CLOSE BEHIND DAVID AS HE CAN.

SCENIC: Arbor

TALENT: David, BB, Snuff

PROPS: #2

APPLICATION AND REVIEW

1. Choose a business or industry in your area that is large enough to benefit from a media training program. Discuss with its training, sales, or human resources director some of its current needs and prepare a half-hour video script designed to solve a specific problem.

2. Discuss with the director of your college or university's public information office some of the current promotion campaigns of the institution and prepare a 15-minute slide plus narration program that can be used for the general public or for prospective students and their parents.

3. Prepare a 15-minute script, either video or audio, that can be used to orient new members of a campus organization of which you are a member.

4. Prepare a treatment for the pilot of a half hour "quality" children's program that you will try to get produced by a local television or radio station or cable system.

5. Using as a base the template found on www.pmmc.com/templates, adapt one of the previous exercises for the Internet.

10

The Play

Writing the play is generally considered to be the most difficult endeavor as well as the highest achievement in the performing arts. Creating the television or film play is the culmination of learning how to write for the media and the basis for all other formats. Whether a 30-second commercial or a two-hour documentary, the script structure depends on the elements of the play: exposition, conflict, complication, climax, and resolution.

Take the commercial, for example. In addition to those commercials that literally are minidramas (one or more characters in a situation that involves the sponsor's product or service), all commercials present a problem (a conflict), show how life is difficult or unfulfilled (complication), and how the problem is solved and life becomes better when the sponsor's product or service is purchased (the climax and resolution). All documentaries depend on dramatic action involving the person, persons, or events being shown in a condensation of the real-life occurrences. Even a disc jockey program that is well planned achieves a rising level of interest that gains and holds the audience's attention.

The play is the staple of prime-time television, whether in sitcom, action adventure, or serious drama form. Daytime television relies heavily on the play, usually sitcoms, but also on whatever other genre happens to be popular enough to draw good ratings and is available in syndication. Soap opera plays are among the most popular television programs, both day and evening.

If you learn the elements that go into writing a good play, even if you never discover within you the motivation or talent to actually write a play, you will be better able to write other television and radio formats effectively.

Brander Matthews, one of the theatre's all-time leading critics and teachers, wrote in his book *The Development of Drama,* "dramaturgic principles are not mere rules laid down by theoretical critics, who have rarely any acquaintance with the actual theatre; they are

laws, inherent in the nature of the art itself, standing eternal, as immitigable today as when Sophocles was alive, or Shakespeare, or Molière."

The rules of playwriting are universal. They apply generally to the structure of the play written for the stage, film, television, or radio. The rules are modified in their specific applications by the particular medium's special requirements.

Don't assume, merely because there are rules, that playwriting can be taught. Genius and inspiration cannot be taught, and playwriting is an art on a plane of creativity far above the mechanical facets of some phases of continuity writing. America's first and foremost playwriting teacher, George Pierce Baker, stated that what can be done, however, is to show the potential playwright how to apply whatever genius and dramatic insight he or she may have, through an understanding of the basic rules of dramaturgy.

Yet, even this much cannot be taught in one chapter or in several chapters. Any full discussion of playwriting technique requires at least a complete book, several courses, and endless practice. What will be presented here is a summary of the rules of playwriting and some new concepts of playwriting for the special needs of the media. If you seriously want to write drama for the electronic media, first explore as thoroughly as possible the techniques of writing the play for the stage. Only then will you have a sound basis for the video play.

Remember that a play is a play is a play. Whether presented over the airwaves (broadcasting) or through cable, satellite, laser beams, or cyberspace, the play is the same—a dramatic presentation reaching people seated in front of an oblong box with a small screen usually ranging from 13 to 25 inches. Therefore, when you see the term *television* used in this chapter, don't say "But I'm going to write for cable." It's the same thing.

Remember that as a television playwright you are not starting from scratch. You have an entire literary tradition to borrow from, if you are willing to learn what it is and how to use it. In an article entitled "The Triumph of the Prime-Time Novel" in *The New York Times Magazine,* Charles McGrath stated that "TV drama is one of the few remaining art forms to continue the tradition of classic American realism." He noted how the writers for the Golden Age of Television Drama, including Paddy Chayevsky and Gore Vidal, "consciously based their work on literary models, and on classical dramatic principles in particular . . . the current generation is no less literary."

SOURCES

Before the actual techniques of writing can be applied, the writer must be able to recognize and exploit the sources out of which the ideas for the play can be developed.

The writer can find the motivating ingredient for the play in an event or happening, a theme, a character or characters, or a background.

Many times a playwright has witnessed or experienced an incident or series of incidents that contain the fundamentals for good drama. From this event or happening the playwright can build character, situation, theme, and background. Remember, however, that what is exciting in life is not necessarily good drama. Drama is heightened life. Drama

compresses a situation's most important elements and requires a rearrangement, revision, and condensation of life to make it dramatic rather than merely human interest reporting. The beginning playwright may have difficulty understanding this, particularly when he or she has participated in or observed an interesting life situation. What seems to be the most tragic, most humorous, most exciting thing that has ever happened to the writer can actually be hackneyed, dull, and undramatic in play form.

Because something seems dramatic in real life does not mean that it will be dramatic if put into a play. Such transposition requires imagination, skill, and, to no small degree, the indefinable genius of playwriting. For example, many of us have seen a situation where a destitute maiden aunt has come to live with a sister and brother-in-law, and in her psychological need has become a disturbing factor in the marriage. To the participants, or even to a close observer, such a situation might have provocative and electrifying undertones. To someone not connected with the situation, it appears, and understandably so, dull and uninspiring. To the imaginative playwright, in this case Tennessee Williams, it could become one of America's all-time great plays, *A Streetcar Named Desire*.

The writer can initiate the preliminary thinking about the play from a theme or an idea. Although censorship often hampers the television and radio playwright, the writer can find basic concepts such as loyalty, independence, and self-realization as motivating factors upon which to develop a drama. The theme must be translated into specific and full-blown people and concrete situations. The theme of loyalty, for example, might include the son who won't marry because of his psychologically motivated belief that he cannot leave his mother. Independence covers many variations of the story of the wife who leaves her husband because she is not accorded the freedom or respect she feels she needs. Self-realization covers an endless supply of potential plays oriented around the artist who prefers living on bread and beans in a cold-water flat rather than accepting a lucrative advertising agency job. The writer must be wary of attempting to develop a play around a theme alone. The theme serves merely as the germ of the idea for the play.

Another source for the play can lie in a background. The backgrounds of war, of high society, of a drug environment, and of the business world have provided the settings and motivations for many plays. The college student could do worse than to use the campus as a background for the play.

A final source for the play can come from a character or several characters, either as a group or rolled into one. In modern dramaturgy, character motivates action; that is, the plot develops from the characters. For this reason, the choice of character as a source provides a potentially stronger play foundation than do the other sources. The writer must be cautious, however, in using this source independently of the others; it is difficult to build a play solely around a character or combination of characters taken from real life. For example, how trite is the idea of a salesman getting fired from a job because he is getting old and cannot make as many sales as he once did! Even if his character is enlarged by adding pride, self-deception, and despondency leading to suicide, the dramatic potential is not yet fully realized. But work on the character, develop his many facets, beliefs,

psychological needs, physical capabilities, and relationships to other people, clarify a theme and background, and you might eventually get to Willy Loman of Arthur Miller's classic play, *Death of a Salesman.*

In his *New York Times Magazine* article, Charles McGrath described the work of the staff writers for the crime-and-punishment television drama, *Law & Order.* He noted that the program's scripts are developed in numerous ways, including looking at newspaper headlines for crimes and for legal issues, such as New York State's instituting the death penalty—an issue that became the basis for one *Law & Order* episode. Sometimes ideas are hard to come by. McGrath quoted executive producer and head writer Michael Chernuchin as saying that at times "we have no idea what we're doing and we just sit around and toss things around."

The sources of the play—situation, theme, background, and character—are individually only germs of ideas. Explore, expand, and revise these elements to determine if they have any dramatic value. If they have, then the playwright can take the next step. Inexperienced writers—and lazy ones—sometimes believe that all they have to do is have an idea and a pretty good notion of where they are going with it, and then sit down and write the play. Unfortunately, this is not the case. The actual writing is the dessert of the playwright's menu. The hard work is devoted to planning the play and, later, to revising the manuscript. After deciding on the source or basis for a play, clarify in your mind and on paper the various elements that develop from the base. For example, if you choose to work from a background, determine the characters, situation, and theme that go with the background.

Ideally, you should write out of personal experience or knowledge to give the play a valid foundation. If you are too close, either emotionally or in terms of time, to the life-ingredients of the play, however, it will be difficult to heighten and condense and dramatize the material; you will tend to be a reporter rather than a dramatist. The playwright should never be part of the play, but should be able to write it objectively. Feel and understand every moment of what you write, but try to do so as a third person. Don't use the play as personal therapy. If you are tempted to do so—and some playwrights have done so successfully—at least be sure that the character who represents you is not so internalized as to be without foibles or otherwise unbelievable. It usually is a good idea to be several calendar years and several emotional light years away from the real-life events and characters when you start to write the play.

STRUCTURE

Until the eighteenth century, with the exception of works by a few playwrights (notably Shakespeare), plot or action was the dominant element in the play. The plot line was the most important factor, and the characters and dialogue were fitted into the movement of the action. Modern drama has emphasized character as most important. The actions that determine the plot are those the characters *must* take because of their particular

personalities and psychological motivations. The dialogue is that which the characters *must* speak for the same reasons.

The three major elements in the play structure—character, plot, and dialogue—all must be coordinated into a consistent and clear theme. This coordination of all elements toward a common end results in the unity of the piece, a unity of impression. The characters' actions and the events must not be arbitrary. Prepare the audience for these actions and events in a logical and valid manner; this is called *preparation*. Give the audience the background of the situation and of the characters; this is the *exposition*. In addition, consider the *setting*, to create a valid physical background and environment for the characters.

After you are certain that you understand and can be objective about the characters, theme, situation, and background, you can begin to create each in depth. Do as much research as possible, to acquaint yourself fully with the potentials of your play.

Each character should be analyzed. Do it on paper, so that you have the characters' complete histories and motivations in front of you at all times. Develop a background for each character, for not only the duration of the action, but also before the play's opening (even going back to ancestors who do not appear in the play but who would have had some influence on the character's personality). A complete analysis of a character also provides an indication of the kind and form of dialogue the character would use. Test the dialogue on paper, putting the character into hypothetical situations with other characters. Remember, the dialogue is not an approximation of real-life speech; it must be heightened and condensed from that of real life.

After the characters have been created, you are ready to create the situation, or plot line. Do this in skeletonized form. You need, first, a **conflict.** The conflict is between the **protagonist** of the play and some other character or force. A conflict can be between two individuals, an individual and a group, two groups, an individual or individuals and nature, an individual or individuals and some unknown force, or an individual and his or her inner self. The nature of the conflict is determined largely by the kinds of characters involved.

After the conflict has been decided upon, the plot moves inexorably toward a climax, the point at which one of the forces in conflict wins out over the other. The play reaches the climax through a series of complications. Each complication is, in itself, a small conflict and climax. Each succeeding complication complicates the situation to a greater and greater degree until the final complication makes it impossible for the struggle to be heightened any longer. Something has to give. The climax must occur. The complications are not arbitrary. The characters themselves determine the events and the complications because the actions they take are those, and only those, they must take because of their particular motivations and personalities.

George Pierce Baker wrote in *Dramatic Technique* that the "situation exists because one is what he is and so has inner conflict, or clashes, with another person, or with his environment. Change his character a little and the situation must change. Involve more people in it, and immediately their very presence, affecting the people originally in the scene, will change the situation."

British playwright Terrence Rattigan wrote similarly in a *Theatre Arts* article, "The Characters Make the Play":

> A play is born—for me, at any rate—in a character, in a background or setting, in a period or in a theme, never in a plot. I believe that in the process of a play's preliminary construction during that long and difficult period of gestation before a line is put on paper, the plot is the last of the vital organs to take shape.
>
> If the characters are correctly fashioned—by which I do not mean accurately representing living people but correctly conceived in their relationship to each other—the play will grow out of them. A number of firmly and definitely imagined characters will act—must act—in a firm and definite way. This gives you your plot. If it does not, your characters are wrongly conceived and you must start again.

A medium interprets for the audience what we have written. Writing for films is different than writing for the stage, just as writing for radio is different than writing for previous media, just as writing for television is different than writing for radio, just as writing for the Internet is different than writing for all of the above. If we take the same basic script elements—plot, characters, setting and dialogue—we would write them to fit the aesthetic and technical requirements and potentials of the given medium.

Once the preliminary planning, gestation, research, and analysis are completed, the writer is ready. But not for writing the play. Not yet. Next comes the scenario or detailed outline. The writer who has been conscientious until now will learn from the scenario whether or not he or she has a potentially good play, if any play at all. Through careful construction and analysis of the scenario, the writer can eliminate the bad points and strengthen the good points before the play is written.

Before writing a detailed scenario, however, the writer must have a knowledge of the concepts of dramaturgy—of the basic rules for the play regardless of the medium, and of the modified rules for the film, video, or audio play, as determined by the special characteristics of these media.

CONCEPTS OF PLAYWRITING

The special characteristics of the television audience and of the medium itself require special approaches by the television playwright, as discussed in Chapters 1 and 2. You can combine the viewer's subjective relationship to the television screen with the electronic potentials of the medium to direct the audience's attention purposefully. Direct the audience to the impact of the critical events in the character's life and to even the character's smallest, subjective experience. Bring the audience close to the innermost feelings and thoughts of the character. The medium's intimate nature makes this possible.

Even though we are many years past the restrictions of live television—including, compared with today, the limited equipment that marked the early so-called Golden Age of television drama—we still have the relatively small screen, the audience members watching

individually or in small groups in their own homes, and the limited hour or half-hour time for most plays. The writer works with about 21 minutes of script for the half-hour show, and about 42 minutes for the hour show.

The best television plays still are those that take advantage of the restrictions, rather than being hampered by them. From good sitcoms such as *Friends* or *Seinfeld* to good dramatic series such as *The West Wing* or *Law & Order,* to an animated adult series such as *The Simpsons,* the concentration is on an intimate, probing, searching, slice-of-life presentation of one or more principal characters.

With the moving camera (or zoom lens), television can capture close-up significant details about a character or an action. And, with the exception of a relatively few shows that are recorded in front of live audiences using live-type studio taping techniques, filming allows the writer to incorporate any number of scenes, indoors and outdoors, with many more characters than can be accommodated in a studio-produced show. Electronic and mechanical techniques, such as the zoom, matte, dissolve, and others, provide excellent fluidity in space and time.

Radio is even more fluid and has rightly been called the "theatre of the imagination." The only limitations in radio are those of the human imagination. There are no restrictions on place, setting, number of characters, kinds of actions, or movement of time. The radio writer can take the audience anywhere and have the characters do anything. Radio can create mental images of infinite variety.

Although plays have almost completely disappeared from radio, writing the radio drama is good training for the person who may one day be writing commercials or other **continuity** for the audio medium.

The classic components of play structure include (1) unity, (2) plot, (3) character, (4) dialogue, (5) exposition, (6) preparation, and (7) setting. The basic principles of each apply to all plays, regardless of the medium for which they are written. The special characteristics that apply to video and audio are noted under each of these principles.

Unity

All elements in a play should relate in a thorough and consistent fashion to all the other elements, all moving toward realizing the playwright's purpose. This is the unity of action or impression. No single extraneous element should detract from the unified total impression the audience receives.

Television

The unities of time and place are completely loose and fluid in television (and film). Television can present many settings of any kind in minutes and even seconds. Television has been able to achieve what playwright August Strindberg, in his "Author's Note" to *A Dream Play,* hoped for in the theatre: a situation where "anything may happen: everything is possible and probable." Strindberg advocated plays where "time and space do not exist," where

"imagination spins and weaves new patterns: a mixture of memories, experience, unfettered fancies, absurdities, and improvisations." Some writers, producers, and directors in commercial television have begun to see the medium as more than a marketplace and are incorporating video art into their dramatic productions.

The unity of action or impression, however, is as vital to the television play as to the most traditional of stage plays, and the television writer should be certain that this important unity is present. Each sequence must be integrated thoroughly with every other sequence, all contributing to the total effect the play is designed to create.

Radio

Radio has no unities of time and place. Radio can take us 20,000 years into the future and transport us 20,000 years into the past. Radio can take a character—and us along with the character—to the North Pole, the moon, a battlefield in a jungle, or the depths of Hades, creating without restriction the settings for our imaginations. Unlike television and the film, radio is not limited by what we can see or believe visually.

No matter how loose the unities of time and place, however, radio, like television, must have a unity of action. The script must maintain a consistency and wholeness of purpose and development.

Plot

The play's plot structure is based on a complication arising from the individual's or group's relationship to some other force. This is the conflict, the point when the two or more forces come into opposition. The conflict must be presented as soon as possible in the play, for the rest of the play structure follows and is built upon this element. Next come a series of complications or **crises,** each one creating further difficulty relating to the major conflict, and each building in a rising crescendo so that the entire play moves toward a final crisis or climax. The climax occurs at the instant the conflicting forces meet head on and a change occurs to or in at least one of them. This is the turning point. One force wins and the other loses. The play can end at this moment. There can, however, be a final clarification of what happens, as a result of the climax, to the characters or forces involved. This remaining plot structure is called the *resolution.*

The elementary plot structure of the play can be diagrammed as follows:

Television

The plot of the television play follows the structure in the diagram. For the one-time television play a half-hour or an hour in length, the time restrictions require a tight plot line and a condensation of movement from sequence to sequence. In brief minutes we must present what life might have played out in hours, days, or years. Real life is unemphatic, whereas drama must be emphatic. The short time allowed for most television plays requires that the plot contain only the essence of the characters' experiences—the heightened extremes of life. Aim for the short, terse scene.

In a continuing series, the plot is deliberately stretched out. Although in each episode some climax(es) must occur to avoid frustrating the audience, the final climax of the continuing basic conflict of some characters may never come—the episode merely moves with new complications from week to week.

How do you effectively condense real life to drama? Consider some approaches presented by George Pierce Baker in his noted book on playwriting, *Dramatic Technique*. First, the dramatist can "bring together at one place what really happened at the same time, but to other people in another place." Second, events happening to a person in the same setting, but at different times can be brought together. Third, events that have "happened to two people in the same place, but at different times may . . . be made to happen to one person." Finally, "what happened to another person at another time, and at another place may at times be arranged so that it will happen to any desired figure." Baker concluded, "The essential point in all this compacting is: when cumbered with more scenes than you wish to use, determine first which scenes contain indispensable action, and must be kept as settings; then consider which of the other scenes may by ingenuity be combined with them."

Unless you are writing a two-hour or longer special, the program time length requires that the conflict come as soon as possible. Although the stage play can take almost a full act to present background through exposition, the television play may even open with the conflict. A major reason for this, aside from the time limitation, is the need to get and hold the audience's attention. Unlike theatre and film audiences, which have paid a fee and feel a compunction to stay, television audience members who are not caught by the play in the opening seconds can press a remote button to take them instantly to another channel.

The point of attack—conflict—in the television play should come quickly and bring with it the first important moment of pressure. That requires bringing in the background, or exposition, even as the conflict is being presented. Through the character's dialogue and actions, you have to tell who they are, show where they are, place the time of the story, and reveal what actions or events have led up to the conflict.

Because of the time and space restrictions (the small viewing screen), a conflict between individuals, or between an individual and himself or herself, usually is more effective than are conflicts between groups or any large bodies or forces.

Don't forget the complications. Although the time length of a single episode limits the number of complications, you must have enough to validate and build the actions of

the major characters. You can't just have the characters do something to move the plot along. All their actions have to be done because they are responding to a complication that causes them to behave in such a way that is consistent with the kinds of people they are. Each complication moves the characters and the action closer to a climax.

The time limitation often forces television to dispense with the resolution entirely, unless some doubt remains about some moral principle involved. Sometimes the resolution can be incorporated as part of the climax. On some shows the play ends with the climax, is followed by a final commercial, and then returns to the playscript for a brief resolution or epilogue.

Radio

The radio play follows the same plot structure as the television play—exposition, a conflict, complications, a climax, and if necessary, a resolution. A rising action must create suspense and hold the audience. Because the conflict can come at the very beginning of the play, exposition is revealed as the action is progressing. A major difference from the television plot line is that the radio writer must concentrate on one or two simple plot lines or conflicts, avoiding too many subplots. This is because the radio audience cannot see and differentiate among characters as easily as in the visual medium.

Character

Character, plot, and dialogue are the three primary ingredients of a play. All must be completely and consistently integrated. Character is the prime mover of the action and determines plot and dialogue. Too frequently the beginning writer or the writer who takes the easy way out tries to conform the characters to a plot structure. Most of the time it doesn't work; the characters appear artificial and sometimes even confusing to the audience.

Not only do the qualities of the characters determine the action, but also character is revealed through the action. This is done not through what is said about a character, but through what a character himself or herself says or does in the play in coping with the conflict and responding to the complications.

Character is delineated most effectively by what the person does at moments of crises. This includes inner or psychological action, as well as physical action. A character must be consistent throughout the play in everything said and done and must be plausible. This does not mean that the characters are copies of real-life persons; they must be dramatically heightened interpretations of reality.

Television

The television writer knows that time restrictions do not allow a character in the play to be the same person you see in life. The playwright cannot validate a character's actions by saying, "But that's what he (or she) did in real life!" Constantly emphasize "heightened life"

and "moments of crisis" in creating your characters. Concentrate on the actions that strikingly reveal the individual character. Concentrate on the few characters whose actions strikingly reveal the purpose of the play. Don't use unneeded people. A character who does not contribute to the main conflict and the unified plot line does not belong in the play. If a character is essential, by all means include him or her. But, if there are too many essential characters, rethink the entire approach to the play. This principle does not apply, of course, to the continuing series, where the continuity of characters over many weeks or months permits longer time for exposition, a slow-moving plot line, and many featured characters.

Television's mechanical and electronic devices permit a physical closeness and empathy between the characters and the audience, facilitating the presentation in depth of the intimate, inner beings of the characters. The television writer, through the director, can direct the audience's attention to details that project the characters' most personal feelings, conveying details about the characters that otherwise might have to be explained verbally.

The continuing television series, whether hour dramas or half-hour sitcoms, begins with clearly conceived characters in defined ongoing conflicts. With the characters, dialogue, and basic plot structure in place, and developed over time, each week's episode becomes essentially the presentation of a further complication, showing how a character reacts to and copes with it. The climax in each episode relates to that complication, and the basic conflict continues into the following week. What we have, then, is a concentration by the writer each week on a new plot element, not on new characters (except for those who are introduced relative to the specific complication or, sometimes, as part of the overall continuing plot).

The good writer does not forget that the relationships among the characters are paramount: byplay between character and plot, with character determining incident and vice versa. Think about any critically acclaimed television drama series you have watched. The characters rather than the plot principally drive the play. Concentrate on weaving a subjective, intimate portrayal, while applying the basic dramaturgical rules for television, and your characters will emerge as the motivating force in your video play.

Radio

The lack of visual perception in radio might be expected to change the revelation of character from what he or she says and does—as in television—to solely what is said. This is not so. Character in any medium is revealed through what the character does. The difference between radio and television is that in radio what the character does is not shown visually, but is presented through sound and dialogue.

Otherwise the same principles apply: The characters must be consistent with themselves, motivate the plot, be heightened from real life, and interact with each other. Because of the lack of visual identification, however, too many voices can become confusing to the radio audience, and the number of roles in the play and in any one scene should be limited.

Dialogue

Because the play does not duplicate real people or real life, as the documentary does, but heightens and condenses them, the dialogue also has to be heightened and condensed rather than duplicated. Real-life dialogue is sometimes colorful and dramatic, but mostly is slow, plodding, and uninspiring. Just as you can't legitimately say, "Oh, but that's what the character did in real life," you can't say, "Oh, but that's what the character *said* in real life." If you do, you've written a documentary script—or a bad play.

The dialogue must conform to the character's personality, be consistent with the character throughout the entire play, forward the plot line, and reveal the character. If you have several characters in the play, each will speak differently, depending on their personalities and backgrounds. If you find you can interchange dialogue among characters, you're in trouble.

Television

Television can substitute visual action for dialogue in forwarding the situation and providing exposition. Establishing shots and closeups eliminates time-consuming dialogue in which the character describes places or things or even feelings. Remember the anecdote in Chapter 1 about the film producer cutting the Broadway playwright's first act screen treatment of 30 minutes of dialogue to 1 minute of visual action? Concentrate on action and reaction, keeping the dialogue to a minimum and the picture the primary object of attention. But be careful not to go too far. Close-ups can become awkward and melodramatic if used too much.

Television dialogue should be written so that the purpose of every exchange of speeches is clear to the audience and carries the plot forward. It is difficult to work exposition into the heightened and condensed dialogue of a show's beginning, when the conflict is grabbing the audience's attention, but you must present the necessary background even while presenting the continuing action. Take a cue from the most successful dramatic programs: keep the dialogue terse and avoid repetition.

Radio

Even more than in television or on the screen, dialogue in radio serves to forward the situation, reveal character, uncover the plot line, and convey the setting and action to the audience. Everything on radio is conveyed through dialogue, sound effects, music, or silence. Because you can't show things visually, dialogue (and sound and music) must clearly introduce the characters, tell who they are, describe them, tell something about them, and even describe where they are and their actions. But it must not be done in an obvious manner. For example, it would be trite to have a character say, "Now, if you'll excuse me, I'll push back this mahogany windsor chair I'm sitting in, take my tan cashmere overcoat hanging on the brass clothes tree right inside your front door, and go." Or, "Now that we're here in my sixth-floor bachelor apartment with the etchings on the wall,

the stereo speakers in the corners by the windows, and the waterbed on the red plush carpet in the center of the room . . ." All that should come out naturally in the dialogue between the characters involved.

Exposition

Exposition reveals the background of the characters and the situation and clarifies the present circumstances. It must not be done obviously or come through some arbitrary device, such as a telephone conversation, a servant, or the next-door neighbor. It must come out as the play unfolds and be a natural and logical part of the action. Exposition must be presented as early as possible, to make the characters, plot, and conflict understandable to the audience.

Television

The short time allotted to the one-time television play permits only a minimum of exposition. The need to get right into the conflict requires the exposition to be highly condensed and presented as soon as possible. In the continuing television series, where most of the audience already know the characters, plot, and setting, the only exposition usually necessary is for the complications that forward the plot line in that particular episode.

Radio

Exposition is difficult in radio because it must be presented solely through dialogue and sound. Because the audience can't see the characters or the setting, the writer must present the exposition clarifying those elements as early as possible. There is a tendency in radio writing to give exposition through verbal description; as in any good play, however, it should be presented through the action. To solve the problem, radio sometimes employs a technique rarely used in other media: the narrator. The narrator can be part of the action (for example, a character talking to the audience about what's happening), or be divorced entirely from the drama.

Preparation

Preparation, or foreshadowing, is the unobtrusive planting, through action and dialogue, of material that prepares the audience for subsequent events, making their occurrence seem logical and not arbitrary. Proper preparation validates the actions of the characters. How many times have you watched the end of a play and said, "Oh, that character wouldn't have done that," or "That's too pat an ending"? Always keep in mind that when you have a character take an action that precipitates the climax or resolves the play, that action should develop from the kind of person the character is and should be something that the character *had* to do. It should not be something that you had the character do to complete your

plot line. The audience members should never be able to say, "Oh, how surprising!" but should always say, even if they didn't expect it, "Why, of course!"

Television

The writer should prepare the audience in a subtle and gradual manner for the subsequent actions of the characters and events of the play. Nothing should come as a complete surprise. The audience should be able to look back, after some action has taken place, and know that the action was inevitable because of the personality of the character who performed the action, or because all of the circumstances leading to the event made it unavoidable. The short time for the video drama means you must condense the clues of preparation and integrate them early in the script.

Radio

Because the radio writer cannot present the preparation visually, with all its subtle nuances (for example, a close-up showing a character carrying a knife, when otherwise the character seems to be a nonviolent, peaceful person), you must be certain that just because you know what the character's motivations are you do not fail to let the audience know. If anything, radio requires an overabundance of preparation.

Setting

Setting is determined by the play's form and by the character's physical environment. The setting reflects the type of play: realistic, farce, fantasy. As well as presenting locale, background, and environment, the setting serves the psychological and aesthetic purposes of the play and the author, creating an overall mood for the audience and the performers. All settings are designed to show the actions of the characters most effectively and must be integrated with the play's forward movement.

Television

Television drama essentially conforms to the play of selective realism, in both content and purpose, and realistic settings usually are required. The medium's electronic and mechanical advantages make it possible, however, to create any kind of setting at any time, from the fantasy set of a dream sequence or flashback to the nonrealistic setting of science fiction. Music videos have influenced the aesthetics of setting and direction in commercials and even in dramas. Although a continuous-action show taped in a studio limits the size and number of settings, pre-taped materials and out-of-studio scenes edited into the live-type production open up the settings considerably.

Radio

Radio settings are limited by the need to present them through dialogue and sound, but otherwise the presentation is limited only by the imaginations of the writer and audience. You can put the audience into any setting you wish, far beyond that available to the video

writer, even with the most sophisticated special visual effects. Although you are not likely to write a play in commercial radio, you may create settings for radio commercials and features.

Movement from setting to setting can be accomplished through silence, fading, narration, a music bridge, or sound effects. Note in Chapter 2 the example of the audience being with the character in a car about to go over a cliff, and the writer's option of keeping the audience at the cliff top watching the car fall into the chasm or going down with the driver.

Don't skimp on sound. The sound effects accompanying the character's actions clarify the setting. Exits and entrances of characters must be made clear through sound. Music establishes the mood and atmosphere of a setting. Sound and music provide transitions of time and place.

DEVELOPING THE SCRIPT

Now you know the principles of good playwriting! That doesn't guarantee that you can write a good play. You need inspiration and talent as well. Suppose you have them. You're still not ready to write the play. First comes the *scenario* or, as it is also called, the *treatment, outline,* or *summary.* Except for the occasional acceptance of a completed script from a known and experienced writer, a television story editor first wants to see a treatment.

The Treatment, Scenario, or Outline

The definitions for scenario, treatment, summary, and outline vary. Sometimes the terms are used interchangeably. Sometimes, as in this book, summary and outline refer to a short, preliminary overview of the proposed script, perhaps only a few pages in length, and scenario and treatment refer to a longer presentation, ranging from a fifth to a third or more of the length of the projected final script. The Writers Guild of America, East, advises, in its booklet *Professional Writer's Teleplay/Screenplay Format,* "nearly every teleplay/screenplay begins with an outline which in more detailed form is called a treatment. It is a scene-by-scene narrative description of your story, including word-sketches of your principal characters. A treatment might also include a few key camera shots and a sprinkling of dialogue." The Guild suggests the following length guidelines for outlines/treatments: 10–15 pages for a half-hour teleplay, 15–25 pages for one hour, 25–40 pages for 90 minutes, and 40–60 pages for the two-hour play.

The treatment/scenario or summary/outline gives the story editor and the producer a narrative idea of what the play is about. It tells them whether the proposed script fits the needs of their particular program. It's a waste of the writer's time to prepare a full script if the play, no matter how good, does not conform to the formula of the specific show.

Some producers/story editors want to see a short outline or summary first, to determine if the overall idea is on the right track. If they like the summary, they then ask for and evaluate the scenario or treatment. And, finally, if the treatment is approved, they will ask for a complete script.

The outline/treatment helps the prospective buyer and can be immeasurable help to the writer as well. It can tell you whether or not you've got a good play. Careful development and analysis of the treatment can help you eliminate weak points and strengthen good ones. The treatment provides a continuing series of checkpoints in the construction of your play, which can save you exhausting work and valuable time by catching problems before they are written into the script. This avoids complete rewrites later to eliminate them.

Before you create the "public" treatment for submission, you should prepare a detailed working treatment designed to help you construct the play. Your working treatment should contain the play's purpose, theme, background, characters, basic plot line, and type of dialogue. You should include case histories for all of your characters. Prepare plot summaries for each projected scene in chronological order. Write down the elements of exposition and preparation. As you develop the plot sequences and think about the character's actions, insert important or representative lines of dialogue consistent with what a given character would say and the manner in which he or she would say it. Even in its simplest form, this kind of working treatment will help you clarify all the basic structural elements before you begin writing the play.

Although the working treatment can be as long as or longer than the final manuscript, the treatment prepared for submission is shorter because it concentrates on a narrative of the plot, character descriptions and actions, and sample dialogue. If you are writing visually you can insert those camera and effects directions that substitute for dialogue and that are necessary to convey exactly what you want the audience to see and feel.

In Chapter 3 you read a sample outline and a sample treatment, preceding the format examples for the Gladys-Reginald beach scene. The outline was only one paragraph in length and the treatment was two paragraphs because they referred to only one page of script. The Writers Guild sample formats in Chapter 3 are a bit longer and are represented in treatment form by the following beginning of an outline.

"The Lost Men"
An Outline for a 1-Hour Teleplay
by
Billy Bard

ACT ONE

The scene is a typical suburban railroad station. It is evening, and commuters are pouring out of the station into wife-chauffeured cars. Among them we see JACK DOBBS, a balding but powerfully built businessman of 40. His friend, FRED McALLISTER, offers him a lift, but Jack says he will wait for his wife. After several minutes of waiting, Jack decides to flag the station taxi instead.

Continued

A few minutes later, the taxi pulls up to a lovely colonial house. Jack pays the driver, and gets out. Then he looks very puzzled by what he sees. The grass on the lawn is overgrown, and an elderly white-haired WORKMAN is nailing wooden boards across the windows. Jack asks the Workman what is going on, but the Workman ignores him. Jack becomes angry. He demands an answer, pointing out that he lives here. The Workman replies that he must be mistaken; that no one has lived in this house for the past five years! On Jack's bewilderment and anxiety, we fade to black.

We are in the office of DR. HARRY WESTON, psychiatrist, who is listening to the tale of his patient, Jack Dobbs. Etc., etc.

From *Professional Writer's Teleplay/Screenplay Format*, written by Jerome Coopersmith.

Following the first working treatment—and as many subsequent ones as necessary to make your preparation as complete as possible—you'll arrive at the point where you feel ready and confident to flesh out the play. This is where the pleasure of accomplishment comes in, for most playwrights the most enjoyable part of writing. If you've planned well, the play will virtually write itself. If you find that some radical departures from the treatment are needed, then your preparation was not as good as it could or should have been. Go back to the treatment and shore it up, even if you have to start all over. Otherwise, you'll find that although you might complete most or all of the first draft of the play, you'll need many more extra drafts to repair all the holes, in the long run requiring much more time and effort than you would have needed with proper preparation.

Play Analysis

The Filmed Play

The filmed play sometimes is more the director's creation than the writer's, compared with the continuous-action taped play. Editing plays a larger role in the single-camera film shoot than in the multi-camera tape shoot, and in the former the director can virtually rewrite the play in the editing room.

Screenwriter William Goldman, in a dialogue with Mal Karman in *Filmmaker's Newsletter*, described screenwriting as a craft. "It's carpentry. I don't mean that denigratingly. Except in the case of Ingmar Bergman, it's not an art." He added that "a screenwriter's most important contribution to film is not dialogue, but structure . . . you try to find something cogent that will make it play as a story; that will take us from A to Z." As a novelist, Goldman found the screenplay form "short, the cameras insist that you hurry, you have little time for detail . . . it's a craft of pacing and structure."

The filmed play has a break at each cut or transition. A sequence lasts just as long as it remains on the one camera shooting, unlike taped television where transitions are done in continuing fashion through control board techniques. Between film sequences the director can change sets, costumes, makeup, reset lights and camera, and even reorient the performers.

In addition, the filmed play is not shot in chronological order. All the sequences taking place on a particular set or location are shot during the same period of time, no matter where they appear chronologically in the script. It is difficult to achieve clear continuity of performance, mood, or rhythm. Editing, therefore, is most critical in pulling together seemingly unrelated sequences and even individual shots into a smooth whole.

The style of production, echoing William Goldman's comment on pacing and structure, does not, however, preclude developing characters in depth using consistent, meaningful dialogue.

Screenwriter and Emerson College professor Jean Stawarz tells how to write the made-for-television movie as differentiated from the theatrical film:

> It would be too simplistic to state that storytelling is storytelling, no matter what form is used to tell the story. Movies that are made for television versus films that are made for a theatrical release are vastly different. Both are accepted forms of storytelling; both adhere to the chosen genre and follow it; both have plot, characters, dialogue, and denouement. They are stories told in acts with beginnings, middles, and ends. But yet there are significant differences between the theatrical feature film and the made-for-television movie that any writer who wishes to write long form scripts must consider.

Budget Considerations

In the world of television movies, decisions are more likely to be financial than artistic. This is not to say that made-for-television movies lack artistry, but more to suggest that the primary motivation for decision making in television movies is budget.

Made-for-television movies are usually produced on a budget that, when compared to the average Hollywood feature film, is scaled down. Today, budgets for mainstream cinema are rarely under ten million dollars, while a television movie budget might come closer to resembling that of a low budget, independently made feature film (well under five million). This decrease in budget imposes restrictions on the made-for-television movie. Movies made for television tend to keep the locations simple, have minimal special effects, and plots that are less complex. A television movie often only employs just one subplot whereas a feature film can have many subplots.

Structure

When a writer sits down to create a screenplay for a feature, her or his structural options regarding the number of acts and the flow of the narrative are limited only by imagination. Film screenwriters have no obligation to tell a story in three acts, or to use a linear structure. But the structure of a television movie script differs from that of a theatrical film script largely due to the insertion of commercial breaks into the story. Made-for-television movies might go so far as to utilize devices such as flashbacks or flash forwards, but typically a made-for-television movie has seven acts and follows a linear narrative.

The reason for this has to do with the insertion of commercial breaks into the movie. Because many commercial breaks disrupt the narrative flow, the writer needs to be concerned with act breaks that will keep the audience engaged enough to continue watching after a three- to five-minute commercial break.

As in a feature film, the made-for-television movie structures each act so that there is a mini plot point, a turning point, or a moment where the tension or conflict escalates at the end of the act. However, in feature screenplays this device is used to create rising action, but in television scripts it is used essentially to keep the audience watching.

Commercials also determine the length of each TV movie act that decreases as the story progresses. The first act is the longest, and each subsequent act becomes progressively shorter. In addition, the first act break almost never comes on the hour or the half-hour. The rationale for this is twofold. First, there is the need to "hook" the viewer with a long first act. Once viewers are engaged with the film, they will be less likely to turn it off or switch channels during the commercials. Second, by avoiding placement of the act breaks on the hour or half hour, the viewer will be less likely to flip through channels throughout the commercial breaks and come upon another program or show that looks more interesting.

Length

A feature film typically runs anywhere from 90–120 pages. And as a general rule of thumb, one page of a properly formatted feature film screenplay equals one minute of screen time. Hence, a 120-page feature would equal approximately 120 minutes, or two hours.

The time allotted for made-for-television movies is also 120 minutes; however, the average television movie only runs about 95 minutes. The other 25 minutes are filled with commercials and network promos. If a writer were to submit a script for a television movie, it would be expected that the script would run about 95 pages.

Content

Another consideration for writing long form scripts is content. Language, nudity, and violence have far greater restrictions for television than they do for feature films. The content of a theatrical film can go as far as the studios and distributors wish to take it, depending on what rating they desire for the film's release. However, theatrical feature films that hope to one day be aired on network television must endure nudity, sexual content, and violence being edited for a television audience. But with language, which is more difficult to edit, feature film directors are careful to shoot television versions, asking actors to replace unacceptable expletives for words or phrases that are acceptable for TV.

Having recently aired on network prime time, the film *Thelma and Louise* replaced the theatrical film version of the line, "I shoulda gone ahead and **fucked** her . . ." with the acceptable television version, "I shoulda gone ahead and **touched** her . . ." The television line had a vastly different meaning and was unlikely to be something that the character would have said considering that he had just attempted rape. However, that change in dialogue, along with some judicious editing, allowed the network to air that particular scene.

While standards for television content have changed, and will most likely continue to change, aspiring television movie writers should be aware of what is considered to be acceptable content for a television audience.

Format

Screenplays are written in their own unique format. Today software programs such as Final Draft or Screenwriter 2000 help make the writer's job easier by providing standard screenplay format.

While the difference between writing a script for a television situation comedy differs from the format for a theatrical feature script, the television movie does not have its own unique format. Writers can use the same format for feature films that they would use for a made-for-television movie. All the elements of the screenplay form—scene headings, character names, parentheticals, dialogue, shots, and transitions are all placed in the same location on the page. The only difference that the writer needs to consider is that scripts for television movies tend to label the beginning and the end of each act, with a page break at the end of each act. Feature films do not call out act breaks on the page, but instead allow the story to flow scene by scene from beginning to end.

Getting Started

The best advice for writers wishing to write made-for-television movies would be to watch these movies and to learn understand the differences between plot and structure for television movies and theatrical features.

While writers should always be encouraged to write stories that come from the heart and for which they feel passion, there is a common thread that runs through the television movies that are made today. The days when movies made for television were dubbed "disease of the week" may be gone, but television movies still tend to focus on social issues.

While there are visible differences between writing a made-for-television movie and a theatrical feature film script, in the end what producers ultimately want is a well-written and compelling story.

Professor Stawarz offers examples of the theatrical film script and the made-for-TV film script. The first is an excerpt from the shooting draft for "The Powwow Highway," written by Stawarz and Janet Haney, produced by Handmade Films and released by Warner Brothers.

Note how the descriptions of the settings and characters combine with the dialogue to create atmosphere and introduce attitudes.

POWWOW HIGHWAY

EXT. VILLAGE—DUSK

ON SCREEN TITLE: NORTHERN CHEYENNE RESERVATION—LAME DEER, MONTANA

The Montana sky is glutted with grey winter clouds. Rundown buildings line the dirt streets of Lame Deer.

Continued

EXT. JIMTOWN BAR—DUSK

Muted laughter and country music waft from a rusty Quonset hut. A faded sign: JIMTOWN.

INT. JIMTOWN BAR—DUSK

Indians crowd the lively hangout, gossiping and trading bawdy jokes. A Skin in a cowboy hat plucks a six string and sings country tunes. Just a pool table, but it's the social backbone of the rez.

INT. AT THE POOL TABLE—NIGHT

An eager crowd is mesmerized by a handsome Cheyenne who dominates the match. Chalking his cue, BUDDY RED BIRD leans across the table. He's lanky and strong, with an intense face.

Buddy SHOOTS, sinking the ball with startling force. BUFFALO HORNS, a pimply rube, pipes up.

> BUFFALO HORNS
> Who's head just rolled down that pocket, Buddy?

> BUDDY
> (grins)
> Looked a lot like Sandy Youngblood to me.

He takes aim and the eight ball ricochets off the side, spinning into the far pocket.

> BUDDY
> And that's the man in the White House.

Buddy's opponent, LOUIE SHORT HAIR, is an energetic hothead with the battle scars to prove it.

> LOUIE SHORT HAIR
> (irked)
> Hey, Red Bird, am I gonna get a shot off, or what?

WHAM! Down goes the six ball.

> BUDDY
> That was the coal mine at Big Mountain.

He angles on the two.

> BUDDY
> …Here's the Swinomish pipeline—

The two clacks into the four. Both vanish.

> BUDDY
> And that fuckin' monstrosity out on Route 314!

A stunning bank shot CLEARS the table. Buddy sets down his cue to a round of CHEERS.

Continued

OLD LADY
Teach ya ta play like that in college, Buddy Red Bird?

LOUIE SHORT HAIR
Let's go, smartass. I'll whip your butt this time.

Louis puts the cue stick in Buddy's hand, but he gives it back.

BUDDY
Naw, I gotta go.

He heads out, to a chorus of protests. As Buddy reaches for the knob, the door CRASHES open.

ANGLE ON DOOR

Two hundred and fifty pounds of flab fill the doorway. Buddy has to struggle to squeeze by. The crowd howls with laughter.

A mammoth Cheyenne bumbles in, six foot four, with a long, greasy braid dangling, PHILBERT BONO would be terrifying, if he didn't have the face of an angel.

VOICES
Hey, fat Philbert!! Speaking'a Big Mountain—

Philbert lumbers toward the bar, ignoring the wisecracks. Someone tosses a lariat around his massive waist. He shimmies out of it, spilling drinks on the surrounding tables. The JEERING escalates.

Philbert commandeers two stools. MANNY sets him up with three cold beers. The fat man goes right down the line, draining them. Manny keeps it coming: chips, pretzels, beef jerky. Three more cold drafts.

MANNY
Okay, Phil?

Mouth fill, Philbert nods. Unwrapping a linty roll of quarters, he settles in front of the droning television.

INSERT—TV COMMERCIAL

A CAL WORTHINGTON-TYPE launches into his spiel. Ridiculous in a polyester suit and Indian headdress, the salesman sits atop a blue Pinto.

SALESMAN (V.O.)
(obnoxious)
How folks! Come down off the ranch or the rez and pick your pony! We got pintos, we got mustangs, we got Broncos, hot to trot and ready to roll. No money down, easy credit, ride one away today.

BACK TO SCENE

Manny picks up the change on the bar.

Continued

> MANNY
>
> You borrowin' Louie's pick-up for the powwow?

Philbert chews, transfixed by the salesman's babble.

> MANNY
>
> You got a ride? Philbert?

The annoying car lot jingle simpers in the background.

> CUSTOMER (O.S.)
>
> Hey Manny! Where's them onion rings?

Manny moves off.

INSERT—TV COMMERCIAL

The giddy Salesman spurs the Pinto. It rolls forward through the car lot.

BEGIN PHILBERT'S VISION #1

A brave riding a spirited paint among a herd of wild horses.

CUT TO:

EXT. DESERT HIGHWAY—DAY

ON SCREEN TITLE: SANTA FE, NEW MEXICO

A yellow Volvo skims past the sage and cactus.

INT. VOLVO—DAY

The driver's window is down, and her long hair whips in the breeze, a glistening banner. BONNIE RED BIRD has the classic fine features of the Cheyenne.

Bonnie's children have inherited her looks: SKY, eight years old, sitting beside her, and seven year old, JANE, reading MAD magazine in the back seat.

There's a carefree feeling about this early morning ride. None of the Red Birds notice a POLICE CRUISER waiting in the brush.

INT. CRUISER—DAY

The OFFICER behind the wheel starts his engine.

> COP 1
>
> That's her. Let's go.

INT. VOLVO—DAY

Bonnie sees the flashing blue light in her rear view mirror.

Continued

> BONNIE
> (startled)
> I'm not speeding!
>
> JANE
> You still gotta stop.
>
> Bonnie turns onto the shoulder. The police car follows.
>
> SKY
> What did we do, Mom?
>
> <div align="right">Reprinted by permission.</div>

The following is from the TV screenplay for a CBC/BBC/PBS movie entitled "Napi's Rope," written by Jean Stawarz and aired under the title "Spirit Rider." Although the excerpt is too short to analyze content, it is a good example of script form and transitions.

ACT TWO

INT. CABIN—NIGHT

Setting his things down, Jesse sneaks a look around. Not much in the way of furniture, but the place is clean and organized.

In one corner is a bed with a faded quilt. On the opposite wall, a rusty army cot is freshly made up with new sheets and a blanket. Offering the only privacy, a sheet hangs on a string between the beds.

> NINA
> I just need your signature here …

The old man stares at the papers spread out on the table, then slowly slides a drawer in the table open. He takes out a pen and signs his name with a flourish.

He carefully recaps the pen and puts it away.

> NINA (CONT'D)
> Well, then I guess that's it. Unless you have questions …
>
> JOE
> No.

Shuffling to the stove, he inspects the contents of a boiling pot.

Nina snaps her brief case shut.

Continued

> NINA
>
> Here's my card. you can call if—

She glances at Jesse.

> NINA
>
> If anything comes up.

The old man nods. Laying her business card on the table, Nina heads for the door.

Jesse follows her outside.

EXT. CABIN—NIGHT

An old, three ton Fargo is parked next to the Ford. Thick dew covers both vehicles. Jesse shivers involuntarily.

> JESSE
>
> Hey, uh …

Nina turns as she opens the car door.

> JESSE (CONT'D)
> (faltering)
> You taking off?

Every chink in his bravado facade shows.

> NINA
>
> Don't worry. It'll be fine.

Instantly, Jesse regrets his weakness.

> JESSE
> (snapping)
> Who said I was worried? He don't bother me.

Nina smiles.

> NINA
>
> Go easy on him, Jesse. He's an elder.

She gets in her car, starts the engine and drives off, leaving Jesse alone, shivering in the cold.

END OF ACT TWO

ACT THREE

INT. CABIN—NIGHT

Joe's eating supper when Jesse comes back in. There's an empty plate on the table. Nervous, Jesse pulls a chair up to it.

Reprinted by permission.

The Taped Play

Some shows are taped with continuous action in front of a live studio audience. The play is performed and recorded in the chronological order of the script. Through editing, sequences can be retaped or produced out of sequence in the field and inserted. A key for the writer in this kind of production is continuity: smooth and logical transitions from one sequence to the next.

One of the most successful television series of all time is *The Cosby Show,* which was taped before a live audience, usually in an hour and a half for each half-hour episode. The following is the first act (5 scenes) from a two-act, 15-scene episode, "Vanessa's Bad Grade." Included is a listing of characters and scenes, usually provided by the writer to the director in the final draft of the script.

Most sitcoms tend to be played for one-liners or visual gags, with considerable stress on either double-entendres or slapstick. *The Cosby Show* found its humor in the characters' personalities, reflecting the gentler nature of a family household, while using for its weekly complication(s) realistic situations that confront many families and with which many viewers identified.

As you read "Vanessa's Bad Grade," note how the writer first establishes the atmosphere of the household and the feelings and personalities of the characters in relation to each other. The exposition comes out of the situation: Those who might not have watched *The Cosby Show* previously quickly learn that Cliff and Clair have found little time to go out by themselves and, in discussing their plans, they reveal that Cliff is a physician. The humor comes out of the situation: Cliff has little opportunity to go to a movie because he may be called upon to deliver a baby at any time. In determining whether Friday night is a possibility, he reads the weather forecast—"Friday's forecast: clear and warmer. No babies." It is not a gag that the writer has thrown in. It is what Cliff would logically say, given his personality.

The conflict, Vanessa wanting a new sweater, is presented immediately. Certainly not an earth-shaking conflict, but one that is common to the homes of many viewers. Will she get the sweater? Most important, given the background of the characters, what conflicts will her efforts to get the sweater engender between Vanessa and her parents? Scene 3, between Cliff and Theo, and later with the Huxtable children, is humorous, developing out of what the characters would naturally do and say. Scene 4, in addition, pushes along the plot line, emphasizing Vanessa's continuing attempts to get the sweater. In scene 5, the conflict is heightened—it is the rising action in the play structure chart presented earlier in this chapter. Vanessa's bad grade, which she received after ostensibly studying with her boyfriend, Robert—she wanted the sweater, to look nice when she went to the dance with him—complicates the situation.

The remainder of the play, not presented here because of space limitations, provides several positive guidelines for family and friends interrelationships: the impropriety of taking clothes without permission, the difference between serious studying and just socializing, and the need for everyone to take personal responsibilities seriously (Cliff

and Clair say they'd like to play more, too, but have to work: "we have bills to pay and allowances to give out").

An overview shows the plot to be rather modest. But when combined with the depth of the characters who have been developed over a period of time, the excellent use of humor stemming from their interpersonal relationships, and a situation with which a substantial part of the audience—adults and children—can identify, we have an excellent script meeting the formula for the sitcom.

THE COSBY SHOW
"Vanessa's Bad Grade"
SHOW #0212-13

CAST

Cliff Huxtable . Bill Cosby
Clair Huxtable . Phylicia Ayers-Allen
Denise Huxtable . Lisa Bonet
Theo Huxtable . Malcolm-Jamal Warner
Vanessa Huxtable . Tempestt Bledsoe
Rudy Huxtable . Keshia Knight Pulliam
Robert . Dondre Whitfield
Announcer (V.O.) . TBA

SET

ACT ONE	PAGE
Scene 1: INT. KITCHEN—MORNING (DAY 1)	(1)
Scene 2: INT. LIVING ROOM—THAT AFTERNOON (DAY 1)	(7)
Scene 3: INT. KITCHEN—CONTINUOUS ACTION (DAY 1)	(9)
Scene 4: INT. LIVING ROOM—TWO DAYS LATER—AFTERNOON (DAY 2)	(15)
Scene 5: INT. RUDY & VANESSA'S ROOM—CONTINUOUS ACTION (DAY 2)	(19)

ACT TWO	
Scene 1: INT. RUDY & VANESSA'S ROOM/HALLWAY—THAT NIGHT (DAY 2)	(21)
Scene 2: INT. LIVING ROOM—LATER THAT NIGHT (DAY 2)	(23)
Scene 3: INT. HALLWAY/RUDY & VANESSA'S ROOM—CONTINUOUS ACTION (DAY 2)	(26)
Scene 4: INT. LIVING ROOM—CONTINUOUS ACTION (DAY 2)	(28)
Scene 5: INT. DENISE'S ROOM—CONTINUOUS ACTION (DAY 2)	(32)
Scene 6: INT. HALLWAY—CONTINUOUS ACTION (DAY 2)	(34)
Scene 7: INT. DENISE'S ROOM—CONTINUOUS ACTION (DAY 2)	(35)
Scene 8: INT. RUDY & VANESSA'S ROOM—CONTINUOUS ACTION (DAY 2)	(41)
Scene 9: INT. KITCHEN—CONTINUOUS ACTION (DAY 2)	(44)
Scene 10: INT. DENISE'S ROOM—A LITTLE LATER THAT NIGHT (DAY 2)	(50)

Continued

<center>ACT ONE
Scene 1</center>

FADE IN:

INT. KITCHEN—MORNING (DAY 1)
(Cliff, Clair, Denise, Vanessa, Rudy)

(RUDY SITS AT THE TABLE BLOWING BUBBLES IN HER GLASS OF MILK. CLAIR ENTERS)

<center>CLAIR</center>
Rudy, don't blow bubbles with your straw.

<center>RUDY</center>
Okay.

(RUDY SUCKS MILK INTO THE STRAW, PUTS IT IN HER BOWL)

<center>CLAIR</center>
Rudy, put the straw down and drink your milk.

(RUDY DRINKS THE MILK OUT OF THE BOWL)

<center>CLAIR (CONT'D)</center>
All right, that's enough. Breakfast is over. Go brush your teeth and get ready for school.

(CLIFF ENTERS)

<center>CLIFF</center>
Hey, Pud.

<center>RUDY</center>
Hi, Daddy. Don't play with the straw.

(RUDY EXITS)

<center>CLAIR</center>
How are you feeling?

<center>CLIFF</center>
Hmmm.

<center>CLAIR</center>
When did you get in?

<center>CLIFF</center>
Hmmm.

<center>CLAIR</center>
Poor baby. That's the third time this week.

<div align="right">Continued</div>

CLIFF

Clair, I would say that during my career, I've delivered about three thousand babies. Somehow, almost all of them decided to be born between two and five A.M. on the coldest winter nights of the year. There must be an all-weather radio station just for babies. When they hear, 'It's two A.M. Heavy snows and arctic winds,' they shoot for daylight.

CLAIR

Maybe we should forget about the movie tonight.

CLIFF

No, no. We're going.

CLAIR

You're too tired.

CLIFF

I'll be fine.

CLAIR

That's what you always say. Then as soon as the lights go out, so do you. Why don't we go Friday night?

(CLIFF PICKS UP THE NEWSPAPER)

CLIFF

Listen to this, Clair. 'Friday's forecast: clear and warmer.' No babies.

CLAIR

Then Friday it is.

(VANESSA ENTERS)

VANESSA

Mom?

CLAIR

Yes?

VANESSA

Can we go shopping? I need a new sweater.

CLAIR

Vanessa, you just got some new sweaters for Christmas.

VANESSA

I know, but Robert's seen me in all those.

CLIFF

You could wear them inside out.

Continued

VANESSA

But Robert's taking me to the school dance on Friday and I really want to wear a new sweater. I've even got one picked out.

CLAIR

Oh?

VANESSA

I want one exactly like the one Denise got.

CLAIR

Why don't you ask Denise if you can borrow hers?

VANESSA

Mom, she's not going to let me have her sweater.

CLAIR

She might. Why don't you tell her why you want it and ask her nicely? You may be surprised.

VANESSA

All right. I'll try. Denise …

(SHE EXITS)

CLIFF

You want to take any bets on this one?

CLAIR

It could happen. Denise has been in that position with Sondra, so she might be understanding.

CLIFF

Okay. A jumbo box of popcorn at the movie says Vanessa doesn't get the sweater.

CLAIR

I'll take that bet.

DENISE

Ha! Are you kidding? No way. You're not getting it.

(DENISE AND VANESSA ENTER)

VANESSA

But, Denise, I asked nicely.

DENISE

I don't care.

Continued

<div align="center">VANESSA</div>

But it's for the dance. Robert is taking me.

<div align="center">DENISE</div>

I haven't even worn that sweater yet. Bye, Dad.

<div align="center">VANESSA</div>

Why don't you wear it today, and then you've worn it. Bye, Dad.

(DENISE AND VANESSA EXIT)

<div align="center">DENISE</div>

No.

<div align="center">VANESSA</div>

But—

<div align="center">DENISE</div>

No.

<div align="center">CLIFF</div>

I like it buttered, no salt.

CUT TO:

<div align="right">WARDROBE CHANGE
(Cliff)</div>

<div align="center">ACT ONE
Scene 2</div>

INT. LIVING ROOM—THAT AFTERNOON (DAY 1)
(Cliff, Theo)

(CLIFF IS ASLEEP ON THE COUCH. THEO ENTERS, SLAMS THE DOOR, REALIZES CLIFF IS THERE, RECLOSES THE DOOR QUIETLY. AS HE PASSES CLIFF REACHES UP WITHOUT OPENING HIS EYES AND GRABS THEO)

<div align="center">CLIFF</div>

You slammed the door.

<div align="center">THEO</div>

Sorry, Dad. I didn't know you were sleeping. But you tell us all the time to make sure the door is closed.

<div align="center">CLIFF</div>

Sit down. Sometimes you slam the door so hard it sucks the air out of the house. That's why I always keep a window open, so the walls won't buckle.

<div align="center">THEO</div>

Got it, Dad. Sorry I woke you.

<div align="right">*Continued*</div>

 CLIFF
It's okay, Son. I've been trying to take a nap ever since Sondra was born.
It's been twenty years. By now I'm so tired that if I ever do take that nap, I
may never wake up.

 THEO
Dad, that's a sad story.

CUT TO:

 ACT ONE
 Scene 3

INT. KITCHEN—CONTINUOUS ACTION (DAY 1)
(Theo, Vanessa, Robert, Denise)

(VANESSA AND ROBERT ARE AT THE TABLE)

 VANESSA
I really love it when we study together.

 ROBERT
Me, too.

 VANESSA
I wish we had all our classes together.

 ROBERT
Me, too.

(THEO ENTERS)

 THEO
Hey, Robert.

 ROBERT
Hey, Theo.

(THEO STARTS RUMMAGING THROUGH THE REFRIGERATOR)

 VANESSA
Sshhh.

 THEO
What?

 VANESSA
Please keep it quiet. We're trying to study. We have a big history test
tomorrow.

 THEO
Okay. I was just looking for some juice.

Continued

(THEO EXITS)

> VANESSA
>
> Did you hear who's playing at the dance Friday?

> ROBERT
>
> No.

> VANESSA
>
> The Spikes.

> ROBERT
>
> Wow. They've got saxophones.

> VANESSA
>
> And did you hear who's in charge of decorations?

> ROBERT
>
> Who?

(THEO ENTERS)

> THEO
>
> What are you guys studying?

> VANESSA
>
> The War of 1912.

> ROBERT
>
> Vanessa, 1812.

> VANESSA
>
> Right.

> THEO
>
> Well, I don't want to bother you because I know a lot happened in that war. I'll be done in a minute.

(DENISE ENTERS FROM THE LIVING ROOM)

> DENISE
>
> Hi Robert, Vanessa.

(AS SHE CROSSES TO THE PHONE)

> DENISE (CONT'D)
>
> Everyone stay out of the living room. I just woke Dad up, and he's real cranky.

(SHE PICKS UP THE PHONE AND STARTS TO DIAL)

> VANESSA
>
> Excuse me. We're studying in here.

Continued

DENISE

I told Monica I'd call her.

VANESSA

Use the phone upstairs.

DENISE

Hey, I'm here.

VANESSA

But we're studying.

THEO

They're having a big test on the War of 1912.

DENISE

Vanessa, you can take a break for a minute so I can make one phone call.

VANESSA

We can't. We have to study.

DENISE

Come on, Vanessa.

VANESSA

Okay, I'll consider taking a break if you let me borrow that certain item of clothing I asked for earlier.

DENISE

I don't have to lend you something that belongs to me to use something that belongs to all of us.

SFX: PHONE RINGS
(THEO ANSWERS IT)

THEO

Huxtable residence. Hi, Janet. Just a second. Vanessa, should I tell her to call back?

VANESSA

No. Let's take a break.

ROBERT

Okay.

DENISE

Hey, wait a minute. You told me you couldn't take a break.

VANESSA

But it's for me.

Continued

> DENISE
> Theo, don't give her the phone.

> VANESSA
> Give me the phone.

> DENISE
> Theo.

> VANESSA
> Theo.

> THEO
> Hey, I'm out of this.

(THEO PLACES THE PHONE ON THE REFRIGERATOR
VANESSA SNATCHES IT)

> VANESSA
> Hi, Janet … She is? When did you find this out? … She must be doing this
> because she found out I was going to wear a red skirt …

> DENISE
> Thanks a lot, Theo.

(DENISE EXITS)

> THEO
> Do you have sisters, Robert?

> ROBERT
> No.

> THEO
> Go home tonight and thank your parents.

DISSOLVE TO:

> WARDROBE CHANGE
> (Vanessa)

ACT ONE
Scene 4

INT. LIVING ROOM—TWO DAYS LATER—AFTERNOON (DAY 2)
(Cliff, Rudy, Clair, Vanessa,
Announcer (V.O.))

(THE LIVING ROOM IS EMPTY. BOBO AND A COUPLE OF OTHER DOLLS ARE SITTING ON THE COUCH,
FACING THE TELEVISION)

Continued

SFX: AEROBICS EXERCISE SHOW WITH COOL MUSIC

(CLIFF ENTERS)

ANNOUNCER (V.O.)

This is the exercise class for the cool people. We are the people who believe you don't need pain to have gain. I'm going to tell you what you can do, but you do what you feel like doing. Just be cool about it. First, let's loosen up that neck. Take your head and just kind of roll it around. If you don't feel like it, that's cool.

(RUDY ENTERS)

RUDY

Hi, Daddy.

CLIFF

Whoa, Rudy, Aren't these your friends?

RUDY

They wanted to watch TV.

CLIFF

Are they trying to get in shape?

RUDY

Yes.

CLIFF

They don't look like they're really into it. Why don't you take them upstairs and read to them.

RUDY

Okay.

(CLIFF LOADS RUDY UP WITH THE DOLLS)

ANNOUNCER (V.O.)

Now, let's stretch out that lower back. Raise your arms. If you want to, raise them high above your head. If not, that's cool. Now bend over and touch your palms to your toes. That's all right. This time we're going to try it with your knees straight. Be cool about it. And remember, if you don't attack your heart, your heart won't attack you.

(CLIFF TURNS OFF THE TELEVISION)

(CLAIR ENTERS)

CLAIR

Hi, Cliff.

Continued

> CLIFF

Hi.

> CLAIR

How are you feeling?

> CLIFF

Great. I'm all ready for the movie tonight.

> CLAIR

Are you sure you're not too tired?

> CLIFF

No. I've gotten lots of sleep the last two days, and I just finished my exercises.

> CLAIR

Good. This is supposed to be a fabulous movie. Carla told me at work today that this film has won major awards throughout Europe.

> CLIFF

The thing that I'm really looking forward to about this movie, is the box of popcorn you owe me.

> CLAIR

Cliff, you'll get your popcorn.

> CLIFF

Not a regular now, Clair. A jumbo. Big. The giant tub. The size where you have to climb in with the popcorn and eat your way out.

> CLAIR

You'll get it.

(VANESSA ENTERS)

> VANESSA

Hi.

> CLAIR

Hi, Vanessa.

> VANESSA

When are we eating?

> CLIFF

I'm not. I'm saving room for popcorn.

> CLAIR

Vanessa, we're going to eat early.

Continued

> VANESSA
>
> Good. Because I want to have time to get ready for the dance tonight.

(VANESSA EXITS)

> CLIFF
>
> And by the way, I also want the jumbo size soda.

> CLAIR
>
> That wasn't part of the bet.

> CLIFF
>
> Well, buy me the soda and I'll let you climb into my tub of jumbo popcorn.

CUT TO:

ACT ONE
Scene 5

INT. RUDY & VANESSA'S ROOM—CONTINUOUS ACTION (DAY 2)
(Theo, Vanessa)

(VANESSA IS SEATED ON THE BED)

> THEO
>
> Hey, Vanessa.

> VANESSA
>
> Theo, can I talk to you for a moment?

(THEO ENTERS)

> THEO
>
> What's wrong?

> VANESSA
>
> I got my history test back.

(VANESSA HANDS HIM THE TEST PAPER)

> THEO
>
> Whoa, this is a 'D.'

> VANESSA
>
> I know. I've never gotten a 'D' before. I've seen them, but never next to my name.

> THEO
>
> And this one's in red. That's the worst kind to get.

Continued

VANESSA

I don't know how it happened. Robert and I studied for this.

THEO

Yeah, I saw that.

VANESSA

When do you think I should tell Mom and Dad?

THEO

The sooner the better.

VANESSA

But if I tell them now, they might not let me go to the dance with Robert.

THEO

Vanessa, there's a chance you may never dance again.

VANESSA

But how can they get mad? I've been getting 'A's' all along. This is just one little 'D.'

THEO

When it comes to Mom and Dad, there are no little 'D's.' Vanessa got a 'D.'

(THEO EXITS. ON VANESSA'S REACTION WE)

FADE OUT

END OF ACT ONE

From "Vanessa's Bad Grade," *The Cosby Show*, written by Ross Brown. Courtesy of *The Cosby Show*.

SPECIAL PLAY FORMS

The Soap Opera

The daytime adult dramatic serial, or soap opera, was described by critic Gilbert Seldes in *The Great Audience* as "the great invention of radio, its single notable contribution to the art of fiction." Although the radio soap opera is no longer with us, the television soap opera has become at least its equivalent in art, interest, and impact. For many years the soap opera was considered to be of interest principally to bored homemakers. But times have changed. Fergus Bordewich wrote in the *New York Times*,

although soap opera aficionados would seem to be a minority among college students, there are nonetheless thousands of young people around the country who daily put aside their Sartre, Machiavelli and Freud . . . to watch the moiling passions of middle-class America as portrayed on daytime TV. What is it about these slow-moving melodramas with their elasticized emotions that today's college students find so engrossing? . . . The fact is that in recent years the subject matter of daytime TV has changed and become much more relevant to the interests of young viewers . . . the "generation gap," abortion, obscenity, narcotics and political protest are now commonly discussed and dealt with on the soap operas of TV.

Daytime soap operas have broadened their viewing audience, and prime-time soap operas have become among the highest rated shows on television, here and abroad.

Most soap opera viewers seek a vicarious excitement that they do not ordinarily experience. Seeing people with problems at least as bad as the viewers' own makes their lives a little more tolerable. Soaps provide information, education, and emotional relief. Some hospitals' group therapy sessions use soap operas as models, where patients relate the characters' problems to their own. Some viewers identify so strongly that they call or write in to the network or station as if the soap characters were real, sympathizing with them, and asking for the names and addresses of the psychotherapist, abortion clinic, or drug rehabilitation center used in the show by the fictional characters, so they can seek the same help.

Like life, soap operas just seem to go on and on with no endings in sight, just a series of continuing complications. Sometimes soaps seem a little too clear cut—good is good and bad is bad. The writer should find appropriate median areas. Keep in mind that soaps offer the audience identification and diversion at the same time, entertaining and educating simultaneously. This means that the plot lines and characters have to be flexible, meeting the audience's needs and reflecting the changes in society.

Technique

The setting should be familiar—the household, doctor's office, school, small town, or large city—presented so viewers anywhere can identify in some way with the background and environment.

The characters, likewise, should be familiar, not necessarily in a detailed way, but in the kinds of persons they are and the problems they encounter. Every viewer should be able to say, "That person is like Uncle Mike, or Cousin Amy, or the plumber, or—even—like me." That means developing the characters on simple and obvious levels, with clear, direct motivations. Think of your favorite soap opera villains or heroines; they are all pretty clear cut, aren't they?

Most important, the characters should be provided with the opportunity to get into infinite amounts of trouble. They must face problems that are basically real, but that can hold the audience with their melodrama. Sometimes the characters must face insurmountable odds, yet somehow overcome them, unless a performer is leaving the

show and you have to kill off or otherwise get rid of his or her character. To create vicarious adventure for the audience, the characters should do things the viewers would like to do, but can't and probably never will.

Because the soap opera's principal purpose is to create viewer empathy and identification with the characters, the characters must be the motivating factors when you create the scripts. Soaps usually require an eight-week story projection, so most writers are constantly working on the series, carrying a dozen or more characters in their heads at the same time. The plot should contain a number of subplots, to accommodate the many characters. Though bearing on the main conflict, the subplots should complicate each character's life almost beyond endurance.

Because the soap must continue year after year, and because some viewers cannot watch each episode, the plot moves very slowly, with one minor event at a time. Naturally, on the weekly soaps, each episode must have a sharp plot, involving many characters in moments of crisis. An unexpected knock at the door can be built into a complication lasting for weeks or months on the daily soaps. Daily soap opera dialogue is like that of real life, slow and undramatic. Listen to the people talk on subways, street corners, and in supermarkets. The dialogue on the weeklies, however, usually reflects their hyperaction.

Start each episode at a peak—the crisis of what seems to be a complication. In each program that complication should be solved, or take another turn and level off. Before the program is over a new complication should be introduced, making it necessary for the audience to tune in the next episode to find out what will happen.

Although the daytime soap follows the live-type taped show approach, the evening soap follows the film form. The five-times-a-week daily soap schedule requires that sets and special effects be kept to a minimum. You may have to rewrite a script to accommodate the real-life problems of a continuing performer; if an actor or actress goes skiing and breaks a leg, you have to justify that character having a leg in a cast or being away from the action for a while.

In all soaps, daily or weekly, you need a **lead-in**—a summary of the basic situation and the previous episode. You also need a **lead-out**—the new complication, the cliff-hanger that brings the audience back.

The Miniseries

The miniseries enables the writer to bypass the usual time restrictions of television. With 4, 6, 8, or even 15 hours and more for the play, the writer can include a great many characters and subplots. Exposition can be presented slowly and carefully. Characters can be explored in depth. You have time to adequately prepare and clearly delineate the sociopsychological as well as physical setting. Sometimes the longer length lures a writer into the soap opera syndrome: a slow, literal pace. The miniseries is not a soap opera, to be carried through dozens and even hundreds of hours. It is a complete play that should hold

the audience for the several episodes that it is on the air. Like any good play, the miniseries needs a tight, consistently developing rising action.

Even though the miniseries usually is produced as a made-for-television movie, don't lose sight of the television medium's special qualities. Regardless of length, don't succumb to the temptation to pad; if the going gets boring, the audience will switch to another channel.

Many miniseries are based on history. Be accurate. While fictionalizing characters and enhancing events, don't misrepresent the facts or the course of history. Always keep in mind that a play is heightened life, and though you should avoid melodrama, you need to make history dramatic.

The Adaptation

Some miniseries are taken from novels or nonfiction works. The adapter's biggest problem is getting away from the original work. Avoid slavishly following the original's action sequence and dialogue. Compared with a play, those elements in a prose work can be undramatic, repetitious, and introspective. The author of a novel or a history can describe people, explain their feelings, clarify situations and motivations, and even present the characters' innermost thoughts without the characters themselves uttering a word. In the play you can *explain nothing;* you must *show everything.*

Get away from the craft of the original work and create anew, using as a base the theme, background, characters, and plot. A sense of the original dialogue is important, but nondramatic dialogue from a book frequently sounds ludicrous when read aloud. Become thoroughly familiar with the original work, then lay it aside and develop your play structure from the elements you have.

Retain the author's intent, but don't be literal. You are adapting, not copying. Where necessary, delete and add scenes and characters, combine characters, change characterizations, add action sequences. Writer-adaptor Irving Elman analyzed some pitfalls as well as advantages of two approaches to adaptation.

> The tendency with the first type is for the writer's creative urge, with no outlet through original creation of his own, to use the material he is adapting merely as a point of take-off, from which he attempts to soar to heights of his own. If he happens to be a genius like Shakespeare those heights can be very high indeed. But if he is not a genius, or even as talented as the writer whose work he is adapting, instead of soaring to heights, the adaptation may sink to depths below the level of the material he "adapted."
>
> The second writer, with sufficient outlet for his creativity through his own writing, is less tempted (except by his ego!) to show up the writer whose work he is adapting, proving by his "improvements" on the other writer's material how much better a writer he is. But if he genuinely likes and respects the material he is adapting, he will restrain himself to the proper business of an adaptor: translating a work from one medium to another with as much fidelity to the original as possible, making only those changes called for by the requirements of the second medium, trying in the process not to impair or violate the artistry of the original.

The Sitcom

Good comedy doesn't only make people laugh; it makes them think and feel at the same time. At an early age some of us are instilled with wit, outrageousness, sensitivity, absurdity, incongruity, incisiveness, and a few other attributes that constitute humor. When we combine these talents with an irreverent look at the sacred cows of the society in which we live, and then learn the techniques of how to express them dramatically, we have the tools for comedy writing.

Good comedy has always been born out of contemplating the seriousness of life. Next time you watch a sitcom on television, see if it leaves you laughing, thoughtful, and stimulated, or whether it narcotizes your brain and your feelings. Too many of the latter type are poorly written sophomoric farces, satisfied with surface characterizations and trite situations. Good sitcoms are good plays. You can create characters with comic flaws—Hawkeye, Archie Bunker, Maude, Cliff Huxtable, Sam and Carla, Frasier, Raymond, Will and Grace, Jerry, Elaine, George, and Kramer—or you can create comic stereotypes. Once the characters have been established, the dialogue and plot emanating from them are clear, and your principal writing job is to find something new or different for them to deal with each week.

The Cartoon

Although the animated cartoon is associated with children's programming and, when written for a children's audience, follows the principles that apply to writing children's scripts, several series have established the viability of the television animated program for adults. Animated characters have one advantage over "live" characters in television plays. They can do and say things that are consistent with their cartoon characters that the audience of a real-character program would not accept. The animated program can satirize behavior, ideas, institutions, and even contemporary figures in a way that the regular drama or sitcom usually does not. The shock of the satirical edge in the animated program is blunted by an unspoken perception that, after all, it's not real but a cartoon, whereas in a "real people" program, similar satire of people or institutions might be seen as a personal attack on one's self, heroes, or ideology.

Whether animated or real, good satire requires consistency in the characters and their motivations. The principles of writing the good play—relating to character, plot, dialogue, exposition, preparation, and setting—apply as much to writing the animated adult cartoon as to writing the nonanimated adult drama or sitcom. *The Simpsons,* for example, represent reality as much as the characters do in a nonanimated drama—the working-class families of the real world, creating empathy between themselves and their audience. As Charles McGrath wrote in an article entitled "The Triumph of the Prime Novel" in *The New York Times Magazine,* "The most realistic TV family of all ... is Homer and Marge and the gang ..."

Reality Programs

In the 1990s a new format took hold in U.S. television: the "reality program." The American viewing public is attracted to the format's combination of truth-based events and people with highly-dramatized script interpretations and highly-stylized productions. The range of format emphases varies from police investigations to adventurous rescues to emergency medical situations to courtroom cases.

Some critics see reality shows as an extension of the documentary, with an emphasis on human interest factors that, as Van Gordon Sauter, former president of NBC news, stated, "form an emotional link between . . . stories and . . . audience." Some critics, however, believe that reality programs distort rather than depict reality. They question whether the events as presented are too selectively untypical of what actually happened, and they express concern that some events shown in reality programs are reenactments, with performers, rather than actual occurrences. Other critics state that reality programs have an educational value, introducing the public to the work and life of people in key professions, such as safety, health, and law.

Writing Approaches

Because the reality program combines the documentary with the dramatic program, the writer-researcher must go beyond obtaining and presenting factual material alone. To heighten a sequence's impact, the writer can include a reenactment or a dramatization. If the story is being told from a first-person viewpoint (that is, a detective in charge of a case, the head of an emergency medical team, a reporter investigating a story), that person's role can be expanded from what it was in real life to create better continuity and cohesiveness in the story. Remember that the reality program is supposed to be just that, reality. Be certain that even with the heightening of the action, the essential material is true.

Writing Technique

One of the most successful reality programs has been *America's Most Wanted*. The show's basic format revolves around wanted criminals, frequently from F.B.I. files. The program reenacts the crime, gives full details about the wanted people, including their criminal acts, their background, where they were last seen, the details of their escape if they had been previously in custody, and what they look like, with special identifying features. The program then provides a phone number so viewers with information about the wanted person can call. Many criminals have been apprehended through information generated by the program.

Philip Lerman, supervising producer of *America's Most Wanted*, advised the would-be writer of reality television, "there are really only two things to remember: One: It's reality. Two: It's television."

Lerman stated, "unfortunately, those two don't always go together easily. But they can be made to work together, with a little bit of effort." In his advice to the writer, he began with the reality part:

Because you're writing about things that really happened—or things that *supposedly* really happened—you have to be very careful. There are only two kinds of "truth" you can report: things you saw happen yourself, and things which a jury decided are true. *Everything else in the world is hearsay,* and you should treat it as such. Watch the careful attribution in good reality programs: it's there for a reason. It's not just a legal dodge to say "police say Shmidlap robbed the bank"; it's a reflection of the reality-writer's world view. You don't *know* anything, other than what you've been told. So be honest about who told you.

Lerman continued his advice to include television considerations:

Television dramas can move at a fairly slow pace; there's a belief that the audience is invested in the characters, emotionally tied to them, and will stay with them. Television reality is just the opposite: the belief is that the audience views this programming as "information," of which there is much available in the world—and the moment this information stops being relevant, interesting, or important, the viewer will turn away.

So, when writing for television, you have to be crisp, brief, emotional; your words must be charged, electric, exciting; you must live in fear that at any moment your audience will become bored with you and turn away. There are those who will tell you that this kind of writing reflects a belief that the audience is dumb and has the attention span of a fruit fly. They are wrong. It does not. It reflects just the opposite. The audience you are writing for is entirely too sophisticated to be fooled by flowery writing. They can spot an interesting show, or a boring one, in seconds. They're busy, and they have a lot of choices, and they will watch what they damn well please—and if you want to maintain their interest, you'd better look and sound damn sharp.

Lerman concludes,

So where does that leave us? Writing for reality means being cautious; writing for television means being bold. Reality TV must be circumspect, yet direct; careful, yet carefree; judicious, yet risky; informational, yet entertaining. It is in that careful balance, it is along that edge, that the good reality writer thrives. Tightrope walkers are never clumsy; therefore, the key element to writing for reality television is simply this: a fine sense of balance, a light touch, and a little bit of grace.

America's Most Wanted has been one of the best-written reality programs, combining the various facets noted in producer Lerman's advice. Following are two scripts from *America's Most Wanted,* the first illustrating the "documentary approach" and the second (the script's opening few pages) illustrating the inclusion of dramatization and reenactment.

◢ _____

| PAUL PLOUFFE | FINAL DRAFT (AS VOICED) | CAMEROTA |

SUGGESTED WALSH INTRO:

Before MTV there was a musical tv show that came out of Pittsfield, Massachusetts. In fact, it's still on the air today. 12-year-old clips from that show's archives are our best clue for finding this next guitar-strumming fugitive. Our reporter Alisyn Camerota visited Pittsfield and brings us this report.

GEORGE MORELL INTRO TO
SHOW—Tape 2A

"Hello everyone and welcome to our show."

THE MORELL SHOW

VO #1
The year was 1982. The place Pittsfield, Massachusetts. And every Wednesday night, local music fans would tune into the George Morell show. "We're gonna do a little singing …"

GEORGE MORELL SHOW

VO #2
Part Hee-Haw, part kareokee, the show featured George Morell and his sidekick, singer and guitar player Paul Plouffe.

PAUL PLOUFFE O/C
Tape 1A

"Giddyup, ahumbop, ahumbop, a - mow - mow …"

MICHELLE WALKING UP ON
STAGE—Tape 1A

VO #3
Plouffe's 15-year-old daughter Michelle was also one of the regulars.

GEORGE MORELL INTRODUCING
MICHELLE

"Now here's Michelle. Hi Michelle." (Michelle sings …)

MICHELLE PLOUFFE O/C
Tape 1—00 25 50

"Everyone thought we were the typical American family. You know, look at her up there, singing with her parents. I don't think that anyone ever really knew. I don't think anyone ever had an idea what was happening."

MORE GEORGE MORELL SHOW

VO #4
What the audience didn't know was that behind the scenes Michelle was suffering a personal hell. According to police, Plouffe had been beating and molesting Michelle and molesting Michelle's best friend since the girls were seven.

PHOTOS OF MICHELLE AND HER
FRIEND AT SEVEN YEARS OLD—
Tape 3—02 05 49

MICHELLE PLOUFFE O/C
TAPE 1—00 30 00

"My father's excuse for everything was let me teach you now so that you don't have to experiment when you're older. I don't want you to grow up and to be 16 years old and go in the backseat of a car with someone. So, let me introduce it to you this way."

Continued

ALISYN STAND UP IN FRONT OF HIGH SCHOOL TAPE 3—02 07 36	AFTER NINE YEARS OF MOLESTATION, MICHELLE COULDN'T TAKE IT ANYMORE. SO ONE DAY WHEN SHE WAS 16, SHE WORKED UP ENOUGH COURAGE TO TELL HER TEACHER HERE AT HER HIGH SCHOOL. THAT AFTERNOON, MICHELLE WAS PLACED INTO FOSTER CARE … AND HER FATHER WENT ON THE RUN.
MICHELLE O/C TAPE 2—01 10 27	"They called me on a Saturday and told me that he had taken off. I was very angry. Very angry."
	VO #5 Two years passed with no sign of Plouffe. Then Michelle received this audio cassette. It was from her fugitive father. On it, Plouffe makes a frightening request.
PLOUFFE AUDIO OVER FREEZE OF HIS PHOTO CUT THIS IN HALF******	"There's something I want to ask you … I'd hate to see myself about to cash in and never have asked you. Would you consider the possibility of meeting me somewhere? And before you panic, hear me out. It would not be where I live, I'd travel a long way. I'd just like to eyeball you."
	VO #5 Michelle declined the offer, hoping her father would have a rendevouz with the law instead. When that didn't happen, it would take an episode of "America's Most Wanted" to give Michelle her next idea.
SLOW-MO OF PLOUFFE SINGING CUT TO AMW INTRO JOHN TALKING ****use a different show of Sharon!!	
MICHELLE O/C—01 13 00 TAPE 2	"I saw previews of America's Most Wanted and I said to myself, 'Wow, that looks like Sharon.'"
	VO #6
AMW RECREATION AND PHOTOS OF SHARON BEING ON THE SET WITH JOHN	Sharon Stone was an old high school friend of Michelle's and the two had a lot in common. Sharon's father had also physically and sexually abused her. Like Plouffe, Sharon's father was also a fugitive. And so was Sharon's mother. That is until America's Most Wanted got involved and captured them.
*****add reaction	"Oh my God ! !"
MICHELLE PLOUFFE VOICE OVER CAPTURE REPORT OF SHARON'S PARENTS	"I remember she called me and she said, 'They found 'em.' And I thought I would fall on the floor. I really did."

Continued

SHARON STONE O/C—TAPE 3	"Finally there was an ending to my story and then that's when she got the notion maybe I can do something about mine."
MICHELLE O/C	"I pretty much believed that if they could do it for her, they may be able to do it for me."
MICHELLE PLOUFFE V/O OVER HER IN THE YARD PLAYING WITH HER CHILDREN	"I guess you could say that if anything that my father had done for me, he has made me strong and he has made me tough. And I will not allow him to live the rest of his life without doing something about it."
REPRISE SONG AND MUSIC HERE FOR BIG FINISH	(End on song . . .)
	WANTED: Paul Plouffe may be earning a living working in a convenience store and singing on the side. This is how he looked in 1986 when he was arrested for theft in Burlington, Vermont.
	Unfortunately, Plouffe was released before he could be extradited back to Pittsfield on the rape charges. If you know where Plouffe and his guitar are tonight, please call 1 800 CRIME TV.

KOBIE MOWATT DRAFT #7 (AS VOICED)

Kobie Mowatt	
PAN of Kennedy Street sign/ MUSIC UNDER	
scenes of hustlers hanging out on the Kennedy St. corridor	SUGGESTED WALSH INTRO: Here in Washington D-C, [crime statistic]. The gangs here are called "crews." Their violence has forced residents to live hiding behind locked doors. Our first story tonight deals with one of the most dangerous crews.

Continued

```
**************************
*****SOUNDWAVE NOTE: Place VO #1 so word "Capital"
lands on the capitol)***
```

PAN of bus, then to the U.S. Capitol

WALSH VO #1 {ends at 01:00:22}
[Read any time]
THEY OPERATE IN THE SHADOWS OF THE NATION'S
CAPITAL.

```
********soundwave note: place vo #1a so that words "first
and kennedy" land on street sign, "kobie mowatt" lands on
mowatt actor********
```

crew members selling drugs to drive by cars, playing dice game, exchanging money and crack

WALSH VO #1a (01:00:22) (19 SECS)
THE CREWS CARVE THE NEIGHBORHOOD BLOCKS INTO
DRUG TURF THEY VIOLENTLY DEFEND. THEY TAKE THEIR
NAMES FROM THE STREET CORNERS THEY CALL THEIR
OWN. THIS CREW WAS KNOWN AS THE FIRST AND
KENNEDY, OR 100-KENNEDY CREW. POLICE SAY KOBIE
MOWATT WAS THE CREW'S MOST VIOLENT MEMBER.

SHOT of street sign on corner of 1st and Kennedy Streets, N.W.

SHOT of Kobie Mowatt playing dice game

CUT to William Ragland walking with groceries as he passes crew members playing dice who are blocking the sidewalk

Nats: crowd comments from the dice game

Kobie Mowatt jumps up from the dice game and bumps into Ragland

RAGLAND: Get out of my way son!

KOBIE: You got a pass Pops?

another crew member jumps up Bennie Lee Lawson

BENNIE: Yo man, yo, yo that's Darlene's gramps, he alright Kobie, go on Pops.

William Ragland walks past the crew

WALSH VO #2 (01:00:55) 3 sec TIGHT! [OR MUST LOSE NATS]

BENNIE LAWSON WAS ANOTHER MEMBER OF THE 100
KENNEDY CREW.

crew members let him proceed, as they watch him walk away

DET. ANTHONY BRIGIDINI: We always knew Kobie was a killer, and an instigator. Who has absolutely no feeling or worry about the well being of others. He's out for himself, and the members of his crew and that is it.

CUT to Det. Anthony Brigidini O.C.

Continued

CUT to shot of crew members gathered together sitting on a couch in a basement apartment, smoking, drinking. Kobie holding and loading a machine gun. CU shot of a member loading a pistol

*****soundwave note: MAKE SURE "KOBIE MOWATT" FALLS ON MOWATT ACTOR [AT 01:01:14] IN FOLLOWING VO

WALSH VO #3 (01:01:12) 13 sec
IN SEPTEMBER OF 1990, KOBIE MOWATT AND SEVERAL OTHER CREW MEMBERS WERE PLANNING A DRIVE-BY HIT ON A RIVAL CREW. BUT ACTING ON A TIP, D-C POLICE STRUCK FIRST.

CU of Kobie holding a machine gun in a mirror, pan back to other crew members on the couch still preparing for the drive-by

DETECTIVE: Police, everybody hands up! Drop it Kobie, drop it now!

MCU of Kobie standing up looking at police with machine gun in hand/CU of detective with gun in hand pointing at Kobie/Kobie puts down gun, they both stare at each other in a hateful way

crew members raise their hands in surrender

WALSH VO #4 (01:01:33) 4 sec
MOWATT, LAWSON, AND ANOTHER CREW MEMBER, GERMAINE GRAVES, WERE ARRESTED.

GERMAINE: I'm having a bad day.

WALSH VO #5 (01:01:40) 12 sec
THE THREE WERE CHARGED WITH ILLEGAL POSSESSION OF FIREARMS. THEIR ARREST BROUGHT RELIEF TO MANY LAW ABIDING CITIZENS, INCLUDING 89 YEAR OLD WILLIAM RAGLAND WHO HAD LIVED IN THE NEIGHBORHOOD FOR MORE THAN THIRTY YEARS.

MCU of William Ragland and elderly women watching the incident

Police walking the crew to the paddy wagon as they get in and sit down on the bench inside.

WILLIAM RAGLAND: Look at him, drug dealing. DRAW SHOWING HOODLUMS. Get these punks out of here! Make our neighborhood like it used to be.

Kobie stares out of the paddy wagon as the door closes/shot of William Ragland still staring

Det. Brigidini/O.C.

DET. BRIGIDINI: Mr. Ragland was someone that you could refer to as the pillar of the community. He was well liked and well respected.

Continued

CUT to street sign at corner of Kennedy St. and 1st St., NW./Mowatt jumping over a porch railing of an abandoned house walking back on the block and greeting friends, and crew members.

WALSH VO #6 (01:02:12) 6 sec
MOWATT, LAWSON, AND GRAVES RECEIVED TWO YEARS IN PRISON FOR THE WEAPONS CHARGES. BUT BY 1994 THEY WERE BACK ON KENNEDY STREET FLAT BROKE ... AND SEEKING REVENGE ON SEVERAL OTHER DRUG DEALERS.

Nats: Mowatt, Lawson, and Graves greeting each other

Kobie Mowatt talking to Lawson and Graves

MOWATT: I can't believe those fools blew our loot. They goin' to make my money back, but right now I'm hatin' life with no cashflow. Now we need to get some product and lucchi from one of those fools.

LAWSON: Yo, man ain't nobody frontin' product on credit.

MOWATT: Look you got heart and a gat, you can get some loot.

LAWSON: I got heart.

GRAVES: I got the gat.

Lawson and Graves slap five

LAWSON: Bang!

GRAVES: What's up!

Kobie still talking to Lawson and Graves

MOWATT: Well check it, word is Jerrell's holdin' and rollin'. He be over his girl's crib round the corner slangin' rocks on the late night. We need to go up in there and jack his ass.

The three slap five and walk off in agreement to the robbery

Agent Mark Guiliano/O.C.

AGENT GUILIANO: On October 26, 1994, Benny Lee Lawson, Germaine Graves and Kobie Mowatt, the three of them were violent members of the 1st and Kennedy St. crew, made a decision that they were going to rob a local drug dealer.

* * *

SPECIAL CONSIDERATIONS

The Children's Program

Three major types of children's shows dominate television: the educational program; the serious drama; and the equivalent of the lowest-common-denominator sitcoms for adults, the Saturday morning children's cartoons. This section deals only with the programs that are in play form—including cartoons. Saturday "kidvid" has always been to some degree exploitative of children, stressing violence and product advertising. Some children's shows have become program-length commercials, making the product (for example, GI Joe) the actual content of the script.

If you are going to write plays for children, you are likely to be faced with the kind of ethical dilemma discussed in Chapter 1. Certainly, your conscience tells you not to create a program that can be psychologically harmful to children, but your checkbook tells you that you need money to pay the mortgage. Nevertheless, we can hope that the writer, first and foremost, would think about the program's effect on the vulnerable minds and emotions of young viewers. Even *unintended* violence and prejudice are inexcusable. If you have any qualms of conscience, try out new program ideas on child experts and advocates before writing the treatment of a script that might prove harmful to children.

Imagination is the key. Some advertisers, producers, and writers think that children will believe anything. Actually, children's imaginations are so sharp that they are sometimes more critical than adults. Children will believe a fantasy, if it has a valid, believable base to begin with. If characters, situation, and environment are established logically in terms of the characters' motivations, the subsequent events and actions will be accepted. The best format is that which respects the child who is watching.

Read the approaches and techniques for writing children's programs in Chapter 9.

Women

The negative images of women in television and radio are legion. Although commercials are the worst offenders, drama—whether soap operas, sitcoms, or serious plays—continues to stereotype many female characters as either incompetent or overbearing. Even in programs where women behave in responsible, respected ways, frequently a tragic flaw makes the female character less competent than her male counterparts. Studies of Saturday morning cartoons show that even children's programs have few females who are principal characters; most females are used to support males in their tasks. Females are usually subservient or submissive and are usually the victims of actions initiated by male characters. Even where a female is a leading character, she frequently encounters a problem that can be solved only by a male.

Adult female representations have changed considerably in recent years, reflecting the growth of the feminist movement and the work of organizations such as the National

Organization for Women. Once principally depicted as dependent housewives, women characters in TV have increasingly been written as professionals in prestigious fields, including government leaders and judges, and in other roles formerly reserved for males, including physicians and police officers. Television writers have given girls and young women new role models on which to pattern their own future careers.

Racial and Ethnic Stereotyping

The principal problems racial and ethnic minorities have with the media are similar to those of women: denigrating, stereotyping, or unrealistically sympathetic or condescending portrayals. Rarely is this because of conscious racism, but rather because of insensitivity. Unless you have been part of the group in the portrayal, you will have difficulty understanding the special experiences of members of that group in society.

Writer Donald Bogle stated that "the television industry protects itself by putting in a double consciousness . . . [it takes] authentic issues in the black community and distorts them." *Washington Post* critic Joel Dreyfuss reviewed a new television series about a Black family, advising that if the producer "gets some black input into the writing end of the program, it might move away from the brink of absurdity and develop into a pretty good television program." Although *The Cosby Show* demonstrated how commercially as well as artistically effective a sensitive portrayal of a Black family in a sitcom can be, the excellent, more serious sitcom about African Americans, *Frank's Place,* disappeared quickly from the air. Similar concerns affect other people of color and, frequently, different ethnic groups.

Loraine Misiaszek, as director of Advocates for Indian Education and producer of television and radio programs, stated her concern about language and terminology as conveyors of stereotypes. "Anyone concerned with script writing," she said, "ought to be aware of this problem. It is not necessarily intentional, but it happens because of the general conditioning in our society that causes people to think of Native Americans in terms of stereotypes." Thomas Crawford, writer-producer of Native American–oriented programs, advised that "in writing scripts with, for, or about Native Americans, one must first of all become familiar with the idioms, patterns of expression, turns of thought, and pronunciations of the Indian community with which one is dealing."

Russ Lowe, as a producer of a weekly radio program for the Chinese Affirmative Action Media Committee, stressed the necessity of getting an accurate understanding of the perspectives and viewpoints of the Chinese American that are not otherwise usually presented on the air.

Dr. Palma Martinez-Knoll, who produced the Project Latino series in Detroit, stated, "too many writers, because of lack of understanding, are either prejudicial or condescending. When writing about Latinos, or creating Latino characters, make them part of everyday society, not an excluded group." She urged the writer to show the Hispanic as a responsible person who is an integral part of the community.

Even long established subgroups of the white majority are subject to stereotyping. How many gangster characters do you see in television dramas who have a last name ending in "a" or "o"? New immigrant groups are particular targets, and Southeast Asians have joined Blacks and Latinos as television's stereotypes of drug pushers. Groups such as the aged and the mentally and physically handicapped are other minorities who have been largely neglected or stereotyped by the media. The key for the writer is sensitivity to people's needs as a whole and an understanding of and empathy with the specific person or group being portrayed.

Internet Considerations

The availability of links within the context of a play presented on the Internet—whether drama, sitcom, soap or any other dramatic genre—enhances the real life approximation of the material. Most of the material on television and virtually all the material in feature films is in play form. In real life, the audience has an infinite number of choices in any given situation, depending on the audience's personal interests and the play's characters' personal traits. As noted earlier in this chapter, the characters write the play. Any given character says and does only what that character must do and say under the given circumstances.

Life is not one-dimensional and neither are people; thus, the existence of choices. In creating empathy between each individual member of the audience and the characters or personalities the writer creates, the writer needs to provide opportunities for the viewers to choose those variables that bring him or her closer to any given character, even to the extent of interactively changing the plot line of the play, inasmuch as in a good play the characters determine the action and complications of the plot, not the other way around. Therefore, the writer could offer multiple exposition possibilities, a variety of possible plot complications to move along the rising action, and even a selection of climaxes or endings, including different resolutions. The viewer becomes more immersed, more a part of the Internet presentation than with other media. The writer should be sure, no matter how many linkage variables, that a consistency of character and dialogue is maintained in any combination of whatever sidebars or choices are available.

Let's say you have a drama scene in which the husband and wife are arguing about a particular vacation they took. In the room is a photo album. Although neither the husband nor the wife wishes to risk being wrong by getting out the photo album to verify where the vacation was, the writer can, during the argument, focus a shot on the album and let the audience know that by clicking the computer cursor on the album it will automatically open, giving the audience an opportunity—if they want to take it—to determine who is right or wrong about the vacation site. The argument might even concern which music they danced to on that vacation; similarly, the writer can enable the audience to click on a designated tape or CD in the record cabinet in the couple's living room and listen to the specific selection. Another example: the couple is being nostalgic about a safari they took in Kenya's Masai Mara game preserve; the viewer can click on an icon for an interactive film and take a

similar trip—with proper computer equipment, even a virtual reality trip—on that safari route. Just imagine the kinds of sci-fi virtual reality experience you, as the writer, can provide, enabling the audience to explore a myriad of choices and experiences—even, perhaps, being eaten by a lion!

Episodic Review is an online magazine "devoted to original Web-based entertainment" that evaluates and promotes Web soap operas, comedy and drama series, serial novels, Internet cartoons, and online journals. It lists the following qualifications for a Web program to be listed as one of its featured sites:

1 High quality writing.

2 Superior editing, with few, if any, grammar errors or misspellings.

3 Accessibility; regardless of special effects, add-ons, or other technology used, the site has to be available to a majority of browsers. If, for example, the Web site can be seen only by Netscape 6.0 users with Flash and high speed access, it is too limited.

4 Good design. The site must be easily navigated, with few if any broken links or images.

5 A special or unique quality that differentiates it from other similar sites.

Episodic Review also provides a link from its Web site that offers information about writing, designing, and producing a Web series.

Essentially, the principles that apply to writing video scripts for the Internet apply as well to writing film scripts for the Internet. Cecilia Nord prepared the following analysis:

The New Media: The implications for writing and producing film on the Internet

The use of the Internet as a new media is forever evolving. As technological improvements advance with the speed of lightning, we are suddenly faced with an amazing array of possibilities for potential uses for the Internet. It already provides us with access to daily news, e-mail, games, search engines, and shopping, to name a few. Because of the millions of users worldwide, many of the more established media are seeking the advantages offered by going online. Various media are testing the potential of the Internet as a showcase or possible take-off platform for their specific forms of expression. For example, the film industry is using the Internet to give audiences easy access to movie previews, show times, and production company events and promotions. But not until very recently has technology provided the possibility of using the Internet as an actual viewing location for entire films. On November 16, 1998, the IFC broke ground as the first company to premiere a full-length feature film via the Internet, proving the viability of the use of new media as a distribution channel (Katz). Other filmmakers are exploring the possibilities of incorporating the intrinsic characteristics of the new media into the film medium to produce a unique form of narrative experience for the viewer.

Being a nascent media, the Internet has yet to establish the same kind of rigid structural and aesthetic requirements as those found in, for example, television and film. The writing of films for the Internet has remained a relatively fluid art form, free of the rigorous

demands of conventional screenplay writing. This is partly because of the novelty of the genre, but also because digital products can be produced at a fraction of the cost of conventional film, thereby presenting less risk for the companies and, consequently, greater freedom of expression for the artists (Atkin).

The Internet does, however, impose a set of its own restrictions on the films showcased online, because of the many technical limitations still to be overcome. At present, the most important restrictions are picture size, frame rates, and bandwidth barriers available to the general public (Brill 51).

The size of an average computer monitor compared to the size of a movie theater screen, even when the distance of the viewer is taken into consideration, makes a significant difference to a viewer's perception of the image displayed. Majestic scenery and big-scale events lose in size and thereby impact. The experience becomes more intimate and less awe-inspiring. The limited size also restricts the amount of information that can be shown to the viewer at any one time. Objects that stand out as an eyesore on the big screen may very well disappear into the background on a computer monitor.

As Nels Johnson points out in his article "Getting Video on the Web," "The biggest obstacle to delivering good-quality Web movies is network bandwidth" (Johnson 40). This problem is caused both by the consumer modem speeds and by the connectivity offered by Internet service providers. If you are using a 14.4kbps or 28kbps modem, a 1MB movie can take up to five minutes to download, and a streaming movie will play at around five frames per second, as opposed to the more optimal 24 frames used by the film industry (Johnson 40). This obviously places severe restrictions on the artistic subtlety available to the filmmaker, rendering more advanced projects either distorted or inaccessible to the general public.

To improve image quality, one should minimize the amount of unneeded detail in the picture. Keeping backgrounds simple and using even lighting makes the image easier to compress. Minimizing frame and camera movement reduces the jarring caused by the fewer frames-per-second ratio. If these measures are taken into consideration, the image quality and speed of transmission can be considerably improved (Johnson 38). These measures will inevitably effect the production companies' choice of projects as well as the writers' freedom of expression. Big action sequences, subtle references through details, and set design might be lost on the current Internet audience.

Because the Internet reaches a worldwide audience, high concept projects are better than more complex narratives with strong national or cultural references and ties. In general, high concept films have wider audience appeal, driven by simple plots and developments easily translated to different languages and cultures. The marketing potential of reaching a global audience also makes the Internet a potential gold mine for merchandising, sequels, and spin-offs.

Internet use habits are potential obstacles for films on the Web. To quote the Editorial Director of Microsoft Interactive, Michael Goff: "... folks are going to their computers to get something done ... they're not just going to see what's on" (Atkin). Most users go to the Internet with a specific purpose in mind; it is sought out for its effectiveness, ease, and speed. There is little patience for any inconvenience, and if the search is unsatisfactory, the user goes elsewhere. Movie theater and television sets are still clearly superior for viewing films, thus it is even more important for films on the Internet to capture interest and attention.

Once the present technological drawbacks have been overcome, the Internet will become an unrivaled distribution channel for the film industry. *The Last Broadcast,* an all-digital film, used a satellite based digital projector. This may prove to become the industry norm in years to come as production companies seek out new ways to cut costs. The IFC's live video-streaming of the same film on its high-speed Web site a month later established an alternative route to reach home audiences (Katz).

The distinguishing trait of the Internet as opposed to other media is its potential for interaction. By using this potential in a story or narrative, the Internet can provide an experience "... that's going to be something special and something different and something that another medium doesn't deliver" (Atkin). Because of the Internet's limitations, Internet films must make full use of the unique aspects of the medium.

The requirements of the Internet will inevitably affect the approach and techniques used by those interested in creating films specifically formulated for online viewing. The limited attention span of the user, stemming from the often utilitarian approach to the medium and the awkwardness of the viewing, gives creators two main options for communicating their full message: brevity and uniqueness. According to Tom Hall, manager of new media for IFC and its sister net Bravo, "Short films are a natural because they don't require 90 minutes of attention ... being focused on a computer screen" (Katz). In 1999 IFC premiered independent short films on its high-speed site.

The second approach involves making use of the new media's unique possibility of user interaction. The value of this feature and its use is being explored through a variety of different means; as Microsoft's Michael Goff puts it, "... there's an ability to act on information and if there's a way for us to build that into stories and into the services we offer, that's going to be important" (Atkin). Interactive writing, as it pertains to film, has evolved and is still largely evolving from computer games. Successes such as Wing Commander III, Riven, and Myst are breaking ground for an entirely new field of screenwriting. As Deborah Todd, a children's interactive writer and game designer, puts it, "Writing for interactive is a very different beast" (Atkin).

As with all good stories, interactive writing depends largely on character and story and good writing. Writer Michael Utvich, a member of WGA's Creative Media and Technology Committee, points out an essential difference: "the audience is the main character in a good interactive show." With the Internet, he continues, "your audience is ... as locked in place as you are when driving a car. You must involve them personally in some way ..." (Boorstin et al.). Thus, it seems that interactive writing asks a lot more both from its audience and most important, from its writers. But the digital interactive media also offers "the potential for a very intimate yet intensely involving collaboration and communication between artist and audience" (Parks).

The creation of an interactive script involves a great deal more work in its creation than a conventional script. First, for the audience to be able to make its own choices and "create" its own adventures, the writer must exhaust all possible outcomes and developments of the story while still working toward one or several different resolutions that stay true to the story's internal logic and character development. This constitutes one of the main challenges for interactive writers, developing their vision of an ambiguous text to engage their audiences into propelling the narrative in a certain direction. The sheer size of these projects can be daunting, ranging from 500 to 1,000 pages (Atkin).

One of the key elements in retaining a story line in these circumstances is the writer's ability to create a specific world, an environment, that can carry the development of the narrative in the same way more traditional forms depend on structure to convey their meaning (Boorstin et al.). For the story to be coherent from multiple perspectives, the writer needs to provide a design or product as well as a story line. Interactive writing has become more than just a writer's medium; it is a highly collaborative medium involving programmers and art directors throughout the creative process (Atkin). At a "cyber-roundtable" discussion, held by the WGA's Creative Media and Technologies Committee in late 1998, seven writers discussed their perceptions of the new medium. The writers all agreed on the fact that writing for the new media involves design as well as writing. Michael Utvich went so far as to declare: "Design is the spike position for interactive. The writing is secondary to the concept, the environment, and the overall conception of the audience experience" (Boorstin et al.).

To demonstrate the characteristics of an interactive script, WGA has posted *Secret Squadron* by Buzz Dixon on its Web site. It consists of a set of sequences that would occur at different times during the film, depending on the aptness and choices of the viewer. It has three main protagonists (Jack, Izzy, and Swifty) and a clearly identified enemy in the form of a vast criminal conspiracy. The plot elements resemble those of a traditional feature film with strong clear-cut characters and a well-defined obstacle. The obvious difference lies in the means to attain a resolution.

A short excerpt from one of the sequences demonstrates some of these points:

ARCADE STRAFING SEQUENCE #3/2 - SECOND PASS
The player will get no searchlights, only tracer FIRE this time. If he destroyed every active AA tower in Strafing Sequence #3/1, then even if he misses some towers here he does not have to make a third pass; however, he will be chased by SAMs for every tower he misses at this level.
If all active AA towers destroyed on first pass:
EXT. FACTORY #3
It EXPLODES in several large fireballs and from this inferno the Silver Dart ROARS TOWARD CAMERA.
INT. COCKPIT - IZZY
aims the Silver Dart's nose high and climbs away. Suddenly an ALARM BEEPS.

 IZZY
That should put a crimp in their plans - uh-oh! Incoming! GO TO AGENT REACTION #3 - F then GO TO DOG FIGHT #3. If all active AA towers destroyed on first pass but some missed on second pass:
EXT. FACTORY #3
It EXPLODES in several large fireballs and from this inferno the Silver Dart ROARS TOWARD CAMERA.
INT. COCKPIT - IZZY
aims the Silver Dart's nose high and climbs away. Suddenly an ALARM BEEPS.

Continued

> IZZY
> That should put a crimp in their plans - uh-oh! Incoming!
> GO TO STRAFING SEQUENCE #3/4.
> <u>If any AA towers were missed on first pass:</u>
> EXT. BALL TURRET - PAST JACK TO BURNING FACTORY #3
> Though there's lots of damage, the factory isn't completely aflame.
>
> JACK
> We need a third pass!
> INT. COCKPIT - IZZY
> BANKS SHARPLY as she returns for a third time.
>
> IZZY
> Well, this is the last time 'cause I'm just about out of missiles!
> EXT. NIGHT SKY - THE SILVER DART
> BANKS SHARPLY as we PAN OVER to show it DIVING TOWARD burning Factory #3 in the FAR
> BACKGROUND. (NOTE: Flop previous animation of this sequence to save time and money.)

Despite the division into sequences and the need for spectator interaction, the script is still very much a cinematic experience. It adheres to the rule "Show, don't tell." The narrative options are carefully constructed to guarantee that an action will be followed by a reaction, rewarding the viewers for their interaction and, hopefully, fueling further interest and participation. It is worth noting that the originality of the writer's creation remains remarkably present throughout the narrative. It is this presentation of an unmistakably original environment, rich and textured, that will make the difference between emotionally engaging the viewer in the narrative and making it a nondescript game without interest. The excerpt also shows the demands made of the interactive writer to explore all possible outcomes and to cover the action from all angles made necessary by the course of events. The interactive writer doesn't make his or her mark by creating a specifically structured narrative but by creating the possibilities for such a narrative to take place by means of the interaction of the work and the audience.

In summary, there are two routes for creating film for the new media: the first is by adapting the content to the present technological limitations of the Internet while preserving the traditional form of the experience. The second route chooses to adapt film to the intrinsic possibilities of the Internet by making it interactive. The two routes offer completely different possibilities for production and experience. At the present time, adapting the content to the existing technology is highly restrictive in its artistic expression, with the restrictions somewhat offset by a previously unheard-of ease of distribution. Interactive writing offers an altogether different experience by creating worlds in

which the audience has the opportunity to custom design the stories. As opposed to Internet distribution of traditional film, the interactive experience brings together the most compatible elements of both film and the Internet, propelling the viewer into the realm of the new media.

References

Abbot, Spencer H. "Peter Greenaway." *Rough Cut,* 6 June 1997.
http://www.roughcut.com/main/drive2_97jun1.html (15 November 1998)

Atkin, Hillary. "Bytes and Gigabytes: The Business of Interactive Writing." *WGA* Excerpt from the Writers Guild Foundation's 1997 Film and Television Writers Forum, "Words Into Pictures," May 3–June 1, 1997, Santa Monica, CA.

Avgerackis, George and Becky Waring. "Industrial Strength Streaming Video." *New Media,* 22 September 1997.
http://www.newmedia.com/NewMedia/97/12/feature2/Streaming_Video.html (15 November 1998).

Axelson, Mary. "The New Storytellers." *New Media,* 22 September 1997.
http://www.newmedia.com/NewMedia/97/12/feature2/New_Storytellers.html (20 November 1998).

Boorstin, Jon, et al., "Interactive Writing: A Roundtable in Cyberspace." *WGA,* February 1996.
http://wga.org/journal/1996/0296/roundtable.htm (21 November 1998).

Brill, Louis M. "Webcasting to a Global Audience." *Digital Video,* August 1997: 51–53.

Dixon, Buzz. "'Secret Squadron' Interactive Script." *WGA*
http://www.wga.org/ia/secretsquadron/html (21 November 1998).

Graser, Marc. "Wavelength releases 1st all-digital pic." *Variety Extra,* 26 October 1998.
http://www.variety.com (21 November 1998).

Johnson, Nels. "Getting Video on the Web." *Digital Video,* August 1997: 29–40.

Johnson, Stephen. *Interface Culture: How New Technology Transforms the Way We Communicate and Create.* Harper, 1997.

Katz, Rich. "IFC preems pic via cable modem." *Variety Extra,* 16 November 1998.
http://www.variety.com (21 November 1998).

McDonnell, Sharon. "On Writers Guild Site, an Inside Look at the Business." *New York Times,* 19 June 1997. http://nytimes.com/library/cyber/week/061997guild.html (15 November 1998).

Parks, Adrienne. "Interview: Terry Borst." *WGA,* February 1996.
http://www.wga.org/journal/1996/0296/borst.html (15 November 1998).

Phillips, Michael E. "Desktop Movie Making." *Moviemaker.*
http://www.moviemaker.com/issues/27/desktop/index.html (15 November 1998).

Smith, Lonon. "Writers on the Menu: Why the Internet May Eat Traditional Television for Lunch." *Written By,* March 1997. http://www.wga.org/journal/1997/0397/menu.html (15 November 1998).

PROBLEMS AND POTENTIALS

You may believe you have written an excellent play, and then find that the final version of your manuscript has little relationship to the subsequent production or shooting script. The production script contains all the revisions, plus technical information, put in by the producer and director. Unless the writer's contract includes the right to approve of any further revisions, the writer may find changes in content, form, and style about which he or she has not even been informed. After a script has run the gamut of script editor, producer screening, agency or network approval, production planning, rehearsal, and final editing for performance, the writer might have difficulty recognizing it. As a writer, all you can do is offer a script of the highest artistic merit of which you are capable, and then fight to keep it that way. At worst you can always request that your name be taken off the credits.

Rod Serling, one of television's most articulate as well as prolific writers (many college students know only his work as creator and principal writer of *The Twilight Zone*), called television a medium of compromise for writers. In an article by D. B. Colen in the *Washington Post*, Serling criticized television for "its fear of taking on major issues in realistic terms. Drama on television must walk tiptoe and in agony lest it offend some cereal buyer." Serling also was concerned about commercial intrusion into the artistic integrity of television plays. "How," he asked, "do you put on a meaningful drama or documentary that is adult, incisive, probing when every 15 minutes the proceedings are interrupted by 12 dancing rabbits with toilet paper?"

Through his *Twilight Zone* series and in many of his other TV plays Serling dealt with social issues such as prejudice, racism, individual liberties, and nuclear war that were otherwise considered too controversial by most networks and sponsors. Despite the restrictions he encountered, shortly before Serling died he said that television had developed to a point where, at least sometimes, "you can write pretty meaningful, pretty adult, pretty incisive pieces of drama."

So, despite the networks *and* sponsors *and* ad agencies *and* story editors *and* producers *and* directors, whether you write something of importance and value depends mostly on you. You can find comfort because your script is still the prime mover, the one element upon which all other elements of the production stand or fall. Without your script, there is no show. With a script of high quality, with writing of ethical and artistic merit, you can at least take pride in knowing that you have made a significant effort to enlighten as well as to entertain, to stimulate as well as to satiate, and to fulfill some of the mass media's infinite potentials.

11

Professional Opportunities

S o you want to write for the media!" could be an advertising heading to entice glamour-struck young people into schools, correspondence courses, books, or computer software all but guaranteed to make them next year's Emmy or Oscar winners.

I am convinced—after many years of teaching television and radio writing, of writing for television and radio, and of knowing television, radio, screen, and Internet writers—that good creative writing cannot be taught.

Putting together words or visual images that conform to specified formats can be taught. In that sense, many people can learn to write rundown sheets, routine sheets, and scripts that are usable for media presentations.

That's not a bad thing. If one accepts a certain format and approach as ethical and contributory to a positive effect upon the viewers, then nothing is wrong with being a competent draftsperson of scripts. You can attain great success in this role of interpretive writer—taking a format already created by someone else and putting it into a form that best presents it to the audience. Like an actor, a dancer, a musician.

Writing in its highest sense, however, is not copying or interpreting. Writing is *creating*. The writer's ultimate aim is to be creative as the composer, the painter, or the choreographer is creative.

Creativity cannot be taught in a classroom but, rather, comes from a combination of motivated talent and experience. Certain forms, techniques, and approaches can and should be learned. Just as the painter must learn what is possible with color, form, line, and texture, so the writer must learn what is possible with the tools available to him or her. That is what this book tries to do.

The *creative* art of writing requires much more. Creative writing is a synthesis of one's total psychological, philosophical, and physical background, heightened into expressive-

ness through a knowledge of form, technique, and approach. I have rarely found a person in any of the classes I have taught who was not able to write an acceptable rundown, routine sheet, or script in each media program genre. But too infrequently have I found a person who could go beyond the basic format and create a script that truly fulfilled the potentials of the media in affecting, in a humanistic, positive manner, the minds and emotions of the audience.

I hope that you who are reading this and contemplating a career in writing for the media are capable of the highest level of creative writing. But even if you are not, career opportunities exist. Indeed, sometimes the creative writer has less opportunity for gainful employment because of difficulty in lowering his or her artistic plane of writing to conform with the formulas of the particular program or script type.

In presenting some views on careers and the opportunities for writers in various areas of the media, I am making no judgment about what you should accept for your particular talents, skills, and ambitions. How far you should go or how limited you should let yourself be only you can decide. But know your capabilities and what satisfies you.

The combinations of potential and restriction, of opportunity and responsibility, of creativity and compromise pertain to virtually all writing jobs for all levels and types and for all broadcast stations and other media-producing organizations. A flyer announcing a Humanitas Prize for television writing by the Lilly Endowment, Inc., expressed this:

> The writer of American television is a person of great influence, for the values projected on the TV screen begin in his or her mind, heart and psyche. Few educators, churchmen or politicians possess the moral influence of a TV writer. This entails an awesome responsibility for the TV writer. But it also provides a tremendous opportunity to enrich his or her fellow citizens. How? By illuminating the human situation, by challenging human freedom, by working to unify the human family. In short, by communicating those values which most fully enrich the human person.

Whether or not the writer is always or ever permitted to do this is another story. Barbara Douglas, whose executive position at Universal Studios included finding scripts, packages, and properties for film and television, acknowledges the frustrations of the writer within the commercial requirements of broadcasting, but believes there is hope for creative talented people who can write alternative scripts that large companies could produce. She affirmed, in *Media Report to Women,* that integrity can be retained within an area of compromise, in which a script has mass commercial value but is not a sellout. "It's this fairly narrow area of quality which I wish our promising young people would consider, instead of either leaping to low-grade imitations of what appears to be a way to turn a fast dollar, or alternatively coming from a place that's so far from the mass mind that the script turns the studio people off before they get to page five."

Barbara Allen, writer, producer, and teacher of television and radio, offered some additional basic considerations for those who want to write successfully for the broadcast media. She suggested that you should be

- Creative enough to turn out bright ideas fast

- Self-disciplined enough to watch others "improve" on them

- Organized enough to lay out a concise production script

- Unstructured enough to adjust to last-minute deviations

- Persistent enough to be able to research any subject thoroughly

- Flexible enough to be able to present it as a one-hour documentary or a 30-second spot

- Imaginative enough to write a script that can be produced at a nominal cost

- Practical enough to have a second plan for doing it at half that cost

- P.S. It also helps if you can spell, punctuate, and type

Where are the jobs in broadcast writing? Allen described the categories as follows:

- *Network radio:* news, editorials, features

- *Network television:* soap operas, game shows, stunts for quizzes, comedy writing, pre-program interviews, research, children's programs, series writing, news, promotion, continuity

- *Local radio and television:* news, promotion, continuity, documentaries, special programs

- *Related areas:* cable systems, independent film production and syndication companies, advertising agencies, freelance commercials, department stores, national and state service groups, safety councils and charity enterprises, utility companies, farm organizations, religious organizations, government agencies, educational institutions and organizations, other corporate business and industry

Although regular staff jobs with stations, corporate organizations, and other entities are on a salaried basis, a great many writers are freelancers; they write scripts on a per assignment basis, negotiating a fee per script with the media outlet, producer, or corporate organization, subject to the minimum compensation standards established for those adhering to the Writers Guild of America contractual requirements. (Some of the payment categories are noted later in this chapter.)

Sometimes the writer works alone on a script; sometimes the producer assigns the writer to a team of writers. In still other circumstances, a salaried or freelance writer finds that after a first rewrite the script is turned over to someone else for completion.

Be prepared for frustration and even unfairness. Just as anyone else entering any phase of the visual or audio fields, you must be willing to break in with a low-level job, usually in a small market or in a junior position on a corporate team.

Writer's Digest, which provides continuing analysis of markets for writers, including radio and television, has summarized opportunities as follows:

Opportunities at local stations and networks include news writing, editing, continuity writing, commercial and promotion writing, and script and special feature writing.

News writers and editors collect local news and select stories from the wire services, often editing and rewriting them for local audiences. Newspeople may also serve as reporters, covering local stories and interviews along with a cameraperson. Continuity writers develop commercials for sponsors that don't have advertising agencies, write station promotional and public service announcements and occasionally program material. Both news and continuity writers are able to get across the essentials of a story in simple, concise language. Most script work is done on a contract or freelance basis, but some staff writers are employed. Special feature subjects are generally sports and news stories, usually written by a staff writer in one of these areas. However, stations are always eager to listen to new feature ideas from staff writers or outside writers.

Good broadcast writers have all the basic writing skills at their command and, since they frequently don't have time to rewrite, develop speed and accuracy. A college education in liberal arts or journalism is desirable, but a good writer who has other talents such as announcing is also well-qualified. As always, the writer with talent and original ideas will get the job.

It is best to approach a broadcast company through an employment agency. If you prefer not to do this, submit a resume with some of your best writing samples to the station or personnel manager and ask for an interview. Apply first at a small station and get that priceless experience that you can list on your work record, then contact the larger organization.

Staff jobs fall into many categories: news, advertising spots, continuity, promotion—all of the format genres and, in addition, administrative areas such as promotion and research that require writing skills. Further, the station that cannot afford to hire a line of writers usually seeks a producer, director, or talent with writing skills. A look at the "help wanted" columns in professional journals reveals ads such as these:

- Morning Show Prep Writers: Do you write comedy for a successful morning show? ABC Radio Networks is looking for full-time writers to expand its Morning Show Prep Service.

- Tease Writer: King 5 Television in Seattle, Washington has an immediate opening for a Tease Writer to join our award-winning news team. This position is responsible for writing and producing all teases and bumpers during 5–7 P.M. news block, hourly updates, and news cut-ins during programming.

- Producer: Hard working top-rated news shop needs producer dedicated to putting out a quality show. Good writer, copy-editor. . . .

- Writer/producer: Chicago's fastest growing TV independent seeks hands-on promotion writer/producer. . . .

- Promotion writer/producer: . . . creation and execution of on-air news promotion, including but not limited to breaking news coverage, mini series, talent showcasing . . . person will write copy for print advertising. . . .

- TV producer/director: ... research, write, edit and coordinate programs.

- Producer: ... good writer, copy-editor. ...

- Associate Producer: For top news operation. Major market news producing and writing experience essential.

- Promotion writer/producer: ... enthusiastic, talented, and creative promotion writer/producer to create on-air promotions. ...

- Radio Newscaster: ... on-air experience required, college optional, excellent writing skills mandatory.

Virtually all ads for news producers have something like the following, from one issue of *Broadcasting & Cable*'s help wanted section: "Must have excellent writing skills"; "Must have strong writing skills"; and "strong hard-hitting writing skills a must."

Jobs are available, provided you are willing to begin in a position somewhat lower on the ladder than head writer for the top-rated network news show or sitcom.

Writing the play is essentially a freelance occupation, although many successful freelancers find themselves part of the writing stable of successful individual programs or production companies, earning a regular salary well above the minimums specified by the Writers Guild of America. Because the stipend for writing the play is relatively high, enabling a writer to live comfortably by selling only a few screenplays or several half-hour or hour dramas each year, the competition is tough.

PLAYWRITING

"Breaking into television is more difficult than for any other writing field," according to former television writer and vice-president of RKO Radio, Art Mandelbaum. "It requires plotting a game plan at least as intricate as plotting the structure of a story or teleplot." Mandelbaum suggested several guidelines for those who want to write for sitcoms or continuing television series:

1 Study very carefully the particular series you want to write for and analyze every major character.

2 Simultaneously find out, if possible, the series rating to determine if it will still be on the air the following year. All series shows are assigned to writers by the producer before the season starts, so that even if your script is read and bought, it won't be seen, probably, for about a year-and-a-half. For this reason, too, don't write anything too timely that might be out-of-date by the time the program is aired.

3 Find out the demographics of each show; contact the networks and learn who watches, where the heaviest audience is.

4 You must obtain an agent in Hollywood. It is a waste of time to send material directly to a producer. An agent can provide you with fact sheets provided to writers on every show. The fact sheets brief writers on formats, requirements, and taboos. The Writers' Guild sends out information on all shows to its members.

5 After studying a particular show, provide your agent with a great many ideas for that show. Don't lock yourself into one show idea. If you come up with 50 one-paragraph thumbnail sketches, your agent will have enough to present to the producer even if the first few are immediately shot down.

6 If your agent sells a show idea, then you can get a contract for a treatment—and you can break into the Writers Guild.

7 Make sure you are grounded in the classics. Basic themes and plots are modifiable and, if you study television shows, you'll note that they are constantly used.

8 Don't let all your friends read your work. By the time their critical appraisals are finished you'll find that your head is spinning or you'll be revising your scripts into something you didn't intend to say in the first place.

9 If an agent offers suggestions that conflict with your ideas concerning a particular show, follow the agent's advice. As a beginner, trying to break in, you are totally dependent on an agent.

10 Television writing is a continuing compromise. The first thing you're pushing is the detergent; the second thing is the content.

Mandelbaum's practical approach combines a range of attitudes: some writers and producers are extremely optimistic about the extent of artistic creativity and social impact possible for the drama writer, others are extremely pessimistic and cynical. All agree, however, that you must have the talent to write plays, must write drama that fits the needs and format of the program series (including the dramatic specials that are not continuing-character series) or the current trend in Hollywood for feature or made-for-TV movies, and must know the given medium's potentials and the limitations.

The editors of *Writer's Digest* analyzed the television play market in a pamphlet entitled *Jobs and Opportunities for Writers:*

> Television has to fill at least 18 hours every day with fresh, appealing material. This necessity makes it one of the best markets for freelancers. It's one of the highest paying, and producers are constantly looking for new ideas and new scripts. Most new show ideas come from freelancers and many of the subsequent scripts are written by other freelancers. Good dialogue writers will find TV a highly rewarding market. . . . TV producers usually accept scripts only through agents, which means that writers cannot submit work directly to them. But writers can keep themselves informed on the current market picture through *Writer's Digest,* whose issues publish information on new TV shows along with practical articles on TV script writing. The annual *Writer's Market* contains a detailed list of agents' names and addresses.

Television and film writer Alfred Brenner stated in *Writer's Digest* that the technological revolution in communications has created a world of expanding markets. He advised the writer, "the only way to break into television … is by writing a professional script." It must be noted, however, that more than one playwright has been quoted anonymously about what happens to a writer in Hollywood: "They ruin your stories. They butcher your ideas. They prostitute your art. They trample your pride. And what do you get for it? A fortune!"

The writer's fee is higher for theatrical screenplays than for television plays. The Writers Guild basic agreement through May 1, 2003, has step clauses that reach a minimum of $94,240 for an original screenplay, including the treatment, for a high-budget production ($5 million or more) and $50,199 for a low-budget (less than $5 million) photoplay. A nonoriginal, high-budget screenplay and treatment reach a minimum of $81,687, and a low-budget one reaches $43,926. A high-budget original story or treatment reaches a minimum of $37,633; a low-budget original story or treatment is $22,744. Of course, a screenplay for a megabucks production earns proportionately more money, and some writers receive well over $1 million for a screenplay. The Writers Guild also specifies lesser fees for lesser work such as rewrites and polishing.

By contrast, the contract for network prime-time television provides a minimum of $13,718 for a 30-minute teleplay, $19,125 for the story and teleplay; $18,506 for the one-hour teleplay, $28,130 for the story and teleplay. Specific fees apply to scripts for other formats, lengths, frequencies and type of writing, including series, narration, and continuity.

Fees are also set for nondramatic programs, such as comedy and variety shows, audience participation programs, documentaries, children's programs, and others. The "schedule of minimums" theatrical and television basic agreement is available on the Writers Guild Web sites, www.wgae.org or www.wgaw.org. Their locations are Writers Guild of America, West, Inc., 8955 Beverly Boulevard, West Hollywood, California 90048 (phone 310-550-1000), and Writers Guild of America, East, Inc., 555 West 57th Street, New York, N.Y. 10019 (phone 212-767-7800). Minimum fee schedules for radio are in a separate agreement that can be obtained from the Guild.

It is to a writer's advantage to join the Writers Guild. Not only does the Guild provide minimum fee protection, but it also offers a pension plan, a health fund, and other union benefits. The Guild also offers advice on legal matters, agent contacts, and a substitute *copyright* system, among other things. The writer who sells a first screenplay or teleplay to a company working under a Guild contract will be required to join.

As emphasized by Art Mandelbaum and the *Writer's Digest,* having an agent is important. To get one you need examples of your writing that will convince the agent that you've got the ability to write scripts that sell and the potential to make money not only for yourself, but also for the agency. Use your writing class and production outlet opportunities in college to write as well as you possibly can, and develop a saleable portfolio. George N. Gordon and Irving A. Falk explain the agent's function in their book *Your Career in TV and Radio.*

> Whenever writers are mentioned in broadcasting circles, you frequently hear talk about literary agents and their role in selling the output of authors. Rarely does a writer for TV

or radio need a literary agency unless he operates as a freelance author, selling his output to the highest bidder. Freelancers usually write for dramatic programs and their scripts are bought for "one-shot" programs. . . . Literary agents help freelance dramatic writers to place their manuscripts with production companies or to search out assignments. For their services, agents receive at least ten percent of the sale price of each script the author writes. Most literary agents will sign contracts only with writers who have established reputations and whose work is known to be marketable. *Remember that ten percent of nothing is nothing.*

The best way to find an agent is through some personal contact, usually a writer friend who puts you in touch with his or her agent. If you have no such contact, you can approach an agent with a letter of inquiry citing your past credits, if any, and a brief description of the project(s) you currently have completed or on which you are working. *Literary Agents of North America* is a good compendium of agents' names and addresses and lists agents under various categories such as Television, Television Movies, Television Series, Television Miniseries, Television Series Proposals, Video Cassettes, and CD-ROM and Radio.

The annual *Writer's Market* also contains a list of agents' names and addresses. The Writers Guild of America provides a list of agents, designating those willing to look at the work of new writers. Before submitting a script to an agency, however, send a summary, and the agency will send you a release form if it is interested in seeing the full script or treatment.

If you want to attempt to freelance your work directly to producers and production companies, look at *Broadcasting & Cable Yearbook*. Under a section entitled "Radio and Television Programming Services," the yearbook contains information about production and distribution companies for television, radio, cable, and even some of the newer technologies.

COMMERCIALS AND COPYWRITING

The three areas that provide the greatest opportunity—in which most writers are employed—are commercials, news, and drama. Kirk Polking, director of *Writer's Digest* School, analyzed careers for copywriters for a *Writer's Digest* article, "The TV Copywriter":

> Of all the writing jobs today, the network television commercial copywriter probably gets paid more, for less actual *writing*, than any other writer. Charles Moss, whose copy jobs include the American Motors account and others handled by the Wells, Rich, Greene agency, points out, "I may spend no more than 15 minutes a week at the typewriter. Much of the rest of my time is spent sitting around this table with art directors and account executives analyzing a client's product and trying to find the right idea to sell it in one minute." *Idea* is the key word here and many top agency copy chiefs say they're looking for "concept creators," not writers. "*Writers* we can always hire," says one creative supervisor. "What's harder to find is the guy with a new idea, a fresh approach—someone who can create the theme for a brilliant, visual short story, with a sales message, in 60 seconds."
>
> . . . Ron Rosenfeld, a copy chief at Doyle Dane Bernbach, says, "We're not necessarily looking for copywriters as such. We want people who have a great sense of the graphic and are good at thinking in pictures."

...The television commercial copywriter has to sell the client first before he can sell his idea to the public. How does he do this? ...A client says, "Too many young copywriters come in with only one idea and can't do a good job of showing why it will effectively sell the product. They're too jealous of their own idea—maybe they're afraid they'll never get another. A real professional can lay aside an idea you don't like, and come up with five others and show you 11 good reasons why each one would be effective."

..."There's a screaming need for good TV commercial copywriters," says Ed Carder, Director of the Radio and TV Department of Ralph Jones, "but the writer has to have a thorough basic understanding of the English language, how TV and radio work and the discipline to work within time and space limitations."

...What about freelancing in this field? It usually takes the form of moonlighting. A small agency will go to a copywriter at a leading agency whose style they like and ask him to do a job on the side. Mostly the agencies work with their own staff people and know fairly well what their next year's needs are going to be in the way of personnel based on their client list. Rarely has an agency bought a TV commercial idea submitted by a writer through the mail. Some of the larger clients and agencies have a form letter rejecting all such submissions automatically to protect themselves from claims of plagiarism. A writer who has what he thinks are some new, fresh approaches to the TV commercial might do best to work with local agencies first, contacting them by mail, with a resume of his professional experience and asking for an appointment to present several specific commercial ideas for specific clients of the agency. If he's good, he'll get a chance.

...Most agencies agree that a good liberal arts background is essential for any copywriting job. Since TV copywriting also requires a knowledge of the things the motion picture camera and the TV studio can and cannot do, background in these areas is also helpful.

Several Doyle Dane Bernbach copywriters discussed in *DDB News* how they judge copywriters, and offered some advice to the person seeking to break into the field. In describing what she seeks in going over someone's portfolio, Sue Brock stated, "The first thing I look for is whether there is an ad there that I would have okayed. And then, if there are none like that, whether there is the germ of a good idea that perhaps was goofed up in the execution. Then, after you've decided that there is something there that is fresh or exciting, you call the person in, and at that point you are influenced by the person's personality. If she sits there hostile and full of anxieties, you lose interest, because this is very much team work, and all the little belles and stars have a very rough time." Judy Protas warned that "in this business, where criticism is very much the order of the day, a writer whose personality can't stand up to criticism would fall apart at the seams." Brock added that "you have to have a pretty good opinion of yourself or you won't survive. You have to have a pretty strong ego, because everyone here is willing to criticize—traffic, the messengers, everyone. And if it happens to be your boss who's criticizing, you're going to have to change your copy." Protas concluded that "you have to know when to stop discussion. You're expected to fight for your opinion, but not start whining and arguing defensively over something in which only your ego is involved."

Eric Schultz, as president and general manager of stations WRKO and WROR in Boston, looked for three principal attributes in copywriters: (1) creativity—the ability to dream up new and exciting approaches to selling the product or service; (2) good listening skills—the ability to hear what the client is saying, what the client wants to sell, and how the client wants to sell it; and (3) excellent writing skills.

Promotion writers, sometimes attached to sales or commercial writing offices in small stations, need to go beyond just a knowledge of broadcast writing, according to Schultz. They need broad-based skills, not only the ability to prepare promos in the medium itself, but to write for all other media, from newspaper releases to billboards to bumper stickers.

George Gray, former president and general manager of WBSM-Southern Massachusetts Broadcasting Company, offered this advice for the person who wants to obtain a job writing commercial copy: "Learn to write a simple, declarative sentence." He believes both experienced and inexperienced applicants should have the ability to write "simple, clear, short sentences, using a lot of nouns and verbs, a limited number of adjectives, and very few adverbs." He advised writers to learn to "express a thought in the simplest terms. Nothing loses a listener more quickly than high-flown imagery. My advice to my own writers is: tell them, tell them what you told them, then tell them again." Gray stated that although managers seek to hire people who have had experience in the real world and who understand the client's business goals and the purposes of the commercials they write, paramount are "the techniques of thinking, habits of study, organization of time and energy, and self-discipline that people who have a college education presumably have learned, and which are all essential for one to be a successful professional broadcast writer."

News

With the increased emphasis on local news, jobs for news reporter-writers at local stations have increased as well. Desired preparation for a career in broadcast journalism varies with stations and station managers. In some instances a pure journalistic background is preferred; in others, specialization in television or radio techniques is wanted; in still other cases judgment and news sense is subjectively evaluated, with training a secondary consideration. Stanley S. Hubbard, as president and general manager of Hubbard Broadcasting, Inc., described in *Television/Radio Age* what he looks for:

> What is a news person? Is a news person qualified because he has a degree from a university which says he graduated in journalism? Or is a news person qualified because he has held a job someplace as a news person? I think not. I think that a news person, in order to really be considered capable, has to prove that he or she has news ability and "news sense." The time restrictions involved in producing television news require that in order to be successful, a television news person has to have genuine news sense. It is not possible, insofar as my experience has indicated, for a person to learn news sense in a journalism school. . . . Journalism schools can prepare you very adequately to go to work

in a news room at a TV station and learn how to successfully fit into the mechanism, but just because a person successfully fits into the mechanism, it is a mistake to think that a person necessarily has news sense or the judgment required of a licensee in the discharge of his public responsibilities.

Background, formal or informal, is required, of course. Because of the attention being directed to local and regional events on local stations, Barbara Allen recommended that, as a potential reporter-writer,

> (1) you need to be familiar with every aspect of city government, the people who make up the power structure in your community, the business and industries that support your area's economy, your schools, colleges and local personalities, (2) the breadth and depth of your knowledge about people and government and art and politics and education, science and social and economic problems will be the underpinnings of your value as a journalist, and (3) your function and responsibility is to see what seem to be isolated events against the background of the forces which cause those events.

Teresa McAlpine, former managing editor of an all-news radio station in Boston, looked for some experiential background when interviewing potential beginning newswriters. She first determined whether the applicants had some experience in writing broadcast news, "which requires different skills than writing for newspapers. Our beginning writers write news for broadcast from many sources, including personally conducted telephone interviews from which they prepare stories. Previous broadcast newswriting is essential. It can have been with a college station or a non-paying internship somewhere ... as long as it's broadcast writing."

The second thing McAlpine looked for was the applicant's ability to write simple sentences in conversational style. She expected the writer to have a sense of news judgment, and she tested applicants by giving them print stories to rewrite for radio and judging whether the writer found the proper lead for radio and presented it in a "catchy, conversational style." Finally, she looked for speed. Fast-breaking radio news stories frequently have to be written very quickly. "To the good newswriter," she stated, "all of this comes naturally."

As for education, McAlpine believes that a liberal arts background is the best preparation, coupled with a continuing knowledge of world events from assiduous reading of newspapers and magazines and listening and watching broadcast news. If the applicants have little or no previous experience in broadcast newswriting, they can balance that by having a communications major or degree. She also believes that courses in radio and television writing will have taught the applicants the essential forms and techniques and that "this is a definite plus."

Irving Fang, in his book *Television News*, reported the news directors' preferences of preparation when hiring young people. They would prefer a reporter with two years' experience and no college education, if choosing between that applicant and a college graduate in broadcast journalism with no experience. Very low in preference are college

graduates with a different major and no experience, a local resident junior college graduate with no experience, and a broadcasting trade school graduate with no experience. Majors other than broadcast journalism, in order of preference, include political science, English, liberal arts, history, general journalism, and telecommunications. News directors see writing as the most important skill. Other skills, including reporting and on-air personality, are secondary. Among personal qualities most desired are eagerness, enthusiasm, self-motivation, and energy. Fang also listed the behavioral attitudes a broadcast journalist should have, according to the American Council on Education for Journalism:

1 Ability to write radio news copy

2 Judgment and good taste in selecting news items for broadcast

3 Ability to edit copy of others, including wire copy

4 Knowledge of the law especially applicable to broadcasting

5 Knowledge of general station operation

6 Understanding of the mechanical problems of broadcasting

7 Appreciation of broadcasting's responsibility to the public, particularly in its handling of news

8 Ability to work under pressure

9 Ability to make decisions quickly

10 Speed in production

11 Familiarity with the various techniques of news broadcasting (including first-person reporting, tape recordings, interviews, remotes)

12 Knowledge of newscast production (including timing or back-timing of script, opens and closes, placement of commercials, production-newsroom coordination)

13 Ability to gather news for radio and television

14 Ability to read news copy with acceptable voice quality, diction, and so on

15 Ability to find local angles in national or other stories

16 Quickness to see feature angles in routine assignments

17 Ability to simplify complex matters and make them meaningful to the listener or viewer

Perhaps 20,000 newswriting positions exist in radio, about the same number in television throughout the country, and an increasing number for the Internet. Yet, each year, there are more applicants than there are job openings. In addition, salaries vary widely from about $25,000 per year and even less at small stations to $70,000 and more at networks.

Where do you look for a job as a newswriter? Everywhere and anywhere. If you're breaking into the field, try the small stations first, where you can gain experience doing all kinds of writing, including news. If you want or need to live and work where there are predominantly large stations, be prepared to start as a copyperson or in another beginning position. Be aware, however, that it is extremely difficult to advance in a network or similar large operation, and the lack of experience and competitive structure can keep you on a rung of the ladder quite removed from newswriting for a long time, if not forever. Most experienced newswriters and managers recommend the small station route as the one with the better chance. If you are studying in a journalism, communications, broadcasting, or similar department, your professors already will have contact with stations in your state or region and usually will recommend capable graduating students for jobs. You can, of course, contact stations anywhere in the country yourself; ask your professors for help in preparing your resume, and don't forget the experience you obtained, it is hoped, with the university's noncommercial station or with a local commercial station while working toward your degree. Your professors can also refer you to national organizations and associations that have placement services. One of the principal groups is the Radio-Television News Directors Association in Woodland Hills, California. Journalist-applicants pay a small fee.

The few freelance newswriter-producers usually are people who have achieved sufficient recognition to be able to name their own spots and terms. For the less experienced and renowned, however, local television and radio stations do provide some outlets. If you are a writer and have a camera that you can use well or a tape recorder with which you can be creative, you can frequently provide special features on local events. Local history, geography, civic affairs, local and state holidays, and unusual happenings and personalities offer a plethora of possibilities. This might be worth trying while you're still in college, on your own time, on a part-time basis. You can get experience with a public television or radio station, if there is one in your community, and experience with and payment from a local commercial station. Some larger stations employ students as news stringers to cover campus news, particularly athletics. Internships provide experience, as well as contacts. And if you've had the foresight to take courses on writing and producing for the Internet, you could look at the growing number of news groups in cyberspace.

Writing is the key to news, no matter what position you hold. Jim Boyd, a newscaster for television station WCVB, Boston, gave credit for his success as a disciplined writer to his early education's emphasis on grammar: "There is nothing more important in the business I'm in—that is, being a newscaster—than writing."

CORPORATE MEDIA

Writer's Market reported that "business and educational films are much bigger business than Hollywood." Business and industry require a great variety of formats and types, including advertising, informational and training films, videotapes, slide shows, and audio tracks, teleconferencing, and increasingly, cyberspace programs.

Many companies have in-house media centers, with the salaries for writers-producers varying just as greatly as in television and radio stations. Freelance corporate writing and producing is a big business. Even many companies with their own production units frequently hire outside talent and consultants. *Video Management* magazine confirms that "the use of freelancers in nonbroadcast video has snowballed over the past several years."

Approach a company whose products or services you already know something about. Prepare yourself well, so that if you obtain an interview with the media center director, personnel chief, or another officer of the company, you can talk as if you not only are an expert in writing and producing corporate media, but an expert in the company's field, as well.

If you make a good impression, you may be asked to submit a proposal on a specific subject. If the proposal is satisfactory, you'll be asked to submit an outline or treatment. Negotiate a contract before you start writing, including a fair fee, a schedule, and a clear statement of what the script's content and purpose are expected to be.

Frank R. King, former director of video training for the John Hancock Mutual Life Insurance Company, advised that if you are planning to enter the corporate video field, you should "pick an industry you think you might enjoy." Students should prepare themselves by learning the content areas of the specific industries in which they are interested. However, more important for the writer than knowing the industry or video techniques, King said, is the ability to write creatively, to use the language correctly, including the basics, and to work with people. He advocated conscientious study in scriptwriting courses. King further advised people applying for jobs in corporate video to bring, if at all possible, a demonstration tape, with a clearly labeled indication of what the applicant did in the production. If the applicant can afford it, a tape should be left for review by additional persons. If that is not possible, the applicant should bring and leave some sample scripts.

Scott Carlberg, writing in *Video Management,* recommended several guidelines for freelancers, to protect their integrity as writers and their status in the field. He suggested that a freelancer must be kept informed at all times of the job particulars, must have direct access to the key people involved in the production, and should meet personally with the client, if necessary, to be certain what the need is for the media project and what objectives should be used in the script to solve the problems. Establish one reliable contact in the company as the internal project coordinator, Carlberg advised, and do not be manipulated into promising or doing work of a superhuman or unreasonable nature. Finally, he warned freelancers about the internal politics found in any organization and the need to avoid being used as "a pawn in internal corporate political games."

Dr. Jeffrey Lukowsky, when communication consultant for Digital Equipment Corporation, confirmed that opportunities exist in corporate media as a whole if you are a writer. Many companies spend huge sums of money on external writers, many have writers-producers on their staff payrolls, and many use both in-house and out-of-house writers, Lukowsky said. Corporate media writers should be skilled in both print- and scriptwriting, he advised. Among the types of writing required, he listed dramatic simulations such as duplicating customer environments to train people in sales techniques, news

about the company's product or service, product technology information and training, and productions enhancing the company image. "If you've written drama," Lukowsky assured, "you'll have a better opportunity to break in. Often a writer is asked to take product information and turn it into a case study or role play for training purposes."

Try first to get a job with one of the smaller corporations, doing whatever job might be available, whether production assistant or assistant script editor, Lukowsky advised the newcomer. After a period of preparation and experience, then you might seek a position with one of the larger "Fortune 500" companies. Other ways of breaking in, Lukowsky suggested, are through corporate media production agencies, which contract with companies for writing and production personnel, and with individual production houses, the so-called vendors contracted with by corporations to produce media programs. In every situation, Lukowsky recommended, come with a portfolio, showing some of the work you have written, and prove your ability to do the work required.

Writer's Market annual yearbook lists key production companies for business and education writing.

The Internet

With more and more entertainment and news programs streamlining onto the Internet and the probability that in the next few years almost everything now found on television and radio will be found on the Internet, the current generation of college students seeking to break into media writing has an opportunity to get in on the ground floor of this new communications phenomenon. One important area for writing jobs is with the traditional media themselves. More and more television and radio stations and cable networks are adapting their programs before releasing them into cyberspace so they can take advantage of the Internet's interactive potentials. This is true, as well, for commercials. Use of attractive and seductive links pulls the potential customer further into the advertising pitch, sometimes making it almost impossible for him or her to leave until a product or service is purchased. Advertising agencies will be fertile fields for new writers who know how to write for the Internet.

The increasing use of the Internet by corporate media portends an expansion of corporate writing and production, both in-house and through outside producers who provide multimedia services. One company breaking new ground in this area is the Pangaea Multimedia Communications Corporation, discussed in Chapter 9. Eric Johnston, founder, president, and CEO of Pangaea, offers the following advice for those who want to break into multimedia, including Internet, writing and production.

> As an employer in the world of new media, including the Internet, we are constantly looking for talented individuals ranging from those with skills in video production to those skilled in the many aspects of computer technology. There is a great deal of competition.

Recent graduates have to compete not only with their peers, but also with those working in the hundreds of new small businesses and, as well, with seasoned professionals.

Writing skills are vital—no matter what your specialty is. If you are able to organize and articulate a thought clearly in the correct medium for your target audience, you will have a greater impact and you will quickly become a critical player. As an employer, our first judgment of an applicant's writing skill is to review her or his cover letter and resume. A potential employer needs to understand your level of experience, and it can be advantageous to clearly state your specific roles, responsibilities, and the skills or understanding you ultimately gained from that experience.

The characteristics of an ideal employee should include a set of attitudes as well as technical skills essential to success. One's writing is not simply a placement of words, but must reflect an understanding of these attitudes and technical skills. The excitement and enthusiasm of recent graduates must be accompanied by the commitment, dedication, and understanding of reality. Simply having taken courses in a particular area and doing class projects qualify only as exposure. If the colleges and universities have done their jobs, their graduates should have solid understanding of their areas of study; but the job applicant who stands out is the one who has applied her or his knowledge to the real world. Work experience gained through internships and entry level work prior to graduation enable the job applicant to integrate theory and practice. For example, those who have only studied and never practiced often don't fully understand some very important aspects of effective work: attention to details, process, procedure, and protocol. They sometimes fail to understand the key elements of commitment, deadlines, and follow-through.

Some employers have observed that "generation X" graduates seem to be focused principally on short-term gain, disregarding higher values such as ethics, standards, and potential long-term benefits. How that person presents subject matter may be drastically different from the way a person who truly believes in their work and the impact of that work writes. When recruiting, we look for long-term commitment and genuine interest and enthusiasm, and we attempt to match individual direction with that of the projects and the company. All of these things are reflected in one's writing and work habits.

Communication is critical. understanding the proper channel and medium of communication is useless if it is not used. The individual must understand who the players are, how to gain access to them, and how to write in ways that communicate effectively to them. An employee needs to apply this communication skill both to clients' projects and internally with co-workers. I have seen too many situations where lack of communication skill caused a loss of productivity, time, or goodwill. If an individual has something of value to add or is unhappy and doesn't communicate it, or has not thought through who should be included in the communication loop, it can result in a loss for the company.

Writing in the new media environment is fast-paced. There is no time to revise or re-think whether or not the communication has been handled correctly. Work must be completed at a high standard of excellence on a tight time-line. The successful employee must understand that missing deadlines can impact not only on the next task or project, but also on compensation and even on employment.

Writing for new media has some unique characteristics. The product is often structured differently than that of traditional writing. There's less space for meandering. The

key point must be made clearly and succinctly at the beginning. Content and examples or explanations must be organized differently than with traditional writing. Each point must be written as a clear "stand-alone" item that the reader can either choose to explore or to overlook. The reader may not follow the same sequence or logic that the writer uses in traditional writing. Therefore, every point must retain its meaning when read in any imaginable order.

Writing for the Internet is a challenge for the employee because, at this point in time, he or she is a key actor in a new field where experimentation is still rewarded. The best of new media writing is still ahead.

THE PROPOSAL

For long formats, including plays and corporate scripts, you need a proposal. The proposal must be accepted before you get the go-ahead to prepare a treatment, which, in turn, is a prerequisite to getting a contract to write the complete script. As a writer you need a proposal for the producer or the station or the advertising agency—for any person or office that must pass initial judgment on the project. The producer who wants to sell a project to a network must first present a proposal.

The proposal tells what the script is about and covers all the logistics necessary for the script's profitable production, including budget, potential distribution, promotion, and other areas. The proposal must sell the idea of the project—its feasibility and the availability of sources for research and development and other resources necessary to the project's completion. Be practical. More than one neophyte who might have been an excellent TV writer has been told by a producer that the proposal simply isn't financially feasible, citing as an example the naive writer's prototype "most expensive line": "The Romans sacked the city." With a television drama show's usual budget, they certainly did not! With Hollywood's film budgets, they might have!

The proposal is, in effect, a sales tool, with which you convince your script's prospective purchaser why that script will result in monetary gain and prestige for the buyer. Your proposal should include the following: (1) an assessment of need—why the prospective purchaser needs that script; (2) the goals to be achieved by that script—Is it a corporate script to train? A sitcom to entertain?; (3) a summary of the idea and the script; (4) the potential audience; (5) the feasibility of the script—Can a series be written? Are materials available and clearable for the proposed single or multiple production? Is talent available? Are necessary writing and production resources obtainable?; (6) anticipated budget, including above- and below-the-line costs; and (7) placement or distribution—its place on the schedule, ratings potential, syndication expectations, corporate limits.

Don't allow all of your planning and hard work to go to waste; remember: *Neatness counts.* In an article, "Scriptwriting," in *Writer's Market,* Michael Singh reminded writers that "a page's appearance and readability—format, type size, neatness—are important assets . . . first impressions play a large role in determining whether or not a reader will continue beyond the first 20 or so pages."

PROGRAM PITCH

The usual way to sell a program idea is through the *program pitch.* Networks and independent producing companies seek new program ideas, and select those considered promising out of hundreds submitted every week. That is, the idea's creator is allowed to present the proposal in person to one or more program development executives representing the network or production company. The presentation is called a program pitch or sometimes, within the television industry, *spitballing.* Although you can submit your idea and request a program pitch on a freelance basis, you have a much better chance if you use an agent.

The purpose of your program pitch is to convince the potential producer or distributor that the series (or one-shot program such as a documentary or a music special) is going to attract a sufficient audience and make money for the company. Therefore, you present more than just the program content. You must describe the characters or performers, the detailed format (including plot and character relationships if it is a sitcom or drama), the setting, and any special attributes that make the content different from similar concepts. In addition, it usually is helpful to present a realistic anticipated budget, some preliminary demographics of potential viewers, the kinds of advertisers the program format and viewer demos are likely to attract, your program's counterprogramming value (that is, in competition with other networks or distributors), likely market clearances, and promotion potentials.

In other words, you try to present a bottom-line plan of production, distribution, and potential sales as well as a detailed program description. If your characters or other program elements lend themselves to ancillary income (such as animal soft toys, character T-shirts, posters, theme recordings, or comedy routines on videos), mention that too.

The pitch should be done clearly, cleanly, and quickly. It must be complete and simple enough that the executive will remember it and be able to repeat it in condensed form to other program development personnel. Above all, don't be boring. The most successful pitches are more than just verbal presentations. You should always include a handout—that is, something on paper to later remind the executive of what she or he heard and saw; an outline or, preferably, a program treatment; an outline if it is a series and an outline or a treatment of at least one episode, plus an outline or overview of several subsequent episodes; a clear list and description of the major characters, plot lines, and settings; an emphasis on any unique program characteristics that make it especially competitive (such as realistic scenes of the Los Angeles Police Department activities or a well-known stand-up comic, assuming you already have an on-paper commitment from such a person); sample sequences with characters and dialogue; special effects or music that give the program a special flavor. Use whatever other materials enhance your presentation: video clips, audio, slides, photos, charts, even puppets of your principal characters.

Your aim is to convince the program development people that your idea is worth taking a chance on and to give you an advance to write one or more complete scripts. If you already have a completed script, make sure it is a good one. If they like it, you may get a

contract for more scripts and possibly even money for a pilot if you are part of a production unit as well as a scriptwriter.

If the powers-that-be don't like your proposal, you'll receive a rejection letter in a short time. If they do like it, your agent (or you, if you don't have an agent) will get a call in a short time. If you hear nothing for a while, don't hesitate to ask your agent to check on your proposal's status; if you don't have an agent, after a respectable time—several weeks—call the network or production company yourself and ask where it stands.

COPYRIGHT

You can't copyright an idea. If you are creative, you will find that some time, some place, one or more of your ideas will be appropriated without compensation or credit to you. It's happened to all of us; series formats, script outlines, and concepts for various kinds of programs have from time to time been adapted or even wholly used by unscrupulous producers and broadcasters. On the other hand, many ideas, script concepts, and formats can be thought up by more than one person at virtually the same time, and when you see or hear on the air under someone else's name a creation that you had submitted to a network or station or agency, it might not be a rip-off at all. Because networks, stations, production companies, and agencies require you to sign a release for the purpose of protecting themselves in instances where your submission was not original or the first one received, you can never quite be sure!

To protect yourself, copyright your work. Unfortunately, not everything that the writer creates for television and radio is copyrightable. Ideas for and titles of radio or television programs cannot be copyrighted. According to the United States Copyright Office, narrative outlines, formats, plot summaries of plays and motion pictures, skeletal librettos, and other synopses and outlines cannot be registered for copyright in unpublished form. Copyright will protect the literary or dramatic expression of an author's ideas, but not the ideas themselves. If you want to copyright a script, it has to be more than an outline or synopsis. It should be ready for performance so that a program could actually be produced from the script. The Copyright Office defines materials not eligible for copyright:

> Works that have not been fixed in a tangible form of expression. For example: choreographic works which have not been notated or recorded, or improvisational speeches or performances that have not been written or recorded. Titles, names, short phrases, and slogans; familiar symbols or designs; mere listings of ingredients or contents. Ideas, procedures, methods, systems, processes, concepts, principles, discoveries, or devices, as distinguished from a description, explanation, or illustration. Works consisting entirely of information that is common property and containing no original authorship.

Unpublished scripts in complete form or a group of related scripts for a series may be copyrighted. If a script is a play, musical, comedy, shooting script for a film, or a similar dramatic work, it can be copyrighted under Class PA: Works of Performing Arts. The

Copyright Office describes this class as including "published and unpublished works prepared for the purpose of being 'performed' directly before an audience or indirectly 'by means of any device or process.' Examples of works of the performing arts are music works, including any accompanying words; dramatic works, including any accompanying music; pantomimes and choreographic works; and motion pictures and other audiovisual works." The latter includes television and radio. Registering a particular script protects that script only and does not give protection to future scripts arising out of it or to a series as a whole.

Video and audio writers should note that an additional category sometimes applies to their works. Whenever the same copyright claimant is seeking to register both a sound recording and the musical, dramatic, or literary work embodied in the sound recording, Form SR: Sound Recordings should be used.

You can obtain copyright forms and detailed explanations of how to determine what is copyrightable as well as the procedures for obtaining a copyright by writing to the Copyright Office, Library of Congress, Washington, D.C. 20559. The copyright fee of $30 protects your work for the life of the author plus 70 years.

Another form of script protection, if you don't want to apply for a copyright, is the Script Registration Service of the Writer's Guild of America, which is available to non-members as well as members. Members pay $10 for 10 years protection. Nonmembers pay a fee of $22 for a script of 150 pages or less; students pay only $17. The oft-used self-addressed registered mail approach could have some value in some future litigation, but more formal registration is advised for better protection.

COLLEGE PREPARATION

Most station managers say that there is no substitute for experience. And many add that colleges are not adequately preparing students for a broadcasting career. Part of their concern is that many people entering the field directly from college do not understand commercial broadcasting. Conversely, station managers are concerned that students do not get a proper blend of social sciences and humanities with hands-on training, but tend to go too much in one direction or the other.

Courses in writing for the media are necessary to help you master the basic techniques and formats. If you are planning to go into a particular aspect of writing, such as copywriting or playwriting, take advanced courses in those areas. Make certain that you've taken the basic courses that give you a grounding in the essentials of grammar, punctuation, spelling, and clear, direct expression of ideas. Be sure, as well, that you take courses that give you the background for thinking, reasoning, and understanding, whether used to create characters and plot lines for a sitcom or a 30-second commercial spot, or to write news and documentaries. Station managers will tell you that they look at your transcript for such courses as history, psychology, political science, and sociology. They want courses that make you a full, rounded person, not a narrow-area specialist whose use to the station or company is limited. If you want to move to

supervisor writing positions, you need to understand financing and budgeting. Include one or more business courses in your personal curriculum. If you expect to be a writer-producer, be sure your interpersonal, presentational, and people skills, oral as well as written, are good. If you've had a course in negotiations, you'll do better for yourself when arranging contracts.

Dr. W. Joseph Oliver, professor of communication at Stephen F. Austin State University in Texas, conducted a study of top-level broadcast executives' for broadcast careers. Practical, applied media courses, and business-oriented courses were highly favored, with liberal arts courses receiving strong support. The managers stressed the importance of solid writing skills for all potential employees.

Dr. Jeffrey Lukowsky, professional communication consultant and a former professor of mass communication, recommended that the student who wants to be a corporate media writer take a variety of courses in both print and script writing, including writing for television, writing for audio, writing for magazines, and short story writing. The latter two are essential preparation for writing the frequent case study scenarios, in both print and dramatic form. Lukowsky also advised getting production as well as writing experience in college, in both video and audio. "There is more audio work in corporate media than most newcomers think."

And it goes without saying that you should take as many courses in new media writing, programming, and producing as you can fit into your schedule. Include those cyberspace courses that stress visual creation and graphics development, and especially those that concentrate on using the Internet's interactive capabilities.

Most important, don't restrict your future professional opportunities by concentrating on too narrow an area. Your college education should go beyond either theory or technical skills alone, and be the best "hands-on/heads-on" learning combination possible.

Glossary

A/B roll A/B/C/D rolls are used in linear postproduction; two or more videotapes run in synchronization to create dissolves or special effects.

Actuality The news event heard or seen as it is actually occurring; a sound or video clip from a news event.

American Research Bureau (ARB) Market research company that conducts surveys.

Analog Nondigital recording of material in radio and TV. (See **Digital.**)

Aperture The diameter of a camera lens opening, also called an iris opening, that controls the amount of light permitted to reach the film.

Ascertainment primer Former FCC requirement that a station applying for a license or for renewal must survey community problems and show how programming has dealt and would deal with these problems.

Associated Press (AP) Preeminent among the wire services used by news programs in the United States.

ATR Audiotape recorder.

Attribution Stating the source of the information or the quote in a news story.

Automation Use of computers to control some media equipment and to perform some duties otherwise required of personnel. The term is also used in television to pick up satellite feeds and to start videotape cassette commercials and prerecorded programs.

Backtiming Applying the time left in the program to the remaining script segments, frequently requiring alternative script endings to fit different time lengths.

Bandwidth Range of signal frequencies, or amount of data, a carrier can handle.

BBC See **British Broadcasting Corporation.**

Bed A music base.

Bite A recorded quote, used in documentaries and news programs.

Blending Sometimes used in radio to denote combining and sending out over the air two or more different sounds at the same time.

Boom A crane, a pole, or other device used in television that holds a microphone or camera at the end, allowing it to follow or move closer to the performers.

Bridge A sound, usually music, connecting two consecutive segments of a radio program.

British Broadcasting Corporation (BBC) The noncommercial public broadcasting system in the United Kingdom.

Broadband High-speed, high-capacity transmission carried on coaxial or fiber-optic cable.

B roll Visuals without voice on a second projector in documentary or news features production.

Browser A computer software program that allows a user to find and access documents from various sources on the Internet. Also, a user engaged in the act of browsing.

Bumper Material added to the beginning or end of the principal part of a commercial or to the end of a program that is coming up short.

Cable Wired, as differentiated from over-the-air or broadcast, television transmission; see **Coaxial cable.**

Cable News Network (CNN) A 24-hour news and talk conglomerate of several different channels.

Camcorder A compact combined camera and videocassette recorder.

Cart Audio cartridge. Radio scripts usually specify a cart number, which designates the segment to be inserted at a given place in a program; some scripts use the term *cut* with a number referring to the segment on audiotape.

Cassette The container/playing device for either an audio or videotape.

CD Compact disk; a 4.5-inch diameter disk containing digital audio or digital computer information that is read by a laser-equipped player. An international format for delivering high-fidelity audio.

CD-ROM Compact disk read-only memory; a form of optical storage used as a central medium for distribution of multimedia applications.

Chain break Network break for national or local ads.

Character generator (CG) Electronic device that cuts letters into background pictures.

Chroma key Electronic effect that can cut a given color out of a picture and replace it with another visual.

Chyron The brand name of an electronic character generator, sometimes used generically, but in error, for all electronic character generators. See **Character generator.**

Close-up Filling the television screen with a close view of the subject. As with other shot designations, it has various gradations (for example, medium close-up) and abbreviations.

CNN Cable News Network

Coaxial cable Metallic conductors that carry a large bandwidth and many channels; wired television.

Computer An electronic system that manipulates information in digital form and controls external devices. A storage and retrieval machine that can be used by the writer as a word processor or with a television, radio, or film format program.

Conflict In a drama, the two or more forces that are opposed, creating the suspense for the play.

Continuity The generic term applied to the radio-television written copy.

Control board Instruments that regulate the output volume of all radio microphones, turntables, and tapes and can blend the sounds from two or more sources. Sometimes referred to as a switcher.

Co-op announcement Multiple sponsors on a network commercial; individual messages locally spotted.

Copyright Legal establishment of the author's right to his or her work, protecting it from use without the author's permission.

Copywriter The person who writes broadcast continuity; frequently applied to commercial writers only.

Crane shot A camera shot achieved by use of a crane, usually enabling movement. See **Boom.**

Crawl Movement of titles on screen.

Credits The list of performers, production personnel, and other people responsible for the program, usually run at the end of the program, but frequently run partly at the beginning.

Crisis In the play, when the conflict reaches its zenith and something has to happen that causes one force to win and the other to lose.

Cross-fade Dissolving from one sound to another.

Cross plug An announcement for one of the station's programs or the advertiser's other products.

CS Close shot. Frequently used for **CU.**

CU Close-up.

Cursor The marker (or light) on the computer screen that indicates your position.

Cut In film, instantaneous switch from one picture to another, created in film editing room; also used to designate end of a shooting sequence. In television, instantaneous switch from one camera to another.

Cutting Moving abruptly from one sound or picture to another.

Cyberspace Where all media converge: audio, video, telephone, television, wire, and satellite. Frequently used interchangeably with the term **Internet.**

DAD (Digitial Audio Delivery) A computerized version of the cart machine.

DAT Digital Audio Tape.

Database A structured collection of information organized so it can be retrieved through a computer system.

DBS See **Direct broadcast satellite.**

Demographics Analysis of audience characteristics.

Detail set A constructed detail of the set to augment close-ups.

Digital Use of digits 0 and 1 to represent data; the code that instructs a computer to read, store, and operate on that data.

Direct broadcast satellite (DBS) Permits an individual with receiving dish to pick up designated satellite signals; sometimes called satellite-to-home transmission.

Dissolve Fading from one picture into another. DISS frequently used.

Dolly A carriage with three or four wheels on which a microphone or camera is mounted. Also, the movement of the carriage with the camera toward or away from the subject.

Drive time Automobile commuter hours, important in determining radio programming formats and placement of commercials.

DV Digital video.

DVD Digital videodisc; can contain a full-length movie on one disc.

ECU Extreme close-up.

EFFX Effects. Usually simply FX.

EFP Electronic field production; the use of mini-cam equipment to produce commercials and other non-news materials away from the studio.

Electronic synthesizer An electronic device that can create and process sound, from silence into music and other complex sounds.

Email Electronic mail. A message, typically text, sent from one computer to another.

Empathy The identification of the audience with the emotions and problems or joys of one or more characters in the program.

ENG Electronic news gathering; the use of mini-cam equipment to cover news stories.

Equal Time Rule Congressional and FCC rule that bona fide candidates for the same political office be given the opportunity to purchase equal time for radio and television ads.

Establishing shot Usually a wide-angle shot to open the program or sequence, establishing the physical environment.

ET Electronic transcription; when used with a number (such as ET #6) refers to a segment on a record to be used in a program. Preceded the use of tapes ("cut #6") and cartridges ("cart #6").

EXCU Extreme close-up.

EXT Exterior; designates setting in a film script.

Fade, fade in, fade out Gradual appearance or disappearance of sound (in radio) or picture (in television).

Fairness Doctrine Former FCC requirement that if only one side of an issue that is controversial for a given community is presented by a radio or television

station in that community, comparable time must be provided for the other viewpoints.

Fax Facsimile; the transmission of written material or pictures through wire or radio.

Federal Communications Commission (FCC) Government agency regulating the use of the air waves.

Federal Trade Commission (FTC) Governmental agency with some regulatory power over advertising.

Feed Transmission from a remote site. Also from a network.

FF Full figure shot.

Fiber optic cable Cable carrying laser light encoded with digital signals; capable of reliably transmitting billions of bits of data per second.

File Generic for almost anything composed on a computer, including documents, graphics, and databases. The storage and retrieval area and list.

Filmed teleplay A drama or comedy produced on film for presentation on television or cable.

Firewire Data transfer format that allows direct feeding of a video signal into a computer.

Flash A software program used for authoring multimedia.

Focal length Relates to the distance between a lens and the imaging device (i.e., film).

Follow shot Movement of carriage and camera alongside of or with subject.

Format The physical layout and placement of content for a given program. Also the instructions telling a computer to set up for a certain script type.

Frame One individual visual picture; usually applied to the commercial storyboard. Also used to denote an individual complete picture of a video or motion picture film.

Freeze-frame Stopping the action and holding on a single frame.

FS Full shot.

Full-service station A radio station with two or more formats; music, news, talk, features, and so on, as differentiated from a specialized station providing predominantly one service (or one form of music or format).

Gamma correction Adjustment of contrast in a film negative. Also used in video to denote the midrange of the luminance signal.

Graphics The visual materials (except the taped or live action) used in a program.

Hard drive A computer's main storage area.

Hard news/hard lead The concrete facts about the story; see **Soft news/soft lead.**

HDTV (High Definition TV) An increased number of lines in a picture (1150 scan lines), giving it much better resolution than current systems, especially the U.S. N.T.S.C. standard of 525 lines, plus a widescreen (16X9) format, better color, and 4-channel digital sound.

Hertz The measure of each frequency unit, one Hertz (Hz) equalling one cycle per second.

Home page An Internet Web site's opening page, which may have links to other pages.

HTML Hypertext markup language that creates links in World Wide Web documents.

HTTP Hypertext transport protocol, providing connections for the World Wide Web.

Hypertext Method of organizing information retrieval that brings together related material and through links allows a shift to other documents in other hosts.

Icon A small picture or symbol representing a computer program, file, or feature.

ID Station identification.

Infotainment Making the news entertaining to draw more viewers, often at the expense of the informational content.

Instant replay Playback of a videotape even as it is recorded, used frequently in live sports events.

INT Interior; designates setting in a film script.

Interactive Two-way communication, currently usually through computer or cable for information retrieval or instruction response; computers, games, multimedia systems, and other hardware that respond to the actions of the user.

Internet The worldwide system of connecting computer networks with other computer networks.

Intro Standard material used to introduce every program or designated segments within a program in a series; also called stock opening.

ISP Internet Service Provider. A company that sets up a computer network that enables its customers to get online.

ITFS Instructional Television Fixed Service; a relatively inexpensive microwave system that permits point-to-point transmission of instructional, professional, and other materials.

ITV Instructional television.

Key A special effect combining two or more video sources, cutting a foreground into a background.

Kine, kinescope The early television picture tube and, before videotape, the term for recording a television program by filming it off the kinescope through a monitor.

LA Live action.

Laser Acronym for *light amplification through stimulated emission of radiation;* a developing technique for multichannel and multidimensional television transmission.

LCU Large close-up.

Lead The first paragraph of a news story, usually containing the 5 Ws.

Lead-in, lead-out The material introducing the substance of a program, such as a recap preceding the daily episode of a soap opera, and the material at the end of a program preparing the audience for the next program.

Limbo Performer, through lighting and position of camera, stands out from a seemingly black or nonexistent background.

Linear Information presented in a set order, from beginning to end.

Linear editing Refers to accessing pre-recorded analog information on a linear tape for assembling into a new video program and can be time consuming. Nonlinear editing refers to randomly accessed digital information for assembling or constructing a new video program.

Lineup List of stories for a news program, in their order of presentation; see **Rundown sheet** and **Routine sheet.**

Link The means of connecting different materials or documents on a computer Web site.

Live-type taped Television directorial technique that uses the continuous-action procedures of the live show. Also called "live on tape"; from the early days of videotape when editing was done by physically cutting the tape—the more put on the tape at the time of recording, the less cutting had to be done later.

Logo Visual identification symbol of a station, company, or product.

Log on Connecting to a host computer or network or a public access site. Also called *Log in.*

LS Long shot.

M2S Medium 2-shot.

Magazine format A program format with a number of different segments not necessarily related in content.

Magnetic tape Tape coated with magnetic particles; used in television for recording, storage, and playback of programs or other materials.

Matte A process by which two different visual sources are combined to appear to be one setting,

such as placing a performer on one camera into a setting on another; same as **key,** but can add color to the image. Also spelled *mat* or *matt.*

MCU Medium close-up.

Medium shot A wider shot than a CU or MCU, but not as wide as a 3/4 shot or full shot. Usually cuts at about the waist.

Memory The storage capacity of the computer.

Mic Microphone.

Microwave Transmission on a frequency 1000 MHz and over (not receivable by ordinary home receiver); used for special point-to-point materials.

Miniature A setting used to simulate one that can't be economically built or located live.

Minicam Lightweight, easily portable camera and tape system that facilitates highly mobile news gathering and remote coverage; see **EFP, ENG.**

Minidocumentary A short documentary feature most often used in magazine-type television programs.

Mix In film, rerecording of sounds to blend them together; in radio, combining several sound elements onto a single tape or track; in television, the point in a dissolve when the two images pass each other (the term is sometimes used in place of **dissolve**).

Modem Modulator/demodulator. A device that converts digital computer signals to analog and vice versa for transmission over a telephone network. Makes it possible to hook up two or more computers by telephone, facilitating long-distance writing and story conferences.

Monitor Television-like device on which your computer displays information.

Montage Blending of two or more sounds or series of visuals.

MOR Middle-of-the-road, a radio format combining popular and standard music.

Mortise A cutout area of a picture where other material can be inserted.

Mouse Device for controlling the cursor on a personal computer's screen.

MS Medium shot.

MU Music.

Multiplex In radio, transmitting more than one signal over the same frequency channel, the additional signals referred to as being transmitted on subcarriers; in television, feeding the signals from two or more sources into one camera.

Narrowcasting With the growth of multiple transmission-reception technologies, more and more programming can be aimed at specialized audiences.

National Association of Broadcasters (NAB) A voluntary association of television and radio stations. Until their abolition in 1983, the NAB's Radio and Television Codes of Good Practice served as self-regulatory guides for much of broadcasting.

Nonlinear A format that allows users to read and access information in any order they choose.

OC, O/C Off-camera.

On-line Being connected to another computer via a telecommunications link.

On mic Microphone position in which the speaker is right at the microphone; this is the position used if no other is indicated.

OS Off-screen sound effects.

Outline An early step in the process of selling a script or program concept; essentially a narrative of the characters and plot; also called a **treatment.**

Outro Standard material used at the end of every program or of designated segments in a program in a continuing series; also called *stock close.*

Outtake Material that has been recorded in the preparation of the show, but is deleted in the completed tape or film.

Pan Lateral movement of the camera in a fixed position.

Participating announcement The commercials of several advertisers who share the cost of a program.

PB Pull back, referring to camera movement or action of zoom lens.

PC Short for personal computer, a reference to IBM-type computers as differentiated from Apple Macintosh computers.

People meter An audience measurement device that requires the viewers to participate, ostensibly resulting in more accurate figures.

Pic The individual still picture, designated on the script. The plural is *pix.*

POV Point of view. Applied to programs, usually documentaries, that present a clear and specific point of view. Also used to describe a particular shot, specifying the character's visual point of view, such as "Jack's POV—panning shot of railroad station parking lot."

Pre-interview Establishment of general areas of questions and answers with an interviewee before the taping or live interview.

Prime-Time Rule PTAR. FCC requirement that television stations allocate at least one hour during prime time to non-network programming was discontinued in 1996.

Promo Promotional announcement; see **Cross plug.**

Protagonist The principal character(s) in the play, who move(s) the plot forward.

PSA Public service announcement.

Psychographics Audience analysis that goes deeper than demographics and includes attitudes, beliefs, and behavior.

PTV Usually means public television, sometimes used to mean pay television.

Quadruplex The use of four overlapping heads on a videotape recorder to produce tapes of almost-live quality; the first commercial magnetic video recording system, from Ampex. Now used to play back the 2-inch quad tape-recorded from 1956 until the type 1-inch C format that is used today was introduced.

RAM A computer's memory capacity, or random access memory.

Rating The percentage of all television homes tuned in to a given program; see **Share.**

Remote Program or materials, usually live coverage, produced at a site away from the studio.

Reuters A worldwide news agency.

Rewrite Writing the story a second (or even a third) time, to add new information or to make it more interesting to the audience who has seen or heard it before.

Routine sheet A detailed outline of the segments of a program, frequently including designation of the routines or subject matter, performers, site if remote, time, and so on.

RT Reel type.

Rundown sheet Sometimes used interchangeably with **routine sheet,** but generally not as detailed.

Scenario Film script outline.

Scroll Moving the computer screen up or down. At one time it was used to list credits on a television show, and sometimes still is where state-of-the-art equipment is unavailable.

SE Sound effects.

Segue Transition from one radio sound source to another.

Server Computing system in a network that shares its resources with other computers.

Service announcement Short informational announcement, not necessarily completely of a public service nature but similar in form to the **PSA.**

SFX Sound effects.

Share The percentage of all television sets actually on at a given time that are tuned to a given program; see **Rating.**

Sitcom Television situation comedy; a staple of television programming since the 1950s.

SL Studio location.

Slide An individual picture, often used in broadcast news, and very frequently in corporate video, with a complete presentation in the latter consisting of slides and voice-over narration. Usually 35 mm format, sometimes larger.

SOF Sound-on-film; frequently describes a news insert, but also refers to other format segments.

Soft news/soft lead Presentation of the feature aspects, such as human interest, rather than the hard facts of the news story; see **Hard news/hard lead.**

Software Instructions telling a computer what operations to perform.

SOT Sound-on-(video)tape; same use as **SOF,** sound-on-film.

Split screen Two or more separate pictures on the same television screen.

Stock Film or tape footage previously recorded that might be used for the present script.

Storyboard Frame-by-frame drawings showing a program's video and audio sequences in chronological order; essential in preparing and selling commercial announcements and sometimes required in showing development of a film story.

STV Subscription or pay television.

Summary An overview of a proposed script, summarizing the idea and content for a prospective producer.

Super Superimposition of one picture over another in television.

Switching See **Cutting.**

Synthesizer See **Electronic synthesizer.**

Talk The term applied to a program that concentrates on interviews, conversations, and other forms of talk.

Tease A program segment, announcement, intro, or other device to get the attention and interest of the audience.

Teleconference An important aspect of corporate video, it enables individuals or groups to hold meetings and conferences although separated by distances.

Tilt Vertical movement of the camera from a fixed position.

Titles Credits and other printed information on the television screen.

Track, track up Following a subject with a camera (see **Follow shot**); raising the intensity of the sound. Used in video as a cue from the director to bring up the pre-recorded audio on a tape that will be currently on line: The director might say, "Roll VTR #1 and track it," meaning that both the video and the audio will be on line.

Travel shot Lateral movement of the dolly and camera. Also called a **truck shot.**

Treatment See **Scenario.**

Truck shot Lateral movement of the dolly and camera. Also called a **travel shot.**

2S Two-shot, the inclusion of two performers in the picture.

URL Universal Resource Locator; an Internet address.

United Press International (UPI) One of the wire services used extensively by news programs.

VCR Videocassette or videocartridge recorder.

VDT Video Display Terminal—the computer screen.

Verification Double-checking the sources of a story to be certain that it is accurate.

Videodisc Successor to videotape; looks and plays like a record and carries large amounts of easily recoverable video information.

Videotape Magnetic tape used for recording, storage, and playback of segments of or an entire television program.

Vidifont See **Character generator.**

VO, V.O. Voice-over; the narrator or performer is not seen.

VTR Videotape recorder.

Webcasting Programs on the Internet.

Web site A set of interconnected Web pages, usually including a home page. Prepared and maintained as a collection of information by a person, group, or organization.

Wide angle lens A lens of short focal length that encompasses more of the subject area in the picture.

Wide shot (WS) Another term for the long shot or establishing shot.

Windows The operating system used in most computers, frequently updated, requiring purchase of a new Windows system.

Wipe A picture beginning at one end of the screen that moves horizontally, vertically, or diagonally, pushing or wiping the previous picture off the screen.

Wirephoto Photo transmitted through telephone for use in news broadcasts.

Worldwide Television News (WTN) Provides services to radio, television, and cable.

World Wide Web or WWW Frequently referred to as the "Web," an Internet client-server hypertext distributed information retrieval system; the global interconnected computer networks. Access is through a universal HTML entry code, followed by "www" and the Internet address.

Wrap, wrap-up The closing for a news program.

WS Wide shot.

WTN Worldwide Television News

XCU Extreme close-up.

XLS Extreme long shot.

ZO Zoom.

Zoom Changing the variable focal length of a lens during a shot to make it appear as if the shot were moving toward or away from the viewer.

Selected Readings

History, Policy, Production, Management

Barnouw, Erik. *A History of Broadcasting in the United States.* In three volumes: *A Tower in Babel* (to 1933), *The Golden Web* (1933–1953), *The Image Empire* (1953–1970). New York: Oxford University Press, 1966, 1968, 1970.

Benedetti, Robert L. *From Concept to Screen: An Overview of Film and Television Production.* Boston: Allyn & Bacon, 2002.

Briggs, Asa, and Peter Burke. *A Social History of the Media: From Gutenberg to the Internet.* Malden, MA: Blackwell, 2002.

Hilliard, Robert L., and Michael C. Keith. *The Broadcast Century (A History of American Television and Radio).* Boston: Butterworth-Heinemann/Focal Press, 3rd edition, 2001.

Hilliard, Robert L., and Michael C. Keith. *Global Broadcasting Systems.* Boston: Butterworth-Heinemann/Focal Press, 1996.

Johnston, Carla Brooks. *Screened Out: How the Media Control Us and What We Can Do About It.* Armonk, NY: M. E. Sharpe, 2001.

Keith, Michael C., *The Radio Station.* Boston: Focal Press. 6th edition, 2003.

Millerson, Gerald. *Technique of Television Production.* Boston: Focal Press, 13th edition, 1999.

Pringle, Peter K. *Electronic Media Management.* Boston: Focal Press, 4th edition, 1999.

Sterling, Christopher H., and John Michael Kittross. *Stay Tuned: A History of American Broadcasting.* Mahwah, NJ: Lawrence Erlbaum, 2002.

Whittaker, Jason. *Web Production for Writers and Journalists.* New York: Routledge, 2002.

Zettle, Herbert. *Television Production Handbook.* Belmont, CA: Wadsworth, 8th edition, 2002.

Commercials

Bly, Robert W. *The Online Copywriter's Handbook.* New York: McGraw-Hill, 2002.

Gettins, Dominic. *The Unwritten Rules of Copywriting: Better Press, Poster, TV, Radio and Web Site Advertising.* London: Kogan Page, 2000.

Meeske, Milan D. *Copywriting for the Electronic Media,* 4th edition. Belmont, CA: Wadsworth, 2003.

Zeff, Robin Lee. *Advertising on the Internet.* New York: Wiley, 1999.

News

Cappon, Rene J. *The Associated Press Guide to Newswriting.* Forest City, CA: IDG Books, 2000.

Carroll, Victoria. *Writing News for Television.* Ames: Iowa State University Press, 1997.

Chantler, Paul. *Local Radio Journalism.* Boston: Focal Press, 1997.

Harper, Christopher. *And That's the Way It Will Be: News and Information in a Digital World.* New York: New York University Press, 1998.

Johnston, Carla Brooks. *Global News Access: The Impact of New Communications Technologies.* Westport, CT: Praeger, 1998.

Yorke, Ivor. *Basic TV Reporting.* Boston: Focal Press, 1997.

Drama

Baker, George P. *Dramatic Technique.* Reprint of 1919 edition. Westport, CT: Greenwood Press.

Blum, Richard A. *Television and Screen Writing: From Concept to Contract.* Boston: Focal Press, 1995.

Cooper, Dona. *Writing Great Screenplays for Film and TV.* New York: Macmillan, 2nd edition, 1997.

Dawson, Jonathan. *Screenwriting: A Manual.* South Melbourne: Oxford University Press, 2000.

Marc, David. *Comic Vision: Television Comedy and American Culture.* Malden, MA: Blackwell, 2nd edition, 1997.

Rouveról, Jean. *Writing for Daytime Drama.* Boston: Focal Press, 1992.

Rowe, Kenneth. *Write That Play.* New York: Funk and Wagnalls, 2nd edition, 1969.

Smethurst, William. *Writing for Television: How to Create and Sell Successful TV Scripts.* Plymouth, MA: How-to-Books, 2nd Edition, 1998.

Talk Shows

Grinstaff, Laura. *The Mopney Shot: Trash, Class, and the Making of TV Talk.* Chicago: University of Chicago Press, 2002.

Hilliard, Robert L., and Michael C. Keith. *Waves of Rancor: Tuning in the Radical Right.* Armonk, NY: M. E. Sharpe, 1999.

Hilliard, Robert L., and Michael C. Keith. *Dirty Discourse: Sex and Indecency on American Radio.* Ames: Iowa State University Press, 2003.

Keith, Michael C. *Sounds in the Dark.* Ames: Iowa State University Press, 2001.

Keith, Michael C. *Talking Radio.* Armonk, NY: M. E. Sharpe, 2000.

Kurtz, Howard. *Hot Air.* New York: Basic Books, 1997.

Shattuc, Jane. *The Talking Cure.* New York: Routledge, 1997.

Timberg, Bernard, and Robert J. Erler. *Television Talk: A History of the TV Talk Show.* Austin: University of Texas Press, 2002.

Children's Programs

Buckingham, David, ed. *Small Screens: Television for Children.* New York: Leicester University Press, 2002.

Pecora, Norma Odom. *The Business of Children's Entertainment.* New York: Guilford Press, 1998.

Priddy, Morris. *Production and Marketing of a Pilot Episode of a Children's Television Show.* Virginia Beach, VA: Regent University, 1998.

Music, Documentary, Interviews, Soaps, Corporate, Other

Biagi, Shirley. *Interviews That Work.* Belmont, CA: Wadsworth, 2nd edition, 1991.

Bonime, Andrew, and Ken C. Pohlmann. *Writing for New Media.* New York: Wiley, 1998.

DiZazzo, Raymond. *Corporate Scriptwriting.* Boston: Focal Press, 1992.

Hobson, Katherine. *Music Industry and the Internet: Usage, Retail & Digital Distribution Projections.* New York: Jupiter Communications, 1998.

Internet Underground Music Archive. *Music's Online Future.* Santa Cruz, CA: IUMA, 1998.

Kilborn, R.W. *An Introduction to Television Documentary: Confronting Reality.* New York: St. Martin's, 1997.

Magne, Lawrence. *1997 Passport to Web Radio: Music, Sports, News and Entertainment from the Hometowns of the World.* Penn's Ark, PA: IBS North America, 1997.

Rosenthal, Alan. *Writing Docudrama: Dramatizing Reality for Film and TV.* Boston: Focal Press, 1994.

Writer's Market. Cincinnati: Writer's Digest Books, published annually; includes "Jobs and Opportunities for Writers."

Van Nostran, William. *The Media Writer's Guide: Writing for Business and Educational Programming.* Boston: Focal Press, 2000.

New Media

Bonim, Andrew, and Ken C. Pohlman. *Writing for New Media.* Hoboken, NJ: John Wiley & Sons, 1997.

Callaham, Christopher. *Journalist's Guide to the Internet.* Boston: Allyn & Bacon, 2nd edition, 2002.

Garrand, Timothy. *Writing for Multimedia and the Web.* Oxford: Focal Press, 2001.

Price, Jonathan and Lia. *Hot Text: Web Writing That Works.* Indianapolis: New Riders, 2002.

On the Web

Contentious, a monthly "Web-zine" for online writers and editors. www.contentious.com

Online Journalism Review. www.ojr.org

Rank Writing Roundtable. www.rankwrite.com

Sun Microsystems guidelines for writing for the Web. www.sun.com/980713/webwriting

Webgrammar. www.webgrammar.com

Writer's Guild of America, West and East. www.wga.org/

Writer's Market. www.writersmarket.com

Writing or advice for freelance writers. www.writing.org

Index